W9-BCN-198

Flammarion Iconographic Guides

The Bible and the Saints

FLAMMARION ICONOGRAPHIC GUIDES

THE BIBLE AND THE SAINTS

GASTON DUCHET-SUCHAUX
MICHEL PASTOUREAU

Flammarion

Paris - New York

Designed by Yves Raynaud
Design adapted for the English edition by Michael Phillips
Picture research by Béatrice Petit
English translation by David Radzinowicz Howell
Edited by Jane Havell
Additional research by Susan Bolsom-Morris

Origination by Bussière Arts Graphiques, Paris
Printed and bound by Mame Imprimeurs, Tours

Flammarion
26, rue Racine
75006 Paris

Copyright © Flammarion 1994.
All rights reserved. No part of this publication may be
reproduced in any form or by any means, electronic,
photocopy, information retrieval system, or otherwise
without written information from Flammarion.

ISBN: 2-08013-575-9
Numéro d'édition: 0810
Dépôt légal: July 1994

Printed in France

REFERENCE
BS
513.2
.D8313
1994

Names of Books of the Bible, in order, with their abbreviations

(All quotations in this book have been taken from the Authorized Version of 1611)

Old Testament

Genesis	Gen.
Exodus	Ex.
Leviticus	Lev.
Numbers	Num.
Deuteronomy	Deut.
Joshua	Jos.
Judges	Judg.
Ruth	Ruth
1 Samuel	1 Sam.
2 Samuel	2 Sam.
1 Kings	1 Kings
2 Kings	2 Kings
1 Chronicles	1 Chron.
2 Chronicles	2 Chron.
Ezra	Ezra
Nehemiah	Neh.
Esther	Esth.
Job	Job
Psalms	Ps.
Proverbs	Prov.
Ecclesiastes	Ecc.
Song of Solomon	Song
Isaiah	Is.
Jeremiah	Jer.
Lamentations	Lam.
Ezekiel	Ez.
Daniel	Dan.
Hosea	Hos.
Joel	Joel
Amos	Amos
Obadiah	Ob.
Jonah	Jon.
Micah	Mic.
Nahum	Nah.
Habakkuk	Hab.
Zephaniah	Zeph.
Haggai	Hag.
Zechariah	Zech.
Malachi	Mal.

New Testament

Matthew	Matt.
Mark	Mark
Luke	Luke
John	John
The Acts	Acts
Romans	Rom.
1 Corinthians	1 Cor.
2 Corinthians	2 Cor.
Galatians	Gal.
Ephesians	Eph.
Philippians	Phil.
Colossians	Col.
1 Thessalonians	1 Thess.
2 Thessalonians	2 Thess.
1 Timothy	1 Tim.
2 Timothy	2 Tim.
Titus	Tit.
Philemon	Phil.
Hebrews	Heb.
James	Jam.
1 Peter	1 Pet.
2 Peter	2 Pet.
1 John	1 John
2 John	2 John
3 John	3 John
Jude	Jude
Revelations	Rev.

INTRODUCTION

A Practical Guide

This guide has been designed to help those countless people who tour churches, museums, exhibitions and great houses, and who want to be able to identify those scenes they encounter containing saints or Bible figures, and understand their meaning. Its purpose, therefore, is essentially practical and it does not seek to be exhaustive. Alphabetical order has been adopted for its evident simplicity; the saints, Biblical characters and scenes from the Old and New Testaments are listed under their most frequent designations. This arrangement will enable readers to remind themselves of the precise meaning of, say, the Ascension of Christ, the Assumption of the Virgin or Pentecost, or of what the expression Ecce Homo means, or what exactly Candlemas or the Trinity are. In the major groups of entries, such as the Life of Christ, the various episodes are presented separately, under specific headwords (these also appear together under the main heading for ease of reference).

The guide also contains a series of subject entries, designating animals (real and imaginary), plants, objects, allegorical personifications and certain religious dignitaries (such as the pope, archbishop, bishop, abbot, deacon and pilgrim), as well as a few of their insignia of office (the mitre, for example).

STRUCTURE OF THE ENTRIES

For the sake of clarity, each entry is of a similar structure. At the top are the different forms of the name or the expression in the main European languages. With people, this is followed by their quality or position (martyr or archbishop, for example) and dates (together with dates of canonization and feast days where relevant).

The entry itself is divided into two main sections: LIFE AND LEGEND for saints or TRADITION for Biblical personages or scenes, followed by REPRESENTATION AND ICONOGRAPHY, which lists various illustrations of the theme in art, the artists' names, where the works are to be found and their dates.

This section also includes a brief account of the evolution of motifs. A catalogue of the main attributes of the personage enables him or her to be quickly identified. Each entry ends with cross-references and a brief bibliography.

SOURCES AND SELECTION

The main bibliography (pages 357-9) gives the essential reading matter in this area. The authors would like especially to acknowledge their admiration for and their debt to Louis Réau's *Iconographie de l'art chrétien*. Reference should if possible be made to that work for any figures and episodes not treated in this guide. Louis Réau's detailed and extensive volumes address, in a methodical manner, the immense majority of questions posed by Christian and Biblical iconography. The other work which made a considerable contribution to the compilation of this guide is the seven-volume *Lexicon der christlichen Kunst*.

Any selection necessary for reasons of space is of course difficult, given the great number of saints and Biblical characters. Figures of greatest iconographical significance were chosen, to give a total of some three hundred entries.

ICONOGRAPHICAL BACKGROUND

An account of saints and their attributes is, in general, relatively simple. Attributes are nearly always linked either to episodes from the saint's legend or to the form, or etymology, of his or her name. The Gospels, apocryphal texts and a mass of commentaries may be consulted to explain the choices made by artists (or by those who instructed them) as to how they portrayed Mary, Jesus, the Apostles, Evangelists or other New Testament figures. With other Biblical characters – from Adam and Eve to those in the Revelations – the approach has been to supply references to the Biblical text and to analyse the pertinent episodes. In this connection, the Fathers and Doctors of the Church are of inestimable value for the understanding of Biblical imagery.

Such supplementary information is essential to comprehend the nature of the scene depicted. It is also a necessary first step in trying to grasp the deeper meaning artists wanted to instil in their creations. All iconographic works of art are related to a context which is in constant flux from one period to the next. The bibliographical details given at the end of each entry will allow readers to gauge the complexity of these issues for themselves should they wish to continue their research.

EXAMPLES OF ANALYSIS

The following examples of analysis should illuminate some of the iconographical problems the authors have encountered, and indicate the chosen methods of dealing with them. Pierre Courcelle, in the *Cahiers archéologiques* for 1948, published under the title "St Laurence's Gridiron" a study of a

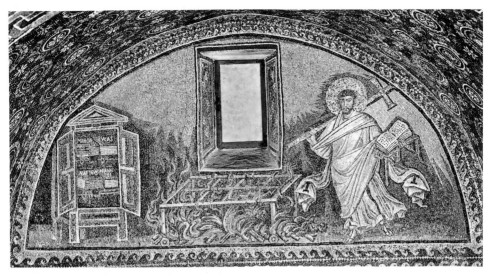

mosaic in the mausoleum of Galla Placidia, the object of some considerable scientific investigation. This mosaic shows a figure standing on the right with a nimbus around his head, dressed in white and carrying a cross in his right hand and an open book in his left. There is no inscription to indicate who he is or what book he is holding. In the centre, there rages a wood fire surmounted by a kind of griddle. This griddle, or gridiron, is equipped with what appear to be four little casters which have always intrigued scholars. On the left stands a cupboard and through its wide-open doors can be read the names of the Evangelists above the four volumes of the Gospels lying on two shelves.

St Laurence
Fifth century. Mausoleum of Galla Placidia, Ravenna.

This image was first thought to portray St Laurence. The gridiron, however, is not the attribute of St Laurence alone, but also that of St Vincent of Saragossa. Can an image of St Laurence reasonably be expected to form part of the decorative scheme of the whole edifice? In fact, the decor includes a number of other images which evoke the martyrdom of St Laurence, but none of them resembles the mosaic in question, either in style or composition. It is not easy to identify positively the figure carrying the cross and the book as St Laurence on his way to martyrdom. Moreover, what is the significance of the little wheels on the griddle?

Courcelle began by examining various existing hypotheses. The haloed figure had been thought to represent Christ himself, but this theory is weakened by the presence of another mosaic, in the same format, representing the Good Shepherd with his flock. Moreover, Christ always wears purple vestments wherever he is depicted in the building and the figure carrying the cross on this mosaic is dressed in white. An eschatological interpretation had also been proposed in which the gridiron was the image of the altar of burnt offering upon which, according to a Syriac version of the Old Testament, sinners

9

were immolated. The gridiron here has nothing in common, however, with the wood and brass altar described in Exodus (27:1-8).

Courcelle was inclined to identify the mosaic as a symbolic interpretation of the martyrdom and vocation of St Laurence. He based his conclusion on his discovery of an authentic text of the fifth or sixth century in an anthology of homilies ascribed, for the most part incorrectly, to Fulgentius. The allegorical interpretation advanced by this text mentions both the gridiron with wheels and the martyr walking to heaven carrying his cross. Courcelle did not conclude from this that the figure is undeniably that of St Laurence, but he considered the text to be generally in accordance with the environment of the building, cautiously stating: "The two mosaics [that apparently representing the martyrdom of St Laurence and that of the Good Shepherd] are complementary. In the former, Galla Placidia, by modelling herself on St Laurence, affirms her faith amidst the cares of the world while in the latter she expresses her hope for the reward of that faith, the expectation of eternal life."

The mosaic has since been the subject of a study by the Canadian scholar, Gillian Mackie, of the University of Victoria. Her 1990 article, "New light on the so-called Saint Lawrence panel at the Mausoleum of Galla Placidia, Ravenna" (*Gesta*, vol. XXIX, 1), demonstrated that the figure might well be St Vincent and not St Laurence after all. Mackie stressed the links between Galla Placidia and the Iberian Peninsula and noted the presence of relics of St Vincent at Ravenna in the sixth century. The scene on the mosaic becomes much clearer when compared to the *Peristephanon* ("Crowns of Martyrs") of Prudentius (384–c.410). The judge Dacien, enraged by Vincent's steadfastness in the face of imminent execution, ordered: "'Let the ultimate tortures be applied – fire, gridiron and heated blades.' Vincent, with rapid step, makes haste towards these gifts. Sprightly, joyous, he hurries on faster than his torturers." (Hymn, *Corona*, v. 205-212). Mackie has thrown new light on this iconographic conundrum, yet it remains unsolved. Texts make a crucial contribution to the explanation and understanding of images which may at first appear mysterious.

Another famous enigma is provided by a number of works illustrating the miraculous cures ascribed posthumously to SS. Cosmas and Damian, the *anargyroi* or "penniless doctors". The sacristan of the church of SS. Cosmas and Damian in Rome suffered from gangrene. Thanks to the mysterious intercession of the two saints, the affected leg was amputated and successfully replaced by that of a recently deceased black man. J. Devisse and M. Mollat in *L'Image du Noir dans l'art occidental*, have a section on this singular theme, depicted most famously by Fra Angelico and his studio in the 1440s on a retable in St Mark's, Florence. The authors stress the cryptic nature of the theme before enumerating various plausible hypotheses that might account for it in the light of critical and historical methods. The episode was illus-

trated for the first time in Tuscany on the predella of a retable by the Master of Rinuccini (now in the North Carolina Museum of Art, Raleigh). It is enlightening to take into account the contemporary context when considering the undoubtedly pejorative attitude towards the black races and to "Moors" embodied by this anecdote. The fourteenth century had more than its fair share of calamities: not only wars, but plague – the Black Death – blighted the population. Furthermore, Islamic expansionism, which gathered momentum inexorably after the surrender of Acre to the Mamluks in 1291, was in the forefront of European minds. But it is a reference to the influence of ancient medicine that supplies the missing piece of the puzzle. According to Galen, Hippocrates recommended treatment *contraria contrariis* – that is, "with opposites". Hence it was thought that the only way to get such a transplant to take was to use a black leg to replace the white one.

Certain formal modifications to cults and legends can also be explained by the changes in emphasis that distinguish the religious life of different periods. Recently, particular stress has been laid on the political background affecting the treatment of certain saints. The Merovingian princess, Radegund, came to the fore in the fifteenth century under the Valois, who pressed her story into service for their own purposes. Similarly, Joan of Arc, who had fallen into relative obscurity by the sixteenth century, became incredibly popular during the nineteenth and twentieth, when modern nationalism – the spoilt child of the French Revolution – latched on to her legend to forge her into a new-style incarnation of the homeland. It is also tempting to evoke the extraordinary metamorphosis of St Hubert during the fifteenth century. He started out as a simple bishop of Liège, only to inherit sections of the legend of the miraculous huntsman St Eustace who had previously been close to the hearts of a warring aristocracy still nostalgic for its knightly past. And one only has to think of Henry VIII's destructive reaction to the growing cult of the twelfth-century Thomas Becket to realise the political importance of such figures at historical turning points.

St Vincent of Saragossa offers a further example of transformation. A vast amount of imagery recounts the episodes of his martyrdom. St Vincent was the deacon of Valerius, Bishop of Saragossa, and was martyred at the beginning of the fifth century. The judge Dacien, who put him to death and who also appears in the legends of St Eulalia, St Sophia and St Faith, is an entirely fictional character. Vincent was racked on a cross saltire, slashed with iron combs, then placed naked on a red hot gridiron. The saint, however, remained unbowed through these trials. He was then thrown into a dungeon carpeted with earthenware shards (or pieces of broken glass) where he was left to die. A miraculous host of angels arrived and the air in the cell was filled with a sweet-smelling cloud. Vincent finally expired. Like a true martyr, he continued to defy his executioner even after death. Dacien inflicted the ultimate opprobrium on his victim by refusing burial to his corpse. The body

was thrown on to wasteland for scavengers. But a huge raven defended the saintly corpse against foragers and even saw off an enormous wolf. Dacien, in a last attempt to be rid of it, tied a millstone round its neck, wrapped it in an animal skin, and had it thrown overboard from a boat. The body was miraculously conveyed to the shore to be given burial by the faithful of Valencia.

The final act of St Vincent's adventure comprises another series of various and contradictory narratives concerning the translation of his remains. One version has the corpse purloined by the Abbot of Conques who finally takes it to Castres, while an iconographically more fruitful version refers to St Vincent in his capacity as patron of Lisbon and reflects an aspect of the start of the Reconquista during the reign of Henry I of Portugal. At first, the saint's body was removed from Valencia to preserve it from the malicious intentions of a Muslim emir and transported to what is now Cape St Vincent near Lagos in Portugal. The saint's tomb was finally discovered by King Alfonso Enriquez (1109-85) and the body ceremoniously removed from Cape Vincent to Lisbon. Two ravens escorted the boat carrying the corpse – one on the prow and the other at the stern.

The changing fortunes of this legend nourished St Vincent's iconography from the twelfth century onwards. The gridiron that was supposed to have been used during his martyrdom and the raven that protected his corpse have since become his personal attributes.

But other problems arise in connection with this saint's representation in art. In the first place, the gridiron is shared by St Laurence. Secondly, such a method of torture was not among those prescribed in the legal system of the later Roman Empire. It was employed, however, in the eastern reaches of the Roman world, and these details may have been imported from the Orient, in written or oral form, and incorporated into the life of St Vincent by those responsible for his legend. They were only transferred to the legend of St Laurence at a later date.

A further richly developed theme is that of the raven. This bird, praised in The Song of Solomon for its black plumage, had acquired by the medieval period a negative connotation, derived from a commentary by St Augustine on a passage of the Bible that had been mistranslated by St Jerome. In the Vulgate, the raven is described as "not returning" (*non revertebatur*) to Noah's Ark after being set free during the Flood. The dove, of course, did return – with an olive branch in its beak. In fact, the Hebrew text states that the raven "came and went". St Augustine's hostility to the bird therefore partially issues from a misunderstanding. It is nonetheless indisputable that the colour connotations of the white dove and the black raven must have had an influence.

The raven, however, plays a positive role in many legends, including those of St Benedict and St Paul as well as St Vincent. It may possess an emblematic function comparable to the sign of the raven depicted on early

medieval war standards of certain Germanic tribes, which may have been derived from the bird's role as the insignia of Odin, god of war.

The legend of St Vincent has remained more or less constant up to the modern period. Yet a fundamental shift occurred around the sixteenth century and became more acute in the seventeenth, when Vincent was adopted as patron by a number of brotherhoods of vine-growers. A number of powerful wine-producing monasteries placed themselves under Vincent's protection, and guilds were gaining increasing influence at that period. The saint's iconography is thenceforth primarily constituted by evidence of their veneration. He is shown holding a pruning-knife and a bunch of grapes, while the more traditional attributes of his martyrdom (gridiron and raven) are relegated to accessories. Historical factors can often explain certain details, as well as the transformations undergone by numerous saints' legends, which initially may appear strange.

St Genevieve underwent radical changes in her appearance and importance. Her iconography was traditionally devoted to that part of her legend when the devil repeatedly extinguished her candle and an angel kept on relighting it. Suddenly, in the sixteenth century, this great Merovingian foundress – who inspired her countrymen to stay calm as invaders arrived at the gates of Paris – was metamorphosed into a shepherdess tending her flock. Why, and how? It may well have been that the new cult of Joan of Arc had taken over the role of national defender.

Not all the complex problems furnished by these examples have been resolved. It is hoped that this guide, as well as providing sufficient information for basic research, will stimulate some readers to venture further into a vast and largely uncharted territory of scholarship

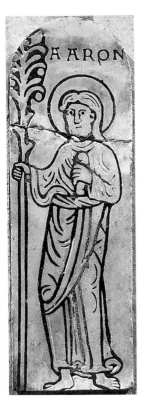

**Aaron and his
Budding Rod**
Tomb of St Lazarus, twelfth
century. Musée Rolin,
Autun, France.

AARON

Italian: Aronne; Spanish: Aarón; French and German: Aaron.

TRADITION
Of the race of Levi, Moses' brother and spokesman to both the Hebrews and the Pharaoh (Ex. 4:14-31, 5:1), Aaron stands by Moses in the battle against the Amalekites and is with him on Mount Sinai. He is traditionally considered to be the paragon of the high priest. Gods selects him from among his people by the miracle of the budding rod (Num. 17:16-26).

REPRESENTATION AND ICONOGRAPHY
At the end of antiquity and at the beginning of the middle ages, Aaron is dressed as a high priest with a bonnet resembling a tiara (frescoes of the Synagogue at Dura-Europos, c.245). In the middle ages proper, he is depicted as a bishop with a mitre or pointed hat. He carries a flowering rod or a censer (Goldene Pforte, Freiburg, Germany, early thirteenth century; archivolt of the south door of Amiens Cathedral, thirteenth century). Among the prophets, he can be recognized in niches of cathedral portals by the budding or flowering rod, which has occasionally been thought of as the archetype of the crozier carried by bishops and abbots. He also appears in scenes from the life of Moses. On the mountain, he embraces his brother. He "stayed up" Moses' hand during the battle against the Amalekites, thereby ensuring Joshua's victory (Ex. 17:12) and filled a pot with manna (Ex. 16:33).

The miracle of the budding of the rod is a frequent subject, enabling Aaron's rod to be easily distinguishable among the serried ranks of the rods of the twelve tribes of Israel (bronze door of the Church of San Zeno, Verona, eleventh century; font at Hildesheim, thirteenth century). At the end of the medieval period, the motif is employel as a sign of Mary's virginity (Jan Van Eyck, *The Virgin with the Provost van Maelbeke*, 1441, Warwick Castle, private collection). The budding rod is also employed as a symbol of the Cross.

Attributes: Budding or flowering rod. Censer.
Cross-references: Moses, Golden Calf.
Bibliography: L. Réau, op. cit., vol. II, 1, pp. 213-6.

ABBOT

Latin: abbas; Italian: abate; Spanish: abad; French: abbé; German: Abt.
The vestment worn by the abbot is that of his religious order. The crozier is his distinctive attribute.

Cross-references: Benedict, Bernard, Brendan, Colomban, Fiacre, Gallus, Giles, Odilia, Radegund.

ABEL *see* CAIN AND ABEL.

ABIGAIL *see* DAVID (DAVID AND ABIGAIL).

Abraham

Hebrew: Abram; Italian: Abramo; Spanish, French and German: Abraham.

Tradition

The events (Gen. 12) concerning Abraham, initially called Abram (Gen. 17:15), took place around 2000 BC. The name Abraham ("Friend of God") derives from his obedience to God's command that he leave the south Mesopotamian town of Ur and move north. He first reached Haran (north of the upper reaches of the Euphrates) and continued to Palestine with his wife Sarai (later Sarah) and his nephew Lot. Abraham and Lot then went their separate ways, the former to the north towards Hebron, the latter to the south, in the direction of Sodom and Gomorrah. Lot was captured by a band of brigands who were later routed by Abraham. The high priest, Melchizedek, brought bread and wine to the victor and God revealed to Abraham the fate reserved for Sodom and Gomorrah.

Too old to conceive, Sarah gave Abraham her slave, Agar, as a concubine. This union resulted in the birth of Ismael but, after a visit from three mysterious messengers on the plains of Mamre, Sarah gave birth to a son, Isaac. She then drove Agar and Ismael into the desert. At this time Abraham is supposed to have been one hundred years old. He continued to Gerar, where he pretended that Sarah was his sister, but the trick was discovered when the king tried to enlist Sarah in his harem. The king returned Sarah to Abraham (Gen. 20). God then put Abraham's faith to the ultimate test by commanding that he offer his own son as a sacrifice, but he relented just as Isaac was about to be killed (Gen. 22).

Representation and Iconography

Artists have illustrated many episodes from Genesis in which Abraham appears: God's commandment; Abraham's separation from Lot; his meeting with Melchizedek (which is treated both as a sign of the Christian Eucharist and as a prefiguration of the Adoration of the Magi); the visit of the three

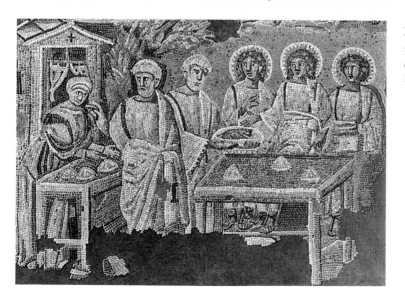

Abraham and the Three Visitors
Mosaic (detail), fifth century. S. Maria Maggiore, Rome.

angels or messengers on the plains of Mamre; Agar's exile and, most frequently perhaps, the sacrifice of Isaac. Abraham can be shown at his prayers (catacomb of Callista in Rome, third century). From the earliest periods, he is depicted as an old man with white hair and a long white beard. In the middle ages, he sometimes appears in the guise of a knight in remembrance of his victory over Lot's enemies.

Among the motifs most highly regarded for their symbolic value, the meeting with Melchizedek, the three visitors and the sacrifice of Isaac require detailed treatment.

The Meeting with Melchizedek

Eucharistic symbolism predominates in this episode. The priest–king wears a crown and holds a chalice or censer. In a series of frescoes from the Church of St Savin sur Gartempe in Vienne (twelfth century), he is consecrating a round loaf marked with a cross. On a relief on the back of the façade of Reims Cathedral traditionally called *The Knight's Communion*, Melchizedek in priestly vestments offers the host to Abraham, who is dressed as a thirteenth-century horseman returning from battle. The theme was also treated by Rubens in the seventeenth century (Musée de Caen, France) and in the eighteenth by Jean Restout (*The Offering of Melchizedek*, 1754, Church of Maastricht).

The Three Visitors at Mamre

In the east, this episode is interpreted as symbolizing the Trinity, the angel in the middle representing God the Father (Andrei Rublev, *The Holy Trinity*, c.1411, Tretyakov Gallery, Moscow). In the western Church, the scene occurs in the nave of the Basilica of S. Maria Maggiore in Rome (fifth century), and in the next century it is found on the mosaic in the presbytery of San Vitale in Ravenna. Rembrandt also painted the scene (1646, Von Pannwitz collection, Bennbrock, Haarlem). For western theologians the episode also symbolizes the virtue of hospitality. The announcement to Abraham of the birth of Isaac is an anagogical symbol of the Annunciation.

The Sacrifice of Isaac

In Judaism, this episode symbolizes the believer's total confidence in the word of God. For Christians, it prefigures rather the sacrifice of Christ on the Cross or the bloodless but real sacrifice of the Eucharist. One of the oldest representations is to be found on the frescoes of the Synagogue in Dura-Europos (c.245). A bronze relief by Bartolommeo Bellano (San Antonio, Padua, second half of the fifteenth century) also illustrates the sacrifice in the early Renaissance. Both Lorenzo Ghiberti and Filippo Brunelleschi depicted the scene in the competition panels for the doors of the Florence Baptistry (1401, Bargello, Florence). The Hand of God often appears emerging from the sky to restrain Abraham at the moment of sacrifice. Rembrandt (1636, Hermitage, St Petersburg) shows Abraham still covering Isaac's face with his left hand after his right has been held fast by an angel. Caravaggio treats the scene with a dose of realism: Isaac screams in terror as his father grasps him round the throat, to be restrained by an angel (1603, Uffizi, Florence).

Abraham's Bosom

The souls of the righteous, such as that of Lazarus the beggar in the parable of St Luke, are received by Abraham into "his bosom" (Luke 16:22). This motif was especially frequent in French medieval sculpture (for example, Church of Moissac, twelfth century). It forms an integral part of scenes of the Last

Judgment (Notre Dame, Paris, thirteenth century). On the portal of Reims Cathedral, the souls of the just are carried up into Abraham's bosom on lengths of cloth. The motif is also met with in Germany (Fursten Tur, Bamberg, thirteenth century). In Byzantine art, Abraham is seated on a throne beside Isaac and Jacob. The mosaic on the dome of the Florence Baptistry (thirteenth century) strongly emphasizes the analogy between the three patriarchs and the Trinity.

Cycles
A large number of works tell the life story of Abraham (mosaics in St Mark's, Venice, twelfth century, and in the Cappella Palatina, Palermo, thirteenth century; tapestry on designs by Bernard Van Orley, second quarter of the sixteenth century, Kunsthistorisches Museum, Vienna).

Cross-references: Annunciation, God, Isaac, Last Judgment, Lot, Trinity.
Bibliography: E. Dhorme, *Abraham dans le cadre de l'histoire*, Recueil E. Dhorme, Paris, 1951. I. Speyert Van Woerden, "The Iconography of the sacrifice of Abraham", *Vigiliae Christianae*, 15, 1961, pp. 214-55.

ADAM AND EVE

Italian: Adamo ed Eva; Spanish: Adan y Eva; French: Adam et Eve; German: Adam und Eva

TRADITION
The story of Adam and Eve is told in the first few chapters of Genesis, at the end of the history of the Creation (Gen. 2; 3; 4:1-2). Jehovah first "formed man of the dust of the ground" (2:7) before creating Earthly Paradise (Eden), and placing man in it, "to dress and to keep it". Adam is allowed to eat "of every tree of the garden" except "the tree of the knowledge of good and evil" (2:15-17).

In a third episode, woman is created. Jehovah put Adam into a deep sleep and, taking one of his ribs, formed it into a woman. The man and woman "were both naked ... and were not ashamed" (2:25). Led into temptation by the serpent, the woman took a fruit from the Tree of Knowledge and ate it. She then offered some to Adam. "And the eyes of them both were opened and they knew that they were naked" (3:1-8). They then covered their nakedness with fig leaves and hid among the trees. After God's judgment and curse, Adam named his wife Eve from the Hebrew *havvah* (life), "because she was the mother of all living". God then made them "coats of skins" before banishing them from the garden. In conclusion the Bible states: "So [God] drove out the man, and he placed at the east of the garden of Eden Cherubims, and a flaming sword which turned every way, to keep the way of the tree of life" (3:24).

The Creation of Eve
Lucas van Leyden, 1529.
Rijskmuseum, Amsterdam.

The story of Adam and Eve has been the subject of countless commentaries, and comparisons with other creation myths. For St Paul, Adam was the first earthly man, whereas Christ is the "New Adam", of divine and celestial origin. The fall of Adam can be compared to Christ's descent into limbo between his death and his resurrection, while the temptation can be related to Jesus' similar experience in the desert (Matt. 4:1-11). For iconography, another telling detail is the occasional presence at the foot of the Cross of Adam (or of his skull) emerging from his grave streaked with Christ's blood.

In a mythological context, the story of Adam has been interpreted in

many different ways. Adam is the microcosm juxtaposed to the macrocosm, while other parallels have been drawn between his God-given dominion over the beasts and Orpheus's power to charm the animals. Catacomb art treated Orpheus as a Christ figure. Eve, whom the Bible designates as the "mother of all living" was quickly adopted by the Fathers of the Church as a symbol of the Church itself. She is thereby more or less assimilated to the Virgin Mary.

REPRESENTATION AND ICONOGRAPHY

Adam and Eve are naked and as such constitute one of the rare Biblical scenes which allow artists to depict the nude figure. Adam, the first man, is shown without a beard throughout the paleochristian era. In the middle ages, however, he also appears bearded. "Man of the mountain", his attribute is often a hill or a pedestal. For one theological tradition, Adam is also *homo caelestis*, and is therefore shown as the microcosm which reigns over the seven planets of contemporary astronomy. As the microcosm he is also, as the Bible makes clear, master over all the animals.

The Creation of Adam

This is represented in a number of forms. On paleochristian sarcophagi, God creates Adam by laying his hand on him or by literally breathing life into him. Elsewhere, the first man is animated by a ray of light coming from the Creator. The Creator can also be portrayed modelling Adam like a sculptor (archivolt of the north door, Chartres Cathedral, thirteenth century).

Adam in the Garden of Eden

God leads Adam through the door by the hand and towards the four rivers (Gen. 2:10-15). Once in Paradise, Adam is shown cultivating the earth or at prayer. Adam's dominion over the animals was not a particularly common subject and in the paleochristian period it is possible to confuse the simplicity of such scenes with those of the Good Shepherd and his flock.

The Creation of Eve

Owing to the symbolic interpretation of the creation of Eve and her union with Adam as the *sacramentum magnum* (the foundation of holy matrimony), this sequence was abundantly illustrated both in the Jewish and Christian traditions (fourth-century sarcophagus, Lateran Palace Museum, Rome; ninth-century Bible, St Paul outside the Walls, Rome). For Christianity, the events also prefigure the mystic marriage between Christ and his Church, and continue to be portrayed right up to the seventeenth century. Michelangelo shows Adam seeing this scene in a vision (Sistine Chapel, Vatican, 1509-10).

The representations of the scene based on Gen. 1:27 tend to show Adam and Eve lying side by side rather than the woman emerging from the man's flank. Gen. 2:21-24 describes the removal of one of Adam's ribs. Two alternative depictions have been adopted by artists. In one series of medieval illustrations, the extraction of the rib is shown first, followed by Eve standing up or else being fashioned by the Creator. In another series, Eve stands behind the sleeping figure of Adam or issues ready-formed from his side (Wiligelmo, reliefs, Modena Cathedral, 1099-1100). In the middle ages, the façade of Orvieto Cathedral (thirteenth century) presents Eve's birth in two separate scenes. In one, the Creator leans over Adam while, in the second, Eve comes forth complete from Adam's side. In the sixteenth century, both Raphael (1503-4, Città di Castello) and Michelangelo treat the theme, the latter exploiting the interpretation of Eve as both the Virgin and the Church (Sistine

Chapel). Although the motif was not very frequent in the baroque, the creation of man is one of the rare Biblical themes which has continued to fascinate modern artists (Fuseli approached the subject through the influence of Milton, *Creation of Eve*, 1793, Kunsthalle, Hamburg; Constantin Brancusi, *Adam and Eve*, 1921, Guggenheim Museum, New York).

The Fall

This sequence is heavily charged with symbolism and as such has been copiously illustrated. In the paleochristian period and in the early middle ages, it is related to the salvation of man, whose death results from Adam's fall and whose new life in heaven is the consequence of Christ's sacrifice. The theories of Philo (1st century AD), adopted by medieval theologians, consider Adam to be the Greek *nous* (spirit) while Eve represents the *aisthesis* (senses).

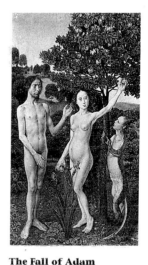

The Fall of Adam and Eve

Hugo van der Goes, early 1470s. Kunsthistorisches Museum, Vienna

The Fall can be seen painted on the walls of the catacombs and in relief on paleochristian sarcophagi. The constitutents of the scene – the figures, the tree and the serpent – are variously arranged and can be invested with different symbolic meanings. In the Roman catacomb of Priscilla (early third century), the serpent stands on the tip of its tail and Eve has already concealed her nudity behind a figleaf. The erect posture of the animal is doubtless intended to recall that only after its crime was the snake made to "go upon [its] belly". The relief decoration of the bronze doors of the Cathedral of Hildesheim (twelfth century) depict Adam, blind to the "dragon" behind him, eating the forbidden fruit Eve receives from the serpent. The Eve represented on the portal of Autun Cathedral (twelfth century) is justly celebrated: she is shown lying on her side and stretching her hand behind her towards the tree in which a devil's talons grasp the apple. On the piers supporting the archivolt in medieval cathedrals, there also occur figures representing the serpent itself with a woman's head. They appear as early as the twelfth century (Nicholas of Verdun, Klosterneuburg altarpiece, 1181, Klosterneuburg Stiftsmuseum, Austria).

From the Renaissance onwards, the symbolic value of the scene has been forgotten or simply ignored in favour of the psychology of the discussion between man and woman, a theme impregnated with humanist values. Anecdotal elements tend to predominate, sometimes with an interest in the erotic potential of the scene.

Judgment and Condemnation

As early as the third century (decoration in the catacomb of St Januarius, Naples), one can find an image of Adam and Eve stricken with shame and trying to conceal their nakedness behind the leaves in the garden. One type of composition, widespread from Carolingian manuscripts to Romanesque basilicas, is based on the notion of a cross-examination: God interrogates Adam, who deflects the questioning on to Eve, who in turn refers to the serpent.

Adam and Eve driven from Paradise

Either God in person commands Adam and Eve to leave or else an angel performs the task on his behalf. The angel carries a sword or emits flames. In later works, Eden is separated from the rest of the world by a wall or a door (Masaccio, Cappella Brancacci, S. Maria del Carmine, Florence, 1426-7, where both Adam and Eve are shown weeping). Other versions include Jacopo della Quercia's relief on the Fonte Gaia (1414-19, Palazzo Pubblico, Siena).

After the expulsion comes the expiation. In the middle ages, Adam's hav-

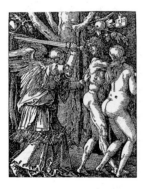

Adam and Eve expelled from Paradise
Dürer, 1510. Germanisches Nationalmuseum, Nuremburg.

ing to work the land as a penance is indicated by a wheatsheaf, and he is often depicted digging. A lamb signifies the spinning to which Eve is condemned. Adam may also be shown next to the wheel of the cherubim, symbolizing the passage of time to which he is now subjugated outside paradise (see Ez. 10).

Adam and Eve after the Expulsion
The theme of Adam and Eve with their children Cain and Abel was a particularly inspirational subject for miniature illuminations from the fifth to the thirteenth centuries. Eve is often shown consoling Abel while Cain turns away. The education of the children is occasionally portrayed. Cain watches Adam digging while Abel is linked to scenes of husbandry (*see* Cain and Abel). The Bible of Manfred (eleventh century, Vatican Library, Rome) shows a tree issuing from Adam's side as he sleeps. In this prototype of the Tree of Jesse, patriarchs appear in the tree's branches. The death of Adam is often linked to the Crucifixion.

Cross-references: Cain and Abel, Cherub and Seraph, Creation, Descent into Limbo, Hand of God, Mary, Tree of Jesse.
Bibliography: S. Esche, *Adam und Eva, Sündenfall und Erlösung*, Düsseldorf, 1957. A. Mazure, *Adam et Eve, le thème d'Adam et Eve dans l'art*, Paris, 1967. G. Sanoner, "La Bible racontée par des artistes du Moyen Age", *Revue d'art chrétien*, 5 (1909) and 6 (1910).

ADORATION OF THE MAGI *see* MAGI.

ADORATION OF THE SHEPHERDS *see* ANNUNCIATION TO THE SHEPHERDS, NATIVITY.

ADULTERY, ADULTERESS *see* WOMAN TAKEN IN ADULTERY.

AGAR *see* ABRAHAM.

AGATHA

Latin: Agatha, Gaetta; Italian: Agata, Gada; Spanish: Agueda, Gadea; French: Agathe; German: Agatha.
Virgin and Martyr. Third century. Feast day 5 February.

LIFE AND LEGEND
Born in Catania, Sicily, at the foot of Mount Etna, Agatha decided to remain a virgin and dedicate her life to Christ. The Prefect of Sicily, Quintian, hearing of her great beauty, tried to seduce her. Faced with her rejection, he sent her into a brothel, but even there she miraculously preserved her virgin state. She was then subjected to a singularly cruel torture. She was attached head down to a column, and her breasts twisted or torn off with a pair of pincers. The next day, St Peter visited her in her dungeon and healed her wounds.

She was then brought before a court and hauled over hot coals until she died, crying out her thanks to God.

Protector of Sicily, Agatha is invoked against the eruption of Etna and other volcanoes, as well as against lightning, fires and earthquakes. Her cult quickly gained the mainland and is strong in central and northern Italy (Cremona, for example) and as far as eastern France, Germany and Spain, where she protects against fire. She is also the patron saint of nursemaids, and of bell-founders (the latter apparently because of the resemblance in shape between bells and breasts).

REPRESENTATION AND ICONOGRAPHY

St Agatha is normally represented as a noble young girl carrying her severed breasts on a platter (Zurbarán, 1630-33, Musée Fabre, Montpellier) along with a pair of pincers. She is sometimes accompanied by St Lucy, who carries her eyes on a similar dish. She can also be shown alone, directly after her torture (Francesco Guarini, second quarter of the seventeenth century, Museo e Gallerie Nazionali di Capodimonte, Naples). Artists have often depicted the removal of her breasts and her martyrdom as acts of brutal sadism (Tiepolo, 1750, Staatliche Museen, Berlin-Dahlem; Cerrini, *Cycle of St Agatha*, c.1630, St Agatha of the Goths, Rome). Her healing by St Peter is a rarer theme (Karl Van Loo, second quarter of the eighteenth century, Musée Calvet, Avignon). She can be also represented as a victorious virgin carrying a palm or as a prophylactic saint, protecting against fire. In the latter case, she holds either a torch or a fiery rod, or else a veil with which she extinguishes the fire.

Attributes: Severed breasts. Dish. Pincers. Torch.
Bibliography: G. Consoli, *Sant'Agata virgine e martire catanese*, Catania, 1951.

St Agatha
Bibliothèque Nationale,
Paris.

AGNES

Italian: Agnese; Spanish: Ignés; French: Agnès; German: Agnes
Virgin and Martyr. Died c.350. Feast day 21 January.

LIFE AND LEGEND

The name Agnes derives from the Greek adjective *agnos* (feminine *agne*) meaning pure or chaste. It was only later related to the Latin *agnus* (lamb) with its allusion to the mystic Lamb of God. The *Depositio martyrum*, dated 354, already attests to Agnes' cult. She is to be counted among the oldest and most venerated saints of Rome. The fifth-century Acts, the source for her legend, state that at the age of thirteen she refused a number of suitors in order to remain faithful to her vow of chastity. One of these suitors, the son of a prefect, was struck down as he left her, but Agnes raised him from the dead. Her virginity (like Agatha's) was miraculously preserved even when she was put in a brothel. Legend recounts that, after being stripped naked, either her long hair hid her body from view or else an angel covered her with a blindingly white cloak. Finally, she was executed by being stabbed in the throat. After her death, her parents saw her appear accompanied by a lamb on her right.

On her feast day, the sheep which provide the wool to make the pallia of the Pope and his archbishops are blessed in the convent of S. Agnese in Rome. She is the patron saint of the betrothed and of young girls.

REPRESENTATION AND ICONOGRAPHY

Agnes' emblem is a lamb (mosaics in San Apollinare Nuovo in Ravenna, sixth

St Agnes
Adriaen Collaert, beginning
of the seventeenth century.
Bibliothèque Nationale,
Paris.

century) and she figures alongside other virgin martyrs. On a marble relief on her altar in S. Agnese fuori le Mura, Rome (fourth century) she is shown at prayer. She is beheaded as she protects a lamb from burning charcoal in a work by Vicente Maçip (1540-50, Prado, Madrid). She is also depicted clothed in her long hair (Jean Pucelle, *Bréviaire de Belleville*, fourteenth century, Bibliothèque Nationale, Paris; *Miracle of the Long Hair*, Netherlands School, first half of the seventeenth century, Palazzo Reale, Genoa).

Attributes: Lamb. Long hair (not to be confused with that of St Mary of Egypt). Sword.

AGONY IN THE GARDEN

Italian: L'Agonia nel Giardino; Spanish: La Oración del Huerto de los Olivos; French: (L'agonie dans) le Jardin des Oliviers; German: Das Gebet Jesu am Ölberg.

TRADITION
Following the Last Supper, Jesus went up to the Garden of Gethsemane at the foot of the Mount of Olives (Hebrew *gethsemani,* oil-press). He left most of his disciples at the entrance, but took with him Peter, James (the Great) and John. According to St Luke (Luke 22:41), he withdrew a "stone's cast" from them to pray alone. Kneeling down with his face to the earth, he prayed to God: "if thou be willing, remove this cup from me" (22:42). The Synoptic Gospels (Matt. 26:36-46; Mark 14:32-42; Luke 22:40-46) concur that, at this moment, he was mortally afraid, and still trusted in his Father to release him from his impending Crucifixion: "not my will, but thine be done" (Luke 22:42). Luke states that an angel then came to fortify him (22:43). Matthew, Mark and Luke recount how Jesus had to rouse his disciples from sleep three times; John, however, makes no mention of these events, but passes directly to the betrayal by Judas.

REPRESENTATION AND ICONOGRAPHY
The agony of Christ in the Garden of Gethsemane is rarely depicted before the eleventh century, and then always with considerable restraint. After this time, the scene appears in Passion cycles, invested with a sense of Christ's agony (Dürer, etchings, 1515 and drawing, 1521, Städelsches Kunstinstitut, Frankfurt; El Greco, 1605-10, S. Maria, Andójar). In a large number of fifteenth-century carved or sculpted groups found in southern Germany and Austria, the influence of that mystic ardour expressed by representations of the Passion mystery known as *devotio moderna* is increasingly visible.

In the middle ages, artists tended to juxtapose a number of different episodes with the Agony, but from the fourteenth century the scene is shown independently. Jesus, on his knees facing a rock, is in the centre, with the three sleeping apostles in the foreground. By the fifteenth century, the Hand of God, which in earlier depictions occupied the upper part of the composition, has been replaced by angels (Mantegna, San Zeno altarpiece, 1459-60, Musée des Beaux Arts, Tours; in another version, Mantegna shows an angel offering Christ his Cross, 1455-60, National Gallery, London). The chalice or cup mentioned by Christ in his prayer, "if this cup may not pass away from me, except I drink it" (Matt. 26:42), finds its place in the hand of the angel, who also sometimes carries a cross (Dürer, *Kleine Passion*, 1507).

At the end of the middle ages, the scene appears increasingly pathetic,

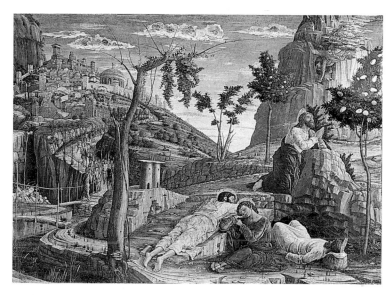

Christ's Agony in the Garden
Mantegna, 1459-60. Musée des Beaux Arts, Tours.

with the emphasis on Jesus' suffering. The composition has become fixed: the kneeling Christ, the angel with the cup, the three sleeping disciples. Though the episode is quite rare in the baroque, little change takes place even in the nineteenth century (Delacroix, 1826, St Paul-St Louis, Paris).

Cross-references: Arrest of Christ, Last Supper, Judas Iscariot.
Bibliography: L Réau, op. cit., vol. II, 2, pp. 427-31.

AHAB *see* ELIJAH.

AHASUERUS *see* ESTHER.

ALBERT THE GREAT

Latin: Albertus Magnus; Italian and Spanish: Alberto Magno; French: Albert le Grand; German: Albert der Grosse.
Dominican. Doctor of the Church, 1206-80. Canonized 1931. Feast day 15 November.

LIFE AND LEGEND
Albert was born in 1207 to a noble family in the Swabian town of Lauingen. In 1225, he went to Padua and entered the Dominican Order of Preachers. After obtaining his degree of Master of Theology, he taught in Paris from 1243 to 1244, where St Thomas Aquinas was among his pupils, and then in Cologne from 1248 to 1254. He was named Bishop of Regensburg in 1260 but resigned two years later. He spent the last ten years of his life in Cologne and was beatified in 1622. Author of works of crucial importance in the history of science, he is the patron saint of miners and, since 1941, of students of the natural sciences.

St Albert the Great
Bibliothèque Nationale,
Paris.

REPRESENTATION AND ICONOGRAPHY

He is generally represented in a Dominican habit, with a doctor's cap (Tommaso da Modena, Dominican chapterhouse fresco, Treviso, 1352). From the fourteenth century, his head often bears a nimbus. He is occasionally shown seated at a desk, with book and quill, like the Fathers of the Church, but can also be shown standing. For the most part he is depicted teaching. In one version, he is pointing from his professorial chair to St Thomas Aquinas who sits among his students, predicting for him a great future (Rudolphus de Novimagio, engraving from the *Legenda Literalis Alberti Magni*, 1480).

Attributes: Dominican habit. Book. Quill. Bishop's crozier.
Cross-reference: Doctors of the Church.
Bibliography: H. Scheeben, C. and A.-M. Walz, *Iconographia Albertina*, Freiburg, 1932.

ALEXIS

Latin and German: Alexius; Italian: Alessio; Spanish: Alejo; French: Alexis. Feast day 17 July, suppressed in 1969.

LIFE AND LEGEND

Alexis is probably entirely legendary. His life, first narrated in a Syriac document composed around 455, was later considerably embroidered. A son of wealthy parents, Alexis was apparently born in Rome. He left his wife on their wedding day, instructing her at great length in the faith beforehand. He made a pilgrimage to the Holy Land, and later lived the life of an almsman in Edessa. After seventeen years, he returned to Rome and there spent the same period of time as an anonymous beggar beneath a staircase in his own father's house. He became so renowned for his saintliness that when he was about to die the Pope hurried to his side. Alexis handed him a letter for his father, revealing his true identity. This legend became immensely popular in both the east and, at the end of the middle ages, in the west.

St Alexis
Georges de La Tour, 1648.
National Gallery, Dublin.

REPRESENTATION AND ICONOGRAPHY

The earliest depiction of St Alexis is to be found on what remains of a fresco in the crypt of S. Alessio in Rome (eighth century), where the saint has no personal attribute. In the eastern Church, Alexis is often linked to St John the Baptist, the Precursor, and portrayed as an ascetic. At the end of the middle ages, with western examples becoming more numerous, he is most often shown in the garb of a pilgrim. His attribute is a staircase. In one altarpiece (Steiermärkisches Landesmuseum Joanneum, Graz, Austria), a servant is shown scornfully throwing a bucket of water over him. At Bad Oberdorf in Germany, an altarpiece shows Alexis standing with his hand leaning on a staircase, which looks very like Simon the Zealot's saw.

Various episodes from the life of Alexis can be found from the eleventh century, becoming abundant in the fourteenth. The Lower Church of S. Clemente in Rome contains wall-paintings comprising a number of episodes (ninth-eleventh centuries). In the seventeenth century, Georges de La Tour composed a torchlit scene of the discovery of his body (Musée Lorrain, Nancy).

Attribute: Staircase.

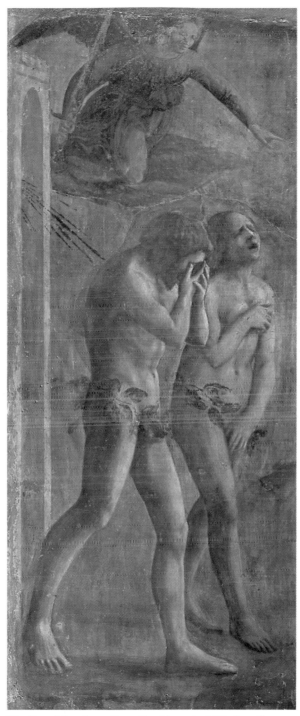

The Expulsion from Paradise. Masaccio, 1425. Cappella
Brancacci, S. Maria del Carmine, Florence.

I

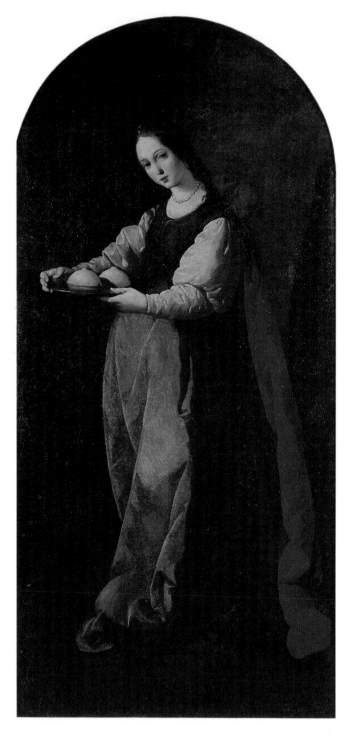

St Agatha. Zurbarán, 1630-33. Musée Fabre, Montpellier.

II

Cross-references: John the Baptist, Simon (Apostle).
Bibliography: "Alessio", *Bibliotheca Sanctorum*, vol. IV, Rome, 1961-9. E. Kirschbaum, *Lexikon der christlichen Ikonographie*, Freiburg im Breisgau, 1968-74, *Ikonographie der Heiligen*, vol. V, cols. 90-95. L. Réau, op. cit., vol. III, 1, pp. 52-4.

ALPHA AND OMEGA *see* APOCALYPSE.

AMAN *see* ESTHER.

AMBROSE

Latin and German: Ambrosius; Italian: Ambrogio; Spanish: Ambrosio; French: Ambrose.
Bishop. Doctor of the Church. 339-97. Feast day 7 December.

LIFE AND LEGEND

Ambrose was born in Trier; his father was a Prefect of Gaul. He became Governor of Aemilia and Liguria and was named Bishop of Milan in 373. His election was apparently decided by a child crying out, "Ambrose, become our bishop!" Milan, the capital of the Western Empire, was a powerful city; Ambrose imposed his authority even on the great Theodosius himself. He was also instrumental in preserving the cultural inheritance of antiquity. Legend recounts how bees deposited the honey of theological knowledge on his lips while he slept in his cradle.

St Ambrose
H. Wierix, after Martin de Vos, 1586. Bibliothèque Nationale, Paris.

REPRESENTATION AND ICONOGRAPHY

Ambrose is often linked to the three other Doctors of the Church (Augustine, Jerome and Gregory) and carries a mitre and crozier (thirteenth-century pulpit, Basilica of St Ambrose, Milan). In Michel Pacher's *Kirchenväteraltar* (Brixen altarpiece or *The Four Doctors of the Church*, Neustift, c.1483, Alte Pinakothek, Munich), Ambrose, seated next to a child in a cradle, writes under the inspiration of the Holy Spirit, shown as a dove. When writing, he commonly has the ox of St Luke by his side in allusion to his *Commentaries* on Luke's Gospel. In certain life cycles, a child is shown pointing him out as bishop.

Other scenes show Ambrose, armed with a whip (Antonio Vivarini and Giovanni d'Alemagna, *Triptych of Charity*, mid fifteenth century, Accademia, Venice), putting the enemies of Milan to flight (Master of the Pala Sforzesca, fifteenth century, Lombard, Petit Palais, Avignon), or discovering the relics of SS. Gervase and Protase of Milan. He can also be shown in historical contexts (Bergognone, *Ambrose and Theodosius*, 1490, Accademia Carra, Bergamo).

Attributes: Beehive. Book. Three-tailed whip. Ox.
Cross-reference: Doctors of the Church.
Bibliography: Ambrosiana, *Scritti di storia, archeologia ed arte*, 1942, pp. 17.

ANASTASIA

Latin, Italian, Spanish and German: Anastasia; French: Anastasie.
Virgin and Martyr. Died 304. Feast day 10 March.

St Anastasia of Sirmium
Woodcut from James of
Voragine's *Golden Legend*,
1483 edition.

St Anastasia
Carpaccio, polyptych, 1487.
Cathedral St Anastasia,
Zadar, Croatia.

LIFE AND LEGEND

Originally, there was a local cult of an Anastasia at Sirmium (Sremska) on the river Sava in ancient Illyria. The patriarch Gennadius translated her relics to Constantinople in the fifth century. Anastasia is venerated in the Church of the *Anastasis* (the Resurrection of Christ), later dedicated to her. The conclusion was all too hastily drawn that this Anastasia was no less than the personification of the Resurrection itself. More prudently, it is now believed that, though an Anastasia certainly existed in Sirmium, her cult acquired a number of other legends which became amalgamated with it. In Constantinople, for example, this saint was assimilated to another Anastasia, a *pharmakolytric* who could cure the sick. In Rome, on the other hand, a church established around the sixth century by a donor of the same name catalysed the cult of a "patrician" Anastasia attested by a contemporary legend which was originally authentic. This other Anastasia was a disciple of St Chrysogonus. After his martyrdom in Aquileia, Anastasia went to Macedonia with other Christians and then on to Sirmium where she was martyred. It is tempting to conclude that the Roman and the Sirmian Anastasia are one and the same. The two Anastasias are conflated not only in the western Church, but in the eastern as well.

Among the legends surrounding Anastasia of Sirmium figures an episode exploited in a number of representations: the Prefect of Illyrium was supposedly struck blind after attempting to rape her. In revenge, he forced her to embark in a rickety and leaking ship with a hundred men condemned to death, but a mysterious power piloted this peculiar vessel to safety.

REPRESENTATION AND ICONOGRAPHY

The two Anastasias are distinguishable by the different natures of their martyrdom. Anastasia of Sirmium is burnt at the stake (miniature in a French martyrology of the thirteenth century, Bibliothèque Nationale, Paris). This Anastasia is revered particularly in Russia and numerous icons show her with St Parascene (the incarnation of Good Friday) or other saints or with the Virgin *Theotokos*, in which case she is represented without any specific attribute. Similarly, in the west, she appears at prayer (twelfth-century bronze doors of the Basilica, St Mark's, Venice, where she is identified by an inscription).

The Roman Anastasia was apparently crucified under Decius or Valerian, before being finally beheaded (miniature in the Menologia of Basil II, c.985, Vatican Library). The story of her martyrdom was successively embroidered with elements taken from other legends: like Agatha, her breasts were severed; like Apollonia, her teeth and nails were removed.

In western art after the middle ages, the three Anastasias are conflated into one character who unites elements from all their various legends.

Attributes: Salve box (recalling her charity). Severed breasts.
Bibliography: L. Duchesne, "Sainte Anastasie", *Mélanges d'archéologie et d'histoire*, 7, 1887. L Réau, op. cit., vol. III, 1, pp. 72-73.

ANCIENT OF DAYS *see* GOD.

ANCHOR

"Which hope we have as an anchor of the soul," says St Paul (Heb. 6:19),

"both sure and steadfast." Symbol of the true faith and of hope in the resurrection of the flesh, the ship's anchor appears on frescoes and reliefs in the catacombs as early as the third century. It can also be found in association with a cross and a dolphin. During the middle ages, the anchor was a many-faceted symbol, but by the fifteenth century it had become the attribute of Christian hope.

Cross-reference: Nicholas.

ANDREW

St Andrew with his Cross
Bibliothèque Nationale, Paris.

Latin and German: Andreas; Italian: Andrea; Spanish: Andrès; French: André. Apostle. First century. Feast day 30 November.

TRADITION

The fact that St Andrew – elder brother of St Peter and, like him, a fisherman on the Sea of Tiberius – was the very first apostle to follow Christ has earned him immense veneration. The Greek Orthodox Church tried to adopt him as its own, employing him in a role analogous to that of St Peter in the Roman Church. In other regions of the west (north and east France, Scotland and southern Italy), however, his cult is almost as important.

He is not only the patron saint of Scotland (where numerous churches are dedicated to him), but also of the house of the Dukes of Burgundy and of the Order of the Golden Fleece (hence his strong presence in Burgundian art of the later middle ages). In fact, it was believed that the ancestors of the inhabitants of Burgundy originally came from the "land of the Scythians" in Russia, a country which St Andrew had evangelized.

The New Testament rarely alludes to St Andrew, but apocryphal texts mention him a great deal. Later, James of Voragine's *Golden Legend* recounts in much detail his legendary apostolate in Asia Minor and Russia.

REPRESENTATION AND ICONOGRAPHY

From the end of the middle ages, St Andrew can be recognized by a single specific attribute: the cross saltire (or St Andrew's Cross), a diagonal cross in the shape of an X. This was supposedly the instrument of his martyrdom at Patras in the Peloponnese. This crucifixion on a particular type of cross was treated in parallel with the death of his brother St Peter, head down on a Latin one. Nevertheless, no text underpins this tradition, which emerged only gradually. A thirteenth-century stained-glass window denotes St Andrew with a Latin cross. The cross saltire is rarely connected with St Andrew before the fourteenth century and it is, above all, Burgundian art which is responsible for its development (Jean Fouquet, *Heures d'Etienne Chevalier*, c.1455, Musée Condé, Chantilly).

In the seventeenth century, Caravaggio depicted St Andrew on a Latin cross (1607-10, Museum of Art, Cleveland), while Rubens (1638-9, chapel of the Real Hospital de los Flamencos, Madrid), El Greco (c.1590, Metropolitan Museum of Art, New York) and Juan de las Roelas (1609, Museo Provincial de las Bellas Artes, Seville) show him on a cross saltire. Guido Reni composed a complete martyrdom in fresco (1608, S. Gregorio al Celio). Francesco Trevisani also treated the theme (late seventeenth century, San Andrea delle Frate, Rome).

The different episodes of his passion (arrest, flagellation, crucifixion and deposition of the cross) often also show Maximilia, the wife of his crucifier,

whom he converted. Also depicted are his vocation (where he is recognizable by his fishing-net and the presence of his brother Peter) and his miracles (Barocci, *Vocation of St Andrew*, 1586, Musées Royaux des Beaux-Arts, Brussels). In Nicea, he chased off seven demons who, in the guise of dogs, terrorized the town; in Salonika, he put out a fire to save a youthful convert, Exoros, whose parents intended to have him burned alive; elsewhere, he dissuaded a bishop from committing a sinful act with the devil disguised as a courtesan.

Attributes: Cross saltire. Fishing-net.
Cross-references: Apostles, Matthew, Peter.
Bibliography: E. Mâle, "L'apôtre saint André dans l'art", *Revue des Deux Mondes*, 5, 1951, pp. 412-20. H. Martin, *Saint André*, Paris, 1928. P. M. Peterson, *Andrew, Brother of Simon Peter. His History and Legends* (Supplements to *Novum Testamentum*, i, 1958).

ANGEL

Hebrew: malachim; Greek: aggelos; Latin: angelus; Italian: angelo; Spanish: angel; French: ange; German: Engel.

TRADITION

The angels, mentioned frequently in both Old and New Testaments, are beings of an essentially spiritual nature, created by God. They ensure the connection between God and man, between Heaven and Earth, and are God's representatives and messengers. They maintain a perpetual liturgy around his throne and sing his praises ceaselessly. They also protect mortal beings. In 1608, Pope Paul V extended to the whole Church the cult of guardian angels, which had originated in Spain during the sixteenth century. In 1667, Clement IX established the first Sunday in September as their feast day. The civilizations of the Mediterranean basin, the Sumerians, Babylonians and Egyptians as well as the Greeks and Romans all recognized divine messengers which can be compared to angels.

REPRESENTATION AND ICONOGRAPHY

Attempts have often been made to show derivation of the earliest examples of Christian angelic iconography from the Graeco-Roman Victories. Such paternity is questionable, not least because all angels are male while the Victories are female and the two forms are in no way dressed similarly.

The angels of the earliest periods have no wings; they are distinguished from mortals by their nimbus, or halo. The first winged angel makes its appearance in the fourth century (apse of St Pudenziana Cathedral, Rome): it is the only naked angel of paleochristian times. Carolingian art preferred the wingless form.

From the twelfth century, representations of angels became more lifelike. In the sculpture of thirteenth-century cathedrals, they appear as youths conforming to the contemporary canon of beauty (e.g. the famous *Ange au sourire* in Reims). The angel in the guise of a child was introduced at this time (the first example comes from the portal of Senlis Cathedral, c.1200). Giotto, influenced by the *putti* of antiquity, painted naked child-angels or cherubs (1304-6, Arena Chapel, Padua). In the fourteenth century, Italian artists began to depict winged angels' heads in the antique style. The end of the middle ages saw a much more lively approach to the representation of angels, who were pressed into serving princes and Capetian monarchs and who were not above carrying heraldic

emblems (the fleur-de-lis for the kings of France, for example).

The more secular approach of the Renaissance produced graceful angels with the faces of young girls or of ephebic young men. This approach gained further ground in the seventeenth and eighteenth centuries as the "guardian angel" became widespread (Carlo Bononi, c.1620, Pinacoteca, Ferrara).

Dress
Angels in paleochristian times wear a tunic, a pallium and sandles. In the middle ages, they wear the dalmatic, like priests or deacons. From the fourteenth century, angels and archangels also appear as knights. By the end of that period, an angel wearing a kind of singlet with plumes (the so-called *gefiederte Engel*, feathered angel) also appears – not satisfied with giving them wings, artists had started giving them birds' feathers. Angels' vestments are sometimes of an incarnadine red (mosaic in the Basilica S. Maria Maggiore, Rome, fifth century). This colour has been interpreted by the Fathers of the Church as a sign of their spiritual nature. Fallen angels wear blue.

Angels and their Functions
Liturgical duties around the throne of God are in general carried out by the cherubim and seraphim (*see* Cherub and Seraph). Acolyte, or assistant, angels are shown swinging censers in many different episodes from the lives of Christ and the Virgin. Angels are associated with various theophanies, the most famous being the visit of three winged strangers to Abraham and Sarah in Mamre (*see* Abraham).

Angel Musicians
The musician angels spring directly from the text of the Bible and are attested by numerous commentaries of the Fathers of the Church, who describe the music of the spheres resulting from the harmonious singing of the heavenly host. Angels playing musical instruments appear in the twelfth century (English manuscripts) and later (Donatello Cantoria, marble, 1433-8, Museo dell' Opera del Duomo, Florence). Choirs of angels are associated with other themes which seem to call for musical accompaniment: the Nativity,

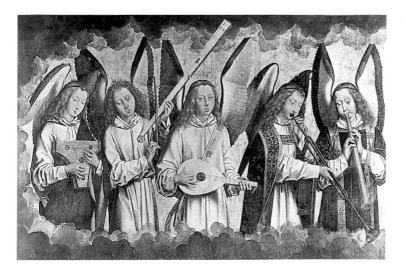

Angel Musicians
Memling, organ shutter (detail), c.1480. Koninklijk Museum voor Schone Kunsten, Antwerp.

the Assumption (Gaudenzio Ferrari, 1534, sanctuary of S. Maria dei Miracoli, Saranno) or the Coronation of the Virgin (mosaics on the dome of the Basilica of St Mark's, Venice). The Last Judgment is normally heralded by angels blowing trumpets ("the last trump").

Angels in the Bible
In the Bible of Worms (twelfth century), the creation of light is identified with angels, who are often associated with the light of heaven and with its fire. Renaissance artists occasionally painted angels whose lower half is simply a shaft of fire.

Attributes: Ribands or scrolls (inscribed with identifying texts). Messenger's staff. Instruments of the Passion (early middle ages).
Cross-references: Abraham, Annunciation, Annunciation to the Shepherds, Assumption, Cherub and Seraph, Creation, Last Judgment, Plagues of Egypt, Revelations.
Bibliography: M.-T. d'Alverny, "Les anges et les jours", *Cahiers archéologiques*, 9, 1957, pp. 271-300. H. Mendelsohn, *Die Engel in der Bildenden Kunst. Ein Beitrag zur Kunstgeschichte der Gothik und der Renaissance*, Berlin, 1907. A. Rosenberg, *Engel und Dämonen*, Munich, 1967. J. Vilette, *L'Ange dans l'art occidental du XIIème au XVIème siècle*, Paris, 1940.

ANIMALS

Both Biblical and Christian iconography allocate considerable space to the world of animals. Few images, in fact, do *not* contain at least one animal, either for its own sake or as an attribute representing a person, a place, an episode or even another animal (a mouse can represent a cat, for example). Each animal species should, therefore, be clearly distinguished and its sig-

The Nativity
French school, fourteenth century.

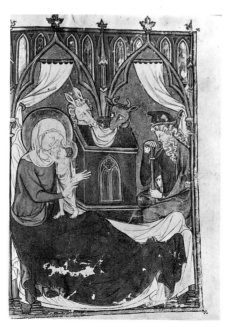

nification appreciated, but as with plants this is no small task since many animals are not iconographically differentiated. This is the case not only with fish and birds, but even with quadrupeds. In medieval art, it is often diffi- cult to tell a dog from a wolf, or a wolf from a fox. Sometimes even sheep or cattle (particularly calves) scarcely differ from some kinds of canine. As for rodents, it is impossible to tell them apart. In most cases, the artist sim- ply provides the characteristics he believes that the animal possesses.

And so, although confusion is still possible, the animals most easily iden- tified are those with obvious anatomical features: the elephant's trunk, the lion's mane, the wild boar's tusks, the stag's antlers, the eagle's talons, the unicorn's single horn. Occasionally, certain traditional iconographical attributes aid identification: the elephant, as well as his trunk, almost always carries a tower on his back; the crane holds a pebble in its foot; an ostrich has a nail or a ring in its beak.

Ass or Donkey

In pictures, the ass (like the mule) is often hard to tell from the horse. If both animals are to be found in a single scene, they can be distinguished by the ass's small size and long ears. On the other hand, when only one appears, context alone can resolve the puzzle. This is an important distinction, because the iconographical signification of the ass is very different from that of the horse. In spite of a popular misconception, the ass is by no means simply the poor man's horse, and does not have a negative image. It may, it is true, stand for ignorance, stupidity, stubbornness or sloth, but this is not usually the case. Christianity tended rather to improve the standing of the ass. Apocryphal gospels placed it with the ox over Christ's manger (the hypoth- esis that the ass stands for evil and the ox for good can be disproved by close study), and had it playing a major role in the Flight into Egypt (*see* Nativity *and* Flight into Egypt). The canonical Gospels detail how the Lord made his entry into Jerusalem seated on an ass (*see* Entry into Jerusalem). Rather than analysing this scene as figuring good astride evil, Christ's mount should be taken as symbolizing humility, poverty, patience and courage. In ancient Near Eastern societies, the ass was ridden by kings as a symbol of peace.

In medieval art, the ass could have both positive and negative conno- tations. In later depictions of the Feast of the Ass or the Feast of Fools, when the world is topsy-turvy – and the animal even allowed within the church itself – it is a sign of unruliness, of parody, of ridicule. In this context, the ass regained its time-honoured place as a sexual symbol, linked to both exces- sive sensuality and earthly pleasures. In antimonastic and anticlerical imagery of the late middle ages and sixteenth century, the ass is often pressed into service to deride a Church forgetful of its spiritual duty. This "asinine" iconog- raphy was revived on a large scale by anti-Papist propaganda.

Peacock

The peacock is less common in Christian iconography than it was in Greek mythology. Nonetheless, it is often met with as a cosmic (and hence Christ- ological) symbol, and as a sign of immortality. Its many colours evoke the heavenly host, while its tail, which seems studded with hundreds of eyes, is an image of the starry sky and of eternal felicity. Occasionally, by contrast, it can stand for the vanity and dim-wittedness of those men and women who spend their time prettifying themselves like peacocks.

See also Pelican, Phoenix, Unicorn.

ANNA

Latin and Italian: Anna; Spanish: Ana; French: Anne; German: Ann.

TRADITION

During the Presentation of Christ in the Temple (Purification of the Virgin), Anna, daughter of Phanuel, of the tribe of Aser, is nearby: "And she coming in that instant gave thanks likewise unto the Lord, and spake of him to all them that looked for redemption in Jerusalem" (Luke 2:38).

REPRESENTATION AND ICONOGRAPHY

In the Orient, Anna is often represented as a prophetess, with a nimbus. She is depicted as an elderly woman, wearing a tunic and a veil, and carrying a book or a scroll (mosaic, S. Maria Maggiore, Rome; Rembrandt, *The Prophetess Anna*, 1631, Rijksmuseum, Amsterdam).

Attribute: Book or scroll.
Cross-reference: Presentation of the Lord.

ANNE

Variants: Ann, Anna, Hannah. Latin and Italian: Anna; Spanish: Ana; French: Anne; German: Ann.
Mother of Mary. Feast day 26 July (west), 25 July (east).

TRADITION

The New Testament nowhere mentions the name of Anne. She appears for the first time in the *Protevangelium* of James, an apocryphal gospel of the second century. The circumstances of her surprisingly late motherhood are adapted from the story of the similarly named Hannah, the mother of Samuel

The Meeting between Anne and Joachim at the Golden Gate
Bibliothèque Nationale, Paris.

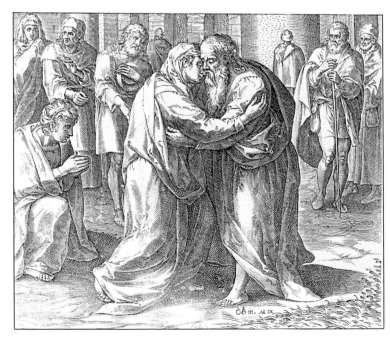

(1 Sam. 1). The most important scene from Anne's legend is her meeting with her future husband, Joachim, at the Golden Gate of Jerusalem.

REPRESENTATION AND ICONOGRAPHY

Anne looks with envy on the fertility of two sparrows in a laurel bush. An angel comes down and announces that she will bring forth a child, Mary. Joachim arrives on horseback at the Golden Gate (lintel, St Anne door, Cathedral of Notre Dame, Paris, thirteenth century). In the fourteenth century, Giotto paints the married couple kissing (*The Meeting at the Golden Gate*, 1304-6, Arena Chapel, Padua).

Anne is often shown with Mary and the Child (Masaccio and Masolino, *Madonna and Child with St Anne*, fifteenth century, Uffizi, Florence), sometimes with Mary as an infant in her arms or teaching her how to read (School of Caravaggio, beginning of the seventeenth century, Galleria Spada, Rome). From the beginning of the sixteenth century, the theme of the meeting and the kiss was overshadowed by the new symbolism of the Immaculate Conception, evoked by Mary descending from heaven in the guise of the Virgin of Litanies. Anne appears in various sequences of the life of Mary. Leonardo da Vinci painted Mary on Anne's lap (*The Virgin, the Child and St Anne*, 1510, Louvre, Paris).

Attributes: Lily. Open book (in scenes of the education of Mary).
Cross-references: Jesus, Mary.

The Virgin and Child with St Anne
Masaccio, 1420-25. Galleria Uffizi, Florence.

ANNUNCIATION

Latin: Annuncatio; Italian: l'Annunciazione; Spanish: la Anunciación; French: l'Annonciation; German: die Verkündigung.
Feast day 25 March.

TRADITION

The Archangel Gabriel announces to Mary that she is to give birth to a son, Jesus, who "shall be called the Son of the Highest", but Mary replies: "How shall this be, seeing I know not a man?" The answer is: "The Holy Ghost shall come upon thee ... therefore also that holy thing which shall be born of thee shall be called the Son of God" (Luke 1:28-35). St Luke is the traditional source (1:26-36) for the core text of the Annunciation. Apocryphal writings later embellished the bald statements of the Evangelist and have enriched it with much additional detail. The most important of these texts are the *Protevangelium* of James (11:1-3) and an Armenian "Infancy Gospel" of immense influence on the art of Byzantium. These apocryphal works were given a wider audience by *The Golden Legend* of James of Voragine. The *Protevangelium* already divided the Annunciation into two phases, a structure adopted by Byzantine art. Firstly, the Virgin draws water from a well and is hailed by the angel; secondly, she weaves the purple veil of the Temple. The Archangel Gabriel suddenly appears and informs her that she will beget the Messiah.

Mary's virginity is constantly compared to the Burning Bush, which never burns itself out (Ex. 3:2), while the Sibyls are often treated as prophetesses announcing the birth of the Holy Infant. The legend of the unicorn is also related in some way to Marian theology as the mythical beast can only be caught and tamed by a virgin.

The Annunciation has been celebrated by the Church since the sixth century. Its feast day is exactly nine months before Christmas.

REPRESENTATION AND ICONOGRAPHY

The oldest depictions of this event, dating from the fourth century, are found in paintings in the catacombs of Priscilla and in SS. Peter and Marcellinus in Rome. The Archangel Gabriel, in the guise of a young man, stands in front of the seated Virgin (catacombs, Via Latina). From a very early date, Gabriel is shown with wings and a messenger's staff. The mosaic of the Annunciation at the Basilica of S. Maria Maggiore in Rome (c.435) is adorned with winged and haloed angels, gathered around the throne of the Virgin *Theokotos*, dressed as an Empress. The Virgin weaves the purple cloth destined for the veil of the Temple, as described in the *Protevangelium* (11:1). The presence of the dove of the Holy Spirit underlines the eschatological value of the episode, while the archangel hovers over the entire scene like a genius.

In the second half of the fifth century, a work in ivory (Opera del Duomo, Milan) introduced a new aspect which became a great success: the Archangel approaches from the left, while Mary appears on the right as a woman about to draw water from a well. In the Carolingian period and in the tenth and eleventh centuries, the Virgin was either seated on a throne or else listening to the angel who, in most cases, enters from the left. In the medieval period, the growth of speculative theology is indicated by the increasing thematic richness of the scene.

At the same time, artists were putting new emphasis on feelings and expression. For example, Mary takes a majestic attitude when being portrayed as *Regina angelorum* (Reims and Chartres Cathedrals; mosaics in S. Maria Maggiore, Rome, 1290). Other artists stress her modesty, her self-effacement or even her surprise in response to the unexpected news the angel brings her (Simone Martini, c.1335, Koninklijk Museum voor Schone Kunsten, Antwerp). Ambrogio Lorenzetti has the Virgin casting her eyes up to the heavens (1330s or 1340s, Pinacoteca, Siena).

The action of the Holy Spirit and the supernatural nature of the events are emphasized by the presence, usual in the west from the thirteenth century onwards, of a dove hovering above Mary's head. At this period, she is

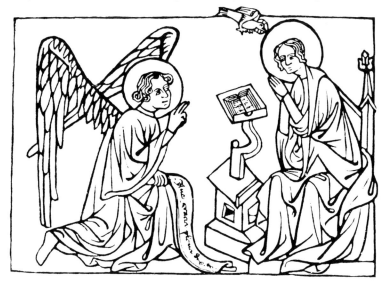

The Annunciation
From *The Apocalypse*,
fifteenth century.
Bibliothèque Nationale,
Paris.

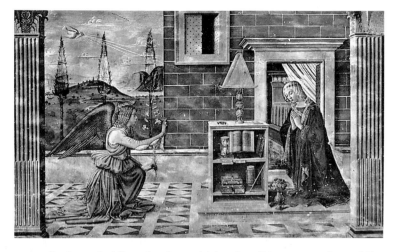

The Annunciation
Ghirlandaio, 1482.
Collegiate Church, San
Gimignano.

normally shown holding a book on which, when it is open, can be read the prediction of Isaiah: "Behold, a virgin shall conceive" (Isaiah 7:14). In medieval Italian art, the setting – the "room in the house of Mary", as Pseudo-Bonaventura has it – is greatly enriched, and the Annunciation takes place in ever more sumptuous architectural decors. The Virgin is often shown next to or carrying a scroll inscribed with the words *Ecce Ancilla Domini,* "Behold the handmaid of the Lord" (Luke 1:38).

At the end of the middle ages, Gabriel hands Mary a lily (Filippo Lippi, 1440s, Galleria Nazionale d'Arte Antica, Rome; Leonardo da Vinci, 1472-75, Uffizi, Florence). This emblem was treated in many various ways: since the sign of the city of Florence was a red lily, its painters adopted that flower with enthusiasm, while the Sienese preferred the olive branch. The theme was always popular, especially in Florence (Simone Martini and Lippo Memmi, 1333, Uffizi, Florence; Fra Angelico, fresco, c.1440-5, St Mark's, Florence). Setting and composition, however, become more flexible (Hans von Aachen, 1613, Narodni Galerie, Prague). The scene could even be nocturnal, with the angel appearing to Mary from above (Sebastiano Mazzoni, c.1650, for San Luca, Accademia, Venice).

Attributes (of the Archangel): Messenger's staff (transformed from the thirteenth century into a fleur-de-lis sceptre and then replaced by a lily or olive branch in the Renaissance).
Cross-references: Angel, Annunciation to the Shepherds, Burning Bush, Gabriel, Mary, Sibyls.
Bibliography: W. Braunfels, *Die Verkündigung*, Dusseldorf, 1949. P. Ladoué, "La scène de l'Annonciation vue par les peintres", *Gazette des Beaux-Arts*, VI, 39, 1952, pp. 351-70.

ANNUNCIATION TO THE SHEPHERDS

Italian: L'Annunciazione ai pastori; Spanish: El Anuncio del angel a los pastores; French: L'Annonce aux Bergers; German: Die Verkündigung an die Hirten.

The Annunciation to the Shepherds
From *Heures à l'usage de Rouen*, fifteenth century. Bibliothèque Nationale, Paris.

TRADITION

Mary brings the Child into the world, "in the city of David called Bethlehem". St Luke reported that "there were in the same country shepherds abiding in the fields, keeping watch over their flocks by night" (Luke 2:8). The night Mary gives birth, an angel announces the Good News to the shepherds, and "the glory of the Lord shone round about them" (Luke 2:9).

REPRESENTATION AND ICONOGRAPHY

A Carolingian ivory relief (c.810, Victoria and Albert Museum, London), shows three shepherds. In the middle ages, the scene is occasionally combined with the Nativity (royal door, west front, Chartres Cathedral, thirteenth century). In the same period, works appear associating the shepherds with the verses of St Luke: "And suddenly there was with the angel a multitude of the heavenly host ... saying, Glory to God in the highest, and on earth peace, good will toward men" (2:13-14). The arrival of easel painting seems to have put an end to the depiction of this scene, though between the fourteenth and sixteenth centuries it often appeared in its own right. The Annunciation to the Shepherds is grouped together with the Nativity and the Adoration of the Magi (Giotto, *The Nativity and the Annunciation to the Shepherds*, 1304-6, Arena Chapel, Padua) and confined to the background. In the seventeenth century the scene regained a certain amount of autonomy (Rembrandt, etching, 1634).

Cross-references: Angel, Annunciation, Magi.
Bibliography: L. Réau, op. cit., vol. II, 2, pp. 232-3.

ANSELM OF CANTERBURY

Latin: Anselmus; Italian and French: Anselme; Spanish: Anselmo; German: Anselm.
Archbishop. Benedictine. Doctor of the Church. 1033/34–1109. Canonized 1494. Feast day 21 April.

LIFE AND LEGEND

Anselm was born at Aosta, Piedmont, and entered the Benedictine Abbey at Bec in 1060, becoming its abbot in 1073. Twenty years later, William the Conqueror named him Archbishop of Canterbury. He was a man of considerable character, who defended ecclesiastical independence against erosion by the monarchy and was an ardent champion of the doctrine of the Immaculate Conception of the Virgin. Exiled in 1097, he was recalled by the new king, Henry I. He was again exiled, in 1103, returning in 1106 to die at Canterbury in 1109. He was canonized in 1494 and made Doctor of the Church in 1720.

St Anselm
Bibliothèque du Musée des Arts Décoratifs, Paris.

REPRESENTATION AND ICONOGRAPHY

St Anselm is traditionally depicted as a bishop or an abbot, holding a quill pen intended to symbolize his work as a theological writer. In the fifteenth and sixteenth centuries, he is often portrayed as a bishop with a scroll identifying him, juxtaposed with images evoking the Immaculate Conception. The scroll or phylactery is normally inscribed with the words "*Non puto esse verum amatorem Virginis qui celebrare respuit festum sue conceptionis* [I do not think that one is a true friend of the Virgin if one is averse to celebrating the feast of her Conception]" (Luca Signorelli, early sixteenth century, S. Maria Novella, Florence).

After the Renaissance and the Reformation, artists remained keen to depict Anselm and his miracles. Mary, flanked by God the Father and Christ, appears to Bishop Anselm and to St Martin, as dual combatants against heresy (Crespi, *St Anselm writing under the inspiration of the Virgin*, c.1738, Louvre, Paris).

Attribute: Quill pen.
Cross-reference: Mary.

ANTONY OF EGYPT

Latin and German: Antonius; Italian and Spanish: Antonio; French: Antoine le Grand.
Founder of monasticism. c.251-356. Feast day 17 January.

LIFE AND LEGEND

Antony's life, initially compiled by St Athanasius and St Jerome, was widely disseminated by *The Golden Legend*. Born in the middle of the third century in Upper Egypt, he withdrew while still young into the desert, where he was repeatedly tempted by the devil. Remaining steadfast, he attracted a number of disciples to a hermit's life in the desert. He was then again driven to solitude, and went further into the desert towards the Red Sea, where he lived alone until over the age of one hundred years. Towards the end of his life, he visited St Paul the Hermit, doyen of the Theban anchorites, who was fed every day by a tame raven. During St Antony's stay, the bird miraculously brought two loaves instead of one. Later, having learnt of St Paul's death, St Antony returned to bury him, engaging the assistance of two lions to dig his grave.

St Antony has always been much admired, even if he did not attain the popularity of his namesake from Padua. His relics, initially transferred from the desert to Constantinople, were reputedly in Dauphiné by the middle of the eleventh century, at the monastery of St Antoine en Viennois. The Order of Hospitallers of St Antony, who specialized in the care of patients with contagious diseases – particularly the so-called St Antony's Fire (ergotism) – contributed to the growth of his cult throughout Christendom, transforming him into a healing saint. St Antony was invoked not only against the fits caused by ergotism, but against plague, leprosy, skin sores and venereal diseases. His healing powers were also effective in veterinary cases, notably with horses and pigs.

REPRESENTATION AND ICONOGRAPHY

St Antony the Hermit's iconography is one of the very richest. He is generally represented as an old man wearing the habit of a hospitaller (black homespun with a hood), carrying a Tau cross (a cross in the shape of a T) and, occasionally, a little bell. He is often accompanied by his most ubiquitous attribute, a pig, left by one of his followers in the desert; this was originally a diabolical wild boar which St Antony tamed and made his most faithful companion.

The temptations of the devil in the desert are the most frequent subjects: both physical attacks by the devil (Rosa, mid seventeenth century, Palazzo Pitti, Florence) and other demons (Martin Schongauer, engraving, c.1470, where they pull his hair) and carnal temptation in the form of naked women (Jean Mabuse, early sixteenth century, Nelson Gallery of Art, Kansas City,

The Temptation of St Antony
Bosch, triptych, 1505-6, Museu Nacional de Arte Antiga, Lisbon.

with the courtesan most elegantly dressed). Later artists have continued to be attracted by this motif (James Ensor, *Tribulations of St Antony*, 1887, Metropolitan Museum of Art, New York). Also important are his visions (Master of the Observance, c.1430, Lehman Collection, New York; Diego Rivera, 1947, Palaço de las Bellas Artes, Mexico City); the visit to him made by the devil disguised as a pilgrim (Bosch, 1505-6, Museu Nacional de Arte Antiga, Lisbon), and the sojourn he made to St Paul the Hermit before burying him (many Irish crosses, c.1000; Grünewald, 1511-16, Isenheim Altar, Musée d'Unterlinden, Colmar, France). His miracles are also often depicted.

Attributes: Bell. Pig. Tau cross. St Antony's Fire.
Cross-reference: Paul the First Hermit.

ANTONY OF PADUA

St Antony of Padua
Cosimo Tura, 1475. Louvre, Paris.

Latin: Antonius Paduanus; Italian: Antonio di Padova; Spanish: Antonio de Padua; French: Antoine de Padoue; German: Antonius von Padua.
Canon. Franciscan. c.1195-1231. Canonized 1232. Feast day 13 June.

LIFE AND LEGEND

Born in Lisbon of a noble family, the future Antony of Padua (he was first named Fernand) studied at Coimbra where he became a canon regular. After the failure of a mission to Morocco, he joined St Francis and his companions, lived for a year in a cave and, having become an Austin canon, taught at Bologna. One day, preaching in place of a sick brother, he showed such incomparable talent that this became the predominant activity of the last ten years of his life. He preached in France and Spain as well as in Italy, attracting huge congregations wherever he went. Returning to Assisi to attend the general council of the Order and supervise the translation of the relics of St Francis, he spent the last two years of his life in Padua, dying there in 1231. He was canonized the following year.

St Antony of Padua was, above all, the greatest preacher of the middle ages and one of the finest orators of all time. Whenever he arrived in a town, everything ground to a halt, shops closed, and listeners gathered in their thousands to listen. He preached poverty and penitence, calling the people to a life of evangelical holiness, comforting the lowly while lambasting both dissolute churchmen and the rich. In a legend which emulates that of St Francis preaching to the birds, one day he gave a sermon on the Creator to the fish, which all gathered at the surface to listen to him. He then blessed them.

For two centuries the cult of St Antony remained in the shadow of St Francis of Assisi, the closest to Christ of all the saints. St Antony's cult, at first confined to Padua, blossomed in the fifteenth and especially the sixteenth centuries. Portugal adopted him as her patron and exported his cult to all four corners of the world, especially Brazil, where he also became the national saint. Seamen, the shipwrecked and prisoners have all taken him as their patron, but it is above all the Christian poor who have adopted him as their favourite. From the seventeenth century onwards, he was invoked to recover lost articles, to regain health and finally to satisfy any wish whatsoever, and became the intercessor par excellence – a strange destiny indeed for a saint who desired merely to be the humble companion of St Francis. In the modern period, no Christian figure is more popular.

REPRESENTATION AND ICONOGRAPHY

Medieval depictions are not very common (stained-glass window, Basilica of St Francis, Assisi, fourteenth century), but from the sixteenth century onwards no saint figures more frequently. Every church of any size has a chapel dedicated to him. He appears as a slight figure in the manner of St Francis, wearing the habit of his Order and the three-knotted cord. So many legends have been added to his cult through the ages that the images are extremely varied (Alvise Vivarini, a kind of portrait, c.1480s, Museo Correr, Venice; Jacques Callot, *Les Images de tous les saints...*, engraving, 1636, in which he carries a lily). He is shown preaching to the people and to the fish or debating in the presence of St Francis or other Franciscans. He is depicted performing miracles (Donatello, *The Miracle of the New-Born Child,* 1443-53, San Antonio, Padua); healing the sick, replacing the leg of a young man who had mutilated himself in contrition (Titian, 1510-11, Scuola del Santo, Padua; Giordano, late seventeenth century, National Gallery, London); making a mule kneel before the Eucharist in an attempt to convince a Jew of the Real Presence; and, above all, in a scene where the Virgin and Child appear to him. Christ himself, seated or standing on a book, became his personal attribute (Murillo, 1668, Museo Provincal de Bellas Artes, Seville).

His iconography is often transposed with that of Antony of Egypt, or even of St Francis.

Attributes: Franciscan habit. Christ Child. Mule. Lily. Fish. Flaming heart (derived from St Augustine).
Cross-reference: Francis of Assisi.

ANVIL *see* ELIGIUS.

APOCALYPSE *see* REVELATIONS.

APOSTLES

Also: Disciples. Italian: Apostoli; Spanish: Apóstolos; French: Apôtres, Disciples; German: Apostel, die zwölf Jünger, die Glaubensboten.

TRADITION

Literally, the apostles (from the Greek *apostolos*, envoy, messenger) are the twelve disciples of Christ whom he sent out to evangelize the nations. The name was also given at a later date to the small number of saints who continued the task of evangelization begun by the first "apostles", and who are also considered as emissaries of Christ. Following St Paul, the apostle of the Gentiles, come, among many others, St Martin, the apostle of the Gauls; St Boniface, apostle of Frisia and Germany; and SS. Cyril and Methodius, apostles of the Slavs. The original twelve formed a group which served to witness that the Jesus they knew was indeed the Messiah.

In the lists given in the New Testament, the earliest disciples – Peter (Simon Peter), Andrew, James the Greater (or Great) and John – are always named first. A second group of four follows: Philip, Bartholomew, Matthew and Thomas. Finally appear James the Less, Jude (or Thaddaeus), Simon the Canaanite and Judas Iscariot. Peter always occupies the first place and Judas

The Collegium of the Apostles
Sarcophagus (detail), fourth century. S. Ambrogio, Milan.

the last; the latter was replaced by Matthias after the betrayal.

Popular piety had all the apostles die for the true faith and their legends include a number of different methods of martyrdom. Like Christ, five were crucified: Peter and Philip upside down and Andrew on a cross saltire.

REPRESENTATION AND ICONOGRAPHY

This entry indicates only the scenes where the apostles are depicted as a group (for individual references see under each name).

The College of the Apostles

The apostles frame the central figure of Christ (sarcophagi from late antiquity). Until the thirteenth century, the figures of the apostles were placed outside, on the uprights of the reveals of the main doors in cathedrals or in the antechurch. From the thirteenth century onwards, they were placed against the nave piers. Louis Réau explained this innovation by relating it to the passage in the Epistle to the Galatians (2:9) where St Paul compares the apostles to the pillars of the Church. The change occurred for probably the first time in the Sainte Chapelle in Paris (1250) and then in a number of cathedrals (choir, Cologne Cathedral, fourteenth century).

The apostles collectively are often juxtaposed with the prophets to make clear that the latter were heralds of the former. This theme appears in Germany in the twelfth century (fonts, Merseburg Cathedral). The apostles are even shown sitting on the shoulders of the prophets (Fursten Tur, Bamberg Cathedral). Other examples include Tilman Riemanschneider's *Schnitzaltar* (1509, Kurpfälzisches Museum, Heildelberg) and Rubens (1603, Prado, Madrid).

The Missions of the Apostles (Mark 16:15)

Christ orders the apostles to "Go ye into all the world, and preach the gospel to every creature" (tympanum of the Basilica at Vézelay, twelfth century).

The Scattering of the Apostles (Mark 16:20)

Mark describes the dispersal of the disciples: "And they went forth, and preached everywhere". The feast of the *Divisio Apostolorum* was introduced into the liturgy in the eleventh century but, in art, the theme seemed to gather momentum only during the fifteenth century (Michael Wolgemut, late fifteenth century, Germanisches Nationalmuseum, Nuremberg). The head of each apostle was surmounted by a nimbus inscribed with his name and missionary destination. The twelve martyrdoms of the apostles were also pre-

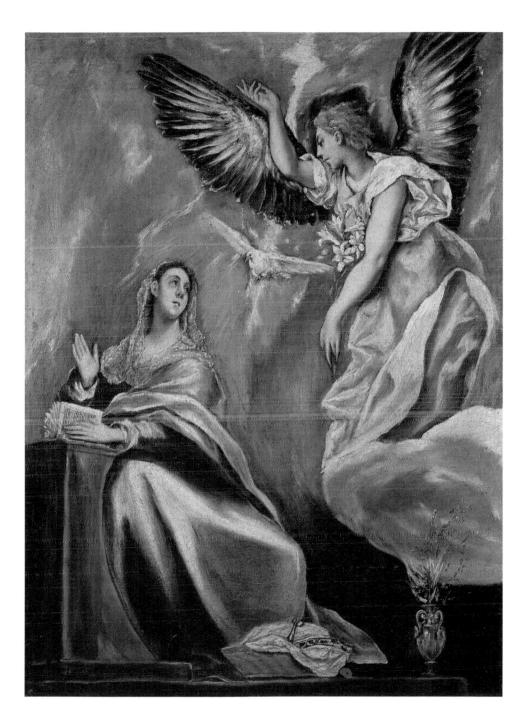

The Annunciation. El Greco, early seventeenth century. Szepmuveszeti Museum, Budapest.

The Apostles John, Peter, Mark and Paul. Dürer, 1526. Alte Pinakothek, Munich.

sented as a cycle (Stephen Lochner, retable of *The Last Judgment*, c.1440s, Städelsches Kunstinstitut, Frankfurt). A series of cartoons by Raphael for tapestries for the Sistine Chapel show various acts of the Apostles, particularly featuring Peter and Paul (1515-16, Victoria and Albert Museum, London).

Attributes

Peter: Key (one or two). Cock (the denial). Papal tiara (baroque age).
Andrew: Cross saltire. Latin cross (middle ages).
James the Greater (or Great): Pilgrim's staff (Galician pilgrims). Large hat and scallop shell.
John the Evangelist: Eagle (next to him or, when writing, on his Gospel). Chalice (from which emerges a little snake or dragon).
Philip: Long-shafted cross.
Bartholomew: Flaying knife (martyrdom).
Matthew: Axe or halberd. Money-bag (referring to his position as a tax official). Angel or (winged) man (when writing Gospel). Spectacles (middle ages).
Thomas : Architect's T-square. Spear or lance (martyrdom).
James the Less: (Fuller's) club (martyrdom).
Thaddaeus (Jude): Club or halberd.
Simon: Saw.
Matthias: Axe.
Judas: Money-bag.
Cross-references: Andrew, Bartholomew, Communion of the Apostles, Evangelists, James the Great, James the Less, John, Judas Iscariot, Last Supper, Mark, Martin, Matthew, Paul, Philip, Peter, Simon, Thaddaeus.
Bibliography: E. Mâle, *Les Saints Compagnons du Christ*, Paris, 1958.

APPEARANCES OF THE RISEN CHRIST

Italian: Apparizioni di Cristo resorto. Spanish: Aparikiones de Jesus; French: Apparitions du Christ; German: Erscheinungen des Auferstandenen.

TRADITION

Between Easter and the Ascension, Christ Resurrected appeared several times to his disciples and those nearest him. The versions proposed by the Gospels differ on a number of points (Matt. 28; Mark 16; Luke 25; John 20, 21).

REPRESENTATION AND ICONOGRAPHY

To the Women (Matt. 28:9-10; Mark 16:1 6)

On Easter morning, Mary Magdalene and "the other Mary", mother of James and Joseph (John), after finding the tomb empty, suddenly see Christ standing before them. "Jesus met them, saying, All hail. And they came and held him by the feet, and worshipped him" (Matt. 28:9).

This scene was rarely depicted in the middle ages, and the number of women varies between two and three. St Matthew's text is the one most often followed. Christ approaches the women, who throw themselves to the ground (Abbess Herrad, *Hortus Deliciarum*, twelfth century; choir screen, Chartres Cathedral, fourteenth century). Jordaens shows Christ as a gardener with the women (seventeenth century, Berlin-Dahlem Staatliche Museen, Berlin and St Catherine, Honfleur). These scenes are often confused with the appearance before Mary Magdalene (*see* Noli me tangere).

**The Miraculous Draught
of Fishes**
Konrad Witz, 1444 (detail).
Musée d'art et d'histoire,
Geneva.

In the Cenaculum: the Mission of the Apostles (Matt. 28:16-20; Mark 16:14-20; Luke 24:36-53; John 20:19-23)

All four Gospels treat this scene. "And as they thus spake, Jesus himself stood in the midst of them." He said: "Why are ye troubled?... Behold my hands and my feet, that it is I myself: handle me, and see" (Luke 24:36-39).

The composition and treatment of this scene vary a great deal, with frequent references to the Last Supper in the eleventh and twelfth centuries. St Luke did indeed introduce a meal into the scene: "Have ye here any meat?" Christ asks. They give him some and he eats it "before them" (Luke 26:41-43). In the fourteenth century, a fresco in the Church of S. Maria Donnaregina, Naples, shows Christ at table. These examples are worth noting because they can easily be confused with the Last Supper.

On the Sea of Galilee: the Miraculous Draught of Fishes (Luke 5:1-11; John 21:1-8)

In a scene from his life reported by Luke, Jesus climbs aboard Simon Peter's boat on the Sea of Galilee and preaches to the assembled people. He then orders Peter that they should throw the nets overboard again after an unsuccessful night's fishing. They do so and catch a "multitude of fishes".

A different scene described by St John has Peter after the Crucifixion taking up his old tradm as a fisherman with some companions. They take nothing all night. In the morning, unrecognized by them, Christ arrives and asks them to cast their nets once more: the result is another miraculous draught of fishes. John, who is on the boat with Peter, says to him, "It is the Lord." Peter throws himself into the water to try to get to Jesus.

In general, artists conflate these two scenes into one. A mosaic in the Basilica of St Mark's, Venice (thirteenth century), follows St Luke, with Christ in the boat. In the fifteenth century, Konrad Witz reproduced the version of St John: Jesus stands on the shores of a lake which is clearly Lake Geneva with Mont Salève in the background (*St Peter Altarpiece*, 1444, Musée d'Art et d'Histoire, Geneva). Raphael's treatment of the scene in his cartoons for the Vatican tapestries can be seen in the Victoria and Albert Museum, London (1515-16).

Jesus Walking on the Water (Matt. 14:22-34; Mark 6:47-52; John 6:16-21)

One night, the apostles' boat was about to capsize in heavy seas. Suddenly, they see Jesus walking towards them on the surface of the water. They take him for a ghost but he reassures them. "Lord, if it be thou," asks Peter, "bid me come unto thee on the water" (Matt. 14:28). Peter gets out of the boat, begins to walk and then starts to sink. Jesus hears his cries for help and comes to the rescue.

This episode was treated as early as the third century (fresco in the Christian chapel of Dura-Europos, c.245). Andrea Orcagna (predella of the retable in the Cappella Strozzi, S. Maria Novella, Florence, 1357) and Rubens (predella of the triptych *The Miraculous Draught of Fishes*, 1619, Musée des Beaux Arts, Nancy) also produced versions of this scene.

Cross-references: Last Supper, Noli me tangere, the Pilgrims at Emmaus, Thomas, Holy Women at the Sepulchre.

Bibliography: L. Réau, op. cit., vol. II, 2, pp. 559-74. G. Schiller, *Ikonographie der christlichen Kunst*, 1971, vol. III, pp. 88 ff.

ARCHANGELS

Greek: arkhaggelos; Italian: arcangelo; Spanish: arcangel, French: archange; German: Erzengel.

TRADITION

In the *Celestial Hierarchy* by Dionysius the Pseudo-Areopagite, the archangels do not occupy the very top of the heavenly system, but the penultimate region of the Lower Order. Unlike the angels they have names, but the Old Testament does not use the word "archangel". It is St Paul who speaks of the

The Archangels Michael, Raphael and Gabriel with Tobias
Botticini, c.1470. Uffizi, Florence.

"voice of the archangel" in connection with the Second Coming of Christ: "For the Lord himself shall descend from heaven with a shout, with the voice of the archangel, and with the trump of God: and the dead Christ shall rise first" (1 Thess. 4:16). Similarly, in the Epistle of Jude (1:9), the apostle writes of "Michael, the archangel".

The Fathers of the Church and medieval theologians record seven archangels, the best-known of whom are Michael, Gabriel and Raphael. They perform God's will and are also his messengers. Additionally, they protect heaven and earth from demons, a task more especially entrusted to St Michael.

REPRESENTATION AND ICONOGRAPHY

Archangels can be dressed like the rest of the angels but, from an early date, they are also differentiated from them and appear in the costume of princes or some other important personages. In a mosaic at San Apollinare in Classe at Ravenna (sixth century), the archangels are clothed in richly decorated tunics and chlamydes, and wear sandles encrusted with precious stones. In the latter half of the middle ages, they also appear in ecclesiastical dress. In the west, they wear predominantly light colours. All have wings which can be coloured like peacocks' wings, while on their heads they wear headbands, diadems or crowns. In medieval churches of Byzantine inspiration, the archangels are often given a place of honour, at the apse, near Christ Pantocrator.

In the fifteenth century, the Florentine school produced a number of paintings showing Raphael and Tobias, sometimes accompanied by Michael and Gabriel.

Attributes: In general, the archangels have a nimbus, in both the west and Byzantium. With variants, they are shown frontally, holding a globe in one hand and a staff in the other. Scrolls (phylacteries) carry inscriptions which serve to identify them individually.

Cross-references: Angel, Gabriel, Michael, Raphael, Tobit.

ARCHBISHOP *see* BISHOP.

ARCHITRICLIN *see* CANA, MARRIAGE AT.

ARK *see* NOAH.

ARK OF THE COVENANT

Also: Ark of Testimony. Greek: Kibìyos; Latin: Foederis Arca; Italian: l'Arca della testimonianza; Spanish: el Arca de la Alianza; French: l'Arche d'Alliance; German: die Bundeslade.

TRADITION

According to Exodus (25:10-22; 37:1-9), the Ark is a casket that Moses had made, constructed in acacia wood and overlaid with gold, which could be carried on two wooden struts rather in the manner of a sedan chair. The Ark

The Ark of the Covenant
Bible of Charles the Bald,
c.870 (detail). St Paul
Outside the Walls, Rome.

contained the Tables of the Law and, following a tradition reported in the Epistle to the Hebrews (9:4), a golden pot holding the manna and Aaron's rod. The Ark was placed in the Holy of Holies in the Temple of Jerusalem.

In the Christian tradition, the Ark symbolizes the Annunciation, but can also prefigure the Presentation of Christ in the Temple (the Purification of the Virgin) or else the Baptism of Christ.

REPRESENTATION AND ICONOGRAPHY

The Ark is represented either as a shallow box (mosaic in the nave of S. Maria Maggiore, Rome, fifth century), a curved topped casket (fresco of the Synagogue at Dura-Europos, c.245) or a chest with a lid in the shape of a roof. It appears three times on the mosaics at S. Maria Maggiore, in the history of Joshua. In the ninth century (apse of the church of St Germigny des Prés, c.806) the Ark, more in accordance with the Jewish tradition, symbolizes obedience to the will of God. At the choir of the Basilica of St Denis, a medallion in a stained-glass window planned by Suger (twelfth century) shows the Ark surrounded by the Evangelists. In the Ark, which resembles rather a chariot, a Crucifix held by God the Father stands next to the Tables of the Law and the rod of Aaron. This schema makes explicit that the Old Testament acts to support the New.

In a prefiguration of the Last Supper, Aaron places the pot of manna in the Ark (Nicholas of Verdun, 1181, Klosterneuberg altarpiece, Klosterneuberg Stiftsmuseum). On the tympanum of the portal of the Virgin at Notre Dame, Paris (thirteenth century), the Ark symbolizes Mary.

Cross-references: Aaron, David, Joshua, Mary.

ARMOUR *see* MARTIN (ON HORSE), WENCESLAS (STANDING).

ARREST OF CHRIST

Italian: l'Arresto; Spanish: el Predimiento; French: l'Arrestation de Jésus; German: die Gefangennahme Christi.

TRADITION

All four Evangelists recount the story of the arrest of Christ in the Garden of Gethsemane (Matt. 26:47-56; Mark 14:43-52; Luke 22:47-53; John 18:4-12). Traditionally, the sequence is divided into two major episodes: the kiss of Judas, and the arrest itself. Jesus walks up to the group advancing behind Judas. They are looking for him. "Jesus saith unto them: I am he," and, as soon as he speaks these words, his pursuers retreat and fall to the ground (John 18:6). Peter strikes off the ear of Malchus, one of the high priest's servants (John 18:10). After the arrest, the disciples flee. The tradition links Judas' betrayal to Cain's murder of Abel as well as to the serpent's perversion of Adam through Eve.

REPRESENTATION AND ICONOGRAPHY

The two episodes _ the kiss of Judas and Christ's arrest _ are often combined in art, with different stresses. Byzantine art juxtaposes the tight-knit band of soldiers with Judas and Christ at its centre with the Malchus scene (mosaic at St Mark's, Venice, c.1200). Giotto invests the scene with considerable drama (*The Kiss of Judas*, 1304-6, Arena Chapel, Padua). In Naumburg Cathedral, Germany, a carved stone jube (thirteenth century) puts the Malchus episode to the fore, while Judas' kiss is relegated to the background. By the end of the middle ages, the scene is interpreted more and more realistically and dramatically (Dürer, *Große Passion*, 1510; Altdorfer, *The Arrest*, retable, Sankt Florian, Austria, nocturnal scene in a wood where the Malchus episode occupies the foreground). From the seventeenth century onwards, the arrest becomes a less frequent theme.

Cross-references: Cain and Abel, Garden of Olives, Judas Iscariot, Peter.

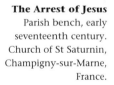

The Arrest of Jesus
Parish bench, early seventeenth century. Church of St Saturnin, Champigny-sur-Marne, France.

ARROWS *see* **CHRISTINA (WITH MILLSTONE AND PALM), EDWARD (CROWNED), GILLES (WITH CROZIER), MARY, SEBASTIAN (YOUNG, NAKED), URSULA (AND VIRGINS).**

ASCENSION

Italian: Ascensione; Spanish: Ascensión; French: Ascension; German: Himmelfahrt Christi.
Feast day Thursday 40 days after Easter.

TRADITION

The Ascension is known through St Mark's Gospel which mentions the event only briefly: "So then after the Lord had spoken unto them, he was received up into heaven, and he sat on the right hand of God" (16:19). Luke is hardly more detailed in his account: "And it came to pass, while he blessed them, he was parted from them, and carried up into heaven. And they worshipped him, and returned to Jerusalem with great joy" (24:51-52). Further details, which provided ample material for artists, were given by Luke in the Acts of the Apostles (1:9-12).

An early tradition derived from legend asserts that the Ascension took place on the summit of the Mount of Olives and that Christ's footprints remained visible on the surface of the rock.

REPRESENTATION AND ICONOGRAPHY

The Ascension does not figure in the art of the catacombs; the first examples date from the fourth century. From earliest times, two types vied with each other: Christ is carried up to heaven by angels, or he is shown rising unassisted and grasping the Hand of God.

The Byzantine Church is dominated by a version showing Christ seated within the mandorla and lifted up by angels. Louis Réau noted that this type derives the most directly from the *apotheosis* of the ancient world where the personage to be deified is lifted up by winged Victories and Genii. Fixed by Byzantine manuscript illuminations and mosaics (cupola of St Sophia, Salonica, ninth century), it scarcely varies. Christ can be shown either seated or standing, framed occasionally by the symbols of the Evangelists and the wheels of fire of the vision of Ezekiel.

Beginning in Italy, this eastern type had some influence in the west. On the wooden door of S. Sabina in Rome (fifth century), Christ is supported by two angels. This version can also be found in France: at Chartres Cathedral (tympanum of the west door, c.1145), Christ stands on a cloud and is borne aloft by two angels. This Byzantine version, distinguished by the "passivity" of Christ, confronts a type one might call "western", where Christ rises up without the aid of angels. Christ can be lifted up by the Hand of God emerging from a cloud (carved ivory plaque, fourth century, Bayerisches Nationalmuseum, Munich); the Ascension can be linked to the visit of the Holy Women to the Holy Sepulchre, after the Resurrection. From the eleventh century, Christ rises up to heaven of his own volition, towards the Hand of God which gives his benediction.

Generally, Mary and the apostles watch the event. There is no fixed number of apostles (they vary from eleven to fourteen) but they are most often twelve, with Paul rather than Matthias replacing Judas. This makes for a two-

The Ascension
Woodcut from James of Voragine's *Golden Legend*, 1483 edition.

The Ascension
Mantegna, triptych of the Adoration of the Magi, 1460. Uffizi, Florence.

level composition, as in the Transfiguration and in some Assumptions. Giotto shows Christ rising accompanied by a whole procession of the just of the Old Testament (1304-6, Arena Chapel, Padua). Below, on their knees, the Virgin and the apostles listen to two angels telling them of the Second Coming. In most cases, the whole body of Christ is visible. Those works which attempt to give the impression of the Body in Glory are the most similar to representations of the Transfiguration.

Around the sixth century, a motif made its appearance in which only the lower half of Christ's body is visible. This became prevalent in the thirteenth century and remained strong until the end of the middle ages (Dürer, *Kleine Passion*, 1507-13). In Renaissance Italy, Christ is shown ascending to heaven in his entirety. In the late sixteenth century, compositions of this theme can be extremely dynamic (B. Spranger, c.1575, Narodni Galerie, Prague). In the seventeenth and eighteenth centuries the theme of the Ascension is more or less eclipsed by that of the Assumption of the Virgin.

Cross-references: Apostle, Assumption, Hand of God, Mandorla, Mandylion of Edessa, Transfiguration.
Bibliography: A. Grabar, *Les Voies de la création en iconographie chrétienne*, Paris, 1979. H. Guthberlet, *Die Himmelfahrt Christi in der bildenden Kunst*, Strasbourg, 1934. G. Schiller, *Ikonographie der christlichen Kunst*, 1971, vol. III, pp. 141-164.

ASPERGILLUM *see* MARTHA.

ASS *see* ANIMALS, BALAAM (MAN ON ASS STOPPED BY ANGEL), DAVID (DAVID AND ABIGAIL), ENTRY INTO JERUSALEM (WITH PALMS), FLIGHT INTO EGYPT (MARY, JOSEPH AND THE INFANT JESUS), MAGI (THREE KINGS), MARTIN (CUTTING HIS CLOAK IN TWO), NATIVITY (WITH OX), OX (NATIVITY), SAMSON (JAWBONE), ZACHARIAH (OLD MAN AND WOMAN WITH BABY).

ASSUMPTION OF THE VIRGIN

Latin: Assumptio; Italian: l'Assunzione della Madonna, l'Assunta; Spanish: la Asunción; French: l'Assomption; German: Mariä Himmelfahrt.
Feast day 15 August.

TRADITION
The belief in the Assumption of the Virgin – her bodily ascension into heaven after death – took a long time to be established. The tradition has no Biblical basis. In the eastern Church, the Dormition (*Koimesis*) – that is, the "Sleep" – of the Virgin, when her soul alone is elevated, is the earlier datable feast. The bodily Assumption was hardly celebrated in this region until the ninth century. In the west, the doctrine only became fixed between the ninth and twelfth centuries and was ratified by the great theologians of the thirteenth century: Thomas Aquinas, Bonaventura and Albert the Great. The

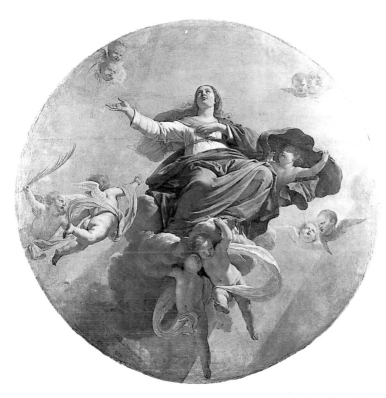

dogma of the Assumption of the Virgin was proclaimed by Pope Pius XII in 1950.

REPRESENTATION AND ICONOGRAPHY

Several motifs combine in the theme of the Assumption. Continuing the theological approach of the eastern Church, various aspects belong to the series of the Dormition of the Virgin. She dies, or rather falls asleep, and Christ receives her soul in the form of a little child (frescoes, Agaç Alti Kilise, Turkey, eleventh century; in the upper section, Christ holds Mary's soul, while behind him an angel holds a sceptre).

In the west, artists have tended illustrate the corporeal Assumption of the Virgin. Like her Son, Mary is resurrected three days after her death and is carried up into heaven by angels. A low-relief in Autun Cathedral (twelfth century) shows her, in an allusion to the Resurrection of Christ, piercing the roof of her tomb. A fourteenth-century relief in a quatrefoil (north end of the main apse, Notre Dame, Paris) presents the Virgin surrounded by a mandorla and lifted up by eight angels.

This motif endured through to the seventeenth century (di Giovanni, c.1474, National Gallery, London; Puget, marble statue, 1660s, Albergo dei Poveri, Genoa, where the Virgin, her arms outstretched and her eyes raised to heaven, stands on a crescent moon and is borne aloft by a group of angels). Titian (1516-18, S. Maria Gloriosa de' Frari, Venice) has the Virgin simply dressed and carried up by cherubs on a cloud to God the Father, while the apostles look on excitedly.

From the sixteenth century onwards, however, the Assumption changes

into an Ascension of the Virgin, in which she rises up unaided. Her forehead encircled by twelve stars and a crescent moon under her feet, she has become the Woman of Revelations, "clothed with the sun, and the moon under her feet, and upon her head a crown of twelve stars" (Rev. 12:1). In the sixteenth century, a stained glass in the Church of St Nicholas de Tolentin (Brou, France) is based on a dual iconographical tradition. In a lower section, the apostles lean over the open tomb of the Virgin which is full of flowers; above, the Virgin floats up to heaven unaided.

In order to exalt still more the importance of the Assumption, much effort was put into enriching the event with details borrowed from the Resurrection. This was the origin of the apocryphal episode of the Virgin's girdle: the apostle Thomas, famous for his incredulity concerning the Resurrection, was also supposed to have questioned the reality of the Assumption (*see* Thomas).

Cross-references: Coronation of the Virgin, Dormition, Mary, Resurrection, Thomas.

Bibliography: Germer-Durand, "L'Assomption", *Revue d'art chrétien*, 8, 1878, pp. 50-63. B. Nieto, *La Asunción de la Virgen en el arte,* Madrid, 1950. G. Schiller, *Ikonographie der christlichen Kunst*, 1980, vol. IV, 2, p. 82.

AUGUSTINE

Archaic variant: Austin. Latin: Augustinus; Italian: Agostino; Spanish: Agustin; French: Augustine; German: Augustin, Augustinus.
Bishop. Doctor of the Church. 354-430. Feast day 28 August.

LIFE AND LEGEND

The life of Augustine of Hippo, the greatest theologian of the Roman Catholic Church, is known above all through his own *Confessions*, which cover the period up to the death of his mother, St Monica, in 387 AD. Born in Tagaste (close to Hippo, near present-day Annaba, in Algeria) on 13 November 354, he went to Milan in 382 to take up a chair in rhetoric. There he met St Ambrose. In 386, at Milan, he was converted. Lying one day under a fig-tree in his garden, he heard a child's voice say to him: "*Tolle, lege* [Take, read]". Randomly opening a copy of the epistles of St Paul he had with him, his eyes fell on Rom. 13:13-14: "Let us walk ... not in rioting and drunkenness, not in chambering and wantonness ... But put ye on the Lord Jesus Christ." After his preparation, he was baptised by St Ambrose himself on Easter night, 387, with his son Adeodatus, and his friend Alypius. His mother, Monica, joined him on most of his travels, and died at Ostia on the return journey from Africa. Augustine returned alone, became a priest in 391 and Bishop of Hippo in 395, and shared in the monastic life of his clerical community. He died in 430, at Hippo, having composed the *City of God* during the seige of the city by the Vandals. He is patron of theologians and printers.

REPRESENTATION AND ICONOGRAPHY

In the oldest surviving depictions, dating from the fifth and sixth centuries, Augustine has no specific attribute and no nimbus. Later, he was portrayed in episcopal dress, with mitre, crozier and various other accoutrements. Several orders regular claim him as their founder – for example, the Austins or Regular Canons of St Augustine, who can be distinguished from Franciscans by their leather belts, and the Premonstratensians. St Augustine is often represented as an Augustinian friar, with a black frock and leather belt.

St Augustine and the Child on the Seashore
1518. Bibliothèque Nationale, Paris.

Two types of depiction predominate. He can be shown as an author with his secretary, dictating under the influence of the dove of the Holy Spirit or an angel. This type appears above all in the manuscripts of his works illustrated with his life. He is also shown on a professorial chair teaching his students, who sit around him (manuscript miniature of the *City of God*, early twelfth century, Canterbury Library). Augustine is occasionally depicted arguing with certain anonymous or identifiable heretics (Faustus, for example, in miniatures from the end of the eleventh century). He can also be shown as a bishop, standing, or seated on the *cathedra* (mosaics in the Cathedral of Cefalù, Sicily, fifteenth century; frescoes, cloister of Nonnberg, Salzburg, twelfth century).

From the fourteenth century, artists combined depictions of St Augustine with those of the three other Doctors of the Church, Jerome, Ambrose and Gregory (Michael Pacher, *Kirchenväteraltar*, before 1483, Alte Pinakothek, Munich, where each occupies a niche). They can also be combined in hagiographical terms (Carpaccio, *St Augustine's vision of St Jerome*, 1502-7, Scuola di San Giorgio degli Schiavoni, Venice, where the same artist's *St Augustine in his Studiolo* can also be found). The spread of the Augustinian Order to Spain (Jaime Huguet, *The Consecration of St Augustine*, late fifteenth century, Museu de Arte Antica de Catalunya, Barcelona) and to the Low Countries encouraged the development of Augustine's iconography. After the Reformation, Augustine as defender of orthodoxy against heresy was the preferred type (Hendrick Verbruggen, pulpit, Augustinian church, Antwerp, seventeenth century; Bartolomeo Altomonte, Herzogenburg Abbey Church, Austria, 1753-64, where the saint is shown holding a pen from which bolts of lightning shoot out; C. Coello, *Triumph of St Augustine*, 1664, Madrid, Prado, where he towers over a dragon).

Principal Scenes

The cycles of St Augustine's life increase steadily in number from the middle ages, becoming very frequent in the eighteenth century (by which time an entire church is devoted to his life story in southern Germany: frescoes by Matthäus Günther, 1738-40, Rottenbuch). The main events of his life are depicted: his early life (Gozzoli, *St Augustine at Tagaste*, 1460s, San Gimignano); his conversion, with the *"Tolle, lege"* scene; his baptism; the vision of the child on the seashore. This last legend was abundantly illustrated. A child, often assimilated to an angel, appeared to the saint who was meditating on the mystery of the Trinity: the child is shown trying to empty the sea with a shell, a task no more futile than attempting to explain the Three in One. (François de Nomé, early seventeenth century, National Gallery, London). This anecdote is not the only allusion to Augustine's cult of the Trinity. An angel points to the Trinity in heaven, before which Augustine kneels (Murillo, 1666-71, Museo Provincal de Bellas Artes, Seville). He also holds a flaming heart (an allusion to love of God and of one's neighbour, and to a passage in the *Confessions*, IX, 2:3). Still another interpretation is to be found in the Augustine retable (Neustift), which shows the Trinity as a man with three faces.

Another scene was particularly inspirational: St Augustine hestitating between the blood of Christ and the milk of the Virgin. *"Positus in medio, quo vertam nescio, hic pastor a vulnere, hic lactor ab ubere,"* St Augustine wrote in his *Meditations*: "I stand between them, which way shall I turn? On the one side the blood of Christ, on the other, the milk of his Mother." Rubens shows

Augustine between Christ exhibiting the wound in his left side, and Mary exposing her breast from which milk is flowing.

Attributes: Child or angel with shell. Transfixed or flaming heart (from the fifteenth century).
Cross-references: Ambrose, Monica, Trinity.
Bibliography: P. et J. Courcelle,*"Iconographie de saint Augustin"*, *Les Cycles du XIVème siècle, êtudes augustiniennes*, Paris, 1965; "Iconographie de saint Augustin", *Les Cycles du XVème siècle*, ibid., Paris, 1969. A. Mandouze, *Saint Augustin*, Paris, 1968. H. I. Marrou, "Saint Augustin et la légende de l'ange", *Bulletin de la Société nationale des antiquaire{ de France*, 1955.

AUXILIARY SAINTS *see* FOURTEEN HOLY HELPERS.

AXE *see* JOHN THE BAPTIST, MATTHEW (WITH BOOK), OLAF.

BABEL (TOWER OF)

Italian: Torre di Babele; Spanish: Torre de Babel; French: Tour de Babel; German: Turm zu Babel, Babylonischer Turm.

TRADITION
In Genesis (11:1-9), the story is recounted of how man tried to build "a tower whose top may reach unto heaven". God, who saw this as a sign of human arrogance, descended and "there confound[ed] their language, that they may not understand one another's speech." God then "scattered them abroad ... upon the face of all the earth: and they left off to build the city".

Traditionally, the architect of the tower was the "mighty hunter before the Lord", Nimrod, son of Cush. Nimrod's "kingdom was Babel, ... and out of that land [he] went forth [to] Asshur [Assyria] and builded Nineveh ... and Calah: that same is a great city" (10:10-12). It is for this reason that he was linked to the building of the Tower of Babel (Babylon). The episode concludes the earliest period of Biblical history, comprising the Creation, the Fall and the Flood.

REPRESENTATION AND ICONOGRAPHY
Three main themes were taken up by artists: the construction of the tower;

The Building of the Tower of Babel
Bedford Book of Hours, c.1424. Department of Manuscripts, British Library, London.

its destruction; and finally the confusion of languages and the scattering of the peoples. The first two were the most inspirational.

The medieval version of the tower was generally built on a rectangular or circular plan. A tower constructed with an outside, railed, spiral staircase made its appearance in the fourteenth century. This was often a slender edifice, without proper storeys, and appeared disproportionately small compared to the figures. In the Low Countries in the sixteenth century, artists mostly chose towers in a pyramidical or skittle-like shape, with only six or seven floors. Some larger edifices, however, do occur (Hendrick van Cleve III, Phil Collection, Limburg-Stirum, Anzegem). By this time, the workers seem minute in proportion to the vast construction (Breugel the Elder, 1563, Kunsthistorisches Museum, Vienna). The Netherlandish painter, Lucas van

Valckenborch (1540-97) specialized in such compositions (examples are in the Alte Pinakothek, Munich). The theme slowly disappeared during the seventeenth century, though in the Church of Johannes der Täufer, Wessobrunn, Germany, the pyramidical tower symbolizes St John the Baptist's excellence.

The destruction of the tower is not mentioned explicitly in Genesis, but it can be deduced from the text. Artists tended to go for inspiration to the passages in Revelations 18 devoted to the casting down of Babylon, the Great Whore. God the Father can appear in both scenes as spectator, as implied in the Bible. He either destroys the town himself, or sends angels or even storm winds to do his bidding. From the end of the middle ages, bright streaks of lightning are often shown felling the tower.

The confusion of languages and the scattering of the peoples were most frequently juxtaposed with these other themes and sometimes even incorporated into them. The confusion of languages was readily associated with representations of the disciples' miraculous speaking in tongues at Pentecost. To show the confusion of the languages, figures are depicted with their fingers over their mouths, while the diversity of the races and the scattering of the peoples is demonstrated by the presence of blacks and Chinese. A thirteenth-century mosaic in the narthex of St Mark's, Venice, shows God scattering the workmen who disperse in four different directions.

Cross-references: God, Noah, Pentecost.
Bibliography: H. Mindowski, *Aus dem Nebel der Vergangenheit steigt der Turm zu Babel, Bilder aus 1000 Jahren*, Berlin, 1959.

BABYLON *see* BABEL (TOWER OF), REVELATIONS.

BALAAM

TRADITION
The history of Balaam is contained in chapters 22 to 24 of the Book of Numbers. Balaam was a seer consulted by Balak, King of Moab, who was disturbed by the arrival of the Jewish tribes at the frontier of his kingdom. As Balaam rode to see Balak, he was stopped by an angel. In a dream, God warned him not to go to the king, but Balaam continued on his way. He enraged Balak by making prophecies of what amounted to blessings on Israel. A somewhat ambiguous figure, Balaam was finally put to death by the Hebrews for advising the Moabites to corrupt them and convert them to their own religion. An ancient tradition credits Balaam with the prophecy according to which "there will come a Star out of Jacob, and a Sceptre shall rise out of Israel" (Num. 24:17).

REPRESENTATION AND ICONOGRAPHY
From the earliest Christian times two episodes from the story of Balaam have been consistently depicted. On a fourth-century fresco in the catacombs of SS. Marcellinus and Peter, Rome, Balaam stands with his hand raised pointing to a star. In the Via Latina catacombs of the same period, he is shown perched on his ass, being halted by an angel. This second scene predominated by the middle ages (sculpture, Autun Cathedral, twelfth century). A stained-glass window in Chartres juxtaposes Balaam standing pointing to his star with the Tree of Jesse. The star is also often linked to the Star in the East

Balaam's Ass Stayed by the Angel
Miroir de l'humaine Salvation, fifteenth century. Musée Condé, Chantilly.

marking Christ's birth. In the seventeenth century, Rembrandt painted the encounter between Balaam and the angel as an autonomous scene (*The Ass of Balaam*, 1626, Musée Cognacq-Jay, Paris).

BANNER *see* CHURCH AND SYNAGOGUE (TWO WOMEN), GEORGE (KNIGHT AND DRAGON), JOAN OF ARC, MAURICE (BLACK).

BAPTISM OF CHRIST

Greek: Baptismos; Latin: Immersio Domini; Italian: il Battesimo di Gesù; Spanish: el Bautismo de Cristo; French: le Baptème de Jésus; German: die Taufe Christi. Feast day 6 January.

TRADITION

The Baptism of Christ is mentioned in all four Gospels (Matt. 3:13-17; Mark 1:9-11; Luke 3:21-22; John 1:29-34). Jesus arrived on the banks of the Jordan from Galilee and asked John to baptize him. John at first refused, "saying, I have need to be baptized of thee" (Matt. 3:14). Jesus, however, declared that he should "fulfil all righteousness" as commanded by God. After the Baptism, the spirit of God came down from the sky "like a dove" and a voice from heaven declared: "This is my beloved Son, in whom I am well pleased."

The Fathers of the Church saw in this episode a manifestation of the Trinity, with God the Father represented by the voice from heaven and the Holy Spirit by the dove. This epiphany, or theophany (divine appearance or manifestation), is commemorated on 6 January, the day on which the western Church now celebrates the coming of the Magi (Epiphany). The Crossing of the Red Sea has also been read as a foreshadowing of the Baptism.

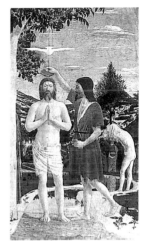

The Baptism of Jesus
Piero della Francesca, 1448-50. National Gallery, London.

REPRESENTATION AND ICONOGRAPHY

The Baptism has been depicted from earliest times. A fresco on the catacomb of Callista in Rome (crypt of Lucina, end of the second century), represents all three elements of the epiphany: Jesus coming out of the water, the heavens opening and the dove descending. In the older examples, Jesus appeared for the most part as a child. In the catacomb of Callista, however, Christ was portrayed as an adult, John the Baptist as an older, bearded figure. The composition is simple, comprising the two isolated figures of Christ and John. From around the sixth century, a number of subsidiary elements were added to the main scene. The two angels which occasionally appear on the opposite shore have been explained by Louis Réau by reference to the liturgy: they perform the office of deacons ready to hand Jesus his vestments. This is made explicit in Gerard David's much later version (1508, Groeningemuseum, Bruges). The Jordan itself may be personified as a bearded river god. Occasionally, a stag drinks from the river, while the Word is sometimes evidenced by the Hand of God.

From about the ninth or tenth century, illustrations appear which clearly refer to the contemporary rite of baptism, with the dove pouring consecrated oil from a phial over Christ's head. This motif was taken up at the same period in depictions of the baptism of Clovis. In the thirteenth and fourteenth centuries, the rite itself underwent a matching change, with the catachumen no longer immersed wholly or partly in water but simply having water poured

over his head from a phial or shell. This motif was employed by Andrea Pisano (relief for the bronze door of the Florence Baptistry , c.1335) where the purificatory water of baptism is poured over Jesus' head. Nicholas of Verdun (Klosterneuberg altarpiece, 1181, Klosterneuberg Stiftsmuseum, Austria) shows one of the earliest examples of christening by infusion, but Jesus is still partially immersed in the river.

The Renaissance tended to concentrate on the act of baptism itself, and showed less concern with the theme of the Trinity (Piero della Francesca, 1450s, National Gallery, London; Andrea del Verrocchio, c.1472, Uffizi, Florence; Joachim Patinir, 1515, Kunsthistorisches Museum, Vienna). Jesus, in an attitude of prayer, receives the water John pours over his head. The dove of the Holy Spirit still hovers over Christ, while angels descend from heaven.

Veronese (c.1580, Pinacoteca di Brera, Milan) interprets the Baptism as a manifestation of divine light, pervading all space, and accompanied by angels singing praises of the Lord. The Temptation of Christ is evoked in the background. In the seventeenth and eighteenth centuries, the two main figures continue to appear, but in general a choir of angels also assists.

Cross-references: Angel, Hand of God, John the Baptist, Moses, Trinity.
Bibliography: G. de Jerphanion, "Le baptème de Jésus dans la liturgie et dans l'art chrétien", *La Voix des Monuments*, vol. I, 1930. L. Réau, op. cit., vol. II, 2, p. 298. G. Schiller, *Ikonographie der christlichen Kunst*, Gütersloh, 1966, vol. I, pp. 137 ff.

St Barbara and the Tower
Beginning of the seventeenth century.
Bibliothèque Nationale, Paris.

BARBARA

Latin, Italian, Spanish and German: Barbara; French: Barbe.
Virgin and Martyr. Feast day 4 December, suppressed in 1969.

LIFE AND LEGEND

The very existence of this saint is open to doubt. According to her legend, she was born in Nicomedia on the Sea of Marmara, her father being a satrap called Discorus. He had her shut up in a tower: in one version so that no man should cast eyes open her, and in another to preserve her from Christian teaching.

Taking advantage of an absence by her father, Barbara became a Christian and had a third window made in her prison tower in honour of the Trinity. Furious at her conversion, her father commanded her death. She escaped, hiding in a crack which miraculously opened up in the rock before her. Betrayed by a shepherd, she was imprisoned and tortured. She was racked, like St Vincent, then birched and carded with metal combs, forced to lie on a bed of sharp shards and seared with red-hot blades. Paraded naked, she was shielded from view by a veil draped over her by an angel. Her father then dragged her up a mountain and had her beheaded. Immediately after her execution, he was struck down by lightning.

Of eastern origin, her cult reached the west only in the fifteenth century, and became especially important in Germany. She was numbered among the *Vierzehn Nothelfer* (the auxilliary saints known as the Fourteen Holy Helpers) with two other female saints, Margaret and Catherine of Alexandria.

Barbara protects against lightning, an allusion to the death of her wicked father. From the fifteenth century she has been the patron saint of gunners, miners and quarrymen and, more recently, of those in a host of similar trades, such as firemen.

REPRESENTATION AND ICONOGRAPHY

The oldest depiction of Barbara dates from the eighth century on a sculpted pillar in S. Maria Antica, Rome. She is accompanied by a peacock which here symbolizes the Resurrection and immortality. The Pähler altarpiece (c.1410, Bayerisches Nationalmuseum, Munich) shows her holding her three-windowed tower. This motif was also employed in a painted statue at the beginning of the sixteenth century (Musée Tavet-Delacour, Pontoise, France). The Master of the Legend of St Barbara chose the episode when Barbara, chased by her father brandishing a sword, disappeared into the rocks which parted to let her through (Flemish, end of the fifteenth century, Musées Royaux des Beaux Arts, Brussels). She can also be shown suffering a similar fate to Agatha, with her breasts removed (Master Francke, c.1410, Ateneumin Taidemuseo, Helsinki). The martyrdom itself continued to be treated at a later date (Theodor van Thulden, c.1633, Musée des Beaux Arts, Dijon).

Jan van Eyck (1437, Antwerp, Koninklijk Museum voor Schone Kunsten) and Boltraffio (c.1502, Berlin-Dahlem Staatliche Museen, Berlin) present her various attributes, while Cavaliere d'Arpino shows her standing next to her tower carrying bolts of lightning (c.1597, S. Maria in Traspontina, Rome). Goya shows her, crowned, holding a ciborium and the palm of martyrdom, with the tower in the background, along with her father attacking her and being struck by lightning (c.1771-5, Private Collection)

Attributes: Three-windowed tower. Ciborium (in Germany and Flanders, crowned with a holy wafer). Lightning. Crown of martyrdom.
Bibliography: A. de Lapparent-Saulnier, *Saint Barbe*, Paris, 1926.

BARNABAS

Latin and German: Barnabas; Italian: Barnaba; Spanish: Bernabé; French: Barnabé.
Apostle. Martyr. Died c.62. Feast day 11 June.

TRADITION

A Cypriot Levite, he was born Joseph, but the apostles renamed him Barnabas, meaning "son of consolation". He gave away all his worldly goods to the poor of Jerusalem and, when Paul went to the city following his conversion, it was Barnabas who convinced the initially sceptical apostles of his sincerity (Acts 9:27). He then accompanied Paul on his first journey (in AD 40-48). Passing through Lystria they were taken for gods, but refused the sacrifices offered up to them by the local priests. The Epistle to the Hebrews and that which bears his name are both incorrectly attributed to him. The voyages he is credited with undertaking to Alexandria, Macedonia, Rome and Milan are all apocryphal.

He was stoned and then burnt alive by Cypriot Jews at Salamis around 62. The church in Milan dedicated to him has given its name to an order of friars, the Barnabites, founded in 1530 by St Antony Zaccaria. Barnabas was purported to have cured the sick by laying a volume of the Gospel of St Matthew on their bodies. He is the patron of Milan, where the relic of his head is preserved, and also of Florence, in memory of her victory over Siena in 1269 on his feast day. He is also the patron saint of weavers.

REPRESENTATION AND ICONOGRAPHY

Barnabas is generally depicted as an aged disciple with a white beard, but he

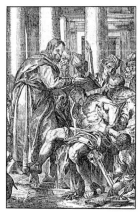

St Barnabas curing the Sick
P. Brébiette, after Veronese, seventeenth century.
Bibliothèque Nationale, Paris.

can also be shown wearing episcopal vestments in memory of his legendary status as first bishop of Milan. He holds in his hand the Gospel of St Matthew. Among the scenes from his life most readily represented are his preaching and his refusal of the sacrifices offered him in Lystria (*Sacrificio di Barnaba e Paolo,* sixteenth-century tapestry after a cartoon by Raphael, Vatican, Pinacoteca). Veronese portrayed him curing a sick man by placing the Gospel of St Matthew on his head (c.1560, Rouen, Musée des Beaux Arts). There is a Venetian *Apotheosis* dating from the mid eighteenth century (Costantino Cedino, nave fresco, San Barnaba).

Attributes: Gospel of St Matthew.
Cross-references: Matthew, Paul, Stephen.
Bibliography: H. Delehaye, "Saints de Chypre", *Analecta Bollandiana,* 26, 1907, pp. 235-7; *Bibliotheca Sanctorum,* pp. 798-813.

BARRABAS *see* FLAGELLATION OF CHRIST, TRIAL OF CHRIST.

BARTHOLOMEW

Variant: Nathaniel. Latin: Bartholomaeus, Nathanael; Italian: Batholomeo, Bartolo; Spanish: Bartolomé; French: Barthélemy; German: Bartholomäus. Apostle. Feast day 24 August

TRADITION
Although he is mentioned in all the lists of the apostles, Bartholomew (occasionally identified with Nathaniel) played no active part either in the Gospels or in the Acts. After Christ's death, he purportedly evangelized Arabia and Mesopotamia, and travelled as far as India before being martyred in Armenia. At Albanopolis, he was first flayed alive, then crucified.

A number of churches in the west claim to possess a piece of his skin as a relic. His martyrdom has earned him a role as the patron of all who prepare skins or work in leather: butchers, tanners, curriers, glovemakers and bookbinders. In many towns, members of these wealthy and powerful trades commissioned depictions of him for churches.

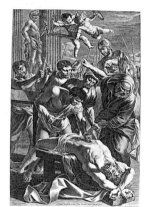

The Martyrdom of St Bartholomew
J. Couvay, after Poussin, seventeenth century. Bibliothèque Nationale, Paris.

REPRESENTATION AND ICONOGRAPHY
Bartholomew is nearly always shown flayed, carrying his skin on his shoulders or over one arm (1537-41, Sistine Chapel, where he acts as Michelangelo's self-portrait; Master of St Bartholomew, c.1480-1510, Alte Pinakothek, Munich), or else upside down on a cross to enable his torturers to strip off his skin more easily. German, Italian and Spanish painters of the baroque occasionally depicted the flaying scene with a degree of morbid voyeurism (Ribera, 1630s, Prado, Madrid).

Attributes: Flaying knife. Skin (over his arm).
Cross-references: Apostles.

BASIL THE GREAT

Italian: Basilio (Magno); French: Basile le Grand; German: Basilius der Grosse. Doctor of the Church. c.330-79. Feast day 2 January (since 1969).

TRADITION

Basil, born at Caesarea in Cappadocia into a noble family that already included a number of saints, received a solid Christian education, studying in his home town and in Constantinople, before spending five years at Athens. There, he became friends with St Gregory of Nazianzus. He then became a monk, visiting Syria and Egypt, before settling as a hermit with Gregory in Neo-Caesarea in Palestine. He refused Emperor Julian the Apostate's invitation to return to court, but abandoned his life of solitude in 364 at the instigation of Eusebius, Bishop of Caesarea. He joined the fight against the persecution of the Christians by the Arian emperor, Valens.

On Eusebius' death in 370, Basil became Bishop and Exarch of Caesarea, overseeing fifty suffragans. He spent his energies fighting the Arianism defended by the Imperial camp. A stubborn proponent of orthodoxy, Basil was never afraid of entering into conflict with political power, and even with papal authority whenever it was at odds with his own theological position. He was also much concerned with the welfare of the people in his diocese. Basil was the Solon of the eastern monastic movement, his Rule coming down to us in two distinct versions: *Regulae brevius tractatae* and *Regulae fusius tractatae*. Basil the Great also bequeathed important doctrinal and theological writings. His treatise on the Holy Spirit is among his most famous.

REPRESENTATION AND ICONOGRAPHY

Though his portrayal in the west remains infrequent, images are common in the east, where a canonical type developed quickly. From the tenth century, he has a long, narrow face, short grey hair, large eyes and a long, pointed beard. A tenth-century version is to be found in S. Maria Maggiore in Rome. A series of icons from Sinai (seventh–ninth centuries) and a mosaic in St Sophia in Kiev (where he is shown full-face) can also be cited. Basil the Great may be combined with other Doctors of the eastern Church, such as Gregory of Nazianzus or John Chrysostom. From the seventh century onwards, he is often shown in profile, holding a scroll inscribed with a passage of liturgical text. On a fresco in St Sophia at Ochrida (1040), Basil celebrates the liturgy in the company of two deacons. Elsewhere, he is shown safeguarding the Nicaean Church against the designs of the Emperor.

Cross-reference: John Chrysostom.
Bibliography: "Basilio", *Bibliotheca Sanctorum*, vol. IV, Rome, 1961-9. E. Kirschbaum, *Lexikon der christlichen Ikonographie*, Freiburg im Breisgau, 1968-74, *Ikonographie der Heiligen*, vol. V, cols. 337-41. D. Hugh Farmer, *The Oxford Dictionary of Saints*, pp. 40-41, Oxford, 1992. A. Grabar, *Byzantine Painting*, Paris, 1953.

St Basil
Theophanes, 1405. Kremlin, Moskow.

BATHSHEBA *see* DAVID.

BEAR *see* BLANDINA (WITH LION *or* NET), COLOMBAN (NEAR CAVE), DAVID, DEVIL, GALL (THORN AND HERMITAGE), MARRIAGE OF THE VIRGIN, MARTIN (AS BEAST OF BURDEN), MIRACLES OF THE VIRGIN (THEOPHILUS).

BEE *see* BERNARD.

BEEHIVE *see* AMBROSE, BERNARD.

BELLOWS *see* GUDULE.

BELSHAZZAR *see* DANIEL, NEBUCHADNEZZAR.

BENEDICT OF NURSIA

Latin: Benedictus Cassinensis; Italian: Benedetto da Norcia; Spanish: Benito;
French: Benoît de Nursie; German: Benedikt.
Abbot. c.480-c.550. Feast day 11 July (since 1969; formerly 21 March).

LIFE AND LEGEND
Benedict was born into an aristocratic family around 480 in the Umbrian
province of Nursia (Norcia). He studied until the age of twenty then went
with his nurse to Enfida (now Affile), about 50km east of Rome. One day,
his nurse dropped an earthenware riddle on the ground, breaking it. Benedict
prayed and it was miraculously repaired.

Around 500, he retired to a cave in a place which was to become known
as Sacro Speco, near the Lake of Subiaco. There, a Roman monk delivered
bread to him in a cavern by lowering it each day in a basket on a rope, inform-
ing Benedict of its arrival by ringing a little bell, which Satan once
smashed. In 529, Benedict founded the Abbey of Monte Cassino and com-
posed his famous Rule, which has served ever since as a basis both for
Benedictines and for western monastic life generally. Benedict was the spir-
itual forefather of all the western orders, and is called the Patriarch of west-
ern monasticism. His miracles were relayed by Gregory the Great (c.540-604)

**St Benedict Repairs the
Broken Riddle**
Spinello Aretino 1386-87. S.
Miniato al Monte, Florence.

in the second book of his *Dialogues*, and included in Voragine's *Golden Legend*.

One episode tells of Totila, King of the Goths, who tried unsuccessfully to hoodwink Benedict by sending an officer dressed in royal costume in his stead. Another famous scene tells of how the monks of a monastery at Vicovaro near Tivoli rose up against the rigorous abbot that Benedict had imposed upon them. One of their number tried to assassinate him by bringing him poisoned bread, but Benedict's tame raven flew off with it, thus saving the saint's life.

Benedict himself predicted the destruction of the Abbey at Monte Cassino, which has taken place three times: in 590, the Lombards razed it to the ground; in 823 it was the turn of the Saracens; finally, in 1943, Allied aircraft bombed it. Benedict died in the monastery around 547 and is buried there with his twin sister St Scholastica. He is the patron of the Benedictine Order and, since 1964, of Europe.

REPRESENTATION AND ICONOGRAPHY

Benedict can be seen wearing the Benedictine cowl, either with or without a beard (Master of Mondsee, c.1515, Österreichische Galerie, Vienna, in his cavern with bread being lowered to him). He is sometimes shown next to Christ (altar front, ninth century, Musée de Cluny, Paris). The episodes of his legend served as a basis for a series of twelfth-century capitals in the Abbey Church of St Benoît sur Loire: repairing the shattered riddle; the demon cutting the rope used to lower his food and breaking his little bell; Benedict seeing through the trick of King Totila. Other episodes show his temptation by Satan and the demon's dancing courtesans, and his self-mortification by rolling on thorn bushes. These last two episodes are also shown on the predella of Ancina (Ambrogio Borgognone, fifteenth century, Musée des Beaux Arts, Nantes). Among the scenes depicted on the frescoes at Sacro Speco in Subiaco (thirteenth century) figure the attempt to poison him and the raven's miraculous interception of the baleful bread. These events were also treated by Michael Pacher (gold leaf wooden statue, Sankt Wolfgang, Austria, 1481).

The repairing of the broken riddle appears on a fresco by Spinello Aretino (San Miniato al Monte, Florence, 1386-87). Luca Signorelli shows him with a monk, probably Roman (last quarter of the fifteenth century, Monte Oliveto Maggiore, Abbazia).

Attributes: Raven (carrying off the poisoned bread). Riddle. Cup (broken, or with a snake crawling out of it).

Bibliography: E. Dubler, *Das Bild des heiligen Benedikt bis zum Ausgang des Mittelalters*, Sankt Ottilien, 1953.

BENEDICTINES

Italian: Benedettini; Spanish: Benedictini; French: Bénédictins; German: Benediktiner.

In the middle ages, Benedictine monks wore a wool shirt, a hooded pelerine which tapered both in front and behind (the scapular), over these a habit or frock, and lastly the cowl (*cuculla*). By the thirteenth century, this last garment had become a kind of narrow frock left free on both sides to reveal the other garments underneath. These overgarments are black, which has encouraged them to be known as Black Monks, whereas the Cistercians, with their

Benedictines
Vincent de Beauvais, *Miroir historial* (detail), fifteenth century. Musée Condé, Chantilly.

white robes and scapulars, are known as White Monks.

Cross-references: Anselm, Benedict, Gall, Gilles, Gregory the Great, Odile.

BERNARD

Latin: Bernardus (Claravallensis); Italian and Spanish: Bernardo; French: Bernard; German: Bernhard.
Cistercian abbot. Founder of the Abbey of Clairvaux. Doctor of the Church. c.1090-1153. Canonized 1174. Feast day 20 August

LIFE AND LEGEND
Bernard entered the Abbey of Cîteaux at twenty-two, but left three years later with a group of monks to found the monastery of Clairvaux which he directed until his death. A reforming prelate, a theologian, author of numerous books, and an abbot who rejected both wealth and images (for his monks he would sanction only the crucifix), St Bernard of Clairvaux is the most important religious and ecclesiastical figure of the twelfth century. All Christendom accepted his authority and, though he remained a stalwart of the Papacy, he was often the arbiter between opposing factions in both worldly and doctrinal disputes. He was material in developing the cult of the Virgin, towards whom his devotion was particularly strong, and in enlarging the Cistercian Order, whose churches are all dedicated to Our Lady. On the mountain at Vézelay, in 1146, he preached the Second Crusade, but was unable to join it himself due to his poor health.

This energetic and charismatic abbot attracted legends from an early period and was credited with several miracles. Appearances to him of Christ and the Virgin are also often recounted in legends and portrayed in art.

REPRESENTATION AND ICONOGRAPHY
Though a mark of his seal is extant, no contemporary portrait of St Bernard survives. Although artists tended to concentrate more on his legend than on his historical life, representations of his death and his preaching of the Second Crusade do occur in later examples. In all these portrayals, Bernard is presented as a figure emaciated by fasting and the monastic life, wearing the white Cistercian habit and holding either a book or a pastoral staff (stone statuette, fourteenth century, Church of Bar sur Aube, France).

Four legendary episodes in particular have attracted artists. One is Christ freeing his arms from the Cross to embrace him (Francesco Ribalta, c.1625-7, Prado, Madrid). Then there is the statue of the Virgin coming to life and moistening his lips with a few drops of milk (the Miracle of Lactation, frequent in Spanish and German art: Master of the Life of the Virgin, *The Lactation of St Bernard*, c.1480, Wallraf-Richartz Museum, Cologne) or his simply contemplating the Virgin (Fra Bartolomeo, *The Vision of St Bernard*, c.1504-7, for the Badia, Florence, now in the Accademia, Venice; Juan de las Roelas, 1611, Hospital of San Bernardo, Seville; Filippo Lippi, 1486, Badia, Florence). The dream of Bernard's mother, while expecting him, is sometimes shown – that she would give birth to a white dog who would frighten off God's enemies. And Bernard rids himself of an incestuous desire for his sister by throwing himself into a frozen pond.

In spite of various cycles of his life (Jörg Breu the Elder, c.1500, Zwettl Stiftsmuseum, Austria), Bernard is a saint more esteemed than popular, and his iconography is not an abundant one. He is shown in an active role with

St Bernard
Vincent de Beauvais, *Miroir historial* (detail), fifteenth century. Musée Condé, Chantilly.

Victor IV by Maratta (1656-8, Duomo, Siena).

Attributes: White dog (alluding to his mother's dream). Chained demon. Instruments of the Passion. Book. Mitre on the ground (alluding to his refusal to become bishop). White Cistercian habit. Beehive or swarm of bees (in reference to his appellation *doctor mellifluus*, which he obtained by virtue of his honeyed eloquence).

Bibliography: E. Gilson, *Saint Bernard*, Paris, 1949. Dom J. Leclercq, *Saint Bernard et l'esprit cistercien*, Paris, 1966. *Saint Bernard et l'art des cisterciens*, catalogue de l'exposition des musées de Dijon, 1953. E. Vancandard, *Vie de saint Bernard*, Paris, 1895.

BIBLE

Italian and Spanish: la Biblia; French: la Bible; German: die Bibel.

The Bible comprises the totality of Holy Writ, both in the Old and New Testaments. Protestants, following the Jewish tradition, acknowledge as canonical Old Testament books only the forty written in Hebrew. Roman Catholics, however, add a further seven or eight, originally written in Greek, called the Deuterocanonical books (in the Protestant Bible, these are often relegated to form part of the Apocrypha).

From the third century BC, the Hebrew Bible was translated into Greek by the Hellenized community of Alexandria. Legend tells of how seventy Jewish scholars working independently presented seventy complete translations which were identical in every respect. Hence the name Septuagint (from "seventy") for this text, the only one known to the Fathers of the Church, and considered divinely inspired.

Only St Jerome, in the fourth century, was apprised of the Hebrew texts and used them to compile a Latin transcription known as the Vulgate. This

also contains a Latin translation of those Greek texts known to Christiins as the New Testament. In the middle ages, the Bible was known collectively as *Bibliotheca*, or *Scriptura* (*sancta, divina*). The word *Biblia* does not occur before the twelfth century.

BIRETTA *see* IGNATIUS OF LOYOLA, IVO (LAWYER).

BIRTH OF THE VIRGIN

Birth of the Virgin
Andrea Delito, c.1480.
Atri Cathedral.

TRADITION
No specific historical reference provides a date or place for this event. Traditionally, the date is 8 September; the place, however, varies between Jerusalem, Nazareth and Bethlehem.

REPRESENTATION AND ICONOGRAPHY
Just as representations of the Assumption are linked with the Resurrection, depictions of the Birth of the Virgin are directly dependent on those of the Nativity of Christ. St Anne is seated or lying on a bed, with several women gathered around her. The motif of the infant's bath, imported to the west from Byzantine art, is often also present. By the end of the middle ages, artists tended to emphasize the picturesque aspect of the scene. Albrecht Altdorfer set it in a church, with angels hovering by the cradle (c.1520, Alte Pinakothek, Munich). The angels reappeared in the seventeenth century.

Bibliography: L. Réau, op. cit., vol. II, pp. 162-64.

BISHOP AND ARCHBISHOP

Greek: episcopos; Latin: episcopus; Italian: vescovo; Spanish: obispo; French: évêque; German: Bishof.

"Chosen by the clergy and the people," according to the reforms of Gregory VII (Pope, 1073-85), a bishop rules over a diocese or see. Successors to the college of the Apostles, bishops are consecrated and invested with canonical powers. They can be recognized by their episcopal rings, mitres and croziers. Originally, they carried a simple pastoral staff, with a curve at the end, like a shepherd's crook, the origin of what is now the crozier. Bishops wear a pectoral cross, an *amice* around the neck and, ceremonially, a purple cassock.

The archbishop can be differentiated from the bishop by his pallium, a band of white wool with black crosses covering his other liturgical vestments. The pallium was originally worn solely by the pope and symbolized his absolute authority. The distinction of the pallium confers on the archbishop the power to ordain bishops and consecrate kings (for example, the Archbishop of Canterbury). The archepiscopal cross, with its long shaft, is a further specific attribute of the metropolitan.

Bishop
Pintoricchio, *St Augustine*,
end of the fifteenth century.
Galleria Nazionale, Perugia.

Cross-references: Albert the Great, Ambrose, Anselm, Augustine, Blaise, Denis, Eligius, Germanus, Hubert, Hugh of Grenoble, Hugh of Lincoln, Ignatius of Antioch, Januarius, Malo, Martin, Médard, Nicholas, Patrick, Remy, Stanislaus, Thomas Becket, Valentine.

The Assumption of the Virgin. Poussin, 1650. Louvre, Paris.

The Burning Bush. Nicholas Froment, panel from a triptych, 1476. St Sauveur Cathedral, Aix-en-Provence.

Black *see* Cosmas and Damian (black leg), Devil, Flagellation, Magi (king), Maurice (Black knight).

Blaise

Variant: Blazey; Latin and German: Blasius; Italian: Biagio; Spanish: Blasco (sometimes Velasco); French: Blaise (sometimes Balu or Blay).
Bishop. One of the Fourteen Holy Helpers. Died 316(?). Feast day 3 February.

Life and Legend

The life of the Armenian bishop St Blaise has been entirely refashioned by legend. Originally a doctor, he was elected as bishop for Sebaste (Sebastea) in Asia Minor and took up episcopal residence in a cave. He cured the sick, including animals, by his benediction.

Once when the Imperial governor of Cappadocia was in the forest capturing wild beasts (to be used for devouring Christians in the circus), he came across the saint's cave. Around it stood a myriad of lions, tigers and bears, waiting patiently for Blaise to finish praying before consulting him. The saint was captured and thrown into a dungeon. He continued working miracles through the narrow prison windows, saving a child from choking by removing a fishbone from his throat; restoring to an old lady her sole possession, a pig, which had been purloined by a wolf (the thankful woman brought him the head and trotters of the animal in his cell). Finally the governor ordered St Blaise to be drowned in a pond. The saint simply walked upon the water; the pagans, attempting to imitate the feat, all drowned. An angel then ordered Blaise to gain the shore and face martyrdom. The saint obeyed and was hung from a post, lacerated by carding-combs and finally beheaded.

Although he was originally an eastern saint, Blaise became very popular in the west, and his relics are to be found in many places. He is one of the most common saints to be invoked against maladies, especially throat afflictions (alluding to the miracle of the fishbone). In German-speaking countries, where his name is associated with the verb *blasen*, to blow, one of his

St Blaise
Bibliothèque Nationale,
Paris.

main attributes is a horn, and his protection is entreated against storms and gales. He is patron of wool-combers (after the carders used in his martyrdom), and pig-butchers (an allusion to the old woman and the pig).

REPRESENTATION AND ICONOGRAPHY
The legend of St Blaise has often been presented as a cycle: on the murals of the château de Berzé-la-Ville (c.1003-9, Saône-et-Loire); on stained glass in the Church of St Radegonde, Poitiers}; on a polyptych by Hans Memling (1491, Lübeck Cathedral). Treated separately, the most popular episodes are Blaise taming wild animals; the removal of the fishbone; the pig returned to the old woman, and the saint's laceration with carding-combs and decapitation.

Attributes: Mitre. Carding-comb. Pig or piglet. Crossed altar-candles (his feast is the day after Candlemas). Horn (in Germany).
Bibliography: M. Guiraud, *Du culte de saint Blaise*, Pezenas, 1893.

The Martyrdom of St Blandina
Bibliothèque Nationale, Paris.

BLANDINA

Latin, Italian and German: Blandina; French: Blandine.
Virgin and Martyr. Died 177. Feast day 2 June.

LIFE AND LEGEND
Everything we know about the martyrs of Lyon, the most important being Blandina and Bishop Ponticus, has come down to us in long extracts from a letter from the churches of Lyon and Vienne contained in Eusebius' *History of the Church*. Hence the historical events surrounding her life can be fixed with certainty.

Arrested under Marcus Aurelius in 177 with other members of the newly fledged church of Lyon, the slave Blandina heroically endured all her tortures, repeating simply, "I am a Christian and we do nothing vile." Placed on a gridiron, she was enveloped in a net provided by a *retarius* (a gladiator armed with a net, a trident and a dagger), and thrown to a wild bull who tossed her into the air with his horns. Finally, her throat was cut. Blandina is the patron saint of Lyon and also, like Martha, of maidservants.

REPRESENTATION AND ICONOGRAPHY
A fresco by Pomarancino (San Stefane Rotondo in Rome, sixteenth century) depicts her martyrdom. An engraving by Jacques Callot (*Les Images de tous les saints...*, 1636) shows her attached to a pole while, in the background, she appears on the gridiron. She can be accompanied by a lion or a bear, as well as a bull.

Attributes: Net. Bull. Gridiron. Bear. Lion.

BLINDFOLD *see* CHURCH AND SYNAGOGUE, MOCKING OF CHRIST.

BOAR *see* CYRICUS.

BOAT *see* APPEARANCES OF CHRIST, JULIAN THE HOSPITALLER, PETER.

BOAZ

Variant, Italian, Spanish and French: Booz; German: Boas.

TRADITION

The story of Boaz appears in the Book of Ruth (2-4). Naomi, returning to Bethlehem with her daughter-in-law Ruth, laments, "The Lord hath brought me home again empty" (1:21). In their hardship, Ruth "gleaned in the field after the reapers" (2:3). By chance, she enters a field owned by Boaz, a kinsman of Naomi. He allows her to "glean even among the sheaves" (2:15), and recalls all that she has done for her mother-in-law since her own husband's death. Naomi encourages Ruth to go to sleep at Boaz's feet, "at the end of the heap of corn" (3:7). Boaz takes Ruth as his wife and buys back all the fields which had once belonged to Elimelech, Naomi's late husband. Boaz and Ruth have a son called Obed, father of Jesse and hence grandfather of King David. The Book of Ruth ends with a recapitulation of the genealogy of David which seeks to emphasize the links between the story of Boaz and Ruth and the origins of the kings of Israel. Medieval commentators saw the union between the two at Bethlehem as prefiguring that of Christ and his Church.

REPRESENTATION AND ICONOGRAPHY

The idyll of Ruth and Boaz does not appear in paleochristian art. A few manuscripts of the early medieval period are illustrated with miniatures of the story, interpreted symbolically. Twelfth-century illuminations depict the actual idyll, while in the thirteenth and fourteenth centuries the emigration

The Meeting between Boaz and Ruth
Poussin, *Summer* (detail), 1660-64. Louvre, Paris.

of Naomi and Ruth to Bethlehem almost entirely predominates (stained glass, Sainte-Chapelle, Paris, thirteenth century). In the seventeenth century, a Rembrandt print shows Boaz pardoning Ruth for gleaning in his fields without permission. Poussin treats the theme in a cycle of the four seasons (*Summer* or *Ruth and Boaz*, 1660-4, Louvre, Paris).

Cross-references: Tree of Jesse, David.

SS. Boris and Gleb
Early fourteenth century.
State Russian Museum,
St Petersburg.

BORIS AND GLEB

French: Boris et Gleb; Spanish: Boris y Gleb; German: heiligen Dulder Boris und Gleb; Russian: Boris i Gleb.
Martyrs. Russian national saints. Died 1015. Feast day 24 July.

LIFE AND LEGEND
Boris and Gleb were the sons of the Russian prince, St Vladimir. After their father's death in 1015, their half-brother, Svyatopolk, had Boris assassinated, on 24 July. Gleb followed on 15 September and, soon after their death, they began to be venerated as Russian protomartyrs. They were canonized by the Orthodox Church in 1071. Above all, they were held in honour for the kindness and mercy they had shown to their killers. Their names (in the west sometimes given as Romanus and David) head the list of Russian national saints. Their cult quickly spread throughout the Slav-speaking countries.

REPRESENTATION AND ICONOGRAPHY
Boris is shown as a young man with black hair, moustache and trimmed beard. Gleb is a beardless adolescent with curly hair. Dressed in the brocade and sable-lined coats of princes, they wear conical fur caps, decorated with pearls. They both carry swords but, as a sign of their pacifism, these remain sheathed. They are most often depicted as a pair, occasionally as knights. The oldest monumental painting dates from 1199 (Nereditza, near Novgorod, destroyed 1942). The earliest icons with their effigies occur in the margin of a large icon of St Nicholas of Lipno (1294). They may be linked to their father St Vladimir or to other Russian princes, or else to the archangel Michael.

Cross-reference: Vladimir.
Bibliography: L. Réau, op. cit., vol. III, 1, pp. 239-40. J. Myslivec, "Boris und Gleb" in E. E. Kirschbaum, *Lexikon der christlichen Ikonographie*, Freiburg im Breisgau, 1968-74, *Ikonographie der Heiligen*, vol. V, cols. 438-41. A. Ponomarev, "Boris and Gleb" in Lopoukhine, *Encyclopédie théologique orthodoxe*, vol. II, Petrograd, 1901, cols. 954-68.

BREAD *see* BENEDICT OF NURSIA (IN BASKET ON STRING), ELIZABETH OF HUNGARY (QUEEN), LAST SUPPER, MARY OF EGYPT (THREE LOAVES), MULTIPLICATION OF THE LOAVES AND FISHES, PHILIP (AND CROSS).

BREASTS (SEVERED) *see* AGATHA, ANASTASIA, BARBARA.

BRENDAN

Variant: Brandon. Latin: Brandanus, Brendanus; Italian: Brandane, Brendano; French: Brendan.
Abbot. c.486-c.575. Feast day 16 May.

LIFE AND LEGEND

Brendan the Navigator (sometimes, the Voyager) was one of the great Irish monks of the sixth century. The abbot of a monastery at Clonfert, Galway, which he founded around 560, Brendan was the hero of a doubtless legendary journey undertaken to some mysterious islands in the heart of the Atlantic Ocean. The *Navigatio Brendani*, composed in the tenth or eleventh century, which has come down to us more or less intact, was an important source for the medieval imagination right up the time of Colombus. Among his other adventures, one shows how, during his voyage, Brendan goes ashore on a whale his companions had taken for an island. Brendan is the patron saint of seamen.

REPRESENTATION AND ICONOGRAPHY

Engravings in a manuscript of the fifteenth century (Universitätsbibliothek, Heidelberg), depict many episodes of his miraculous voyage. A print in the *Nova Typis Transacta Navigatio Novi Orbis Indias Occidentalis* of Honorius Philoponus (1621) shows the saint, near the Isles of Brendan, celebrating Mass on the back of a whale, watched by fish.

Attributes: A lighted altar-candle or a house on fire (alluding to his name, which has been linked to the German *brennen*, to burn). Fish in his hand.
Cross-references: Malo, Miraculous Sea Voyage, Paul.

BRIDGET OF SWEDEN

Latin: Birgitta; Italian: Brigida; French: Brigitte; German: Birgitta.
Visionary and mystic. Foundress of the Brigettine Order.
1303-73. Canonized 1391. Feast day 23 July.

St Bridget of Sweden
Boucicaut Hours, fifteenth
century. Musée Jacquemart-
André, Paris.

LIFE AND LEGEND

Bridget was a Swedish noblewoman of royal ancestry who was widowed at about forty with eight children. She retired into a Cistercian nunnery and experienced the first of her many famous visions. In 1346, she founded the Order of the Holy Saviour (the "Brigettines"), only to leave the monastery at Vadstena three years later and move to Rome, where she lived a life of total conformity to the Gospels, constantly advocating penitence.

Her renown as a mystic was considerable and she was consulted by both kings and popes. She strongly advised the latter to return from Avignon to Rome, but was not fortunate enough to see her request granted. The Papacy returned to Rome three years after she had died while returning from a pilgrimage to the Holy Land which, she said, was the high point of her life. She was canonized in 1391. She was the mother of St Catherine of Sweden (or of Vadstena), who survived her by eight years. The patron saint of Sweden and of pilgrims, Bridget is particularly venerated in Scandinavia, Poland, Hungary, Germany and Austria.

REPRESENTATION AND ICONOGRAPHY

Between the fifteenth and eighteenth centuries, the iconography of Bridget

of Sweden was abundant, especially in painting (Stenradt von Lübeck, altarpiece, 1459, Vadstena Church, Sweden). She is shown as a widow (wearing a veil), or an abbess (in the black-and-white habit of her order and carrying a crozier), or on occasion as a pilgrim (with staff, wide-brimmed hat and scrip). She is also often shown writing or dictating her *Revelations* (*Revelation on the Birth of Christ,* fresco, fourteenth century, S. Maria Novella, Florence), and sometimes praying to a crucifix. The order of the Brigettines is dedicated to the Passion of Christ. Its emblem is five red flames representing the five wounds of Our Lord, another occasional attribute in the saint's iconography.

Attributes: Altar-candle (legend recounts that she poured molten wax over her hands as mortification). Five little red flames. Flaming heart or heart marked with a cross. Crown (underlining her royal blood). Crozier. Book. Veil.
Cross-reference: Burning bush.

BRUNO

Latin, French and German: Bruno; Italian: Brunone.
Founder of the Carthusian Order. c.1030-1101. Feast day 6 October.

LIFE AND LEGEND
Born around 1030, Bruno became canon of St Cunibert's in Cologne and joined the Catholic school in Reims in 1057. He decided to become a hermit under the direction of Robert of Molesme. A charter from St Hugh, Bishop of Grenoble, conferred on him the mountainous region of the Chartreuse where, in 1084, he constructed an oratory set around by cells, thereby founding the Carthusian Order. Urban II called Bruno to Rome in 1090 where he played a role in his reforms. In 1101, he died in the charterhouse he had founded at La Torre, in Calabria.

REPRESENTATION AND ICONOGRAPHY
The first representation of St Bruno dates from as late as the end of the fifteenth century, with the triptych of the Meister der heiligen Sippe (Wallraf-Richartz Museum, Cologne). A sculpture by Houdon shows him in the white robes of a Carthusian monk (1767, S. Maria degli Angeli, Rome), but without further attributes. Most often represented are Bruno at prayer in the wilderness of the Chartreuse, refusing the mitre, and his death (Le Sueur, *The Death of St Bruno,* 1645-8, Louvre, Paris). Some works can portray his more active side (Zurbarán, *Conversation between St Bruno and Urban II,* mid seventeenth century, Museo Provincal de las Bellas Artes, Seville). The appearance of the Virgin is a further subject (Simon Vouet, c.1626, San Martino, Naples). He can also be shown meditating on a skull.

Attributes: White Carthusian robes. Star on his breast (alluding to St Hugo's vision of seven stars which heralded the arrival of the first seven Carthusians). Mitre and crozier at his feet (spurning of worldly honours). Skull.
Cross-reference: Hugh.
Bibliography: G. and M. Duchet-Suchaux, *Les Ordres réligieux: Guide historique,* Paris, 1993.

BULL *see* BLANDINA (TOSSED BY BULL), EUSTACE (HUNTSMAN).

St Bruno
Adriaen Collaert, beginning of the seventeenth century.
Bibliothèque Nationale, Paris.

BURIAL OF CHRIST *see* ENTOMBMENT.

BURNING BUSH

Latin: Rubus igneus incombustus; Italian: Il roveto ardente sull'Orebbo; Spanish: La Zarza ardiendo; French: le Buisson ardent; German: der brennende Dornbush.

TRADITION
The Bible tells of how Moses led his flock to Horeb, the mountain of God. There, the angel of the Lord appeared to him as a flame of fire in a bush. Moses saw that although the bush burnt, the flames did not consume it (Ex. 3:1-4).

REPRESENTATION AND ICONOGRAPHY
Moses was ordered by an angel to take off his shoes before the burning bush. He heard the Voice of God: "Put off the shoes from off thy feet, for the place whereon thou standest is holy ground" (Ex. 3:5). The invisible voice is sometimes represented by the Hand of God, occasionally replaced by an angel. Moses removed his shoes in homage, just as present-day Muslims do on entering the mosque. This theme is associated with the rod which transforms into a serpent and back again in Exodus 4 (1-4; also 7:15), a miraculous power accorded to Aaron and Moses to impress the Pharaoh.

The most ancient depictions of the burning bush are to be found on the frescoes of the synagogue at Dura-Europos (c.245). Moses is shown removing his shoes and raising his hand towards the flaming bush. The theme was taken up once again in the fifth century on the frescoes of S. Maria Maggiore in Rome and, in the fifteenth century, in stained glass in the collegiate Church of Wimpfen, Germany.

In the middle ages, the burning bush was linked to themes of Christ's Incarnation. Hence it was coupled with the Annunciation (Portal of the Virgin, Laon Cathedral, thirteenth century), the Visitation (north door, Chartres Cathedral, early twelfth century) and the Nativity (Chapel of the Magi, Cologne Cathedral, thirteenth century).

In the fifteenth century, the Coronation of the Virgin (Enguerrand Quarton, 1453-54, hospice at Villeneuve-lès-Avignon) identifies the burning bush with the glorification of the Virgin. God himself appears in it. Bouts (mid fifteenth century, John G. Johnson Collection, Philadelphia), Raphael (Loggo, Vatican, 1510-19) and Poussin (1640-42, Statens Museum for Kunst, Copenhagen) treated this theme.

Marian Symbolism
The liturgy compares the burning bush which never burns out with the virginity of Christ's Mother who, though penetrated by the flame of the Holy Ghost, remains unconsumed – that is, intact. This theme was also exploited by Bridget of Sweden in her *Revelations*. Of Byzantine origin, it appeared as early as the thirteenth century (north door, Chartres Cathedral, c.1210, where the Virgin stands over a burning bush). It was during the fifteenth century, however, that the theme became widespread, following a vision by the poet Adam de Saint-Victor in Paris (Nicholas Froment, triptych, 1476, Aix-en-Provence Cathedral). A reredos in the Chapel Royal at Granada presents scenes from the vision of Moses on Mount Sinai around a burning bush,

above which the Virgin sits on a throne. Two sculptures which depict this motif show a Virgin and Child next to Moses in the guise of a child placed within the burning bush (choir screen, St Mammès at Langres, fourteenth century; Hôtel Dieu, Tonnerre, first half of the fifteenth century). After the Council of Trent the theme becomes rare.

Cross-references: Aaron, Annunication, Exodus, Hand of God, Mary, Moses.

BURNING COAL *see* ISAIAH.

CAIAPHAS *see* MOCKING OF CHRIST.

CAIN AND ABEL

Italian: Caino ed Abele; Spanish: Cain y Abel; French: Caïn et Abel; German: Kain und Abel.

TRADITION
The Book of Genesis (4:1-16) tells the story of Cain and Abel, sons of Adam and Eve: "And Abel was a keeper of sheep, but Cain was a tiller of the ground" (4:2). They both offered sacrifice to God – Cain the fruit of the ground and Abel the "firstlings" of his flock. "And the Lord had respect unto Abel and to his offering: But unto Cain and to his offering he had not respect" (4:4-5). An angry Cain killed his brother in a field; no mention (4:8) is made of the weapon used. God cursed the murderer, and Cain lamented: "Behold, thou hast driven me out this day from the face of the earth ... and it shall come to pass, that every one that findeth me shall slay me" (14). But the Lord "set a mark upon Cain, lest any finding him should kill him" (15). The patristic tradition sees in Abel a type of Christ, while Cain represents the Jews who crucified him. The sequence was often divided into three main episodes: the brothers' offerings and God's reaction; the murder of Abel by Cain; and the curse and mark of Cain.

REPRESENTATION AND ICONOGRAPHY
The episodes preferred by artists are the offerings made by the two brothers, and the murder of Abel.

Abel murdering Cain
V. Lefebvre, after Titian,
seventeenth century.
Bibliothèque Nationale,
Paris.

The Offerings

Abel carries the sacrificial lamb on his shoulders, like the Good Shepherd
(mosaic, basilica of St Mark's, Venice, twelfth century), whereas Cain carries
a basketful of flowers and leaves. In the middle ages, an altar stands in the
centre of the composition. Cain and Abel walk towards it carrying their sac-
rifices (leaf of the bronze doors of Hildesheim Cathedral, Germany, 1015; *St
Louis Psalter*, c.1260, Bibliothèque Nationale, Paris). The presence of
Jehovah is signalled by his Hand blessing Abel from a corner of the sky.

The Murder of Abel

Almost universally, Abel is unarmed. As he kneels at an altar, Cain smites
him on his head and he falls to the ground. Cain can use a stone, club, hoe
or billhook. In a few isolated examples he employs the jawbone of an ass,
like Samson. The stained-glass window at Chartres (thirteenth century) is just
one of a host of examples of this scene.

The other episodes of the story hardly appear other than as part of story-
cycles on Adam and Eve. These scenes depict the brothers as children help-
ing their father in the fields. Manuscripts of the Bible and psalters show them
burying Adam. In the middle ages, Adam and Eve lamenting the loss of Abel
are related to the Deploration of the Virgin Mary over Christ's body at the
Descent of the Cross, while Abel's sacrifice is linked both to Melchizedek's
offering and to the sacrifice of Isaac. It occurs on numerous altarpieces as well
as on the mosaics in San Apollinare in Classe, Ravenna.

Cross-references: Abraham, Adam and Eve, Good Shepherd, Hand of God, Isaac, Samson.
Bibliography: P.-H. Michel, "L'iconographie de Caïn et Abel", *Cahiers de civilisation médievale*, 1, Poitiers, 1958, pp. 194-99.

CANA, WEDDING *or* MARRIAGE AT

Variant: The miracle of changing water into wine.
Latin: Nuptiae in Cana; Italian: Le Nozze di Cana; Spanish: Las Bodas de Cana; French: Les Noces de Cana; German: Hochzeit zu Kana.

TRADITION

The only source for this story is the Gospel according to St John (2:1-11). Besides Jesus and his disciples, Mary was also present at the scene, which took place in Galilee. During the wedding, there was a shortage of wine, which was brought to Jesus' attention by his Mother. He asked the servants to fill six stone pots with water, "after the manner of the purifying of the Jews", and said to them, "Draw out now, and bear unto the governor of the feast." The water has become wine. The governor compliments the bridegroom on its quality: "Thou hast kept the good wine until now" (10). This, concludes St John, constituted Jesus' first miracle.

The Fathers of the Church and other theologians have interpreted this episode in various ways, often linking it to the Last Supper. Following Origen (c.185-c.254), it symbolizes the completion of the Old Testament in the coming of Christ and in the Gospel. By the fourth century, the scene was being regarded as a prefiguration of the Eucharist. Inspired by St Augustine and his treatise on the Gospel of St John, medieval theologians interpreted the wedding meal as an image of the marriage between Christ and his Church, the stoneware vessels standing for the six ages of the world which preceded the arrival of the Messiah. Each of these periods during which Christ remained concealed from the sight of the world was represented by a Biblical figure: Adam, Noah, Abraham, David, Jeconiah (Coniah) and John the Baptist. Christ was also anagogically accredited with having changed the water of the Old Testament into the wine of the New.

REPRESENTATION AND ICONOGRAPHY

The miracle of changing water into wine appears as early as the paleochristian

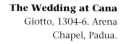

The Wedding at Cana
Giotto, 1304-6. Arena
Chapel, Padua.

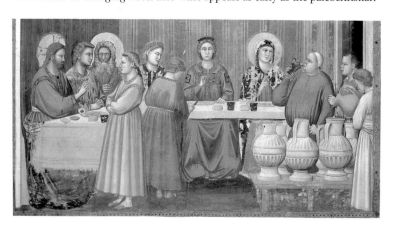

period. It occurs among the carvings on the wooden door of St Sabina, in Rome (c.430) where it is juxtaposed with the Feeding of the Five Thousand, probably in a dual symbol of the Eucharist. During late antiquity and the early middle ages, Jesus holds a stick or a wand with which he touches the jars. The scene, initially elementary in design, gradually accumulated anecdotal additions, Mary making her appearance by the middle of the fifth century. In Byzantium, for the most part, the layout is reminiscent of the Last Supper, the liners sitting round a semi-circular table. Christ, also seated it the table, blesses the jars as they are being filled by servants. One of these hands the governor (*architrichnus*), or Christ, a goblet to taste. In the west, Christ is seated during the meal: the *architrichnus* can be identified by his Jewish cap. Due to a confusion between this figure and the bridegroom, the *architrichnus* can even be shown as a saint. Giotto groups the diners around a square table, and places Jesus on the left (Arena Chapel, Padua, 1304-6) This was the most frequent composition during the middle ages. Gerard David (c.1503, Louvre, Paris) later depicted the scene as a prefiguration of the Eucharist. Veronese, in a more secular spirit, painted a sumptuously appointed banquet with rich costumes and shimmering colours (1562-3, Louvre, Paris).

Cross-reference: Last Supper.

CANDLE *see* BLAISE (CROSSED CANDLES). BRENDAN (LIGHTED). BRIDGET (QUEEN). GENEVIEVE (WITH DEVIL BLOWING IT OUT). LUCY (WITH PALM). SIBYLS.

CANDLEMAS *see* PRESENTATION OF THE LORD.

CARDINAL

Cardinals are either priests (cardinal-priests) or other religious dignitaries (cardinal-deacons and cardinal-bishops) who are chosen to assist the Pope in administering the Church. Together forming the Sacred College, cardinals are divided into two categories: those of the Curia, who remain in Rome and take an active part in pontifical government, and residential cardinal-bishops, who remain in their dioceses. Since 1294, cardinals have worn a red cassock. Paul II (between 1464 and 1471) gave them an additional hat and the red *zucchetto*, or skullcap. The cardinal's hat (the "red hat"), bestowed on a new cardinal by the Pope himself, is of red cloth with a broad rim and flat crown, bedecked with two strings each tied with fifteen red tassels. It is this ceremonial headwear that most often figures in art. Cardinals possess two other hats: black with a red silk ribbon, gold braid and gold tassels; and the pontifical hat, in red felt, with gold braid.
Type: Jerome.

CARMELITES *see* ELIJAH, TRANSFIGURATION.

CARRYING OF THE CROSS *see* CRUCIFIXION, TRIAL OF JESUS, VERONICA.

Cardinals
Raccolta of Jaccopo Fontano (detail), sixteenth century. Bibliothèque de l'Arsenal, Paris.

CARTHUSIANS

Italian: Certosini (charterhouse: certosa); Spanish: Cartuji; French: Chartreux (charterhouse: chartreuse); German: Kartäuser.

Austere monastic order founded by Bruno in 1094 near Grenoble, France. The habit of the Carthusians is of white wool. It comprises a long robe tied round the waist with a leather belt and a scapular (or else a *cuculla*, cowl), attached to it by a number of long bolts of white cloth.
Type: Bruno.

Cross-references: Bruno, Hugh of Grenoble, Hugh of Lincoln.
Bibliography: G. and M. Duchet-Suchaux, *Les Ordres réligieux: Guide historique*, Paris, 1993.

St Catherine of Alexandria and her Wheel
Woodcut from James of Voragine's *Golden Legend*, 1483 edition.

CATHERINE OF ALEXANDRIA

Variant: Katharine. Greek: Aikaterine; Italian: Caterina; Spanish: Catalina; French: Catherine; German: Katharina.
Virgin and Martyr. Died 310(?). Feast day 25 November, suppressed in 1969.

LIFE AND LEGEND

There are strong doubts about Catherine's historical authenticity. Born of a noble family in Alexandria, she refused to marry the Emperor Maxentius himself because of her previous "mystic marriage" to Christ. The Emperor ordered fifty Alexandrian philosophers to prove to her the absurdity of her faith, but she effectively countered all their arguments. The emperor, enraged by this rebuff, ordered the philosophers to be burnt alive and Catherine to be broken on a spiked wheel. The wheel miraculously falls to pieces, and Catherine is finally beheaded.

This story, entirely legendary, became well-known during the ninth century. St Catherine was enormously revered in the middle ages and her cult became particularly strong in England; Joan of Arc invoked both St Catherine and St Margaret. Catherine is patron saint of young girls (who were allowed to crown her statue with a wreath of flowers on her name day), of students, and hence of the clergy, as well as of wheelwrights and millers.

REPRESENTATION AND ICONOGRAPHY

In early examples, she wears the crown of martyrdom and is grouped with the virgins, SS. Barbara and Margaret. She is very often represented with one or several broken Catherine wheels of her martyrdom. She is also shown entering into a mystic marriage with the Infant Jesus on his Mother's knees. (This can be contrasted with the marriage of Catherine of Siena, where Christ is most often an adult.) In England, the oldest of some sixty murals devoted to her life is in the Chapel of the Holy Sepulchre in Winchester Cathedral (c.1225). Among numerous other examples, the cycle by Spinello Aretino (Oratorio degli Alberti, Antella, near Florence, end of the fourteenth or beginning of the fifteenth century) may be mentioned. The mystic marriage was depicted by M. Coffermans (sixteenth century, Musées Royaux des Beaux Arts, Brussels), by Andrea del Sarto (c.1512, Gemäldegalerie, Dresden), who shows her "wedding" beneath a baldachino supported by angels, and by Ribera (1648, Metropolitan Museum of Art, New York). A wooden statue by Hans von Witten (c.1515, Bayerisches Nationalmuseum, Munich) depicts her

crowned, trampling Maxentius underfoot. The full horror of her martyrdom is rendered in Lelio Orsi's work (c.1560, Galleria Estense, Modena).

Attributes: One or several broken spiked wheels. Crown of martyrdom. Executioner's sword.
Cross-references: Catherine of Siena, Fourteen Holy Helpers.
Bibliography: H. Brémond, *Sainte Catherine*, Paris, 1923.

CATHERINE OF SIENA

Latin: Catharina Sinonsis; Italian: Catarina da Siena; Spanish: Catalina de Siena; French: Catherine de Sienne; German: Katherina von Siena.
Virgin. 1347-80. Canonized 1461. Feast day 29 April.

St Catherine of Siena
Attributed to Cristofano Allori, early seventeenth century. Musée de Picardie, Amiens.

LIFE AND LEGEND
Caterina Benincasa, born 25 March 1347, entered the Third Order of the Dominicans aged sixteen, donning the black-and-white habit of the Dominican tertiaries. She was both an ascetic and a mystic, and soon attracted a number of followers. On the fourth Sunday in Lent 1375, at Pisa, while she was working for ecclesiastical peace during the Avignon papacy, St Catherine received the stigmata, like St Francis of Assisi before her. She was later sent as ambassadress from Italy to Avignon where, despite ridicule from the women of the Papal court, she convinced Gregory IX to return to Rome. On his death, the Great Schism broke out; Catherine, now leading an ascetic life in Rome, struggled to repair the resulting divisions within the Church. She died aged only 33 in April 1380. Patroness of both Siena and Italy, she was named by Pius IX the second patron of Rome.

REPRESENTATION AND ICONOGRAPHY
She is shown with a crown of thorns and a crucifix with, occasionally, a scourge and a heart at her feet. A symbolic skull, a book and a lily can also appear. She is often coupled with Catherine of Alexandria (Ambrogio Borgognone, *Madonna and Child with two Saints Catherine*, end of the fifteenth century, National Gallery, London). She echoes the latter's mystic marriage; her own became a frequent subject from the sixteenth century (Fra Bartolomeo, 1511, Louvre, Paris). The Sienese Domenico Beccafumi painted her receiving the stigmata (1513-15, Pinacoteca, Siena). Sodoma (1526, Oratory of the Bernardines, Siena) shows her receiving the stigmata supported by two followers, while she is presented reading more peacefully by Correggio (1531, Hampton Court, Royal Collection).

Attributes: White robes. Lily. Book. Crown of thorns. Heart.

CAULDRON *see* CHRISTINA (OF BURNING OIL), VITUS.

CECILIA

Variants: Cecily, Celia. Latin: Caecilia; Italian: Cecilia; French: Cécile; German: Cäcilia.
Virgin and Martyr. Feast day 22 November.

LIFE AND LEGEND
Cecilia, one of the most famous Roman saints, is purely legendary. She is

St Cecilia
Adriaen Collaert, beginning
of the seventeenth century.
Bibliothèque Nationale,
Paris.

meant to have lived in the second or more probably the third century, but only appears in the tradition in the fifth and sixth centuries. A young girl of noble background, she was betrothed, in spite of her vow of chastity, to a noble Roman, Valerius. After the apparition of an angel in the marriage chamber, she converted the young man to Christianity and persuaded both him and his brother, Tibertius, to receive baptism. She then refused to make an offering to the pagan gods and was condemned to be suffocated in a boiler, but was saved by the descent of a refreshing cloud from the sky. She was then taken to be beheaded, but the executioner, even after three violent blows, could not detach her head. She lingered on, mutilated, for three days before expiring.

REPRESENTATION AND ICONOGRAPHY

Iconography shows her most often either at her wedding, where the arrival of the angel heralds the conversion of Valerius (Saraceni, c.1610, Palazzo Barberini, Rome), or else being suffocated in a boiler or bathroom. More and more frequently, from the end of the fifteenth century, whenever she appears alone, she is depicted with a musical instrument: a portative organ (Raphael, 1516, Pinacoteca, Bologna; Rubens, Staatliche Museen, Berlin-Dahlem, Berlin); a harp (Pierre Mignard, 1691, Louvre, Paris); a violin (Domenichino, 1610s, Musée des Beaux Arts, Orléans; Cavallino, c.1645, Museo e Gallerie Nazionali di Capodimonte, Naples) and regal reed-organ (Pierre Puget, 1651, Musée des Beaux Arts, Marseille). This musical Cecilia arose from a misunderstanding. It was believed that she went to her martyrdom playing the organ, while in fact "she sung in her heart" to drown out the pagan music that accompanied her wedding.

She can also be shown as a crowned martyr (Sebastinao Concha, *The Crowning of St Cecilia*, 1725, S. Cecilia in Trastevere, Rome) or as a martyred body (Stefano Maderno, marble, c.1600, S. Cecilia in Trastevere, Rome, where her head is covered; anonymous eighteenth-century painted sculpture, Basilica St Cécile, Albi, France, where her gashed neck is exposed). She is the patron saint of musicians, singers and instrument makers.

Attributes: Musical instruments. Wound in the neck. Wreath of flowers on her head.
Bibliography: J. P. Kirsch, *Die heilige Cäcilia, Jungfrau und Märtyrerin*, Regensburg, 1901. E. Poirée, *Sainte Cécile*, Paris, 1920.

CENSER

Variant: thurible. Greek: thymiaterion; Latin: incensorium; Italian: incensiere; Spanish: incensario; French: encensoir; German: Rauchfass.

A censer (more formally termed a thurible) is a perfume-burner for incense. It is generally comprised of a container with a lid, initially round but later examples can be polygonal, hung from three or four chains enabling it to be swung. In traditional liturgy, the altar is incensed, but the censer is put to many other uses in solemn ceremonials and processions (fresco in the Church of St Nicholas, Arges, Rumania, fourteenth century: Moses and Aaron as high priests incense the Tabernacle.)

CHAINS *see* DENIS (CHAINED AS CHRIST BRINGS THE HOST), PETER (APOSTLE IN PRISON), SIBYLS.

CHALICE *see* CHURCH AND SYNAGOGUE, ELIGIUS (GOLDSMITH *or* BISHOP), HUGH OF LINCOLN (CONTAINING INFANT JESUS), LAURENCE (CONTAINING MONEY).

CHARLES BORROMEO

Latin: Carolus Borromaeus; Italian: Carlo Borromeo; Spanish: Carlos Borromeo; French: Charles Borromée; German: Karl Borromeäs.
Archbishop of Milan. Founder of the Oblates of St Ambrose. 1538-84. Canonized 1610. Feast day 4 November.

LIFE AND LEGEND
Charles Borromeo was born in the castle of Arona, on the shores of Lake Maggiore, on 20 October 1538. He was tonsured as a priest when only seven and was in receipt of the revenues of the local commendatory abbey at twelve. In 1559, he had hardly finished his studies in law in *utruque jure* when an uncle on his mother's side, Gian Angelo de' Medici, became Pope Pius IV. The new pope called Charles to Rome, made him cardinal in January 1560, covered him in honours and benefices, and soon promoted him to secretary.

Charles then founded a literary society called the Vatican Nights. The death of his brother in 1562 incited him to adopt the strictest religious life. He was ordained on 15 August of the same year, and in 1563 he was consecrated archbishop of Milan. He returned to Rome on the death of Pius IV and participated in the conclave which elected Pius V.

He was highly active in his archbishopric, calling six councils of the province and eleven synods, in the course of which he drew up a series of guidelines promulgating some of the decisions taken by the Council of Trent. In 1564, he organized a seminary, initially under the auspices of the Jesuits. Fourteen years later, in 1578, he founded the Oblates of St Ambrose, entrusting them with the care of the diocesan seminary for the following year. In this way he hoped to give a solid grounding to the clergy of his see. Charles either created or rejuvenated many of the Milanese confraternities, concentrating particularly on the Ursulines, founded by St Angela Merici at Brescia. He assigned and directed visitors to the fifteen sees of the metropolitan dioceses of Milan, to develop the Orders of St Ursula and St Anne in the larger towns. The paramount significance of Charles Borromeo derives from the impetus he gave in Piedmont to the religious reform stemming from the Council of Trent.

REPRESENTATION AND ICONOGRAPHY
Posthumous portraits of the saint by a member of the Accademia Ambrosiana, G.-B. Crespi (1620s, Galleria Ambrosiana, Milan) and Guido Reni (fresco, 1636, S. Carlo dei Catani) show his strong features to good effect. In the main he is shown wearing archbishop's robes and with a cardinal's hat, though he is occasionally depicted wearing a penitential cord of hemp round his neck with a death's head at his feet.

The main scenes show him curing the sick (Karel Skreta, 1637, Galerie Narodni, Prague), especially the plague-stricken (Jacob Jordaens, mid-seventeenth century, Poldi-Pezzoli, Milan; Pierre Puget, low relief, c.1688/94, Musée des Beaux Arts, Marseille). He is also depicted kneeling at prayer before a crucifix (Charles Lebrun, late seventeenth century, Church of St Nicolas du Chardonnet, Paris, shows his feet bleeding from flagellation). The saint's apotheosis figures on the dome of the Karlskirche in Vienna (J. M. Rottmayr, fresco, 1725).

Attributes: Archbishop's robes. Cardinal's hat. Cord round neck (sometimes). Death's head (occasionally).

Bibliography: L. Ferretti, *S. Carlo Borromeo nell'arte*, Rome, 1923. E. Kirschbaum, *Lexikon der christlichen Ikonographie*, Freiburg im Breisgau, 1968-74, vol. V, cols. 273-76. L. Réau, op. cit., vol. III, i, pp. 298-300.

CHARIOT OF FIRE *see* ELIJAH (ASCENSION), EZEKIEL (AND WINGED ANIMALS).

CHERUB AND SERAPH

Plural: cherubim. Italian: cherubino; Spanish: querubin; French: chérubin; German: Cherub.

Seraphim
Thirteenth century.
St Mark's, Venice.

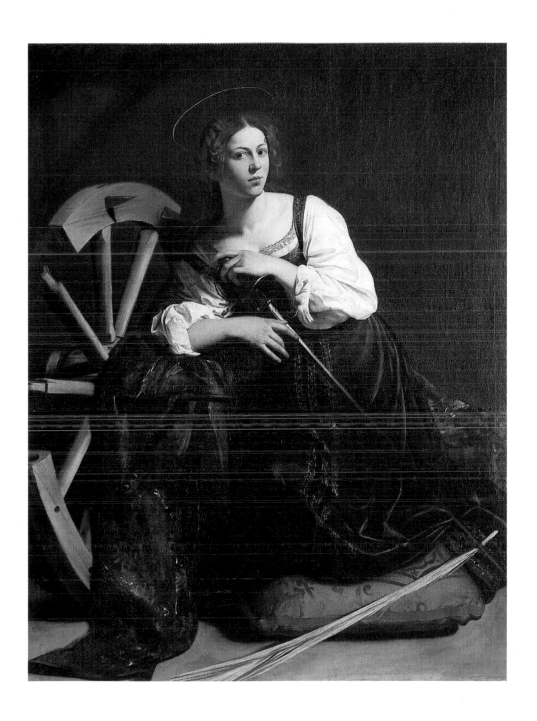

St Catherine of Alexandria. Caravaggio, 1598. Collection Thyssen-Bornemisza, Lugano.

The Last Supper. Dirk Bouts, 1468. St Peter's Collegiate Church, Louvain.

Plural: seraphim. Italian: serafino; Spanish: seraphin; French: séraphin; German: Seraph.

TRADITION

The cherubim and seraphim are at the very summit of the Celestial Hierarchy, according to Pseudo-Dionysius the Areopagite (c.500). They encircle the throne of the Godhead or protect with their wings the Ark of the Covenant, itself a divine symbol. Isaiah 6:1-2 describes the prophet's vision: "I also saw the Lord sitting upon a throne, high and lifted up ... Above it stood the seraphim: each one had six wings."

Cherubim have four wings. The prophet Ezekiel (1:5-10) describes them: "They had the likeness of men. And every one had four faces and every one had four wings ... they four had the face of a man, and the face of a lion on the right side; and they four had the face of an ox on the left side; they four also had the face of an eagle" (*see* Tetramorph). These cherubim have men's hands, feet like calves' and eyes on their wings. Next to them, the prophet sees two coaxial wheels, also with eyes on wings.

REPRESENTATION AND ICONOGRAPHY

The distinction between seraphim and cherubim became blurred in the early middle ages. They were associated with the other angels and, by the end of the sixth century, the cherub guarding Paradise could only be distinguished from the heavenly host by a wheel. The wheels also enable the cherubim to act as a mobile throne for God.

Cross-references: Angel. Archangels. Tetramorph.

CHILDHOOD OF CHRIST *see* CIRCUMCISION, FLIGHT INTO EGYPT, PRESENTATION OF THE LORD.

CHI-RHO, CHRISMON *see* MONOGRAM OF CHRIST.

CHRIST

Latin and German: Christus; Italian and Spanish: Cristo; French: Christ.

Christos is the Greek translation of *Messia*, itself a Hebrew transcription of an Aramaic word meaning the Lord's anointed (compare chrism). The word Messiah designates the King, the Covenant, the Saviour prophesied by Holy Writ, who comes to establish the Kingdom of Jehovah. For Christians, Jesus is the Messiah, the Christ who fulfils the Messianic prophecies of the Old Testament. Peter is the first to employ the name Christ for Jesus. When Jesus asks (Matt. 16:15-16): "But whom say ye that I am?", Peter replies, "Thou art the Christ, the Son of the living God." After the Resurrection, Christians used the term Jesus Christ when speaking of the Saviour, thereby affirming that the Jesus whom the apostles followed was indeed the Messiah expected by Israel. Hence St Paul in his Epistles and St Luke in the Acts of the Apostles use the expressions Jesus Christ and Christ Jesus.

Cross-reference: Jesus [under which all references are grouped].

Christ Emmanuel
Mid-twelfth century,
Tretiakov Gallery, Moscow.

CHRIST AT THE COLUMN *see* FLAGELLATION.

CHRIST EMMANUEL

Variant: Immanuel. Russian: Meladenets Khristos; German and French: Christ Emmanuel.

TRADITION
This description of Christ refers to the Book of Isaiah: "Behold, a virgin shall conceive, and bear a son, and shall call his name Immanuel" (7:14), Hebrew for "The Lord is with us". The verse occurs in the Byzantine rite for Christmas.

REPRESENTATION AND ICONOGRAPHY
The name Emmanuel accompanying an image of Christ appeared in the sixth century on a number of *ampullae* from Monza. The term became more frequent and the iconography was fixed from the eleventh century. Christ is young, short-haired, with no beard, blessing the world with his right hand, and often carrying a book – open or closed – in his left. He can be depicted full- or half-length, the latter being frequent in Byzantine medallions as early as the tenth and eleventh centuries. A century later the theme of Emmanuel refers above all to the Christ-Logos, the Word not yet made Flesh. Christ Emmanuel can be flanked by two angels or cherubim. He appears in the company of prophets in St Mark's, Venice (thirteenth century). As in the case of Christ Pantocrator, any exact iconographical definition remains an open question. One can only be certain of such a type if the inscription "Emmanuel" actually appears.

Cross-references: God (Ancient of Days). Pantocrator.
Bibliography: E. Kirschbaum, "Christus Sondertypen: 1) Christus-Emmanuel", *Lexikon der christlichen Ikonographie*, Freiburg im Breisgau, 1968-74, *Allgemeine Ikonographie* (vol. III), col. 390.

CHRIST IN MAJESTY

Variant, Latin and German: Majestas Domini; French: Christ en Majesté.

TRADITION
The expression "Christ in Majesty" or *Majestas Domini* is closely linked to the

tetramorph. Medieval thought was guided essentially by second-century commentaries on the fundamental texts by St Irenaeus (in his treatise *Adversus Haereses*, II, 11:8), and by the eleventh-century *Carmina paschalia* by Sedulius Scottus (I, 355-61).

REPRESENTATION AND ICONOGRAPHY

The expression Christ in Majesty should be reserved for the depiction of Christ in Glory, enthroned between the symbols of the four Evangelists, the "four living creatures" (Ez. 1:5-21). The theme appeared in Egypt around the fifth century. First, Christ was unbearded, sitting on a throne surrounded by a mandorla. Around him were placed the four winged creatures, two at his head and two at his feet, embodying an image of the cosmic rectangle. The structure of this representation derives from texts which precede the threefold invocation of the Sanctus (the *trisagion*) in the liturgy of a number of eastern churches.

Christ in Majesty
Fresco. Bauit, Egypt.

In the west, the creatures appear in half-length. They emerge from a cloud of fire, surrounding the image of the *Majestas Domini* in the apse of S. Pudenziana, Rome (fourth century). This form is also to be found on the apse's triumphal arch. The ninth-century scriptorium at Tours, France, presented an original typology, which was to become singularly popular in the west. The four creatures, occasionally flanked by the four major prophets, are arranged in a diamond shape around the central figure of the Living God. Later, as in the east, the disposition in keeping with the cosmic rectangle is adopted: the man (Matthew) and the eagle (John) at the top, the bull or ox (Luke) and the lion (Mark) at the bottom. From the end of the ninth century, Christ sometimes sits enthroned on the cosmic globe which, with a circle around his upper body, forms a figure of eight, probably a creation symbol. The motif is often found illuminating the beginning of Evangeliaries and was doubtless used to decorate the apse of pre-Romanesque and Romanesque churches.

From the twelfth century, the theme spread to Gothic architecture. The apse may be decorated with Christ in Majesty encircled by the four "living creatures" and sometimes by cherubim poised on their double wheels. From 1100, the theme extended to portal tympana (at Moissac, then at the Royal Portal at Chartres, 1144-50), but became increasingly rare from the beginning of the fourteenth century. Thirty examples are extant in France alone, however, before the motif gave way to the theme of the Coronation of the Virgin or the Last Judgment.

Cross-references: Evangelists, Tetramorph.
Bibliography: F. van der Meer, "Majestas Domini", in E. Kirschbaum, *Lexikon der christlichen Ikonographie*, Freiburg im Breisgau, 1968-74, *Allgemeine Ikonographie*, vol. III, cols. 136-42.

CHRIST MOCKED

Variant: The Mocking of Christ; Italian: Il Nostro Signor Beffeggiato, Oltraggiato; Spanish: Cristo escarnecido; French: Christ aux Outrages; German: Verspottung Christi.

TRADITION

After his arrest, Jesus appeared in the Sanhedrin before the High Priest. Caiaphas handed him over to the guards who beat him, spat in his face and mocked him (Matt. 26:67; Mark 14:65; Luke 22: 63-65). Luke placed this scene before the interrogation: "And the men that held Jesus mocked him, and smote him. And when they had blindfolded him, they struck him on the face, saying, Prophesy, who is it that smote thee?" Another allied scene occured in the *praetorium* (Matt. 27:27), after Pilate's cross-examination. Jesus at that stage wore a crown of thorns, a robe or cloak, and carried a reed sceptre.

REPRESENTATION AND ICONOGRAPHY

In the middle ages, this scene is often linked with the Crowning with Thorns and the two are sometimes confused. The influence of mystery plays is particularly noticeable in depictions of this dramatic episode. The mocked Christ often has his eyes covered with a blindfold, as St Luke relates, and his hands are bound tight. Grünewald introduced musicians among those who set about him. In the Low Countries the scene was treated with brutal realism (Bosch, late fifteenth century, Escorial, Madrid). The episode is rare in sculpture

Christ Mocked
Hendrick Ter Bruggen,
c.1620 (detail). Musée de
l'Assistance Publique, Paris.

(Zacarias Cora, Church of San Francisco, San Luis Potosi, Mexico, mid eigh-
teenth century). The general tendency from the end of middle ages was to
add to the number of figures and increase the drama of the scenes of the
Crowning with Thorns and the Mocking of Christ. Its pathetic quality has
made it one of the most enduring of religious themes (Georges Rouault, 1932,
Museum of Modern Art, New York.)

Cross-references: Crowning with Thorns. Ecce Homo. Flagellation.
Bibliography: L. Réau, op. cit., vol. II, 2, pp. 446-8.

CHRIST'S DESCENT INTO HELL

Variant: Descent into Limbo, the Harrowing of Hell (medieval). Greek:
Anastasis; Latin: Descensus ad Infernos; Italian: l'Anastasi, la Discesa del
Salvatore al Limbo; Spanish: la Bajada al Limbo; French: la Descente du Christ
aux Limbes; German: die Höllenfahrt Christi.

TRADITION
The origin of this tradition is to be found in the Apocryphal text, the Gospel
of Nicodemus. According to Hugh of St Victor (twelfth century), Christ's soul,
separated from his body at death, did not descend into the Hell of the eter-
nally damned, but only as far as Limbo, to the souls excluded from beatific
vision, including those of the Patriarchs of the Old Testament.

REPRESENTATION AND ICONOGRAPHY
Artists have often represented Jesus after his Resurrection. Armed with his

Christ's Descent into Limbo
Duccio, *Maestà* polyptych (detail), 1308-11. Opera del Duomo, Siena.

Cross, he crushes Satan beneath the doors of Hell, and leads the Just, the Patriarchs and Adam and Eve into the light. These two sequences are often amalgamated into one. For example, on a fresco in the crypt in the Church of Tavant (Touraine, twelfth century), Adam and Eve are shown naked. Christ, with one hand, pulls Adam out of Hell by the wrist and, with the other, impales the horned Devil with a spear. The Hand of God emerges from a cloud, coming to Christ's aid with another spear that is also thrust into the Devil. Behind Adam and Eve come Abel with his shepherd's crook, followed by Abraham, an aged and bearded David, and a young and beardless Solomon. There is also a fresco in Istanbul (c.1310-20, Mosque of the Ka'riye).

Certain details in other works can be explained by the influence of mystery plays. In the middle ages, the opening into Limbo was represented as the jaws of Hell, while in the early fourteenth century Duccio presented Adam and Eve clothed (Opera del Duomo, Siena). In the Renaissance, Limbo was occasionally shown in the guise of pagan Hades, its entrance guarded by Cerebus, the three-headed dog. Renaissance examples include Mantegna (Barbara Piasecka Johnson Collection, Princeton, N.J.), Bartolomé Bermejo (c.1480, Institute of Hispanic Art, Barcelona) and Giovanni Bellini (1475-80, Bristol Museum and Art Gallery, UK). The theme more or less disappeared in the sixteenth century (Bastianino, c.1580s, San Paolo, Ferrara), although figures from Limbo still appeared in the seventeenth (Ludovico Carracci, *Christ crucified above figures in Limbo*, 1614, S. Francesco Romana, Ferrara).

Cross-references: Deposition, Hand of God, Hell.
Bibliography: J. Monnier, "La Descente aux Enfers", *Etude de pensée religieuse, d'art et de littérature*, Paris, 1902. L. Réau, op. cit., vol. II, 2, pp. 511-37.

CHRIST'S ENTRY INTO JERUSALEM

Latin: Ingressus Christi, Festum Palmarum; Italian: Entrata in Gerusalemme,
Domenica delle Palme; Spanish: Entrada in Jerusalèn; French: l'Entrée à
Jérusalem, la Fête des Rameaux; German: Einzug in Jerusalem, Palmenzug
Christi.
Feast day Palm Sunday.

TRADITION

An episode narrated by all four Evangelists (Matt. 21:1-11; Mark 11:1-11; Luke
19:28-38; John 12:12-16), the Entry into Jerusalem occupies a privileged posi-
tion in Christian tradition. Jesus approaches Jerusalem where his Passion is
to take place. At the Mount of Olives, Christ (according to the Synoptic
Gospels) sends two of his disciples to the village of Bethphage to look for a
she-ass, or else a "colt ... whereon no man sat" (Mark 11:2). (According to
John, however, Jesus found the ass foal by chance.) On this ass, Jesus made
his entry into Jerusalem (Matt. 21:8): "And a very great multitude spread their
garments in the way; others cut down branches from the trees, and
strawed them in the way." "All this was done," Matthew makes clear (21:4),
"that it might be fulfilled which was spoken by the prophet." The Evangelist
then quotes from the Book of Zechariah (9:9): "Behold thy King cometh unto
thee ... lowly, and riding upon an ass".

Medieval commentators treated the triumph of David, after his victory
over Goliath, as a prefiguration of Christ's Entry. The latter is commemorated
on Palm Sunday, the Sunday immediately preceding Easter.

REPRESENTATION AND ICONOGRAPHY

The episode appears on sarcophagi of around the fourth century. The scene
appears initially simple: Christ astride an ass, which lifts its head, while one
or two children lay cloaks in front of him as he passes (Mark 11:8). Jesus can
be accompanied by two or three disciples. Zacchaeus, perched on a
sycamore tree for a better view, also occasionally appears, although in the

**Christ's Entry into
Jerusalem**
Twelfth century. Cappella
Palatina, Palermo.

middle ages this theme was correctly treated as a different episode (miniature, Gospel, eleventh century, Biblioteca Quirina, Brescia).

In the Byzantine world, Christ is shown side-saddle and the ass lowers its head. These two Byzantine characteristics are found in later medieval Italian art (mosaic, Cappella Palatina, Palermo, twelfth century) until about the fourteenth century. The episode was enriched with additional details and figures (carved rood-screen, Church at Bourget in Savoie, thirteenth century, where St Peter follows Christ, carrying his keys; Ghiberti, north door of the Baptistry, Florence, 1403-24). In the modern period, a taste for the picturesque predominates (James Ensor, *The Entry of Christ into Brussels*, 1888, Louis Franck Collection, Antwerp).

Cross-references: David, Jericho.
Bibliography: L. Réau, op. cit., vol. II, 2, pp. 396-401.

CHRISTINA OF BOLSENA

Italian: Cristina; French: Christine; German: Christina.
Virgin and Martyr. 3rd century(?). Feast day 24 July.

LIFE AND LEGEND

This young noblewoman came from Bolsena, Tuscany. The historical basis of the martyrdom commemorated in her name has never seriously been contested, although its subject may not in fact have been called Christina. A convert, Christina refused to sacrifice to Apollo, smashed the gold and silver idols and gave the pieces to the poor. Her father handed her over to the executioners, who whipped her and racked her on a wheel which fell to pieces. She was locked in a tower (like St Barbara) and visited by angels who brought her fruit and flowers. This last detail links her legend to those of SS. Dorothy and Elizabeth of Hungary. Her torturers then threw her into the Lake of Bolsena with a millstone around her neck, but Christ himself rescued her from drowning. She was then hurled into a cauldron of burning oil and locked up with a collection of venomous snakes but was immune to their poison. Arrows were also useless against her, but she was finally despatched by a blow from the axeman which split her skull open.

She has an eastern counterpart, Christina of Tyre, who did not exist but whose legend is identical in every respect. Christina of Bolsena is the patroness of Bolsena, where she has been venerated since the fourth century, and of Palermo and Torcella. She is the patron saint of archers, millers and Italian seamen.

REPRESENTATION AND ICONOGRAPHY

Christina is represented as a young girl with a crown, the palms of martyrdom and, often, a veil. She is generally accompanied by attributes relating to her long martyrdom. She is a frequent subject in Central Italy and Rhineland Germany, where veneration of her is steadfast. She is shown with a crown in the series of virgin martyrs at San Apollinare in Classe, Ravenna (sixth century) and with a cross and crown on a fresco in the crypt of St Peter's at Carpignaro. From the fifteenth century, she has been represented with arrows (Lucas van Leyden, stained glass at Zabern, first half of the sixteenth century). The different episodes of her passion were treated by Veronese (Accademia, Torcella) as well as in stained glass at Evry-le-Châtel (Aube). Her

St Christina of Bolsena and the Millstone
After David Teniers, seventeenth century. Bibliothèque Nationale, Paris.

drowning in the Lake of Bolsena inspired Vincenzo Catena (after 1520, S. Maria Mater Domini, Venice): the martyr kneels before a lake with a millstone around her neck as three angels come to lift her above the water. A print shows Christina with her various attributes, including the snakes (from the treatise *Speculum pudicitae*, beginning of the eighteenth century).

Attributes: Crown. Millstone. Wheel. Arrows. Snakes.

CHRISTMAS

Latin: Dies Natalis; Italian: Natale; Spanish: Navidad, Nochebuena; French: Noël; German: Weihnachten, die heilige Nacht.
Feast 25 December.

The Christian world has celebrated the Nativity of Christ on 25 December since the fourth century. It is traditionally kept as one of the four main feast days of the Christian year, the others being Easter, the Ascension and Pentecost.

Cross-reference: Nativity.

CHRISTOPHER

St Christopher
L. Bertelli, 1573.
Bibliothèque Nationale, Paris.

Greek: Christophoros; Latin and German: Christophorus; Italian: Cristofano, Cristoforo; Spanish: Cristobal; French: Christophe.
Martyr. 3rd century(?). Feast day 25 July.

LIFE AND LEGEND

A group of legends accumulated in Asia Minor around the figure of Christopher, purportedly martyred under Decius. Apart from his name, which means "bearer of Christ", nothing is known about him except that he was venerated in Chalcedon from the fifth century. One of his many curious legends recounts that he was born with the name Reprobus, and belonged to a certain mythical dog-headed race, and was only later baptized Christopher when he took on human features.

The cult of Christopher soon spread all over Christendom. Legend transformed him into a giant Canaanite who desired to serve the most powerful king in the world. He began by serving under Satan, until he noticed that the mere sight of the crucifix put his master to flight. He then decided to serve Christ by helping travellers to ford a dangerous river. One day, a child asked for his assistance. Christopher lifted him upon his shoulders but, as he crossed the river, he felt his load getting heavier and heavier. Leaning painfully on his staff, guided by a hermit with a lantern, the giant eventually reached the opposite bank. The child then revealed that he was Christ himself, "the king thou seekest, him that created and made all the world thou hast borne upon thy shoulders." As proof, the child instructed Christopher to stick his staff into the soil, saying that it would flower and bear fruit the very next day. This prediction is fulfilled.

Later, Christopher was supposed to have preached the Gospel in Lycia with great success. He was then imprisoned by Decius, when he refused to make offerings to pagan divinities. He was thrown into prison in the company of two courtesans whom he converted, before being subjected to various tortures selected from among the extensive corpus of hagiographical leg-

end: he was beaten with rods of iron, placed on a griddle and shot with arrows which turned back on those that fired them. In common with many saints, he was finally beheaded.

The uncertainty surrounding the life of Christopher did not hinder him from being intensely venerated, right up to the sixteenth century. He is the patron saint of the dying: simply looking at any image of him prevents one from dying without first receiving the sacraments. The Holy See has now demoted his cult to local status, but it still thrives. He is the patron of travellers, whom he protects from accidents.

REPRESENTATION AND ICONOGRAPHY

Depictions of St Christopher seems on the surface relatively constant but, in fact, their history is rather more complicated. Most ancient images show him as a young saint with no distinguishing characteristics. South of the Alps, a mystical interpretation of his name was adopted in the twelfth century, designating the living presence of Christ in his martyrs. The saint, wearing a long robe with a belt, carries in his arms – or sometimes holds against his heart – Christ in Majesty, who raises his hand in blessing (fresco in Sankt Petrus von Bacharach, Germany: the saint is shown with features similar to Christ's). In France the following type evolves: Christopher supports Christ in Majesty perched upon his shoulders (Amiens Cathedral, fifteenth century).

After this symbolic phase, artists began to concentrate on the various incidents of his developing legend. In the *Hildesheim Psalter* (Donaueschingen, thirteenth century), Christopher carries the Infant Jesus in his arms after the manner of a Madonna and Child. Picturesque elements become predominant from the fourteenth century, with details such as the hermit with the lantern (Dürer, engraving, sixteenth century).

Christopher is generally of giant stature, while the often naked Child on his shoulders stretches out his hand in an act of benediction or else holds a globe. Jan Wellens Cock shows Christopher as an Atlas, supporting an immense globe on which the Child is enthroned (c.1520, Bissing Collection, Munich). Patenier (early sixteenth century, Nuevos Museos, El Escorial) places the scene in a detailed landscape, showing the old hermit. In a hermetic work by the Master of Messkirch (sixteenth century, Kunstmuseum, Basel), the Child stands within a transparent geographic globe.

Scenes from Christopher's martyrdom figure in a limited number of cycles (San Vicento di Galliano, near Como, eleventh century). The cycle known as *cynocephalic* is prevalent in the east, and forms a special category. In this, Christopher has the head of a dog, his nose is long like a snout, and his ears are particularly pointed. These figures have been compared to likenesses of the Egyptian dog-headed god Anubis, without there being any direct relationship between the two. This type can be found either as a separate motif or as forming part of a cycle (Byzantine manuscripts; Greek icon, *O Christophoros*, 1685, Museum of Byzantine Antiquities, Athens). Other more conventional cycles also exist (Ansuino da Forli, mid fifteenth century, Eremitani, Padua).

Attribute: Flowering staff (not to be confused with St Joseph's). Christ Child on shoulders.

Bibliography: Z. Ameisenova, "Animal-headed Gods, Evangelists, Saints and Righteous Men", *Journal of the Warburg and Courtauld Institutes*, 12, 1949, London, pp. 221-45. L. Réau, op. cit., vol. II, 1, pp. 304-13. G. Servière, "La légende de saint Christophe dans l'Art", *Gazette des Beaux-Arts*, V, 3-63, 1921.

CHURCH *see* ADAM AND EVE, CHURCH AND SYNAGOGUE, CRUCIFIXION, DAVID, DEPOSITION, REVELATIONS.

CHURCH AND SYNAGOGUE

Greek: Ekkesia; Latin: Ecclesia; Italian: Chiesa; Spanish: Iglesia; French: église; German: Kirche.
Latin: Synagoga; Italian and Spanish: Sinagoga; French: Synagogue; German: Synagoge.

TRADITION

The Acts of the Apostles (15), and the Epistles of St Paul (Romans 15:8-13 and Galatians 2:1-10) both allude to an early Christian debate between the Church of the Gentiles (that of the pagan converts) and the Church of the Circumcised (that of converted Jews). In the middle ages, theology followed the Second Epistle of St Paul to the Corinthians, defining the Church as the Bride of Christ: "I have espoused you to one husband, that I may present you as a chaste virgin to the Christ." This was the era of the *Concordia*, of hope in a peaceable future between the two churches. During this period, however, positions hardened. Hostility to the Jews surfaced in the title of the sermon *Contra Judeos* (baselessly ascribed to St Augustine), as well as in the dialogue *De altercatione Ecclesiae et Synagogae* – a significant text, though doubtless composed after the events it describes. By the thirteenth century, Albert the Great described the Synagogue as a blindfolded woman who had lost her crown and carried her head lowered. This image derives directly from the text of the Lamentations of Jeremiah: "The crown is fallen from our head, woe unto us that we have sinned! For this our heart is faint; for these things our eyes are dim." (Lam. 5.16-17). Hostility to the Synagogue was strengthened by the theatre and mystery plays which heaped upon it all the sins of the world.

REPRESENTATION AND ICONOGRAPHY

On a fifth-century mosaic (S. Sabina, Rome), two praying figures are placed on an equal footing: one has the inscription *Ecclesia ex circumcisione* and the other *Ecclesia gentilium*. A number of motifs unite them, and no connotations of competition are present. They appear flanking the Cross (Carolingian manuscript miniatures; ivory relief carvings, tenth century, Museum, Tournai). In early depictions, they can be distinguished neither by their attributes, nor their clothing, although occasionally the Synagogue appears as an old man.

In the middle ages, the Church was furnished with a chalice in which she gathered up the Blood of the Crucified. The twelfth-century stained-glass window designed by Suger for the basilica of St Denis, France, is in keeping with this untroubled perspective. Christ crowns the Church and removes the Synagogue's blindfold. From the second half of the thirteenth century, however, the theme became more popular and a new hostility to the *Synagoga* began to appear. The Church, like a triumphant queen, was placed next to the Tree of Life, confronting the Synagogue whose eyes are put out by a demon armed with a stake (stained glass, *The Passion*, Chartres). Or, in an allusion to the instruments of the Passion, the Synagogue holds a broken lance and turns away, head bowed and blindfolded (1230, Musée de l'Œuvre

The Church
Lucas van Leyden,
beginning of the sixteenth
century. Rijksmuseum,
Amsterdam.

The Synagogue
Lucas van Leyden,
beginning of the sixteenth
century. Kunstsammlungen
der Veste, Coburg.

Notre-Dame, Strasbourg). Konrad Witz follows this tendency in a work inspired by the *Speculum humanae salvationis* (*Polyptych of the Mirror of Salvation*, c.1435, Kunstmuseum, Basel). The Synagogue is also often shown with a closed book, while the volume held by the Church, symbolizing the New Testament and the New Law, is open. By the Renaissance, the theme has become very rare.

Attributes: Church: Crown on head. Banner with Cross. Chalice. Open book. Synagogue: Blindfold. Crown on ground. Instruments of the Passion (broken lance). Closed book.

Bibliography: E. Kirschbaum, *Lexikon der christlichen Ikonographie*, Freiburg im Breisgau, 1968, vol. I, *Allgemeine Ikonographie*, pp. 562, 570. L. Réau, op. cit., vol. II, 2, p. 744. G. Schiller, *Ikonographie der christlichen Kunst*, Gütersloh, 1976, vol. IV, pp. 38-89.

CHRYSOSTOM *see* JOHN CHRYSOSTOM.

CIBORIUM

Latin: ciborium; Italian: ciborio; Spanish: copón, hostiario; French: ciboire; German: Ciborium, Speisekelch.

The ciborium is a sacred vessel placed inside the tabernacle, which holds the reserved host to be used at the Eucharist. It is derived from the early pyx, given a stem and a lid during the middle ages. It is also used to carry the Eucharist to the sick.

Cross-reference: Barbara.

CIRCUMCISION

Latin: Circumcisio: Italian: Circoncisione; Spanish: Circuncisión; French: Circoncision; German: Beschneidung.
Feast day 1 January.

TRADITION
The Book of Genesis presents circumcision (the removal of the foreskin) as a sign of a covenant between God and Abraham: "And God said to Abraham, Thou shalt keep my covenant therefore, thou, and thy seed after thee in their generations. This is my covenant, which ye shall keep ... Every man child among you shall be circumcised. And ye shall circumcise the flesh of your foreskin" (Gen. 17:9-12). The custom of naming on the day of circumcision was also respected in Jesus' case: "And when eight days were accomplished for the circumcising of the child, his name was called Jesus" (Luke 2:21). On this day, Christ's blood flowed as it was to do at his Passion. The Society of Jesus determined Circumcision as its principal feast day and, in many of its churches, the large painting above the high altar depicts this subject.

REPRESENTATION AND ICONOGRAPHY
The Circumcision of Christ first appeared in art at the end of the tenth century. The episode was often incorporated into a cycle of the life of Christ or of Mary, and generally placed before the Adoration of the Magi and the

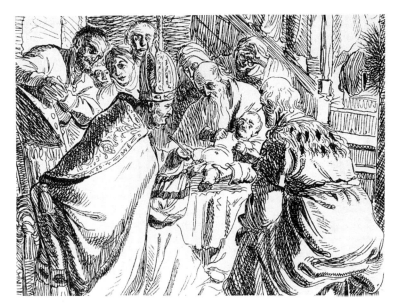

The Circumcision
Rembrandt, 1626.
Rijksmuseum, Amsterdam.

Presentation of the Lord (the Purification of the Virgin). The latter has an obvious relationship to the Circumcision, and artists nearly always treated only one of them. The Circumcision can also be linked to corresponding episodes in the Old Testament. Hence Nicholas of Verdun (1181, Klosterneuberg altarpiece, Klosterneuberg Stiftsmuseum, Austria) juxtaposes it with two other scenes of the same rite, portraying Samson and Isaac. The two other children struggle as the operation is performed, but Jesus submits quietly to the application of Mosaic law.

The numbers of figures included varies widely. There are three main characters: the Virgin, Christ and the priest who circumcises the Child with a knife. Joseph was included from the thirteenth century, and several other priests could appear. From the twelfth century, the priest could look rather cruel and Christ and his parents almost frightened of him. This theme is treated by Rembrandt (1661, National Gallery, Washington).

Cross-references: Magi, Mary, Presentation of the Lord.

CISTERCIANS

Italian: Cisterciensi; Spanish: Cistercienses; French: Cisterciens; German: Zisterzienser.

On 21 March 1098 Robert, abbot of the Benedictine Abbey at Molesmes, together with about twenty other brothers, founded a new community in the forest of Cîteaux, near Dijon. His aim was to return to a more strict observance of the Rule of St Benedict which had fallen into disuse. The beginnings of the Cistercian Order were fraught with difficulties, in spite of the composition of the *Institutio monarchorum cisterciensium* in 1101. The new order owed its success to St Bernard, abbot of the Cistercian Abbey of Clairvaux from 1115 to his death in 1153. The Cistericians wear a habit of unbleached

raw wool. They are popularly known as White Monks, in contradistinction to the Benedictines, the so-called Black Monks.

Bibliography: G. and M. Duchet-Suchaux, *Les Ordres réligieux: Guide historique*, Paris, 1993: articles on Bernard of Clairvaux, Cistercians, Robert of Molesmes.

CLARE

Latin: Clara; Italian: Chiara; Spanish: Clara; French: Claire; German: Klara. Foundress of the Minoresses or Poor Clares. 1194-1253. Canonized 1255. Feast day 11 August.

LIFE AND LEGEND

Clare was born of noble family in Assisi. At 18, she heard St Francis preach and decided to join him as a nun at the Pontiuncula in Assisi. After a period of monastic preparation in two Benedictine abbeys, St Francis offered her a small house adjacent to the Church of St Damian in Assisi. She became abbess of this new community in 1215 and it was soon to include both her sister, St Agnes, and her widowed mother. The *Privilegium paupertatis* (allowing the nuns to live on alms) was delivered by Gregory IX in 1228, and confirmed the austere nature of this order. Clare never left the convent in Assisi, where she strove to put into practice the ideals of St Francis. She devoted herself entirely to her fellow-sisters despite suffering numerous illnesses for almost thirty years.

On two occasions, Assisi was almost sacked by the armies of Emperor Frederick II, which included a number of Saracens. The bedridden St Clare was carried up on to the city walls and, armed solely with a monstrance (or pyx), she routed the attackers. She was canonized in 1255, only two years after her death. She is occasionally found as a patroness of the blind.

REPRESENTATION AND ICONOGRAPHY

Clare is represented in the habit of a Franciscan nun, with the three-knotted cord around her waist. The scenes most often represented are St Francis cutting her hair and dressing her in her habit; her taking leave of St Francis; the Pope confirming her privilege, and her putting the Saracens to flight with a monstrance (wooden relief carving, Lower Church at Assisi, fifteenth century). The frescoes at the basilica of S. Clara at Assisi by Cimabue (late thirteenth century) present the principal episodes of her life (see also the stained glass at Königsfeld Church, Aargau, Switzerland). Clare, surrounded by a choir of angels, is crowned by Christ and the Virgin (upper section of the altarpiece of the Convent of the Poor Clares, fifteenth century, Germanisches Nationalmuseum, Nuremberg).

St Clare
Puccio Campana,
mid-fourteenth century.
Lower Church of St Francis,
Assisi.

Attributes: Habit of the Poor Clares. Monstrance or pyx. Cross surmounted with an olive branch (symbolizing her adoration of the crucifix). Lily (in Sienese and Umbrian painting). Oil lamp or processional lantern.
Cross-reference: Francis of Assisi.
Bibliography: G. and M. Duchet-Suchaux, *Les Ordres réligieux: Guide historique*, Paris, 1993: articles on Clare, Poor Clares.

CLOAK *see* MARTIN, MOCKING OF CHRIST.

CLOVER *see* PATRICK.

COCKEREL

Christianity made the cockerel, a bird associated with the sun, a symbol of the Resurrection which signals a New Testament and a New Kingdom. The cockerel was an ancient pagan symbol of vigilance and continued in this guise in the Carolingian period, being placed on church steeples and bell-towers to guard the surrounding countryside and protect it from demons. In the twelfth and thirteenth centuries, the cockerel became a symbol of the preacher who, by chasing away the darkness of the world and encouraging the faithful to live in the Light of the Lord, awakens Christians from their slumbers. Only after 1000 did the cock become associated with St Peter, as the bird which heralded his betrayal of Christ (John 13:38); formerly, he had simply carried keys.

Cross-references: Odilia, Peter.

COLOMBAN

Variant and Latin: Columbanus; Italian: Colombano, Spanish, French and German: Columban.
Abbot. c.543-615. Feast day 23 November (21 November in Ireland).

LIFE AND LEGEND

Columban left his abbey at Bagnor in Ulster around 580 with some ten other monks, including St Gall. He founded three monasteries in the Vosges on land allotted him by the King of Austrasia: Annegray, Fontaine and Luxeuil in the Haute-Saône (c.590). Colomban's rule for his monks was extremely strict. In 610 he was chased out of Gaul by Queen Brunhild, whose depravity he had unambiguously condemned. He escaped over the Alps and founded another community, in 614, at Bobbio, near Pavia, where he died a year later. The legend of St Colomban stresses his love of nature and of wild animals. He was a friend of wolves and bears, and a bear was supposed to have given up his cave to him during his escape to Switzerland. Colomban is the patron saint of Bobbio and a patron of Ireland.

St Columban
Bibliothèque Nationale, Paris.

REPRESENTATION AND ICONOGRAPHY

Colomban is shown in a monk's loose frock. He wears a beard and carries a book (often bearing the inscription *Christi simus, non nostri*), a stick (alluding to his severity), or an abbot's crozier (Bernardino Lanzano da San Colombano, fresco, sixteenth century, Borgo San Colombano). He appears as a hermit (engraving, Burgoing de Villeforte, Paris, 1708) or accompanied by St Gall (copper engraving, H. Murer, *Helvetica Sacra*, 1648.)

Attributes: Book (inscribed). Whip. Sun on his chest. Stick or crozier. Bear.
Cross-reference: Gall.
Bibliography: M. M. Dubois, *Un pionnier de la civilisation occidental: saint Colomban*, Paris, 1950. R. Olmi, "L'Iconografia di San Colombano", *Convegno storico Colombaniano, 1-2 September 1951*, Bobbio, 1953, pp. 33-40.

COLOURS

The complex problems posed by colour in imagery have rarely been addressed by art historians and iconographers. In themselves, colours have no specific meanings, they merely have various uses. These uses, however, are exceptionally varied and should be studied closely since they have a role to play in the construction, syntax, music, significance, and artistic or aesthetic dimension of the image.

It is no use beginning with general considerations of the properties or symbolism of colours. Rather, it should be observed exactly how they are employed and distributed over the surface of a certain image or document. Frequency and distribution, rhythm and order, connections and oppositions – all have to be examined. It is in these areas that colour is a singularly powerful tool; iconographical, aesthetic and symbolic criteria emerge only at a later stage. Priority should be given to the document itself and to its internal structural analysis before bringing into play any more general observations on colour in any particular period, region or body of work, either from a single artist or from a studio. If, for example, the Virgin in a sixteenth-century miniature wears blue, one should not jump to the conclusion that the conventional iconographical and symbolic values of this traditionally Marian colour are necessarily intended. In this particular illustration she may wear blue simply because the background is red; whereas, on a later folio, she may be dressed in red on a blue background. Analysis should always begin at this level. At a later stage, general observations can be introduced, derived from outside the given document or from a series of similar documents: these may include iconographical tradition, studio custom, artistic concerns, pictorial considerations, colour symbolism and mythology, let alone more technical matters linked to the familiarity, cost and availability of pigments.

Colour symbolism is eminently culture-dependent, differing from society to society, and even within a given cultural sphere it can vary a great deal both in time and even in space. What is significant in Palestine in Biblical times is no longer so in ancient Greece or Rome, nor in the medieval west and still less in the European Renaissance or Baroque. One should avoid that selectivity which allows one to support one's own hypothesis while carefully throwing out everything that might jeopardize it.

COLUMN *see* FLAGELLATION OF CHRIST, SAMSON, SEBASTIAN.

COMMUNION OF THE APOSTLES

French: Communion des Apôtres; German: Apostelkommunion.

TRADITION
The theme of Christ giving the apostles Eucharist cannot be dissociated from the Last Supper. The Communion of the Apostles has its basis in the Synoptic Gospels (Matt. 26:26-29; Mark 14:21-23; Luke 22:19-20). It appeared in the eastern Church and soon became widespread, though it is rare in the west.

REPRESENTATION AND ICONOGRAPHY
In general, the motif is strongly influenced by liturgy. The table of the Last

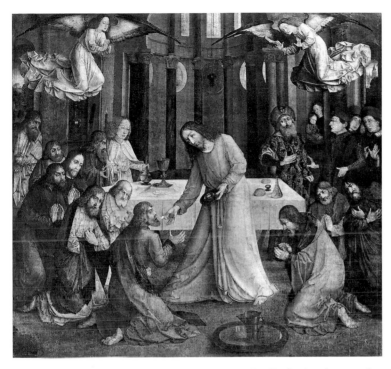

**Communion of the
Apostles**
Justus of Ghent, 1474.
Palazzo Ducale, Urbino.

Supper is often replaced by an altar. To receive the Eucharist, the apostles
advance towards Christ, who stands behind the altar table. The earliest known
depictions date from the second half of the sixth century and are found on
patens and on copies of the Gospels.

In the eastern Church, the theme is employed both in psalters and evan-
geliaries. A miniature in the *Evangelium* of Rossano is the source for a recur-
rent type. The artist has split the composition to show the Communion in
two parts, with the figure of Christ in both. In one, Christ presents the bread
to the apostles; in the other, he hands them the chalice. This arrangement
is taken up in the Byzantine period, between the eleventh and fourteenth
centuries, but with the addition of an altar. Occasionally, the artist chooses
to represent Christ preaching or praying just prior to the Communion. The
theme often serves to decorate Byzantine churches, often on the conch of
the apse. It is rarely employed on the dome, however.

In the western Church, Byzantine influence, though important in early
examples, slowly waned and the theme remains rare. There exists a four-
teenth-century polyptych (Vatican Museum), where the apostles are
grouped round a table with Christ in the foreground. At the end of the mid-
dle ages, Christ gives communion with bread alone, as in the painting by Joos
van Wassenhove (c.1475, Galleria Nazionale delle Marche, Urbino). In the
period following the Council of Trent, the Last Supper is often depicted sim-
ply as a Communion of the Apsotles.

Cross-reference: Last Supper.
Bibliography: "Apostelkommunion", in E. Kirschbaum, *Lexikon der
christlichen Ikonographie*, Freiburg im Breisgau, 1968-74.

St Constantine
Piero della Francesca,
c.1465. San Francesco,
Arezzo.

CONSTANTINE THE GREAT

Italian: Constantino; French: Constantin le Grand; German: Konstantin der Grosse.
Roman Emperor, between 306-337.

LIFE AND LEGEND

Son of Constantius Chlorus, Constantine was proclaimed Augustus by his father's legions at Chlorus' death. His mother was the humbly born Helen, whom Constantine was later to make Empress and the Church to canonize. His title was contested by Galerius, master of the eastern half of the Empire. Constantine gained the good graces of Maximian, an Augustus of the east, by marrying his daughter, but soon broke with him and, after taking him prisoner in 309, forced him to take his own life. After the death of Galerius in 311, Constantine made an alliance with Lucinius Licinianus, another eastern potentate. At last having nothing to fear from the east, he was able to take the fight to Maximian's son, Maxentius, the Augustus of the west. The decisive battle took place at the Malvian Bridge on the Tiber downstream from Rome, on 28 October 312, during which the vanquished Maxentius drowned in the river trying to escape.

Prior to the battle, Constantine had a vision in which he saw a sign – perhaps the chrismon – which he then had carved on his soldiers' shields with the inscription "*En touto mika* [*In hoc signo vinces,* Defeated by this sign]". In early 313, jointly with Licinius, he took a number of decisions collectively known as the Edict of Milan which allowed Christians a considerable degree of tolerance. After a series of pugnacious clashes with his former ally, the defeated Licinius handed himself over, and was executed in 324. Constantine thus became the absolute master of the Roman Empire.

Since 312, Constantine had been effectively Christian, and from 324 the Christian complexion of his law-making became predominant. His donations to the free Christian communities in Africa were more than generous and, in Rome, Imperial foundations flourished. The Council of Arles, in 314, uniting all the bishops of the west, marked the retreat of papal authority before growing Imperial power, which now regulated the episcopacy. Faced with the Arian controversy, Constantine convoked the first Council of Nicaea which condemned Arius and spelt out the Catholic Creed. He died in 337 and was inhumed in the Basilica of the Holy Apostles in Constantinople. His cult soon grew and the Greek Church venerates him as a saint, almost the equal of the apostles (*isapostoplos*). A *Life of Constantine* published under the name of Eusebius of Caesarea spread his legend. The Orthodox Church celebrates his feast on the same day as that of his mother, St Helen, 21 May.

Constantine seems to have promoted a kind of synthesis between Christianity and certain aspects of paganism. Throughout his life, he favoured a cult of the Sun, similar to the pagan cult of Mithra, and one could posit that he proposed to combine Christianity with sun worship of the *Sol invictus* to which Roman Emperors of the third and fourth centuries had erected so many temples. Apparently, he subscribed to a symbolic view which made the sun into an image of Christ Transfigured. He was actually baptized only on his deathbed.

REPRESENTATION AND ICONOGRAPHY

Thanks primarily to Imperial coinage, there survive a large number of portraits of Constantine. He is represented as both a Roman Emperor and a

Byzantine *basileus*. These portraits tend to be idealized, and images of the
Emperor borrow facial features from Caesar Augustus, for Constantine was
styled "the new Augustus". From 326, official coins were stamped with a pro-
file of Constantine crowned with a diadem, his face turned towards
heaven. After 330, he took on the appearance of a majestic patriarch, while
another series of coins made reference to the image of the *Sol invictus*. One
of the medallions on the Arch of Constantine in Rome is supposed to be an
authentic portrait of him. His attributes are primarily the Cross, alluding to
the Invention (discovery) of the True Cross by his mother St Helen, and the
chi-rho monogram, the *labarum* standard, in reference to his vision on the
eve of the battle at Malvian Bridge.

Later in the west, Constantine is portrayed as a feudal lord on horseback,
with a knight's mantle and a falcon. A fresco in the baptistry of St Jean at
Poitiers (twelfth century) comprises an example of this knightly type, espe-
cially common in Poitou and Aquitaine. The most frequent scenes depicted
in the west are the battle at Malvian Bridge, and the donation of Constantine
(based on an apocryphal document worked up by the Papal Chancery in the
twelfth century) by which he was supposed to have bestowed territory on
the papacy which became the Papal States. The most famous work of art con-
nected with Constantine is Piero della Francesca's *History of the True Cross*
at Arezzo (c.1452-64, S. Francesco).

Cross-reference: Helen.
Bibliography: "Constantino" in *Bibliotheca Sanctorum*, vol. IV, 1961-9. A.
Fliche and V. Martin, *Histoire de l'église*, (1934-), vol. III.

CORONATION OF THE VIRGIN

Variant: Coronation of Our Lady. Italian: Incoronazione della Vergine;
Spanish: Coronación de la Virgen; French: Couronnement de la Vierge;
German: Krönung Mariä.

TRADITION
The belief in the Coronation of the Virgin has no basis in scripture. It is
derived from an apocryphal text attributed to a Bishop Melito of Sardis, and
taken up by Gregory of Tours in the sixth century before being more widely
publicized in the *Golden Legend* of James of Voragine. The Virgin's
Coronation purportedly took place just after her Assumption. She was
described as being crowned by Christ, God the Father or the Trinity. The
theme therefore differs from the Triumph of the Virgin where she is merely
imagined as wearing a crown. Moreover, when the Virgin is shown holding
the Christ Child and surrounded by angels, the theme can only very loosely
be described as a Coronation.

REPRESENTATION AND ICONOGRAPHY
The theme of the Coronation developed out of the theological speculations
of Abbé Suger. Invented in France, it occurred for the first time in art on the
tympanum of the main door of the Cathedral of Senlis (c.1190), where the
Virgin, already wearing her crown, is shown sitting to the right of Christ who
is blessing her. She is also crowned by her Son on the tympanum of the Portal
of the Virgin at Bourges Cathedral. The theme appeared on stained glass at
Antwerp Cathedral (twelfth century), but with the crowning carried out by
an angel. Hans Holbein the Elder painted a Coronation (Eichstätt, Episcopal

The Coronation of the Virgin
Enguerrand Quarton, 1453-54. Museum at Villeneuve-lès-Avignon, France.

Chapel). Hans Burgkmair (1507, Städtische Gemäldegalerie, Augsburg) showed the events against a backdrop of Italian Renaissance architecture.

In Italy a mosaic at the apse of S. Maria Maggiore in Rome presented a crowning by Christ (J. Torriti, 1295). Lorenzo Monaco took up the theme (panel, 1413, Uffizi, Florence) as did Fra Angelico, showing the Virgin lowering her head slightly as receives the crown from Christ's hand (fresco in a cell at the convent of St Mark's, Florence, 1438-50). Filippo Lippi had her receiving her crown from God the Father (panel, fifteenth century, Uffizi, Florence). In the older style, Veneziano shows the Coronation in a precious gold "icon" (before 1460, Accademia, Venice). Although the theme, as the final Mystery of the Virgin Mary, continued in importance throughout the Renaissance (Veronese, 1555, S. Sebastiano, Venice) and the baroque, it never regained the supremacy it had had in the Romanesque and early Gothic periods.

Cross-references: Assumption, Mary.
Bibliography: G. Schiller, *Ikonographie der christlichen Kunst*, Gütersloh, 1982, vol. IV, 2, p. 147.

COSMAS AND DAMIAN

Greek: Kosmas, Damianos; Latin: Cosmas et Damianus, Sancti Medici; Italian: Cosimo e Damiano; Spanish: Cosmi y Damian; French: Côme et Damien; German: Cosmas und Damian.
Martyrs. Died 287(?). Feast day 26 September (west), 1 July or 1 November (east).

LIFE AND LEGEND
These twins, who practised medicine in a town in Cyrrhus but refused all payment in order to convert their patients, were called the *anargyroi*, "the penniless doctors". Their cult is of Greek origin. They could cure animals as well

**Cosmas and Damian
heal Justinian the
Deacon**
Fra Angelico, S. Marco
altarpiece, 1438-40. Museo
del Convento di S. Marco,
Florence.

as people and one day they healed a camel's injured hoof. The different
episodes of their martyrdom are purely legendary. They were chained together
and thrown into the sea (like Vincent of Saragossa), but an angel broke their
bonds and brought them ashore. The proconsul, Lysias, persevered and had
them tied to a post to be burnt alive, but the very flames flared up against
their would-be executioners. The latter then tried to have the two brothers
stoned, but the stones all fell short, while arrows shot at them also fell harm-
lessly to the ground. Lysias finally had them both beheaded.

The cult of Cosmas and Damian was spread throughout Europe by *The
Golden Legend* of James of Voragine. Another legend told of a posthumous
miracle. A sacristan of the church dedicated to them in Rome had a gan-
grenous leg amputated; through the saints' intercession, the leg of a recently
dead black man was successfully grafted on. The sacristan as a result is
depicted with one white and one black leg.

Representation and Iconography
The miraculous grafting of the sacristan's leg is represented for the first time
by the Master of Rinuccini (altarpiece of SS. Cosmas and Damian, fourteenth
century, North Carolina Museum of Art, Raleigh), then by Fra Angelico (*The
Healing of Justinian the Deacon*, retable for San Marco presented by Cosimo
de' Medici 1438-40, Museo di S. Marco, Florence). Episodes and the most
famous miracles in the lives of the saints also occur in the sixteenth century
(frescoes on the dome of Essen Cathedral): the healing of the camel; their
martyrdom; the Hand of God giving them a surgeon's bag. There is a man-
neristic version by Lancelot Blondeel in Bruges (1523, St James). The cycles
continued at a later period (Antonio Balestra, first half of the eighteenth cen-
tury, San Giustino, Padua).

Attributes: Lined robes. Hoods or cylindrical physicians' hats. Surgeons' bags
and instruments.
Cross-references: Hand of God.
Bibliography: J. Devisse, M. Mollat, *L'Image du Noir dans l'art occidental*,
Fribourg, 1979, vol. II, p. 74.

COW *see* PERPETUA.

CREATION

Italian: creazione; Spanish: creación; French: création; German: Schöpfung.

TRADITION

The Biblical story of the creation occupies the first few chapters of the Book of Genesis. God created the world in six days (Gen. 1, 2). The first day, he separated the light from the darkness; the second and third, he parted the waters from the sky and the earth. The fourth, he set a sun and a moon in the heavens to light the earth, while the fifth was devoted to the creation of the animals. On the sixth day, God consummated his work by creating man, who was the only being created in his image: "So God created man in his own image, in the image of God he created him; male and female created he them" (1:27). Man and woman were therefore incarnated as complementary equals. The creation proper can be divided into its various phases. The episodes concerning the creation of man are treated separately: Adam and Eve in the Garden of Eden, the Temptation, Adam and Eve expelled from Paradise (*see* Adam and Eve), Cain and Abel, Noah and the Flood.

REPRESENTATION AND ICONOGRAPHY

Earlier artists tended to represent the Creator in the guise of Christ with a crossed nimbus. From the fourteenth century, he is shown as an old man, often wearing a tiara. In France, the frescoes at St Savin sur Gartempe (Vienne, twelfth century) show the various moments of the creation. There are also similar cycles in Italy (mosaics in the narthex of St Mark's, Venice, thirteenth century; Ghiberti, bronze doors, Baptistry, Florence, 1403-24). Michelangelo (ceiling of the Sistine Chapel, 1508-12) and Raphael (Logge, Vatican, 1518-19) chose to represent the Creator hovering in the sky.

The Creation of Light (Gen. 1:2-5)

"And the Spirit of God moved upon the face of the waters. And God said, Let there be light: and there was light. And God saw the light, that it was

The Creation: the Dividing of the Waters from the Firmament
Caedmon, *Poems*, tenth century. Bodleian Library, Oxford.

The Creation of the Animals
Tintoretto, 1550-53. Accademia, Venice.

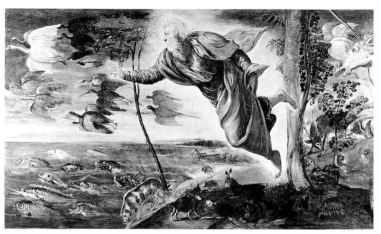

good." According to certain theological speculations which have percolated through in much art, the formation of light could be identified with the creation of the angels. This moment is illustrated by a mosaic in St Mark's, Venice (twelfth century). In the sixteenth century, Raphael painted God parting the clouds to let through the light (Logge, Vatican).

The Separation of the Waters and the Sky (1: 6-8)
"God divided the firmament and divided the waters which were under the firmament from the waters which were above the firmament." At the portal of the Cathedral of Freiburg im Breisgau (Germany, fourteenth century), God is placing a kind of lid on the waters, symbolizing the vault of heaven.

The Separation of the Waters from the Earth (Gen. 1: 9-13)
The creation of the earth and of the plants are grouped together on the third day (Michelangelo, Sistine Chapel; Raphael, Logge, Vatican).

The Creation of the Sun, the Moon and the Stars (Gen. 1: 14-19)
"God made two great lights; the greater light to rule the day, and the lesser light to rule the night: he made the stars also." This episode is depicted in a number of different ways. Sometimes God himself hangs two disks representing the sun and the moon on the firmament (quatrefoil medallion at the base of the portal walls, Cathedral of Auxerre, fourteenth century: God seated hangs up the sun, with the moon and the stars already in place). Sometimes, God can be assisted by two angels.

The Creation of the Animals and of Man (Gen. 1:20-23 and 26-28)
On the fifth day: "God said, Let us make man in our image, after our likeness: and let them have dominion over the fish of the sea, and over the fowl of the air, and over the cattle, and over the earth." On the sixth day, God made the four-footed animals and man "in his own image" (Orvieto Cathedral, low reliefs, fourteenth century, with the creatures arranged according to their size. Tintoretto also depicted this moment. 1550-53, Accademia, Venice).

The seventh day sees the completion of God's work (Gen. 2:1-3): "And God blessed the seventh day, and sanctified it." (William Blake, watercolour, c.1805, private collection.) This consecration lays the foundation both for the Jewish sabbath and the Christian Sunday observance. A thirteenth-century mosaic in the narthex in St Mark's, Venice, presents God seated on his throne surrounded by six angels, one representing each day of the week; God blesses one remaining angel (without wings) who symbolizes rest on the seventh day. In stained glass on the façade at Laon Cathedral (twelfth century), the Creator is shown leaning on his stick and falling asleep after his labours.

Cross-references: Adam and Eve, Cain and Abel, Noah, Paradise.
Bibliography: G. Senoner, "La Bible racontée par les artistes du Moyen Age", *Revue de l'Art chrétien*, 1907-10.

CRISPIN AND CRISPIAN

Variant: Crispin and Crispinian. Latin and German: Crispinus; Italian: Crispino; Spanish: Crispin; French: Crépin.
Martyrs. Died c.285. Feast day 25 October.

LIFE AND LEGEND
Born of noble Roman lineage, these two brothers escaped the persecution

**SS. Crispin and Crispian
in their Workshop**
Bibliothèque Nationale,
Paris.

of Diocletian by fleeing to Soissons. There, they became cobblers and converted many of their poorer customers while supplying them with free shoes. Arrested in their workshop on the orders of Maxentius, they were handed over to a certain Rictovarus, as was St Quentin, with whom, legend has it, they had earlier escaped to Gaul. The episodes of their martyrdom are similar to those of that saint. They are the patron saints of shoemakers and cobblers, and are sometimes conflated into one person. In England they are always associated with the English victory over the French at the Battle of Agincourt, which fell on their feast day in 1415.

REPRESENTATION AND ICONOGRAPHY
They are for the most part pictured in their workshop handing out various types of footwear or repairing a poor man's shoes (painted carved group, Church of St Pantaleon at Troyes, Aube, sixteenth century; altarpiece, sixteenth century, Schweizerisches Landesmuseum, Zürich). Their arrest and martyrdom are occasionally represented, with cobblers' awls being forced under their fingernails.

Attributes: Shoes. Lasts.

CROSS

From the fifth century onwards, the Cross became the official symbol of the Church and of the Christian religion, replacing the chrismon (the chi-rho), which predominated during the paleochristian period. With the passing centuries, the iconography of the Cross has become abundant, and the symbol has been employed in a myriad of different ways. It can take several forms: Latin Cross; Greek Cross (with equal arms); Cross saltire or St Andrew's Cross (X-shaped); with two (patriarchal or Lorrain Cross) or three crosspieces (Papal or triple Cross); Cross fleury (like a fleur-de-lis; the Cross of Cleves); Cross moline (with ends like a wallbrace); the Tau, the Egyptian or St Antony's Cross (like a T); Maltese Cross (a four-pointed star); Cross potent (Greek, but with secondary struts at the arms' ends), etc. Each form is invested with a particular significance. Apart from being the personal attribute of Christ, the Cross, as a religious symbol or ecclesiastical emblem, is naturally an attribute of many saints – for example, Antony of Padua, Bernard, Bonaventura, Catherine of Siena, Helen, and Margaret.

Cross-references: Crucifixion, Helen, Monogram of Christ.

CROSS SALTIRE *see* ANDREW, EULALIA.

CROW *see* RAVEN.

CROWN

The crown is a multifaceted symbol whose meanings include authority, glory, virtue, victory and prosperity. In the ancient world, divinities, kings and heroes could wear crowns, but medieval Christianity followed Tertullian – whose *De corona* (c.220) underlined the pagan nature of the insignia – and used it sparingly. The Christian crown is, above all, a glorious reward sym-

Christ Mocked. Jan Sanders van Hemessen, c.1560 (detail). Musée de la Chartreuse, Douai.

Deposition. Rubens, 1612. Antwerp Cathedral.

bolizing sainthood. The Virgin's crown shows that she is the Queen of Heaven, while the saints who are shown wearing one (Popes, emperors and empresses, kings and queens) do so in reference to their earthly status. The Crown of Thorns is a Passion symbol (Matt. 27:27-31; Mark 15:16-18) and it can be depicted in many different ways.

Cross-references: Church and Synagogue, Crowning with Thorns, Coronation of the Virgin, Ecce Homo, Mary Magdalene, Mocking of Christ, Trial of Jesus.

CROWNING WITH THORNS

Italian: Coronazione di spive; Spanish: Coronación de espinas; French: Couronnement d'Epines; German: Dornenkrönung.

The Crowning with Thorns

Dürer, *Albertina Passion*, c.1495. Albertina, Vienna.

TRADITION

After Pilate has decided to release Barabbas, he "delivered Jesus, when he had scourged him, to be crucified" (Mark 15:15). The episode of the Crowning with Thorns takes place inside the *praetorium*, the common hall, where the soldiers had led Jesus: "And they clothed him with purple, and platted a crown of thorns, and put it about his head" (15:17). Matthew adds that they put a "reed in his right hand" (27:29). Then, in a revolting parody, they all troop past him, shouting: "Hail, King of the Jews!", spitting on him and striking him with the reed.

In 1239, St Louis of France bought, from a Venetian merchant, a relic which had been venerated as the true Crown of Thorns. To house it respectfully, he had built the Sainte-Chapelle in his palace on the Ile de la Cité in Paris, thereby marking the onset of the cult surrounding this relic.

REPRESENTATION AND ICONOGRAPHY

The Crown of Thorns formed the subject of very few works before the fourteenth century (Duccio, *Maestà*, 1308-11, Museo del Duomo, Siena). The motif of the henchmen crushing the crown down on to Christ's head is found, however, at a relatively early date, in The Bible of Ripoll, Catalonia (eleventh century). At that period, Christ, seen from the front, is standing. The theme had become more widespread by the end of the middle ages, when the taste for the bizarre typical of the period shows in the bestial expressions given to Christ's tormentors. He is shown seated.

Titian (c.1545, Louvre, Paris), Van Dyck (1620, Prado, Madrid) and Rubens (1601-2, Grasse Cathedral, France) all treated this theme. Honthorst, (c.1610-20, Cappuccini, Rome), Orazio Gentileschi (early seventeenth century, Herzog Anton Ulrich Museum, Brunswick), all paint this scene with varying degrees of violence (occasionally, the crown is forced down on Christ's head with sticks), until the more decorous faith of the eighteenth century abandons it almost entirely.

Cross-references: Mocking of Christ, Crucifixion, Ecce Homo, Flagellation.
Bibliography: L Réau, op. cit., vol. II, 2, pp. 457 ff.

CRUCIFIXION

Latin: crucifixio; Italian: crocifizzione; Spanish: crucifición; French: crucifixion; German: Kreuzigung.

Christ Carrying the Cross
Dürer, *Albertina Passion*,
c.1495. Albertina, Vienna.

TRADITION

The Crucifixion of Jesus is related in all four Gospels (Matt. 27:32-56; Mark 15:21-41; Luke 23:26-49; John 19:16-37). A bystander, whom Matthew calls "a man of Cyrene, Simon by name" (27:32), is commandeered to carry the Cross. At the place of the skull, Golgotha, Jesus is crucified. "They gave him vinegar to drink mixed with gall", but Christ refuses it. After his Crucufixion, they "parted his garments, casting lots". A sign above his head proclaims that the Crucified is "Jesus of Nazareth the King of the Jews" (John 19:19). Luke, in his account, mentions that the soldiers taunt Jesus. According to Luke, a crowd had gathered (23:35), "and the people stood beholding." Their chiefs derided Christ. Near to the Cross, John states, "there stood ... his mother, and his mother's sister, Mary the wife of Cleophas, and Mary Magdalene" (19:25). There are three crosses on Golgotha: that of Christ, and those of two thieves to the left and right of him, as Matthew makes clear. After Jesus "gave up the ghost" one of the soldiers came and lanced his side to make sure he was dead. The thieves had their legs broken, but Jesus' were left intact.

REPRESENTATION AND ICONOGRAPHY

Paleochristian art seems to have avoided depicting the Crucifixion. The earliest representations which have survived date from the fifth century (the wooden door at the Church of S. Sabina, Rome, c.430, presents it, among other carved motifs). Christ is normally bearded and girded in a simple loincloth. His eyes are open and he does not, in early examples, appear to be in pain. All three crosses were treated with the same simplicity but, as examples became more frequent from the sixth century, the accent was increasingly put on the glorification of Christ. The Hand of God makes its appearance in the ninth century under Byzantine influence (triptych of Khakhuli, Tbilisi Museum, Georgia). Christ has his eyes wide open: he is the Living Cross. Two white disks on either side at the top of the Cross dominate the composition: the sun and the moon.

The motif of the dead Christ, eyes closed, with the Crown of Thorns on his head, began to be widespread in northern France and in Rhineland Germany from around the end of the eleventh century (an example of this new trend can be seen on stained glass in Chartres, twelfth century). Louis Réau attributed this striking development to an alteration in religious sensibility under Franciscan influence, with increasing attention given to a piteous, suffering Christ. The change is echoed in the vogue for the Pietà at the end of the middle ages, and literary influence may also have played a part.

In the west, the Crucifixion is not a widespread subject on the tympana of the great edifices of the Romanesque period. Nonetheless, relief sculpture on several large bronze doors of the eleventh and twelfth centuries does include the Crucifixion (Hildesheim Cathedral, beginning of the eleventh century). The Crucified Christ is framed by John and the Virgin. The number of figures gradually increases in monumental Romanesque sculpture. The grief-striken figure of Mary is emphasized, while John and the women attempt to console her. This group is confronted with the Roman captain and the soldiers who had tormented Christ. In painted or sculpted ensembles, the composition can include just the three figures of Christ, Mary and John. This reduction gained favour in the Gothic period through respect for the sacramental aspects of the scene (left tympanum of the west front of Reims Cathedral, thirteenth century). The end of the middle ages underlines the pathos in the scene (Cimabue, Crucifix, c.1280-85, Santa Croce, Florence).

106

The Crucifixion
Grünewald, Isenheim Altar,
1511-17. Musée
d'Unterlinden, Colmar.

It is also at this time that the mystical motif of the winepress began to be established. Christ, lying in a winepress, spills his blood and becomes a fountain of life in order to wash away the sins of the world.

Later Italian artists increased the number of those present and imbued them with new life. Apart from the women who give Mary succour, the soldiers appear, throwing dice or casting lots for Christ's garments, while Mary Magdalene repents at the foot of the Cross (Mantegna, 1460, Louvre, Paris; Grünewald, Isenheim Altar, 1511-17, Musée d'Unterlinden, Colmar, France, shows Christ at the moment of death, with Mary, the apostle John and John the Baptist, as well as Mary Magdalene). The centurion St Longinus also figures frequently.

Depending on their place of origin and the theological references which inspired them, artists could vary widely in their depictions of the Crucifixion (a rare profile example is one by Cranach, 1503, Alte Pinakoteck, Munich). During the Renaissance, Christ is often situated in a landscape with, in the distance, the walls of Jerusalem clearly visible (Masaccio, 1426, Museo e Gallerie Nazionale di Capodimonte, Naples).

In the sixteenth century, still more figures join the action – praying donors, for example, and accompanying saints (they include Veronica with a piece of cloth, the Veil, with which she wipes the Holy Face). Christ is now generally represented as dead on the Cross (the sequence of the Passion engraved by Dürer is the epitome of the scene as treated in this period). In the seventeenth and eighteenth centuries, many lesser artists took up the iconography introduced by Tintoretto in his Crucifixion (*The Passion of Christ*, 1564-7, Scuola di San Rocco, Venice). This type of crucified Christ became the norm: Rubens shows him with his head drooping (1638, Musée des

Augustins, Toulouse), while Rembrandt devoted a whole series of engravings to the Crucifixion.

The tendency to dramatize and to strain for maximum impact became acute in the baroque under the impetus of the prevailing theatrical aesthetic. In the eighteenth century, finally, confusion between the Crucifixion and the crucifix became common. In the twentieth century, Picasso (1930, Musée Picasso, Paris), Dalí (1951, Glasgow Art Gallery and Museum) and Graham Sutherland (1948, St Matthew's, Northampton, England) have all produced versions.

Cross-references: Deposition, John, Mary, Mary Magdalene, Veronica.
Bibliography: H. Biedermann, *Le Crucifix, des origines au concile de Trente*, Nantes, 1969. L. Brehier, *Les origines du crucifix dans l'art religieux*, Paris, 1904. Forret et Müller, *Kreuz und Kreuzigung in ihrer Kunstentwicklung*, Strasbourg, 1894.

CUNEGUND

Italian: Cunegonda di Bamberga; French: Cunégonde; German: Kunigunde. Empress. Died 1033. Canonized 1200. Feast day 3 March.

LIFE AND LEGEND
In common with many saints, Cunegund descended from a noble family. She was the daughter of Count Siegfried von Lützeburg (Luxembourg). She married Henry, Duke of Bavaria (973-1024), who was to become king and emperor under the name Henry II. The marriage remained childless, a circumstance which instigated the legend that her marriage was, like that of Joseph and Mary, unconsummated. Cunegund was an accomplished queen who took her share of the responsibilities of government. She presided over

St Cunegund Dismissing the Dishonest Workmen
Tilman Riemenschneider, tomb of Henry II, 1499-1513. Bamberg Cathedral.

the creation of the See of Bamberg and passed her widowhood in the Abbey of Kaufungen in Hesse which she had founded. She was initially buried there in 1033, before being exhumed and transferred to Bamberg Cathedral in 1201. Cunegund is revered in Germany and her cult has spread to Austria, Basel and Luxembourg.

REPRESENTATION AND ICONOGRAPHY

Cunegund is always furnished with the accoutrements of a queen, often including sceptre and crown. She is shown holding a model of the Cathedral of Bamberg (Adam door, Bamberg Cathedral, thirteenth century). She may carry a moneybag and coins to evoke her renowned charity. The scenes of her life and legend most often represented include Christ crowning Henry and herself; her temptation by the Devil in the guise of a young man; her walking on upturned red-hot ploughshares to prove her constancy to her husband (she is shown holding a ploughshare to her breast on an altarpiece at Merseburg, fifteenth century); her being brought before a court which subjects her to an ordeal by fire; the Emperor's abdication; her paying the workmen who built St Stephen's, Bamberg, by taking money from her miraculous bag; her weeping at Henry's deathbed.

Attributes: Sceptre. Crown. Moneybag. Ploughshare.
Bibliography: G. Beck, *S. Heinrich und S. Kunigunde*, Bamberg, 1961.

CYRICUS

Variants: Cyriacus, Cyrus, Quiricus. Greek: Kirykos; Latin: Cyricus, Quiricus; Italian: Quirico, Cyro; French: Cyr; German: Quiricus, Cyrus.
Child martyr. Feast day 16 June.

LIFE AND LEGEND

Cyricus, the son of St Julitta, was Syrian (hence his name). He was martyred with his mother at Tarsus when he was less than three years old. The tradition recounted by the *Golden Legend* has him suffering a considerable number of tortures, apparently without injury. As in the case of St Quentin, nails were forced into his skull and through both his shoulders. The judge then smashed his head against the stairs of the court.

A legend from the region of Nevers tells of a dream of Charlemagne: a naked child promises to halt a wild boar charging the emperor, as long as he is given a veil to hide his nudity. Once covered, the child straddles the boar and leads it to Charlemagne, who kills it. The Bishop of Nevers – whose cathedral is dedicated to St Cyricus – elucidated the dream: the child was none other than St Cyricus, while the veil stood for the roof to the cathedral, which needed repairing. The emperor duly provided the necessary funds.

In the middle ages, St Cyricus' cult was widespread in Italy, Spain and France. He is the patron of pit sawyers. This alludes to one of his tortures: the executioners apparently attempted to cut him in two (this may derive from a dreadful pun on his French name, Cyr or Cy, pronounced the same way as *scie*, meaning saw).

REPRESENTATION AND ICONOGRAPHY

A tapestry (1521, Museum, Nevers) shows the young St Cyricus being sawn through by two henchmen. More frequent is the scene where the judge Alexander smashes the child's skull. Frescoes in S. Maria Antica, Rome (eighth

The Martyrdom of St Cyricus
L. Durameau, 1750. St Nicolas de Chardonnet, Paris.

century) present the various tortures of his martyrdom. In the Church of St Barthélemy de Chénerailles (Creuse), Cyricus is beheaded and not thrown to the ground. In the eighteenth century, Louis Durameau painted a *Martyrdom of St Julitta and St Cyricus* (St Nicolas du Chardonnet, Paris). The child lies lifeless on the steps of the court. In the region of Nevers, any sculpture or painting showing a boy on the back of a wild boar is certain to be that of St Cyricus.

Attribute: Wild boar.

CYRIL AND METHODIUS

Greek: Kurillos; Italian: Cirillo e Methodio; Spanish: Cyrilo y Metodio; French: Cyrille et Méthode; German: Kyrillos und Methodius.
Brothers. Apostles of the Slavs. Cyril: 826/28-869. Methodius c.825-6 April 885. Feast day 14 February (west), 11 May (east).

Cyril
Cyril was born Constantine in Thessalonica around 826, and changed his name only when he became a monk shortly before his death. Methodius (originally Michael) was one of his six brothers and sisters. Their father was an officer in the Legion of Thessalonica and the two brothers spoke the Slavic dialect of Macedonia, hardly surprising in a Byzantine province full of Slav Macedonians.

Cyril was fourteen when his father died. He moved to Constantinople where the chief minister, the Empress Theodora, looked after his instruction and he studied philosophy at the Imperial univeristy. Methodius accepted a post as district governor, whereas Cyril was ordained priest before being named librarian at St Sophia and eventually becoming a professor at the university. After a mission to the Arabs, he joined his brother who had retired to a monastery on Mount Olympus, in Bythnia. In 860, they were both sent by Emperor Michael III as missionaries to the partly Christianized Khazars, and in 862 to Moravia, where the duke had requested Slavonic-speaking priests. There, Cyril invented the Glagolithic alphabet (which later produced Cyrillic), and translated into Slavonic both Biblical and liturgical texts.

Thanks to the two brothers, Greek clerical influence increased in Moravia, at the expense of the Latin clergy who had originally evangelized the country and settled there. Gradually, tension mounted between the two rival priesthoods. The position was similar in Pannonia (which corresponds to a part of the old Austro-Hungarian Empire). There, in spite of the support given the brothers by Prince Kozel, Bavarian bishops found their intrusion intolerable. In Pannonia, a Slavonic liturgy was utilized and the brothers promoted the use of this vernacular in church. At the end of 867, approbation from Rome was sent by Pope Hadrian II to the two brothers in a Greek monastery. Cyril, who was seriously ill, took monastic orders and died soon after; he was buried in S. Clemente, in Rome.

Methodius
In 840, Methodius left state service – he was governor (*archon*) of a Slav province – and became a monk in Bythnia. He accompanid his brother Constantine on his mission to the Khazars. He was named Archbishop of Pannonia and Moravia the year his brother died (869) and was made Papal Legate to the Slavs. Methodius returned to Pannonia, where he met with resis-

tance from the Bishop of Salzburg. Condemned by a synod held at Regensburg, he was exiled to Ellwangen. Pope John VIII released him in 873, although he forbade the Slavonic liturgy. Finally, however, although Latin was used in the liturgy, the vernacular was not disregarded. Tension between Methodius and the suffragans imposed by Rome was defused only on his death in 885.

Cyril and Methodius were the founders of the Slavonic liturgy. Their influence spread to part of the southern Slav, Russian and Bulgarian populations. At the beginning of the twentieth century, in 1909, M. Jankola founded the Sisters of Saints Cyril and Methodius at Danville, Pennsylvania.

Cross-references: Cosmas and Damian. Crispin and Crispinian.
Bibliography: "Kyrillos" in E. Kirschbaum, *Lexikon der christlichen Ikonographie*, Freiburg im Breisgau, 1968-74, *Ikonographie der Heiligen*, vol. VI, cols. 23-26. "Kyrillos" in *Lexikon für Theologie und Kirch*, vol. VI. "Cyril and Methodius" in *New Catholic Encyclopaedia*, vol. 4, 1967.

DANIEL

Italian: Daniele; Spanish, French and German: Daniel.

TRADITION

The book of the Bible called after Daniel was not actually written by him, but recounts his exploits. Probably mythical, this figure is nonetheless considered one of the great prophets of the Old Testament. During his exile in Babylon at the time of Nebuchadnezzar, Daniel was admitted to the royal court. There he was the hero of a series of legendary adventures, tirelessly retold and interpreted by theologians.

First, Daniel was the only person capable of explaining a dream which had terrified Nebuchadnezzar; the king therefore looked favourably on him (2:1-49). Next comes the story of the three Hebrews designated by the king to manage the province of Babylon (3:1-23). They refused to bow down before a gold statue Nebuchadnezzar had had erected. Thrown into a "burning fiery furnace", they survived unscathed thanks to the intercession of the "most High God". The king was astonished to hear them singing inside the furnace a hymn which echoed St Francis' *Canticle of the Creatures* (3:26-30).

In a further episode during a banquet, the new king Belshazzar profaned certain gold and silver pots purloined from the Temple of Jerusalem by his putative father (he had been incorrectly presented as the son of Nebuchadnezzar). An inscription miraculously appeared on the wall, filling the king

Daniel in the Lions' Den
Miroir de l'humaine Salvation,
fifteenth century. Musée
Condé, Chantilly.

with terror. Daniel was called and deciphered the mysterious text, which announced the ruin of Belshazzar and the fall of his kingdom (5:5-31). The king was assassinated that same night and his territory fell into the hands of Darius (the true son of Nebuchadnezzar).

The story of Daniel in the lions' den is a famous one (6:2-29). Darius' satraps, jealous of the favour Daniel was enjoying at his court, denounced him to the king. They stated that he had broken the royal command that prayers must be addressed to none save the king, on penalty of being thrown to the lions. Daniel, by worshipping God, had infringed the edict and was thrown into the lions' den. The Lord, however, sent an angel who shut the lions' mouths. The king, who loved Daniel, was thankful for this intercession and replaced him in the den with his accusers, who were immediately torn to pieces. The account ends: "And this Daniel prospered in the reign of Darius and in the reign of Cyrus the Persian" (6:28).

Under Cyrus, Daniel was once more condemned to be thrown to the lions. He had been accused by the Babylonians of killing the great dragon and of overturning the god Bel. Daniel remained six days in the den, after which the king had him taken out and his accusers fed to the animals in his stead (Daniel 14:23-42). In the Protestant Bible, this story is relegated to the Apocrypha.

Daniel is also celebrated for dreaming of the Statue and the felled Tree. His visions both heralded and inspired those of St John in Revelations. The prophet saw "four great beasts" emerging from the sea: a lion, a bear, a griffin and a ten-horned hydra (7:1-8), standing for each of the four empires which preceded the kingdom of the saints. In another famous dream, Daniel saw a "ram that had two horns" (8:6) and a victorious goat that came out of the west with a "notable horn between his eyes" (8:5).

At the end of the Book of Daniel (13), a sequence which appears to have been added at a different stage tells the story of Susanna, the wife of a wealthy man called Joachim, surprised during a bath in her husband's garden by two elders. She rebuffs their advances and, in revenge, they publicly accuse her of meeting a young man in the garden. The youthful Daniel comes to the aid of the falsely accused Susanna and judges the case; the two old men are stoned (*see* Susanna).

The Book of Daniel has been much and variously interpreted through

the ages by Christian thinkers and theologians. Daniel has been envisaged as a precursor of Christ. His spells in the lions' den are explained in reference to Christ's descent into Hell between the Crucifixion and the Resurrection. Others see the symbol of the just man persecuted but in the end upheld by God. For Origen (c.185-254), Daniel in the lions' den symbolizes Christ trampling his enemies underfoot and illustrates the supreme power of prayer.

REPRESENTATION AND ICONOGRAPHY

Daniel is generally shown as a beardless young man wearing the Phrygian bonnet, in allusion to his time in Babylon. Catacomb art of late antiquity shows a certain predilection for the episode of Daniel in the lions' den; the young Hebrews in the fiery furnace; and the story of Susanna.

The Burning Fiery Furnace (3:1-23)

This scene representing the three Hebrews cast into the furnace for refusing to worship a golden statue occurs in paleochristian catacombs (fresco of the *cubiculum* of Velatio, catacomb of Priscilla, early third century). The series continues in the twelfth century (miniature in the *Bible of Etienne Harding*, Dijon Library). The three boys are protected, not by an angel as in the text, but by the Son of God himself, covering them with his mantle. In the thirteenth century, under the impact of the growing Marian cult, the Hebrews were taken as the symbol of the virgin motherhood of Mary (sculpture, Portal of the Virgin, Laon Cathedral).

Belshazzar's Feast (5:5-31)

This sequence, although preserved in the common stock of Biblical memory, has not been abundantly illustrated. Occurring in the eleventh century (*Apocalypse de St Sever*, Bibliothèque Nationale, Paris), it was also the subject of the main door of the Cathedral of Amiens (thirteenth century). In the seventeenth century, Rembrandt's version is the most important (c.1635, National Gallery, London). In Christian symbolism, Belshazzar represents the Antechrist.

Daniel in the Lions' Den (6:2-29)

This theme already featured in the third century (crypt of Lucina, catacomb of Callista). Often, Daniel is at his prayers between two lions (catacomb of SS Peter and Marcellinus, Rome, second half of the third century). This theme continues (on belt buckles of eastern nomads, for example) up to the period of the great migrations. In rare medieval cases, Daniel has a halo. In the eastern Church, this episode is presented in a large number of manuscripts and on many frescoes.

In the west, the motif occurred on a fresco in the Lower Church at San Clemente, Rome (c.1080), and became immensely popular on Romanesque capitals before falling into obsolescence during the Gothic period. Under Protestant impetus, the sentimental potential of a scene with animals continued to appeal to later artists (Briton Riviere, 1883, Walker Art Gallery, Liverpool).

Attributes: Lions. Ram (in his vision).
Cross-references: Susanna, Revelations.
Bibliography: E. Cassin, "Daniel dans la 'fosse' aux lions", *Revue de l'histoire des religions*, 139, 1951, pp. 129-61. C. Grosset, "L'origine du thème roman de Daniel", *Etudes mérovingiennes*, Poitiers, 1953, pp. 147-56.

David Victorious over Goliath
E. Marchiori, 1741. S. Rocco, Venice.

DAVID

Italian: Davide; Spanish, French and German: David.

TRADITION

David succeeded the first king of Israel, Saul. The eighth son of Jesse, he descended from the tribe of Juda and lived between 1000 and 960 BC. "He was ruddy and withal of a beautiful countenance and goodly to look at" (1 Sam. 16:12). Without Saul's knowledge, Samuel anointed David while he was still a shepherd boy. David was later admitted to the king's entourage in his capacity as a musician. Playing the psalterion, he was the only one able to lift Saul's melancholy. Saul's chief concern was the war against the Philistines. The giant Goliath, "an uncircumcised Philistine", defied the "armies of the living God" (17:26). David told the king of how he used to protect his father's sheep against lions and bears, and persuades him to let him challenge Goliath.

David's argument (1 Sam. 17:34-37) has been understood as an annunciation of Christ in the guise of the Good Shepherd. St Augustine in one of his sermons (number 197) read David engaged against the rapacious lion and the bear as an image of Christ descending into hell to free its captives and rescue the Church from the empire of Satan. David kills Goliath with a stone thrown from his sling (17:39-54) and then beheads him. According to theologians, David's triumph prefigures Christ's victory over Satan. By the same token, his return to camp after the duel announces Christ's entry into Jerusalem. David inspired mounting jealousy from Saul, who later committed suicide on learning of the death of his son, Jonathan, in battle against the Philistines.

David was also the ruler who unified his kingdom by capturing Jerusalem. He made it his capital, and had the Ark of the Covenant transferred there. As a great monarch, he listened attentively to the prophets, Gad (1 Kings 22:5; 2 Kings 24:12) and Nathan (2 Kings 7:12). It was David who constructed the royal palace at Jerusalem, although Solomon was responsible for the temple. During the ceremonies of the cult, David executed a ritual dance around the holy Ark placed beneath the tent (1 Kings 19:13; 2 Kings 6:20). As a musician, he accompanied himself when singing his psalms, and he is traditionally considered to be the author of the Book of Psalms. He both announced and prefigured the Messiah (Ez. 34:23) and as such occupies a position of great significance in both Jewish and Christian traditions. Nonetheless, this priest-king, in whom the Fathers of the Church celebrated the Christ King to come, sent Uriah, one of his own commanders, to his death in a treacherous manner simply because he coveted Uriah's wife, Bathsheba. In spite of this crime and many other misdemeanours which cast a shadow over his reign, David is considered a type of ideal king by the prophets and the Fathers of the Church. In the middle ages, David was the patron of musicians, and became patron of choirs during the sixteenth and seventeenth centuries.

REPRESENTATION AND ICONOGRAPHY

The iconography representing David is outstanding as much for its variety as for its sheer volume. He is presented in three main forms: as shepherd, musician and prophet. At the end of antiquity, and in the art of the catacombs, David was represented as a beardless and youthful shepherd. In late antiquity, he wore a tunic which left one side of his chest bare. By the middle ages, he was shown in the traditional dress of a peasant, with a shepherd's

crook, occasionally carrying the sword he took from the dead Goliath as well as the latter's head. Another frequent motif was King David as musician, bard and composer of the Psalms. The psalmist was an old man with a beard, playing the harp or psalterion. A third motif showed David as prophet or knight, and appeared in the second half of the medieval period.

The Musician–King

An aged David, bearded and crowned, holds his harp (or psalterion) with which he accompanies himself as he sings his psalms. This image of David was disseminated in psalters and in works representing the tree of Jesse. It is found on a huge number of early painted organ-case shutters. From the twelfth century, examples include the famous *Psalter of Westminster Abbey* (British Museum, London) and a capital from the cloister at Daurade (Musée des Augustins, Toulouse). In the thirteenth century, David appears with both a crown and a nimbus in his capacity as Christ's ancestor (stained glass at Bourges and Chartres). At the beginning of the fifteenth century, Claus Sluter (*The Well of Moses*, 1395-1403, Charterhouse at Champmol, Dijon) shows David as a king wearing a crown and holding a scroll of the Psalms. The lower half of his harp is also visible. David the harpist (the psalterion has by this time been forgotten) is often placed above the organ in rococo churches (1740s, Aufhausen, Germany).

Cycles of the Life of David

The first of these cycles dates from the frescoes at the Synagogue of Dura-Europos (c.245). Another monumental cycle can be found on a mosaic on the floor at the church of St Gereon in Cologne (second half of the eleventh century), while others occur at Vézelay, on the north front at Chartres and on the west front at Reims. In the sixteenth century, a Flemish tapestry was devoted to the history of David and Bathsheba (c.1515, Musée de Cluny, Paris). Francesco Salviati composed a grand David cycle in fresco for the Ricci-Sacchetti Palace in Rome (1552-54).

David the Shepherd (1 Sam. 16)

In the tenth century, a miniature in the *Psautier de Paris* shows David among his flock, playing a stringed instrument. The composition here owes a great deal to late antique portrayals of Orpheus.

David Anointed by Samuel (1 Sam. 16:13)

Samuel pours oil from a horn over David's head. The end of the horn is touched by the hand of God. As a young shepherd, David is pictured with his three brothers and his father Jesse behind him (frescoes in the Synagogue at Dura-Europos, c.245; miniature in the *Psalterium Aureum* at St Gallen, Switzerland, twelfth century). Raphael treated this theme in the Logge in the Vatican (1518-19).

David Slays the Lion and the Bear Threatening his Flock (1 Sam. 17:34-36)

The scene is illustrated on a capital at Vézelay (twelfth century). It can be confused with the episode of Samson killing the lion. David is younger than Samson, and can also be distinguished by being shown pulling a lamb from the jaws of the animal, never the case with Samson. Moreover, David is often depicted pushing his knee into the small of the lion's back, like Mithra with his bull.

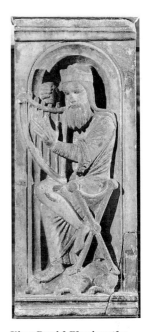

King David Playing the Harp

Capital, twelfth century. Musée des Augustins, Toulouse.

David and Goliath (1 Sam. 17:31-52)

In a scene which is rarely illustrated, Saul, persuaded to allow David to meet the giant Philistine in single combat, offers to give him weapons which the young man refuses. Artists have preferred the combat itself or David's victory with their heavy symbolism (wooden carving, door of the Basilica of S. Ambrogio, Milan, fifth century; a twelfth-century low relief in the cloister at Moissac shows the angel of the Lord blessing David before he confronts Goliath; also, an illumination in the *Heures de Laval*, fifteenth century, Bibliothèque Nationale, Paris).

Young David, Slayer of Goliath

David is shown as almost a boy before the duel, ready to loose his sling. The theme inspired a large number of Italian artists after the fourteenth century (Donatello, bronze, 1430-3, and earlier marble version, 1408-9, both in the Bargello, Florence). In the seventeenth century, Caravaggio painted David as victor, carrying the giant's sword in one hand and, in the other, his head (Goliath might be a self-portrait; 1607-10, Galleria Borghese, Rome; version, Kunsthistorische Museum, Vienna). Guido Reni composed a similar work (1610-14, Louvre, Paris). Goliath's head often lies at David's feet. Bernini's version (marble, 1623, Galleria Borghese, Rome) shows David just at the moment when he flings the stone from his slingshot.

David Victorious (1 Sam. 18)

The Israelite women welcome the hero home with song and by playing the harp and lute (M. Rosselli, c.1620, Hermitage, St Petersburg). David carries Goliath's head impaled on his sword, or else he stands on it holding the giant's sword (Tanzio de Varallo, c.1610s-20s, Pinacoteca, Varallo, Italy). In a Greek psalter (tenth century, Bibliothèque Nationale, Paris), David, carried aloft on a shield (like Clovis), is crowned in glory. A tapestry at Chaise-Dieu Abbey (Auvergne), sets David's triumph besides Christ's entry into Jerusalem. Raphael treats this subject too in the Vatican Logge.

David and Saul (1 Sam. 16-19)

Organ shutters are for the most part decorated with sculptures or paintings showing David calming Saul by playing the harp. The scene symbolizes music's power to calm the troubled mind. In a moment of madness, Saul attempts to kill David, with a lance, a spear or a sword. David wards off the blow with his harp (typological stained-glass window at St Etienne in Mulhouse, fourteenth century). This envious perfidy symbolizes hatred, which always returns good with evil.

David's Escape from Michal's Chamber (1 Sam. 19)

Aided by his wife, Saul's daughter Michal, David escapes through her chamber window using a rope (stained glass, Auxerre Cathedral ambulatory, twelfth century). This scene is often compared to St Paul's escape over the walls of Damascus.

David Bringing the Ark of the Covenant back to Jerusalem (2 Sam. 6:1; 1 Chron. 15)

The whole sequence from the seizing of the Ark by the Philistines to its return to Jerusalem is heavily charged with symbols that extend from the arrest of Jesus to the identification of the Ark with the Virgin. The theological encyclopedias of the twelfth and thirteenth centuries see in the Ark's triumphal entry into David's city a prefiguring of the Virgin's entrance into the king-

dom of Jerusalem. David is shown dancing naked before the Ark as his wife Michal jeers at him (tapestry, *History of David and Bathsheba*, sixteenth century, Musée Cluny, Paris).

David and Abigail (1 Sam. 25:20)

Of the numerous wives of David, Abigail was the most important. She was able to calm David's anger directed at her first husband, Nabal, and was sagacious enough, after Nabal's demise, to marry her protector. Medieval thinkers saw in Abigail a figure of the Virgin as mediatrix of all graces, interceding in favour of the souls of the dead at the day of judgment. In several works of art, Abigail is shown climbing off her ass and beseeching the mounted David on her knees. He touches her with his sceptre to show that he has spared Nabal. Sometimes the entreating Abigail bares her breasts (Rubens, *The Meeting of David and Abigail*, Institute of Art, Detroit).

David and Bathsheba (2 Sam. 11-12)

This story, with all its ramifications, includes not only David seeing Bathsheba bathing, but also David handing her husband Uriah the letter which sends him to his death (2 Sam. 11:14), the prophet Nathan's admonitions, and David's penitence. In the main, the first scene alone interested artists, including Hans Memling (1485, Staatsgalerie, Stuttgart) and Lucas Cranach (1526, Berlin-Dahlem Staatliche Museen, Berlin, David spying on Bathsheba bathing her feet). Other examples include Cornelius van Haarlem (1594, Rijksmuseum, Amsterdam, with a black maidservant); Poussin (1633, the Duke of Bedford's Collection); Rubens (c.1635, Gemäldegalerie, Dresden); Rembrandt (*Bathsheba at her Toilet*, 1643, Metropolitan Museum, New York, and 1654, Louvre, Paris).

Attributes: Crown. Sling (for the young David). Harp or psalterion (for the aged and bearded king).
Cross-references: Ark of the Covenant, Good Shepherd, Hand of God, Tree of Jesse, Nine Heroes.
Bibliography: L. Réau, op. cit., vol. II, 1, pp. 254-81.

DAY OF JUDGMENT *see* LAST JUDGMENT.

DEACON

Latin: Diaconus; Italian and Spanish. Diacono, French. Diacre; German: Diakonus.

In the hierarchy of the Roman Catholic Church, deacons occupy a position just below priests. Ordained, they assist the priest or bishop at Mass. Bishops ordain deacons by the laying on (imposition) of hands, a consecration dating from Apostolic times. The traditional vestments of the deacons are characterized by the dalmatic and the stole (since the eleventh century). The sleeves, long until the 1300s, gradually become shorter, eventually being slashed up the sides. Portrayals of St Stephen (one of the first Seven Deacons in Acts 6:1-6), St Laurence and St Vincent of Saragossa provide good examples of the vestments and general appearance of deacons.

DEATH OF THE VIRGIN *see* DORMITION.

Deacon wearing a Dalmatic
Bibliothèque Nationale, Paris.

DELILAH

Hebrew: Delilah; Greek, Italian, Spanish: Dalida; French and German: Dalila.

TRADITION

The history of Delilah, the woman of either Hebrew or Philistine origin who seduced Samson and led him to his death, is recounted in Judges (16:4-21). She came from Sorek on the border between Dan and the land of the Philistines, a few kilometres from Zorah, where Samson lived. Encouraged by "the Lords of the Philistines", she attempted to extract from Samson the secret of his colossal strength. Samson threw her off the scent by informing her that, if tough ropes of withy were used to tie him down, he would become as weak as any other man and be at her mercy. Once bound, the giant merely snapped the ropes "as a thread of tow is broken when it toucheth the fire". The next time he was asked, Samson revealed that he could be tied down only by new rope; this time, too, he broke his bonds with ease, "like a thread". Then, once more at Samson's instigation, Delilah wove seven hairs of her head with the web of a cloth, and fixed it to a beam. On waking, Samson remained as powerful as ever, and simply pulled the whole contraption to the ground. Delilah then employed all her wiles until Samson finally con-

Samson and Delilah
Choir stall, 1527.
Montbenoît Church.

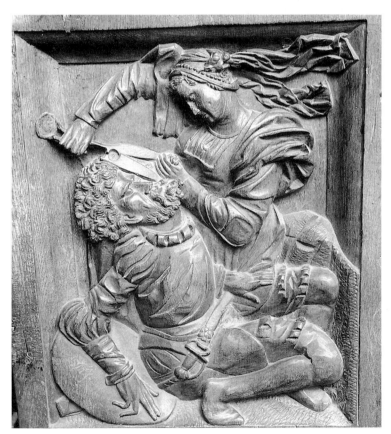

fessed, "There hath not come a rasor upon mine head ... if I be shaven, then my strength will go from me, and I shall become weak, like any other man" (16:17). Summoned by Delilah, the Philistines arrived on the scene with money to reward her for her duplicity. Delilah rocked Samson to sleep "on her knees" and asked a man to shave "his seven locks" from Samson's head. Now weakened, the Philistines captured him, "put out his eyes", and put him to work turning the millstone at Gaza. They derided him and forced him to play the fool. Samson was tied between the two pillars of the Philistine temple. God restored his strength for one last effort and, heaving the columns asunder, Samson brought the whole temple down, killing himself and all "three thousand" Philistines within. The chapter of the Bible which narrates this episode concludes: "And he [Samson] judged [i.e. ruled] Israel twenty years" (16:31).

This mythical tale is pregnant with possible interpretations. Medieval clerics were all too ready to denouce the demonic figure of Delilah, yet another incarnation of that Eve who was responsible for the Fall of Man. The number seven is also given considerable mystical significance in the story: seven withies, seven hairs and seven locks are mentioned. The ridicule to which Samson was subjected prefigures the Mocking of Christ.

REPRESENTATION AND ICONOGRAPHY

The carvers of choirstall misericords often chose to represent Delilah taking advantage of Samson sleeping to cut off his hair herself (Montbenoît Church, Doubs, sixteenth century). A mosaic at St Gereon, Cologne (twelfth century), depicts Samson blinded by his attackers. A monochrome work of the second half of the fifteenth century shows Samson asleep beneath a serpentine vine as Delilah finishes cutting his hair (Mantegna, National Gallery, London). At the beginning of the seventeenth century, Rubens showed Delilah cutting Samson's hair while the Philistines tie his hands behind his back (1609-10, Art Institute of Chicago). A Rembrandt portrays the Philistines coming to blind the weakened Samson at Delilah's call and forcing him to turn the millstone like a slave (1636, Städelsches Kunstinstitut, Frankfurt).

Cross-reference: Samson.

DELUGE *see* CREATION, NOAH.

DENIS

Variants: Denys, Dionysius. Latin and German: Dionysius; Italian and Spanish: Dionisio; French: Denis, Nisard.
First bishop of Paris. Died c.250. Feast day 9 October.

LIFE AND LEGEND

The life of St Denis, martyr beheaded in Paris in the third century, is totally obscure. It was therefore rapidly assimilated with that of Dionysius the Areopagite (Athenian), a figure who appeared in the Acts of the Apostles (18:34) and reputedly became the first bishop of Athens. The monks of the Abbey of St Denis near Paris encouraged this amalgamation which made their patron saint into Christ's contemporary.

Converted by St Paul, Dionysius became the head of the Athenian Christian community before leaving for Gaul to be the first bishop of Paris.

St Denis
Woodcut from James of
Voragine's *Golden Legend*,
1483 edition.

Arrested on orders from the Emperor, he was subjected to all the usual tortures inflicted on early Christians (thrown to wild animals, roasted in a furnace, whipped, crucified, etc.), but his faith enabled him to withstand all these onslaughts. He wis then beheaded with his companions, the priest Rusticus and the deacon Eleutherius. Once the executioner had done his work, however, St Denis arose, picked up his head and walked all the way to the sepulchre. His two companions did likewise and St Denis continued to perform numerous posthumous miracles in the neighbourhood of his tomb.

Beginning in Paris, St Denis' cult became widespread and remains healthy in Germany (especially Bavaria) and Italy, as well as in France. The kings of France selected this canonized bishop as the patron saint of the kingdom and of its successive dynasties. In 639, King Dagobert translated the saint's relics to the Church of St Denis, near Paris, which has since become the sanctuary of the French monarchy.

REPRESENTATION AND ICONOGRAPHY
The most famous of the *cephalophore* saints, Denis is nearly always depicted carrying his head (statue, sixteenth century, St Pierre, Erneuville, Belgium). Normally this has been simply removed from his neck, but sometimes only the top of the skull has been sliced off, the executioner having brought down his sword on that spot (this is the version maintained by the monks of St Denis). Occasionally the saint is shown with two heads, one in his hands and the other in place on his shoulders. Apart from his decapitation and the miracle hich follows, artists have also depicted Denis' preaching in Athens and Paris, the tortures which preceded his martyrdom (gridiron, furnace and wild beasts) and his last communion in prison the day before his execution (Henri Bellechose, c.1415-16, Louvre, Paris). Christ is shown bringing the host to the saint in chains (miniature, *Missale de saint Denis*, eleventh century, Bibliothèque Nationale, Paris).

Attributes: Head (carried in his hands). Chains. Mitre.

DEPOSITION
Variant: Descent from the Cross. Italian: Deposizione della Croce; Spanish: Descendimiento, Bajada de la Cruz; French: Descente de la Croix, Déposition; German: Kreuzabnahme.

TRADITION
After Jesus' death, Joseph of Arimathaea obtained permission to bury his body. All four Evangelists recount this event (Matt. 27:57-61; Mark 15:42-47; Luke 23:50-56; John 19:38-42) and the Synoptic Gospels also record the presence of Mary Magdalene and of the "other Mary", the mother of Joseph and James. Apocryphal gospels give a more detailed account and set forth how Christ might have been taken down from the Cross. The Gospel of Peter (second century) recounts how, once Christ had been removed from the Cross and laid out on the ground, the earth began to shake and the sun starting shining again. Louis Réau rightly underlined the necessity of differentiating three phases: the Descent from the Cross, the Deposition proper and the Lamentation.

REPRESENTATION AND ICONOGRAPHY
In Carolingian times, miniaturists fixed the Cross itself in the centre of these compositions. Christ's hands have been detached and Joseph of Arimathaea

Eliezer and Rebecca. Salomon de Bray, c.1640s (detail). Musée de la Chartreuse, Douai.

Hell. Dirk Bouts, 1470s. Musée des Beaux Arts, Lille.

has gathered up his body, carrying it over his shoulders. In the early middle ages, the motif of the Deploration (the Pietà) predominates, with Mary holding Christ's hand to her lips.

From around the twelfth century, intimations of the Crucifixion abound (Benedetto Antelami, low relief, c.1178, Parma Cathedral). Italian art of the eleventh and twelfth centuries introduced the symbolic thematic of the sun and moon shown weeping or shining anew. In some works the Church and Synagogue or the casting of lots for Christ's garments appear: both motifs were borrowed from the iconography of the Crucifixion. In the thirteenth and fourteenth centuries, the scene underwent no fundamental changes, but numerous additional figures made their appearance. The *Très Belles Heures du duc de Berry* (c.1395-1400) also showed an influx of motifs from the Crucifixion. In the fifteenth and sixteenth centuries, the requirements of a heightened sense of devotion imposed an accent of the pathetic on the grieving figures of the Virgin and St John and on the penitent

Deposition
Rembrandt, 1654.
Rijksmuseum, Amsterdam.

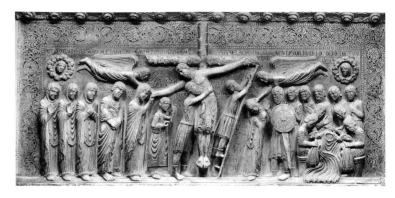

Magdalene (Fra Angelico, Santa Trinità altarpiece, c.1440, S. Marco Museum, Florence; Memling, *Passion*, c.1470, Galleria Sabauda, Turin; Rogier Van der Weyden, c.1435, Prado, Madrid).

Grünewald's work (Isenheim Altar, 1511-16, Musée d'Unterlinden, Colmar, France) is an example of this new sense of the pathetic. Another version from Italy shows the mannerist tendencies which may dilute this aspect (Daniele da Volterra, 1540s, Orsini Chapel, S. Trinità dei Monti, Florence), while in Rosso's version (1521, Volterra, Museo Civico), a figure is shown pointing to the wound in Christ's side. A number of figures may be shown assisting Joseph of Arimathaea in removing Christ from the Cross. In sixteenth-century Spain, the Descent from the Cross was a privileged theme of decoration for the retables in front of the altar (Juan de Borgoña, fresco, 1509-11, Chapterhouse, Toledo Cathedral, Christ being let down by a shroud; Pedro Machuca, c.1520-30s, Prado, Madrid, where the soldiers are still present). The art of the seventeenth and eighteenth centuries accentuates the dramatic potential of the scene (Rubens, 1611, Antwerp Cathedral; Rembrandt, 1633, Alte Pinakothek, Munich).

Cross-references: Crucifixion, Church and Synagogue, John, Mary Magdalene.
Bibliography: E. Mâle, *L'Art religieux à la fin du Moyen Age en France*, Paris, 1949. L. Réau, op. cit., vol. II, 2, pp. 513-18.

DESCENT FROM THE CROSS *see* DEPOSITION.

DESCENT INTO HELL *or* INTO LIMBO *see* CHRIST'S DESCENT INTO HELL.

DEVIL

Variant: Satan. Latin: Diabolus, Daemon, Satanas; Italian: il Diavolo; Spanish: el Diabolo; French: Diable, Satan; German: der Teufel.

TRADITION
The Old Testament (though it mentions Satan) does not refer to the Devil as a demonic force or as an incarnation of evil capable of defying God on

an equal footing. The Bible never adduces and is fiercely hostile to any dualistic perspective which would pit a principle of good against one of evil. Christian tradition, following the Gospels, acknowledges the existence of a malevolent being, inferior to God, yet enjoying an impressive freedom of action. Satan, as a fallen angel, holds a similar rank in the infernal hierarchy to that of St Michael in the celestial host. In Revelations, Satan becomes both Antichrist (the adversary of Christ, the "deceiver") and the Antechrist whose brief reign will precede the Apocalypse. It is Satan who tempts Eve in the guise of a serpent, persuading her to eat the forbidden fruit, and it is he who tempts Jesus on the mountain. After the Resurrection, however, Christ puts paid to him forever during his Descent into Limbo.

REPRESENTATION AND ICONOGRAPHY

Iconographically speaking, the Devil is derived from antique pagan images of the satyr (horns, hairy ears, monkey-like tail and cloven feet). He did not make his appearance in art before the sixth century, and became widespread only during the eleventh. He first occurred in human form in Resurrection cycles. A blue angel made an entrance in a mosaic at S. Apollinare Nuovo, Ravenna (sixth century), illustrating the parable of the Last Judgment (Matt. 25:31-46). In such eschatological scenes the Devil never has wings. Later, however, in the twelfth and thirteenth centuries, he was provided with those of a bat. From the eighth century on, he was encountered in the Descent into Hell or Limbo, and in the Last Judgment. He also figured in the miracle of Theophilus (when the Virgin destroyed Theophilus' diabolical pact) and in the temptation of St Antony. He was of frightening aspect, with his hair bristling, his mouth open from ear to ear, cloven feet, faun's ears, bat's wings and a monkey's tail. The colours in which the Devil is shown vary according to period and to the specific case: black, blue, red and green predominate.

He occurs countless times on cathedral tympana of the twelfth (Autun, Conques, Moissac) and the thirteenth centuries (Paris, Amiens, Bourges, Reims). The iconography continues in the fifteenth (Stephan Lochner, *The Last Judgment*, 1435-40, Wallraf-Richartz Museum, Cologne) and sixteenth centuries (Dürer, *The Knight, Death and the Devil,* copper engraving, 1513).

A second iconographical series was constituted by the Devil's numerous manifestations as an animal. He appeared as a serpent during the Temptation of Christ and the Fall, as a conventional dragon in his duel against St Michael (low relief of the choir of Bamberg Cathedral, c.1250, where St Michael rides a horse) or as a many-headed one in the Revelations of St John. His manifestation as a dragon linked him with St George, who transfixed the dragon with his lance. Satan also occurs in the episode where Daniel kills Bel the Dragon (Dan. 14:28, Apocrypha). Other animals, such as the lion, the bear, the goat and the bat can also take on demonic forms.

Another allied theme, whose twisted forms made it particularly popular in Mannerist circles, is the Fall of the Rebel Angels (Beccafumi, c.1530s, Pinacoteca, Siena; Frans Floris, 1554, Antwerp, Musée Royal des Beaux Arts; M. Fréminet, begun 1608, Chapel of the Trinity, Fontainebleau; Giambattista Tiepolo, 1726-28, staircase ceiling, Palazzo Arcivescovile, Udine.)

Attributes: Horns (of a faun). Cloven feet. Bat's wings. Tail.
Cross-references: Adam and Eve, Antony of Padua, Christ's Descent into Hell, Daniel, Dragon, George, Last Judgment, Lion, Michael, Serpent, Temptations of Christ.
Bibliography: D. Grivot, *Le Diable*, Paris, 1960.

The Devil at the Last Judgment
Tympanum, Bourges Cathedral (detail), thirteenth century

DIONYSIUS *see* DENIS.

DIVINA PASTRIX, DIVINE SHEPHERDESS *see* PASTRIX BONA.

DOCTORS OF THE CHURCH

Italian: Dottori della chiesa; Spanish: Doctores de la Iglesia; French: Docteurs de l'église; German: Kichenlehrer.

The Church has bestowed the title of Doctor on several authoritative ecclesiastical writers. The four traditional Doctors of the western Church – SS. Ambrose, Augustine, Gregory and Jerome – have now been joined by Anselm, Bonaventura and Thomas Aquinas. The prestigious title has also been granted to Bernard (1830) and Teresa of Avila (1970). In the eastern Church there are four equivalent figures, the *megaloi didsacaloi*: Basil the Great, Gregory of Nazianzus, John Chrysostom and Athanasius.

Cross-references: Ambrose of Milan, Augustine, Gregory the Great, Jerome.

DOE *see* GILES.

DOG *see* BERNARD (WHITE), DOMINIC (BLACK AND WHITE), HUBERT (HUNTING DOGS), ROCH (CARRYING LOAF).

DOMINIC

Latin: Dominicus; Italian: Domenico; Spanish: Domingo; French: Dominique; German: Dominikus.
Founder of the Dominican Order. 1170-1221. Canonized 1234. Feast day 8 August.

LIFE AND LEGEND

Domingo Guzman was born in Castile. At an early age, he became canon of Osma Cathedral and accompanied his bishop to Languedoc to join the Cistercians in their efforts to convert the heretical Albigensians. At the death of the bishop in 1207, Dominic became prior of the mission, preaching ceaselessly, living a simple life among the laymen and surrounded by a few companions with whom he prayed, studied and made penance. Dominic's apostolate among the Albigensians and Cathars failed, but in 1215 he travelled to the Lateran Council in Rome and the following year obtained approval from Pope Innocent III to found an order of Friar Preachers. The last years of his life were devoted to the organization of this order and to several missions to France and Italy. In 1221, he died in Bologna after the first General Chapter of his order.

Legends abound in the life St Dominic. His birth – like that of Jesus and of all the greatest saints – was apparently heralded by strange portents. When pregnant, his mother had a dream in which she saw her unborn son marked

The Death of St Dominic
Fra Angelico, panel from the predella of *The Coronation of the Virgin*, 1434-5. Louvre, Paris.

with a star in the middle of his forehead and accompanied by a black and white dog holding a flaming torch between its jaws (in some versions the infant himself is the dog). This vision, based on a pun linking *Dominicus* to *Domini canis* (the dog of God), was treated as an indication that Dominic would act as a guard dog to defend the Church against heresy. Dominic was also credited with performing many miracles, notably raising a young man who had died falling from a horse, and saving pilgrims from drowning in the River Garonne on their way to Santiago de Compostella. Dominic was canonized as early as 1234. Although never as popular as Francis of Assisi, he was revered all over Italy, in Spain and in southern France. Thanks to the success of the Order, his iconography is very widespread.

REPRESENTATION AND ICONOGRAPHY

St Dominic is nearly always depicted wearing the white robes and black cope of the Dominican habit. A star shines above his head and he is sometimes shown with a dog at his side. The main events of his life have provided material for numerous works of art: his mother's vision when expecting him; the various episodes of his preaching in Languedoc (especially his miracles); the founding of the Dominican Order itself; his death (Fra Angelico, predella to the *Coronation of the Virgin*, 1434-35, Louvre, Paris). On occasion, other legends can also be found: the brotherly embrace of St Dominic and St Francis; the vision of a Dominican friar who saw two ladders held by Christ and the Virgin enabling St Dominic to ascend into heaven; and, following a tradition which dates from some time after the fifteenth century, the appearance to the saint of the Virgin of the Rosary at Albi. His triumph in heaven is also treated (G. B. Piazzetta, fresco, *The Glory of St Dominic*, 1727, Cappella San Domenico, SS. Giovanni e Paolo, Venice). The miracle of the pilgrims in the Garonne can also be shown (Francesco Triani, 1345, Museo Nazionale di San Matteo, Pisa).

Attributes: Dominican habit. Dog with markings. Lily. Star. Book. Torch.
Cross-references: Dominicans, Francis of Assisi.

DOMINICANS

Italian: Domenicani; Spanish: Dominicani; French: dominicains; German: Dominikaner.

The Dominicans or Friar Preachers (Black Friars) can be distinguished from both the Benedictines and the Cistercians. They wear a black cope or mantle over white robes. Dominican nuns wear a white robe, black mantle and white veil.

Types: Dominic, Catherine of Siena.

Cross-references: Albert the Great, Dominic.
Bibliography: G. and M. Duchet-Suchaux, *Les Ordres réligieux: Guide historique*, Paris, 1993.

DORMITION

Variant: Death of the Virgin. Greek: Koimesis tes hagias Theotokon; Latin: Dormitio Beatae Mariae Virginii; Italian: Dormizione; Spanish: Dormicion; French: Dormition; German: Tod Mariens.
Feast day 15 August.

TRADITION

The Catholic Church translates the Byzantine *Koimesis* (a word related to *koimeterion*, cemetery) by *dormitio*, thereby assimilating the death of the Virgin to a sleep. No information about her death appears in the Gospels, but there are two legendary traditions. According to one, Mary followed St John to Ephesus and died there. The other has her buried in Jerusalem, where a basilica was built over her supposed tomb. These episodes arise from legends or apocryphal writings which themselves might well have sprung from oral traditions.

In areas under Byzantine influence, devotion to the *Koimesis* was always marked. Byzantine thought emphasizes more strongly than Latin theology the actual death of Mary. Her soul, having been separated from her body and received by Christ, then returns to it by the Grace of the Son. In fact, both Churches acknowledge Mary's resurrection. Two of the main monasteries on Mount Athos are dedicated to the Dormition, as is Vladimir Cathedral in Moscow. In the eastern Church, it is the Assumption of Mary's soul that is stressed, while the west places the accent on her bodily Assumption (*see* Assumption).

The Dormition of the Virgin
Tympanum, Portal of the Virgin, Cathedral of Notre-Dame, Paris, thirteenth century.

REPRESENTATION AND ICONOGRAPHY

In the east, the theme is exploited only from the tenth and eleventh centuries, after the two iconoclasms in the eighth and ninth. Mary is shown lying on her deathbed. Behind her, Christ carries away her soul and entrusts it to an angel. At one end of the bed stands Peter with a censer while at the other Paul kisses the Virgin's feet. John, as an old man, leans over her. This motif also became

widespread in the churches of Cappadocia and on the outskirts of the Byzantine Empire (frescoes in the New Church, Tokali, Turkey, eleventh century).

In the west the dying Virgin is represented holding a candle. The oldest known depiction of this event is a miniature in the British Library (*Benedictional of St Aethelwold*, 975-80). Mary is seated, bidding farewell to the apostles assembled in two groups around her. Above, four angels lean over her and, in the centre, the Hand of God confers a crown. In Italy, Byzantine tradition was dominant until the fifteenth century (Paolo Veneziano, 1333, Museo Civico, Vicenza, shows the Virgin lying, her soul taken by Christ into heaven). The motif of the bodily Assumption, however, became more prevalent; Taddeo di Bartolo juxtaposes the scenes of Mary's death and her Assumption (fresco, Palazzo Pubblico, Siena, 1406-8).

In France (west door of Senlis Cathedral, end of the twelfth century), the apostles bustle round Mary's deathbed. Two of them swing censers while angels carry off Mary's soul in the guise of a figure half-wrapped in a shroud. In the thirteenth century, the death of the Virgin is depicted on cathedral tympana (Chartres, Laon, Paris). In the fifteenth century, Hugo van der Goes (c.1480, Groeningemuseum, Bruges) shows Mary facing outwards and holding a candle. Her body turns away slightly, while Christ between two angels hovers over her.

In Germanic art of the fifteenth century, Mary is often shown expiring in a kneeling position (Veit Stoss, reredos, Czartoriski Museum, Cracow). Occasionally, angels close her eyes and lips. In a retable by Konrad von Soest (altarpiece of the Marien Kirche, Dortmund, c.1420) one angel closes her mouth, while another places a candle in her hand. The moralizing purpose of these images is to show how a good Christian should die. The theme continued to be widespread in the Renaissance (Carpaccio, 1504-8, Ca' d'Oro, Venice, with Christ and cherubs awaiting her soul). The baroque taste for the macabre gave new impetus to the theme: a painting by Caravaggio for S. Maria della Scala in Trastevere, Rome (1606-7, Louvre, Paris) was actually rejected for its excessive realism.

Cross-references: Angel, Apostles, Assumption, Mary.
Bibliography: J. Duhr, "La Dormition de Marie dans l'art chrétien", *Revue nouvelle de théologie*, 72, 1950, p. 134. G. Schiller, *Ikonographie der christlichen Kunst*, Gütersloh, 1966-87, vol. IV, 2, p. 83.

DOROTHY

Italian and Spanish: Dorotea; French: Dorothée; German: Dorothea. Virgin and Martyr. Died c.300/10. Feast day 6 February, suppressed in 1969.

LIFE AND LEGEND
Dorothy was sent to her death by Fabritius, governor of Caesarea in Cappadocia, for refusing to marry or worship idols. On her way to martyrdom, a young lawyer named Theophilus asked her jestingly to bring him some apples and roses from the Garden of Paradise. Dorothy (whose name means "gift of God") promised to do so. An angel then appeared with a basket containing three roses and three apples. Theophilus was immediately converted and he too died a martyr. Dorothy's cult started around the fifteenth century and is prevalent above all in Germany and Italy. She is the patron saint of florists.

St Dorothy
Adriaen Collaert, beginning
of the seventeenth century.
Bibliothèque Nationale,
Paris.

REPRESENTATION AND ICONOGRAPHY

Dorothy is represented with the Christ Child or a little angel who hands her a basket of roses. She awaits her martyrdom on her knees. Sometimes, she holds roses in her hands or folded in her cloak. In Francesco di Giorgio Martini's work of around the 1470s (National Gallery, London), she is shown crowned with roses, holding by the hand a cherub who also carries a basket of them. Holbein the Elder shows her kneeling, waiting for the fatal blow as the Christ Child offers her a basket of roses (1499, Städtische Gemäldegalerie, Augsburg).

Attributes: Crown of flowers (roses). Rose in hand. Basket of roses (and fruit).

DOVE

In the ancient world, the dove was sacred to Venus, but it became the Christian symbol for the Holy Spirit at an early date. The basis for the choice can be traced back to St John in a passage concerning the Baptism of Christ: "I saw the Spirit descending like a dove and it abode upon him" (1:32). Seven doves represent the seven gifts of the Holy Spirit. The dove is also more generally an image of the divine breath, raising the dead, inspiring holy writings (the dove is often shown whispering in the ear of Evangelists or Doctors of the Church), or proclaiming the Son of Man at the Annunciation. It can also be shown emblematically, surrounded by the seven virtues (A. M. Sforza, manuscript attributed to Johannes de Deo, *Columba*, c.1475, Osterreichische Nationalbibliotek, Vienna). Elsewhere the dove is a symbol of peace (after the Flood, for example) or else of purity or innocence. It is in this respect the opposite of the raven.

Cross-references: Annunciation, Baptism of Christ, Doctors of the Church (whispering in ear), Eulalia (emerging from mouth), Evangelists (whispering in ear), Gregory (whispering in ear), Holy Spirit, Noah (releasing dove from Ark), Pentecost (descending from heaven), Remigius (bishop), Tree of Jesse (in branches).

DRAGON

The dragon is the largest of the "serpents" and, like the snake, is an image of both evil and the Devil. He can appear in many forms: spitting fire, two- or four-footed, and with or without wings. His head and feet are of monstrous aspect, his tail is like a snake's and his whole body is covered in slime. Victory over a dragon occurs in many legends of the saints and is a frequent theme in art.

Cross-references: Devil, George (saint on horseback), John (in Revelations), Margaret (saint emerging from or standing on its belly), Martha (saint has a sprinkler), Michael (archangel), Olaf (with human head), Philip (with idols), snake, Revelations (two beasts), Theodore (Roman soldier).

DREAM *see* DAVID, JACOB, JOSEPH.

EAGLE

In practically all the cultures of antiquity, the eagle was divine. Christianity turned it into a symbol of both God the Father and of Christ. In the first case, the king of the birds incarnated the omnipotent dominion of God while, in the second, it constituted a symbol of the Resurrection and is related to the Ascension. This notion derived from an ancient tradition, attested in the Book of Psalms (103:5), according to which the eagle, when it feels itself becoming old, is able to regain its lost youth by first flying close to the sun and then diving into a fountain. In this way, it is also associated with baptism and the catachumen whose life is renewed by that sacrament. According to Greek bestiaries, it also was able to look without flinching at the sun, which later became a symbol of Christ's divinity. The eagle is above all the attribute of St John the Evangelist, following Ezekiel's vision (5:10) of the tetramorph.

Cross-references: Ascension, John the Evangelist (as emblem), Maurice (on banner), Médard (hovering above him), Revelations, Tetramorph.

EASTER

Italian: Pasqua; Spanish: Pascuas; French: Pâques; German: Ostern.

Easter celebrates the Resurrection of Christ, which took place on a Sunday. In 325, the Council of Nicea proclaimed that Easter would fall on the first Sunday after the Paschal full moon of the equinox. The Church has been considering allocating this feast a fixed Sunday. It is one of four main feasts of the Christian year, with the Ascension, Pentecost and the Nativity.

Cross-reference: Resurrection.

EASTERN SAINTS

The division of the Empire under Theodore in 395, and the liquidation of the Western Empire in 476, resulted in the adoption of Constantinople as capital of the surviving Imperial power. The Byzantine Empire grew out of a sort of symbiosis between the Roman world, the Christian religion and Hellenistic culture. After the Council of Constantinople in 381, the Greek Church underscored its individuality, the Patriarch of Constantinople setting himself up as a rival to St Peter's successors in Rome. The official split between the Roman Catholic Church and the Greek Church of Byzantium, made concrete in 1054, became definitive after the sacking of Constantinople during the Fourth Crusade in 1204. The Greek Church has developed a number of rites specific to it: both its liturgy and language are distinct. Similarly, a number of saints are peculiar to and venerated in the eastern Church, and are incorporated into the calender of the universal Church.

Cross-references: Alexis, Basil the Great, Boris and Gleb, Cyril and Methodius, Demetrius, John Chrysostom, Vladimir.

ECCE HOMO

Variants: Behold the Man, Christ shown to the People. Italian: Gesù mostrato al popolo; Spanish: Cristo presentado al pueblo; French: Ecce Homo; German: Schaustellung Christi.

Ecce Homo
Beginning of the sixteenth
century. Musée des Beaux
Arts, Troyes.

TRADITION

The expression *Ecce Homo* is the Latin form of Pontius Pilate's utterance "Behold the man." The episode, described by St John (19:4-6), occurs after Jesus' Flagellation and the Crowning with Thorns. As the soldiers jeer at Christ, crying, "Hail, King of the Jews!", Pilate announces that he is about to produce the accused. "Then came Jesus forth, wearing the crown of thorns and the purple robe. And Pilate saith unto them, Behold the man!" When the high priests and their men see Christ, they all cry out that he should be crucified.

REPRESENTATION AND ICONOGRAPHY

Traditionally, Christ is shown half- or full-length, wearing the purple robe and Crown of Thorns and holding the reed sceptre he has been given in mockery. This type of Ecce Homo is often confused with the figure of Jesus as he appears during Christ Mocked, a scene which takes place in the house of the high priest, after he is brought brought before Caiaphas. The earliest depictions of the Ecce Homo arise in the Carolingian period, in the ninth or tenth centuries. Christ did not appear naked beneath the purple robe, and his hands, unlike in later examples, were not bound. The reed sceptre was often omitted.

By the end of the middle ages, the lacerated body of Christ is naked beneath the robe, and he holds the reed sceptre and wears the Crown of Thorns (Antonello da Messina, third quarter of the fifteenth century, Museo Civico, Piacenza). He leans forward slightly, his hands crossed and tied together before him (Urban Gortschacher, 1508, Osterreichische Galerie, Vienna). During the end of the fifteenth and sixteenth centuries this version – the Man of Sorrows – begins to include additional figures, with donors sometimes placed among the onlookers. The Jewish people demand Christ's execution, and even Pilate's wife is occasionally shown observing the proceedings from high up on a balcony (Bosch, end of the fifteenth century, Städelsches Kunstinstitut, Frankfurt; engravings by Dürer and Lucas de Leyden).

The Ecce Homo became a subject for widely distributed pious engravings during the sixteenth and seventeenth centuries, and the episode is often confused with Christ Mocked. The theme continued to be treated from the sixteenth to the eighteenth centuries (Luis de Morales, mid-sixteenth century, Prado, Madrid, in half-length). A number of prints were disseminated a version which owed a great deal to Caravaggio (1604-5, Palazzo Rosso, Genoa). It has remained a theme of interest to artists up to the present day (Georges Rouault, 1938, Staatsgalerie, Stuttgart).

Attributes: Crown of Thorns. Purple robe. Reed sceptre.
Cross-references: Christ Mocked, Crowning with Thorns, Crucifixion, Flagellation, Trial of Jesus.
Bibliography: G. von Osten, "Der Scherzenmann", *Forschungen zur deutschen Kunstgeschichte*, 7, Berlin, 1935.

EDEN *see* ADAM AND EVE.

SS. Edmund and Edward the Confessor
Panel, The Wilton Diptych (detail), c.1395. National Gallery, London.

EDMUND

Variant: Eadmund. Latin: Edmundus; Italian: Edmondo; French: Edmond; German: Edmund.
King and Martyr. 841-69. Feast day 20 November.

LIFE AND LEGEND
King of East Anglia from 855 to 869, Edmund was captured by the Danes at the Battle of Thetford. Having confessed his faith, he was attached to a tree, shot with arrows and finally beheaded. Legend relates that a bear (or a wolf) guarded his severed head, crying *"Hic! Hic!* [Here! Here!]" to guide anyone who looked for it. In 1020, King Cnut founded the Abbey of Bury St Edmunds on his tomb. Edmund is an early patron saint of England.

REPRESENTATION AND ICONOGRAPHY
Edmund is shown wearing a royal crown and carrying an arrow in reference to his martyrdom. The *Vita* in the manuscript of Bury St Edmunds (c.1130, Pierpont Morgan Library, New York) illustrates his life in 32 miniatures, the majority pertaining to his martyrdom. An engraving by Jacques Callot (*Les Images de tous les saints...*, 1636) shows him being shot at with a musket. The motif with arrows, however, is closer to that of St Sebastian.

Attributes: Royal crown. Arrows.
Bibliography: Francis, Lord Hervey, *The History of King Edmund the Martyr*, Oxford, 1929.

EDWARD THE CONFESSOR

Latin: Eduardus; Italian: Edoardo; Spanish: Eduardo; French: Edouard le Confesseur; German: Eduard der Bekenner.
King. 1003-66. Canonized 1161. Feast day 13 October.

LIFE AND LEGEND
Edward was the last Anglo-Saxon king of England before the Conquest by William of Normandy in 1066. A rather colourless individual, he nonetheless founded Westminister Abbey and his life has attracted the legend of scores of miraculous occurrences. Edward saw the Lord himself above the altar during Mass in Westminster, but the most popular legend is the miracle of the

ring, attested as early as the twelfth century. St John the Evangelist, it runs, desired to put Edward's charity to the test. Disguising himself as a beggar, he asked alms of the King. Edward, who had no money about him, gave him his gold ring. Seven years later, St John appeared to an English pilgrim in Palestine, giving him the ring and instructing him to inform Edward that his time had come and that he would soon be called to the elect. St Thomas Becket was instrumental in moving his remains to Westminster in 1163. Edward the Confessor was a patron of England until Edward III (king from 1327 to 1377) replaced him with St George.

REPRESENTATION AND ICONOGRAPHY

Edward is depicted as a bearded monarch with crown and sceptre. Occasionally, he is shown curing a leper. An engraving by Hans Burgkmair (first third of the sixteenth century) shows him carrying a sick man on his shoulders. His distinctive attribute is his gold ring (stone reredos, Sainte-Chapelle at St Germer, c.1275, Musée de Cluny, Paris, where he is shown offering his ring to St John as a pauper; the ring is later returned to him by a messenger from the apostle). One of the panels of the Wilton Diptych (c.1395, National Gallery, London) shows Edward carrying his ring and Edmund with his arrow presenting the young Richard II to the Virgin Mary.

Attributes: Gold ring. Crown. Sceptre.
Cross-references: Edmund, John, Thomas Becket.

ELEAZAR *see* MACABEES.

ELIEZER *see* ISAAC.

ELIGIUS

Variant: Eloi, Eloy. Latin: Eligius, Eulogius; Italian: Eligio, Lò; French: Eloi; German: Eligius.
Bishop of Noyon. c.590-659. Feast day 1 December.

LIFE AND LEGEND

Eligius, who was born in Limousin, has become one of the most popular saints of the Christian west. Chaucer's Prioress swore "by St Eloi". He started life as a goldsmith whose talent led him to the court of the Merovingian king, Clotar II, who promoted him to be his "treasurer". Dagobert, who succeeded Clotar II in 629, took Eligius into service as his chief counsellor and entrusted him with many missions, both diplomatic and governmental. At Dagobert's death, in 639, Eligius became a priest before being named bishop of Noyon. He spent the last twenty years of his life administering his see, one of the largest in the kingdom, devoting himself to the poor and freeing slaves.

Ancient tradition credits Eligius with extraordinary talent as a goldsmith, notably in the making of reliquaries, as well as with numerous miracles. One day, Eligius cut off a horse's hoof to shoe it with greater ease; once the work was done, he simply replaced the whole hoof. Another time, the Devil came to his workshop disguised as a young woman; Eligius gripped his nose with a pair of pincers and forced him to flee.

St Eligius as a Farrier
St Eligius Triptych, fifteenth century (detail). Louvre, Paris.

The cult of St Eligius spread very quickly from his native Limousin and his bishopric in Noyon. It is strong in northern France, Holland, Germany and Italy. He is the patron saint of goldsmiths and blacksmiths, both powerful trades which were able to dedicate funds to the creation of churches, chapels, statues, stained glass and images of every kind in their saint's name. In addition, he is the saint protector of the horse, and patron of all equestrian crafts.

REPRESENTATION AND ICONOGRAPHY
St Eligius' iconography is rich and varied. He can be depicted as a bishop, with mitre and crozier; as a goldsmith, with a chalice or a piece of goldwork (Master of Bileam, engraving, c.1458, Rijksprenten Kabinet, Amsterdam), or a blacksmith (farrier) with pincers, hammer, anvil or horseshoe. The most frequently represented scenes are those showing him replacing the horse's hoof, resuscitating a hanged man, grabbing the Devil's nose with his pincers, and advising Clotar or Dagobert.

Attributes: Chalice. Mitre. Crozier. Horse (or hoof). Anvil. Horseshoe. Hammer. Pair of pincers.

ELIJAH

Variant: Elias (in the New Testament). Latin: Elias; Italian: Elia; Spanish and German: Elias; French: Elie.

TRADITION
In Old Testament hierarchy, Elijah occupies the second place, immediately after Moses. His story is recounted in the two Books of Kings (1 Kings 17-21;

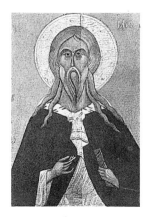

The Prophet Elijah
Icon, School of Novgorod,
fifteenth century. Tretiakov
Gallery, Moscow.

2 Kings 1-2). He makes his first appearance around 864 BC, during the reign of Ahab, King of Israel in Samaria. Ahab married Jezebel, daughter of the king of the Zidonians, and encouraged the worship of foreign idols. Suddenly, a man in a long mantle stood before him: Elijah of Gilead, a province east of the Jordan. Elijah predicted a dreadful drought, sent by the God of Israel as a sign. He then fled over the Jordan and was given shelter by a widow at Zarephath. Soon afterwards, Elijah's host's son died. In despair, the widow cursed the prophet of doom she saw in her new guest. Jehovah came to Elijah's aid, however, and resurrected the child.

Three years later, Elijah was told by Jehovah to return to Samaria. King Ahab agreed to Elijah's proposal to assemble the people on Mount Carmel to organize a kind of ordeal or trial of the gods, between the priests of Baal brought by Jezebel to Israel, and Elijah, prophet of the true God. In this way, it would be ascertained which of the two sacrifices was acceptable. The God of Israel alone made himself known by sending fire down from heaven which consumed the holocaust prepared by Elijah (1 Kings 18:39). The priests of Baal, in spite of their clamour, failed to summon up their gods and were all put to the sword. God's anger was thus appeased and an abundant rain fell, ending three years of drought and famine.

Threatened with death by Jezebel, who sought to avenge the priests of Baal, Elijah fled once more into the desert (1 Kings 19:3-8). At Mount Horeb, the Lord revealed himself in a "still, small voice". Jehovah ordered Elijah to anoint Elisha "to be prophet in thy room [stead]". Elijah found Elisha ploughing and threw his mantle over him; Elisha immediately left his oxen and ran after the prophet.

Called once again by Jehovah, Elijah returned to Ahab and reproached him bitterly for having despatched Naboth of Jezrael, whose vineyards the king coveted (1 Kings 21:17). Jezebel, Elijah predicts, would be torn apart by dogs on that very land. He was finally lifted up into heaven in a chariot of fire, while Elisha was left to pick up his mantle left behind on earth (2 Kings 2:11-14).

Elijah was embraced as a holy man by both the Greek and Roman Churches. In the west, the Carmelites consider him to be founder and patron of their order, due to his victory over the false gods on Mount Carmel. He is thought to prefigure St John the Baptist, Precursor of the Messiah, for the prophet Malachi says, "Behold I will send you Elijah the prophet before the coming of the great and dreadful day of the Lord" (Mal. 5:4). John the Baptist is therefore also called the second Elijah. Elijah's anguish in the desert (1 Kings 19:3) prefigures Christ's Agony in the Garden of Gethsemane, while the resurrection of the widow's son at Zarephath can be compared to that of Lazarus. Christ's Ascension and the Assumption of the Virgin are both prefigured by Elijah's ascent in the chariot of fire, and he also appears with Moses at Christ's Transfiguration on Mount Tabor (Matt. 17:1-9; Mark 9:2-10; Luke 9:28-36).

REPRESENTATION AND ICONOGRAPHY

Cycles of Elijah's Life

The prophet Elijah is generally represented as a bearded old man. No complete or partial cycle of his life predates the wall paintings on the Synagogue at Dura-Europos (c.245). The Carmelites had a number of such sequences executed for their monastery chapels (Carmelite cloister in Barcelona, beginning of the seventeenth century, twenty scenes; fresco series by Gaspard Dughet, begun 1647, S. Martino ai Monti, Rome). The order often placed the scene

of the Transfiguration, in which Elijah appears, above the main altar of its abbey churches (1683, Carmelite Church, Paris).

Elijah Fed by Ravens (1 Kings 17)
This theme, reused in the legend of St Paul of Thebes "the first Hermit", is illustrated on a fresco at the Church of the Holy Trinity, Lublin, Poland (1428), and occurs on the decoration of the refectory of the monastery at Lavra (Mount Athos, 1502).

Elijah's Holocaust on Mount Carmel (1 Kings 18:20-40).
A flame of divine fire consumes the offering on Elijah's altar, while the priests of Baal show their desperation. On the fresco of the Synagogue at Dura-Europos (c.245) and on stained glass in the cloister of St Etienne du Mont, Paris (seventeenth century), fire is shown descending from heaven on to Elijah's altar.

Elijah in the Desert Fed by an Angel (1 Kings 18:5-7)
A fourteenth-century fresco in the Cathedral of Orvieto presents this scene. It is treated as a prefiguration of the Last Supper by Dieric Bouts (panel of the Last Supper triptych, 1468, Louvain Cathedral) and by Tintoretto (1577-8, Scuola di San Rocco, Venice).

Elijah's Ascension on a Chariot of Fire (2 Kings 2.11-14)
This episode has been addressed by artists countless times in compositions which often owe a great deal to the ancient world – specifically to the chariot of the sun god Helios or Apollo (catacombs, Via Latina, Rome, fourth century). As Elijah is raised up on his chariot of fire, his gaze turns towards the angel who bears him aloft, while a personified River Jordan lies on a riverbank (door of the Church of S. Sabina, Rome, fifth century).

Attributes: Raven bringing food. Fiery sword (alluding to the flames which consumed Elijah's holocaust). Wheel of the chariot of fire.
Cross-references: John the Baptist, Last Supper, Transfiguration.
Bibliography: L. Réau, "Iconographie du prophète Elie", *Etudes carmélitaines*, Paris, 1956.

ELISABETH

Variant: Elizabeth. Italian: Elisabetta; Spanish: Isabel; French: Elisabeth, Isabelle; German: Elisabeth, Elsbeth.
Mother of John the Baptist. 1st century BC. Feast day 3 November.

TRADITION
Elisabeth is known to us essentially through two texts. Firstly, the Gospel according to St Luke (1:8-22) tells of the birth of St John the Baptist. Elisabeth's marriage to a priest "of the course of Abia", Zacharias (Zachary), was barren and both were "well stricken in years". One of the angels "that stand in the presence of God", the archangel Gabriel, sent Zacharias a dream while he was in the sanctuary: "Thy prayer is heard; and thy wife Elisabeth shall bear thee a son, and thou shalt call his name John" (Luke 1:13). Zacharias, not believing the angel's revelation, was struck dumb until the birth of his son. Mary visits Elisabeth (Luke 1:39-40). This is followed by the Visitation proper (1:39-54).

The second text, the apocryphal *Protevangelium* of James, is more infor-

Elisabeth and Zacharias
Bernard Strigel, 1500-20s.
Neue Pinakothek, Munich.

mative, and tells of the Flight into the Desert. During the Massacre of the Innocents, Elisabeth tried to escape with her child into the mountains. She was surrounded by her would-be captors, but escaped into a gap in the rock which opened miraculously before her.

REPRESENTATION AND ICONOGRAPHY

Elisabeth is shown as a matron wearing a long gown and a hooded mantle. The Visitation is a very frequent theme (portal of Reims Cathedral, thirteenth century). A series of frescoes by Ghirlandaio (1485-90, S. Maria Novella, Florence) is devoted to St John the Baptist's nativity. The rock opening up to let Elisabeth and her child escape is shown in an icon of the eleventh century (St Catherine, Sinai).

Attributes: Long gown. Hooded mantle.
Cross-references: John the Baptist, Massacre of the Innocents, Visitation, Zakharias.

ELISHA *see* ELIJAH.

St Elizabeth of Hungary
Woodcut from James of
Voragine's *Golden Legend*,
1483 edition.

ELIZABETH OF HUNGARY

Variant: Elizabeth of Thuringia. Hungarian: Erszébet; French: Elisabeth de Hongrie; German: Elisabeth von Ungarn.
Queen. 1207-31. Canonized 1235. Feast day 17 November.

LIFE AND LEGEND

Elizabeth, daughter of King Andrew II of Hungary, was born in 1207, and betrothed at the age of four to the son of Hermann, Landgrave of Thuringia. They married when she was 14. She became a convert to the ideals of saintly life as embodied by St Francis, and devoted herself to the care of lepers and to the sick and destitute. Widowed at 20, she retired to Marburg, in Hesse, where she lived the austere life of a Franciscan Tertiary until her death in 1231 at the age of 24. Two legendary scenes are particularly famous. Surprised by her brother-in-law pilfering provisions for the poor from the kitchen in their castle, she explained that she was only getting some roses to plait herself a crown. The food in her basket thereupon miraculously turned into roses. One night, she put a leper into her marriage bed. Her husband was initially horrified but then, with the eyes of the soul, he recognized Christ beneath the leper's hideous appearance. Her cult, spread by the Franciscans, centres on Kassa in Hungary and on Marburg. She is patron saint of bakers, beggars and charities.

REPRESENTATION AND ICONOGRAPHY

She is shown as a richly dressed princess, carrying two or three crowns or with her hands resting on a book (from the fourteenth century, in the Rhineland and the Low Countries). She is also represented as a Franciscan Tertiary, with attributes embodying her charity: bread, fish, and a pitcher from which she gives water to a beggar or leper at her feet. In one relief (reliquary casket in the Church of St Elizabeth in Marburg), she wears the habit of a Tertiary and distributes alms to some beggars. Like St Dorothy, she often carries roses in a fold of her dress.

Attributes: Crown. Round or long loaves. Book. Sceptre.

EMMANUEL *see* CHRIST EMMANUEL.

EMMAUS *see* PILGRIMS AT EMMAUS.

ENTOMBMENT

Italian: Seppellimento di Cristo; Spanish: Santo Entierro de Cristo, Colocación en el Sepulcro; French: Mise au Tombeau; German: Grablegung Christi.

TRADITION
Gospel tradition varies slightly with regard to this theme. The episode follows the Crucifixion (Matt. 27:57-60; Mark 15:42-47; Luke 23:50-54; John 19:18-42). Joseph of Arimathaea obtains permission to bury Christ's body. He places it a tomb in the rock and shuts it up with a round stone. The body is wrapped in a shroud and, once embalmed, wound with "linen cloths" (John 19:40). According to John, Joseph is helped by Nicodemus (19:39). Luke states that certain women are also present, but he does not say which. According to Matthew and Mark, it is Mary Magdalene and the "other Mary".

REPRESENTATION AND ICONOGRAPHY
In the west, the theme is not attested before the tenth century. John's version is followed until the thirteenth century: Joseph of Arimathaea and Nicodemus lay Jesus' body in the tomb. The theme was commonly associated with the Deposition and slowly began to include additional figures. The two themes tended to converge. In fifteenth- and sixteenth-century sculpture, the Entombment was given a monumental architectural setting, filled with figures, some of whom derived from an apocryphal source, the *Acta Pilatii* (St Martin, Pont à Mousson, c.1420). Pontormo's version at the S Felicità in Florence (1525-8) shows one of the two figures carrying the body in a kneeling position, while the full drama of the scene was exploited by Dierck van Baburen (c.1617, San Pietro in Montorio).

Cross-references: Crucifixion, Deposition, John, Mary Magdalene, Resurrection, Holy Women at the Sepulchre.
Bibliography: E. Mâle, *L'Art religieux de la fin du Moyen Age en France*, Paris, 1949; *L'Art religieux du XIIIème siècle en France*, Paris, 1958; *L'Art religieux du XIIème siècle en France*, Paris, 1966.

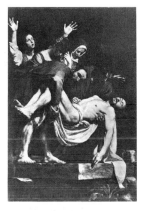

The Entombment
Caravaggio, 1602-4.
Vatican, Rome.

ENTRY INTO JERUSALEM *see* CHRIST'S ENTRY INTO JERUSALEM.

EPIPHANY *see* MAGI.

ESAU *see* ISAAC, JACOB.

Esther and Ahasuerus
Filippo Lippi, fifteenth
century. Musée Condé,
Chantilly.

ESTHER

Italian and Spanish: Ester; French and German: Esther.

TRADITION

The Jewish Esther was chosen by Ahasuerus, King of Persia, to replace his queen Vashti, after the former was disavowed by the king for refusing to appear before the people at a feast. Mordecai, Esther's tutor, requested her to appear before the king unannounced, an offence punishable by death. This she did in the hope that, by directly appealing to the king, she could prevent the Jews from being massacred on the orders of his vizir, Haman. Ahasuerus received his favourite, who threw herself at his feet. To indicate his clemency, the king pointed his sceptre towards her and lowered it. Esther invited Haman to a feast and implored Ahasuerus to spare the Jewish people. At the banquet (Esther 7), she exposed Haman and Ahasuerus had him hanged on gallows the vizir had prepared for Mordecai. Haman had decided the day for the intended massacre by casting lots. In Persian, this is called *pur*, from which is derived the name Purim (Feast of Lots), the Jewish festival which commemorates the day Esther saved her people (9:29-32).

For Christian commentators, Esther is an antecedent of the Virgin Mary: her crowning by Ahasuerus prefigures the Coronation, while her petition to the King of Persia foreshadows the intercession of the Virgin before her Son at the Day of Judgment.

REPRESENTATION AND ICONOGRAPHY

Esther is represented as a beautiful and richly dressed young woman wearing a crown. The episodes treated by artists include her plea on behalf of her people; Ahasuerus catching her as she faints; Ahasuerus lowering his sceptre in forgiveness (H. Burgkmair, 1528, Alte Pinakothek, Munich, with Haman hanging in the background); Ahasuerus and Haman at the banquet; Haman begging for Esther's mercy; Mordecai's victory over Haman; Haman being hanged in the presence of Esther and Ahasuerus; Ahasuerus crowning Esther.

The most frequently represented scene shows Esther interceding at the foot of Ahasuerus' throne. This popularity arises from the Marian interpretation of the scene, in which Esther is likened to the Virgin (the archivolt of the north door at the transept of Chartres Cathedral, twelfth century, has Ahasuerus marrying Esther, Mordecai alerting her to the threat to the Jews, Esther at Ahasuerus' feet, Mordecai announcing the revocation of the edict condemning the Jews). Michelangelo juxtaposes Esther with Judith, who also saved her people (1511, Sistine Chapel, Vatican).

Thanks to Racine's tragedy, *Esther* (1689), the theme became popular in France during the seventeenth century. Later painters showed her preparing for her meeting with Ahasuerus (Théodore Chassériau, *The Toilet of Esther*, 1841, Louvre, Paris).

EUCHARIST *see* LAST SUPPER.

EULALIA

Latin, Italian and German: Eulalia; Spanish: Olalla; French: Eulalie.
Virgin and Martyr. 4th century. Feast day 10 December.

LIFE AND LEGEND

The two saints of this name known from Spanish martyrologies (Eulalia of Merida and Eulalia of Barcelona) are, in reality, one person. Eulalia of Merida, in Estremadura, is the subject of a hymn by the fourth-century poet Prudentius, which contains some information of a clearly legendary nature. Aged 12, Eulalia ran away from her parents' house and went of her own accord to the magistrate. Refusing to sacrifice to pagan gods or to repudiate her Christian faith, she suffered excruciating tortures. She was beaten with sticks, attached to a cross, scourged with iron hooks and cast into a cauldron of boiling oil. Naked, she was then delivered up to be burnt at the stake, but her long hair (which, as in the case of Agnes, hid her body from view) caught fire and the flames formed a protective screen around her. She was finally beheaded, and legend states that a white dove symbolizing her soul flew out of her innocent mouth as she died.

Eulalia is the most revered female martyr in Spain, where her cult is as universal as that of Vincent of Saragossa. It is also present in north Africa and in the south of France. The *Cantilène de sainte Eulalie* ("The Song of St Eulalia"), composed at the period of the translation of her relics to Barcelona at the end of the ninth century, was the first literary text to be written in French. She is the patron of women in labour.

REPRESENTATION AND ICONOGRAPHY

Eulalia appears as one of the virgins (mosaics at S. Apollinare Nuovo, Ravenna, sixth century), but she does not appear to have a constant specific attribute. She carries a cross saltire, the crown of martyrdom (anonymous, fourteenth century, Museo Episcopal, Vich, Catalonia) or else a book and palm (manuscript of Elne, fourteenth century, Perpignan Library). She is linked to a large St Andrew's cross in Luis Dalmau's *The Virgin with Councillors* (1445, Museu de Arte Antica de Catalunya, Barcelona: the five town councillors are presented to the Virgin by SS. Andrew and Eulalia). Scenes from her martyrdom are depicted in series (retable in the Cathedral of Palma de Mallorca, fifteenth century, with Eulalia in the centre, encircled by twelve narrative scenes arranged on four levels). Bernardo Martorell shows her surrounded by wise men and saints (second quarter of the fifteenth century, Museu de Arte Antica de Catalunya, Barcelona).

Attributes: St Andrew's cross. Crown. Dove (flying out of her mouth).
Bibliography: J.-F. Roig, *Iconographia de los santos*, Barcelona, 1950, p. 101.

St Eulalia
Luis Dalmau, altarpiece,
The Virgin with Councillors
(detail), 1445. Museu de Arte
Antica de Catalunya,
Barcelona.

EUSTACE

Variant, Latin and German: Eustachius; Italian: Eustachio; French: Eustache, Vitasse.
Martyr. Feast day 20 September, suppressed in 1969.

TRADITION

The history of St Eustace is purely legendary. One day, Placidius (or Placidas), a Roman general serving under Trajan, saw a crucifix appear between the antlers of a stag he was hunting. The stag addressed him, calling upon him to convert to Christianity. Placidius did so and, taking the name Eustace, converted his entire family. Ten days later, the stag reappeared and asked Eustace to take courage and pray, for the Devil was about to assail him. Eustace gradually lost all his cattle and his fortune. While trying to escape to Egypt, he

St Eustace and the Stag
Woodcut from James of
Voragine's *Golden Legend*,
1483 edition.

was captured by pirates and sold into slavery. This was followed by a series of ordeals which would have tried the patience of Job, but Eustace was eventually reunited with his family. They all refused to sacrifice to the pagan gods and were put into a brazen bull placed over a blazing furnace. Miraculously spared all pain, they rose up into heaven singing hymns of grace. Eustace is the patron saint of huntsmen, and his cult was widespread in France and Germany during the middle ages, but his renown declined due to competition from another huntsman, St Hubert.

REPRESENTATION AND ICONOGRAPHY

Eustace and Hubert can be confused, particularly in the episode where the saint encounters the stag sporting the Crucifix (Dürer, engraving, 1505; Pisanello, 1440-50, National Gallery, London), but Eustace is dressed as a Roman soldier (stained-glass window, St Eustache, Paris, 1631), whereas Hubert is nearly always depicted as a knight or young nobleman. The other episodes of his life (he carries his children over a river at the north-west tower of the west front of Wells Cathedral, Somerset, c.1240) are more infrequent, although his martyrdom in the brazen bull also figures (miniature, *Monologion* of Basil II, Vatican Library).

Attributes: Stag or antlers with crucifix. Roman soldier's uniform. Brazen bull.
Cross-references: Hubert, Stag.

EVANGELIST

Italian and Spanish: Evangelista; French: Evangéliste; German: Evangelist.

TRADITION

The four Evangelists owe their place in the Christian religion to two factors. They are primarily the authors of the canonical Gospels. In addition, two of them (Matthew and John) are numbered among the twelve apostles who knew Jesus personally. The other two (Mark and Luke) did not know Christ and composed their Gospels in the second half of the first century. All four are the object of immense veneration in the Church.

REPRESENTATION AND ICONOGRAPHY

The four Evangelists are often presented as a group, embodying the notion of the unity of the four Gospels with respect to Christ. During the paleochristian period, they are gathered around Jesus, who is shown teaching. They are each identified by inscriptions on scrolls of parchment (fresco, catacombs of SS. Peter and Marcellinus, fourth century). While in the first centuries of Christianity the Evangelists were represented by a dove or a lamb, they were soon each designated a specific personal symbol.

From the fifth century they were symbolized by four living beings: a man (often winged) for Matthew, a lion for Mark, a bull for Luke and an eagle for John. These emblems originated in the vision of Ezekiel (Ez. 1:1- 28) and Revelations (4:1-11), and can either accompany the Evangelists or appear on their own. The depictions of the Evangelists themselves derive from ancient world models. They extend their right hands, like Greek or Roman orators, while their pensive demeanour proceeds from that of the philosophers. In the medieval west, they appeared as beardless young men (*Coronation Gospels*, c.800, Kunsthistorisches Museum, Vienna), but there was a tendency, especially in the east, to show Matthew and Luke as old and John

and Mark as youthful. By the end of the medieval period, only John remains a young man.

The Evangelists are depicted standing, facing frontwards, or in half-profile (Jordaens, c.1622, Louvre, Paris). They carry books or scrolls. They are often seated before desks or tables with writing instruments, such as quills and inkwells, often with Christ enthroned between them (tympanum of the north door of the Abbey Church at St Benoît sur Loire, twelfth century).

The Symbols of the Four Evangelists

For the most part, their depictions conform to the description in Revelations, but their emblems are furnished with only two wings (and not six, as the text has it). They frame Christ's mandorla (carving on the wooden door of the Church of S. Sabina, Rome, c.430). Sometimes they occur without their wings. These emblems were associated with the Evangelists as early as the sixth century (mosaic in the choir octogan at San Vitale, Ravenna, with Mark and Luke turning towards their respective symbols). The man leans towards Matthew, who is writing, as if to inspire him. Sometimes the emblems are subordinated and employed as stools, chairs or writing desks by the Evangelists. At a later date the symbols can be presented autonomously (Veronese, c.1565-70, Contini Boncossi Collection, Florence).

These symbols are often used in conjunction with the Cross (mosaics in the mausoleum of Galla Placidia, Ravenna, fifth century). The Evangelists are then presented as the fourfold source of holy life, comparable to the four rivers of paradise, which can also serve as Evangelical emblems.

Attributes: Man, often winged (Matthew). Lion (Mark). Bull or ox (Luke). Eagle (John).
Cross references: Christ in Majesty, Ezekiel, Four Living Creatures, John, Luke, Mark, Matthew, Revelations, Tetramorph.
Bibliography: Z. Ameisenova, "Animal-headed Gods, Evangelists, Saints and Righteous Men", *Journal of the Warburg Institute*, 12, 1949, pp. 21-43.

EVE *see* ADAM AND EVE.

EWE *see* GOOD SHEPHERD.

EXODUS

Greek: Exagoge; Italian: Esodo; Spanish; Exodo: French: Exode; German: Exodus.

The Symbols of the Evangelists: Matthew, Mark, Luke and John
Lecterns, Dinant, beginning of the fifteenth century. Walters Art Gallery, Baltimore, Maryland.

The Exodus from Egypt and the Crossing of the Red Sea

TRADITION

"Come now therefore, and ... bring forth my people the children of Isreal out of Egypt" (Ex. 3:10). Such is the mission given Moses by the "God of [his] fathers" and revealed to him in the episode of the Burning Bush on Mount Horeb. Moses returns to Egypt, where Jehovah wrests permission from the Pharaoh for the Hebrews to leave the country by a host of miraculous events, during which Aaron's rod becomes a serpent and Egypt is laid waste by ten plagues. During the last of these plagues, in a prefiguration of the Massacre

The Crossing of the Red Sea
Greek Psalter, ninth century (detail). Bibliothèque Nationale, Paris.

of the Innocents under Herod, "all the firstborn in the land of Egypt" are killed while all the children of the Jews are spared.

Moses takes with him the body of Joseph. On his deathbed, the son of Jacob had ordered the Hebrews to swear to "carry up [his] bones away with [them]" if ever they left Egypt (13:19). The "sons of Israel" at last left Egypt, guided by a "pillar of cloud" by day and a "pillar of fire" by night. The Pharaoh, however, reneged on his promise and sent six hundred chariots after them. The Lord did not abandon his people but said to Moses: "But lift thou up thy rod, and stretch out thine hand over the sea and divide it ... and I will harden the hearts of the Egyptians, and they shall follow them" (14:16-17). The sea opens up and the sons of Israel advance on foot on to the seabed, the waters forming two walls on either side of them. Their pursuers follow, "and the Lord overthrew the Egyptians in the midst of the sea" (14:27). Medieval authors interpreted this sequence as a symbol of Christian salvation through baptism and of the damnation of their enemies.

REPRESENTATION AND ICONOGRAPHY

The Crossing of the Red Sea is represented on two frescoes in the catacomb in Via Latina, Rome (fourth century), adjacent to the Raising of Lazarus. Moses is shown dividing the waters with his rod; the sea then closes over the Egyptians. The Red Sea can be depicted as vertically structured (Synagogue, Dura-Europos, c.245; mosaic at S. Maria Maggiore, Rome, 432-40). On the door of S. Sabina (Rome, c.430), the sea is laid out horizontally in bands, while above, the Hebrews are guided by an angel, the Hand of God and a pillar of fire. The fugitives can also be represented in conjunction with the water closing over the Egyptian chariots (frescoes at the Church of St Savin sur Gartempe, Vienne, France, twelfth century; Poussin, 1633-35, National Gallery of Victoria, Melbourne). In the twentieth century, the Exodus was illustrated by Marc Chagall in his etching for the Bible.

The Children of Israel in the Wilderness

TRADITION

The itinerary of the Hebrews after the crossing of the Red Sea is a subject of some controversy. The Lord's care for his children is evidenced by flocks of quail covering the fields (16:13). Then, in the morning, after the first dews, there lay "a small round thing, as small as the hoar frost on the ground" (16:14). Moses explains that this is the manna, "the bread which the Lord hath given you to eat". Like the bread and wine Melchizedek offered

142

Abraham, the miracle of the manna from heaven has often been interpreted as an annunciation or prefiguration of the Eucharist.

The final miracle of importance in this sequence is Moses' smiting the rock and bringing forth a spring. At Rephidim, there was no water for the people to drink, and they began to murmur against Moses: "Behold, I [the Lord] will stand before thee there upon the rock in Horeb; and thou shalt smite the rock, and there shall come water out of it that the people may drink" (17:6).

REPRESENTATION AND ICONOGRAPHY

The flocks of quail inspired more Byzantine art than western (mosaic series at S. Maria Maggiore, Rome, fourth century; reliefs on the wooden door at S. Sabina, Rome, fifth century; stained glass in the cloister at the Church of St Etienne du Mont, Paris, sixteenth century, where it is adjacent to the manna from heaven).

The manna is a recurrent theme (Tintoretto, 1577, Scuola San Rocco, Venice; Noël-Nicolas Coypel, 1713, Church of St Nicolas du Chardonnet, Paris). On Moses' orders (16:33), Aaron puts a quantity of the manna in a pot and places it within the Ark of the Covenant (Nicolas of Verdun, 1181, Klosterneuberg altarpiece, Klosterneuberg Stiftsmuseum, Austria; stained glass at St Etienne du Mont, Paris). The golden urn containing the manna is laid in the Ark and guarded by two angels.

The miracle of Moses smiting the rock is illustrated no fewer than two hundred times in the catacombs. The motif is often used to decorate fountains. Poussin executed two works on the theme (1633-35, National Gallery of Scotland, Edinburgh; 1649, Hermitage, St Petersburg). A decorative version from eighteenth-century Venice is in the Accademia, Venice (Mario and Sebastiano Ricci, 1720s).

Cross-references: Aaron, Ark of the Covenant, Burning Bush, Joseph the Patriarch, Massacre of the Innocents, Moses, Plagues of Egypt.

EXPULSION OF THE MERCHANTS or MONEY-CHANGERS FROM THE TEMPLE see MERCHANTS IN THE TEMPLE.

EYE see LUCY (GIRL: EYES ON PLATTER), ODILIA (ABBESS: EYES ON BOOK).

EZEKIEL

Italian: Ezechiele; Spanish: Ecequiel; French: Ezéchiel; German: Ezekiel.

TRADITION

This prophet is known to us through the Book of the Bible which bears his name. Probably deported into Babylon around 579 BC, he lived with the captive Jews in exile and pronounced his prophecies in the region of present-day Tel Aviv. One day, his life was penetrated with the "glory of the Lord", which he discovered in a series of visions.

Ezekiel's Vision
Bible dite de Jean XXII,
fifteenth century.
Bibliothèque de la Faculté de
Médecine, Montpellier.

At the heart of a great "cloud and a fire infolding itself" he saw four flying creatures supporting a throne. The prophet described them at length (1:6-14): all four "had the face of a man, and the face of a lion on the right side; and they four had the face of an ox on the left side; they four had the face of an eagle" (1:10). Their wings "were stretched upward", yet "their appearance was like burning coals of fire". These "living creatures" move freely in all directions. Next to these fantastic beings, which have been viewed as a prefiguration of the four Evangelists, the visionary could also make out "a wheel in the middle of a wheel" of terrifying size. Above this strange mechanism lay a "likeness of the firmament". Finally, the prophet heard a "noise of great waters", the voice of the Almighty (1:24).

Crushed by the sheer size of the beings around him, Ezekiel perceived the glory of the Almighty leaving the Temple and withdrawing from Jerusalem (11:22-23). This abandonment is the consequence of the sins of the Hebrews, who are vilified by the prophet. After learning of the capture and destruction of Jerusalem by Nebuchadnezzar in 586, he predicted the extermination of the enemies of Israel.

The Book of Ezekiel, shot through with imprecations, also contains a message of hope: the dead will live once more. The Lord went with him as he walked in a valley full of dry bones. At the Word of God, the bones rose up and "lived", and "an exceeding great army" arose in their place (37:1-10). This event heralded Israel's rebirth, and would be read by Christians as the annunciation of the resurrection of the body at the Last Judgment. At the centre of the New Jerusalem, the prophet sees the Temple where the Lord will once more be worshipped. The rules regarding access to the house of the Lord must be respected: "This [east] gate shall be shut, it shall not be opened, and no man shall enter in by it; because the Lord, the God of Israel, hath entered in by it" (44:1-2).

REPRESENTATION AND ICONOGRAPHY

Three episodes have particularly attracted artists: the Vision of Ezekiel, the valley of dry bones and their resurrection, and the closed temple gate. The prophet can generally be identified by a scroll containing the words *"Porta clausa est, non aperietur* [This gate shall be shut, it shall not be opened]". His other attributes include the chariot of fire he saw in his vision and the double wheel (statue of Ezekiel, St Firmin door, Amiens Cathedral). In the vision (2:8-10; 3:1-2), he devours the *rotulus* (the "roll of a book") given him by a divine hand (quatrefoil carving on façade, Amiens Cathedral, thirteenth century).

The Vision of the Glory of the Lord (1:26-28)

This vision of the "likeness of the Glory of the Lord", seated on a throne above the four living creatures and the wheels of the chariots of fire, is illustrated in Syriac manuscripts from the fifth century. In the early middle ages, however, the theme occured only rarely. Occasionally the visions of Ezekiel and Isaiah (7:14) are associated with the Revelations of St John the Evangelist. Since the twelfth century, frescoes of the vision also figure in Catalan churches.

The four living creatures of Ezekiel are identified with the four Evangelists, following Irenaeus' second-century commentary (notably in a Bible from the Abbey of Bury St Edmunds, twelfth century, now in Corpus Christi College Library, Cambridge). Fra Angelico joins the twelve prophets to the twelve apostles in a double wheel, according to this extrapolated read-

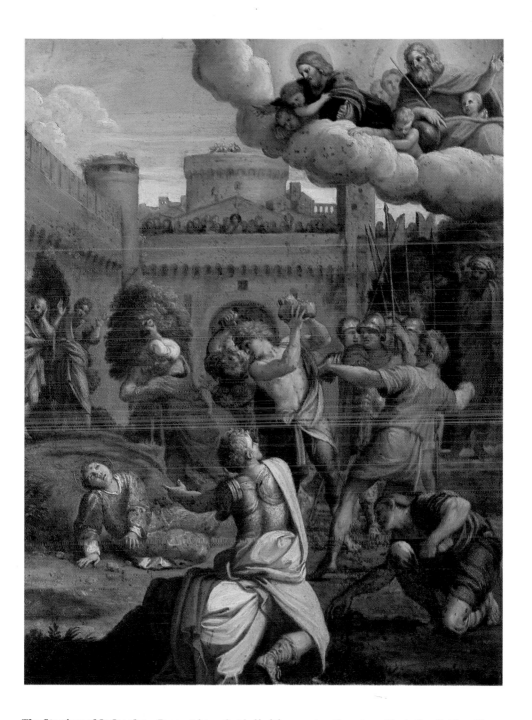

The Stoning of St Stephen. Domenichino, first half of the seventeenth century. Musée Condé, Chantilly.

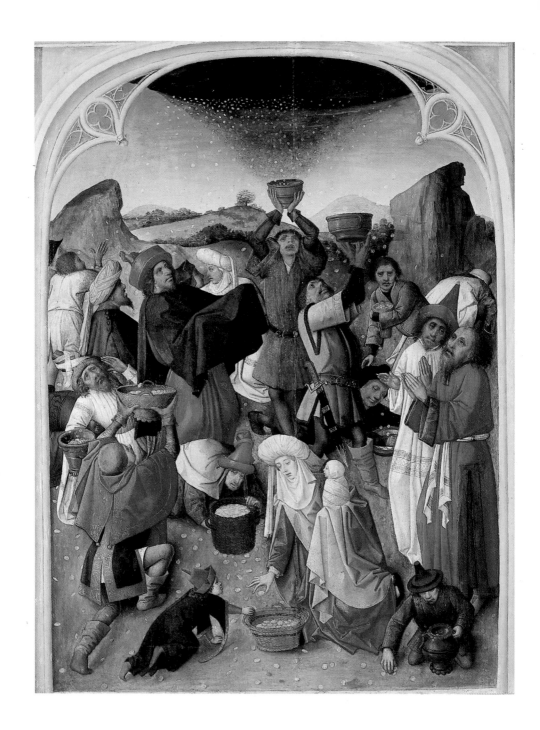

Manna from Heaven. Master of the Manna, c.1470. Musée de la Chartreuse, Douai.

ing of the vision (*Scenes from the Life of Christ*, 1450, Museo San Marco, Florence). In the Renaissance, in the wake of a new rationale, Raphael shows the Almighty hovering between the four animals above a landscape (1518, Pitti Palace, Florence). Holbein the Younger (engraving from the *Icones Historiarum Veteris Testamenti*, 1538) has God seated on a throne between the tetramorph and the sealed wheels. The Renaissance spirit, demanding clarity and the picturesque, in the main dissolves the inherent mystery and the grandeur of the vision. The vision becomes unified in later works (Matthäus Gundelach, 1614-17, St Vavrinec, Zebrak, Bohemia).

The Valley of Bones (37:1-14)
This vision was represented as early as the third century (Synagogue at Dura-Europos c.245). Luca Signorelli treated it as a prefiguraton of the resurrection at the Last Judgment (fresco, Cappella San Brizio, Orvieto Cathedral, 1499-1504).

The Shut Gate (44:1-3)
This prophetic text was interpreted as heralding the mystery of the Virgin, as a symbol of Mary herself as the gate of heaven and the eternally virgin Mother. Often, Ezekiel holds a scroll with the words "*Vidi portam in domo domini clausam*" or, again, "*Porta clausa est, non aperietur*" (door of the Church at Fidenza, fourteenth century).

Attributes: Heavenly chariot. Double wheel (symbolizing the Old and New Testaments). Open scroll (with inscription concerning the Shut Gate). Rotulus ("the roll of a book").
Cross-references: Evangelist, Last Judgment, Revelations, Tetramorph.
Bibliography: E. Mâle, *L'Art religieux du XIIIème siècle en France*, Paris, 1958.

FAITH

Variant: Foy. Latin: Fides Concathensis; Italian: Fede; Spanish: Fe de Agen; French: Foy; German: Fides.
Virgin and Martyr. Died 303(?). Feast day 6 October.

LIFE AND LEGEND
Faith was from Agen (Lot et Garonne, France) and was martyred, possibly in 303, aged 12, like St Agnes. She is supposed to have been put to death by the proconsul Dacien. After suffering a series of mortifications, Faith was

placed on a griddle kept white-hot by molten fat. A dove flew down from the heavens, bringing with it dew which quenched the flames. Faith was later beheaded.

This young martyr from Agen has often been confused with Faith, daughter of St Sophia, a personified cardinal virtue. The sequence of the griddle has been linked to St Laurence's gridiron, but it is more fruitful to note the connections with Vincent of Saragossa. Both were tortured by Dacien, a figure of doubtful authenticity, who also appears in the lives of several Spanish saints. Faith's griddle seems to be derived from that of St Vincent, who has bequeathed a further element: at the end of his suffering, St Vincent, lying in a dungeon on a bed of pottery shards, was carried up to heaven by a miraculous dew. St Faith's relics were translated to Conques in the ninth century. The abbey is one of the main stopping places on the pilgrimage to Santiago de Compostella.

REPRESENTATION AND ICONOGRAPHY
St Faith is depicted with a robe and a cloak. Her face is not that of a young girl of 12, but of a mature woman. The oldest and most famous representation is the late tenth-century reliquary statue called the *Majesté de sainte Foy* in the treasury of the Abbey at Conques. It has the appearance of a barbaric idol with no other specific attributes. Thirteenth-century stained glass at Chartres shows her martyred on a gridiron which two torturers keep ablaze with bellows. In the sixteenth century, Romain Buron composed a series of stained-glass windows on her martyrdom (St Foy, Conques, Eure).

St Faith
Reliquary, end of the tenth century. Abbey treasure, Conques.

Attributes: Crown. Griddle.
Cross-reference: Sophia.
Bibliography: A. Bouillet, "Essai d'iconographie de sainte Foy", *Congrès archéologique*, 68, 1901, pp. 373-412. E. Mâle, *L'Art religieux en France au XIIIème siècle*, pp. 100 ff. *L'Art religieux en France à la fin du Moyen Age*, pp. 312 ff.

FEEDING OF THE FIVE THOUSAND *see* MULTIPLICATION OF THE LOAVES AND FISHES.

FELICITAS, FELICITY *see* PERPETUA.

FIACRE

Latin: Fiacrius; Italian: Fiacrio; French: Fiacre, Fèvre; German: Fiakrius. Abbot. Died 670. Feast day 30 August.

LIFE AND LEGEND
The very popular St Fiacre was of Irish descent. One legend has him being given a piece of land at Breuil near Meaux by Bishop St Faro, to found a hermitage. Fiacre was told that he could have as much land as he could dig a ditch around in a single day. The hermit simply marked out the border with his staff and the ditch miraculously dug itself. To feed pilgrims, St Fiacre planted a vegetable garden in a glade he had cleared. He is therefore the patron saint of gardeners.

REPRESENTATION AND ICONOGRAPHY

St Fiacre is depicted either as a hermit or as a peasant, with a spade. In a sixteenth-century stone statue, he holds the open Gospels in one hand and in the other carries a spade (the Church of Notre Dame at Verneuil sur Avre, Eure). A stained-glass window (St Maclou, Troyes, sixteenth century) shows him first being received by Bishop Faro at Meaux, then digging. St Fiacre carrying his spade should not be confused with Christ appearing as a gardener to Mary Magdalene after the Resurrection.

Attributes: Spade. Book.
Cross-references: Appearances of the Risen Christ, Noli me Tangere.
Bibliography: L. Gourgaud, *Les Saints irlandais hors d'Irlande*, Paris, 1936, pp. 86-92.

FISH

At home in water, the fish contributes substantially to the symbolism of this element. A sign of purity, wisdom, fertility and resurrection, it is frequently associated with the iconography of baptism, particularly in its use as decoration for baptismal fonts.

As far as diet is concerned, for Christians as for the peoples of the Bible, the flesh of fish is considered purer than that of fowl or animals, hence there is always more value in eating fish than meat. In medieval iconography, fish is very frequently seen on tables showing meals. At the Last Supper, Christ and the Apostles share bread and wine, while plates of fish grace the table. Within such images, fish often have a eucharistic significance.

However, for early Christians, fish also evoked Christ through the symbolism of words: the Greek *Ichtys*, fish, was read as an acrostic of *Iesus Christos Theou Yios Soster* (Jesus Christ, Son of God, Saviour). From the first century, this ideogram was adopted by the followers of Christ as a sign of their recognition of and reverence towards(him, and it took its place on numerous objects and monuments, appearing with particular frequency in funerary inscriptions. From the fourth century, when Latin had taken the place of Greek as the official language of the Church, the ideogram, difficult to understand, was transformed into a sort of riddle, and its use became rare. It was replaced by the cross as a common symbol to identify all Christians.

Fish also represent the faithful followers caught by the symbolic "fishers of men": Christ, the apostles and the priests. Christ directly addressed Simon Peter, the fisherman. "From henceforth, thou shalt catch men" (Luke

St Fiacre
Sixteenth century.
Church of Notre Dame,
Verneuil-sur-Avre.

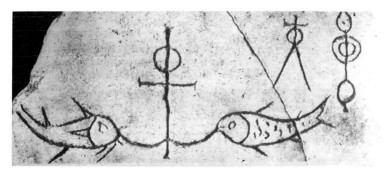

Fish
From the Catacombs, Rome.

147

5:10). The fish is the attribute of a great number of saints and religious characters, among them Andrew (in allusion to his occupation as fisherman); Gregory of Tours (said, like Tobias, to have cured his blind father by feeding him fish liver); Antony of Padua (fish would put their heads above water to hear his sermons), and Judas (who, during the Last Supper, hid behind his back a fish he had stolen).

Cross-references: Antony of Padua, Appearances of the Risen Christ, Brendan, Last Supper, Malo, Multiplication of the Loaves and Fishes, Peter, Raphael, Tobias.

FLAGELLATION OF CHRIST

Variant: Scourging of Christ; Italian: Flagellazione; Spanish: Flagelación; French: Flagellation du Christ; German: Geisselung Christi.

TRADITION
Pilate, after interrogating Jesus, washes his hands, releases Barabbas, and delivers Jesus over to soldiers who beat him with whips stuck with lead and fragments of bone. Matthew (27:26), Mark (15:15) and John (19:1) make a bald statement of the events: "Pilate ... delivered Jesus, when he had [had him] scourged, to be crucified" (Mark 15:15).

REPRESENTATION AND ICONOGRAPHY

The Flagellation of Christ

Dürer. *Albertina Passion*, c.1495 (detail). Albertina, Vienna.

The theme of the scourging of Christ appears in ninth-century psalters; Christ is naked or else wears a simple tunic. From the twelfth century, he is dressed only in a loincloth. In a motif borrowed from the Mocking, he is often shown with his hands crossed. The men who scourge him – there are often just two – are equipped with sticks or whips made from thongs which are either knotted or fitted with metal weights. Christ is tied to a pillar or column. Until the sixteenth century, this pillar had been based on the tall, slender columns of the Church of the Holy Sepulchre in Jerusalem. After the Council of Trent, however, artists tended to adopt as their model the squat, balustrade-like pillar which, since the thirteenth century, had been in the basilica of S. Praxedes in Rome.

Before the fourteenth century, the scene included just three figures, Christ and the two henchmen. Duccio (Maestà, 1308-11, Opera del Duomo, Siena) introduced both Pilate and Jewish onlookers. Giotto figured a black man among the men scourging Christ (1304-6, Arena Chapel, Padua). With the passing centuries, the number of figures continued to grow. Piero della Francesca (1455, Urbino, Galleria Nazionale delle Marche) included three courtly personages. Luca Signorelli's version (c.1480, Pinacoteca di Brera, Milan) appears influenced by Piero's. The violence of the act is brought out particularly in the north (Jörg Ratgeb, Harrenberg altarpeice, 1519, Staatsgalerie, Stuttgart). The theme was particularly popular in the seventeenth century (Rubens, *The Fifteen Mysteries of the Rosary*, c.1614, Saint-Paul, Antwerp).

Christ at the Column
From the fifteenth century on, paintings and sculptures proliferated showing Christ after the Flagellation. Christ, his hands still bound, can be seated on the ground next to the column with an angel pointing him out to a praying child (Velasquez, 1632, National Gallery, London). He is more often

shown alone and still bound to the column (Bramante, c.1490, Pinacoteca di Brera, Milan; A. Cano, 1657, Carmelite Abbey, Avila).

Cross-references: Crowning with Thorns, Crucifixion, Ecce Homo, Mocking of Christ, Trial of Christ
Bibliography: E. Panofsky, "Imago pietatis", *Mélanges Friedländer*, 1927, p. 285. L. Réau, op. cit., vol. II, 2, pp. 451-56. P. D. Running, "The Flagellation of Christ", unpublished dissertation, State University of Iowa, 1951.

FLAME *see* BRIDGET OF SWEDEN (FIVE RED FLAMES). ELIJAH (CONSUMING HOLOCAUST). FAITH (WITH DOVE AND GRIDIRON). IGNATIUS OF LOYOLA (WITH TALAR AND BIRETTA). JANUARIUS (FURNACE AND PHIAL).

FLAMING HEART *see* ANTONY OF PADUA (FRANCISCAN). AUGUSTINE (BISHOP IN BLACK FROCK). BRIDGET (AS ABBESS *or* VEILED). IGNATIUS OF LOYOLA (WITH IHS). MÉDARD (WITH EAGLE *or* HEART).

FLIGHT INTO EGYPT

Latin: Fuga in Aegyptum; Italian: Fuga in Egitto; Spanish: Huida a Egipto; French: Fuite en Egypte; German: Flucht nach Aegypten.

TRADITION
Only the Gospel of St Matthew records this episode (2:13-15). An angel of the Lord comes to Joseph in a dream and orders him to "take the young child and his mother, and flee to Egypt ... for Herod will seek the young child to destroy him. When he arose, he took the young child and his mother by night and departed into Egypt." Apocryphal texts embellished this short passage with a mass of extraneous detail, such as Herod's pursuit of the Holy Family and the miracle of the wheatfield. Hard pressed by Herod's soldiers, the Holy Family meet a man at work in the fields. Mary asks him to tell their pursuers that he had seen the three fugitives while the field was being sown. The wheat growing in the field miraculously shoots up and is ready for harvest when Herod's men arrive. Thinking that the family they seek passed by long before, the soldiers abandon their search. This theme was destined for considerable success in western folklore and a similar miracle occurs in the legend of St Radegund. The apocryphal gospel of Pseudo-Matthew also informs us that the Holy Family ended their journey at Sotina (Hermopolis), "the village of the idols".

REPRESENTATION AND ICONOGRAPHY

Joseph's Dream (Matt. 2:13)
Joseph is warned by an angel in a dream (capital at the Cathedral of Autun, twelfth century; Rembrandt, 1627, Musée de Tours).

The Flight
The central theme has been treated copiously since the fifth or sixth centuries.

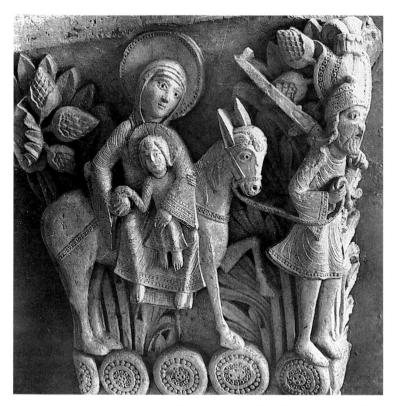

The Flight into Egypt
Capital, twelfth century. St Lazare Cathedral, Autun.

As well as the Virgin, Christ and Joseph, who leads or follows the ass, there often appears an angel to guide them. Artists have also treated the moment when the family makes a halt. In the middle ages, the Flight generally figured as a part of a cycle and was enriched with references to apocryphal texts dealing with the lives of the Virgin or of Jesus. The Flight is habitually combined with the family's arrival at Sotina (Duccio, c.1290, Opera del Duomo, Siena).

Since the end of the medieval period, artists have tended to combine several episodes in a single image. At the turn of the sixteenth century, Flemish painters would place the miraculous wheatfield in the foreground. The pause for rest became the predominant scene in the sixteenth and seventeenth centuries, investing the landscape with a considerable degree of importance. Correggio (*Madonna of the Bowl*, 1530, Pinacoteca Nazionale, Parma) marries the rest to the angel's warning. As examples of the variations of the theme in the seventeenth century, one might cite A. Elsheimer, c.1609, Alte Pinakothek, Munich (nocturnal); Joos II de Momper, c.1600s, Ashmolean Museum, Oxford (snowscape); Murillo, c.1645, Art Institute, Detroit (twilight); Cornelius van Poelenburgh, first half of the sixteenth century, Fogg Art Museum, Cambridge, Mass. (among ruins); Juan Sanchez Cotán, first quarter of the seventeenth century (with still lifes). Poussin, in lavish style, depicted the Virgin, among a mass of draperies and cherubs, seated next to a tree-trunk with the Christ Child standing on her knees (1657, Hermitage, St Petersburg). Boucher, in a painting in the same museum (c.1750), com-

bined the rest with a meeting between the Christ Child and an infant John the Baptist. The theme remained popular throughout the nineteenth century (J. Schnorr von Carolsfeld, 1828, Kunstmuseum, Düsseldorf).

Cross-references: Joseph of Nazareth, Massacre of the Innocents, Nativity.
Bibliography: L. Réau, op. cit., vol. II, 2, pp. 273-88.

FLOOD *see* CREATION, NOAH.

FOUR LIVING CREATURES

This term designates the four living creatures (or animals) in the Book of Ezekiel. They appear again in the Tetramorph, where each one stands for an Evangelist. The Book of Ezekiel describes the prophet's vision (Ez. 1:4-5) in this manner: in the centre of a "great cloud, and a fire infolding itself, and a brightness", the text describes "the likeness of four living creatures." And the text continues: "And every one had four faces and every one had four wings" (*see* Tetramorph).

Cross-references: Christ in Majesty, Evangelists, Ezekiel, Tetramorph.

FOURTEEN HOLY HELPERS

Variant: The Fourteen Auxiliary Saints, Auxiliaries or Intercessors. Latin: Auxiliatores: Italian: i Quattordici santi Ausiliatori; Spanish: los Catorce Intercesores, Auxiliares; French: les Quatorze Intercesseurs; German: die Vierzehn Nothelfer.

TRADITION
The very name of this group of saints witnesses the significance and symbolic value that medieval minds invested in numbers. The idea of a company of saints originates in the notion that their power as protectors might be increased by their acting together. These Intercessors, as they are also called, generally comprise the following: Acacius, Barbara, Blaise, Catherine of Alexandria, Christopher, Cyricus, Denis, Eustace, George, Giles, Margaret of Antioch, Panteleon, Vitus and Erasmus, Bishop of Formiae. The cult of St Barbara in Germany was mainly shown in that of the Fourteen Holy Helpers, a collective cult which grew up in the first quarter of the fifteenth century. Its appearance has been connected to the plague epidemics and endemic state of war during that period. Devotion to them is supposed to have been born in a Dominican monastery in Regensburg and disseminated mainly by German mendicant friars.

REPRESENTATION AND ICONOGRAPHY
The Fourteen Holy Helpers are normally depicted on two levels, either half- or full-length. The composition is sometimes organized around a figure of the Christ Child carried by St Christopher. Most often, the centre is occupied by the Virgin and Child. Works representing the Helpers are nearly all of German origin, dating in the main from the fifteenth and sixteenth centuries, though the best-known shrine, a collection of statues by J. J. M. Kächel, in Balthasar Neumann's Vierzehnheiligen Church on the Main, dates from the 1750s.

Cross-references: Barbara, Blaise, Catherine of Alexandria, Christopher, Cyricus, Denis, Eustace, George, Giles, Margaret, Vitus.
Bibliography: E. Kirschbaum, *Lexikon der christlichen Ikonographie*, Freiburg im Breisgau, 1968-74, *Ikonographie der Heiligen*, cols. 546-50.

FRANCIS OF ASSISI

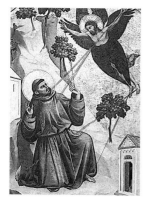

St Francis receiving the Stigmata
Giotto, 1300. Louvre, Paris.

Latin: Franciscus; Italian: Francesco; Spanish: Francisco; French: François; German: Franz, Franziskus.
Founder of the Franciscan Order. 1182-1226. Feast day 4 October.

LIFE AND LEGEND

Francis is the saint whose life has given rise to the greatest number of books, images, studies and commentaries of all kinds. He was the first to be considered the perfect Christian by the Church. He was born in 1182 at Assisi, son of a wealthy draper. Baptized John, he was later known as Francis because his mother was Provençal and his father often travelled to France; since his death it has become one of the commonest baptismal names. After a rather turbulent youth, at 25 he was converted and thenceforth sought to imitate the Lord in every act. After renouncing his inheritance, he lived pennilessly as the *Povorello*, as one who had, in his words, "wed Lady Poverty". Slowly, disciples began to join him and, by 1209, they formed the nucleus of what Francis humbly called the Friars Minor.

They gathered round the tiny chapel of the Portiuncula at the foot of the hill of Assisi. Innocent III, after an initial period of distrust, finally approved their rule and encouraged their work. In 1212, with St Francis' help, Clare of Assisi founded the Order of the Poor Ladies (Poor Clares). About ten years later, a Tertiary Order was created for laymen who wished to live monastically, but without abandoning their position in the world.

As a soldier of Christ, Francis longed to go on a crusade. Three times he tried to go to preach in Islamic territory, but succeeded only once. In 1219, he disembarked in Egypt and was received by the Sultan himself. Back in Umbria, he reshaped his Order, but found it difficult to moderate those friars who wanted to devote themselves to their studies or to possess large and wealthy monasteries. His ideal of absolute poverty was no longer compatible with the size and importance of the movement he had started. He therefore abandoned the Order and went to live alone on Mount La Verna in 1224. There, on the feast of the Exaltation of the Cross, Christ Crucified appeared to him in the guise of a seraph. From his wounds emanated rays of light which impressed corresponding stigmata in the saint's flesh. Henceforth St Francis, by this time almost blind, was venerated as a saint. He survived two more years; and was singing as he died on the night of 3 October 1226.

St Francis became a legend while still alive. Posthumously, the legend grew, and his life was remodelled on that of Christ. Many episodes of Francis' life are juxtaposed with the Lord's and he is credited with countless miracles. Considered practically as God's second son, he was canonized in 1228 and rapidly became the most revered saint in Italy and later in all Christendom. His numerous followers multiplied, disbanded and refashioned the order. To this day, they form the largest of all the religious orders.

REPRESENTATION AND ICONOGRAPHY

St Francis' iconography is vast. Among saints who were not apostles with

Christ, only his companion St Antony of Padua has a comparable number of depictions. Unlike St Antony's, however, St Francis' imagery is not confined to the domain of popular piety, but has been highly influential in the evolution of art and iconography in general.

He is always shown wearing the homespun robe of the Franciscans, tied round his waist with the three-knotted cord, which evokes the three vows of poverty, chastity and obedience (Zurburán, 1645, Musée des Beaux Arts, Lyon). He is identifiable by the stigmata on his hands and feet as well as his chest wound, often visible through a gash in his habit. Artists occasionally show rays of light emanating from his wounds to stress their Christ-like nature. Early on, St Francis is depicted with a beard, but for Giotto (who devoted a large part of his output to the saint) he is clean-shaven and remains so until the sixteenth century. The art of the Counter-Reformation transformed him back into a bearded saint who had become less outgoing and more sorrowful (Pedro de Mena, 1663, wooden polychrome statue, Toledo Cathedral). Episodes from all periods of his life have provided source material for images in every shape and form.

Beginning in Italy, his iconography had spread throughout Christendom by the end of the middle ages: cycles often follow his life story as described by Thomas of Celano and above all by St Bonaventura (Master of the St Francis Cycle, c.1295, Upper Church of St Francis, Assisi, Sassetta, cycle, 1437-44, panels in National Gallery, London; Borgo San Sepolcro, Siena; Berenson Collection, Florence, etc.). He is depicted being born in a stable like Christ; renouncing his father's inheritance (in such scenes he can be shown naked: Giovanni di Paolo [attributed], c.1440, illustration for *The Divine Comedy*); engaging in a mystic marriage with Lady Poverty (Ottavino Nelli, second quarter of the fifteenth century, Vatican Gallery) and performing all kinds of miracles. Pope Innocent III is shown approving his rule; the Sultan of Egypt receives him during his travels (Fra Angelico, first half of the fifteenth century, Lindenau Museum, Altenburg, Germany); and St Dominic embraces him fraternally. He is represented creating a crib in Greccio in remembrance of his pilgrimage to Bethlehem, preaching to the birds, and taming a wolf which had been terrorizing the town of Gubbio (Sassetta, fifteenth century, National Gallery, London).

Two episodes have received particular attention from artists and makers of religious images: the impression of the stigmata at Mount La Verna (Giotto, 1300, Louvre, Paris) and his death at the Portiuncula. In the stigmatization, the Christ-seraph is on the Cross and streams of blood or golden beams emanate from his wounds and extend down into the saint's body. There is often a single witness to the events, Friar Leon, who is shown half-asleep or blinded by the light (Hans Fries, 1501, Alte Pinakothek, Munich), while Francis himself is in ecstasy (Giovanni Bellini, 1470s, Frick Collection, New York; a late baroque version in Brazil shows the extent and continuance of the tradition, Manoel da Costa da Ataáde, 1816-17, São Francesco, Mariana). The saint's death gave rise to more conventional imagery (Bartolomé Carducho, 1593, Museu Nacional, Lisbon): surrounded by his brothers fervently kissing his stigmata, a sanctified St Francis lies peacefully. Angels come and carry off his soul to heaven and occasionally St Clare is shown bending over his body like Mary at the Pietà.

Attributes: Homespun habit and three-knotted cord. Stigmata. Crucifix.
Cross-references: Clare, Dominic, Franciscans.

FRANCIS XAVIER

Latin: Franciscus Xaverius, Xaverius Japonicus; Italian: Francesco Saverio; Spanish: Francisco Javier; French: François Xavier; German: Franziskus Xaverius, Franz Xaver.
Jesuit and missionary. 1506-52. Canonized 1622. Feast day 3 December.

LIFE AND LEGEND

Francis was born in the castle of Javier in the diocese of Pamplona to an aristocratic family from Navarre. In 1529, while studying at the University of Paris, he encountered Ignatius Loyola. He took vows of chastity and poverty, and swore to make a pilgrimage to Jerusalem. Having managed to get as far as Venice, he was forced to curtail his journey as the sea route was cut off by the Barbary fleet. In Rome, he took an active part in the meeting at which Loyola and his companions prepared the ground for the foundation of the Society of Jesus. The pope assigned to Francis the task of answering King John III of Portugal's plea for prelates able to give support to the converts (the paravers) on the south Indian coast.

Xavier set off in the dual posts of royal envoy and papal legate and, on 6 May 1542, landed in Goa, the capital of the Portuguese Indies. After three years of missionary work among the paravers, he went first to Malacca, then on to Amboina, whence he tried to convert the inhabitants of the Moluccas. His supposed gifts as a faith healer made Francis especially popular among these peoples and his efforts were later seen as the epitome of the missionary zeal of the Jesuits. In 1547 Francis returned to Goa in preparation for his last great mission, to Japan. He left Malacca on a Chinese junk, arriving in Kagoshima on 15 August 1549. After two years in Japan, where he managed to gather a Christian community of some five thousand, he returned once again to Goa. In Japan he had shown his renowned sense for varying his evangelism in response to the circumstances, by using more sophisticated techniques of conversion than the mass baptisms he had employed in India.

Wherever he went, Francis was concerned to bequeathe religious administrations which would gain the confidence of the local populace, and to this end he composed a series of short treatises. His letters are a fund of missionary technique and comprise detailed expositions of the Catholic faith. He died on the island of Chan-Chuen-Shan (Shangchwan) on a final journey from Malacca to China, on 13 December 1552.

One legend recounts how, during a storm in the Moluccas, Francis tried to calm the waves by holding his crucifix over them, but a huge wave swept it overboard. Once safely on shore, Francis saw a large crab coming towards him, carrying the cross between its pincers.

REPRESENTATION AND ICONOGRAPHY

The crab mentioned in his legend occasionally serves to identify Francis who is often shown in distant exotic lands or on the sea shore. In Goa, numerous representations are to be found, especially in the main Jesuit church, where G.-B. Foggini (1691-97) painted a cycle of his life and legend. As with other important missionaries, Francis is often depicted curing the sick (Rubens, 1619, Kunsthistorisches Museum, Vienna). G.-B. Gaulli (il Baciccio), the artist of the main Jesuit church in Rome, the Gesù, decorated S. Andrea al Quirinale with several scenes from Francis' life (late seventeenth century).

In later art, a certain amount of stylization and idealization surface: Goya

depicted the missionary dying in ecstasy in a Franciscan habit (1771-75, Museo Provincal de Bellas Artes, Saragossa: he lies on the sea shore, while a ship passes in the distance, and shells hang from his vestment), while in Joseph-Marie Vien's painting of his mission (1753, Versailles), a certain unexpected Chinoiserie is apparent.

Attributes: Jesuit biretta or talar. Crab. Exotic setting. Ship.
Bibliography: E. Kirschbaum, *Lexikon der christlichen Ikonographie*, Freiburg im Breisgau, 1968-74, vol. V, cols. 324-27. L. Réau, op. cit., vol. III, i, pp. 538-41.

FRANCISCANS

Variants: Greyfriars, Friars Minor. Italian: Franciscani, Frati Minori; Spanish: Franciscanos, Frailes Menorcs; French: Franciscans, Frères mineurs, cordeliers; German: Franziskaner, Minoriten.

They wear a simple hooded habit of brownish homespun. They also wear a three-knotted cord around their waist which earns them the name of cordeliers in France.
Type: Francis of Assisi.

Cross-references: Antony of Padua, Elizabeth of Hungary, Francis of Assisi, Louis, Ivo.
Bibliography: G. and M. Duchet-Suchaux, *Les Ordres réligieux: Guide historique*, Paris, 1993.

FURNACE *see* DANIEL (WITH HEBREWS), HELL, JANUARIUS.

St Francis of Assisi in Franciscan Habit
Zurbarán, 1645. Musée des Beaux Arts, Lyon.

GABRIEL

Italian: Gabriele, Gabriello; Spanish, French and German: Gabriel.
Archangel. Feast days 13 July and 29 September.

TRADITION
The archangel first appears in the Book of Daniel (8:15-27; 9:20-27). His name means "Man of God" or "Man in whom God has trust". God's messenger, he intervenes in the annunciation to Zachariah of the birth of John the Baptist (Luke 1:11-20). He is sent by God to Nazareth to apprise Mary that she will give birth to Jesus (Luke 1:26-38). The various apocryphal texts are

full of information concerning the archangel Gabriel: he is a guardian angel and shares with St Michael the responsibility of preventing demons from entering churches. On 1 April 1951 he was made patron saint of telecommunications.

REPRESENTATION AND ICONOGRAPHY

Gabriel is for the most part depicted as a beardless youth. From the fifth century, he was winged and had a nimbus (mosaics, S. Maria Maggiore, Rome, fifth century). In Italy, from the fourteenth century on, he possessed feminine features, a tendency that persisted well into the seventeenth century. For the Annunciation, he wears a long tunic or liturgical vestments (Melozzo da Forli, fifteenth century, Uffizi, Florence). He can be found at Zachariah's side, facing an altar where incense burns.

Attributes: Messenger's staff. Lily. Sceptre (occasionally). Scroll (with message to Mary: *Ave Maria Gratia Plena*). Unicorn (he hunts).
Cross-references: Annunciation, Archangels, Elisabeth, John the Baptist, Michael, Visitation, Zachariah.

GALL

Variants: Gallech, Gilianus, Gallus. Latin: Gallus; Italian: Gallo; Spanish: Galo; French: Gall; German: Gallen, Gallus.
Benedictine abbot. Died c.640. Feast day 16 October.

TRADITION

Gall, an Irish companion of St Columban, went with him to France and shared in the founding of the abbey of Luxeuil in the Vosges. Growing sick, he remained in Switzerland from 612. He founded the hermitage of St Gallen on the shores of Lake Constance, where he was later buried. According to

St Gall
R. Sadeler, after Martin de Vos, seventeenth century. Bibliothèque Nationale, Paris.

legend, a bear helped St Gall build his hermitage after he had pulled a thorn from its foot. His cult spread to Rhineland Switzerland and thence to southern Germany, Bohemia and Hungary.

REPRESENTATION AND ICONOGRAPHY

St Gall is represented as a Benedictine monk with a crozier, or else in full abbot's habit. An ivory plaque (c.900, St Gallen Library) links the episode of the bear bringing St Gall a wooden trunk to the Assumption of the Virgin. He is also shown giving the bear bread in return for his assistance. A miniature (manuscript of the life of St Gall, 1452, St Gallen Library), shows Columban and Gall crossing Lake Constance in a small boat. Many wooden statues and carved wood reliefs from the fifteenth to the eighteenth centuries to be found in St Gallen and the surrounding region depict him.

Attributes: Bear. Abbot's crozier.
Bibliography: *Sankt Gallus*, Gedenkenbuch, St Gallen, 1952.

GARDEN OF GETHSEMANE *or* OF OLIVES *see* AGONY IN THE GARDEN.

GENEALOGY OF CHRIST *see* TREE OF JESSE.

GENEVIEVE

Latin: Genofeva; Italian: Genoveffa; Spanish: Genoveva; French: Geneviève; German: Genovefa.
Virgin. Died c.500. Feast day 3 January

LIFE AND LEGEND

Passing through Nanterre, Bishop Germanus of Auxerre noticed the piety of eight-year-old Genevieve. One day, her mother was struck blind after slapping her, but her sight was immediately restored when Genevieve used water she had sanctified. At 15, she took the veil. She was at one point a victim of slander, but Germanus took up her defence. She was instrumental in the construction of the first basilica of St Denis, in Paris. One night, when visiting the site with her fellow-sisters, the wind blew out the altar candle they were carrying to light the way. Geneviève took the candle, and it immediately relit and the flame then withstood every gust of wind. During the invasion of Attila the Hun, she managed, though with some difficulty, to prevent the inhabitants of Paris from panicking and abandoning the city. At her death, her royal friends, Clovis and Clotilde, built a church on her tomb, initially dedicated to St Peter, but which rapidly became known as St Geneviève. She is the patron of Paris.

REPRESENTATION AND ICONOGRAPHY

Until the sixteenth century, Genevieve was generally depicted in the dress of a young noblewoman, and only rarely as a nun. She holds an altar candle which a demon tries to blow out and an angel keeps alight (*Belles Heures du duc de Berry*, 1407-8, Cloisters, Metropolitan Museum of Art, New York). In another scene, she restores her mother's sight. Hugo Van der Goes showed her with a devil on her arm trying to blow out her candle (c.1470s,

St Genevieve
Hugo van der Goes, c.1470s.
Kunsthistorisches Museum, Vienna.

Kunsthistorisches Museum, Vienna).

There was a radical change at the end of the fifteenth century, when the noblewoman suddenly turned into a shepherdess with her flock. This transformation could be linked to the appearance of the *Pastrix bona*, the Virgin's counterpart to the Good Shepherd (but this motif really surfaced only during the seventeenth century) or to a possible confusion with the early life of St Joan of Arc. Genevieve is shown seated, carrying a shepherd's crook in the middle of a cromlech surrounded by sheep (Fontainebleau School, St Merry Church, Paris). In the nineteenth century, Puvis de Chavannes dedicated a whole cycle to her childhood (1874, Panthéon, formerly Church of St Geneviève, Paris).

Attributes: Candle (and Devil). Book. Shepherd's crook.
Cross-references: Germanus, Good Shepherd, Pastrix bona.
Bibliography: L. Beaumont-Maillet, *Sainte Geneviève de Paris*, Paris, 1982.

GEORGE

Latin: Georgius; Italian: Giorgio; Spanish: Jorge; French: Georges; German: Georg.
Martyr. Died c.300. Feast day 23 April.

LIFE AND LEGEND

George is a totally fictive saint, whose very existence theologians had already begun to doubt by the fifth century. His cult was born in the east and remains particularly strong in Greece and Russia. The crusades contributed to its spread to the west where St George became one of the patron saints of Genoa, Venice and Barcelona, as well as that of the Teutonic Order (thirteenth century) and of England (where he replaced Edward the Confessor). St George was also the patron of all Christian knights.

Allegedly born in Cappadocia of Christian parentage, George became an officer in the Roman army. One day, he was travelling through a city terrorized by a fearsome dragon. The animal not only devoured all the cattle of the surrounding countryside but also insisted on a daily tribute of two young people chosen by lot. St George arrived just as the monster was about to devour the king's daughter. The knight joins battle with the dragon and, with Christ's help, overcomes it. The princess is set free, while the dragon, according to *The Golden Legend* and other versions, is merely wounded and henceforth follows her like a dog on a leash. Later, George falls victim to Diocletian's persecutions and is horribly martyred in Palestine: after miraculously surviving being burnt, boiled and crushed under a wheel, he was finally beheaded.

REPRESENTATION AND ICONOGRAPHY

St George, the personification of knightly ideals, is shown armed on horseback (the horse is usually white), sporting a banner, silver with a red cross. The red cross on a white ground was the crusaders' banner and later became the English national flag. The combat between St George and the dragon symbolizes the triumph of good over evil and is an extremely common subject, above all from the thirteenth century (icon, Novgorod School, end of the fourteenth century, Ostroklov Collection, Moscow; Donatello, marble, 1416, Bargello, Florence). George carries a lance (more rarely, a sword) and slays the monster (Michel Colombe, relief altar from the Château de Gaillon, 1508,

St George Killing the Dragon
Icon, School of Novgorod, fifteenth century. Tretiakov Gallery, Moscow.

Louvre, Paris; Carpaccio, 1502-7, Scuola San Giorgio degli Schiavoni, Venice; Cosmè Tura, 1469, Museo del Duomo, Ferrara; Uccello, c.1456, National Gallery, London, shows the dragon already leashed, while in his version c.1450-60, Musée Jacquemart-André, Paris, the two-legged animal attacks). The princess can be shown praying, in the background (Raphael, c.1504, Louvre, Paris). In L. Beck's version (c.1515, Kunsthistorisches Museum, Vienna), he has also killed one of the dragon's offspring. The scene occurs in the shadow of the city walls, or near the seashore (Altdorfer, 1510, Alte Pinakothek, Munich, presents the figures lost in a landscape). A rococo depiction by Egid Quirin Asam (1717-21, high altar, Weltenburg) shows the knight covered in black and gold armour and sporting golden plumes. He can also appear in the company of other saints (with St Christopher, Paris Bordone, c.1525, Galleria dell'Accademia di Belle Arte "Tadini", Lovere).

St George's passion has also given rise to a rich iconography (Altichiero da Zevio, c.1384, Cappella San Giorgio, Duomo, Padua; and, in polychrome sculpture, Jan Borman, 1493, Musée des Antiquités, Brussels). The most frequent scene shows him on a wheel stuck with blades (e.g. Marzal de Sas, c.1410s-20s, Victoria and Albert Museum, London).

Attributes: Dragon. White banner with red cross. Broken lance.

GERMANUS OF AUXERRE

Latin: Germanus; Italian: Germano; Spanish: German; French: Germain; German: Germane.
Bishop. Died c.448. Feast day 31 July.

LIFE AND LEGEND
Born in Auxerre of Romano-Gallican parents, Germanus was married and a governor when the local bishop, Amator, nominated him as his successor in 418. Germanus led a monkish life, giving away his property to the poor. In 429 and again in 447, he travelled to England with St Lupus of Troyes to fight against the Pelagian heresy, which rejected the concept of original sin. He saved the Britons from defeat at the hands of an alliance of Picts and Saxons. Passing through Nanterre on his way to Paris, he blessed the young St Genevieve. An episode in the *Golden Legend* relates how, while he was still governor of Auxerre, he was so proud of his hunting exploits that he would hang the carcasses of the animals he killed from the branches of one of his pine trees. He died at Ravenna in 448, whence he had gone to plead the cause of the rebellious Bretons. The Empress Galla Placidia had his body embalmed and, according to legend, placed on an ox-cart to be sent back to Auxerre with an honorary escort.

REPRESENTATION AND ICONOGRAPHY
Germanus is represented as a bishop with mitre and crozier (trumeau statue for the portal of St Germain l'Auxerrois, Paris, twelfth century, now in a chapel). He is often found in conjunction with his namesake, Germanus of Paris, with St Genevieve and St Lupus of Troyes.

St Germanus
Fifteenth century. St Germain l'Auxerrois, Paris.

The details of his life cycle were fixed in the fourteenth century (tympanum of the cloister at the abbey church of St Germain l'Auxerrois, Paris). On horseback, he pursues a hind; he hangs his trophies from a tree; he dedicates St Genevieve to God. Among the other elements of the cycle, the tympanum of the north door at Auxerre (fifteenth century) presents a series show-

ing the journey of St Germanus' body from Ravenna back to his birthplace. His corpse lies on an ox-cart and is followed by a bishop on horseback. Puvis de Chavannes (cycle of St Genevieve's childhood, 1874, Panthéon, Paris) has Germanus blessing the young St Genevieve as he passes through Nanterre with St Lupus.

Attributes: Mitre. Crozier.
Cross-references: Genevieve.
Bibliography: G. Le Bras, *Saint Germain d'Auxerre et son temps*, Auxerre, 1950.

GETHSEMANE *see* AGONY IN THE GARDEN, ARREST OF CHRIST.

GIANTS *see* CHRISTOPHER, SAMSON.

GILES

St Giles
Woodcut from James of Voragine's *Golden Legend*, 1483 edition.

Variant, Latin and German: Aegidius; Italian: Egidio, Gilio; French: Gilles. Benedictine abbot. Died c.725. Feast day 1 September.

LIFE AND LEGEND

This Benedictine abbot's life is almost entirely legendary. Born in Athens, he made his way to Rome before retiring into a forest between Arles and Nîmes in southern France. He lived there as a hermit surviving on milk from a tame doe. One day, the king, out hunting, wounded both the deer and the hermit. In repentence, he built a monastery nearby of which Giles became the abbot. This story is linked to the legend of the foundation of the Abbey of St Gilles (Gard, France), an important place of pilgrimage, containing the saint's relics, on the way to Santiago de Compostella. The abbey was also the main port for boats from France to the Holy Land before the building of Aigues-Mortes in the thirteenth century.

As an abbot, Giles gives counsel to popes and kings. Legend tells how Charles Martel (often incorrectly replaced in this episode by Charlemagne) asks absolution for a sin so vile that he is unable to confess it. Later, when St Giles is celebrating Mass, an angel appears carrying a piece of parchment inscribed with the name of the offence (it was incest with his sister) and places it on the altar. As Giles pronounces his prayers, the writing on the parchment slowly vanishes.

In the middle ages, the cult of Giles gained in currency, not only in Provence, but in all Latin Christendom. He became the saint to whom people most enthusiastically confessed their sins, for he guaranteed them absolution. He was repudiated, however, both by the Reformation and the Council of Trent.

REPRESENTATION AND ICONOGRAPHY

Giles is sometimes shown as a hermit (when his attribute is the doe who fed him) and sometimes as a Benedictine abbot complete with crozier. In Italy, he is occasionally provided with a lily, since his name Gilio and that of the flower, *giglio*, are very {imilar.

Two particular episodes have attracted artists. Giles protects a doe pur-

St George Killing the Dragon. Raphael, 1505. Louvre, Paris.

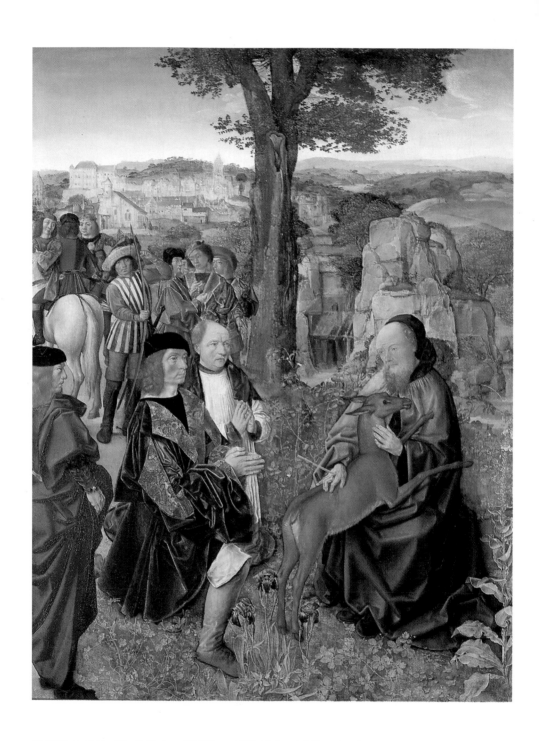

St Giles and the Hind. Master of St Giles, c.1500. National Gallery, London.

sued by huntsmen (stained glass, sixteenth century, St Nizier, Troyes); he says Mass (the "Mass of St Giles") during which he expurgates Charles Martel's mortal sin (Charlemagne reliquary, 1215, Cathedral of Aachen, where the episode is attributed to Charlemagne).

Attributes: Doe. Abbot's crozier. Lily.

GLEB *see* BORIS AND GLEB.

GLOBE *see* ARCHANGEL, SIBYLS, VITUS.

GOBLET *see* BENEDICT, OLAF (WITH LID).

GOD

Latin: Deus; Italian: Dio; Spanish: Dies; French: Dieu; German: Gott.

REPRESENTATION AND ICONOGRAPHY

God
Stained glass, Chapelle Jacques Coeur, Bourges Cathedral, c.1450.

The Bible expressly proscribes any representation of the eternal: "Thou canst not see my face: for there shall no man see me, and live" (Ex. 33:20). Mosaic Law, as inscribed on the Tables of Mount Sinai, prohibits any physical likeness of Jehovah. Deuteronomy reiterates this interdict: "Cursed be the man that maketh any graven or molten image, an abomination unto the Lord" (27:15). The early Church Fathers subscribed to this tradition and, in the pale ochristian period, artists invoked God indirectly by signs, never employing any figurative representations. Among the symbols used are the Burning Bush and the pillar of fire which led the Hebrews to the Promised Land.

The Triangle

An equilateral triangle, sometimes in conjunction with the monogram of Christ or alpha and amega, can be enlisted to symbolize the godhead. It is still found with this original signification in the sixteenth and seventeenth centuries, inscribed with the Hebrew name for God. In the middle ages, however, it had come to stand for the Trinity. In the eighteenth century, the Eye of God often replaces the Hebrew inscription.

The Hand of God

Another sign was employed right up to the modern period to signify God's omnipotence: the Hand of God emerging from a cloud. It appears frequently in depictions of Abel's offering to Cain, of the divine commandment to Noah instructing him to build the Ark, in the Sacrifice of Isaac, and when Moses receives the Tables of the Law. The Hand of God is also seen blessing Jesus in the Garden of Gethsemane, at Golgotha and during the Ascension (*see* Hand of God).

The Ancient of Days

This tradition derives essentially from two sources. The Mesopotamian God, El, known from the religious texts at Ras Shamra (fourteenth to thirteenth centuries BC), is the father of the gods and of men, an old man with a white beard, inhabiting a mysterious land in the depths of the abyss, at the foun-

tainhead of all rivers. Secondly, a vision of the prophet Daniel (Dan. 7:9) corresponds to this version: "The Ancient of days did sit, whose garment was white as snow, and the hair of his head like the pure wool" (William Blake, etching, early nineteenth century, Whitworth Art Gallery, Manchester). The Ancient of Days is depicted as an old man with a full white beard, seated on the clouds arranged in a mandorla (Niccolo Pizzolo, second quarter of the fifteenth century, Chapel Ovetari agli Eremitani, Padua). The baroque and later art continued using this traditional likeness.

As Pope or Emperor
By the end of the fourteenth and beginning of the fifteenth centuries, the divine patriarch is seated beneath a canopy. He wears an imperial crown or, more often, a five-tiered tiara and carries a globe topped with a cross.

Cross-references: Burning Bush, Christ in Majesty, Creation, Daniel, Exodus, Hand of God, Holy Spirit, Jesus, Monogram of Christ, Pantocrator, Trinity.
Bibliography: L. Réau, op. cit., vol. II, 1, p. 8.

GOLD RING *see* EDWARD THE CONFESSOR.

GOLDEN CALF

Italian: Vitello d'oro; Spanish: Becerro de oro; French: Veau d'or; German: goldene Kalb.

TRADITION
The Jewish people, while Moses was on Mount Sinai receiving the Tables of the Law, asked Aaron to make them "gods, which shall go before us" (Ex. 32:1). Aaron demanded all their gold earrings and moulded them into a Golden Calf. The Hebrews offered up sacrifices to their new idol. Moses,

The Adoration of the Golden Calf
Ingeburghe Psalter, 1210.
Musée Condé, Chantilly.

descending with the Law, heard singing and saw the people dancing around the Golden Calf. Enraged, he smashed the Tables of the Law. He then took "the calf which they had made and burnt it in the fire, and ground it to powder, and strawed it upon the water, and made the children of Israel drink of it" (Ex. 32:20). Christianity has traditionally identified the Golden Calf with Satan and has seen in the people's adoration a prototype of idolatry. Since the twelfth century, Christian theologians have interpreted Moses smashing the Tables of the Law as a symbol of the inefficacy of the Old Testament.

REPRESENTATION AND ICONOGRAPHY

The various scenes – from the building of the Golden Calf to its destruction – are incorporated into Moses cycles with a moralizing or symbolic purpose. The Golden Calf stands on an altar (Raphael, 1518-19, Logge, Vatican) or on the top of a column. Another dramatic version is Tintoretto's for S. Maria dell'Orto, Venice, 1560s.

In the Low Countries, during the sixteenth century, artists tended to stress the dance around the idol and the Jews' feasting as a symbol of the vice of luxury ("and the people sat down to eat and to drink", Ex. 32:6). This type became prevalent in France (Poussin, 1633-5, National Gallery, London) and in Italy (D. Gargiulo, mid seventeenth century, Hermitage, St Petersburg), and the sequence tended to lose its symbolic character, with the emphasis going towards the picturesque. The theme reappeared in Expressionist art (Nolde, 1910, Foundation Nolde, Seebüll); Kirchner, 1930s, Musée National d'Art Moderne, Paris). Moses could be shown breaking the Tables over the Calf itself, from which a demon emerges (capital, Vézelay Basilica, twelfth century). From the fifteenth century, this theme became frequent in Italy.

Cross-references: Aaron, Moses.

GOLGOTHA *see* CRUCIFIXION.

GOLIATH *see* DAVID.

GOOD SAMARITAN

Italian: il Samaritano; Spanish: el Samaritano; French: le bon Samaritain; German: der gute Samariter.

TRADITION

The parable of the Good Samaritan is recorded by St Luke (10:30-35) as an answer to a question put to him by a scribe: "Who is my neighbour?" One day, a man travelling from Jerusalem to Jericho is attacked by robbers who wound him, strip him naked and leave him for dead. A priest comes past but does not offer help. He is followed by a Levite who even "looked on" the injured man before he "passed by on the other side". A Samaritan (member of a race despised by the Hebrews) sees the wounded man, approaches him and treats his wounds with oil and wine. He then takes him to an inn and pays the bill. For Origen (early third century), the victim was Adam and the Samaritan Christ, Jerusalem was Paradise while Jericho stood for the earth, the priest incarnated the Old Law and the Levite symbolized the prophets.

The Good Samaritan
Rembrandt, 1633.
Rijksmuseum, Amsterdam.

REPRESENTATION AND ICONOGRAPHY
The oldest illustration of this parable is to be found in a sixth-century Byzantine manuscript, where Christ is assimilated to the Good Samaritan while an angel assists him in his act of mercy. In the west, six scenes from the parables are linked to the creation of Adam and Eve, to the expulsion and to Christ giving his benediction (large stained glass, Chartres Cathedral, twelfth century). Still in France, the same symbolic interpretation figures on the stained-glass series in the cathedrals of Sens, Bourges and Rouen. The theme remains common from the sixteenth century (J. Bassano, c.1560, Galleria Capitolina, Rome; D. Feti, first quarter of the seventeenth century, Fine Arts Gallery, San Diego, California) to the nineteenth century (Rodolphe Bresdin, engraving, 1860, Bibliothèque Nationale, Paris). The Samaritan is often shown in the foreground, treating the man's wounds, while in the background the priest and the Levite pass by. Rembrandt treats the arrival at the inn (1630, Wallace Collection, London); Delacroix (1849, Private Collection, Paris) illustrates the moment when the Samaritan puts the victim "on his own beast".

Cross-reference: Adam and Eve.
Bibliography: L. Réau, op. cit., vol. II, 2, pp. 231-33.

GOOD SHEPHERD

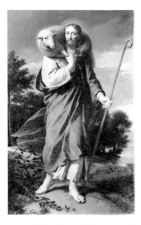

The Good Shepherd
Philippe de Champaigne,
c.1654. Musée des Granges
de Port-Royal.

Latin: Pastor bonus; Italian: il buon Pastore; Spanish: el Buen Pastor; French: le Bon Pasteur; German: de gute Hirt.

TRADITION
The parable of the Good Shepherd who goes in search of the lost sheep occurs in Matthew 18:12-13 and Luke 15 (the lost sheep), and John (10:1-6). The theme is prefigured in Psalm 23: "The Lord is my shepherd," and also in the Book of Ezechiel (34:12-16): "As a shepherd seeketh out his flock in the day ... I will feed them in good pasture ... I will cause them to lie down ... I will seek that which was lost." It also occurs in Isaiah (40:11): "He will feed his flock like a shepherd." For the Christian tradition, the symbolism of this motif is clear: the Good Shepherd is Christ who is always ready to save a sinner who repents.

REPRESENTATION AND ICONOGRAPHY
The Good Shepherd is often portrayed in painting (walls and ceilings of certain catacombs, second century), and relief sculpture on the sarcophagi (e.g. second and third centuries, Lateran Museum, Rome). Two different versions were prevalent in early Christian art. The Good Shepherd watches over his flock: he stands or sits amid his sheep, ready to defend them against the rapacious wolf (mosaic in the mausoleum of Galla Placidia in Ravenna, fifth century). This theme is associated with Orpheus, a figure who appears in art of the paleochristian period as a symbolic likeness of Christ. A more frequent version shows the Shepherd coming back carrying the lost sheep on his shoulders. This motif derives from ancient *moscophore* prototypes or from Hermes *criophore*, Hermes carrying the ram (fresco, chapel in Dura-Europos, c.245; paintings in the Roman catacombs of Priscilla, Domitilla and Callista).

The theme disappeared in the middle ages to return again occasionally during the sixteenth century. In the seventeenth century Philippe de

Champaigne treated it (1654, Musée des Granges de Port-Royal). The motif reappears in the theme of the *Pastrix bona* or the Virgin as shepherdess. The transformation of St Genevieve into a shepherdess in seventeenth-century art is probably connected with the *Pastrix bona*.

Attribute: Sheep (ewe) on shoulders.
Cross-references: Genevieve, Pastrix bona.
Bibliography: J.-M. Tézé, *Théophanies du Christ*, Paris, 1988.

GOOSE *see* MARTIN.

GOSPEL *see* BIBLE, EVANGELIST.

GREGORY THE GREAT

Latin: Gregorius Magnus; Italian: Gregorio Magno; French: Grégoire le Grand; German: Gregor der Grosse.
Pope and Doctor of the Church. c.540-604. Feast day 3 September.

LIFE AND LEGEND

Of the numerous St Gregorys (there are at least eight, including the historian of the Franks, Gregory of Tours, who died in 594), Gregory the Great is the most famous and the most important for the history of Christendom and the Church. Born in Rome around 540, he became Benedictine abbot of a monastery he founded on his family's land, and Pope in 590. A prodigious administrator and reformer (particularly in matters of liturgy), he was also an erudite philosopher and theologian, composer of numerous works which had a profound influence on medieval thought. He is one of the Four Latin Doctors of the western Church (with Augustine, Ambrose and Jerome). His name will always be associated with Gregorian Chant (plainsong), and he sent early missionaries to England.

REPRESENTATION AND ICONOGRAPHY

Gregory the Great is shown in papal garb. He can be depicted writing under the inspiration of the dove of the Holy Spirit and being observed by his young deacon and secretary, Peter (miniature, *Sacramentary*, St Denis, ninth century (?), Bibliothèque Nationale, Paris; Master of the *Registrum Gregorii*, c.984, Staatsbibliothek, Trier). He is also represented at prayer, interceding for the souls in Purgatory. Legend recounts how in this way he saved Emperor Trajan, a figure who, despite his paganism, was admired in the middle ages for his justice.

At the end of the middle ages, and in the sixteenth century, another motif with a dogmatic message began to be widespread: the Mass of St Gregory. One day, during the celebration of Mass by Pope Gregory, one of the servers began to doubt the real presence in the Eucharist. St Gregory started to pray and Christ himself descended from heaven to appear to the faithful, showing his stigmata and surrounded by the instruments of his Passion (from the century during which the theme was most popular: Master of St Bartholomew, c.1480-1500, Wallraf-Richartz Museum, Cologne; Pedro Berruguete, last quarter of the fifteenth century, Museo Arqueologico, Burgos;

St Gregory the Great
Zurbarán, 1626-7. Museo Provincal de Bellas Artes, Seville.

and, with the whole panoply of the Crucifixion, Master of Flémalle, first half of the fifteenth century, Musée des Beaux Arts, Brussels). Artists have tended to linger over the wounds of Christ and add other instruments and figures related to his Passion (Baldung Grien, c.1518, Museum of Art, Cleveland, Ohio; G.-B. Crespi, c.1615, S. Vittore, Varese, adds angels).

Attributes: Papal crozier (three crosspieces). Tiara. Dove.
Bibliography: G. and M. Duchet-Suchaux, *Les Ordres réligieux: Guide historique*, Paris, 1993.

GRIDDLE, GRIDIRON *see* BLANDINA (WITH NET AND BULL), FAITH (WITH DOVE), LAURENCE (WITH CROSS *or* CHALICE), MACCABEES, SOPHIA (QUEEN AND THREE DAUGHTERS), VINCENT OF SARAGOSSA (WITH CROSS SALTIRE *or* MILLSTONE).

GUDULE

Variant, Latin and Spanish: Gudula; Italian: Guedela; French: Gudule; German: Gudula, Guda, Gudrun.
Virgin. Died 712. Feast day 8 January.

LIFE AND LEGEND
Born of a noble family in Brabant, she was brought up by her stepmother and spent her time in penitence and prayer. The most famous episode of her legend – in a duplicate of that of St Genevieve of Paris – shows her one night in a faraway church at her devotions, keeping alight a lantern which a demon persists in trying to extinguish, by virtue of her piety alone. She is the patron saint of Brussels.

REPRESENTATION AND ICONOGRAPHY
Dressed in a long robe, Gudule wears a bonnet. In a grisaille (Everart Van Orley, sixteenth century, Church of St James, Antwerp), it is a candle that

St Gudule
Misericord, fifteenth century. Musée des Beaux Arts, Troyes.

the angel keeps alight, and the demon who attempts to blow it out bites his arm in frustration. In most cases, however, a lantern is shown, while the devil is equipped with a pair of bellows. This allows Gudule to be distinguished from Genevieve, who is always shown with a candle. Joos van Cleve depicts the demon hanging from Gudule's lantern (triptych, *Death of the Virgin Mary*, 1530, Alte Pinakothek, Munich).

Attributes: Lantern. Bellows.

HAIR *see* AGNES (WITH LAMB), DELILAH (CUTTING SAMSON'S HAIR), EULALIA (WITH DOVE AND CROSS SALTIRE), MARY OF EGYPT (AGED, WITH THREE LOAVES), MARY MAGDALENE, SAMSON (DELILAH CUTTING HIS HAIR).

HALO *see* NIMBUS.

HAND OF GOD

Latin: Dextra Dei; Italian: Braccio raggiante di Dio, Dextra divina; Spanish: Diestra del Señor; French: Main de Dieu; German: Hand Gottes, die Rechte des Herrn.

TRADITION

In the Old Testament, the hand symbolizes God's omnipotence. Among many Biblical references can be cited Deuteronomy 2:15: "For indeed the hand of the Lord was against them, to destroy them from among the host" and 1 Samuel (5:6): "The hand of the Lord was heavy upon them of Ashdod, and he destroyed them." The image is taken up in the New Testament, for example in St Luke: "And the hand of the Lord was with him [the Christ Child]" (1:66), and in St John: "No man is able to pluck them [Christ's sheep] out my father's hand" (10:29).

REPRESENTATION AND ICONOGRAPHY

The divine hand is the main figurative form of God the Father from the fourth to the eighth centuries. It symbolizes the Voice of God and its active intercession in earthly life. More rarely, it represents Christ or the Holy Spirit. Most often, it emerges from the sky sometimes with three beams of light emanating from it, symbolizing the Trinity.

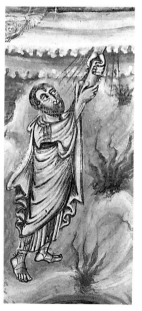

The Hand of God
Grandval Bible, ninth century (detail). British Library, London.

This figuration of divine power is present in early Jewish art. The Hand of God can be seen in Ezekiel's visions (Synagogue at Dura-Europos, c.245). Introduced into the west during the period of Constantine, the motif is widespread until the thirteenth century, before becoming rare and then disappearing entirely.

The Hand appears in paleochristian art in several Old Testament episodes: the sacrifice of Isaac, and Moses being presented with the Tables of the Law, for example (catacombs, Via Latina, Rome; c.430, carved decoration on the door of the Church of S. Sabina, Rome). The Hand of God is also nearby during certain scenes of the Life of Christ (Baptism, Transfiguration) and here also symbolizes the Voice of God. During the Ascension, as represented during the paleochristian and early medieval periods, the Hand of God holds Christ's right hand, as if to assist him in his ascent into heaven.

Finally, the Hand appears in a limited number of scenes of the lives of the saints, for example in that of St Stephen (his martyrdom: fresco, crypt in the Church of St Germain, Auxerre, eleventh century). *See also* God.

Cross-references: Abraham, Baptism of Christ, Burning Bush, David, Christ's Descent into Hell, Ezekiel, God, Holy Spirit, Moses, Stephen, Transfiguration, Trinity.

Bibliography: R. Gaudin, "Les mains divines dans l'art roman", *Mémoires de la Société archéologique et historique de la Charente*, 1957, pp. 7-19. H. et J. Jursch, *Hände als Symbol und Gestalt*, Berlin, 1951.

HARP *see* DAVID.

HEAD *see* DAVID (CARRYING GOLIATH'S), DENIS (CARRYING HIS OWN), JOHN THE BAPTIST (ON PLATTER), JUDITH (CARRYING SEVERED MAN'S HEAD), SALOME (WITH HEAD ON PLATTER).

HEAVEN *see* PARADISE.

HEIFER *see* PERPETUA.

HELEN

Variant, Latin and German: Helena; Italian and Spanish: Elena; French: Hélène.
Mother of Emperor Constantine. c.250-330. Feast day 18 August.

TRADITION

Helen was the Christian wife of Constantius Chlorus. On becoming Emperor of the Gauls in 292 he repudiated her, but her son Constantine (306-337) became the first Christian Emperor. Held in the greatest honour, and associated with the development of the Imperial cult, she encouraged the

St Helen and the Miracle of the True Cross
Attributed to Simon Marmion, third quarter of the fifteenth century (detail). Louvre, Paris.

growth of Christianity throughout the Empire. She owed her fame and her cult, however, to the Invention (Finding) of the True Cross in Jerusalem around 327. On a journey to Palestine to search for relics of Christ and to found churches, she apparently discovered(all three crosses of Golgotha as well as the nails used to crucify Christ. There are varying explanations as to how she was able to differentiate the True Cross from the other two: either because the inscription in three languages remained fixed to it or, as *The Golden Legend* has it, because she was informed by a Jew called Judas, or else through the numerous miracles performed by the true Cross after its discovery.

REPRESENTATION AND ICONOGRAPHY
Helen is represented as a woman of advanced years in Imperial costume, holding the Cross or the nails (Hans Witten, sixteenth century, Rathaus, Halle; Andrea Bogli, marble statue, 1639, St Peter's, Rome), although she can also be a young woman shown dreaming of it (Veronese on a design by Raphael, c.1570-75, National Gallery, London). She is often found in association with her son Constantine (Cornelius Engelbrechtsz, late fifteenth or early sixteenth century, Alte Pinakothek, Munich, where she holds a tau cross): they are treated as a pair in much devotional imagery and mural painting in Byzantium and Russia. She is shown presenting Constantine with the Cross (retable, eleventh century, Capella St Elena, Cuenca Cathedral, Spain). She is most often depicted in whole scenes of the discovery of the True Cross (Agnolo Gaddi, c.1380s, S. Croce, Florence; Piero della Francesca, 1460, San Francesco, Arezzo; Jan van Scorel, 1541, Grote Kerk Museum, Breda). She is present as the crosses are exhumed, and at the miracles realized by the wood of the True Cross such as the healing of a sick woman, the resurrection of a dead man or the appearance of an angel who shows her where to search for the relics of Christ.

Attributes: Imperial crown and mantle. Cross. Nails. Model of a church held in her hand.

Cross-reference: Constantine the Great.
Bibliography: H. H. Lauer, *Kaiserin Helena, Leben und Legende*, Munich, 1967.
J. Maurice, *Sainte Hélène*, Paris, 1930.

HELL

Italian: Inferno; Spanish: Infierno; French: Enfer; German Hölle.

TRADITION

The New Testament describes Hell as a place of darkness, an abyss or bottomless pit, a lake of fire, or a great furnace. Also mentioned are the ordeal of the damned, the worms and the eternal nature of the punishment. Depictions of Hell owe a great deal to apocryphal texts, to the Acts of Thomas, in particular. Louis Réau noted that Hell is the exact corollary of paradise: the fiery furnace is the opposite of heaven's cool freshness, infernal darkness corresponds to celestial light, eternal torment to the kingdom of peace. Hell as symbolized by the open maw of Leviathan contrasts with the bosom of Abraham, the abode of the elect.

REPRESENTATION AND ICONOGRAPHY

Hell does not figure in paleochristian art. Its earliest depictions date from the ninth century in scenes of the Last Judgment. In the middle ages, Hell was subsumed under this theme (tympanum at St Foy de Conques, Eure, twelfth century) and comprised a multiplicity of motifs. Already on the tympana of

Hell
Hieronymus Bosch. The Seven Deadly Sins, 1475-80 (detail). Prado, Madrid.

the eleventh and twelfth centuries, a dragon is shown emerging from the jaws of Hell. The damned are crammed into a cauldron, a devil prodding them towards the boiling mixture with a pitchfork (Autun, twelfth century). Until about the twelfth century, Hell was depicted mainly in painting; later, sculpture predominated (church of Asnières sur Vègre, Sarthe, thirteenth century).

Dante's *Divina Commedia*, written in the fourteenth century, marked a turning point. Dante imagined Hell as a kind of funnel divided into various pits (*bolgie*) which correspond to different types of sin. Following these divisions, attempts were made to make Hell conform to the theological categories of the seven deadly sins, and artists competed with each other to make each of the torments parallel a particular sin (Juan de Borgoña, fresco, chapterhouse, Toledo Cathedral, beginning of the sixteenth century, where each capital sin has its Latin inscription, *Superbia, Avaritia, Luxuria, Ira*, etc.; Bosch, *The Seven Deadly Sins*, 1475-80, Prado, Madrid).

Louis Réau stressed the revolution catalysed by Michelangelo's Sistine Chapel (1536-41, Vatican). An almost baroque tumult of movement breaks completely with earlier, stratified arrangements. Rodin, in a work begun in 1888 (*La Porte de l'Enfer*, Musée Rodin, Paris), devoted a monumental work to this theme.

Cross-references: Abraham, Christ's Descent into Hell, Devil, Last Judgment, Paradise.
Bibliography: R. Hughes, *Heaven and Hell in Western Art*, London, 1968. E. Mâle, *L'Art religieux de la fin du Moyen Age en France*, Paris, 1949, pp. 457 ff.

HELMET *see* WILLIAM OF GELLONE.

HEROD *see* JOHN THE BAPTIST, MAGI, TRIAL OF JESUS, SALOME.

HERODIADE *see* JOHN THE BAPTIST, SALOME.

HOLOCAUST *see* ELIJAH.

HOLOFERNES *see* SALOME.

HOLY FACE

French: sainte Face; Italian: Volto Santo.

The Face of Christ is traditionally said to have been imprinted directly on to a piece of cloth – the Holy Shroud, the Mandylion or the Veil of Veronica, for example.

Cross-references: Mandylion of Edessa, Veronica.
Bibliography: O. Celier, *Le Signe du linceul: Le Saint Suaire de Turin: de la relique à l'image*, Paris, 1922.

HOLY FAMILY *see* CIRCUMCISION, FLIGHT INTO EGYPT, JOSEPH OF NAZARETH, NATIVITY, PRESENTATION OF THE LORD.

HOLY HELPERS *see* FOURTEEN HOLY HELPERS.

HOLY SEPULCHRE *see* ENTOMBMENT, HOLY WOMEN AT THE SEPULCHRE.

HOLY SPIRIT

Variants: Holy Ghost, Paraclete. Greek: Hagion Pneuma; Latin: Spiritus Sanctus; Italian: Spirito Santo; Spanish: Espiritu Santo; French: Esprit Saint, Saint-Esprit; German: heilige Geist.

TRADITION

The third person of the Holy Trinity, the Holy Spirit is differentiated from the Father and Son in both the Gospels and in the Acts of the Apostles. The Holy Spirit was the subject of a particular cult during the middle ages, and it was in its honour that St Bernard founded the convent of the Paraclete (Aube, France), of which Heloise was the first abbess. The Greek word *parakletos* means advisor or intercessor. Hospital chapels are often dedicated to the Holy Spirit for its capacity to offer solace to the sick and the afflicted. The foundation of the Order of the Holy Ghost, recognized by Henri III of France in 1579, gave its cult national scope. The corporations of spirits distillers have adopted the Holy Spirit as their patron.

The Holy Spirit
Abraham Bosse, seventeenth century. Bibliothèque Nationale, Paris.

REPRESENTATION AND ICONOGRAPHY

At the Creation, the Holy Spirit wafts over the waters. Most often – at the Annunciation, on the Tree of Jesse, at the Baptism of Jesus and in the lives of certain saints – it appears as a white dove. The origin of the figure of the dove is to be found in a passage of the Gospel according to St Mark (1:10), where the Spirit descends as a dove during Christ's Baptism. Sometimes, particularly in depictions of the Tree of Jesse, seven doves represent the seven gifts of the Holy Spirit (*Sapientia, Intellectus, Consilium, Fortitudo, Scientia, Pietas* and *Timor*: wisdom, understanding, counsel, fortitude, knowledge, piety and fear of the Lord). In the *Ingeburghe Psalter*, (c.1210, Musée Condé, Chantilly), the Tree is encircled by doves giving inspiration to the prophets and the kings. In representations of Pentecost, the Holy Spirit appears as a tongue of fire to each of the apostles.

Cross-references: Annunciation, Baptism of Jesus, Dove, Pentecost, Tree of Jesse.

Bibliography: F. Boespflug, *Dieu dans l'Art*, Paris, 1984. H. Küches, *Der Heilige Geist in der Kunst*, Knechtsteten, 1923. G. Schiller, *Ikonographie der christlichen Kunst*, Gütersloh, vol. IV, 1, pp. 11-36.

HOLY WOMEN AT THE SEPULCHRE

Latin: Vistatio Sepulcri; Italian: le Pie Donne al Sepulcro; Spanish: las Santas Mujeres al Sepulcro; French: les Saintes Femmes au Tombeau; German: die Frauen am Grab, der Gang der Frauen zum Grab.

TRADITION

The women's arrival at Christ's empty tomb is the crux of the events of Easter, announcing as it does his Resurrection. The Gospel versions, for the most part in agreement, differ as to certain details. Matthew (28:1-10) and Mark (16:1-8) have the two Marys arriving at the tomb with perfume vases (full of "sweet spices", Mark 16:1). According to Matthew, an angel clamorously rolls away the stone in front of the tomb. For Mark, the stone already lies to one side by the time the women arrive. Both Gospels agree that the angel is dressed in a white garment and that he announces that Christ is risen. Luke (24:1-11) and John (20:8-18) mention two angels: for Luke, there are three women, Mary Magdalene, Joanna and Mary, the mother of James. John mentions only Mary Magdalene and he is the only one to speak of the "napkin, that was about his head" (20:7). The "linen clothes" (shroud) are rolled up separately.

The Holy Women at the Sepulchre
Capital, twelfth century.
Church at Mozac.

REPRESENTATION AND ICONOGRAPHY

Depictions of the women purchasing ointment and perfume occur in the third century (frescoes, Christian baptistry at Dura-Europos, c.245) and are faithfully followed in medieval texts and liturgy. The episode in which the women discover the empty tomb was immensely popular from the third to the ninth centuries (once again at Dura-Europos). It was often juxtaposed with Christ's Ascension, but had become autonomous by the Carolingian period proper (*Gospels of Emperor Henry II*, ninth century, Munich Library). The angel sits to the left of open tomb, and the women arrive from the right with vessels containing perfume. They turn towards the angel who tells them of the Resurrection. In the middle ages, Christ's tomb was designated by a sarcophagus the lid of which has been raised or simply shifted to one side.

Sequences in Gothic cathedrals show the women on their way to Christ's sepulchre (main door, west front, Strasbourg Cathedral, thirteenth century). From the fourteenth century, and especially during the fifteenth, the theme is allied to that of the Resurrection itself (Hohenfurth altarpiece, c.1350, Narodni Galeri, Prague). Christ emerges from the open tomb lying diagonally across the composition. In his left hand, he holds the banner of the Redeemer and, with his right hand, makes a sign of benediction. The three women arrive from afar, while the angel unrolls the shroud towards them. By the end of the middle ages, the arrival of the women at the tomb had become a secondary element.

A motif showing an angel holding aloft the shroud of Christ was treated repeatedly from the sixteenth to the eighteenth centuries. The visit was soon linked as much to the Ascension as to the Resurrection. St John encouraged the assocation of the theme with that of the Noli me tangere as he mentions only Mary Magdalene, who later mistook the Risen Christ for a gardener (John 20:14-18). A work by the Master of Augsburg (1477, Kereszteny Museum, Esztergom, Hungary) places the three women in the foreground dressed as rich German burghers of the time, while an angel stands on the edge of the tomb. Mary Magdalene wraps herself in the Holy Shroud he hands them. In the background, in a conventional landscape, the Noli me tangere scene is

shown. Christ, naked from the waist up, pushes Mary Magdalene gently away with his right hand.

From the sixteenth century onwards, the holy women at the tomb became a more whimsical subject, which concentrated increasingly on the backdrop and the play of light rather than on any inherent religious quality. Schedone, however, shows the women kneeling in amazement (1610s, Galleria Nazionale, Parma). In the seventeenth and eighteenth centuries, two angels are shown rather than one (Rubens, c.1620, Czernin Gallery, Vienna; Gustave Doré, *Bible illustrée*, 1866). There are occasional late, large-scale versions (A. Bouguereau, 1890, Koninklijk Museum voor Schone Kunsten, Antwerp).

Cross-references: Appearances of the Risen Christ, Ascension, Deposition, Entombment, Noli me Tangere, Resurrection.
Bibliography: A. Grabar, "La fresque des saintes Femmes au tombeau de Doura", *Cahiers archéologiques*, 1956, pp. 9-26. R. Louis, "La visite des saintes femmes au tombeau dans le plus ancien art chrétien", *Mémoire de la Société des antiquaires de France*, 9th series, 3, 1954.

HOREB *see* MOSES.

HORN (ANIMAL) *see* SAMUEL; (INSTRUMENT) *see* BLAISE (BISHOP), HUBERT (HUNTSMAN *or* WITH HUNTING HORN).

HORSE *see* APOCALYPSE (FOUR HORSEMEN), ELIGIUS (SEVERED HOOF REPLACED), GERMANUS (HUNSTMAN WITH HIND), JAMES THE GREATER (PILGRIM), MARTIN (KNIGHT WITH CLOAK).

HORSESHOE *see* ELIGIUS.

HUBERT

Latin: Hubertus; Italian: Umberto; Spanish: Huberto; French: Hubert, Humbert; German: Humbrecht, Huprecht.
First Bishop of Liège. Died 727. Feast day 3 November.

LIFE AND LEGEND
Hubert was born in the middle of the seventh century, son of a Duke of Aquitaine, but was documented only from the time of his election as Bishop of Maastricht around 705. Later he was transferred to Liège, becoming its first bishop, and evangelized the Ardennes. At the end of the middle ages, his life was enriched with a number of episodes borrowed from the legend of St Eustace, in particular his encounter with a miraculous stag. One Good Friday Hubert, a fearsome hunter, fell upon a stag with a crucified Christ between its antlers. Blinded in the manner of St Paul on the road to Damascus, he fell from his horse and knelt down. He heard a voice, "Hubert, Hubert, why do

you pursue me? Will your love of hunting make you forever forgetful of your salvation?" Hubert immediately changed his life and retired to the forest of Ardennes. He then succeeded St Lambert as Bishop of Maastricht and performed numerous miracles. His cult is particularly prevalent in the Low Countries and in the Rhine valley. He is the patron saint of hunters and protector of hunting dogs, and can be invoked against rabies and snake bites.

REPRESENTATION AND ICONOGRAPHY

The number of images representing St Hubert increased in the fifteenth century, becoming common in northern Europe. He is represented as either a huntsman or a bishop, whereas St Eustace wears the uniform of a Roman soldier. The vision of the stag is by far the most frequent scene shown (choir screen, Church at Walcourt, Belgium, sixteenth century; Jan Mostaert, early sixteenth century, Walker Art Gallery, Liverpool, England).

Attributes: Stag with cross between antlers. Dogs. Hunting horn. Mitre.
Cross-reference: Eustace.

St Hubert and the Stag
Choir screen, sixteenth century (detail). Church at Walcourt, Belgium.

HUGH OF GRENOBLE

Latin: Hugo Gratianopolitanus; Italian: Ugo, vescovo di Grenoble; Spanish: Hugo, opisco de Grenoble; French: Hugues de Grenoble; German: Hugo, Bischof von Grenoble.
Bishop. 1053-1132. Feast day 1 April.

LIFE AND LEGEND

Pope Gregory VII consecrated Hugh bishop in 1080. In 1084, he presented St Bruno with a vast area of his diocese to build the Grande Chartreuse. One legend recounts that he saw St Bruno and his six companions in a dream represented by seven stars, while another tells how, when Hugh surprised the seven monks eating roast chicken on a day when meat was forbidden by their

St Hugh of Grenoble Receiving St Bruno
Eustache Le Sueur, 1645-8 (detail). Louvre, Paris.

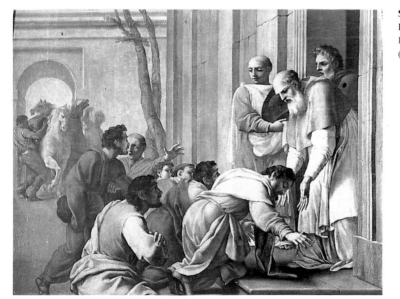

rule, he nonetheless blessed the meal and the birds at once turned into tortoises.

REPRESENTATION AND ICONOGRAPHY
St Hugh is sometimes depicted as a bishop, but more often as a Carthusian monk (Zurbarán, 1637, Museo Provincal de Bellas Artes). The vision of the seven stars is illustrated on stained glass from Freiburg im Breisgau Cathedral (Baldung Grien, c.1515, Germanisches Nationalmuseum, Nuremburg) and by Jacques Callot, (engraving, *Les Images de tous les saints...*, 1636). Above all, Hugh of Grenoble appears in connection with St Bruno, the co-founder of the Carthusians (Le Sueur, three scenes dedicated to the founding of the Grande Chartreuse, cycle of the life of St Bruno, 1645-48, Louvre, Paris). Hugh sees Bruno appearing with his companions; sitting on a mule, he measures out the site of the new monastery; he enrobes St Bruno in the Carthusian habit. Zurbarán also painted the transformation of chicken flesh into tortoise (1633, Museo Provincal de Bellas Artes, Seville).

Cross-references: Bruno.

St Hugh of Lincoln
School of Amiens, c.1460.
Private Collection.

HUGH OF LINCOLN

Latin: Hugo Lincolniensis; Italian: Ugo vescovo di Lincoln; Spanish: Hugo de Lincoln; French: Hughes de Lincoln; German: Hugo von Lincoln. Carthusian. Bishop. c.1140-1200. Canonized 1220. Feast day 17 November.

LIFE AND LEGEND
Of French origin, Hugh was born at Avalon near Grenoble, and entered the Grande Chartreuse in 1166, later becoming its procurator. He was made prior of the Charterhouse in Witham, Somerset. King Henry II was instrumental in elevating him to Bishop of Lincoln and he became an energetic reformer, respected by three monarchs. He died in 1200 after having built Lincoln Cathedral. As early as 1220 he was canonized by Pope Honorius III.

REPRESENTATION AND ICONOGRAPHY
Hugh of Lincoln is depicted either as a bishop with mitre and crozier, or as a Carthusian monk. He is often pictured with a swan, recalling a wild one that he had tamed and that heralded his master's death by refusing food (statue on the spire of St Mary's, Oxford, fourteenth century).

As a bishop, St Hugh holds his crozier in his right hand and carries a chalice from which the Infant Jesus emerges (anonymous, fifteenth century, Signières Collection, Abbeville). The chalice is also encountered in stained glass (Baldung Grien, c.1515, Germanisches Nationalmuseum, Nuremburg). Occasionally, Hugh of Lincoln and Hugh of Grenoble are confused: they are combined in a single work by Anton Woensam (1535, Narodni Museum, Warsaw).

Attributes: Chalice (from which the Infant Christ emerges). Swan.
Cross-reference: Bruno.

HUNTING *see* EUSTACE (ROMAN AND CROSS-BEARING STAG), GERMANUS (TROPHIES HANGING FROM TREE), HUBERT (KNIGHT AND CROSS-BEARING STAG), JULIAN THE HOSPITALLER (STAG).

IGNATIUS OF ANTIOCH

Latin: Ignatius; Italian: Ignazio; Spanish: Ignacio; French: Ignace; German: Ignaz, Ignatius.
Bishop and Martyr. Died c.107. Feast day 17 October.

LIFE AND LEGEND

This bishop of Antioch was arrested under Trajan (98-117) and taken to Rome where he was thrown to the lions. His early cult was fostered by the seven letters he composed during his journey to Rome. His remains were translated from Rome to Antioch shortly after his martyrdom, only to be returned in the sixth or seventh century when a Muslim incursion threatened Antioch. Ignatius is one of the most revered saints of the eastern Church, where he is celebrated as a father of orthodoxy.

St Ignatius of Antioch Torn Apart by Lions
H. Wierix, beginning of the seventeenth century. Bibliothèque Nationale, Paris.

REPRESENTATION AND ICONOGRAPHY

Ignatius of Antioch is shown as an aged bishop with a white beard (mosaics in the central nave of the Basilica of St Sophia in Istanbul, ninth century; mosaics in the Cappella Palatina, Palermo, twelfth century). He is depicted as being attacked by two lions, one making for his upper body, the other for his feet (Juan de las Roelas, last quarter of the sixteenth century, Museo Provincal de Bellas Artes, Seville). Unlike Daniel's, these lions are hostile. Scenes of his legend appear sporadically in both the east and the west. Byzantine miniaturists show the translation of his remains. Another episode requires explanation: his heart is cut reverently out of his body, for he said that the name of Christ would be found carved upon it (Botticelli, S. Barnaba altarpiece, 1490, Uffizi, Florence).

Attributes: Two lions.

IGNATIUS OF LOYOLA

Latin: Ignatius; Italian: Ignazio; Spanish: Ignacio, Iñigo; French: Ignace; German: Ignaz, Ignatius.
Founder of the Society of Jesus. 1491-1556. Canonized 1622. Feast day 31 July.

LIFE AND LEGEND

Ignatius was born in 1491 in the Spanish Basque country of noble lineage. He grew up at the court of Ferdinand II (the Catholic) and distinguished himself as a military man. He was converted on his sickbed by reading Ludolph's *Life of Christ* and the *Golden Legend* while recovering from a wound he received during the siege of Pamplona by the army of Francis I. Henceforth, he desired solely to serve Christ and he founded an Order of Chivalry. He made several pilgrimages, including one to Montserrat, and lived as a beggar, experiences which contributed to the composition of the famous *Spiritual Exercises*. After a further pilgrimage to the Holy Land, he devoted himself to study in Barcelona, Alacal, Salamanca and Paris until 1535. His preaching and teaching earned him the attentions of the Inquisition. On 15 August 1534 at Montmartre he took monastic vows with six of his companions. In 1537, the group put itself at the disposition of the papacy and, in 1540, Paul III formally approved the Order of the Society of Jesus (Jesuits).

Ignatius compiled the *Constitutions* of the order, which traditionally

St Ignatius of Loyola
H. Wierix, beginning of the seventeenth century. Bibliothèque Nationale, Paris.

emphasizes education, the direction of conscience and missionary work. By the time of his death in 1566, it had been established throughout Europe and had missions in Japan and India. Ignatius was canonized in 1622 at the same time as his disciple, St Francis Xavier. He is the patron saint of the Society of Jesus, and of all soldiers.

REPRESENTATION AND ICONOGRAPHY

Depictions of St Ignatius of Loyola become frequent in the sixteenth century and derive from two portraits painted after his death mask, one by Jacopino del Ponte and the other by Alonso Sánchez Coello (c.1585, lost). From his beatification in 1609, Ignatius was always depicted with a halo. He wears a black *talar*, biretta and coat. He may exceptionally be shown as a knight. He often figures as a missionary, his eyes cast heavenwards (Baciccia, 1674-82, decoration of the Gesù, Rome). He carries a flaming heart (G. Fernandez, statue, early seventeenth century, Church of Santiago de Compostella).

Ignatius can be linked to other saints – to St Francis Xavier, for instance – when they are compared to Peter and Paul (Baciccia, dome of the Gesù, Rome). He is often found in association with his first six companions. In cycles, the major events of his life – his vows at Montmartre, for example – are also depicted. Miracles also appear (Rubens, *St Ignatius exorcising the possessed*, 1619-20, Kunsthistorisches Museum, Vienna): one concerns the flames which appeared over his head as he celebrated Mass, while another, called the *Vision at Storta*, is particularly popular. On his journey from Venice to Rome, Ignatius saw God the Father accompanied by Christ on the Cross. They revealed his mission by the words, "In Rome I will be by your side" (J. C. Storer, c.1657, Kunstmuseum, Lucerne; P. Bedeau, c.1700, St Jean Baptiste du Faubourg, Aix-en-Provence, France). Another theme is the promotion of the true faith by the Jesuits.

Attributes: Black *talar*. Biretta. Flames (alluding to the passage in St Luke 12:49: "I am come to send fire on the earth"). Flaming heart. Book of *Constitutions*. The Jesuit motto "*Ad majorem Dei Gloriam* [for the greater glory of God]". Ensign "*IHS*" (with Cross and three nails above the H).

Bibliography: A. Hamy, *Essai sur l'iconographie de la Compagnie de Jésus*, Paris, 1875. L. Von Matt et H. Rahner, *Ignatius von Loyola*, Würzburg, 1955. G. and M. Duchet-Suchaux, *Les Ordres réligieux: Guide historique*, Paris, 1993.

IMMACULATE CONCEPTION *see* ANNE, ANSELM, MARY, REVELATIONS, TREE OF JESSE.

IMMANUEL *see* CHRIST EMMANUEL.

INSTRUMENTS OF THE PASSION *see* ANGEL, BERNARD, CHURCH AND SYNAGOGUE, GREGORY THE GREAT, LOUIS.

ISAAC

Italian: Isacco; Spanish and French: Isaac; German: Isaak.

TRADITION
Son of Abraham and Sarah, Isaac was the unwitting hero of the sacrifice that Jehovah demanded of Abraham, but curtailed at the crucial moment. Isaac married Rebecca who had been chosen among his father's family in Mesopotamia by Eliezer, Abraham's steward (Gen. 24). The meeting between Rebecca and the aged Eliezer at a well near the town of Nahor is viewed in Christian terms as prefiguring the Annunciation. In his old age, Isaac went blind, enabling Rebecca to obtain fraudulently his blessing for their second son, Jacob, rather than for his rightful heir, Esau (Gen. 27:5-40; *see* Jacob).

REPRESENTATION AND ICONOGRAPHY
For the sacrifice of Isaac, *see* Abraham. The meeting between Eliezer and Rebecca at the well is the most frequently represented scene. Rebecca gives water to Eliezer (V. Castello, second quarter of the seventeenth century, Hermitage, St Petersburg) and his camels, and Eliezer responds by offering

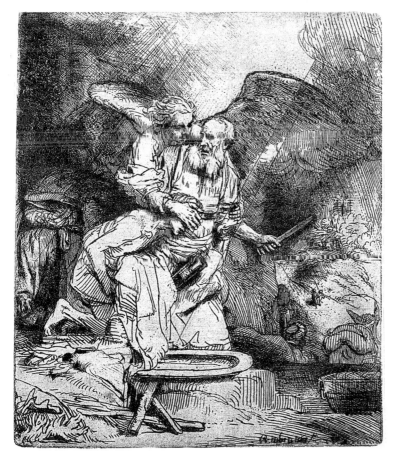

The Sacrifice of Isaac
Rembrandt, 1654. Albertina, Vienna.

her jewels and other finery from a casket. They then leave together (mosaics, Cappella Palatina, Palermo, twelfth century; mosaics, Monreale Cathedral, c.1180). The theme was treated by Poussin, minus the bizarre addition of the camels (1648, Louvre, Paris), and by Tiepolo (Louvre, Paris).

Cross-references: Abraham, Annunciation, Jacob.
Bibliography: J. Daniélou, "La typologie d'Isaac dans le christianisme primitif", *Biblica*, 1947, pp. 363-93.

ISAIAH

Greek: Esias; Latin: Isaias; Italian: Isaia; Spanish: Isaias; French: Isaïe, Esaïe; German: Isaias.

TRADITION
Isaiah is held to be the earliest of the three great prophets, with Jeremiah and Ezekiel. He lived in Jerusalem between around 766 and 701 BC. His Book of Isaiah possesses a complex internal structure and was supplemented with additional elements in the sixth century BC. Isaiah lived and worked during a prosperous period for the kingdom of Judah. The prophet castigated the moral laxity of the times, predicting that the wrath of God would descend upon the Hebrews: the era was then dominated by the rise of Assyria.

The Christian tradition has emphasized in particular three Messianic prophecies. The first is Is. 7:14: "Therefore the Lord himself shall give you a sign; Behold, a virgin shall conceive and bear a son." The Septuagint translated the Hebrew "young woman" as "virgin" in Greek, allowing the passage to be read as an annunciation of the virgin birth. In the same way verse 9:6, "For unto us a child is born, unto us a son is given," is understood as heralding the advent of Jesus, the awaited Messiah. The third prophecy is Is. 11:1 and reads: "And there shall come forth a rod out of the stem of Jesse and a Branch shall grow out of his roots." Jesse is the father of David, and Joseph, Mary's husband, descends from David. Other themes which recur include the vision of the temple (6:1-7): "I saw also the Lord sitting upon a throne, high and lifted up ... Above it stood the seraphims: each one had six wings." Isaiah is mortally frightened for, as a man of "unclean lips", he should not have cast his eyes upon the Lord: "Then flew one of the seraphims unto me, having a live coal in his hand ... And he laid it upon my mouth and said: ... thine iniquity is taken away." The vision in Is. 66:1 lies at the source of the iconographical tradition of Christ in Majesty: "Thus saith the Lord, The heaven is my throne, and the earth is my footstool."

The Prophet Isaiah
Grünewald, Isenheim Altar,
The Annunciation , 1512-16
(detail). Musée
d'Unterlinden, Colmar.

REPRESENTATION AND ICONOGRAPHY
Conforming to the archetypal prophet, Isaiah is an old man, with a long beard; Michelangelo alone portrays him without a beard (1508-12, Sistine Chapel, Vatican). Isaiah is often accompanied by other prophets, when he is always placed first (Sluter, *The Well of Moses*, 1502, Champmol Charterhouse, Dijon).

References to Mary and to the Annunciation
The prophecies pertaining to the birth of Christ are often linked to depictions of the Virgin and to the Annunciation (statue of Isaiah, c.1180, Church at Souillac). At Clermont-Ferrand (left side pier of the south door, Notre Dame du Port, twelfth century), Isaiah forms part of a Marian cycle.

Messianic Prophecies *see* Tree of Jesse.

The Vision of the Lord
This sequence occurs only in a limited number of manuscripts (vision of the Temple, eleventh-century Bible, Roda, Bibliothèque Nationale, Paris). It is closely linked to the figure of the *Majestas Domini* (*see* Cherubim and Seraphim, God).

The Vocation of the Prophet
Isaiah's lips are purified by a live coal (Is. 6:5-13). This sequence has been turned into the prophet's distinctive attribute (in illustrated medieval Bibles; fresco, from Santa Maria, Barcelona, in the Museu de Arte Antica de Catalunya). Isaiah is shown with Elijah, whose lips are also burnt by a seraph.

Isaiah's Martyrdom
A legend transmitted by apocryphal texts describes how King Manasseh, son of Ezekias, ordered Isaiah to be sawn in two in the tree where he was hiding to escape persecution. The story was well known as it afforded a further opportunity to link the prophet to Christ and to the martyred saints. In twelfth- and thirteenth-century Bibles his death is placed at the beginning of his Book.

Attributes: Scroll (containing the text of one of his prophecies). Leafy branch (in reference to the Tree of Jesse). Saw (of his martyrdom). Live coal.
Cross-references: Annunciation, Cherubim and Seraphim, Elijah, God, Tree of Jesse.

ISIDORE

Isidore the Farm-Labourer or the Farmer. Latin: Isidorus; Italian(and Spanish: Isidoro; French: Isidore; German: Isidor.
c.1080-c.1130. Canonized 1622. Feast day 10 May.

LIFE AND LEGEND
Isidore, born near Madrid, was forced to flee the region before the advancing Saracens. He became a farm labourer at a very early age and worked for three masters, ending in the employment of John of Varges as his steward. The other labourers, jealous of him, accused him of neglecting his work in favour of pious deeds. Varges decided to ascertain the truth for himself and, spying on Isidore, caught him at prayer while two angels harnessed to the plough worked in his place. John, overwhelmed, was immediately converted. Isidore's cult, extending from Spain, reached Brittany, Franche-Comté and the Tyrol. He is the patron saint of Madrid.

REPRESENTATION AND ICONOGRAPHY
Isidore is furnished with a flail or sickle and a wheatsheaf. On a fourteenth-century wooden reliquary casket, he is portrayed as a miracle-working farm-labourer. He occurs on a sideboard (possibly sixteenth century, in the Salle de la Verrerie, La Rochère, France). He is also shown standing in seventeenth-century costume with, at his feet, a tiny figure leading a plough pulled by two oxen (wooden sculpture group, seventeenth century, Church of Magny-les-Jussey, Haute-Saône, France).

Attributes: Plough. Wheatsheaf. Flail.
Bibliography: Z. Garzia Villada, "San Isidoro labrador en la historia y en la literatura", *Razon y Fe*, 62 and 63, 1922.

St Isidore the Farm Labourer
Seventeenth century.
Church at Magny-les-Jussey.

Ismael *see* Abraham.

Ivo

Variant: Yves. Latin: Yvo; Italian, Spanish and German: Ivo; French: Yves de Tréguier.
Franciscan Tertiary. Lawyer. 1263-1303. Canonized 1366. Feast day 19 May.

Life and Legend

Yves Hélory was born in Kermartin, near Tréguier in Brittany. After studying law at the University of Paris and at Orléans he was named as a judge of canon law at Rennes. He defended the poor, widows and orphans, accepting no fee. Ordained a priest by the Bishop of Tréguier, he followed a saintly life in conformity with the ideals of St Francis of Assisi. His cult, while remaining most popular in Brittany, spread across Europe to Spain, Germany, the Low Countries and even Rome, where a church is dedicated to him. St Ivo is the patron saint of lawyers, magistrates, jurists, barristers and professors of law.

Representation and Iconography

St Ivo's iconography dates from his canonization and became widespread only in the fifteenth century. He appears in lawyer's robes, wearing a biretta. He carries a pouch containing a Bible or else trial rolls. He is shown in isolation (statue, fifteenth century, Barcelona Cathedral; statue, sixteenth century, Saint-Jean, Chaumont, Haute-Marne). A second type also became common: Ivo delivering his verdict standing or seated between two opposing parties, one rich, the other poor (stained glass, Moncontour Church, sixteenth century). In the seventeenth century, Rubens painted a *St Ivo* defending a widow and an orphan (Louvain Museum).

Attributes: Lawyer's robes. Biretta. Drawstring bag.

St Ivo
Heures de Marguerite de Clisson, fourteenth century.
Bibliothèque Nationale, Paris.

JACOB

Italian: Giacobbe; Spanish and French: Jacob; German: Jakob.

TRADITION

Second son of Isaac and Rebecca, Jacob obtained his older brother Esau's birthright for a plate of "red pottage" (Gen. 25:30-34). With his mother's complicity, he passed himself off as Esau and was blessed by his blind father (27:16-27). Jacob fled his brother who, in his wrath, wanted to kill him, and went as far as Haran in Mesopotamia, the country of his mother and of his grandfather, Abraham. On the way, he slept outside and saw in a dream "a ladder set upon the earth, and the top of it reached to heaven ... and the angels of God ascending and descending on it" (28:11-12). At Haran, he became a shepherd in the service of his uncle, Laban; as salary, he was given both Laban's daughters, Leah and Rachel, as wives (29:1-30). Jacob finally returned to Canaan where he was reconciled with Esau. On his return journey, he fought with an angel (32:24-29) and received the name Israel, for he had "power with God" (32:28). Jacob adopted and blessed his son Joseph's two sons, Manasseh and Ephraim (48:8-20).

Since paleochristian times these episodes have been the subject of typological interpretations by the Fathers and Doctors of the Church. In the sequence of Isaac's benediction, the Church Fathers saw in Jacob a prefiguration of the Church of the Gentiles, open to pagans, while Esau stood for the Church reserved for Jews alone and, more generally, the Jewish people itself. For St Augustine in *The City of God* (xvi, 37), Isaac blessing his son represented Christ, whose word was addressed to all peoples.

The rungs of the ladder which appear in Jacob's dream have been compared with the different degrees of human virtue. St Benedict saw the ladder as the prototype for the *scala humilitatis*, the "ladder of humility" whose twelve rungs a monk must climb. St Hilary of Poitiers (c.315-c.368) considered the angel that Jacob fought with to be God himself, who saved Jacob by his blessing.

REPRESENTATION AND ICONOGRAPHY

Jacob's iconography is not constant: he is shown both young (without a beard) and older (with a beard).

The Benediction of Jacob by his Father Isaac (27:22)
Isaac lies in bed, blind. In front of him stands Jacob, whom Rebecca presents as Esau. A fourth figure, probably Esau, enters from the right (fresco, catacomb at the Via Latina, Rome, c.320-50). Ghiberti (bronze door, c.1403-24, Bapistry, Florence) shows Isaac seated. Isaac identifies his son by touch (Giordano, second half of the seventeenth century, Graf Harrach'sche Sammlung, Rohrau, Austria, with Rebecca pushing forward Isaac, who wears kidskin over his forearms to disguise himself as his hirsute brother (Gen. 27:16, 27)).

Jacob's Dream (Gen. 28:12)
In the paleochristian era, Jacob is shown lying down, his head leaning against a stone. Nearby, two or three angels are shown ascending a ladder. The oldest example is in the Syangogue at Dura-Europos (c.245), where the angels wear Persian costume. From the twelfth century, the number of angels increases (mosaic in the Cappella Palatina, Palermo, twelfth century; capi-

tal in the cloister of Monreale, late twelfth century). From the fourteenth century, this type of representation is no longer the norm and by the sixteenth, it is the background landscape which is highlighted (Aert de Gelder, last quarter of the sixteenth century, Dulwich Picture Gallery, London; Michael Willmann, *Landscape with Jacob's Dream*, c.1690, Museum, Breslau). Ribera (1643, Prado, Madrid), Feti (first quarter of the seventeenth century, Accademia, Venice) and Rembrandt (drawing, Louvre, Paris) treated the theme. It has remained popular in the twentieth century (Chagall, 1973, Private Collection; Arthur Boyd, 1946-7, Private Collection, Cambridge, England).

Jacob's Meeting Rachel at the Well (Gen. 29:9-11)
Jacob and Rachel stand by the well encircled by sheep (sarcophagus fragment, fourth century, S. Callista Museum, Rome). In the sixteenth and seventeenth centuries, artists stressed still further the pastoral qualities of the scene, which was linked to the motif of the Good Shepherd and its offshoots.

Jacob Wrestling with the Angel (Gen. 32:24-29)
In the early Christian period, the two figures grasp each other round the shoulders or hips, following the rules of Graeco-Roman wrestling. The angel at this stage has no wings (Irish stone crosses at Killarney, Kilrea, Castledermot, Clonmacnois, Durrow and Galloon Island). In the eleventh century, the fight appears on a fresco at the choir of Essen Cathedral. Very widespread by the twelfth (capitals, Vézelay), the theme became rarer in the thirteenth and fourteenth centuries. In the seventeenth (Morazzone, first quarter of the seventeenth century, Galleria Arcivescovile, Milan; Rembrandt, 1659, Berlin-Dahlem Staatliche Museen, Berlin) and eighteenth centuries, artists were drawn by the dynamic character of the scene. In the nineteenth, it was treated by Delacroix (1861, Chapelle des Saints-Anges, St Sulpice, Paris) and Gauguin, *La Vision après le Sermon*, 1888, National Gallery of Scotland, Edinburgh).

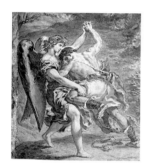

Jacob Wrestling with the Angel
Delacroix, 1861 (detail).
St Sulpice, Paris.

Jacob Blesses Manasseh and Ephraim (Gen. 48:8-20)
Traditionally, care is taken to show Jacob crossing his hands to bless Joseph's younger son, Ephraim, with his right hand, and the elder, Manasseh, with his left. The scene symbolizes the Crucifixion (twelfth-century Romanesque enamel crosses from the Meuse region of France). During the Renaissance, this blessing was approached in a less symbolically charged manner (Holbein the Younger, woodcut, 1526). In the seventeenth century, Rembrandt followed the traditional prototype (1656, Gemäldegalerie, Kassel).

Cycles
Five scenes from the life of Jacob are shown on twelfth-century mosaics in Monreale. The most complete sets occur in Byzantine manuscripts. In the thirteenth century, the story of Jacob spread to the monumental sculpture of the Gothic cathedrals. Raphael composed six scenes for the Vatican Logge (1518-19).

Cross-references: Angel, Genevieve, Good Shepherd, Isaac, Woman of Samaria.

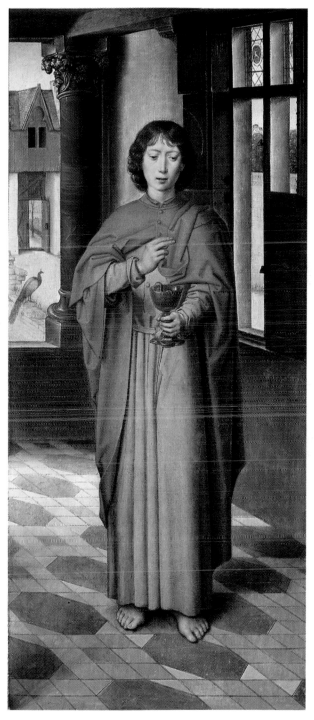

St John the Evangelist. Memling, panel from *The Donne Triptych*, c.1480. National Gallery, London.

St Jerome in the Desert. Lorenzo Lotto, 1506. Louvre, Paris.

JAMES THE GREATER

Variant: James the Great; Latin: Jacobus; Italian: Giacomo, Jacopo (il Maggiore); Spanish: Santiago, Iago, Jaime, Diego; French: Jacques le Majeur; German: Jacob, Jakobus.
Apostle. Died 44. Feast day 25 July.

TRADITION

James the Greater, son of Zebedee, was the elder brother of the apostle John, and a fisherman on the Lake of Galilee. He was – with Andrew, Peter and John – one of the first disciples called by Christ. With Peter and John, he was present at the Transfiguration and at Christ's Agony in the Garden of Gethsemane. His apostolate after the Ascension is more unclear than that of most of the other apostles. Leaving as a preacher for Syria, he returned to Jerusalem where he was beheaded by Herod Agrippa, probably in AD 44 (Acts 12:2).

In the vacuum of information regarding the last years of his life, many legends have sprung up. The most celebrated makes him into the evangelizer of Spain (whose patron he became) and places his sepulchre in Galicia, at Santiago de Compostella. These traditions are relatively late, emerging during the Reconquista (ninth to eleventh centuries), but they contributed considerably to the growth of his Spanish cult which then spread to all Christendom. By the end of the first millenium, the journey to his tomb at Compostella had become the most important pilgrimage in the west, next to Rome. Churches were dedicated to him and relics abound. James was the medieval patron of pilgrims and knights. In the modern period, his cult has declined with the decrease in pilgrimages.

REPRESENTATION AND ICONOGRAPHY

James the Greater can be represented as a barefoot apostle, holding a scroll or his sword of martyrdom (Puerta de las Platerias, twelfth century, Cathedral of Santiago de Compostella), as a knight (mounted on a white charger pursuing the fleeing Moors), but most frequently as a pilgrim (El Greco, c.1580-95, Museo de Santa Cruz, Toledo, in a landscape). He then wears a long mantle and a broad-brimmed hat, carries a scrip and leans on a pilgrim's staff with a distinctive large pommel. His clothing is decorated with one or more scallop-shells ("St James' shells") which have become his main personal attribute (statue in the Church of St Jacques de L'Hôpital, fourteenth century, Musée de Cluny, Paris).

Artists have occasionally depicted his vocation together with his brother, John; his apostolate; his triumph over the magician Hermogenes, and the latter's subsequent conversion; his preaching and later beheading in Jerusalem (Jean Fouquet in the *Heures d'Etienne Chevalier*, c.1461, Musée Condé, Chantilly; A. Bloeklandt, c.1570, Stedelijk Museum, Gouda). Above all, however, it is his legendary sojourn in Spain which has provided the most iconographic material. This includes his numerous miracles (the resurrection of a hanged man and of a brace of dead fowl); his victories over the Moors; his witnessing an appearance of the Virgin in Saragossa; and the translation of his relics to Galicia, conveyed on a cart pulled by two wild bulls rendered tractable by the sign of the Cross.

Attributes: Scallop-shells. Sword (of his martyrdom). Pilgrim's dress (staff, broad-brimmed hat, long mantle, scrip). More rarely: archbishop's crozier

St James the Greater
Beginning of the sixteenth century. Private Collection, Brussels.

(he was allegedly the first archbishop of Spain).
Cross-references: Andrew, Apostles, James the Less, John, Peter.

St James the Less
Bibliothèque Nationale,
Paris.

JAMES THE LESS

Latin: Jacobus Minor, Italian: Giacomo, Jacopo il Minore; Spanish: Santiago el Menor; French: Jacques le Mineur; German: Jakobus der Jüngere.
Apostle. Died 62. Feast day 3 May.

TRADITION

James the Less was probably a cousin-german of Jesus (son of a half-sister of the Virgin) or else another relative (St Paul calls him Jesus' "brother", but the term was probably used loosely). James, one of the twelve apostles, was given the name "the Less" to distinguish him from his namesake, St James the Greater. Certain authors assert it was because James so closely resembled Jesus that Judas betrayed the latter with a kiss to avoid any mistake.

After Peter left for Rome, James became the head of the Christians in Palestine and, in this respect, is often considered to have been the first bishop of Jerusalem. One day, while preaching in the vicinity of the Temple, Caiaphas ordered him to be thrown from his pulpit. James survived, but soon afterwards was stoned by the Jews and his skull smashed by a blow from a fuller's club.

His very popular namesake has had a negative effect on James the Less's cult. In spite of his supposed blood relationship to Christ, it has never been as widespread as that of the other main apostles.

REPRESENTATION AND ICONOGRAPHY

James the Less is often depicted as Bishop of Jerusalem and linked to St Philip, with whom he shares his feast day. His attribute is the fuller's club with which he was martyred. He takes his place in the scenes from the Life of Christ among the other apostles and (as a relation of Jesus) even occasionally in scenes with the Holy Family. Artists have concentrated on scenes of his martyrdom (mosaic, thirteenth century, St Mark's, Venice) or of his being tumbled off his pulpit (sometimes he is even thrown from the top of the Temple). In the modern period, he is often confused with James the Greater and given a pilgrim's staff or scallop-shells.

Attributes: Fuller's club. Bishop's vestments.
Cross-references: Apostles, James the Greater, Philip.

JANUARIUS

Latin and German: Januarius; Italian: Gennaro; Spanish: Januario, Janero; French: Janvier.
Bishop of Benevento. Martyr. Died c.305(?). Feast day 19 September.

LIFE AND LEGEND

Little is known for sure about St Januarius, whose life was absorbed into legend at an early stage. Born in Naples, he was elected bishop of Benevento. As with many other saints, he was the victim of the great Diocletian persecution of 305. His martyrdom takes various forms: he was thrown to the lions and bears, who refused to devour him; he was cast into a fiery furnace, but escaped unscathed; he was beheaded, the executioner managing at one stroke

to remove both his head and the index finger of his right hand.

Patron saint of Naples and Benevento, Januarius is one of the most popular saints of southern Italy. He is invoked against the eruptions of Mount Vesuvius (as he survived the heat of the furnace), while his blood, gathered by a loyal nursemaid, is the object of a cult and is responsible for extraordinary miracles. Preserved in a pair of phials at Naples Cathedral in the inner sanctum of the treasury, this blood, normally coagulated, liquifies and even boils on certain dates when placed in the vicinity of the saint's reliquary; the miracle has been attested since the fourteenth century.

REPRESENTATION AND ICONOGRAPHY

Januarius is shown as a bishop, praying over the flames or, more commonly, holding a book upon which stand the two phials containing his wondrous blood (Andrea Vaccaro, seventeenth century, Prado, Madrid; Francesco di Maria, second half of the seventeenth century, Musée des Beaux Arts, Nantes). He is also shown interceding on a *bozzetto* by Mattia Preti for a lost fresco in Naples for one of the city gates (c.1657, Museo e Gallerie Nazionale di Capodimonte, Naples).

Attributes: Phials. Flames. Mitre. Book.

JAWBONE OF AN ASS *see* CAIN AND ABEL, SAMSON.

JEHOVAH

In Hebrew the word Yahweh, transcribed as Jehovah, is the name which God applies to himself (Ex. 3:13-15), explaining it thus: "I am that I am." The Hebrew word is comprised of four consonants which can be represented as JHVH.

Cross-reference: God.

JEREMIAH

Latin: Jeremias; Italian: Geremia; Spanish: Geremias; French: Jérémie; German: Jeremias.

TRADITION

Constantly persecuted and prey to the unyielding power of the Word of God ("like a hammer that breaketh the rock in pieces," Jer. 23:29), Jeremiah, in the middle of a relatively peaceful period, predicted the irruption of an implacable enemy upon Jerusalem and the kingdom of Judah. Between 605 and 587 BC, the armies of Nebuchadnezzar, King of Babylon, laid waste Syria and Palestine. After the destruction of Jerusalem by Babylonian troops, Jeremiah was taken as prisoner to Babylon where he died. That his own people stoned him to death is a legend, but it was mentioned by Tertullian (second century); Isidore of Seville (c.560-636) encouraged the spread of this myth throughout the middle ages.

REPRESENTATION AND ICONOGRAPHY

Like the other prophets, Jeremiah is a white-haired old man with a beard. By the end of the medieval period, he wears a headdress, turban or Jewish

The Prophet Jeremiah
Claus Sluter, *The Well of Moses*, 1395-1405.
Chartreuse de Champmol, Dijon.

187

cap. Dressed in flowing robes, he carries a book, but otherwise possesses no specific attribute.

The Vocation of the Prophet (1:11)
"The word of the Lord came unto me, saying, Jeremiah, what seest thou? And I said, I see a rod of an almond tree," (stained glass, Sainte-Chapelle, Paris, thirteenth century).

The Sign of the Buried Girdle (13:1-11)
On orders from Jehovah, the prophet buries his new "linen girdle" in a hole in the rock. When he is commanded to retrieve it, it has been rendered useless. "After this manner [God] will mar the pride of Judah" (13:9).

Jeremiah Thrown into a Dungeon full of Mire (38:6-13)
A capital in the Basilica of Vézelay (twelfth century) is decorated with this scene.

Jeremiah Lamenting the Fate of Jerusalem (52)
Numerous manuscript miniatures exist showing Jeremiah's lamentation, the most widely depicted sequence. In deep sorrow, the prophet sits in the vicinity of Jerusalem, which is being either besieged or sacked on the orders of Nebuchadnezzar (Rembrandt, 1630, Rijksmuseum, Amsterdam).

The Stoning of Jeremiah
The episode occurs in the thirteenth century (archivolt of the door of the *Vierge Dorée*, Amiens Cathedral).

When shown in a group outside cathedral portals, Jeremiah and the other prophets represent the Old Testament and are often balanced by a series of apostles, witnesses to the New. Jeremiah himself is closely linked to the Passion of Christ (statue on the pier supporting the archivolt of the right-hand wing of the Royal Door, Chartres Cathedral, c.1150).

Attributes: Turban or Jewish cap. Book.
Bibliography: P. Bloch, "Nachwirkungen des Alten Bundes in der kirchlichhen Kunst", *Monumenta judaica*, Cologne, 1963.

JERICHO

Italian: Gerico; Spanish: Jericó; French: Jéricho; German: Jericho.

TRADITION
The capture of Jericho, after the collapse of the city walls, forms part of the narrative of the conquest of the Promised Land that occupies most of the Book of Joshua, who himself plays the dominant role in the story. Arriving at Jericho, Joshua saw a man armed with an unsheathed sword appear suddenly before him: "[I am] captain of the host of the Lord," he said (5:14). Like Moses in the presence of the Burning Bush, Joshua was ordered to remove his sandles, "for the place whereon thou standest is holy" (5:15). Following the Lord's command, the soldiers, led by the Ark and seven priests each carrying a ram's horn, marched around Jericho for six whole days. On the seventh, they circled the town seven times, blowing their horns. The people then raised a great shout and the walls of the city tumbled down (6:1-21). The Hebrews seized the city and the entire population was put to the sword, save for the prostitute Rahab, who had given shelter to the two spies sent into the

**The Collapse of the
Walls of Jericho**
Raphael, 1518-19. Logge,
Vatican.

city by Joshua (*see* Joshua). The horns of Jericho were interpreted in the middle ages as prefiguring the trumpets of the Last Judgment.

REPRESENTATION AND ICONOGRAPHY
The town of Jericho is most often depicted as an imposing walled city studded with towers. Sometimes it is half-moon shaped, because the name Jericho is derived from a Hebrew word meaning moon.

St Michael appears to Joshua
Joshua throws himself to the ground before the archangel who carries a spear (mosaics, S. Maria Maggiore, Rome, fourth century)

The Destruction of the Walls of Jericho (Jos. 6:20)
In addition to the mosaics at S. Maria Maggiore, one can cite the famous miniature of the *Antiquités juad ques* (Fouquet, c.1470-75, Bibliothèque Nationale, Paris) as well as Ghiberti's bronze low-relief (1425-52, Baptistry, Florence).

Cross-references: Ark of the Covenant, Burning Bush, Entry into Jerusalem, Joshua, Last Judgment, Michael.
Bibliography: F. de Mély, "Les trompettes de Jéricho", *Revue archéologique*, 5, series 33, 1931, pp. 111-16.

JEROME

Variant, Latin and German: Hieronymus; Italian: Geronimo, Girolamo; Spanish: Jeronimo; French: Jérôme.
Doctor of the Church. c.340-420. Feast day 30 September.

LIFE AND LEGEND
St Jerome, with Ambrose, Augustine and Gregory, is one of the Four Latin Doctors of the Church. His life is reasonably well documented. Born in Dalmatia around 340, he left for Rome and learnt Greek and Latin under the celebrated grammarian, Donatus. He was baptized and travelled to the Holy

St Jerome with the Lion
Dürer, c.1492.
Kupferstichkabinett, Basel.

Land. In the manner of St Paul the First Hermit (whose biographer he was), he retired to the Syrian desert as an anchorite for three years' penance. Returning to Rome in 382, he became a familiar of Pope Damasus who directed him to produce a Latin translation of the Greek version of the Septuagint and of the preseved Hebrew manuscripts. Jerome dedicated the remainder of his life to this considerable task, first in Rome, then in Palestine, whence he withdrew after the death of his protector. He finished his translation after years of immense effort and died in Bethlehem in 420. His translation, called the Vulgate, has been revised and supplemented more than once but is recognized by the Roman Catholic Church as the official version of the Bible, as laid down by the Council of Trent in the sixteenth century.

The legends embroidered on Jerome's life as a hermit and scholar include the temptation to which he was subjected in the desert (like Christ and St Antony); his visions (he imagined himself scourged by angels for being too fond of reading Cicero); and, above all, his lion, whom he had befriended by removing a thorn from its paw. Too much of an intellectual to become a truly popular saint, Jerome has been the patron of theologians and scholars from an early date. Renaissance humanists greatly admired him and published editions of his complete works.

REPRESENTATION AND ICONOGRAPHY

Jerome's iconography gives precedence to legend over biography. He is nearly always shown as an old man with a cardinal's hat (in fact he was never raised to that office) and accompanied by his loyal and thankful lion (J. Bellini, mid fifteenth century, Museo de Castelvecchio, Verona). Three scenes are particularly frequent: Jerome doing penance in the desert (Leonardo da Vinci, 1480, Pinacoteca Vaticana, Rome; J. Bassano, c.1550-60, Accademia, Venice), where he is shown scourging himself or beating his breast with a stone (Gozzoli, c.1440-60, Thyssen-Bornemisza Collection, Lugano, Switzerland); Jerome translating the Bible seated it a desk, writing like an Evangelist (Antonello da Messina, c.1470s, National Gallery, London); and with a dove whispering the Word of God into his ear.

At the end of the middle ages and in the Renaissance, he often wore glasses. In the group of the Four Doctors of the Latin Church, he is the one dressed as a cardinal. The scenes of the temptation in the desert are a later innovation. Unknown in medieval art, these cycles – which show naked women dancing provocatively or Jerome lashing himself (divine judgment having found him too much of a Ciceronian) – remain comparatively rare. On the other hand, the story of the taming of the lion has produced a wealth of imagery: the saint extracts a thorn from the animal's paw (Colantonio, c.1445, Museo e Gallerie Nazionale di Capodimonte, Naples); the lion gives chase to thieves (Carpaccio, *St Jerome and the Lion in the Monastery*, 1501-7, Scuola di San Giorgio degli Schiavoni, Venice).

Attributes: Bible. Cardinal's hat. Lion.
Cross-references: Ambrose, Augustine, Gregory the Great.

JERUSALEM *see* EZEKIEL, REVELATIONS.

JESSE *see* TREE OF JESSE.

JESUS

Latin and German: Jesus; Italian and Spanish: Gesù; French: Jésus.

The life of Jesus is generally divided into the episodes below. *See also* Christ Emmanuel, Christ in Majesty, Holy Face, Mandylion of Edessa, Monogram of Christ, Pantocrator.

BIRTH *see* ANNUNCIATION, ANNUNCIATION TO THE SHEPHERDS, JOSEPH OF NAZARETH, MAGI, MARY, MASSACRE OF THE INNOCENTS, NATIVITY.

CHILDHOOD *see* CIRCUMCISION, FLIGHT INTO EGYPT, PRESENTATION OF THE LORD.

PUBLIC LIFE *see* APOSTLES, BAPTISM OF CHRIST, ENTRY INTO JERUSALEM, JOHN THE BAPTIST, LAST SUPPER, MERCHANTS IN THE TEMPLE, MARY MAGDALENE, TEMPTATIONS OF CHRIST.

MIRACLES *see* LAZARUS (RAISING OF, MULTIPLICATION OF THE LOAVES AND FISHES, WEDDING AT CANA.

PARABLES *see* GOOD SAMARITAN, PRODIGAL SON, WISE AND FOOLISH VIRGINS, WOMAN OF SAMARIA, WOMAN TAKEN IN ADULTERY.

TRANSFIGURATION *see* TRANSFIGURATION.

TRIAL OF JESUS *see* AGONY IN THE GARDEN, ARREST OF CHRIST, JUDAS ISCARIOT, TRIAL OF JESUS.

MOCKING AND FLAGELLATION *see* CROWNING WITH THORNS, ECCE HOMO, FLAGELLATION, MOCKING OF CHRIST.

CRUCIFIXION *see* CRUCIFIXION, DEPOSITION, DESCENT INTO HELL, ENTOMBMENT.

RESURRECTION *see* RESURRECTION.

APPEARANCES OF THE RISEN CHRIST *see* APPEARANCES OF THE RISEN CHRIST, HOLY WOMEN AT THE SEPULCHRE, NOLI ME TANGERE, PILGRIMS AT EMMAUS.

ASCENSION *see* ASCENSION.

JESUS WALKING ON THE WATER *see* APPEARANCES OF THE RISEN CHRIST.

JEZEBEL *see* ELIJAH.

JOACHIM *see* ANNE, MARRIAGE OF THE VIRGIN.

St Joan of Arc
Registre du parlement de Paris,
1449. Archives Nationales,
Paris.

JOAN OF ARC

Latin: Johanna ab Arce; Italian: Giovanna d'Arco; Spanish: Juana de Arco;
French: Jeanne d'Arc; German: Johanna von Arc.
Virgin and Martyr. 1412-31. Canonized 1920. Feast 30 May.

LIFE AND LEGEND

Born 6 January 1412 at Domrémy in the Vosges to wealthy parents, Joan
learnt neither to read nor write. One day, aged 13, she was in her parents'
garden and heard the voices of St Michael, St Margaret and St Catherine
speaking to her of religious matters. From an indeterminate date (perhaps
1428), these voices began to demand that she save the Dauphin and France,
threatened by English occupation. On 23 February 1429, she left with six
men-at-arms for Chinon, where she managed to convince the Dauphin and
his entourage of the authenticity of her mission. In May, the English seige
of Orléans was raised; on 17 July 1429, Charles VII was consecrated and
crowned at Reims.

Joan tried unsuccessfully to liberate Paris and was wounded. She was cap-
tured on 24 May 1430 at Compiègne by men belonging to the Duke of
Burgundy, who delivered her to the English. She was imprisoned and tried
for sorcery and heresy by an ecclesiastical court in Rouen, whose intention
was to prove that a witch was behind Charles VII's consecration and that
therefore it was null and void. After a trial lasting three months, she was con-
demned to death on 24 May 1431. She was burnt at the stake on 30 May,
at Rouen. Twenty-five year later, on 7 July 1456, she was declared innocent
and became the object of a cult centred on Orléans.

Only after the French defeat of 1870, however, was she elevated to the
status of a national heroine. She was beatified by Pius X on 18 April 1909
and canonized after the Allied victory in the First World War in 1920: her
popularity has always gone hand-in-hand with political developments. The
second patron saint of France (after the Virgin of the Assumption) accord-
ing to a directive from Louis XIII, she is also patron of Orléans and Rouen.
Due to her "voices", she is the protectress of radio broadcasting and teleg-
raphy.

REPRESENTATION AND ICONOGRAPHY

Joan of Arc's iconography is practically entirely limited to France. In the fif-
teenth and sixteenth centuries, it first appeared in a number of manuscripts
produced by the entourage of the Royal Court. Between the sixteenth and
nineteenth centuries, she fell into oblivion: only from the second half of the
nineteenth century do images of a stereotyped nature begin to be frequent.

The oldest representation is a sketch in the margin of a parliamentary
record made during the hearing which quashed the charges against her in
1449. Joan was depicted as a young girl with pennon and sword. Manuscript
miniatures of the fifteenth century can show her either armed (Musée de
l'Històire de France, Paris) or dressed as a woman. No contemporary portrait
survives. A votive sculpture group erected by Charles VII on the bridge at
Orléans was destroyed by Protestant soldiers in 1562. A Swiss tapestry (fif-
teenth century, Musée Johannique, Orléans) is the oldest complete depic-
tion of Joan which has survived. It is a conventional enough image, show-
ing her arrival at the Château of Chinon with her escort. In the seventeenth
century, she appeared in an engraving by Abraham Bosse for the 1656 title-
page of Jean Chapelain's *La Pucelle ou la France délivrée* ("The Maid, or France

Liberated"). Painted and sculpted versions become far more common in the nineteenth century (Jules Bastien-Lepage, 1879, Metropolitan Museum of Art, New York).

Attributes: Pennon or banner. Sword.
Bibliography: M. Desnoyers, *L'Iconographie de Jeanne d'Arc*, Orléans, 1891. P. Doncoeur, Y. Lanhers, *Documents et recherches relatifs à Jeanne la Pucelle*, Paris, 1952-61, 5 vol. R. Pernoud, *Vie et mort de Jeanne d'Arc*, Paris, 1954.

JOB

Latin: Jobus; Italian: Giobbe; Spanish and French: Job; German: Hiob.

TRADITION
Job's trials and tribulations occupy the Book of Job, one of the most commented-on books of the Bible. Job, a wealthy and pious man, was suddenly subjected to a series of appalling calamaties (1:13-19). He asked himself why God harried him in this way. This question became an obsessive lamentation, repeated continually throughout a sequence of dialogues and verse "parables". At the heart of the debate lies the question of the mystery of suffering and the mystery of God. Father of seven sons and three daughters, Job is an honest, upright and God-fearing man. One day, God and Satan are discussing Job's piety when the Devil decides to defy the Lord: as this Job is a rich man, would it not be easy to try his piety (1:6-12)? The series of disasters that befall Job are extremely varied; each is announced by a messenger. His servants are murdered and his flocks massacred; then his children perish; finally, Satan smites him with leprosy. Job ends up on a pile of dust and ashes, abject and utterly destitute.

Job on the Dungheap
Hans Baldung Grien, first half of the sixteenth century. Bibliothèque Nationale, Paris.

An apocryphal text, *Testamentum in Job* (first century BC) tells how Job used to be entertained by music during his feasting. The story was taken up in the west in the fifteenth century when Job was adopted as patron saint by various brotherhoods of musicians.

REPRESENTATION AND ICONOGRAPHY
Job makes an early appearance in art (Synagogue at Dura-Europos, c.245; Roman catacomb paintings including Domitilla). In Byzantine miniatures and in western art, he is shown as an old man with a beard and long hair. From the tenth century, he is frequently depicted with a nimbus, though this is rarer in the west than in the east. The feasting with his children, before the catastrophes, is often evoked (1:4). He is shown as a king on a richly covered bench, accompanied by his wife and children. In the fourteenth century, Taddeo Gaddi shows him giving alms to the poor (c.1342, Composanto, Pisa).

His sufferings are interpreted as prefiguring Christ's Passion and his final victory (Bernard van Orley, 1521, Musées Royaux des Beaux Arts, Brussels). They symbolize the salvation of souls and are associated with Noah and with Daniel (in Roman catacombs). God points out Job's felicity to Satan (capital, Pamplona, Musée de Navarre, twelfth century, with Job's children making merry). After the long series of misfortunes, Satan himself gives Job leprosy, or else monsters breathe their putrid stench over him.

The commonest scene is Job sitting on his dungheap. He can be in the company of three or four friends. Around 1500, the type showing Job alone became predominant and, under the influence of the *Testamentum in Job*,

musicians console him with song. At the end of the series, God renders him rich and happy while his family offer him theiz congratulations. From the seventeenth century, it is his suffering which is stressed (Georges de La Tour, *Job raillé par sa femme*, c.1650, Musée Départemental des Vosges, Epinal; William Blake, *Satan Smiting Job with Sore Boils*, c.1826, Tate Gallery, Lonlon).

Cross-references: Daniel, Devil, Noah.
Bibliography: V. Denis, "Saint Job, patron de musiciens", *Revue belge d'archéologie et d'histoire de l'art*, 21, 1952. W. Weisbach, "L'histoire de Job dans les arts", *Gazette des Beaux-Arts*, 1936.

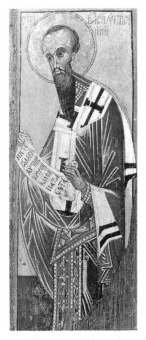

St John Chrysostom
School of Tver, late
fourteenth century.
Tretiakov Gallery, Moscow.

JOHN CHRYSOSTOM

Italian: Giovanni Crisostomo; French: Jean Chrysostome; German: Johannes Chrysostomus.
Doctor of the eastern Church. Archbishop of Constantinople. c.347-407. Feast day 13 September (west), 13 November (east). The Orthodox Church celebrates the feast of John Chrysostom with the other Holy Hierarchs, Basil and Gregory of Nazianzus, on 30 January.

LIFE AND LEGEND

John was born to Christian parents at Antioch and bought up by his mother Antusa following the death of his fither, an officez of the Roman army. He studied literature and oratory. At the age of twenty, after a few months spent in the courtrooms of Antioch, he changed his way of life and began studying scripture in the *asceterium* of Diodorus (the future bishop of Tarsus), becoming a special assistant to Archbishop Melitius in 371. In 372, he dedicated himself to the ascetic life under the guidance of a Syrian *geron*, and in 376 withdrew as a hermit into a cave. Having composed a number of dogmatic treatises, he returned to Antioch in 381 and resumed his post of assistant. Early in 386, he was ordained by Flavian, successor to Melitius, who had died without resolving the schism in Antioch.

John was particularly active as a preacher and his talent earned him the nickname *Chrisostomos*, "Mouth of Gold". His dogmatic writings added to his fame, but above all it is for his 21 homilies on "Statues" that he is celebrated. These "Statues", portraying Theodosius and the Imperial family, had been smashed during a revolt in 387. John's eloquence calmed the situation, saving the city from the Emperor's wrath. The Archbishop of Constantinople died in 397 and Emperor Arcadius designated John as his successor. He was consecrated by Theophilus, Archbishop of Alexandria, who had originally coveted the post, and who never recovered from the failure of his candidacy.

John set about reforming the morality of his priests and, revered by the people, criticized the nobles for their obsession with games and public entertainments. Eudoxia, proclaimed Empress in 400, felt that she was the real object of these attacks and her displeasure, further fanned by Theophilus, who had organized a cabal against John, resulted in an assembly of bishops from Theophilus' coterie condemning him for treason. John was initially deposed and exiled, but following a fearsome earthquake was recalled by Eudoxia. He resumed his preaching and Theophilus his intrigues. John was finally condemned by a council at Antioch and, in 404, first banished to Cucusus in Armenia, then imprisoned in the fortress at Arabissa. He died,

following an exhausting march, at Comana in Cappadocia, on 14 September 407. Thirty-one years later, on 27 January 438, his remains were brought back to Constantinople by Eudoxia's son, Theodosius II. Among his many works, the numerous *Homilies* and his exegetical works remain authoritative.

REPRESENTATION AND ICONOGRAPHY

The earliest extant depiction of John is on a wall painting in S. Maria Antiqua in Rome (705-6). He is traditionally shown with a high forehead, strong cheekbones, a moustache and a short, pointed beard. This ascetic type, the rule in the eleventh and twelfth centuries, became less severe in the fourteenth, notably in an example in St Mark's, Venice. He was often portrayed at the apse of Byzantine churches. John Chrysostom is often linked to the other Holy Hierarchs, SS. Basil and Gregory, but his life is rarely represented. An illumination in a manuscript of the *Menologion* of Basil II (eleventh century, Vatican Library) shows him on a mule leaving for exile. Another manuscript, this time of his own *Homilies* (eleventh century, Bibliothèque Nationale, Paris) shows him presenting their text to Emperor Botoniat.

One curious legendary scene was much illustrated in the modern period, above all in Protestant countries: John was supposed to have had a child by a certain princess. In punishment, he was forced to walk about on all fours like an animal. The episode was engraved by Dürer, Cranach the Elder and Hans Sebald Beham (1525-8, Albertina, Vienna).

Cross-reference: Basil.
Bibliography: "Giovanni Crisostomo" in *Bibliotheca Sanctorum*, 1961-9, vol. IV.

JOHN THE BAPTIST

Latin: Johannes Baptista; Italian: Giovanni Battista, Giambattista; Spanish: Juan Baptista; French: Jean-Baptiste; German: Johannes der Täufer. Prophet and Martyr. Feast day 24 June (his birthday), 29 August.

TRADITION

The Evangelists consider John the Baptist as the last in the line of prophets. He announces and precedes the coming Messiah (Matt. 11:13) and is therefore known as the Precursor. Luke tells of his miraculous birth and circumcision, at which he receives his name: "They called him Zacharias, after the name of his father. And his mother answered and said, Not so; but he shall be called John" (Luke 1:59-60). Luke dedicates five lines to John's childhood (Luke 1:80). The apocryphal *Protevangelium* of James provides an abundance of details, but beyond a number of unlikely events little is known about John until he began baptizing in the River Jordan around 27 AD.

John was an ascetic, announcing the coming Messiah, for whom preparation must be made by repentence (Luke 3:2-8). The future apostles Peter and Andrew were numbered among his disciples. He baptized Jesus and recognized in him the Messiah when the Holy Spirit descended "in bodily shape like a dove upon him" (Luke 3:22) and a voice came from heaven saying, "Thou [Jesus] are my beloved son." John later asked Jesus, "Art thou he that should come?" (Luke 7:19) and Jesus replied, "For I say unto to you, Among those that are born of women there is not a greater prophet than John the Baptist" (Luke 7:28).

John was imprisoned for censuring the incestuous marriage between

St John the Baptist
Fifteenth century. Cathedral of St Anne, Apt.

Herod Antipas and Herodias, the wife of his brother. Salome, the daughter of Herodias and Herod Philip, exploits her uncle's weakness to have the prophet executed. His head is presented on a platter to Herodias, instigator of the murder (Matt. 14:3-11; Mark 6:17-28; Luke 3:19-20).

John the Baptist is the only saint whose birthday is celebrated as his feast day (as with Jesus and Mary). Numerous baptistries are consecrated to him. He is the patron of a number of cities: Turin, Genoa and Florence. In Rome, the Basilica of St John Lateran is dedicated to him.

REPRESENTATION AND ICONOGRAPHY

During the paleochristian period, John wears an ancient philosopher's mantle, with no other distinctive sign. From Constantine's time, he was depicted as a desert anchorite. Dressed in a raw camelhair tunic, he stands, gaunt and emaciated (the extreme version of this is Ercole de'Roberti, fourth quarter of the fifteenth century, Berlin-Dahlem Staatliche Museen, Berlin). At the end of the middle ages, he can wear a sheepskin instead, the head and feet hanging down in front (statue, sixteenth century, Musée de Montargis, France; V. Carducho, 1610, Real Academia de San Fernando, Madrid, and A. Bloemaert, early seventeenth century, Rijksmuseum, Amsterdam, show him preaching). He carries a stick topped by a medallion inscribed with a lamb holding a crucifix (for, one day, as Jesus was walking in front of him, John said, "Behold the Lamb of God", John 1:36). The same animal figure can also be found sitting or standing on a book. Sometimes, a platter is shown bearing the martyr's head. This motif can also stand alone (Giovanni Battista, bronze, sixteenth century, Musée Mayer Van der Burgh, Antwerp). *See also* Salome.

In eastern Byzantium, from the thirteenth century on, John the Baptist can be denoted with wings. He is thus an angel, sent by Christ: "Behold I send my messenger [*angelos*] before thy face, which shall prepare thy way before thee" (Mark 1:2). During the Renaissance, the hermit character is emphasized (Franciabigio, 1518-19, two scenes from the life of John the Baptist, Convento degli Scalzi, Florence; Geergten tot Sint Jans, 1485-90, Berlin-Dahlem Staatliche Museen, Berlin; Domenico Veneziano, 1445-48, predella from S. Lucia de Magnoli, National Gallery, Washington). His beheading is another popular motif (Nickolaus Manuel Deutsch, c.1520, Kunstmuseum, Basel; J. Bassano, c.1640s, Statens Museum for Kunst, Copenhagen; Puvis de Chavannes, late nineteenth century, National Gallery, London).

Cycles

There exist numerous sculpted or painted cycles of the principal events of St John the Baptist's life: childhood (annunciation to Zacharias, *see* Zacharias); Mary's visit to Elisabeth (*see* Visitation); naming of the child (*see* Zacharias). Their main inspiration is the Gospels, apocryphal texts and James of Voragine's *Golden Legend*. Another legendary episode – a duplicate of the Flight into Egypt – is Elisabeth's fleeing with the infant John into the desert. The main episodes of John's later life are Christ's Baptism in the River Jordan (Piero della Francesca, 1448-50, National Gallery, London) and the dance of Salome (see those entries).

In the fourteenth century, his cycle was treated by Andrea Pisano (bronze, 1330-37, south door, Baptistry, Florence) and in the fifteenth by Filippo Lippi (frescoes, 1452-64, choir of Prato Cathedral) and Ghirlandaio (1485-90, S. Maria Novella, Florence). Grünewald placed him at the base of the Cross as a living symbol of Christ's divinity (Isenheim Altar, 1511-17, Musée

d'Unterlinden, Colmar, France). Andrea del Sarto (1514, Convento degli Scalzi, Florence) provides a later example. Other presentations include Geertgen tot Sint Jans (*The Burning of St John's Bones*, 1485-90, Kunsthistorisches Museum, Vienna) and the Master of Flamelle (*John with Enrique De Werl*, c.1420-30, Prado, Madrid).

Attributes: Lamb with Cross. Axe ("And now also the axe is laid unto the root of the trees", Matt. 3:10). Camelskin or sheepskin tunic.
Cross-references: Alexis, Elizabeth, Zacharias.
Bibliography: E. Mâle, "Le type de saint Jean-Baptiste dans l'art", *Revue des Deux Mondes*, 1951, pp. 53-61. A. Masseron, *Saint Jean-Baptiste dans l'art*, Paris, 1957.

JOHN THE EVANGELIST

Greek: Ioann Theologos; Latin and German. Johannes; Italian: Giovanni; Spanish: Juan; French: Jean.
Apostle and Evangelist. Feast days 6 May, 27 December.

TRADITION

John appears in many New Testament episodes. With James and Simon Peter, he followed Jesus after the miraculous draught of fishes on the Sea of Galilee. He was present at the Transfiguration on Mount Tabor and with Jesus in the Garden of Gethsemane. His head rested on Christ's chest during the Last Supper. At the foot of the Cross, he supported the fainting Virgin. After the Apostles scattered, he travelled to Asia, settling at Ephesus with the Virgin. There, as a very old man, he was apparently arrested and thrown into burning oil, but survived unhurt. Exiled to the Island of Patmos (Sporades) under Domitian, he wrote the Revelations. Benefiting from an amnesty, he returned to Ephesus and, at the request of the local bishop, composed his Gospel in an effort to counter heresy. He survived an ordeal set him by the high priest of Ephesus: he was unaffected by a beverage concocted from snakes' venom. A legend also recounts how he was lifted up by an angel in an Assumption which could be compared to the Virgin's. He is the patron saint of booksellers.

REPRESENTATION AND ICONOGRAPHY

In the west, he is a beardless young man, often holding the palm given him by the Virgin to carry before her coffin at her funeral. In the east, he is pictured as an old man, bald, but with a long white beard. He appears with Jesus in a number of scenes, notably at the Last Supper and at the foot of the Cross, succouring the Virgin (Grünewald, Isenheim Altar, 1511-17, Musée d'Unterlinden, Colmar, France). He is also shown composing his Gospel or Revelations on the tiny island of Patmos, accompanied by an eagle (H. Burgkmair, 1518, Alte Pinakothek, Munich), whose outstretched wings he may be using as a desk.

The episode of the poisoned cup is indicated by the device of a snake or little dragon emerging from a cup or chalice above which hovers a host. The emperor can be depicted ordering him to be cast into a vat of boiling oil (Dürer, woodcut, *Apocalypse*, 1497-98; stained glass in the Upper Church at Assisi). Jean Fouquet (*Heures d'Etienne Chevalier*, before 1461, Musée Condé, Chantilly) shows the destruction of the Temple of Diana at Ephesus in answer to John's prayers. The cycle of his life is illustrated by Giotto (frescoes, c.1310-

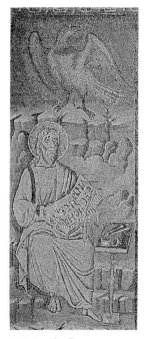

St John the Evangelist
Sixth century. S. Vitale, Ravenna.

12, Cappella Peruzzi, S. Croce, Florence) and in stained glass at Bourges and Chartres.

Attributes: Eagle. Vat of boiling oil. Book (Gospel, Revelations). Serpent, snake or dragon emerging from a cup or chalice.

Cross-references: Agony in the Garden, Appearances of the Risen Christ, Crucifixion, Evangelists, Last Supper, Revelations, Tetramorph, Transfiguration.

Bibliography: Martinov, "L'Iconographie de Saint Jean l'Evangéliste", *Revue de l'art chrétien*, Paris, 1879.

JONAH

Variant, French and German (New Testament): Jonas; Italian: Giona; Spanish: Jonás.

TRADITION

The story of Jonah, indubitably mythical, is the subject of the Book named after him. The Almighty ordered Jonah to go to Nineveh and exhort its inhabitants to turn away from wickedness (Jonah 1:2). Mortally afraid, Jonah tried to escape and embarked on a Phoenician vessel. A storm broke out which the sailors were convinced was caused by their passenger; they threw him overboard and the storm immediately subsided. Jonah was swallowed by a whale, and spent three days and three nights in the belly of the beast before God finally set him safe and sound on the Syrian coast. This time, Jonah preached as he was commanded (3), and the people of Nineveh mended their ways and obtained God's forgiveness. Jonah was outraged by this undeserved leniency, and left the town. While sitting in the shadow of a "gourd" (4:6) he was punished by God for his defiance: the tree dried up above his head, and he suffered sunstroke.

Christian symbolism is very partial to this story, seeing in it a prefiguration of the Entombment and Resurrection of Christ. Matthew explained the connection: "For as Jonas," says Christ, "was three days and three nights in the whale's belly; so shall the Son of man be three days and three nights in the heart of the earth" (12:40).

Jonah Coming Out of the Whale's Mouth
Herrad von Landsberg, *Hortus Deliciarum*, c.1180.

REPRESENTATION AND ICONOGRAPHY

On paleochristian frescoes and sarcophagi, Jonah is a naked young man. There are a great many examples of his legend from this period; fifty-seven survive on catacomb frescoes. By the middle ages he is bald and has grown a beard, aged like all the prophets. His story survived to the twelfth century and Nicolas of Verdun continued to show it as a Resurrection example (1181, Klosterneuberg altarpiece, Klosterneuberg Stiftsmuseum, Austria), but the motif disappeared during the Renaissance. Due to the presence of an animal, it has occasionally resurfaced in later periods (J. B. Flannagan, 1937, Institute of Fine Arts, Minneapolis). The associated theme of the miraculous voyage is a recurrent one in hagiography and occurs in the legends of SS. Brendan and Vincent.

Jonah Thrown into the Sea (Jonah 1:15)

A Roman sarcophagus (Lateran Museum, Rome) portrays the scene in a justly celebrated relief sculpture. On the Klosterneuberg altarpiece, Jonah is first swallowed up, then regurgitated by the whale (Nicolas of Verdun, 1181,

Klosterneuberg Stiftsmuseum, Austria). Rubens also illustrates this theme (1618-19, Musée des Beaux Arts, Nancy).

Jonas Vomited out on to Dry Land (2:10)
In paleochristian art, Jonah's torso is shown emerging from the mouth of a sea monster. He is naked and at prayer.

Jonah in the Shadow of the Gourd (4:5-6)
Jonah cradles his head in his hand (catacomb of Priscilla, Rome, early thirrd century). The scene generally takes place in an arbour, with Nineveh in the background.

Attribute: Whale.
Cross-references: Entombment, Miraculous Sea Voyage, Resurrection.
Bibliography: A. Ferrua, "Paralipomeni di Giona", *Rivista di Archeologia Christiana*, 38, 1962, pp. 7-69. H. Leclercq, *Dictionnaire d'archéologie chrétienne et de liturgie*, vol. VII, pp. 2572-631.

JOSEPH OF ARIMATHAEA *see* DEPOSITION, ENTOMBMENT.

JOSEPH OF NAZARETH

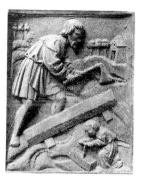

Latin: Josephus; Italian: Giuseppe; Spanish; José; French and German: Joseph. First century. Feast days 19 March, 1 May.

TRADITION
In the genealogy which opens the Gospel according to St Matthew, Joseph descends from the line of David. He is a carpenter in Nazareth, Mary's husband and Jesus' foster-father. Matthew tells of the annunciation of Jesus' birth made known to Joseph in a dream (1:20). Joseph appears in the Adoration of the Magi, in the Flight into Egypt and in the return to Nazareth. Luke recounts the episodes of the Birth, Circumcision, Presentation in the Temple and the disappearance of the 12-year-old Jesus in Jerusalem. Certain apocryphal texts (the *Protevangelium* of James and the *History of Joseph the Carpenter*, a Coptic document of the fifth or sixth century) are designed to fill the yawning gaps in Joseph's biography left by the Gospels. According to one text, Joseph is chosen among Mary's suitors because the rod he carries burst into flower.

Joseph of Nazareth
Altarpiece section, sixteenth century. Church at Kampillon.

Joseph was venerated in the east from the sixth century. His cult was extended to the west in a meaningful sense only on the initiative of St Teresa of Avila and the Jesuits. Thanks to the latter, he was made patron saint of Mexico in 1555 and of Canada in 1624. In 1870, Puis IX proclaimed him Patron of the Universal Church and fixed his feast on19 March. In 1955, Pius XII instituted another feast, that of St Joseph the Worker, on May Day.

REPRESENTATION AND ICONOGRAPHY
Throughout the middle ages, Joseph appears only in scenes concerning the Holy Family as a whole. He is a meditative figure (capital, Notre Dame du Port, Clermont-Ferrand, twelfth century). Nicolas of Verdun (1181, Klosterneuberg altarpiece, Klosterneuberg Stiftsmuseum, Austria) presents him with a long beard and a priestly appearance at the Circumcision. In the thir-

teenth and fourteenth centuries, he is still bearded and wears a pointed hat. At the end of the medieval period, the wedding of Mary and Joseph has also become a regular subject.

In the sixteenth century, during the promotion of his cult by St Teresa of Avila, a great transformation in Joseph's iconography took place. Joseph is represented with his Son, carrying a lily. He is shown as a craftsman (Robert Campin, fifteenth century, Cloisters, Metropolitan Museum of Art, New York). He can carry a small axe in his left hand and the Child's hand in his right (wooden sculpture group, Church of Esseintes, Gironde, sixteenth century; Georges de La Tour, second quarter of the seventeenth century, Louvre, Paris). Under Jesuit influence, this image of Joseph was incorporated into Marian cycles during the seventeenth century.

Attributes: Pilgrim's staff or rod topped by a fleur-de-lis cross (fifteenth and sixteenth century). Carpenter's tools (northern Europe). Lily (when he accompanies the Child: symbol of chastity).

Cross-references: Flight into Egypt, Jesus, Magi, Marriage of the Virgin, Mary, Presentation of Our Lord in the Temple.

Bibliography: Grimouard de Saint-Laurent, "Etude sur l'iconographie de saint Joseph", *Revue de l'art chrétien*, 26, 1883, pp. 347 ff. J. Seitz, *Die Verehrung des heiligen Joseph bis zum Konzil von Trient dargestellt*, Freiburg im Breisgau, 1908.

JOSEPH THE PATRIARCH

Latin: Josephus; Italian: Giuseppe; Spanish; José; French and German: Joseph.

TRADITION

The son of Jacob and Rachel, Joseph is his father's favourite, as he belongs to that special category of Biblical children born to parents of such an

Joseph and Putiphar's Wife
Guerchino, c.1649. John and Mabel Ringling Museum, Sarasota, Florida.

Job and his Wife. Georges de La Tour, c.1650. Musée départemental des Vosges, Epinal.

Lot and his Daughters. School of Leiden, first half of the sixteenth century. Louvre, Paris.

advanced age that their birth seems miraculous. His story appears in two different versions in the Bible. Joseph is misguided enough to tell his brothers about a dream he had in which his parents' preference for him is revealed all too clearly. His jealous brothers sell him as slave. He is taken to Eygpt and thrown into prison on the orders of the wife of the commander Putiphar, who cannot forgive him for rejecting her advances. This does not prevent Joseph from eventually gaining the favourable regard of the Pharaoh and becoming a high-ranking Egyptian official. His dreams and his most important adventures are recounted in Genesis (30:22-24; 37; 39-50).

Since the second century, the predominant interpretation in exegeses and sermons has been of Joseph as a Christ figure. Joseph is betrayed by his brother, like Jesus by Judas. He is taken off to Egypt like the Infant Christ. His very success at the Egyptian court prefigures Christ as Saviour of the World.

REPRESENTATION AND ICONOGRAPHY

The oldest depictions of the story of Joseph are to be found in the two bene-dictions on the frescoes of the Synagogue at Dura-Europos (c.245). Remarkably, Joseph is absent from catacomb art, although he is quite frequent in Byzantine manuscripts. In the middle ages, Joseph is rarely shown in isolation, figuring rather in series of the Patriarchs or Prophets who announce the Coming (cathedral portals). By the thirteenth century, he is a good-looking young man without a beard (statue at the north transept of Chartres Cathedral with, on the base, a scene showing Putiphar's wife listening to the unwholesome advice of a demon). The scene showing his attempted seduction remained a favourite one in the baroque (Orazio Gentileschi, late 1620s, Royal Collection, Hampton Court).

Cycles

In the east, the life of Joseph finds its illustration for the most part in miniatures and in the decorative arts. In the west, however, he appears in works of a monumental nature (fifteen scenes in the mosaics in the Bapistry, Florence, 1280-1320).

His story is also recounted in stained glass from the thirteenth century onwards (twenty-five medallions placed beneath the figure of Christ in Majesty, Chartres Cathedral; forty-five scenes in two main windows at the choir, Erfurt Cathedral, end of the fourteenth century). Rembrandt often painted him (*Joseph telling his dreams*, 1638, Rijksmuseum, Amsterdam; *Joseph's Dream*, 1645, Berlin-Dahlem Staatliche Museen, Berlin; *Joseph accused by the Wife of Putiphar*, 1655, National Gallery, Washington). Bachiacca (second half of the seventeenth century, Galleria Borghese, Rome) and Mola (1657, Quirinale, Rome) both produced cycles.

Cross-references: Jacob, Jesus.
Bibliography: J. Daniélou, "La typologie biblique traditionnelle dans la liturgie lu Moyen Age", *Settimane di studio del Centro italiano di studi sull'Alto Medioevo*, 10, Spoleto, 1962-63. P. Fabre, "Le développement de l'histoire de Joseph dans la littérature et dans l'art au cours des douze premiers siècles", *Mélanges d'archéologie et l'histoire*, 39, 1921-22, pp. 193-211.

JOSHUA

Italian: Giosue; Spanish and French: Josué; German: Josua.

Joshua
Colin Nouailher. Sixteenth
century. Louvre, Paris.

TRADITION

Oshea, the son of Nun, is renamed by Moses as Joshua (Jehoshua in Num. 13:16, a doublet of the name Jesus), when he is sent to spy out the land of Canaan. At the death of Moses, Joshua was commanded to lead the people of Israel across the River Jordan towards the Promised Land, which God did not permit Moses to see. Joshua the warlord accomplished his mission. Just as Moses conducted his people across the Red Sea, so Joshua, in what for the Christian tradition is a prefiguration of the rite of the Baptism, crossed the Jordan at the head of the people entrusted to him.

He then sent a pair of spies into Jericho to study its defences. They were unmasked but took refuge with Rahab, a prostitute. Her house, recognizable by the scarlet thread the spies had asked her to tie from the window through which they had made their escape (Jos. 2:18), was the only one spared during the ensuing sack of the city. A crucial episode occured after the fall of the walls of Jericho (Jos. 6): during the battle against the Amorites, the sun stopped in its course. On Joshua's orders, it remained motionless the whole day, "until the people had avenged themselves on their enemies" (Jos. 10:13). As well as the Book which bears his name, Joshua's exploits occupy passages of Exodus, Numbers and Deuteronomy. Since St Paul and the Fathers of the Church, Joshua has been considered as a prefiguration of Christ, not only by his actions, but through his name.

REPRESENTATION AND ICONOGRAPHY

Joshua rarely occurs in isolation. In the Renaissance he is accompanied by David and Judas Maccabeus or forms part of the Nine Heroes motif, and is of no set type. In the paleochristian period, he is a young warrior (mosaic of S. Maria Maggiore, Rome, fifth century). In the twelfth and thirteenth centuries he is youthful, but has lost his soldier's attributes. Sometimes he is simply represented as a bearded patriarch.

Joshua Spies out Canaan (Num. 13:24)

After exploring the land of Canaan, Joshua and Caleb return carrying bunches of grapes hanging from a rod. In the middle ages a bunch of grapes was interpreted as a Eucharistic symbol and the whole scene was linked to the Crucifixion. In the seventeenth century Poussin took up the theme (*Autumn, or the Bunch of Grapes from Canaan*, 1660-64, Louvre, Paris).

The People of Israel cross the Jordan (Jos. 3)

This motif can be distinguished from the crossing of the Red Sea by two factors: no army pursues the Israelites and the priests carry the Ark of the Covenant (which has by this time become Israel's *palladium*). The two scenes are, however, often presented together in the decoration of fonts. This crossing is already found in the fifth century (mosaic in S. Maria Maggiore, Rome).

The Capture of Jericho (Jos. 6) *see* Jericho

The Miracle of the Standing Still of the Sun and Moon (Jos. 10:12)

This miracle reiterates Jehovah's action (Ex. 17:11) during Moses' battle against the Amalekites (mosaics at S. Maria Maggiore, Rome). In the eighteenth century, Tiepolo produced a version (Museo Poldi-Pezzoli, Milan).

Cycles

The mosaics already mentioned in S. Maria Maggiore in Rome contain fifteen scenes of the story of Joshua, linked to a Moses cycle. Illuminated Bible

manuscripts often include a cycle. In the fifteenth century, one of Ghiberti's panels took in elements from Joshua (1403-24, Bapistry, Florence). None of these cycles shows the death of their subject for, correctly speaking, they are narratives of the conquest of the Promised Land rather than Joshua cycles proper.

Cross-references: Ark of the Covenant, Exodus, Jericho, Moses, Nine Heroes.

Bibliography: A. Z. Keck, "Observations on the Iconography of Joshua", *Art Bulletin*, 32, 1950, pp. 267-74. L. Roussel, *Le Livre de Josué*, Paris, 1955.

JUDAS ISCARIOT

Italian: Giuda; Spanish, French and German: Judas.
Apostle.

Judas' Kiss
Giotto, *The Arrest of Christ*, 1304-6 (detail). Arena Chapel, Padua.

TRADITION

One of the twelve apostles, Judas is pointed out as the one who is to betray Jesus at Bethany when Mary, sister of Martha and Lazarus, is anointing Jesus' feet with expensive ointment. Judas, who has just asked which of the disciples is to betray Jesus, pretends to take umbrage: "Why was not this ointment sold for three hundred pence, and given to the poor?" He himself is given thirty silver pieces for his treachery by the high priests, and then waits for a convenient moment to deliver Jesus to them. During the Last Supper, Christ foretells his perfidy (Matt. 26:21-36; Mark 14:10-21; Luke 22:1-23; John 13:21-30).

Judas signals Christ out from among the disciples by giving him a kiss. After Christ's arrest, he receives his reward, but is filled with remorse and tries to return it to the high priests. They will have nothing to do with it or him and, after throwing the money down "in the temple", he hangs himself. The high priests then pick up the money and with it buy the "potter's field ... to bury strangers [foreigners] in". Hence, Matthew concludes (27:3-8), the field is afterwards known as the "field of blood", because it has been bought with blood money. A different explanation is offered in the Acts of the Apostles: "Now this man purchased a field with the reward of his iniquity; and falling headlong, he burst asunder in the midst, and all his bowels gushed out" (Acts 1:18). Exegetes see prefigurations of Judas' treachery both in Joseph sold by his brothers and in Delilah betraying Samson.

REPRESENTATION AND ICONOGRAPHY

In paleochristian art, Judas is not marked out as being different from the other apostles; his features and clothes are the same, and his appearance normal. He is seen merely as an instrument necessary for Christ's final victory. In the sixth century, his betrayal and kiss are connected to Christ's arrest. In the middle ages, from around the ninth century, Judas begins appearing in Passion cycles.

Henceforth, the ignominy in which he is held can be read in his hideous features and his yellow or motley clothing. Giotto (1304-6, frescoes in the Arena Chapel, Padua) presents him as a brutish figure, dressed in yellow and crowned with a black nimbus. His cupidity is manifest in the emphasis given to his brimful money-bag. The moment of betrayal can also be treated (Barna da Siena, c.1340-50, Collegiate Church, San Gimignano, shows him accepting the money from the priests). In images of the Last Supper, Judas is iso-

lated from the other apostles. His eviscerated body can be shown hanging from a fig tree. The scene of his death can be associated with the Crucifixion. On a twelfth-century capital (St Lazare Cathedral, Autun) Judas is hanged while two demons await the fate of his soul. Rembrandt painted a canvas showing Judas' remorse (*Judas returning the thirty pieces of silver*, 1629, Private Collection, Whitby).

Cross-references: Apostles, Arrest of Christ, Crucifixion, Last Supper.
Bibliography: L. Réau, op. cit., vol. II, 2, pp. 413-15, 432-5, 441-3.

JUDAS MACCABEUS

Italian: Giuda Maccabeo; Spanish: Judas Maccabeo; French: Judas Maccabée; German: Judas Makkabäus.

TRADITION

Son of Mattathias, Judas is the head of a Jewish revolt against the Greek kings of Syria. The name he came to be known by, Maccabeus, is a transcription of the Hebrew *maccaba* (hammer), an allusion taken up by Charles Martel (whose name evokes *marteau*, also hammer), the Frankish ruler who halted the Muslim advance at Poitiers. The name Maccabeus was extended to all Judas' brothers as well as to the partisans under his command. This hero greatly occupied the thoughts of medieval men, whose minds were full of Biblical allusion, and he was, with David and Joshua, made one of the three Jewish members of the Nine Heroes.

REPRESENTATION AND ICONOGRAPHY

Judas Maccabeus figures in all representations of the Nine Heroes. Christian iconography, however, has above all kept alive the episode (2 Macc.12:38-46) in which Judas prepares a "Sacrifice for the Dead". After his victory over Gorgias Judas buries the dead. On the corpses of the Jewish soldiery who had fought under the pagan are found amulets stolen from the Jamnites' tem-

Judas Maccabeus
Gerard von Honthorst, c.1620s. Cathedral of St Bavo, Ghent.

ple. Judas organizes a collection to pay for a reparatory "sin offering" at the Temple of Jerusalem. The text makes clear that Judas had acted "therein very well and honestly, in that he was mindful of the resurrection. For if he had not hoped that they that were slain should have risen again, it had been superfluous and vain to pray for the dead" (2 Macc.12:43-45).

Catholic commentators value this episode highly as it forms an early expression of faith in the Resurrection of all flesh. The Catholic Reformation, anxious to reply to Protestant criticism, cited this as a passage in Scripture which justifies a belief in Purgatory. Louis Réau revealed how the canons of Tournai Cathedral commissioned a picture from Rubens on this theme (1634-6, Musée des Beaux Arts, Nantes).

Cross-references: Nine Heroes, Resurrection.
Bibliography: L. Réau, op. cit., vol. II, 2, p. 304.

JUDE [THADDEUS] *see* APOSTLES, SIMON.

JUDGMENT OF JESUS *see* TRIAL OF JESUS.

JUDITH

Italian: Giuditta; Spanish: Judit; French and German: Judith.

TRADITION
Like the Book of Esther (in the Protestant Apocrypha), the Book of Judith, composed probably during the Maccabean period around the second century BC, is centred on a single female character. Bethulia, a small town in Palestine, is besieged by one of Nebuchadnezzar's generals, Holofernes. (According to legend Nebuchadnezzar was King of Nineveh; he was in fact King of Babylonia.) Judith, widow of Manasses, puts on her finery and goes over to the enemy camp in order to save the town. Holofernes finds her "beautiful in [her] countenance and witty in [her] words" (11:23). Judith, tak-

Judith
Caravaggio, 1598. Galleria nazionale d'arte antica, Rome.

205

ing advantage of Holofernes' drunken stupor after their feasting, strikes off his head with his own scimitar.

REPRESENTATION AND ICONOGRAPHY

Among the episodes of the life of Judith, artists have tended to prefer the moment when she beheads the general (capital, Basilica of Vézelay, twelfth century). Certain twelfth-century illuminated Bibles connect Judith's victory to that of the Virtues over the Vices, as presented in Prudentius' *Psychomachia* (348-c.410). Other manuscripts link Judith to the combat between humility and pride. The theme detaches itself from this moral and theological context during the Renaissance (Mantegna, guazzo, 1495-1500, National Gallery of Ireland, Dublin, with Judith carrying a broken sword). The accent leans towards anecdotal elements while the sense of symbolism fades.

Donatello (bronze, 1456-60, Palazzo Vecchio della Signoria) presents Judith as the middle ages did, poised over her victim, menacingly brandishing the sword above the head of the already dead Holofernes. Tiny figures round the base evoke the general's drunkenness in a bacchanal. Judith has become simply an incarnation of triumphant womanhood. In treatments by Giorgione (c.1500, Hermitage, St Petersburg) and Cristofano Allori (c.1615 versions, Royal Collection, Windsor; Palazzo Pitti, Florence) the face of Holofernes may well be self-portraits. The violence of the scene is stressed by J. Liss (c.1625, National Gallery, London) and Artemisia Gentileschi (1620s, Uffizi, Florence). In the seventeenth century, the privileged theme was Judith triumphant (Caravaggio, c.1598, Galleria Nazionale, Palazzo Barberini, Rome; Rubens, c.1625, Palazzo Pitti, Florence; Strozzi, c.1635, Christ Church College Gallery, Oxford). Another associated theme is Judith showing the head of Holofernes to the people (Cranach the Elder, c.1530, Kunsthistorisches Museum, Vienna; A. Bloemaert, 1593, Kunsthistorisches Museum, Vienna; Giambattista Tiepolo, 1735, Rossello Collection, Milan).

Cross-reference: Nebuchadnezzar.

JULIAN

Variant: Julian the Hospitaller. Latin and German: Julianus Hospitator; Italian: Giuliano il Parricida; Spanish: Julián el Hospitalario; French: Julien l'Hospitalier.
Feast day 12 February.

LIFE AND LEGEND

Julian the Hospitaller or the Parricide is a legendary saint whose story was much popularized by the *Golden Legend*. While out hunting, Julian encountered a stag that informed him that he would one day kill his mother and father. To escape such a horrifying destiny, Julian emigrated, becoming a knight and marrying the rich widow of a lord. His parents, stricken by his absence, searched for him high and low, and eventually found his castle. Julian was away, so his wife gave them the marriage bed to sleep in. Returning in the middle of the night, Julian took the couple in his bed for his wife and a lover, and slaughtered them both. Discovering his mistake, he then became a hermit on a river bank, helping pilgrims to cross it. One evening, a shivering leper asked to be taken across and given hospitality. Julian welcomed him and warmed him in his own bed: it was Christ, who informed the hermit that his sin was at last forgiven.

Julian the Hospitaller
Gardner Hale. Private
Collection, Florida.

REPRESENTATION AND ICONOGRAPHY

Julian was at one time the patron saint of pilgrims, travellers and inn-keep-
ers. A number of inn signs told his story. All the episodes of his legend are
depicted in cycles: the meeting with the stag; his self-exile; the murder of his
parents (Masaccio, 1426, predella of the Pisa polyptych, Berlin-Dahlem
Staatliche Museen, Berlin); his helping pilgrims across the river; his hospi-
tality to the leper (Francesco Laurana, c.1470s, Camporosso Church,
Liguria).

Attributes: Small boat. Stag. Sword (with which he kills his parents).

KEY

The key possesses a three-fold symbolic value. First, it indicates ownership
and authority; second, it is a metaphor for a new life, the door to which it
can open; and, third, as an everyday article, it represents the house. The key
as the attribute of St Peter includes all three levels of symbolism and appears
in images from the fifth century, becoming widespread from the eighth. The
choice of this attribute for the chief of the apostles derives from the Christ's
own words to St Peter: "And I will give unto thee the keys of the kingdom
of heaven: and whatsoever thou shalt bind on earth shall be bound in heaven:
and whatsoever thou shalt loose on earth shall be loosed in heaven"
(Matt.16:19).

Starting life as St Peter's personal attribute, the key was to become, by
the late Carolingian period, first a papal and then an ecclesiastical symbol.
From the twelfth century, heraldry systematized the symbol of the Church

into two crossed keys – one gold, one silver – tied together by a red cord. As a metaphor for the house and household goods, the key is sometimes seen also as the attribute of St Martha, patron saint of housewives.

Cross-references: Martha, Petronilla, Peter.

KNIFE *see* BARTHOLOMEW.

LADDER *see* JACOB.

LADLE *see* MARTHA.

LAMB

Latin: agnus; Italian: agnello; French: agneau; German: Lamm.

The lamb is one of the most frequent symbols for Christ. It incorporates the Lord's sacrifice (in the Jewish rite a sheep was sacrificed to wash away sin), the redemption of man, and also alludes to St John the Baptist's famous words: "Behold the Lamb of God which taketh away the sin of the world" (John 1:29). Primitive Christianity often depicted Christ as a lamb (or even as a sheep or ram), generally lying down. At a later date, the lamb is shown with a halo, standing and holding a long-stemmed cross or banner in its hoof (Grünewald, *Crucifixion*, c.1515, Musée d'Unterlinden, Colmar). As the Mystic lamb, it can even form the centre of attention in an altarpiece (Hubert and Jan Van Eyck, *The Mystic Lamb*, Ghent altarpiece, 1432, St Bavo, Ghent). In Spain, a lamb, symbolically tied up, can be the subject of an entire canvas (Zurbarán, 1632, Private Collection, Madrid).

The lamb is also the attribute of St John the Baptist, who himself designated Christ as a lamb. St Agnes is also depicted with a lamb due to a pun on the Latin form of her name, *agnus*. Elsewhere the lamb is used simply to evoke innocence or purity.

Cross-references: Adam and Eve (husbandry), Agnes (martyr), Cain and Abel (husbandry), Genevieve (virgin shepherdess), Good Shepherd, Jesus, John the Baptist, Nativity (symbol), Pastrix Bona, Revelations, Samuel (sacrifice), Sibyls.
Bibliography: A. M. Armand, *L'Agneau mystique*, Paris, 1961. F. Nicolash, *Das Lamm als Christussymbol*, Vienna, 1963.

LAMENTATION *see* DEPOSITION.

LAMP *see* LUCY, WISE AND FOOLISH VIRGINS.

LANCE

The lance, or spear, which pierces Christ's side is numbered among the Instruments of the Passion. It is also one of St George's main attributes and that of a number of warrior-saints. In addition, it figures as the instrument of martyrdom of certain saints, in particular St Thomas.

Cross-references: Crucifixion, George (and dragon), Matthew, Michael (with dragon or Satan), Simon (with book, apostle), Theodore (legionary), Thomas (late, with set-square), Wenceslas (royal knight), William of Gellone (with pennon).

LANTERN *see* CLARE, GUDULE.

LAPIDATION *see* STEPHEN, JEREMIAH.

LAST (SHOEMAKER'S) *see* CRISPIN AND CRISPIAN.

LAST JUDGMENT

Italian: il Giudizione universale, Spanish: el Judicio final; French: le Jugement dernier; German: das Weltgericht, das Jüngste Gericht.

TRADITION
The Book of Psalms (7:7-15) already mentions the Last Judgment: "The Lord shall judge the people." Another primary source is Daniel, who announces

The Last Judgment
Book of Pericopes of St Henry II, beginning of the eleventh century. Bayerische Staatsbibliothek, Munich.

a "time of trouble, since as never was since there was a nation ... And many of them that sleep in the dust of the earth shall awake, some to everlasting life, some to shame and everlasting contempt" (12:1-2). Matthew (25:31-46) forecasts a time when the sun shall go dark, the moon stop shining and the stars fall from heaven: "When the Son of man shall come in his glory, and all the holy angels ... And before him shall be gathered all the nations". The Apocalypse echoes the Book of Daniel: "And I saw a great white throne and him that sat on it" (20:11). After the opening of the books, "the dead were judged out of those things which were written in the books according to their works" (20:12).

REPRESENTATION AND ICONOGRAPHY

The complete sequence of the Last Judgment developed in Byzantine art during the ninth and tenth centuries. Christ was enthroned in glory with "all the holy angels". At this time various scenes in hell appeared, such as the weighing of souls. The dead are awakened by an angel blowing the last trump. Frescoes on Panakia Kalkeon Church (Thessaloniki, eleventh century) add details such as the angel rolling the heavens "together as a scroll" (Is. 34:4), the sea giving up its dead (Rev. 20:13) and the cherubim guarding the east of the garden of Eden (Gen. 3:24). This many-faceted presentation prevailed in the eastern Church until the end of the middle ages.

In the west, the Last Judgment was not represented as such in early medieval art, but was evoked obliquely by showing the parable of the Wise or Foolish Virgins, or of the separating of the sheep from the goats (Matt. 25:33): "And he shall set the sheep on his right hand, but the goats on the left" (mosaic, S. Apollinare Nuovo, Ravenna, sixth century). Around the turn of the ninth century one finds a depiction of the Judgment which conforms to the full complexity of Scripture. The various components occur on a much damaged fresco in the Church at Mustair, in Switzerland (c.800, back of the façade). The composition is organized on three levels, with the *Adventus Domini* at the top and the angel separating the elect from the damned at the bottom. The Supreme Judge in Majesty on a throne with a Cross appears in the Carolingian period (Reichenau manuscripts). This type persists in Romanesque and Gothic monumental sculpture: Christ, bare-chested, shows the wound in his side (St Foy, Conques, eleventh century); Christ in Majesty dominates the composition (St Trophime Cathedral, Arles, end of the twelfth century). The damned and the three Patriarchs, Abraham, Isaac and Jacob, slowly make their appearance; sometimes Abraham alone is shown receiving the souls of the elect into his bosom.

On the tympana of Gothic cathedrals, Christ in Judgment exposing his wounds occupies pride of place, with angels carrying the Instruments of the Passion. The Virgin, St John, the damned and the elect (occasionally shown in Abraham's bosom) are also constants. St Michael weighs the souls on a pair of scales which a demon tries to tilt in his direction. Sometimes Christ himself weighs the souls while the damned are cast into Hell (Lucas van der Weyden, Altarpiece, c.1446-8, Hôtel-Dieu, Beaune). As in scenes of the Holy Women at the Sepulchre and the Passion, the influence of liturgical drama and later of mystery plays is apparent.

For the most part, the Last Judgment is presented on the west front of churches and cathedrals as well as on numerous altarpieces of the fifteenth century (Van Eyck, c.1424, Metropolitan Museum of Art, New York; Memling, c.1473, Centralne Muzeum Morskie, Gdansk, Poland). In the latter half of the century, Signorelli produced a work much influenced by the

theology of Savonarola (1499-1504, Cappella S. Brizio, Orvieto Cathedral).

Michelangelo's fresco (vault of the Sistine Chapel, 1536-41) introduces turbulence into the scene of the Last Days. A being of superhuman power, Christ, no longer exposing his wounds, sits in judgment. On his left, the Virgin sits enthroned and the Instruments are presented. Prophets, apostles and saints are each placed around Christ. Below, the dead are resurrected and St Michael holds the book of life (Rev. 20:12). Rubens' composition emphasizes the tragedy of the damned, stressing their torment, like Michelangelo before him (1614-16, Alte Pinakothek, Munich). This approach continues during the nineteenth century (John Martin, c.1852, Tate Gallery, London; Rodin, *Porte de l'Enfer*, bronze, begun 1880, Musée Rodin, Paris). The theme's eschatological power has attracted modern painters (Stanley Spencer, 1923-7, Tate Gallery, London, sets the events in his native Cookham in Berkshire; Scipione, 1930, Museo Civico, Turin, sets them in modern Rome).

Cross-references: Abraham, Angel, Cherubim and Seraphim, Daniel, Ezekiel, Lazarus (raising of), Michael, Revelations, Wise and Foolish Virgins.
Bibliography: M. Cocagnac, *Le Jugement dernier dans l'art*, Paris, 1955. J. Fournée, *Le jugement dernier*, Paris, 1964. L. Réau, op. cit., vol. II, 2, pp. 727-57.

LAST SUPPER

Latin: Cena Domini; Italian: il Cenacolo; Spanish: la Ceña del Señor; French: la Cène; German: das letzte Abendmahl.

TRADITION

All four Gospels, with very few variants, recount the last meal Christ took with his twelve disciples (Matt. 26:17-30; Mark 14:12-26; Luke 22:7-38; John 13:17-30). Two major themes dominate in both tradition and iconography. The first episode concerns Jesus' disclosure that he will be betrayed by one of his own disciples: "Now when the even was come, he sat down with the twelve. And as they did eat, he said, Verily I say unto you, that one of you shall betray me. And they were exceeding sorrowful, and begun every one of them to say unto him, Lord, is it I? ... Then Judas which betrayed him, answered and said, Master, is it I? He said unto him, Thou hast said" (Matt. 26:20-25).

The Last Supper
Tintoretto, late sixteenth century. S. Trovaso, Venice.

The second episode comprises the institution of the Eucharist: "Take eat, this is my body" (Matt. 26:26). Then Christ took a cup and, filling it with wine, "gave thanks, and gave it to them, saying, Drink ye all of it; For this is my blood of the new testament, which is shed for many for the remission of sins" (26:27-28).

REPRESENTATION AND ICONOGRAPHY

The Forecast of Judas' Treachery

The theme of the Last Supper is absent from paleochristian art in general, the earliest depiction being on an ivory diptych of the fifth century (Tesoro, Duomo, Milan). Starting in the sixth and seventh centuries, and throughout the middle ages until the sixteenth, artists chose to depict the moment when Jesus revealed that he is to be betrayed in preference to any other scene (mosaic, S. Apollinare Nuovo, Ravenna, sixth century). Several variations are possible which allow Judas to be identified (Matt. 26:23): Judas stretches his hand out to the dish, or Jesus hands him a piece of bread (Holbein the Younger, c.1520, Kunstmuseum, Basel).

The Institution of the Eucharist

Until the fifteenth century, this was a very rare subject (Dirk Bouts, triptych, 1468, Louvain Cathedral; Joos van Wassenhove, 1473-75, Galleria Nazionale, Urbino). Christ blesses the consecrated host as John looks on, his hands clasped in prayer.

In the sixteenth century, some Protestant painters of altarpieces invested the Last Supper with much symbolic meaning. The theme also became increasingly frequent in Catholic art and iconography of the period following the Reformation. In the seventeenth century, Philippe de Champaigne composed a Last Supper with Christ blessing the bread and wine (1648, Louvre, Paris), while Poussin showed Jesus in the act of giving communion to the apostles (*The Seven Sacraments*, second cycle, 1644-48, Duke of Sutherland Collection, National Gallery of Scotland, Edinburgh).

The Placing of Christ and the Apostles around the Table

Initially, Christ and the apostles were shown in a half-prone position around a semi-circular (or *sigma*) table. This version disappeared in the west during the Carolingian age and the diners were henceforth shown seated. The oval or round table was not totally abandoned, however, and the older arrangement was occasionally readopted in the seventeenth and eighteenth centuries.

The scene takes place at night (Matt. 26:20) and can be lit by firebrands, torches or by lamps hanging from the ceiling. Fish were served during the fifth or sixth centuries and two appear next to the bread in S. Apollinare (mosaic, sixth century). Fish were the rule in the east, while in the west their Christian symbolism vanished at an early date.

From the fifth century, Christ sits at a corner of the table, on the left. He conserves this position until the middle ages in the west and throughout the whole period in the east. Later, however, Christ occupies a central position (Leonardo da Vinci, 1495-7, refectory of the monastery of S. Maria delle Grazie, Milan). Most often, he raises his right hand, prophesying.

The number of disciples also varies until twelve becomes the accepted number. They are grouped around the table or sit behind it, while Judas tends to be found in a more isolated position. He is often placed in front of Christ, in the foreground, as if to signal him out for public opprobium (Castagno,

c.1450, refectory of S. Apollonia, Florence, where he sits alone on the near side of the table). In the west, medieval artists tended to put John to Jesus' left and show him laying his head on Christ's breast (John 13:23). Giotto shows John with his eyes closed as if asleep, leaning on Christ's breast (1304-6, Arena Chapel, Padua). The theme has sometimes been painted in more recent times (Emil Nolde, 1909, Statens Museum for Kunst, Copenhagen).

Cross-references: Apostles, Cana, Communion of the Apostles, John, Judas Iscariot.
Bibliography: J. Kühn, *Die Darstellungen des Abendmahles im Wandel der Zeiten*, Schaffenhausen, 1948. M. Vloberg, *L'Eucharistie dans l'art*, Paris, 1946. K. Wessel, *Abendmahl und Apostel-Kommunion*, Recklinghausen, 1964.

LAURENCE

Variant: Lawrence. Latin: Laurentius; Italian and Spanish: Lorenzo; German: Laurentius, Lorenz.
Roman deacon and Martyr. Died 258. Feast day 10 August.

LIFE AND LEGEND
Laurence was born in Huesca, Aragon, and became deacon under Sixtus II. During the Valerian persecutions, he was martyred just a few days after the Pope, on 10 August 258. This much, and his generosity in almsgiving, is attested with certainty. The postponement of his execution until after the Pope's is explained by his being the Church treasurer: the authorities apparently attempted to persuade him to turn over ecclesiastical property and documents. As Valerius' edicts prescribed simple execution, the gridiron upon which Laurence suffered his martyrdom is certainly legendary. It most probably derives from Phrygian sources and was incorporated into Laurence's legend via the *Acts* of Vincent of Saragossa, a different Spanish deacon with whom he has been constantly linked. Laurence is patron saint of the poor.

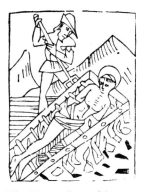

The Martyrdom of St Laurence
Woodcut from James of Voragine's *Golden Legend*, 1483 edition.

REPRESENTATION AND ICONOGRAPHY
In the east, Laurence is often associated with both St Stephen and St Vincent. He is most often depicted wearing a deacon's dalmatic. He also has a book of the Gospels, palm fronds and the gridiron upon which he was supposed to have been martyred. He is shown triumphantly carrying a cross over his right shoulder and a book of the Gospels in his left hand (mosaic, mausoleum of Galla Placidia, Ravenna, fifth century). He advances towards the gridiron heated by burning coals, while a chalice full of gold coins evokes his generosity. Sometimes the executioners or demons are shown keeping the fire ablaze with bellows (capital in the cloister at St Pierre, Moissac, eleventh century; stained glass at Poitiers and Bourges; tympanum of Genoa Cathedral). Titian treated the theme of his martyrdom as an act of extreme violence (c.1548-9, Gesuiti, Venice).

Attributes: Chalice (containing a moneybag or gold coins). Dalmatic. Gospels. Gridiron. Processional cross.
Bibliography: P. Courcelle, "Le gril de saint Laurent", *Cahiers archéologiques*, 3, 1948, pp. 29-39. P. Franchi de Cavalieri, "San Lorenzo e il supplicio della graticola", *Römische Quartalschrift für christliche und Altertumskunde*, 14, 1985, pp. 159 ff.

**Lazarus the Poor Man at
the Rich Man's Table**
F. Francken II, first half of
the seventeenth century.
Musée Municipal, Cambrai.

LAZARUS (THE POOR MAN AT THE GATE)

Latin: Lazarus, dives Epulo; Italian: il ricco Epulone, il povero Lazzaro; Spanish: Epulón, el pobre Lázaro; French: Epulon le riche et Lazare le pauvre; German: Lazarus.

TRADITION

The only source in the Gospels for this parable of Jesus is St Luke (16:19-31). Lazarus is a pauper "which was laid" at the rich man's gate,"full of sores". He is given nothing to eat, "moreover the dogs came and licked his sores". After his death, Lazarus' soul "was carried by angels into Abraham's bosom". The rich man, tormented in hell, however, begs Abraham to send Lazarus to him with a little water. Abraham refuses, saying, "Remember that thou in thy lifetime receivedst thy good things, and likewise Lazarus evil things" (17:25). Abraham also makes clear that it is impossible for a soul in heaven to cross the chasm to hell.

REPRESENTATION AND ICONOGRAPHY

The theme is illustrated in a number of manscripts and in large-scale sculpture from the eleventh century. From the tenth century, the two last scenes have been associated with the Last Judgment (Byzantine ivory carving, tenth century, Victoria and Albert Museum, London). French monumental sculpture of the twelfth and thirteenth centuries often shows this parable (capital on the St Lazare portal, north side door, Autun Cathedral, twelfth century; low-relief on the portal of St Pierre, Moissac, twelfth century). The Evangelist Luke is presented next to the various episodes.

Protestant artists of the sixteenth century, in illustrated versions of Luther's Bible, stressed the rich man's hardness of heart. In the middle of the seventeenth century, Jan Steen treated the rich man's feasting as a genre scene (Musée des Beaux Arts, Strasbourg; a servant gives the remains of the meal to the dogs).

Cross-references: Abraham, Hell, Last Judgment.
Bibliography: L. Réau, op. cit., vol. II, 2, pp. 348-52.

214

LAZARUS (RAISING OF)

Latin: Lazarus; Italian: Lazzaro; Spanish: Lázaro; French: Lazare; German: Lazarus.

TRADITION

The miracle of the raising of Lazarus is mentioned solely in the Gospel according to St John (11:38-44). This Lazarus is the brother of Martha, of "that Mary which anointed the Lord with ointment" (John 11:2). He fell ill and Jesus, called by his sisters, came to his house, but arrived four days after his friend had died. A cave with a stone over the entrance served as his tomb. Jesus had the stone removed and cried in a loud voice, "Lazarus, come forth." And Lazarus, "he that was dead", his hands and feet bound with "graveclothes", his face wrapped with a "napkin", got up, and Jesus said: "Loose him, and let him go."

REPRESENTATION AND ICONOGRAPHY

The oldest representation of this miracle is a painting in the catacomb of Callista, in Rome (third century). Christ, standing in front of Lazarus whom he has just resurrected, holds in his left hand a stick which has been compared to the magic wand with which Hermes summons up the dead from Hades. In the catacomb frescoes and on paleochristian sarcophagi, Jesus holding his stick and raising Lazarus is linked to Moses smiting the rock and bringing forth a spring (Ex. 17:3-6). Gradually, however, this stick becomes a cross. In the mosaics of S. Apollinare Nuovo in Ravenna (beginning of the sixth century), Lazarus, still in his "graveclothes", lies in a coffin beneath an *aedicula*. The Jews roll away the stone and Lazarus' soul is freed from Hades. The cave, with the coffin at its entrance, belongs to Byzantine imagery.

In western art, on the other hand, the cave hardly ever appears. Lazarus can lie on top of the coffin (capital, St Benoît sur Loire, twelfth century). This formula derives from a "tomb of Lazarus" that was formerly in St Lazare in Autun, but which has since disappeared, where Lazarus could be seen lying in a coffin and wrapped in a shroud. The lid of the coffin was held open by

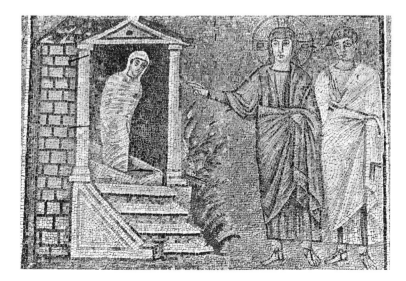

The Raising of Lazarus
Fifth century. S. Apollinare Nuovo, Ravenna.

Peter, Andrew, Mary Magdalene and Martha (shown holding a corner of her drmss to her nose). Nicholas Froment's example (1461, Uffizi, Flormnce) alludes to the same passage (John 11:39). This miracle is often juxtaposed with the Resurrection and placed at the beginning of Passion cycles (Giotto, 1304-6, Arena Chapel, Padua). A fifteenth-century version shows the whole scene taking place in a church (A. van Ouwater, c.1440-70, Berlin-Dahlem Staatliche Museen, Berlin).

Art of the Protestant Reformation promoted the iconographical thematic of the paleochristian period. Cranach the Younger shows Luther and other Reformers witnessing the scene (after 1537, Gemäldegalerie, Dresden). Sixteenth-century artists included in the scene active figures such as the men rolling away the tombstone. Carel Fabritius paints the drama of the act in crepuscular tones (1642, Narodni Museum, Warsaw) while another example shows Lazarus' arms emerging from the coffin while the rest of his body remains invisible (Jan Lievens, 1631, Brighton Art Gallery, UK). Rubens, placing the two figures on the same level, shows Lazarus walking towards Christ (c.1624, Louvre, Paris); Rembrandt opposes a prone Lazarus in his tomb to a Christ who stands (1630, County Museum of Art, Los Angeles); Sebastiano del Piombo shows a dazed Lazarus with his bandages hanging off (1517-19, National Gallery, London).

Cross-references: Moses, Resurrection.

Bibliography: E. Mâle, "La résurrection de Lazare dans l'art", *Revue des arts*, 1, 1951, pp. 44-52. A. Pér;até, "La Résurrection de Lazare dans l'art chrétien primitif", *Mélanges d'archéologie et d'histoire*, supplement, 1892. L. Réau, op. cit., vol. II, 2, pp. 386-91.

LEVI *see* MATTHEW.

LEVIATHAN *see* HELL.

LILY

The lily is the first Biblical and Christian symbol of purity, an emblematic flower fitting for both Christ himself and the Virgin. By extension, from the thirteenth century onwards, it was assigned to a number of saints to stress their purity or chastity. The presence of a lily in most representations of the Annunication has made it an attribute of Gabriel since the middle ages. It is a symbol of sovereignty and a royal attribute which can occasionally be carried by Christ or by God the Father. It can be a heraldic lily, a fleur-de-lis which refers to the Capetian dynasty (which probably chose the flower in the twelfth century in order to place itself under the protection of the Virgin).

Cross-references: Anne (elderly woman), Annunciation, Antony of Padua (Franciscan and child), Catherine of Siena (with crucifix and crown of thorns), Clare (black cowl), Dominic (black cape), Francis of Assisi (with stigmata), Gabriel (archangel), Giles (with hind), Joseph of Nazareth (carpenter), Louis (with crown), Mary.

LIMBO *see* CHRIST'S DESCENT INTO HELL.

LION

In the west, the lion is, with the eagle, the animal most often represented in iconography both of the Christian and ancient worlds. The lion, while it always evokes power and authority, can be indifferently good or evil. The good lion is a courageous animal, fearing nothing: this is the majestic lion which, at the relatively late date of the twelfth or thirteenth centuries, ousts the bear as king of the beasts. He is a generous creature, a saint's faithful companion. The evil lion is a cruel and bloodthirsty beast, enemy of Hercules and Samson, the lion of the Book of Psalms and the Book of Daniel. The mythological lion and the Biblical lion are often malevolent, but the Christian lion – which, according to medieval bestiaries, was capable of resurrecting its still-born offspring with its breath – is highly prized. It is often associated with Christ's Resurrection and more generally with power and sovereignty.

The lion can take any number of forms. A man wrestling with a lion can, according to the context, be identified as Hercules, Samson or David. In an arena, the man is Daniel or, more rarely, a martyred saint from the earliest period of Christianity. As a saintly companion, the lion is most often shown with St Jerome, or St Paul the First Hermit. If it possesses wings, it is the attribute of St Mark the Evangelist; if a winged emblematic lion holds a book, then it is rather the heraldic figure of Venice. In an Old Testament context, the lion is the insignia of two tribes – Judah, the first tribe of Israel, and Solomon – and therefore has a positive connotation. In cycles of months of the year, it stands for July and refers to the zodiacal sign which bears its name, Leo. In the modern age, the lion can be an allegorical symbol of authority, courage or anger, as well as of Africa.

Cross references: Blandina (with net), Daniel (in arena), David (with lamb, fighting), Devil, Evangelists (Mark), Ignatius of Antioch (two lions attacking), Jerome (cardinal or hermit), Mark (with Gospel, often winged), Mary the Egyptian (one lion digs her grave), Paul the Hermit (two lions dig his grave), Resurrection, Samson (fighting), Solomon (king), Tetramorph.

LOAF *see* BENEDICT OF NURSIA (IN BASKET ON STRING), ELIZABETH OF HUNGARY (QUEEN), LAST SUPPER, MARY OF EGYPT (THREE LOAVES), MULTIPLICATION OF THE LOAVES AND FISHES, PHILIP (AND CROSS).

LONGINUS *see* CRUCIFIXION.

LOT

Italian and German: Lot; French Lot(h).

TRADITION
Lot is a patriarch whose story, closely linked with that of his uncle Abraham, is recounted in the Book of Genesis (13-14, 19; *see* Abraham for the separation of Lot and Abraham, Gen. 3, and for Abraham's victory over Lot's enemies). Tradition has preserved two episodes in particular. The first is the destruc-

Lot and his Daughters
School of Leiden, first half
of the sixteenth century
(detail). Louvre, Paris.

tion of Sodom and Gomorrah followed by the flight of Lot and his two daughters. His wife turns round to look at the destruction and is turned into a pillar, or statue, of salt (Gen. 19:12-27). The departure of Lot's family is interpreted as a prefiguration of the Magi's surreptitious departure from Bethlehem at the behest of the angel.

The second episode is the incest Lot commits unknowingly with both his daughters (Gen. 19:31-35). After they flee Sodom, all three take refuge in a cave. Lot's daughters, to ensure that their father has male descendants, get him drunk and sleep with him one after the other. The medieval Bible, with its moralizing purpose, compared Lot with his daughters to a hermit encountering the demon's temptations.

REPRESENTATION AND ICONOGRAPHY

The Destruction of Sodom and Gomorrah (Gen. 19:1-29)

The conflagration which destroys Sodom, and Lot's flight, are depicted in a basically unvarying manner. On the left-hand side of the composition, fire from heaven descends and the town of Sodom collapses. Lot and his two daughters flee in the opposite direction. Lot's wife, who has just looked round, is transformed into a pillar or statue of salt .

In the earliest known examples (catacomb in the Via Latina, Rome, fourth century), Lot holds his daughters by the hand and the three figures face outwards. In Byzantine art, the flames fall from the sky. Lot's wife is represented by a white or pale grey figure; she can also appear at a later date as a pillar of salt from which her head emerges. From the fifteenth century, though the treatment of the theme hardly changes, the background is depicted in a more realistic manner. From the sixteenth century, in distinction to the medieval period, it is the angels who are shown disgorging the wrath of God on to the town (Rubens, 1625, Louvre, Paris). Guido Reni also treats the theme (c.1615, National Gallery, London).

Lot's drunkenness (Gen.19:31-35)
In the middle ages, this scene is relatively rare and figures predominantly only in Old Testament cycles. On the west door of Lyon Cathedral (beginning of the fourteenth century), the sculptor, to avoiding scandalizing passers-by, has carved the scene in a sketchy and indistinct manner. In the sixteenth century, Lot is still shown drinking alone, but can also appear kissing one of his daughters while the other offers him more wine (School of Leyden, sixteenth century, Louvre, Paris). The theme is often linked to that of Susanna in the bath and became widespread in the sixteenth and seventeenth centuries (Altdorfter, 1537, Kunsthistorisches Museum, Vienna; Rembrandt, drawing, 1633, Städtelsches Kunstinstitut, Frankfurt). Several artists (Vouet, 1633, Museum, Angoulème; Furini, c.1630-40, Prado, Madrid) stress the erotic character of the episode, with the daughters shown naked.

Cycles
Both eastern and western manuscripts of the Bible present six or seven scenes from the history of Lot. Sculpture groups are rare, however (west door, Lyon cathedral, beginning of the fourteenth century).

Cross-references: Abraham, Magi, Noah, Susanna.

LOUIS

Variant: Lewis. Latin: Ludovicus; Italian: Ludovico, Luigi; Spanish: Luis; French: Louis; German: Ludwig.
King of France. 1214-70. Canonized 1297. Feast day 25 August.

LIFE AND LEGEND

St Louis, Louis IX of France, canonized soon after his death, is a well-known figure: biographies and documents concerning his life abound. He was born in 1214 and was already king by 1226, after the death of his father, Louis VIII. A regency was established under his mother Blanche de Castille, the young king later ruling jointly with her. The unsuccessful first crusade detained him from 1248 to 1252 in the east. When he returned, he astonished his contemporaries by his behaviour which was described as that "of a king who would be saint". He departed on another crusade in 1270 and died near Tunis in the same year.

The long reign of this extraordinary king is one of the most important for the history of France. He was canonized by Pope Boniface VIII in 1297 (partly for political reasons), but his legend, which credits him with numerous miracles, preceded his canonization. Nonetheless, his cult spread only gradually beyond the borders of his kingdom. During the eighteenth century he became a dynastic and national saint, protector of France and its monarchy. The Jesuits were most instrumental in extending his cult beyond France.

REPRESENTATION AND ICONOGRAPHY

St Louis is depicted either as a king, exercising the fullness of monarchical power or, more often, as a saint (statue, fourteenth century, Chapelle St Louis, Manneville, Eure; Vouet, *Apothéose de St Louis*, second quarter of the seventeenth century, Gemäldegalerie, Dresden). He always wears a crown, and occasionally carries a sceptre (which often has a finial in the shape of a hand), and wears a fleur-de-lis robe (the fleur-de-lis on statues and pictures of St Louis

St Louis
Beginning of the fourteenth century. Chapelle St Louis, Manneville.

led to the destruction of many of them in the French Revolution). He feeds the poor, visits the sick, washes lepers' feet, is given a scourge by his confessor and performs numerous miracles.

His iconography is often entangled with that of St Francis of Assisi (St Louis did in fact belong to a tertiary order). The features of the French king reigning at a particular time may also occasionally serve as a model for those of the saint. A number of episodes, including the translation of the Crown of Thorns, occur on stained glass in the Sainte-Chapelle in Paris (thirteenth century) which he had built to house the relic. Outside France, he can be shown in the company of other saints (Sebastiano del Piombo, 1511, organ shutter, S. Bartolomeo al Rialto, Venice).

Attributes: Royal crown. Sceptre (with or without hand finial). Crown of Thorns. Nails. Lily or robe decorated with fleur-de-lis.
Cross-reference: Crown of Thorns.

LUCY

Italian and Spanish: Lucia; French: Lucie; German: Luzia, Lucia.
Virgin and Martyr. Died 304. Feast day 13 December.

LIFE AND LEGEND

Lucy died, a victim of Diocletian's persecution, at Syracuse in 304, where an inscription concerning her survives (c.400). Her name appears in the very earliest martyrologies. The narrative of her legend which became known through James of Voragine's *Golden Legend* derived from her *Acts* in Greek and Latin. A rich woman of Sicily, she apparently refused marriage and gave away all her money to the poor. One of the rejected suitors then denounced her to the authorities; the judge condemned her to a brothel but she was miraculously protected. The authorities, failing in their attempts to burn her at the stake, have her stabbed in the throat with a sword.

REPRESENTATION AND ICONOGRAPHY

Lucy's iconography derives uniquely from the legendary aspects of her life. The earliest depiction is to be found on a mosaic dedicated to virgin saints at S. Apollinare Nuovo in Ravenna (sixth century). She appears with no specific attribute. Her name derives from the Latin *lux* (light), and explains certain aspects of her cult. In northern Europe, on her feast day, young girls crowned with candles herald the approach of the solstice. A fifteenth-century fresco (crypt, Atri Cathedral, Italy) shows Lucy herself with altar candles.

St Lucy
R. Sadeler, after Martin de Vos, seventeenth century. Bibliothèque Nationale, Paris.

The motif of St Lucy carrying her eyes on a charger or in a goblet hardly occurs before the fourteenth century and illustrates an episode which appears in her legend only at a late date. Lucy apparently gouged out her own eyes and sent them to her suitor; they were later miraculously restored to their rightful place. Pietro Lorenzetti shows her with her eyes on a platter and carrying her other attribute, a lamp (c.1332, S. Lucia Frole Rovinante, Florence). Bellange (etching, late sixteenth or early seventeenth century) shows her martyrdom, while Lotto paints her in the presence of the judge (1542, SS. Giovanni e Paolo, Venice). Zurbarán depicts her carrying both the palm of martyrdom and her eyes on a platter (1636, Musée de Chartres).

Lucy is occasionally juxtaposed with the patron of Sicily, St Agatha. According to legend, Lucy and her mother made a pilgrimage to the tomb

of St Agatha who had cured the latter of a serious illness. In the second quarter of the eighteenth century Lucy is found in the company of St Agatha, St Catherine and St Agnes (polychrome statues, Pedro Duque Cornejo, Charterhouse at Paular, Spain).

Attributes: Two eyes (on a platter or dish, or in a goblet). Lamp or altar candles. Sword (of martyrdom).
Bibliography: M. Capdevilla, *Iconographia de Santa Lucia*, 1949. O. Garanna, *Santa Lucia nella traditione, nella storia, nell'arte*, Syracuse, 1958.

LUKE

Greek: Loukas; Latin: Lucas; Italian: Luka; Spanish: Lucas; French: Luc; German: Lukas.
Evangelist. Feast day 18 October.

TRADITION
The compiler of the third Gospel, the Acts of the Apostles and Paul's companion "Luke the physician" have all traditionally been identified as the same person. A sixth-century legend presents Luke as the painter of a number of icons of the Virgin. He is therefore given the status of the painter *par excellence*, able to capture even the Virgin on canvas. Luke has been the patron saint of various painters' guilds since the fifteenth century. The Roman Accademia di S. Luca was founded in 1577, superseding the guild which had been established in the Church of S. Luca in 1478. Luke is also the patron saint of doctors.

St Luke at his Desk
Jean Colombe, *The Gospel according to St Luke*, end of the fifteenth century.
Musée Condé, Chantilly.

REPRESENTATION AND ICONOGRAPHY
The oldest depictions of St Luke show him writing his Gospel (third quarter of the eleventh century, Greek Patriarchal Library, Jerusalem). A lying or kneeling ox serves as his desk. The ox, St Luke's traditional attribute, refers to the sacrifice in the Temple with which his Gospel opens (1:9) (miniature in the *Evangelium* of Otto III, end of the tenth century, Bayerische Staatsbibliothek, Munich, where the saint is in a mandorla surmounted by an ox or bull). Luke paints the Virgin on the mosaics in S. Maria Maggiore (Rome, c. eighth century) and in Constantinople (destroyed by the Turks in 1453). In the fifteenth and sixteenth centuries, his abundant iconography shows the artist with the Virgin as his model (Rogier van der Weyden, c.1435, Museum of Fine Arts, Boston; Raphael, c.1511, Accademia di S. Luca, Rome; Mabuse, 1520, Kunsthistorisches Museum, Vienna, where an angel assists him). The theme continues, if attenuated, at a later date (Nicolas Regnier, 1618-20, Musée des Beaux Arts, Rouen, in seventeenth-century dress; Guercino, 1652, *St Luke Displaying his Picture of the Virgin*, Nelson Gallery of Art, Kansas City, Missouri).

Attributes: Gospel. Ox (generally winged, serving as a writing-desk). Painter's palette.
Cross-references: Evangelists, Paul.

Antiochus and the Seven Brothers of Maccabeus

Flavius Josephus, *The Jewish Wars*, end of the fifteenth century (detail). Musée Condé, Chantilly.

MACCABEES

Italian: i Maccabei; Spanish: los Maccabeos; French: les Maccabées; German: die Makkabäen.

TRADITION

There is no blood relationship between the Maccabees and Judas Maccabeus. The Bible (2 Macc., Apocrypha) simply mentions "seven brothers" whom King Antiochus IV Epiphanes had arrested and martyred because they refused to eat pork. Antiochus had decided to eradicate superstition (in particular, Jewish dietary proscriptions) from his kingdom, including Israel and Judea. He erected an altar dedicated to Olympian Zeus within the Temple of Jerusalem with express orders for the daily sacrifice of a pig. The seven brothers were assimilated to Christian martyrs by the Church Fathers and are venerated as such by the Catholic Church in the west.

REPRESENTATION AND ICONOGRAPHY

It is intriguing to note the appearance of a gridiron in this narrative (2 Macc. 7:3): "Then the king, being in a rage, commanded pans and caldrons to be made hot". Perhaps this is the origin of the gridiron which occurs in so many saints' legends, the most famous being Laurence and Vincent. In the west, the seven brothers are shown in a cauldron, exhibiting their mutilated members, for they had been first scalped and their hands and feet severed. Their mother looks on, exhorting them to remain steadfast (Harding Bible, twelfth century, Dijon Library). In the medieval period, the brothers are often linked to Eleazar, who was executed on the same grounds (2 Macc. 6:18-31). The Church of St Andrew in Cologne contains a reliquary illustrated with the story of the Maccabees (c.1525). The presence of the Coronation of the Virgin and of the Passion in the same work shows the mystical affiliation between these themes. Jacopo Bassano, in an early work, depicts the brothers in a fiery furnace (c.1534-6, Palazzo Pubblico, Bassano).

Attributes: Gridiron or cauldron.
Cross-reference: Judas Maccabeus.
Bibliography: L. Réau, op. cit., vol. II, 2, pp. 305-9.

MADONNA *see* ANNUNCIATION, ASSUMPTION, CORONATION, DORMITION, MARRIAGE OF THE VIRGIN, MARY, NATIVITY.

MAGI

Variant: the Wise Men from the East, the Three Wise Men, the Three Kings.
Italian: i Magi; Spanish: los Magos; French: les Mages, les Rois mages; German: die Magier, Die drei Könige.
Feast day Epiphany, 6 January.

TRADITION

The Gospel of St Matthew (2:1-12) tells us how certain Magi (Latin for wise men) from the Orient were apprised of the birth of a king in Judea by the

appearance of a star. King Herod made them promise to return once they had found the Child, so he too could go and worship him. Guided by the star, they discover the Infant in a house at Bethlehem, worship him and present him with their gifts. A dream warns them not to return to Herod's court and they set off instead for their own country. Apocryphal gospels have enriched and embellished Matthew's account. The Evangelist does not say how many wise men there were, nor give their names. Since Origen (185-224), the agreed number has been three.

The Adoration of the Magi
G. Starnina, beginning of the fifteenth century. Musée de la Chartreuse, Douai.

An ancient tradition has compared the three Magi to both the three ages of man and to the three parts of the world which came to render homage to the Saviour. At that time, only three continents were known: Europe, Africa and Asia. It was Tertullian (c.160-230) who first spoke of the three Magi as kings, referring to Psalms (67:30, 71:10) and to Isaiah (60:3): "kings [shall come] to the brightness of thy rising". "*Ille magi reges sunt* [these Magi are indeed kings]," St Caesarius of Arles stressed in the sixth century. Doubtless the intention was to differentiate these Magi from other sorcerers or wise men. The names Caspar (or Gaspar), Melchior and Balthasar appeared in the eleventh-century *Liber Pontificalis* in Ravenna.

The Three Kings were adopted as patrons by travellers and pilgrims. In the thirteenth century, the Cathedral of Cologne was reconstructed to house a shrine containing their relics. It was dedicated to the *Heiligen Drei Könige* (the Three Holy Kings).

REPRESENTATION AND ICONOGRAPHY

In catacomb art, the Magi were linked to Christ's Nativity, but an independent cycle developed from the fourth century. Paleochristian art juxtaposed the motif with Balaam's prophecy of a star (Num. 24:17). The Magi were presented in Persian costume (Phrygian cap, trousers, chiton belted round the waist). They were given the royal dress of long robes and crowns around the eleventh century. The Magi numbered three from the very beginning and, as we have stated, from the early medieval period, they represented the three ages of man. On the other hand, they hardly ever stood for the three continents until one of them started to be depicted as black, a "Moor".

The Adoration of the Magi

In the paleochristian period, particularly in the catacombs, Mary sits to one side of the composition with the Infant on her lap. The Three Kings bring their gifts on simple dishes. This schema was derived from the ancient ceremony of the triumph, where the defeated peoples paid homage to the victorious general. Camels make their appearance in the Magi's escort. A different schema shows the Virgin in the centre with the Magi on either side of her.

In the Byzantine world, an angel points to the star while the first of the kings goes down on one knee. In the medieval west, the Magi wear royal crowns and mantles and can be shown asleep, being warned by an angel. Their gifts are presented in vessels (sometimes chalices) made of precious metal. In the thirteenth century, a new type evolves: the first king kneels, while the second, turning round, points out the star to the third. In cathedral sculpture cycles (e.g. on the tympanum at Vézelay), the Adoration of the Magi is linked to the Marian cult. From the fourteenth century the scene began to include picturesque elements such as hunting scenes or even battles. The Adoration of the Magi was often coupled with the Annunciation to the Shepherds (Master of Hapsburg, c.1500, Osterreiche Galerie, Vienna). The orientalism of the Renaissance relative to this theme transpires in Mantegna's version (1497-1500, John Paul Getty Museum, Malibu, California), while Gozzoli features headdresses worn by the suite of Jean VII Paleologue during his visit to Florence (1459-61, Medici Chapel). From the sixteenth century, religious symbolism makes way for a more anecdotal approach (Breugel the Elder, c.1556, Musées Royaux des Beaux Arts, Brussels; Rubens, 1624, Koninklijk Museum voor Schone Kunsten, Antwerp).

Narrative Cycles

Certain cycles include all or some of the following six scenes: the star heralds the birth of a king; the Three Kings meet and they make their way on horseback to Jerusalem; they visit Herod; the Adoration; an angel comes to the Magi in a dream; their return voyage. In the middle ages, the return journey began by a sea passage at Tarsus (the land route was avoided in iconography as it would resemble too closely their inward journey). Furious at being deceived, Herod has all the ships moored in the port set on fire. The sculpture cycle representing this sequence in Amiens Cathedral shows a singular richness of interpretation. A more or less complete cycle can figure as a continuous series across a given altarpiece (Gentile da Fabriano, 1423, Uffizi, Florence).

Cross-references: Angel, Annunciation to the Shephezds, Nativity.
Bibliography: H. Kehrer, *Die Heiligen Drei Könige in Literatur und Kunst*, Leipzig, 1908-9.

MAJESTAS DOMINI *see* CHRIST IN MAJESTY.

MALCHUS *see* ARREST OF CHRIST.

St Luke Painting the Virgin. Maerteen van Heemskerck, c.1545-50. Musée des Beaux Arts, Rennes.

The Removal of St Mark's Body. Tintoretto, 1562-66. Accademia, Venice.

**The Miraculous Sea
Voyage of St Malo**
Bibliothèque du Musée des
Arts décoratifs, Paris.

MALO

Latin: Machutus, Maclobius; Italian: Macuto; French: Malo, Malou, Maclou
(Normandy); German: Maklovius.
Bishop. Died c.630. Feast day 15 November.

LIFE AND LEGEND
St Malo is known to us through two predominantly legendary *Lives* of the
ninth century. He was born in Wales and entered monastic life before leav-
ing for Brittany. He founded a monastery on the Isle of Aaron (near Aleth,
in what is now St Servan). He became the first bishop of Aleth and died a her-
mit near Saintes, around 630. Legend made him a companion of St
Brendan in his miraculous sea voyage to a mythical island in the polar
regions. He moored his craft on the back of a whale and there celebrated Mass
(an episode borrowed from the legend of St Brendan). His relics have been
repeatedly translated.

REPRESENTATION AND ICONOGRAPHY
Malo is depicted with the accoutrements of a bishop (statue from St Hilaire
du Harcouët, thirteenth century, Museum of Fine Arts, Boston, in which he
carries the model of a church). He can also appear as an abbot, with a crozier.

Attributes: Bishop's or abbot's crozier. Mitre. Whale.
Cross-references: Brendan. Miraculous Sea Voyage.

MANDORLA

Italian and German: mandorla; French: mandorle.

Mandorla
Seventh century. Crypt of
St Paul, Jourre, France.

TRADITION

The Italian for almond, the mandorla is a geometrical frame around an entire figure, occasionally round, but in general taking the form of an almond-shaped ellipse or oval. The oldest examples are to be found in paleochristian art of the fifth century.

REPRESENTATION AND ICONOGRAPHY

Initially, the mandorla sought to evoke divine protection and as such was found encircling Moses (S. Maria Maggiore, Rome). Nonetheless, it was normally reserved for images of the godhead or of its symbols. Western medieval art often placed Christ in Majesty within a mandorla, as in an enamel bookcasing to be found in the Musée de Cluny in Paris. At S. Apollinare in Classe, Ravenna (fifth century), the mandorla framed both Chrismon and Cross. In the heart of the medieval period, the mandorla was employed in Byzantium to encircle theophanies such as the Transfiguration and the Ascension.

Cross-references: Ascension, Christ in Majesty, Nimbus, Transfiguration.
Bibliography: W. Messerer, "Mandorla", in E. Kirschbaum, *Lexikon der christlichen Ikonographie*, Freiburg im Breisgau, 1968-74, *Allgemeine Ikonographie*, vol. III, col. 147-49.

MANDYLION OF EDESSA

Greek: To hagion mandylion; Russian: Sviaty Dubrous; Latin: Edesseum; Italian: Imagine Edessea; French: le Mandylion d'Edesse; German: das Christ Ubbild, Agbarbild.

The term Mandylion designates a piece of cloth embroidered with the image of a religious figure.

TRADITION

A contemporary of Jesus, Agbar, a king or "toparch" of Edessa (Syria), wrote

inviting Christ to his city and offering him shelter from his persecutors. Christ refused, so the king sent a painter instead with orders to reproduce his portrait. The artist, overawed by the face of the Redeemer, avowed that the task was beyond him. Christ sympathized, and pressed his face up against a part of his cloak, leaving imprinted upon it the image of his features. After the Ascension, the apostles Simon and Jude (Thaddaeus) bring Agbar this imprint of the "Holy Face". According to another version of the legend, King Agbar, being unwell, wrote begging Christ to cure him of his illness: the famous portrait was brought by a messenger in lieu of a reply. Christ's visage appears, with long curls hanging down on either side. The portrait saved Edessa in 544 when it was affixed to the city gate during a seige by the Persians.

The Mandylion remained in Edessa until it was taken to Constantinople in 944. Appropriated by the crusaders in 1204, it has since been kept in Rome, in S. Silvestro in Capite. A twelfth-century Russian icon derives from the original Mandylion: the Holy Face (*Sainte Face*) of Laon. In 1249, this was sent from Rome by the future Pope Urban IV to the Convent of Montreuil-des-Dames, Laon; it was removed to the city's cathedral in the seventeenth century. Louis Réau has stated that, by the thirteenth century, a similar image stamped on brick (the *Keramion*) made its appearance in a number of Byzantine and post-Byzantine churches: the image of the Mandylion had been imprinted on the brick behind which the cloth had been walled. The Keramion was removed to Constantinople from Syria in 968.

Another miraculous image is that imprinted on the Veil of St Veronica. The Holy Face, or *Volto Sancto*, formerly preserved in St Peter's, disappeared during the seige of Rome in 1527. Unlike the Mandylion of Agbar, Veronica's Veil shows Christ at his Passion, with the Crown of Thorns.

Cross-references: Ascension, Holy Face, Veronica.
Bibliography: "Agbar Legende" in E. Kirschbaum, *Lexikon der christlichen Ikonographie*, Freiburg im Breisgau, 1968-74, *Allgemeine Ikonographie*, vol I, cols. 18-19. L. Réau, op. cit., vol. 2, II, p. 18. A. Grabar, *La Sainte Face de Laon*, Prague, 1931.

MANNA *see* ABRAHAM, EXODUS, MOSES.

MANTLE

For a long time, the mantle was one of the most important attributes of sovereign power and, as such, was worn by both gods and kings. In the Bible, many representatives of authority wear one, and it becomes an insignia of status, participating in its owner's power. The most famous Biblical mantle is that worn by Elijah who bestows it on his successor and disciple Elisha (1 Kings 19:19). The mantle or long cloak is also a symbol of protection and is worn by various saints and by the Virgin of All Mercy. Finally, the mantle can also be emblazoned with emblems that denote affiliation to a religious or monastic order, brotherhood or official body.

Cross-references: Elijah, Mary, Martin.

St Margaret and the Dragon

Woodcut from James of Voragine's *Golden Legend*, 1483 edition.

MARGARET

Variant: Marina. Latin and Spanish: Margarita; Italian: Margherita; French: Marguerite; German: Margarete.
Virgin and Martyr. Third century. Feast day 20 July, suppressed in 1969.

LIFE AND LEGEND

Margaret is a legendary saint whose life, which occurs in a number of Greek sources, became known in the west thanks to the *Golden Legend*. Daughter of a pagan priest, she was born in Antioch and converted to Christianity by her nurse while still a young shepherdess. She later attracted the attention of the Roman governor, Olybrius, but rejected him in view of her vow of chastity, and was thrown into prison. There she was attacked by the Devil and, while at prayer, swallowed by a dragon. Fortunately, since she was carrying a little crucifix, she was able to cut a hole in the monster's belly and escape. This experience, like Jonah's three days in the whale, left her unscathed. The miracle precipitated numerous conversions, but Margaret's trials and tribulations were by no means over. Olybrius put her through tortures so excruciating that he could not bring himself to look, and so covered his eyes with his robe. Margaret was finally beheaded.

A most popular saint, Margaret is particularly venerated by pregnant women for whom her intercession guarantees a trouble-free and painless birth. Her cult is widespread throughout Christendom and her relics were at one time numerous.

REPRESENTATION AND ICONOGRAPHY

Margaret's popularity is evidenced by an abundant iconography. Her main attribute is a dragon attached by a leash or lying at her feet. In a version by Annibale Carracci (after 1595, S. Caterina dei Funari, Rome) she is shown trampling the monster underfoot. Occasionally she is linked to two other virgin martyrs: Catherine of Alexandria and Barbara. Represented in isolation, she miraculously emerges from the belly (or mouth) of the monster (Raphael and Giulio Romano, 1518, Louvre, Paris). More rarely, she guards sheep or undergoes her martyrdom: she is whipped, burnt, attacked with pincers, then beheaded (a painted altar frontal, twelfth century, Archeological and Artistic Museum, Vich, Barcelona, shows her flagellation). Following a confusing medieval tradition, she is sometimes assimilated to the princess rescued by St George from the dragon, in which case she wears a crown (Martini, c.1340, entrance porch, Avignon Cathedral).

Attributes: Crucifix or cross (held in her hands). Dragon. Pearl rosary (a pun on *margarita*, pearl).
Cross-references: Barbara, Catherine of Alexandria.

MARK

Latin: Marcus; Italian: Marco; Spanish: Marcos; French: Marc; German: Markus.
Evangelist. Feast day 25 April.

TRADITION

Composer of the second and shortest of the Gospels at the behest of the Romans, Mark was reputedly the favourite disciple and spokesman of Peter, who called him his son (1 Peter 5:13); since he was Peter's faithful companion,

this is certainly true in a spiritual sense. One tradition asserts that his Gospel was in fact dictated by St Peter. (Rather confusingly, as Mark is his Roman name, the Acts of the Apostles call this Evangelist John.)

If we are to believe Pseudo-Jerome and Eusebius, Peter sent Mark to Egypt where he became the first bishop of Alexandria. On his arrival he had his sandles repaired by a cobbler called Anian who injured himself seriously with his awl. Mark cured him in a miracle. At Alexandria in 67, he was apparently seized at the altar as he was celebrating Mass and martyred. As he was dragged through the streets on the end of a rope and battered almost to death with a club, he expired before his executioners had the time to stone him. A miraculous rain extinguished the pyre on which his body was to be incinerated. His corpse was interred in Alexandria, but purloined by the Venetians in 829.

St Mark's relics were received in Venice with much solemnity. By the tenth century, the city of the Doges has already become the main focus of his cult and he had supplanted St Theodore as patron saint. In Venice, many legendary *Lives* were composed which, among others things, tell of the miracles performed by the Evangelist after his death. As he was St Peter's secretary, guilds of lawyers and scribes placed themselves under his patronage. Both the Dominican monastery in Florence and the Byzantine Basilica in Venice are dedicated to St Mark.

St Mark
Woodcut from James of Voragine's *Golden Legend*, 1483 edition.

REPRESENTATION AND ICONOGRAPHY

There is an early depiction of St Mark in the ninth-century Ebbo Gospels (Bibliothèque Municipal, Epernay). Since the twelfth century, Byzantine tradition has depicted St Mark as a middle-aged man with a forceful expression, black hair, a full beard and a moustache. In his quality as the first bishop of Alexandria, he is often shown in the pontifical vestments of a Greek patriarch. From the fifteenth century on, certain elements of his dress are oriental: he often wears a turban. A female figure, Sophia, or a lion (his attribute) dictate his writings, which he inscribes on a papyrus scroll or else in an open book.

Another typical image represents St Mark being handed the text of the Gospel by Peter. Alternatively, seated at Peter's feet, he takes down the words of the apostle preaching to the Romans (Fra Angelico, *Triptych of Linaiolo*, 1433, Museo di S. Marco, Florence). A different tradition has him writing under the direct inspiration of an angel or of Christ himself.

At the end of the middle ages, the invention of perspective joined forces with a taste for the curious and allowed for the emergence, around the figure of the saint, of articles taken from the contemporary scholar's study. On the book St Mark is writing often appear the words, "The beginning of the gospel of Jesus Christ, the Son of God" (Mark 1:1) or else, "Behold, the Lion of the tribe of Juda, the Root of David, hath prevailed to open the book" (Rev. 5:5). The background and setting of this type are similar to those in images of St Jerome.

St Mark's main attribute is a lion, often with wings, a characteristic that allows for it to be distinguished from St Jerome's companion. This lion refers to John the Baptist's prediction, like a "voice of one crying in the wilderness" (Mark 1:3), identified with the roaring of the lion. The winged lion with a book of the Gospels sometimes symbolizes the Evangelist himself (Carpaccio, 1516, Palazzo Ducale, Venice). The translation of his remains (Accademia, Venice) and the discovery (Brera, Milan) have both been the subject of works by Tintoretto (1562-66).

Attributes: Lion (often with wings). Quill or pen with other writing instruments. Scroll of parchment or book (open or closed).
Cross-references: Evangelists, Peter, Theodore, Thomas Becket.
Bibliography: G. Guerzoni, *San Marco nell'arte e nella storia*, Padua, 1878. J. Schultze, *Markus*, Recklinghausen, 1966.

MARRIAGE OF THE VIRGIN

Italian: la Sposalizio della Virgine; Spanish: Desposorios de la Virgen; French: Mariage de la Vierge; German: Verlobung Mariä.

TRADITION

As with most Marian themes (Assumption, Coronation, Dormition), Mary's engagement and marriage are not mentioned in Scripture. The *Golden Legend* and other earlier apocryphal texts fill the resulting gap very imaginatively. When Mary was fourteen, they relate, the high priest gathered together all the descendants of David who were of marriageable age. Each had to bring with him a rod and the suitor whose rod blossomed into flower would be Mary's husband. Joseph, no longer young, carried the day: the dove of the Holy Spirit came down and alighted on his flowering rod. The wedding itself was celebrated according to the Jewish rite.

REPRESENTATION AND ICONOGRAPHY

The marriage cycle is divided into three episodes: the choice of suitor, the wedding and the wedding procession.

The Marriage of the Virgin
Orcagna, relief of a tabernacle, fourteenth century (detail). Orsanmichele, Florence.

The Choice of Suitor

The suitors are summoned by a blast of trumpets. They arrive at the Temple and place their rods on the altar. Joseph's rod blossoms, or the dove of the Holy Spirit alights on it. His younger rivals become angry. Giotto depicts all the phases of the marriage, concentrating on the trial of the suitors (1304-6, Arena Chapel, Padua). A common theme is that when Joseph's rod bursts into flower, one of the other suitors snaps his in disappointment (*Tenture de la Vierge*, c.1600, Notre Dame, Beaune; Jean Baleison, fifteenth century, Chapel of Notre Dame des Fontaines, La Brigue, Alpes-Maritimes).

The Wedding Ceremony

The scene comprises the three figures of the high priest, Mary and Joseph; sometimes, Joachim and Anne are added. In Italy, the Umbrian School in particular promoted this theme. Joseph, holding his rod, puts the ring on Mary's finger as the high priest blesses them (Giotto, Arena Chapel, Padua; Perugino, c.1503, Musée des Beaux Arts, Caen; Raphael, 1504, Brera, Milan). In Germany, Dürer engraved the wedding scene, transposing it to sixteenth-century Germany (*The Life of the Virgin*, c.1505).

The Wedding Procession

Seven maidens, with torches and accompanied by musicians, escort Mary to Joseph's house or back to her parents' house in Nazareth. The musicians lead the way to the house, where a palm leaf hangs from the window (Giotto, frescoes, Arena Chapel, Padua, 1304-6).

Cross-references: Aaron, Holy Spirit, Joseph of Nazareth.
Bibliography: L. Réau, op. cit. vol. II, 2, pp. 170-3.

MARTHA

Latin and German: Martha; Italian: and Spanish: Marta; French: Marthe.
Virgin. Died c.80. Feast 29 July.

TRADITION
During Christ's visit to the sisters of Bethany, Martha busies herself while
Mary listens to the visitor (Luke 10:38-42). Martha looks on while Christ raises
her brother, Lazarus, from the dead (John 11:1-44), and is present when Mary
anoints Jesus' feet with perfume (John 12:1-8). A Provençal legend describes
how, after the Ascension, she arrived in Marseille with her brother and sis-
ter. With the aid of holy water and a crucifix, she defeated the Tarasque, a
river dragon, and was buried at Tarascon by St Front of Périgueux. She is there-
fore particularly venerated in Provence – at Aix and at Tarascon – as well as
in Tuscany. She is patron saint of housewives and cooks. She incarnates the
active life, while Mary stands for the contemplative.

REPRESENTATION AND ICONOGRAPHY
She generally wears an uncomplicated dress, a cloak and a veil. Sometimes
a bunch of keys hangs from her belt (altarpiece at Mülhausen, fifteenth cen-
tury, Sankt Blasius, Saxony). From the fourteenth century onwards, her vic-
tory over the dragon is also represented: she sprinkles holy water from an
aspergillum over the monster (statue, sixteenth century, St Madeleine, Troyes).
Ramón Destorrents (St Martha Altarpiece, fourteenth century, Church at
Iravals) depicts the various episodes of her legend. A Hand of God protects
her on her deathbed (stained-glass window, Church at Semur-en-Auxois, thir-
teenth century). Velasquez also illustrates Christ's visit to the sisters (1619-
20, National Gallery, London). Nicolas Froment shows her kneeling at Christ's
feet, asking forgiveness for her criticism of Mary (second half of the fifteenth
century, Uffizi, Florence).

Attributes: Aspergillum. Bunch of keys (hanging from her belt). Dragon.
Ladle.
Cross-references: Lazarus (raising of), Mary Magdalene.
Bibliography: G. Maillet, *Sainte Marthe*, Paris, 1932.

St Martha
End of the fifteenth century.
St Urban, Troyes.

MARTIN OF TOURS

Latin: Martinus; Italian, French and German. Martin.
Apostle of the Gauls. Bishop of Tours, c 316-97. Feast day 11 November.

LIFE AND LEGEND
During the middle ages, and part of the modern period, Martin was the most
popular saint in France. His earliest biographers, Sulpicius Severus and Gregory
of Tours, enhanced his popularity and added countless legendary episodes
to his life. Born in Pannonia (now Hungary), Martin joined the Roman army
at an early age. He served in Italy and then in Gaul where the famous episode
of his "Charity" took place. One winter's day in the year 337 at Amiens, near
the city gate, Martin met a beggar shivering with cold. The saint cut his cloak
into two and handed one half to the imploring pauper. (A later tradition
explains that St Martin presented the beggar with only half the cloak as the
other belonged to the Roman army and so was not his to give.) The very next
night, Christ, wearing the half piece of cloak he had given the pauper,

St Martin Sharing his Cloak
Woodcut from James of Voragine's *Golden Legend*, 1483 edition.

appeared to St Martin in a dream, thanking him for his charity. Martin decided to leave the Roman army and converted to Christianity. As the Emperor refused to discharge him, St Martin was baptized only some years later and put himself at the disposal of the great Bishop of Poitiers, St Hilary.

Martin, after founding the monastery of Ligugé in Poitou, gradually acquired a considerable reputation and, in 370, he was elected bishop of Tours. Martin fulfilled his episcopal functions for 26 years, but he continued to live as a monk in the monastery of Marmoutier which he had founded on the right bank of the Loire and which soon became one of the largest abbeys in the west. Until his death in 397, Martin worked as a missionary not only in his diocese, but throughout western France. He converted country people, destroyed pagan temples and founded churches and monasteries. His religious work gave him the name Apostle of the Gauls.

To this already eventful life legend added many episodes, thereby encouraging the spread of his cult from Tours, which was near his tomb and one of the most important western pilgrimage sites. There was kept his famous cloak, the most precious saintly relic conserved in France during the early middle ages. The Merovingian and Carolingian kings promoted it into a national and dynastic emblem: the place where the cloak (*chape*) was venerated is at the origin of the word *chapelle*. Place names also prove the extraordinary popularity of his cult in France: even today, more than five hundred villages and almost four thousand parishes are named after him.

St Martin is the patron saint of soldiers and knights, as well as of drapers, furriers and tailors (numerous signs depict his sharing his cloak with the beggar). He was also, together with St Louis and St Denis, one of the patrons of the French monarchy. The Feast of St Martin was a red letter day in the French country calender, when people marked the onset of winter with feasting, bonfires and the payment of debts, rents and tenancy dues. Since domestic fowl were often used as a means of payment for such dues, it became customary to eat a goose on St Martin's feast day, a tradition that explains why one of his attributes is a goose. A legend also tells how, at the announcement of his election to the see of Tours, a goose apparently revealed by cackling the place where he was hiding.

REPRESENTATION AND ICONOGRAPHY

St Martin's iconography is as prolific as his cult is widespread. The saint is figured as a Roman soldier or else as a bishop. In the scene of his charity – perhaps the most frequent theme of medieval hagiography (Van Dyck, seventeenth century, Windsor Castle) – he is dressed as a soldier, wearing a long cloak and mounted on a charger (in Germany, however, he is a foot soldier). The beggar at Amiens' gate is almost naked and, as he is often assimilated to Christ, assumes a nimbus. El Greco's version shows the armoured Martin on a white warhorse, while a late example emphasizes the humanity of the scene (G. R. Donner, lead sculpture, c.1735, Bratislava Cathedral).

In scenes from his episcopate, as well as in those numerous episodes where he outwits the Devil, Martin is a prelate, with crozier and mitre. In the scene called the Second Charity (also known as the Mass of St Martin), he celebrates the ceremony dressed only in a dilapidated tunic because he has just given his pastoral vestments to a pauper. Two angels, preceded by a ball of fire, come down from heaven and dress him more appropriately.

Among his miracles the most frequently depicted is that of the hewn pine. During his struggle against the pagan tree cult, Martin requests that the coun-

trymen cut down a venerated pine tree. The peasants agree to do so, provided that the saint is tied to the place where the tree will land when it is felled. St Martin obeys and, as he makes the sign of the Cross, the pine falls harmlessly to the other side. St Martin is also shown protecting animals, notably donkeys and horses. The *Golden Legend* recounts how Martin, on his way to Rome, witnesses his ass being eaten by a bear. Furious, the saint loads his luggage on to the bear's back and orders it to convey it to Rome.

Attributes: Ass. Bear. Cloak. Goose. Horse. Roman soldier's uniform.

MARY

Hebrew: Myriam; Greek: María; Latin, Italian, Spanish and German: Maria; French: Marie.
Feast days: Annunciation 25 March; Assumption 15 August; Immaculate Conception 8 December; Nativity 8 September; Presentation 21 November; Visitation 31 May.

TRADITION

Mary is pre-eminent among all the saints, as she is the Mother of Jesus who, according to the Christian faith, is by nature both fully human and entirely divine. Scripture tells us nothing about her birth, and she makes her first appearance in the Gospels at the Birth of Christ (Matt. 1:18; Luke 1:27-80). In their descriptions of the Annunciation, both Evangelists assert with equal ardour the Immaculate Conception of Christ. Christ's Nativity (25 December) is one of the most important feast days in the Christian calender. Mary also appears, though in the background, in a number of other scenes from Jesus' public life (at the Presentation of Christ at the Temple, also known as the Purification of the Virgin – celebrated at Candlemas, 2 February – and at the Wedding at Cana). John, in his Passion narrative, tells us that she was at the foot of the Cross at the Crucifixion (John 19:25). Finally, the Acts of the Apostles note her presence among the disciples at Pentecost. Certain sources inform us that she died and was buried at Ephesus, while others prefer Jerusalem.

The doctrine of the Assumption of Mary's body into heaven was professed by the Church as early as the sixth century. In the west, the Assumption is celebrated on 15 August and is the most significant Marian feast. In the east, where this phenomenon was celebrated at an even earlier date, it is known as the Dormition.

Patristic tradition devoted itself to elucidating the complex mystery of the "new Eve". St Irenaeus (c.130-200) and St Justin (c.100-c.165) were the first to celebrate this parallel, explaining that, as she encapsulated the virtue of obedience, Mary was a new Eve, the contrary of the original Eve.

A more bitterly debated theme was the Immaculate Conception of the Virgin herself. According to this doctrine, instituted as a dogma by the Roman Catholic Church only in 1854, Mary, like Jesus, was born "without sin", fruit of a kiss between Anne and Joachim at the Golden Gate of Jerusalem. This belief was the source of much controversy in the middle ages and, in the twelfth and thirteenth centuries, first St Bernard and then Thomas Aquinas were its steadfast opponents.

Mary has always been immensely venerated. Her cult, however, can be seen to have evolved in conjunction with changes in theological perspec-

Our Lady of Expectation.
Piero della Francesca, *Madonna del Parto*, 1460 (detail) Cappella del Cimitero, Monterchi, Sansepolcro.

233

tive. Hence the early middle ages favoured the hieratic Virgin *Theotokos* (the God-bearer, of Byzantine origin), whereas the thirteenth century was more attracted to the human side of the mother of Jesus, and her maternal tenderness. The fourteenth and fifteenth centuries stressed the Seven Sorrows of the Virgin, the tragedy of the Passion and the *Mater dolorosa*.

REPRESENTATION AND ICONOGRAPHY

The eastern and western Churches form two main subdivisions in Marian iconography. In addition, it is important to distinguish between the different types of Virgin to whom devotion is offered – the Virgin of Misericord (or the Virgin of All Mercy), the Virgin and Child (Madonna), the Virgin of Sorrows (the Virgin *dolorosa*) – as well as the various episodes of significance in her life, from her Immaculate Conception and her suffering at Calvary to her heavenly Assumption: the Visitation, Annunciation, Nativity, Purification and Assumption.

The Virgin in Catacomb Art

The most ancient portrait of Mary is, if one is to believe the legend, that painted by St Luke. Historically, Mary is first depicted in the catacombs. She is shown at her prayers, standing with her arms outstretched. She can also be shown, in a prototype which has an impressive history, nursing the Infant (catacomb of Priscilla, Rome, second century).

Byzantine Art

Byzantine Art enriched the catacomb tradition with the type of Virgin of Alexandrian origin called the *Panagia* or *Theotokos*, the God-bearer, which takes a host of forms. *Platytera* has a bosom generous enough to serve as a haven for Christ Incarnate. Once again, she stands, arms oustretched, in an attitude of prayer, carrying on her breast a medallion with an image of Christ hypostatized. *Hodigitria* ("The Pathfinder") shows the way, carrying on her arms the Infant who gives his benediction.

She can be *Panagia Nikopoïa*, the giver of victory, seated with the Infant held out in front of her. In the west, this type was destined to become predominant in the form of the Virgin in Majesty. The same fortune attended the Virgin as image of motherly tenderness with the Infant at her breast, shown countless times by the Sienese School.

With the *Panagia Eleousa*, it is not the Virgin who expresses her tenderness, but the Child who holds his cheek to his mother's. Her gaze focuses, not on her Child, but on the far distance, as if lost in contemplation. This type is abundantly illustrated by icons (*The Virgin of Vladimir*, eleventh century, Historical Museum, Moscow).

Another type is the protective Virgin, Mediatrix of All Graces, who, in the company of the Precursor, John the Baptist, beseeches Christ the Judge. She first appeared to St Andrew the Innocent at the Church of the Blaphernes in Constantinople, unfolding a protective veil over the city. Numerous icons restated this popular legend: two angels hover in the clouds above the Virgin's head and hold an unfurled veil. Sometimes Mary holds this veil herself. In the west, the Virgin of All Mercy is an example of this type and may even have originated from it.

Western Art

Depending on the period concerned, different aspects of the Virgin have been stressed: the Virgin protector with her Child (at her prayers, catacomb of S.

Agnese fuori le Mura, Rome, fourth century); the Virgin, Queen of Heaven and of Earth, with diadem, necklace and a dress studded with gems (mosaic, fifth century, S. Maria Maggiore, Rome).

Until around the twelfth century, representations of the Virgin had a hieratic appearance (*The Crucifixion with Mary*, mosaic, seventh century, S. Maria Antica, Rome). The stiffness characteristic of this Byzantine type was softened by the rhythm introduced by Cimabue (Maestà with St Francis, fresco, 1279, Lower Church of St Francis, Assisi). Duccio gave the *Madonna Rucellai* (1285, Uffizi, Florence) a smiling elegance which was to reach its zenith in Giotto's *Virgin in Majesty* (1306-10, Uffizi, Florence). In France, at the same time, the hieratism of the great Romanesque constructions was replaced by the grace of Gothic cathedral sculpture. In the Quattrocento, there are countless masterpieces of Marian art (Fra Angelico, 1438-44, Convento di S. Marco, Florence; Ghiberti, *Adoration of the Magi*, 1403-24, north door, Baptistry, Florence; Ghirlandaio, fresco of life cycle, S. Maria Novella, Florence).

The Main Types of Virgin Mary

In the west, devotion to the Immaculate Conception, of Byzantine origin, and the advent on earth of a Virgin without stain were hardly portrayed at all before the end of the middle ages. In the seventeenth century, Murillo painted a Purísima dressed in white and crowned with stars, standing on a crescent moon (1678, Prado, Madrid). This type derives from the Song of Solomon and Revelations (12).

The Virgin *parturiente*, heavy with child, occurs in the thirteenth century (Nuestra Señora de la Espera, Santa Maria de la Regla, León, Spain). This theme, Our Lady of Expectation, circulated widely only at the end of the middle ages, however (Piero della Francesco, *Madonna del Parto*, 1460, Cappella del Cimitero, Monterchi, Sansepolcro).

One of the most celebrated types is the Virgin and Child, which appears in many manifestations. In the Virgin in Majesty, which developed in the fourth century, she is seated on a throne with the Child at her breast. The Virgin Enthroned became exceedingly widespread and scholars have studied the parallels drawn between the Virgin Queen and the Church. Many Virgins in Majesty are to be found in Auvergne; numerous examples were carved on the portals of Gothic cathedrals (Royal Tympanum, Chartres, c.1150; St Anne Portal, Notre Dame, Paris, c.1170; north side-aisle, Reims, c.1175). Under the name of Maestà, this type became widely established in Italy (Simone Martini, fresco, 1315, Palazzo Pubblico, Siena). From the thirteenth century, the Virgin and Child as a tender expression of maternity becomes more frequent and was immensely popular throughout the nineteenth and even the twentieth centuries (Gauguin, *La Orana Maria*, 1891-93, Metropolitan Museum of Art, New York).

A less prevalent variant is the Virgin nursing the Child or the Madonna of the Milk (Fouquet, *Vierge au lait*, right panel, Melun diptych, c.1450, Antwerp, Koninklijk Museum voor Skhone Kunsten). A further and very charming variant is the Madonna of the Rose Bush (Lochner, 1440, Wallraf-Richartz Museum, Cologne): this theme can be traced to the Song of Solomon where the Shulamite maiden is compared to a rose.

The type known as the Virgin of Misericord (of All Mercy), born in Constantinople, fulfils Mary's mediating function, interceding with Christ on behalf of suffering humanity and protecting men and women under her

Byzantine Madonna: the Panagia Eleousa
Virgin of Tzar Dusan, icon, c.1350. Abbey Church, Decani.

mantle (Lippo Memmi, *Madonna dei Recommandati*, c.1330, Orvieto Cathedral; Piero della Francesca, Madonna of Mercy polyptych, commissioned 1445, Pinacoteca, Borgo San Sepolcro). Benedetto Bonfigli's Virgin of Misericord (1464, Galleria Nazionale dell'Umbria, Perugia) deserves particular attention. It shows the Virgin protecting the Perugians from the arrows of plague, fired by Christ, by sheltering them under her mantle. Four saints intercede on behalf of the people who are being decimated by death, in the guise of a skeleton with bat's wings. This theme is transposed, *in toto*, into the iconography of St Sebastian.

Our Lady of Pity correlates with the sensibilty of the late medieval period. The dead Christ has just been brought down from the Cross and Mary lays him on her lap. In the fourteenth century, Christ is represented on his Mother's knees (stone sculpture group, Naumburg Cathedral, c.1320; Enguerrand Quarton, Pietà from Villeneuve-lès-Avignon, 1454-56, Louvre, Paris). In the sixteenth century, Christ is depicted laid out at Mary's feet. Spain was particularly susceptible to the theme of the Seven Sorrows of the Blessed Virgin, or the Virgin of Solitude, in which Mary, after the Crucifixion, remains alone with her grief.

Cross-references: Anne, Annuciation, Assumption, Baptism of Christ, Birth of the Virgin, Cana (Wedding at), Dormition, Flight into Egypt, Fourteen Holy Helpers, Joseph of Nazareth, Luke, Marriage of the Virgin, Miracles of the Virgin, Nativity, Presentation of Mary, Presentation of the Lord, Visitation.

Bibliography: J. de Mahuet, "Marie. Iconologie", *Catholicisme*, vol. VIII, cols. 586-608.

MARY OF BETHANY *see* MARY MAGDALENE.

MARY OF EGYPT

St Mary of Egypt
Jacques Callot, *Images de tous les Saints...,*1636.

Latin: Maria aegyptica; Italian: Maria egiziaca; Spanish: Maria egipciaca; French: Marie l'Egyptienne, German: Maria von Aegypten.
Martyr. Feast day 2 April.

LIFE AND LEGEND

Mary of Egypt, a prostitute from Alexandria, went to Jerusalem curious to know what was so attractive to pilgrims there: she took a boat, paying her passage by offering herself to the captain. An "invisible hand" stopped her on the threshold of the Church of the Holy Sepulchre as the crowd thronged past her. Full of repentence, she suddenly saw before her an icon of the Virgin which had been placed in the narthex. She begged forgiveness of the Virgin for her past life, which was granted, allowing her to enter the church unhindered.

She then retired to the desert. An anonymous donor gave her three loaves of bread, which were enough to feed her for sixty years. She purified her hair by washing it in the River Jordan. In the desert her body dried up, her clothes fell to pieces and her long hair hung lank, half covering her naked body. An old hermit, Zosimus, found her and covered her with his mantle. Returning a year later, he found her corpse and buried it with the help of a lion. Angels carried her soul to Paradise.

REPRESENTATION AND ICONOGRAPHY

She is generally emaciated, her naked body visible under her long hair. She can be confused with St Agnes or with Mary Magdalene, but can be differentiated from them by the three loaves she carries (statue under the porch of St Germain l'Auxerrois, Paris, fifteenth century; Ribera, second quarter of the seventeenth century, Musée Fabre, Montpellier). All or part of her legend can be depicted in stained glass or sculpture (windows, thirteenth century, Chartres, Bourges and Auxerre Cathedrals). Mary, carrying a sword, is pushed away by an angel (capital, thirteenth century, Musée des Augustins, Toulouse). The Virgin herself forgives her and a figure hands her three coins with which she purchases the three loaves. She immerses her hair in the River Jordan. A lion helps to bury her in the desert.

Attributes: Long hair. Three loaves.

MARY OF MAGDALA *see* CRUCIFIXION, DEPOSITION, HOLY WOMEN AT THE SEPULCHRE, MARY MAGDALENE.

MARY MAGDALENE

Latin, Spanish and German: (Maria) Magdalena; Italian: (Maria) Maddalena; French: (Marie) Madeleine.
Follower of Christ. Feast day 22 July.

TRADITION

From an early period, Christian tradition conflated in the figure of Mary Magdalene three women whom the Gospels record as having either followed or met Christ: the unnamed sinner who, during a meal at the house of Simon the Pharisee, anoints the Saviour's feet with perfume and dries them with her hair (Luke 7:37-38); Mary of Bethany, sister of Martha and Lazarus, who joined Jesus' entourage, received him in her house and persuaded him to raise her brother from the dead; and finally, "Mary called Magdalene" (Luke 8:2), Mary of the town of Magdala, who was possessed by devils that Jesus exorcised, and who is present both at the Crucifixion and at the Entombment, and whom Christ graces with his first appearance as Redeemer in the episode known as the Noli me tangere. The question of whether Mary Magdalene is three women combined or one unique figure has been debated at length by medieval and modern theologians alike. Tradition, however, has remained stronger than reason and, as one of the most popular of all saints, her legend has resisted all theological and scholarly revision. Her story became still more complicated when aspects of the life of Mary of Egypt were appended to it.

After the Ascension, Mary Magdalene, with Martha and Lazarus, reputedly travelled to Provence where all three made numerous converts. Then, desiring to make penance, she withdrew from the world to the cave of St Beaume in the Maritime Alps where she lived for thirty years. She died in Aix-en-Provence, where she had been brought by angels to receive extreme unction; her relics were later translated to Burgundy. This Provençal branch of her legend has no basis either in history or scripture and seems to have been invented by the monks of Vézelay in an attempt to account for and authenticate the relics in their church which were the subject of an important pil-

St Mary Magdalene
Donatello, 1455. Baptistry, Florence.

grimage. Her cult, however, was never restricted to Burgundy or Provence but spread throughout Christendom. The Counter-Reformation, by turning her into the personification of the sacrament of Penitence, encouraged its extension still further.

In Christian tradition, Mary Magdalene above all exemplifies the repentant and sanctified sinner. She is the patron saint of prostitutes, and also of hairdressers and perfumiers (in reference to her anointing Jesus' feet), and of gardeners (the Risen Christ appeared to her with the appearance of a gardener).

REPRESENTATION AND ICONOGRAPHY

Mary Magdalene can be recognized by her physical beauty and her long hair which she wears loose (like Mary of Egypt). Before her repentance, she is depicted as a seductive courtesan, wearing make-up and finery (Jan van Scorel, 1529, Rijksmuseum, Amsterdam) and in the Renaissance can even be amalgamated to the figure of Venus. In penitence, she is depicted totally differently: she is poor and wretched, covered only by her hair. Tears flow down her cheeks (Donatello, 1455, Baptistry, Florence; Orazio Gentileschi, c.1626, Kunsthistorisches Museum, Vienna; G.-C. Proccacini, c.1610s, Brera, Milan; Pedro da Mena, polychrome wood sculpture, seventeenth century, National Museum of Sculpture, Valladolid)).

Her oldest and most frequent attribute is the vessel containing the ointment with which she annointed Christ's feet in the house of Simon and which she took to the Holy Sepulchre. The courtesan's mirror, crown of thorns and death's head (before which she meditates and prays in the cave of St Beaume) are later additions. (Quentin Metsys, c.1520, Koninklijk Museum voor Schone Kunsten, Antwerp; Guercino, first half of the seventeenth century, Pinacoteca Vaticana).

She also occurs in numerous scenes from the Life and Passion of Christ: in the meal at the house of Simon, and Christ's visit to Martha and Mary where she is shown seated, or kneeling at Christ's feet. She is shown during the resurrection of her brother Lazarus, and is present at the foot of the Cross at the Crucifixion and at the Deposition. She is among the Holy Women at the Entombment and at the Holy Sepulchre (Savoldo, c.1540, *Mary Magdalene approaching the Holy Sepulchre*, National Gallery, London). The most frequently represented scene, however, is the first appearance of the Risen Christ. Mary recognizes him and wants to touch him, but the Redeemer orders her not to do so (*see* Noli me tangere).

From the Provençal legend, artists represented the arrival of the three saints in Marseille (in a rudderless ship without a sail); the Magdalene's penitence in the cave at St Beaume (she is often shown naked under her long hair); her mystical ecstasy and heavenly rapture (seven times a day, angels convey her to heaven to hear the celestial choirs: Lanfranco, c.1605, Museo Nazionale di Capodimonte, Naples; Ribera, 1636, Real Accademia di San Fernando, Madrid); her last communion (she receives the host from Maximin, bishop of Aix-en-Provence).

Attributes: Long, loose hair. Crown of Thorns. Mirror. Death's head. Perfume or ointment pot.

Cross-references: Crucifixion, Deposition, Entombment, Lazarus (raising of), Mary of Egypt, Martha, Noli me tangere, Resurrection, Holy Women at the Sepulchre.

MASSACRE OF THE INNOCENTS

Italian: la Strage degli Innocenti; Spanish: la Degollación de los Santos Inocentas; French: le Massacre des Innocents; German: der bethlehemitische Kindermord.

TRADITION

Alone among the Evangelists, Matthew makes mention of this event (Matt. 2: 16-18), which occurs immediately after the Flight into Egypt. Herod, discovering that he has been deceived by the Magi who do not return to tell him where the Christ child is, gives the order to kill "all the children that were in Bethlehem, and in all the coasts thereof, from two years and under" (2:16). Matthew underlines the prophetic nature of the passage in Jeremiah (31:15), which he quotes (2:18): "In Rama was there a voice heard, lamentation, and weeping, and great mourning, Rachel weeping for her children". The apocryphal *Protevangelium* of James mentions an additional detail: at the same time, Elisabeth flees with her son, John the Baptist.

REPRESENTATION AND ICONOGRAPHY

The episode can already found in monuments of the fifth century (mosaics, c.435, decorating the triumphal arch of S. Maria Maggiore, Rome). During the medieval era, Herod watches the massacre, seated on his throne (his evil intent is emphasized in Matteo dei Giovanni, 1482-91, S. Agostino, Siena). Often, Elisabeth's escape with John the Baptist figures in the distance. The massacre can also occupy the background in paintings of the Flight into Egypt (Duccio, Maestà, 1308-11, Opera del Duomo, Siena).

At the end of the middle ages, an accentuated realism is used in the depiction of the massacre (Cranach the Elder, c.1515, Gemäldegalerie, Dresden; Bonifacio de' Pitati, c.1530, Accademia, Venice). The Mannerist Cornelius van Haarlem (1591, Frans Hals Museum, Haarlem) treats the scene with incredible violence. In the seventeenth century, Reni (1611-12, Galleria Nazionale, Bologna) and Poussin (c.1635, Musée Condé, Chantilly) both illustrated the scene. Stanzione's close-up and foreshortened version allows the spectator to participate in the danger (second quarter of the seventeenth century, Schloss Harrach, Rohrau, Austria). By this time, Herod is represented,

The Massacre of the Innocents
Pieter Bruegel the Younger, beginning of the seventeenth century (detail). Musée Municipal, Dole.

if at all, by his palace in the background. The subject is rare in the eighteenth century.

Cross-references: Flight into Egypt, John the Baptist, Magi, Plagues of Egypt.
Bibliography: L. Réau, op. cit., vol. II, 2, pp. 267-72.

MATTHEW

Latin and German: Matthaeus; Italian: Matteo; Spanish: Mateo; French: Matthieu.
Apostle and Evangelist. Feast day 21 September (west), 16 November (east).

TRADITION
Called Levi by Luke, and Levi son of Alphaeus by Mark, Matthew is traditionally believed to be the author of the first Gospel. Before his vocation (Mark 2:14) he was a publican (a collector of taxes and excise duties) at Capharnaum. The Gospels are silent regarding his life story, but apocryphal writings give some details. After the scattering of the apostles, Matthew went to preach the Gospel in Ethiopia, there unmasking two magicians who were worshipped as gods. He also triumphed over the magicians' dragons and resurrected the daughter of King Hegesippus, who was thus converted. He was executed for protesting against the marriage of King Hirtiacus with his niece Iphigenia, by beheading, burning at the stake or stoning. The Abbey of St Matthew in Brittany claimed at one point to possess the relic of his head, which had been mysteriously brought from Ethiopia to Finistere. Matthew is the patron saint of bankers and tax officials.

REPRESENTATION AND ICONOGRAPHY
Mosaic medallions of the sixth century (S. Vitale and S. Apollinare in Classe,

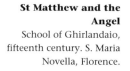

St Matthew and the Angel
School of Ghirlandaio, fifteenth century. S. Maria Novella, Florence.

Madonna of Mercy. Piero della Francesca, polyptych panel, c.1460. Pinacoteca Communale, Sansepolcro.

Mary Magdalene. Rogier van der Weyden, panel of the Braque Triptych, middle of the fifteenth century. Louvre, Paris.

Ravenna) are the earliest known effigies of St Matthew. The composition of the first Gospel is the most frequent theme: Matthew sits in front of a desk and writes, inspired by an angel (School of Tours, miniature, Grandval Bible, ninth century, British Museum, London; Luca della Robbia, bronze door, Florence Cathedral, 1460; Poussin, *Landscape with St Matthew*, 1643-4, Berlin-Dahlem Staatliche Museen, Berlin), by a child (Andrea Castagno, 1442, Cappella S. Tarasio, S. Zaccaria, Venice) or by a boy (Romanino, 1521, S. Giovanni Evangelista, Brescia). In the sixteenth century, Veronese painted a meal at the house of Levi (1573, Accademia, Venice). St Matthew's vocation was treated by Caravaggio (1599-1600, S. Luigi dei Francesi, Rome) and, in his wake, Terbrugghen (1621, Centraal Museum, Utrecht).

His martyrdom figures on a mosaic (narthex, St Mark's, Venice) and once again inspires Caravaggio (1599-1600, S. Luigi dei Francesi, Rome, with a henchman grasping the saint as he falls at the bottom of a staircase and threatening him with a sword). Matthew can also be stabbed, rather than simply beheaded (Vignon, 1617, Musée Municipal des Beaux Arts, Arras).

Attributes: Angel, boy or child dictating. Book or scroll (Gospel). Sword (not to be confused with St Paul's).
Cross-references: Apostles, Evangelist.
Bibliography: H. Martin, *Saint Matthieu*, Paris, 1926.

MAURICE

Latin and German: Mauritius; Italian: Maurizio; Spanish: Maurico.
Martyr. Third century. Feast day 22 September.

LIFE AND LEGEND

Maurice's life is almost entirely legendary. He came from Christian Egypt and joined the Roman army. At the head of the Theban Legion, he was sent to fight in the Alps. There, traditionally in 287, for refusing to sacrifice to the Roman gods and reneging on their faith, Maurice and his companions were massacred on the orders of Emperor Maximian. They offered no resistance.

St Maurice's cult grew up on the reputed site of the massacre itself: Agaunum (now St Maurice en Valais, in Switzerland). The abbey of St Maurice, which possessed the saint's relics, became a major pilgrimage at an early date. From here, the cult became widespread all over the Alps and in the Rhône Valley, before extending to Germany and Italy. King René contributed to his cult in Anjou and in Provence. Like St George, Maurice figured among the patrons of knights and soldiers. Both Switzerland and Austria include him among their national saints.

REPRESENTATION AND ICONOGRAPHY

From the twelfth and thirteenth centuries on, due to a linguistic similarity between the name Maurice and *maurus*, he is more and more often shown as a Moor. He is thus one of the very rare black saints. His attribute is a banner or pennon like St George's: white with a red cross (occasionally an Imperial eagle replaces the cross). The two saints, however, are easy to tell apart: George is white and rides a horse; Maurice is black and is nearly always a foot soldier. His legend is generally reduced to his passion: he is shown being beheaded with his companions from the Theban Legion (El Greco, 1580-81, El Escorial).

St Maurice
Hans Baldung Grien, panel,
The Adoration of the Magi,
1507. Berlin-Dahlem
Staatliche Museen, Berlin.

Attribute: White banner with a red cross or an Imperial eagle.
Bibliography: G. and M. Duchet-Suchaux, *Les Ordres réligieux: Guide historique*, Paris, 1993.

MÉDARD

St Médard
Jacques Callot, *Images de tous les Saints...*, 1636.

Latin: Medardus Noviomensis; Italian: Medardo; French: Médard de Noyon; German: Medardus.
Bishop and martyr. Died c.560. Feast day 8 June.

LIFE AND LEGEND
The oldest surviving life of St Médard, the *Vita S. Medardi*, dates from the beginning of the seventh century. Médard was born at Salency (Picardy) during the last quarter of the fifth century. He spread the Gospel in Picardy and became Bishop of Noyon around 548. He consecrated Queen Radegund as deaconess when she left her husband Clotaire I and took the veil. Médard died around 560 and is buried at St Médard at Soissons. According to popular belief in France, if it rains on his feast day, the rain will continue for forty days (the same belief is attached in England to the feast of St Swithin on 15 July, and to other saints in other lands). He is the patron saint of farmers due to his influence on the weather and the harvest.

REPRESENTATION AND ICONOGRAPHY
Médard is depicted as a bishop with crozier (low-relief, twelfth century, former Abbey Church at Braunweiler, near Cologne). Because he was invoked against toothache, he is often shown with his mouth open and showing his teeth. An engraving by Jacques Callot (*Les Images de tous les saints...*, 1636) shows an eagle hovering over him: his legend recounts that, as a child, Médard was sheltered from the rain by an eagle with wings spread. He is also represented holding a heart.

St Médard joined the ranks of the saints who are invoked to protect the French monarchy during the reign of Charles VII (1427-62), at the same time as Radegund, to whom that king also showed the greatest veneration. St Médard's cult corresponds to the Capetian monarchy's efforts to substantiate their legitimacy and, in opposition to Bedford's claims on behalf of the young English king Henry II, to consolidate the line leading from Clovis, their founder, to the Valois.

Attributes: Bishop's crozier. Eagle (hovering over the saint). Heart (symbolizing his charity).
Bibliography: L. Maître, "Le culte de saint Médard", *Annales de la Bretagne*, 1950.

MELCHIZEDEK *see* ABRAHAM.

MERCHANTS IN THE TEMPLE

The Expulsion of the Merchants (or Money-changers) from the Temple. Italian: Cacciata dei Mercanti; Spanish. Expulsión de los Mercadores; French: Christ chasse les marchands du Temple; German: Die Vertreibung der Händler aus dem Tempel, Tempelreinigung Jesu.

TRADITION

This episode is recorded by all four Evangelists (Matt. 21:12-13; Mark 11:15-17; Luke 19:45-46; John 2:14-17) and occurs (following the Synoptic Gospels) after the Entry into Jersualem. Christ enters the Temple and, having made "a scourge of small cords" (John 2:15), he chases out the sheep and oxen and sets free all the sacrificial doves. He throws over the money-changers' tables and spills their money all over the floor. This scene was read by medieval commentators as a fulfilment of the prefiguration of the Expulsion from Paradise.

REPRESENTATION AND ICONOGRAPHY

The earliest depictions (in illuminated manuscripts) date from around the sixth century. In the middle ages, artists took their inspiration above all from the Gospel of St Mark, adding certain elements taken from St John (most importantly, the scourge). There is a restricted number of images of this sequence (Giotto, 1304-6, Arena Chapel, Padua; sculptand relief on the bronze door of S. Zeno, Verona, twelfth century). It was taken up once again by Dürer (*Kleine Passion*, 1507-13), but flourished most in the seventeenth and eighteenth centuries when it was often juxtaposed with the Passion and Resurrection. It was treated no fewer than three times by El Greco (1570-75, National Gallery, Washington; 1572, Institute of Arts, Minneapolis; 1595-1605, Frick Collection, New York). Rembrandt exposes all the violence of the scene: equipped with his whip, Jesus pushes over a money-changer's table and the money spills on to the floor (etching, 1635). For Jordaens, the expulsion is just a joyous flurry of animals and men (seventeenth century, Louvre, Paris), while Giordano treats the theme with more severity (1684, Chiesa dei Gerolomini).

Cross-references: Adam and Eve, Agony in the Garden, Entry into Jerusalem, Resurrection.
Bibliography: L. Réau, op cit., vol. II, 2, pp. 401-3.

Jesus Driving the Merchants from the Temple
Ghiberti, relief, 1405-24 (detail). North door of Baptistry, Florence.

MICHAEL

Latin and German: Michael; Italian: Michele; Spanish: Miguel; French: Michel. Archangel. Feast day 29 September.

TRADITION

St Michael the Archangel is the chief of the heavenly host, the celestial army that defends the Church. He fights the rebel angels and the dragon of Revelations. He is also St Michael *psychopomp*, escorting the dead and weighing their souls at the Last Judgment.

Scholars have affiliated his cult to that of certain ancient gods: Anubis, Hermes, Mercury, Wotan. In the west, the cult of St Michael began to develop from the fifth and sixth centuries, beginning in Italy and France, then spreading to Germany and throughout Christendom. By the turn of the millenium, the churches and chapels dedicated to him had become innumerable. St Michael being a celestial saint, they are often placed on high ground. From the fourteenth century, Michael, as a military saint, was particularly revered by the kings of France. The Counter-Reformation saw in him the head of the Church in its war against Protestant heresy, and so his cult increased still further. He was patron of knights and of all trades allied to the production of weapons and scales.

St Michael Fighting the Dragon
Dürer. c.1497-8.
Bibliothèque Nationale, Paris.

REPRESENTATION AND ICONOGRAPHY

Though St Michael's iconography is extremely rich, it is also relatively unchanging (rose window, Saint-Chapelle, Paris, c.1490; Dürer, engraving in the *Apocalypse*, 1497-8; Jacobello del Fiore, 1421, Accademia, Venice; Bermejo Bartolomé, late fifteenth century, Wernher Collection, Luton Hoo, Bedfordshire). Most often he is shown as a soldier or knight carrying a lance or sword and a shield emblazoned with a Cross. He can be distinguished from St George not only by his wings, but also because he fights the dragon (Rev.12:7-9) either on foot (Raphael, 1505, Louvre, Paris) or in the air, whereas George is nearly always mounted on a horse. When he weighs the souls of the deceased, Michael resembles more an angel than a knight: he often holds the scales himself and plays an essential role in representations of the Last Judgment (Romanesque sculpture).

Attributes: Wings. Pair of scales. Dragon. Shells (in connection with the pilgrimage to Mont-Saint-Michel in Normandy).

MILL *see* PAUL.

MILLSTONE *see* CHRISTINA, QUENTIN, VINCENT OF SARAGOSSA

MIRACLES OF CHRIST *see* CANA, LAZARUS (RAISING OF), PETER.

MIRACLES OF THE VIRGIN MARY

TRADITION

A number of legends (for the most part of eastern origin) recount the miracles the Virgin is supposed to have performed after her death. In the seventh century, Gregory of Tours drew together several of these stories in his *De gloria martyrum*. In the Byzantine world, two themes are predominant: the pardoning of Mary of Egypt (*see* Mary of Egypt) and the miracle of the deacon Theophilus. Theophilus wrote out a document in his own blood in which he retracted his faith, which he then sealed and gave to the devil, thus entering his service. The Virgin interceded, allowing him to recover the pact and set himself free.

REPRESENTATION AND ICONOGRAPHY

Theophilus

The legend of Theophilus inspired many medieval artists. Theophilus is shown first kneeling before Satan and signing his pact, then kneeling before the Virgin who, forgiving his error, seizes the covenant from Satan and returns it to him (low relief, tympanum, Church at Souillac, c.1140; tympanum, entrance to cloister, Notre-Dame, Paris, thirteenth century, illumination, *Ingeburge Psalter*, c.1200, Musée Condé, Chantilly). The deacon also occurs in many of the stained-glass ensembles in the major French Gothic cathe-

drals (Chartres, Le Mans). Theophilus stands in front of the Devil and they clasp hands (Troyes Cathedral, sixteenth century). Theophilus is paraded on a leash by Satan, who appears as a bear (sixteenth century, Church of Grande Andely, Eure).

The Child Abducted by the Devil
This legend, which shows the Virgin armed with a whip or a club rescuing a child whom the Devil tries to kidnap, became widespread in Umbria under the name of the Madonna del Soccorso. The Devil tries to snatch a naked child from the cradle. The mother, praying to the Virgin, holds on to the infant by his foot. Mary intercedes and forces the Demon to let the child go (Niccolo di Liberatore da Foligno, fifteenth century, Galleria Colonna, Rome).

Our Lady of the Snows
This miracle is closely associated with the most ancient Roman church dedicated to the Blessed Virgin. On the night of 3 August 352 the Virgin is supposed to have shown Pope Liberius and the patrician, John, where to build the church of S. Maria Maggiore by spreading a blanket of snow over the site. This legend became immensely well-known all over Europe (mosaics, S. Maria Maggiore, 1308; statue, Notre Dame des Neiges, fifteenth century, at the Church of Notre Dame, Vernon, Eure). In Germany, Grünewald painted Liberius' dream and the foundation of S. Maria Maggiore (wing of the Maria Schnee Altar, 1519, Augustinermuseum, Freiburg im Breisgau). The theme also reached Spain (Murillo, *The Foundation of the Church of S. Maria Maggiore*, 1665-6, Prado, Madrid).

The Translation of the Holy House to Loreto
The legend of the Holy House (*Santa Casa*) appeared in the latter half of the fifteenth century and was connected to the growing Marian pilgrimage to Loreto, near Ancona, Italy. In 1294, after the fall of Acre to the Muslims (1291) and the expulsion of the crusaders from the Holy Land, angels miraculously carried off the Holy House in Nazareth (in which the Virgin had lived) and transported it to Loreto (stained glass, St Etienne, Beauvais, sixteenth century). This scene is illustrated by numerous votive and other images. The Virgin, the Child in her arms, sits on the roof of the house as it rises into the air.

Cross-references: Devil, Mary, Mary of Egypt.

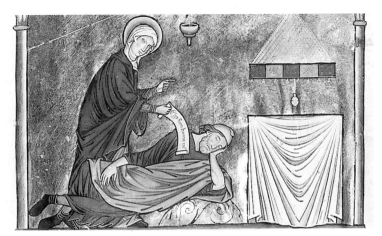

The Miracles of the Virgin: the Miracle of Theophilus
Ingeburge Psalter, c.1200.
Musée Condé, Chantilly.

MIRACULOUS SEA VOYAGE

This theme has a very long history. It has its origins in, among other episodes, the Biblical story of the voyage of Jonah in the belly of the whale. This directly inspired the legend of Brendan, who was accompanied by St Malo on his travels. Miraculous sea voyages occur in the lives of many saints (particularly in Brittany), who arrive on the shores of the continent after wondrous journeys across the ocean. Similarly, in the *Golden Legend*, Martha, Lazarus and "his sister Mary Magdalene" find themselves together with other travellers on a vessel without oars, sails or rudder (Lukas Moser, 1432, panel of the St Mary Magdalene altarpiece, Tieferbronn Church, near Pforzheim). God sets them safe and sound at Marseille.

This legend spawned others. St Anastasia, for example, has exactly the same experience. Two miraculous voyages occur in the legend of Vincent of Saragossa. Like St Vincent, Christina of Bolsena (or of Tyre) is tied to a millstone to be drowned but survives unharmed. The kindred Biblical episode in which St Peter tries, like Christ, to walk on the water also occurs in the legends of a number of Breton saints.

Cross-references: Brendan. Christina. Giles. Jonah. Lazarus (raising of). Malo. Martha. Vincent of Saragossa.

MIRROR *see* MARY MAGDALENE.

MISSION OF THE APOSTLES *see* APOSTLES, TRINITY.

MITRE *see* BISHOP.

MOCKING OF CHRIST *see* CHRIST MOCKED.

MONEY-BAG *see* CUNEGUND (QUEEN), JUDAS, LAURENCE (IN CHALICE), NICHOLAS (THREE).

MONEY-CHANGERS IN THE TEMPLE *see* MERCHANTS IN THE TEMPLE.

MONICA

Latin, Italian, Spanish: Monica; French: Monique; German: Monika.
Mother of St Augustine. 322(?)-387. Feast day 27 August (since 1969; formerly 4 May).

LIFE AND LEGEND

Her life is known directly only through the works of her son St Augustine,

St Monica
Adriaen Collaert, beginning of the seventeenth century.
Bibliothèque Nationale, Paris.

more particularly the *Confessions*. She was probably born at Tagaste (near present-day Annaba, in Algeria) in 332. After a period of unhappiness, during which she was forced to watch her son lead a disorderly life in Carthage and become a Manichean, she eventually managed to convert her "son of so many tears" in 387 at Milan. She died shortly afterwards at Ostia (of which she is the patron saint) on the return journey to Africa.

REPRESENTATION AND ICONOGRAPHY
St Monica's iconography began to grow only in the fifteenth century and was disseminated above all by Augustinian convents and abbeys. She is always shown in widow's weeds, a black dress with a belt, veil and wimple. She is encircled by twelve Austins (Filippo Lippi, second half of the fifteenth century, S. Spirito, Florence). Michael Pacher shows Monica in the company of her son (Kirchenväteraltar from Neustift, before 1483, Alte Pinakothek, Munich). She is often shown with Augustine or St Nicholas of Tolentino by artists with Augustinian affiliations (Girolamo di Benvenuto, fifteenth century, Fogg Art Museum, Cambridge, Mass.).

Attributes: Widow's dress or nun's habit.
Cross-reference: Augustine.

MONOGRAM OF CHRIST, CHRISMON

Variants: Chi-Rho, Christogram. Italian: il Monogramma di Cristo; Spanish: Crismón, anagrama de Cristo; French: le Monogramme du Christ, Chrisme; German: Christogramm, das monogrammatische Kreuz, Chrismon.

TRADITION
The monogram of Christ is made up of the first two Greek letters of his name, chi (χ) and rho (ρ) and was designed to invoke the prophylactic power of Christ's name. The monogram was widely circulated in 312 when Constantine's victorious army against Maxentius emblazoned the sign on their shields.

REPRESENTATION AND ICONOGRAPHY
The most frequent form consists in crossing the χ over the shaft of the ρ, but other forms do occur. The commonest of these comprises a crossbar through the shaft of the ρ. Arian conflict had the effect of bringing the characters alpha (α) and omega (ω) into the ambit of the design to underscore the divine nature of Christ as beginning and end of all things. At the same time, during the fourth century, the christogram became a symbol and appeared, not long after 312, on silver coins issued by Constantine (Staatliche Münzsammlungen, Munich). After the Constantinian period, the monogram continued to be found on fifth- and sixth-century sarcophagi.

Monogram of Christ
Detail from a sarcophagus.
Lateran Museum, Rome.

Cross-reference: Revelations.
Bibliography: M. Sulzberger, "Le symbole de la croix et les monogrammes de Jésus", *Byzantion*, 2, 1925, p. 337.

MONSTRANCE

Variant: Ostensorium. Italian: ostensorio; Spanish: custodia; French: ostensoir; German: Monstranz, Ostensorium.

The monstrance (from *monstrare*, to show) or, more rarely, ostensorium (from *ostendere*, also to show) is for exposing the consecrated host to the faithful. Fourteenth-century monstrances look like examples of Gothic architecture; the present form, which appeared in the sixteenth century, is like a sun encircled with beams.

Cross-reference: Clare.

MOSES

Hebrew: Mosheh; Arabic: Moussa; Italian: Mosé; Spanish: Moisés; French: Moïse; German: Moses.

TRADITION

Moses, the prophet whom God entrusts to liberate the Chosen People, occupies the summit of the First Testament hierarchy. He was born in Egypt, where the Hebrews were enslaved, and was saved from the massacre of the Jewish children by the Pharoah's daughter who discovered him in a basket floating on the Nile (Ex. 2:3-10). He killed an Egyptian, however, and had to flee into the desert. While Moses was guarding the flock belonging to his father-in-law Jethro, Jehovah revealed himself in the Burning Bush and ordered him to bring the sons of Israel out of Egypt. The Pharaoh was by no means prepared to let them go, however, and Jehovah forced him to acquiesce only through a succession of scourges, the Ten Plagues of Egypt (Ex. 7-11), which the institution of the Passover brought to a close (Ex. 12:3-11). The Hebrews marked the doors of their houses with the blood of the sacrificial lamb, as commanded by Jehovah, "and it came to pass that at midnight the Lord smote all the firstborn in the land of Egypt" (Ex. 12:28), including the Pharaoh's own son. Only the Hebrew children, whose doors were smeared with sacrificial blood, were saved.

Moses
Michelangelo, c.1515.
S. Pietro in Vincoli, Rome.

The Hebrews were then free to leave in the Exodus, crossing the Red Sea and then, with much suffering, entering the desert. There, when they lamented their fate, manna fell from heaven for food and the prophet struck the rock for water. In this popular episode (Ex. 17:3-7), the thirsty people were murmuring against Moses and the Lord advised him,"I will stand before thee there upon the rock in Horeb; and thou shall smite the rock, and there shall come water out of it." To perform this miracle, Moses used the same stick with which he divided the waters of the Red Sea.

God also made himself known to Moses on the summit of Mount Sinai (Ex. 19:10-15) where he handed him the Tables of the Law which formed the alliance between Jehovah and his chosen people (Ex. 24). The people, however, had again rebelled and made a golden calf, an abominable idol in the sight of the Lord (Ex. 32:1-6). Moses destroyed it (Ex. 32:20).

In the episode of the brazen serpent (Num. 21:6-9; 2 Kings 18:4), Jehovah, weary of the Hebrews' complaints, released into their midst numerous poisonous snakes. Moses prayed for the people and complied with Jehovah's command to make a serpent of brass, which he fixed to the top of a shaft. All those who gazed on it were safe from the snake venom. This strange story had its corollary in the construction of a portable sanctuary, the Ark, which embodied the covenant made between God and the Hebrews. In the middle ages, the Ark of the Covenant was one of the symbols of the Virgin, who nurtured the Word made Flesh in her womb.

248

REPRESENTATION AND ICONOGRAPHY

Initially, Moses is shown, in the catacombs and on paleochristian sarcophagi, as a young man without a beard (mosaics in S. Maria Maggiore, Rome, fifth century). In the middle ages, he is normally bearded and wears long robes (central portal of Chartres Cathedral, thirteenth century; sculpture ensembles and stained glass in the cathedrals at Amiens, Reims, Laon, and at Notre-Dame, Paris).

From the twelfth century, Moses is occasionally shown with horns (manuscripts; Claus Sluter, *Well of Moses*, 1395-1403, Charterhouse at Champmol, Dijon; Michelangelo, Tomb of Pope Julius II, 1513-16, S. Pietro in Vincoli, Rome). These are explained by a mistranslation in the Vulgate (not followed in the Authorized Version of the Bible). In the Book of Exodus (34:29), it is written that Moses shone brightly when he came down from Sinai after he had been given the Tables of the Law. St Jerome translated the Hebrew verb for shine, similar to the word *geren* (horn), by *cornatus*, horned: "*Videbant faciem Moysi esse cornutam* [They saw that Moses' face was horned]". From the sixteenth century, Moses' beard is often trimmed into two points.

The Finding of Moses

The episode where the infant Moses is saved from the waters of the Nile occurs among the frescoes of the synagogue at Dura-Europos (c.245), Poussin produced a number of paintings on this theme, where he personified the Nile as a river god (c.1624, Gemäldegalerie, Dresden; 1638, Louvre, Paris). A more usual version is that of Orazio Gentileschi (1633, Prado, Madrid), while in Bartolomeus Breenberg's version (1636, National Gallery, London) the landscape is the dominant aspect. One imaginative interpretation is to be found on a capital in the Church of St Nectaire (Puy-de-Dôme, twelfth century) where a man carrying a stick snatches the child from three open-mouthed crocodiles.

Passover (Ex. 12:11)

This theme was a favourite one of goldsmiths and enamel-workers from the region of the Meuse (Niholas of Verdun, 1181, Klosterneuberg altarpiece, Klosterneuberg Stiftsmuseum, Austria). A capital (twelfth century, Vézelay) illustrates the death of the Pharaoh's son at the hands of an exterminating angel (Ex. 12:23-29).

Burning Bush (Ex. 3:1-6) *see* Burning Bush.

Crossing of the Red Sea (Ex. 13:17-22; 14) and the People in the Wilderness (13.22-27; 16, 17) *see* Exodus.

Golden Calf (Ex. 32:1-24) *see* Golden Calf.

Cycles

The frescoes from the synagogue at Dura-Europos (c.245) and the wooden door to the Church of S. Sabina (Rome, fifth century) present almost complete cycles of all the principal episodes. The mosaics in the Basilica of S. Maria Maggiore in Rome (fifth century) describe Moses saved from the Nile by the Pharaoah's daughter, his marriage to Jethro's daughter Zipporah, the crossing of the Red Sea, the manna from heaven and the quails, and his death. In the twelfth century, an important ensemble is represented by the frescoes of St Savin sur Gartempe (Vienne). A later cycle can be found in the Sistine

Chapel (Botticelli, c.1482). Moses also appears with Elijah at the Transfiguration of Christ. Christ is replaced by a triumphal cross on a mosaic in the apse of S. Apollinare in Classe at Ravenna. Raphael floods the two prophets with the light emanating from Christ (1518-20, Pinacoteca Vaticana).

Cross-references: Aaron, Ark of the Covenant, Burning Bush, Elijah, Exodus, God, Golden Calf, Passover, Plagues of Egypt, Transfiguration.

MULE *see* ANTONY OF PADUA.

MULTIPLICATION OF THE LOAVES AND FISHES

Variant: The Feeding of the Five Thousand; Italian: la moltiplicazione dei pani; Spanish: la multiplicación de los panes; French: la multiplication des pains; German: das Wunder der Brot- und Fischvermehrung.

TRADITION

The miracle of the loaves and fishes is reported by all four Evangelists. In it, Jesus feeds five thousand people gathered on the shores of Lake Galilee with five loaves and two fishes; the remains fill twelve baskets (Matt. 14:13-21; Mark 6:31-44; Luke 9:10-17; John 6:1-13). Matthew and Mark both recount another similar miracle: with seven loaves and a few fish Jesus also fed four thousand people (Matt. 15:32-39; Mark 8:1-9). The Fathers of the Church read these miracles as symbolic of the Eucharist.

REPRESENTATION AND ICONOGRAPHY

In catacomb art, the miracle is alluded to rather than represented: a Eucharistic meal is shown with, nearby, baskets of bread. At the time of Constantine (fourth century), Christ is shown blessing the bread and fish, or else touching them with a stick (fresco on cubiculum III, catacomb of Domitilla, Rome; wooden carvings on the door of S. Sabina, Rome, c.430). The motif of a front-facing Christ who blesses the bread is adopted in large-scale artworks from the sixth century (mosaics, S. Apollinare Nuovo, Ravenna). This type is embroidered further during the middle ages: Christ blesses the food while his apostles hand it out to the people. Michael Pacher explicitly linked the multiplication of the bread to the Last Supper (altarpiece, 1481, Sankt Wolfgang, Austria).

A narrative cycle with many episodes, which had been the rule in the Gothic period, gives way to compositions placed in a unitary landscape, for example in a work by Ambrosius I Francken (altarpiece of 1598 donated by millers and bakers in Koninklijk Museum voor Schone Kunsten, Antwerp). From the sixteenth to the eighteenth centuries (Feti, 1621, Palazzo Ducale, Mantua; Paul Troger, 1738, Abbey of Geras, Austria), the scene is the object of vast, teeming compositions, often presented by charitable brotherhoods. Tintoretto also associated the theme with the Last Supper (c.1580, Scuola di S. Rocco, Venice).

Cross-reference: Last Supper.
Bibliography: G. Schiller, *Ikonographie der christlichen Kunst*, vol. I, 1966, pp. 173-76.

The Multiplication of the Loaves and Fishes
Limbourg Brothers, *Les Très Riches Heures du Duc de Berry*, c.1413. Musée Condé, Chantilly.

NAIL *see* HELEN (WITH CROSS), INSTRUMENTS OF THE PASSION, QUENTIN (IN HIS BODY).

NATIVITY

Latin: Nativitatis Domini; Italian: la Nascita di Cristo, il Presepio; Spanish: la Natividad; French: la Nativité; German: die Geburt Christi.
Feast day 25 December.

TRADITION

Only St Luke gives a complete account of the miraculous circumstances surrounding the birth of Jesus (Luke 2:1-20). Matthew simply mentions the fact that "Jesus was born in Bethlehem of Judea in the days of Herod the king" (2:1) and then continues without further ado with the arrival of the "wise men from the east". Jesus was born just as an edict issued by Ceasar Augustus ordered a census of the Empire. Everyone had to return to their home town to give their particulars. Joseph and Mary therefore returned to the "city of David which is called Bethlehem" (Luke 2:4), for Joseph was of the line of David. There was no room at the inn and so the child was born in a stable (or cave). Jesus, wrapped in swaddling clothes, was placed in a manger. Luke mentions neither ox nor ass and their presence in iconography is explained by a passage in the apocryphal gospel known as Pseudo-Matthew which takes

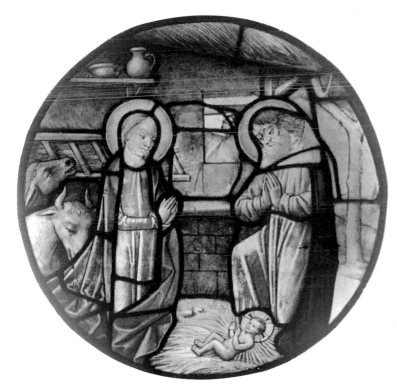

Nativity
Thirteenth century.
St Urbain, Troyes.

251

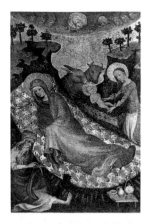

Nativity of Christ
Flemish, fourteenth century.
Museum Mayer van den
Bergh, Antwerp.

up a verse from Isaiah, "The ox knoweth his owner and the ass his master's crib" (Is. 1:3). The feast of the Nativity was celebrated in the west on 25 December from the middle of the fourth century and in Constantinople from 379.

James of Voragine's *Golden Legend* lists the numerous miracles which accompanied Christ's birth: on Christmas night, the vineyards at Engedi flowered, produced grapes and gave wine. In Rome, a fountain began to run with oil and flowed abundantly into the Tiber: this, the text underlines, fulfilled the Sibyl's prediction concerning the birth of the Saviour. Similarly, the Romans, who had been enjoying a twelve-year period without war, had built a temple of peace. The oracle was consulted as to how long peace would last: until a Virgin gives birth, came the reply. Just at that moment, Mary was delivered of Jesus and the temple crashed to the ground.

On Christmas Day 1223, St Francis of Assisi celebrated the Nativity in a cave at Gubbio by having it acted out by real people. In spite of certain authors, however, this event does not necessarily lie at the origin of Nativity cribs.

REPRESENTATION AND ICONOGRAPHY

Beginning in the first half of the fourth century, the birth of Christ has given rise to a huge quantity of iconography. At this early date, the ox and ass are already present and one or several shepherds look on. The stable, its tiled roof resting on bare rafters, is open to the sky. Joseph is not shown and the Child lies on a piece of cloth covering the manger which itself often resembles an altar. Mary, sitting to one side, soon begins to occupy pride of place. From the fifth century, Joseph makes his appearance, while the Adoration of the Magi is no longer combined with the Nativity but portrayed separately.

In Romanesque art, Mary often lies next to the Child wrapped in its swaddling clothes, the accent being put on the closeness of the relationship between Mother and Infant. In the thirteenth century, the Child looks up from the manger at the Virgin bending over him. The scene loses its heiratic character and is imbued with life: Mary occasionally lifts an edge of the cloth which covers the crib.

At the end of the medieval period, she takes the Infant out of the crib altogether, cradling him in her arms. This is an obvious enough development, but the relationship between Child and Mother symbolizes that between Christ and his Church, as adumbrated by countless theologians (Alesso Baldovinetti, 1460-62, SS. Annunziata, Florence). In the fourteenth and fifteenth centuries, the Virgin puts Jesus to her breast (Jean Pucelle, *Heures de Jeanne II de Navarre*, fourteenth century). In Flemish and German art, a certain taste for the curious transpires (for example, in the Master of Vyssi Brod, c.1350, Narodni Galerie, Prague, Joseph abandons his thoughtful attitude and prepares Jesus' bath).

The sixteenth century sees the predominance of the motif of the Adoration of the Infant by both the Virgin and the shepherds and, occasionally, by saints and donors as well (Dürer, Paumgartner Altarpiece, 1502-4, Alte Pinakothek, Munich; Master of Moulins, c.1480, *Nativity and Cardinal Rolin*, Musée Rolin, Autun). The religiosity of the scene is conserved, albeit in different forms; in a spirit derived from Franciscanism, the faithful are invited to think of the mystery of the Incarnation and additional episodes are associated with the central theme, such as the annunciation to the shepherds, their arrival at the stable, the choir of angels (Bramantino,

c.1505, Pinacoteca Ambrosiana, Milan). In the eighteenth century, monumental altarpieces become still more frequent and the adoration of the shepherds is the privileged scene. The lamb brought by the shepherds is treated as a symbol of the Coming of Christ in both Venetian painting and southern German art (C.D. Asam, 1724-26, dome, Einsiedeln, Switzerland).

Cross-references: Annunciation to the Shepherds, Joseph of Nazareth, Magi, Mary.
Bibliography: H. Cornell, *The Iconography of the Nativity of Christ*, Uppsala, 1924. L. Réau, op. cit., vol. II, 2, pp. 213-55. J. Sanchez Cantón, *Nacimiento e Infancia de Christo*, Madrid, 1948. M. Vloberg, *La Vierge et l'Enfant dans l'art français*, Paris, 1954.

NEBUCHADNEZZAR

Variants: Nebuchadrezzar, Nabuchodonosor. Italian and Spanish: Nabucodonosor; French: Nabuchodonosor; German: Nebukadnezar.

TRADITION

Nebuchadnezzar was King of Babylon from 625 to 602 BC. His reign marked the high point of the Second Babylonian Empire. He is mentioned in the Bible (2 Kings 24, 25; 2 Chron. 36) and appears in the Book of Daniel. His dreams (Dan. 2) provide one opportunity for the prophet to prove his superiority over the Chaldean seers (another surfaces during Belshazzar's feast). The Nebuchadnezzar of the Book of Daniel, however, has little in common with the historical figure except for his name. Theological speculation has been fired by two of Nebuchadnezzar's dreams: that of the "great image" with feet of clay which a stone falling without human agency breaks "to pieces" (Dan. 2:31-35) and that of the felled tree (Dan. 4:4-26) which, in the Christian tradition, is linked to the Crucifixion. Nebuchadnezzar also appears in the sequence with the three Hebrews in the furnace (Dan. 3; "The Song of the Three Holy Children", Apocrypha) as well as when Daniel is thrown to the lions (Dan. 14:31-42; "Bel and the Dragon" 28-42, Apocrypha).

REPRESENTATION AND ICONOGRAPHY

The Idol with Feet of Clay (Dan. 2:1-35)
Daniel triumphs over the Chaldeans as he alone is able to explain the enigma of the fallen idol. God will install an eternal kingdom after destroying all earthly powers, beginning with the empire of Nebuchadnezzar. St Jerome and the Fathers of the Church saw in this interpretation the annunciation of Christ who, without human intervention, is born of a Virgin (dado at the Portal of La Mère de Dieu, Amiens Cathedral, thirteenth century).

The Felled Tree (Dan. 4:4-26)
In this dream, the branches of a huge tree offer shelter to the birds of the air and shade to the beasts of the field. An angel from heaven commands that it be cut down. The tree, Daniel reveals, is Nebuchadnezzar's pride, which will be laid low (fresco, Chapterhouse of Bauweiler Benedictine Abbey, near Cologne, thirteenth century; wall-hanging, sixteenth century, Musée de Cluny, Paris).

Nebuchadnezzar's Punishment (Dan. 4:27-29; 5:21)
Daniel tells Nebuchadnezzar that he will one day lose his mind and eat grass

Nebuchadnezzar: the Dream of the Felled Tree
Miroir de l'humaine Salvation,
fifteenth century. Musée Condé, Chantilly.

like an animal. Only if he repents will he be saved. In these scenes, the king is represented as a hairy monster, browsing on all fours like a beast (Blake, engraving and watercolour, 1795, National Gallery, London). These sequences were popularized by Beatus' *Apocalypse* and inspired the carved capitals of the cloister at Moissac.

Cross-references: Daniel, Jeremiah, Judith.

NEMROD *see* BABEL (TOWER OF).

NET *see* ANDREW (FISHING NET), BLANDINA (MARTYRED WITH GLADIATOR'S NET), PETER (AS FISHERMAN).

NICODEMUS *see* ENTOMBMENT.

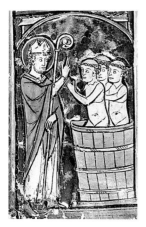

St Nicholas and the Three Children
Book of Hours, c.1250.
Bibliothèque de Carpentras,
Vaucluse.

NICHOLAS

Latin: Nicolaus; Italian: Nicola, Niccolo; Spanish: Nicholas; French: Nicolas, Colas, Colin; German: Nickolaus, Klaus.
Bishop of Myra. Fourth century (?). Feast day 6 December.

LIFE AND LEGEND

The life of Nicholas – one of the most popular saints in the calendar – belongs more to legend than reality. His cult, beginning in the Greek Church, became important in the east before spreading to Italy. His relics were translated to Bari in 1087 and from there his cult spread throughout western Europe. During the twelfth century, he was particularly celebrated in Italy, Lorraine, eastern France and Rhineland Germany.

Nicholas was born in Asia Minor around 270 and was named Bishop of Myra in Anatolia while still a young man. He suffered much for his faith until the accession of Emperor Constantine and the proclamation of Christianity as the official Imperial religion. His charisma and zealous assault on the Arian heresy made him an exceptional figure. He probably died in 343.

Two episodes from his rich legend stand out: his giving a dowry to three virgins, and the resurrection of three children thrown into a brine tub. Through association with the "Charity of St Martin", the first of these deeds is occasionally called the "Charity of St Nicholas". An impoverished nobleman is ready to prostitute his three daughters as no one will accept them in marriage without dowries. To save them from such a dishonourable fate, Nicholas, on three successive nights, throws each of them a bag full of gold through their window. More famous still is the story of the three children (or students or soldiers). During a famine, they craved hospitality of a butcher (or innkeeper), who slaughtered them, chopped them into pieces and "threw them into the brine-tub like suckling pigs" to serve them to his customers. Nicholas, by simply making the sign of the Cross, managed to reassemble the various pieces and resurrect the children.

Numerous other miracles were attributed to St Nicholas, mainly taking place at sea; he became the patron saint of seamen at an early date before

becoming that of travellers generally. He is also the patron of children, unbetrothed virgins, perfumiers (a pun on Myra and myrrh), apothecaries and of Russia. By the end of the eleventh century, his relics at Bari had become a recognized stop on the voyage to the Holy Land, and a pilgrimage to the shrine of St Nicholas was an important one in its own right. By the end of the middle ages, probably because of the gifts he offered to the three virgins and because his feast day is in December, St Nicholas had become the saint who gives presents at Christmas. He has retained that function and plays the role of Father Christmas (Santa Claus) throughout much of the Christian world.

REPRESENTATION AND ICONOGRAPHY

Nicholas is shown as a bishop in the prime of life, often carrying his crozier. His attributes are three money-bags and occasionally a ship's anchor. A child is often depicted kissing his hand. In the scene of the "Charity", he throws a money-bag through the window of the three virgins' room as they sleep together in a single bed. In the episode of the three children cast into the brine-tub, it is the miraculous resurrection which is the most often shown: one of the children climbs out of the tub to thank the saint, while the terrified butcher makes himself scarce (one variant of this is by Ambrogio Lorenzetti, 1332, Uffizi, Florence).

Other miracles are now and then to be found: St Nicholas as a baby refuses to suckle on Fridays (ivory crozier finial, twelfth century, Victoria and Albert Museum, London); Nicholas as patron saint of seamen calms a storm; Nicholas as Bishop of Myra saves the town from famine by miraculously drying and multiplying the sacks of wheat which had fallen into the sea.

Attributes: Bishop's crozier. Three money-bags. Ship's anchor.

NIMBUS

In Virgil, the word *nimbus* signifies a cloud surrounding a god. In Christian parlance, the nimbus or halo is a disk shown above or around a saint's head. It is the specific insignia of sainthood.

Cross-reference: Mandorla.

NINE HEROES

Variant: Nine Worthies. Italian: i Prodi; Spanish: los Nueve de la fama; French: les Neuf Pieux; German: die neun guten Helden.

TRADITION

This mythical body first appeared in courtly literature of the twelfth century. Paired with the Twelve Knights of Charlemagne, they gradually formed an instituted group. From the fourteenth century, they were equally famous in France and Germany and embodied knightly virtues. Membership varied greatly but, according to the version in Tommaso di Saluzzo's *Le Chevalier errant* (1394, Bibliothèque Nationale, Paris), they could be divided into three groups. Julius Caesar, Hector of Troy and Alexander the Great appear for pagan antiquity; Joshua, David and Judas Maccabeus for the Jewish period, and Charlemagne, King Arthur and Godefroi de Bouillon for the Christian world.

REPRESENTATION AND ICONOGRAPHY

The Nine Heroes are depicted as early as the fourteenth century (miniatures in Tommaso di Saluzzo, *Le Chevalier errant* (1394, Bibliothèque Nationale, Paris; *Tenture des Neuf Preux*, tapestry, c.1385, Cloisters, Metropolitan Museum of Art, New York; sculpture group, *Neun Helden*, Town Hall, Cologne; stained-glass window, Town Hall, Lüneburg).

Cross-references: David, Joshua, Judas Maccabeus.
Bibliography: F. Küsthardt, "Die neun guten Helden", *Zeitschrift des Vereins für Hamburgs Geschichte*, 7, 1883.

NOAH

Latin: Noe; Italian: Noè: Spanish and French: Noé; German: Noah.

TRADITION

Noah, the Patriarch and descendant of Seth, is the hero of the Flood (or Deluge) and hence one of the main characters in Genesis.

The Flood

Man has gone forth and multiplied over the face of the earth (Gen. 6:1). The Lord sees that "the wickedness of man was great" (6:5) and decides to wipe out all living things from the face of the earth for, he says, "it repenteth me that I have made them". Only Noah finds grace in his eyes, so the Lord commands him to build the Ark, a boat made of pitched gopher wood. This will safeguard him, his family, and one couple of each animal species from the waters which are to "destroy all flesh". Once the Ark is sealed, the "windows of heaven were opened" (7:11) and "all in whose nostrils was the breath of life, of all that was in the dry land, died" (7:22). But God remembered Noah and "made a wind pass over the earth and the waters asswaged" (8:1). After forty more days, Noah opened a window in the Ark and "sent forth a raven which went to and fro ... [and] he sent forth a dove ... and, lo, in her mouth was an olive branch" (8:7-11). At the end of the Flood, Noah emerges with his family and all the beasts "after their kinds" (8:16-19). Through his three sons, Shem, Ham and Japheth, Noah is the ancestor of postdiluvian man.

Noah: the Flood
End of the eleventh century (detail). St Mark's, Venice.

REPRESENTATION AND ICONOGRAPHY

Throughout history, Noah has been depicted in the same guise: as an old man with a long beard, he is the very epitome of the patriarch. Artists have concentrated their efforts on three main episodes.

The Construction of the Ark (Gen. 6:14-22)

In paleochristian and early medieval art, Noah's Ark is often depicted as a large chest, and then as a kind of houseboat; it is only during the middle ages proper and in the Renaissance that it becomes a real ship. The building of the Ark (Raphael, Logge, Vatican, 1518-19) and, even more often, the embarcation of the animals two by two are abundantly illustrated. The choice of species included is generally full of significance.

The Flood (Gen. 7:11-24; 8:1-13)

The Flood lasts for forty days and forty nights (Poussin, *Winter* or *The Flood*, 1660-64, Louvre, Paris; Uccello, *The Flood*, c.1445-7, S. Maria Novella, Florence, shows the beginning of the deluge, with people drowning and the Ark floating on the water). The retreat of the waters and the end of the Flood, however, are more often represented. Noah sends out first the raven and then the dove to ascertain whether or not the earth is habitable again. The raven reputedly chooses to feed on carrion and does not return to the Ark (this claim is in fact the result of a mistranslation), while the dove flies back with an olive branch in its beak. Medieval art produced many scenes depicting the contrasting behaviour of these two diametrically opposed birds.

Noah's Drunkenness (Gen. 9:20-27)

After the Flood, Noah not only resumes agriculture but also invents winegrowing. He plants the first vines and is the first man to drink intemperately. His drunkenness, not often depicted in the middle ages, became a favourite theme in the Renaissance and in the baroque. While he sleeps, drunk and naked, Ham tells his brothers about his misfortune. Shem and Japheth cover him with a "garment" for decency's sake, making sure that they do not look at him naked. Noah curses Ham, and traditionally his descendants are the enemies of God (the Egyptians, the Canaanites, etc.). Occasionally, a simple allegory showing the patriarch planting vines or picking grapes is substituted for a scene showing him drunk.

Attributes: Ark. Dove or olive branch. Raven. Beard. Vine.
Cross-reference: Creation.

NOLI ME TANGERE

Italian: Apparizione di Gesù risorto alla Maddalena; Spanish: Aparición a la Magdalena; French: Noli me tangere, Apparition du Christ à Marie Madeleine; German: Christus erscheint Maria Magdalena.

TRADITION

The appearance of Christ to Mary Magdalene is mentioned both by Mark (16:9) and John (20:14-18). Mark baldly states that after the Resurrection, Jesus "appeared first to Mary Magdalene out of whom he had cast seven devils". St John provides more ample details. Mary Magdalene remains alone near the tomb, weeping. In the sepulchre, she discovers "two angels in white sitting ... where the body of Jesus had lain". While she is replying to the angels who have asked her the reason for her wretchedness, she turns around and

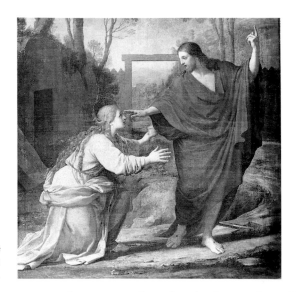

Noli me Tangere
Eustache Le Sueur, 1651
(detail). Louvre, Paris.

sees an unknown man whom she takes for a gardener. She asks him where she can find Jesus' body. The man then allows himself to be recognized as Jesus, and pronounces the enigmatic phrase, "Touch me not [*Noli me tangere*]".

REPRESENTATION AND ICONOGRAPHY

This Easter scene appears in ninth- and tenth-century manuscripts, inspired more or less directly by the Gospel of St John. The two angels are shown sitting near the empty tomb. Mary Magdalene turns round and chances upon Christ who steps back. Christ has a nimbus with a cross and wears a tunic and pallium. From the eleventh to the thirteenth centuries, illuminators depicted only two figures: Mary Magdalene and Jesus. Christ carried a standard emblazoned with the Cross, for he had conquered death. At the start of the fourteenth century, the banner can be inscribed with the words *Victor Mortis* and the angels reappear. The scene can also occasionally incorporate the visit of the women to the empty tomb. From the fifteenth century, stress is laid on the moment when Christ – shown as a gardener complete with spade – recoils from Mary Magdalene (Fra Angelico, 1438-45, Convento San Marco, Florence; Bronzino, 1561, Louvre, Paris). In the seventeenth and eighteenth centuries, Christ, his right hand pointing to heaven, carries neither standard nor spade (Rembrandt, c.1650, Herzog Anton Ulrich-Museum, Brunswick).

In the fifteenth century, a new theme appeared which was linked with a Provençal legend originating in a relic of Mary Magdalene's skull. Mary Magdalene kneels and Christ places two fingers on her head (Fra Bartolomeo, c.1506, Convento della Maddalena, Le Caldine; Le Sueur, 1651, Louvre, Paris).

Cross-references: Appearances of the Risen Christ, Holy Women at the Tomb, Mary Magdalene, Resurrection.
Bibliography: M. Ansett-Janssen, *Maria Magdalena in der abendlichen Kunst*, Frankfurt, 1961. L. Réau, op. cit., vol. II, 2.

NUMBERS

Numbers, whether as numerals written within the pictorial space, or in the form of an enumeration of personages, groups, objects or animals, can play a vital role in imagery. In this area, however, it is notoriously difficult to tell what is relevant from what is not, and one should avoid overstating their symbolism, which is as culturally and historically bound as that of colour, and should therefore be treated with caution.

Attitudes towards numbers changed radically in the Renaissance. Before this period, numerals were thought of as qualities rather than as quantities. Each number had its particular properties, its vices and virtues, its music, its own mythology. Numbers governed the world not only in conformity with mathematical laws, but also according to a divine rhythm. Hence ancient geometry was not the study of quantities and measurement so much as that of the harmony of forms, while astronomy examined less the distances between celestial bodies, their masses and temperatures than the rhythm of the universe itself. Numbers are always rhythm, proportion, harmony and music. In a theological perspective, numbers are supposed to reveal veiled truths.

In medieval imagery, numbers signified rhythm, order, distribution, symbolism, revelation and ontological truth unified. The particular symbolism of each numeral – or at least of the most important and most frequently cited in the Bible or by the Church Fathers, such as one, two, three, seven, twelve and forty – had to be clearly understood. As early as the paleochristian period, treatises began to be compiled which elucidated the symbolism of each numeral. During the Carolingian period, such works proliferated, becoming still more common during the golden age of numerology, the twelfth century. These often copied treatises according to a single principle: the "value" of each particular numeral was first stated according to dogma, before being verified by an examination of the passages in Scripture in which it appeared. As always in medieval thought, abstract speculations and concrete exampla were constantly mixed.

Three texts appear to lie at the source of many others: Boetius' *De arithmetica*, Augustine's *De musica* and the *Liber numerorum* of Isidore of Seville. The Book of Numbers was also frequently pressed into service, not so much because it was more concerned with numerical symbolism than any other book of the Bible, but simply because its very title (chosen merely because it contains two lists of the tribes of Israel) conferred upon it a certain authority in this area.

As a general rule, odd numbers were thought of as more sacred than even ones. Indivisible by two, and remaining odd even after the addition of an even number, they were supposed to be incorruptible and often symbolized perfection, purity, and (especially if they were also prime numbers) the eternal and the divine. On the other hand, even numbers, unambiguously divisible and hence less pure, referred to the created world – to humankind, to the earth, to everything which lacked perfection. Sometimes even numbers directly evoked sin, evil and death: in numerous texts, the wicked go in twos or fours, and the righteous in threes. One even number, however, was always seen in a good light: the number twelve. In reference to harmony, proportion and music, tertiary rhythm often suggested the idea of perfection, whereas binary rhythm that of imperfection.

Above and beyond the signification of each particular numeral, number

symbolism was based on a series of opposing pairs: one and multiple, integral and divided, odd and even, previous and subsequent. Whenever six represented labour, seven stood for the ensuing rest. If twelve was linked to the notion of completeness, eleven stood for incompleteness and thirteen for excess. Numbers begot other numbers, and the qualities associated with the first were often met with again in the second.

Symbolism of Selected Numerals

ONE: impossible to divide without destroying, the number one symbolizes God the Father. Certain theologians, echoing Aristotle, do not even consider it to be a real number.

TWO: the number of comparison, of symmetry, of opposition. It refers to the two Testaments and to the two-fold nature of Christ.

THREE: the medieval Christian number par excellence. Symbolizing the Trinity, the soul (made in the image of the Trinity) and of spiritual things in general (*see* Trinity). In the case of the Magi, three refers at once to the three ages of man and to the three regions of the then known world.

Trinity
A. Roublev, 1422-27.
Tretiakov Gallery, Moscow.

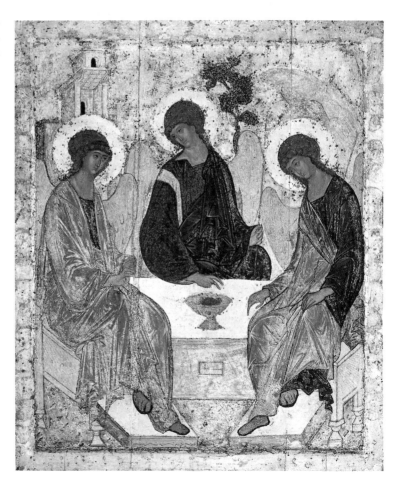

According to the Bible and to Christianity, three and four enjoy a close and incomparable relationship. Added together, they give seven, while multiplied, they make twelve. St Augustine, the father of medieval symbolism, considered that three referred to the soul or to the mind, and four to the body or to matter. Their sum or multiple designated the union of the soul and the body in man and in the universal Church, symbolized in turn by the twelve disciples.

FOUR: often the complement or the contrary of three. It evokes all that is earthly, human and mortal. On earth, we live by the number four; in heaven, by three. The four Evangelists and the four major prophets (Isaiah, Ezekiel, Daniel and Jeremiah) confront the Trinity. There exist four elements, four seasons, four humours or temperaments, and four cardinal points. Four, the number of the created world, is inevitably linked to death. The Cross may be associated with the Tetragrammaton.

SEVEN: the perfect, sacred and mysterious number, not only for medieval Christians, but also for the peoples of the Bible. Seven suggests harmony, perfection and a completed cycle, hence the abundance of groups of seven: not only the seven sacraments, seven gifts of the Holy Spirit (*see* Holy Spirit), Seven Sorrows of the Virgin, seven cardinal and seven theological virtues (*see* Virtues and Vices) and seven mortal sins, but also the seven planets of ancient astronomy, seven days of the week, seven ages of man, seven colours, seven liberal arts, etc. It is the number most often cited in the Bible (partikularly in Revelations) and by the Church Fathers, resulting in its frequent occurence in iconography.

EIGHT: seven plus one is the number of new beginnings, of renewal, of new life. It is often associated with baptism (hence the octagonal shape of early fonts) and with everything concerning the start of a new cycle (for example, the role of octaves in hagiographical cults and in music). Eight appears to be more important in Judaic than in Christian symbolism.

NINE: devoted to heaven and its angels, which are divied into nine hierarchics. It is a tripling of the number of the Trinity.

TWELVE: the product of three times four, twelve is the number of completeness, of fulfilled totality, and in this role it competes with seven. The number twelve is given enormous significance in the Bible and in Christianity. There are twelve tribes of Israel, twelve apostles, Jerusalem possesses twelve doors, just as there are twelve signs of the zodiac and months in the year. It is also the numeral most used in daily life: until the triumph of the decimal system, reckoning was always done in dozens or twenties.

FORTY: in the Bible, this is the number of expectation, of trials and of chastisement. The Flood lasts forty days and nights; Moses goes up to Sinai for forty days; Jesus fasts for forty days in the desert. Many kings (Saul, David and Solomon) are said to reign "forty years", meaning "for a long time", while the Jews spend forty years in the wilderness before gaining the Promised Land. Christianity has adopted this ancient symbolism in the observance of expectation or penitence. Lent lasts for forty days from Ash Wednesday to Easter (the Roman Church designation Quadragesima means forty) and the Ascension is another forty days later. In ancient societies, forty simply suggested a very considerable number – whether of days, distances, amounts of money or goods, men or animals.

St Odilia
Swiss School, sixteenth century. Musée des Beaux Arts, Dijon.

ODILIA

Variant: Ottilia. Latin, Italian and Spanish: Odilia; French: Odile; German: Ottila.
Benedictine abbess. Died c.720. Feast day 13 December.

LIFE AND LEGEND

The first version of the life of St Odilia dates from the beginning of the tenth century. The major part of her life is legendary. She was the daughter of a duke of Alsace, Adalric (also known as Etich or Hetticon) and was born blind. Her father rejected her and a serving-maid took her to the monastery of Balma (probably either Baume-les-Dames or Moyenmoutier, in Doubs). At her baptism administered by St Erhard (brother of St Hidulphus) her sight was suddenly restored. She was the first abbess of the convent of Hohenburg (known as Odilienburg), reputedly founded by her father, to whom she was reconciled and whom her prayers later delivered from Purgatory.

She died on 13 December at the beginning of the eighth century, without the last rites, but was resuscitated through the prayers of her sisters and received extreme unction from a chalice she had brought to her. She is the patron of the blind and of opticians. Since 1807, she has been the patron saint of Alsace.

REPRESENTATION AND ICONOGRAPHY

Odilia always appears in the habit of a Benedictine abbess, wearing a robe which, in remembrance of her legendary royal descent, is occasionally faced with ermine. This dress allows her to be differentiated from St Lucy. Her eyes are placed on a book which sometimes lies open (stained glass, thirteenth century, Strasbourg Cathedral). From the fourteenth century, her attribute can be a cockerel, presumed to announce the triumph of light over darkness (Michael Pacher, 1481, statue in the altarpiece at Sankt Wolfgang, Germany). A tapestry (c.1480, St Etienne, Strasbourg) shows her baptism at the hands of Bishop Erhard and an angel bringing her the last communion. The scene showing an angel saving Odilia's father's soul from the flames of Purgatory is a favourite one (portal, Church at Thann, fourteenth or fifteenth century).

Attributes: Abbess's crozier and robe (occasionally with ermine facing). Two eyes placed on a book. Cockerel (from the fourteenth century.
Cross-reference: Lucy.
Bibliography: M. Barth, *Die heilige Odilia, ihr Kult in Volk und Kirche*, Strasbourg, 2 vols.,1938. C. Champion, *Sainte Odile*, Paris, 1930.

OLAF

Norwegian: Olav(e); Latin: Olavus; Italian: Olao; French and German: Olaf.
King. c.990-1030. Feast day 29 July.

LIFE AND LEGEND

For two centuries, bands of Norman brigands undertook raids on the French coast. Olaf, the son of King Harald, had joined them, but converted to Christianity around 1008 when at Rouen. He was king of Norway from 1015 to his death and struggled to complete the evangelization of his country. A revolt nourished by Cnut drove him out of Norway. He died at the battle of Stiklestad on 31 August 1030 while trying to win back his kingdom. Though

particularly bloodthirsty and dissipated, Olaf of Norway's heroic death has made him a national martyr. He is the national hero of Norway, and is also venerated in Sweden, where he is the patron of Uppsala.

REPRESENTATION AND ICONOGRAPHY

Olaf is depicted wearing a royal crown and either an open mantle or a breast-plate. He often carries a battleaxe (Olaf Altar, Trondheim Church, beginning of the fourteenth century, Statens Museum for Kunst, Copenhagen). He tramples on a human-headed dragon, symbolizing his defeat of paganism (wooden statue, 1470, St Annen Museum, Lübeck). He also holds a hanap (lidded goblet), alluding either to his taste for strong liquor or to a miracle in which water is said to have been turned into wine or beer.

Attributes: King's crown. Open mantle or breastplate. Battleaxe. Hanap (lidded goblet). Dragon with a human head.
Bibliography: Frederik B. Wallem, *Iconographia Sancti Olavi*, ed. Larsen, 1947.

OLIVE BRANCH or TREE see ANNUNCIATION, CLARE, NOAH.

OX

The bull, symbol of strength and fertility in all ancient religions, was replaced in Christian iconography by the hard-working and self-sacrificing ox. The ox is the attribute of St Luke the Evangelist and by the sixth century is found in the stable warming the baby Jesus with its breath (the Gospels make no mention of any animals). The Golden Calf worshipped by the Hebrews (Ex. 32:1 6) can also be depicted as an ox or a bull.

Cross-references: Blandina (martyr tossed by bull), Evangelists, Golden Calf, Luke, Magi, Moses (Golden Calf), Nativity, Perpetua (tossed by heifer), Tetramorph.

St Olaf
Thirteenth century. Church at Vallö, Denmark.

PALM SUNDAY *see* ENTRY INTO JERUSALEM.

PANTOCRATOR

Italian: Pantocratore; French: Pantocrator; German: Pantokrator.

TRADITION
Pantocrator is a specifically Byzantine term which initially meant the omnipotent, almighty God. Later, the word began to designate God as the one who kept alive and controlled all things. In patristic literature, the Pantocrator is the subject of theological amplification.

REPRESENTATION AND ICONOGRAPHY
The most widespread type of Pantocrator depicts a half-length, bearded Christ with long hair. His right hand extends in blessing and his left holds a book. This type appeared on coins from Justinian II (565-78) with the epigraph *Rex regnantium*. From the eleventh century, this variant of the Pantocrator, complete with an inscription identifying him, became increasingly common. Christ could be represented full-length, though he remained half-length when figuring on the dome of an edifice or, more rarely, at the apse (St Sophia, Kiev, eleventh century; Daphni, Greece). The half-length Pantocrator also occurred on icons. The exact definition of the Pantocrator is a difficult question which remains open.

Cross-references: Christ Emmanuel, Christ in Majesty.
Bibliography: L. Réau, op. cit., vol. II, p. 39. E. Kirschbaum, *Lexikon der christlichen Ikonographie*, Freiburg im Breisgau, 1968-74, vol. III, col. 393.

PARABLES *see* GOOD SAMARITAN, WISE AND FOOLISH VIRGINS, WOMAN OF SAMARIA, WOMAN TAKEN IN ADULTERY.

PARADISE

Italian: Paradiso; Spanish: Paraiso; French: Paradis; German: Paradies.

TRADITION
The Greek *paradeisos* comes from the Persian *pardes* and designates an enclosed garden. The Book of Genesis (2:8-9) describes the garden planted by God "eastward" in Eden with, in the middle, the tree of life and the "tree of knowledge of good and evil". The garden is full of flowers and fruit, and water is plentiful thanks to a river which "went out of Eden to water the garden [and] parted ... into four heads" (2:10).

Apocalyptic literature locates Paradise not on earth, but in heaven. It is related to the promised exaltation of Jerusalem at the end of the world and designates in Revelations the New Jerusalem (21, 22). For the Fathers of the Church, Paradise, as the abode of the blessed, is a place filled with light and grace. From the fourteenth century, Dante's *Divine Comedy* was a crucial influence on the image of Paradise.

St Michael Slaying the Demon. Raphael, 1518. Louvre, Paris.

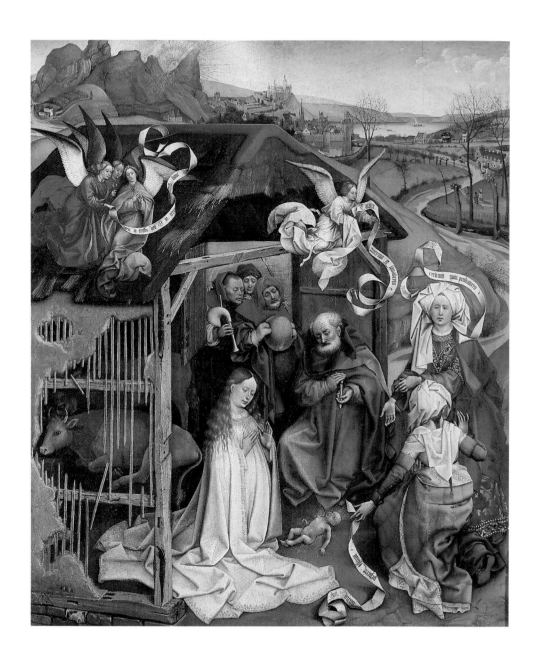

The Nativity. Master of Flémalle (Robert Campin), first half of the fifteenth century. Musée des Beaux Arts, Dijon.

Earthly Paradise
Limbourg Brothers. *Les Très Riches Heures du Duc de Berry*, c.1413. Musée Condé, Chantilly.

REPRESENTATION AND ICONOGRAPHY

In paleochristian art, the Earthly Paradise is a flowery garden, full of birds (catacomb of Domitilla, Rome) and is treated in a bucolic spirit. It is often linked with the theme of the Good Shepherd, while the occasional palm tree recalls the motif's Persian origins. In the fourth or fifth century, in connection with a passage in Revelations (14:1), a new interpretation appears: the Lamb of God stands on a mountain from which flow the four rivers of Paradise. At the apse of SS. Cosmas and Damian in Rome (sixth century), the composition is dominated by the figure of Christ surrounded by his saints. Around Jesus stretches a plain with palm trees and flowers, while stags drink at the waters of life. In a succession of horizontal bands above lies a sky speckled with stars. The garden of Eden can be placed next to the heavenly city of Revelations with its walls of gold and gemstones (S. Pudenziana, Rome, sixth century).

In the middle ages, Paradise is linked with various theophanic themes, such as the Coronation of the Virgin placed at the centre of the hierarchy of heaven. Celestial Paradise is represented by the host of angels, together with the prophets and the patriarchs (archivolt, north door, Chartres Cathedral, thirteenth century). Stephan Lochner shows the cohorts of the blessed proceeding towards the heavenly city (c.1438-40, Wallraf-Richartz Museum, Cologne). The blessed can also be shown in Abraham's bosom, another symbol of Paradise (Cathedrals of Chartres, Reims and Bamberg). At the end of the medieval period, the Earthly Paradise is walled and in the centre stands a Gothic fountain, built over the spring from which flow the four rivers (Limbourg Brothers, *Très Riches Heures du Duc de Berry*, after 1413, Musée Condé, Chantilly). From the sixteenth century, the symbolic aspect wanes as the picturesque takes precedence. Tintoretto painted a massive canvas on the subject, with Christ and the Virgin Mary at the centre of a composition filled with people (after 1579, Sala del Maggior Consiglio, Palazzo Ducale, Venice). Bosch depicts a *Garden of Delights* flanked by *Paradise* on the one

side and *Hell* on the other (first quarter of the sixteenth century, Prado, Madrid).

Cross-references: Abraham, Adam and Eve, Coronation of the Virgin, Hell, Last Judgment, Revelations.
Bibliography: R. Hughes, *Heaven and Hell in Western Art*, London, 1968.

PAROUSIA *see* ASCENSION.

PASSION OF CHRIST *see* AGONY IN THE GARDEN, ARREST OF CHRIST, CHRIST MOCKED, CROWNING WITH THORNS, CRUCIFIXION, ECCE HOMO, ENTOMBMENT, NOLI ME TANGERE, TRIAL OF JESUS.

PASSOVER

Greek: Paskha; Italian: Pasqua dei Ebrei; Spanish: Pascua; French: Pâque; German: Passah.
The Passover, the most important Jewish festival, commemorates the foundation of the people of Israel when the Hebrews left Egypt in the Exodus (*see* Exodus). Each Jew had to go once a year on a pilgrimage to Jerusalem.

Cross-references: Exodus, Plagues of Egypt.

PASTRIX BONA

Variants: Divina Pastrix, Divine Shepherdess. French: Vierge pastourelle.

In the baroque, the Virgin Mary is occasionally depicted as a shepherdess, like a female equivalent of the Good Shepherd (eighteenth-century painting in Sankt Wolfgang am Lech, Germany). A streak of lightning springs from the heart of the richly dressed shepherdess as she smites a monstrous wolf on the head. She blesses a lamb with her right hand.

Cross-references: Genevieve, Good Shepherd, Joan of Arc, Mary.
Bibliography: E. Kirschbaum, *Lexikon der christlichen Ikonographie,* Freiburg im Breisgau, 1968-74, vol. II, cols. 293 and 298. "La Virgen como pastora", Archivo español de Arte, 1957, vol. XXX, pp. 242-45.

PATRIARCHS *see* ABRAHAM, ISAAC, JACOB, LOT.

PATRICK

Latin and German: Patricius; Italian: Patrizio; Spanish: Patricio; French: Patrick, Patrice.
Bishop. c.390-c.463. Feast day 17 March.

LIFE AND LEGEND
The life of St Patrick is known from a limited number of authentic documents

on which have been embroidered numerous legends. Born in Britain, Patrick was the son of a *dicurio*, a town official, who was also a deacon and whose father had been a priest. Captured by Irish pirates in his youth, Patrick spent six years in slavery. He managed to escape and was reunited with his family. He succeeded Palladius – the first evangelizer of Ireland – and continued his good work in that country, establishing the Christian community and giving particular place to monasticism.

His legend, circulated in a number of lives composed at various periods, is an abundant one. It credits him with being the first real apostle of Ireland. As a miracle-worker, St Patrick, armed with a stick, expelled the snakes which had infested Ireland until his arrival. He used his emblem, the three-leaved shamrock, to explain to the Irish the mystery of the Trinity: the plant has become the national emblem of Ireland. At the Last Judgment, Patrick will lead the Irish to the place of judgment. He is invoked against the torments of Purgatory and of Hell because one day, to convert certain unbelievers, he dug a hole from which streamed forth the flames of Purgatory. He is the patron of Ireland and of the anguished souls of Purgatory.

REPRESENTATION AND ICONOGRAPHY
The oldest images of St Patrick are two scenes appearing on a carved stone cross of King Flann (ninth or tenth century, Clonmacnoise, Ireland). In the middle ages, he is depicted as a bishop with mitre and crozier. The shamrock, which is his main attribute, probably developed out of the episcopal crozier. Patrick tramples a snake underfoot (stained glass, fifteenth century, Doddiscombsleigh Church, Devon); a snake twists around his crozier (stone relief from Faughant, fifteenth or sixteenth century, National Gallery of Ireland, Dublin). From the seventeenth century, Patrick is shown as a bearded bishop holding the shamrock. In a work by Tiepolo, he cures a paralyzed man, while a child carries his crozier (1746, Museo Civico, Padua). In the United States, a stained-glass window by H. Clark (twentieth century, St Patrick's Cathedral, New York) is an example of how widespread the cult of the apostle of Ireland has become.

Attributes: Shamrock. Snakes. Mitre. Bishop's crozier.
Bibliography: L. Gougaud, *Les Saints irlandais hors d'Irlande*, Liège, 1936. H. Morris, "The Iconography of St Patrick", *Down and Connor History Society's Journal*, 7, 1936, pp. 5-20.

St Patrick Exorcising Devils
Giambattista Tiepolo, 1746 (detail). Museo Civico, Padua.

PAUL (APOSTLE)

Latin and German: Paulus; Italian: Paolo; Spanish: Pablo; French: Paul.
Apostle of the Gentiles. c.10-64. Feast day 29 June, in conjunction with St Peter.

TRADITION
After Christ himself, St Paul is the second most important figure in the history of Christianity. His life is known to us through the Acts of the Apostles and through his own writings. He was born around AD 10, at Tarsus, in Asia Minor, into a Jewish family of Greek culture and, like his father, was a naturalized Roman citizen. His name was initially Saul, after the first king of Israel, but he changed it after his conversion out of humility (the Latin *paulus* means small).

To start with, it seems that Saul persecuted Christians and "consented

St Paul on the Road to Damascus
Woodcut from James of Voragine's *Golden Legend*, 1483 edition.

to the death" of the first martyr, St Stephen (Acts 8:1). One day, going from Jerusalem to Damascus, he was blinded by a glorious light and knocked off his horse. Christ addressed him, "Saul, Saul, why persecutest thou me?" (Acts 9:4). This meeting effected Paul's conversion and, cured of his temporary blindness, he was baptized at Damascus, becoming the most extraordinary missionary and zealot the new religion had produced.

After about three years of seclusion, Paul returned to Damascus, escaping from persecution by being let down in a basket over the city wall. He then went to Jerusalem where he met Peter and the disciples and, after an initial period of distrust, was accepted into the Christian community. The itinerary of his three missionary voyages is well known. They took him throughout Asia Minor to Cyprus and, in 50, to Greece, where he preached the gospel in the Areopage, though with little success. At length he arrived in Rome, there meeting with Barnabas and Luke the Evangelist. Paul preached above all to the Gentiles, that is to the non-Jews. His peripatetic apostolate lasted almost a quarter of a century. In 60, he once again joined Peter at Rome. Tradition states that they were both martyred during the persecutions of Nero, around 64: Paul, as a Roman citizen, had the privilege of being beheaded, while Peter was crucified like a slave.

Paul performed numerous miracles. During the voyage to Rome, his ship was wrecked on the coast of Malta. Paul, searching for dead wood to make a fire, encountered an adder which fastened itself to his arm. The apostle was unharmed, however, and threw the animal into the fire (Acts 28:3-5). The apocryphal *Visio sancti Pauli* narrates the legend of his descent into Hell, the prototype both of St Patrick's Purgatory and of the voyage of St Brendan.

Paul is considered to be the founder of the Universal Church since he not only took the Gospel to all corners of the Graeco-Roman world, but also separated Christianity once and for all from Judaism. Although he never knew Jesus, he is nonetheless called an apostle. His cult has always been linked to that of St Peter and numerous churches are dedicated simultaneously to both saints. In isolation, Paul is not a particularly popular saint. The Reformation stressed his importance because he preached the justification of human acts through grace (one of its main tenets), and was through this position opposed to St Peter; as a result, he became less popular among Catholics. Paul is the patron saint of missionaries, of wicker-workers and of ropemakers. After St Peter, he is the second patron of Rome.

REPRESENTATION AND ICONOGRAPHY

Although Paul played a major role in the spread of Christianity, his iconography is relatively limited, especially if compared to that of St Peter. Nonetheless, his is a rare example of a physical type which has remained unchanged from early medieval times. He is usually small in stature, misshapen and bald, with a long beard and a domed forehead (mosaic in the Mausoleum of Galla Placidia, Rome, sixth century). A different tradition, derived from the Acts of the Apostles, however, depicts a vigorous man, wearing a trimmed beard, similar in appearance to St Peter himself. From the thirteenth century, his traditional attribute has been the sword, the instrument of his martyrdom. In primitive Christian art, he carries a book or parchment scroll like the Evangelists.

When he is associated with St Peter, the latter has pride of place, to the right. Dürer, a Protestant, however, put Paul to the fore (*The Apostles*, 1526, Alte Pinakothek, Munich). Paul also appears as an Evangelist, writing his

Epistles. He can also appear teaching (Lucas van Leyden, Last Judgment trip-
tych, 1526-7, Stedelijk Museum, Leiden, with ships in the background). All
the episodes of his life and his travels have been illustrated (frescoes, late
twelfth century, St Anselm Chapel, Canterbury Cathedral; Sir James
Thornhill, grisaille, 1716-19, dome of St Paul's Cathedral, London). During
the stoning of St Stephen, it is Paul (Saul) who guards the pile of clothes of
those responsible (tympanum, Cathedral of St Etienne, Bourges, thir-
teenth century).

The Conversion on the Road to Damascus (Acts 9: 3-9)
Saul, when he meets Christ, is on foot (mosaic, Cappella Palatina, Palermo)
or still on his horse, or unsaddled (Moretto da Brescia, late sixteenth century,
S. Maria presso S. Celso, Milan; Parmigianino, c.1520-30s, Kunsthistorisches
Museum, Vienna). Unseated, he lies on his back next to his dappled horse
(Caravaggio, 1601, S. Maria del Popolo, Rome; T. Zuccaro, c.1593, S. Marcello
al Corso, Rome). He is blinded by a radiant beam which symbolizes both the
divine light and the voice of Christ. Often, the Christ persecuted by Saul
appears in the clouds above in the guise of the Redeemer with the Cross.

The Escape from Damascus (Acts 9:25)
As Paul was in the Synagogue, preaching that Christ was the Messiah, the
Jews tried to take him captive. He escaped over the city walls in a basket
(Paulian mosaics, thirteenth century, Monreale, Sicily). This scene is asso-
ciated with Virgil hanging in a basket. Similarly, in Jericho, the prostitute
Rahab had let the two spies sent by Joshua escape in a basket on the end of
a rope.

Paul's Preaching in Athens (Acts 17:16-17)
Paul is shown preaching at both Athens and Ephesus (Raphael, cartoon, 1515,
Victoria and Albert Museum, London).

Paul's Miracles
Paul blinds the sorcerer Elymas (Acts 13:8-11); he cures a cripple at Lystra (Acts
15:8-10); he survives an encounter with an adder (Acts 28:3-5).

The Beheading of Paul
His blindfolded head bounced three times on the earth and brought forth
three fountains (the Tre Fontane in Rome). The execution appears on a low-
relief in Catalonia (Church at Ripoll, twelfth century). Paintings by Holbein
the Elder (1503-4, Städtische Gemäldegalerie, Augsburg), de Vos (1648,
Koninklijk Museum voor Schone Kunsten, Antwerp) and a sculpture by
Algardi (1641-7, S. Paolo, Bologna), among others, treat of the subject.

The "Mystic Mill"
Paul leans over to gather up the flour ground from grain that the Prophets
pour into the mill (capital, twelfth century, Basilica at Vézelay). The episode
is a commentary on a text by the Abbé Suger of St Denis, who also stated that
he made a stained-glass window on the theme.

Reformation art added to these themes scenes of Paul's ecstacies and visions,
called the "Rapture of Paul to the Third Heaven", a motif close to that of the
Ascension (Poussin, 1649-50, Louvre, Paris).

Attributes: Book or rotulus (scroll). Sword (of martyrdom, from the thirteenth
century). Three fountainheads or springs.

Cross-references: Apostles, Barnabas, Luke, Peter, Stephen.
Bibliography: E. Mâle, "Les apôtres Pierre et Paul", *Revue des Deux Mondes,*
1955. I. Pandurski, *Die Heiligen Apostelfürsten Peter und Paulus im Gottesdienst
und in der Ikonographi*e, Sofia, 1952.

PAUL (THE FIRST HERMIT)

**St Paul the Hermit and
St Antony the Great**
Dürer, c.1502. Bibliothèque
Nationale, Paris.

Variant: Paul of Thebes; Latin: Paulus Thebaeus; Italian: Paolo primo Eremita;
Pablo primer Ermitaño; French: Paul Ermite; German: Paulus von Theban.
Hermit. c.229-342. Feast day 15 January.

LIFE AND LEGEND

Considered as the first Christian hermit, Paul was born in Thebes, in Upper
Egypt, supposedly in 229 and died in 342, after a life of total seclusion, in
the desert whence he had retired to escape the persecutions of Emperor
Decius. His legendary life was composed by St Jerome and is very like that
of Antony of Egypt. Indeed, the most momentous episode of Paul's life is the
visit he receives from Antony in the Theban desert. Antony, having
dreamed of an anchorite who had preceded him in his retreat into the wilder-
ness, desired to make his acquaintance and, guided by a centaur and a satyr,
managed to find Paul's cell in the shade of a palm tree. Initially distrustful,
in the end Paul received him, even sharing his frugal meal with the illustrious
visitor. He informed Antony that, for sixty years, a raven had always brought
him a day's ration of half a loaf of bread. That very day, the raven brought
a whole loaf which the two hermits shared fraternally (some versions talk
of an initial half-loaf, followed by a miraculous doubling of the ration). They
remained for some time in each other's company, but then Antony bade
farewell to his friend. On his way home, he saw a pair of angels carrying off
Paul's soul. He turned back to find Paul's lifeless body in an attitude of prayer.
Two lions made their appearance and helped Antony dig a grave for the first
hermit. He had apparently lived in the desert for ninety-nine years.

REPRESENTATION AND ICONOGRAPHY

Paul the Hermit is always shown as a very old man, dressed in a tunic of palm
leaves sewn together. From the thirteenth century, the visit by Antony and
the breaking of the bread is the most common scene. Both saints lean on a
tau cross. Paul's cult and imagery are more frequent in central and eastern
Europe than in the west, and are particularly strong in Hungary.

Antony's visit to Paul

Stress is laid on the raven who brings the bread. The eucharistic symbolism
of the scene can be underlined by an inscription such as *"Paulus et
Antonius fregerunt panem in deserto* [Paul and Antony broke bread in the
desert]", as on the Ruthwell Cross, Northumbria, c.700. Velasquez also painted
the two hermits (1642, Prado, Madrid).

The Burial of Paul

The two lions dig a hole in the sand as Antony looks on. The corpse is
wrapped in strips of cloth (capital, Basilica of Vézelay, twelfth century).

Attributes: Palm tree. Raven. Two lions.
Cross-references: Antony of Egypt, Jerome.

PEACOCK *see* BARBARA.

PELICAN

The pelican swallows the fish it catches in its throat pouch, and then feeds its young ones by regurgitating the half-digested food. On this observation, the *Physiologus* (second or third century) embroidered a fabulous story which was taken up by medieval bestiaries. One day, the father pelican was looking after his fledglings when they started assailing him with such vigour that they caused him pain. He retaliated, killing them. The mother bird returned after a further three days and, stabbing herself in the breast with her beak, poured her blood over her dead babies, which soon revived. The bestiaries explained the parallel with Christ, who gave his blood at the Passion to save humanity. The texts refer to Isaiah 1:2: "I have nourished and brought up children, and they have rebelled against me", and the Psalm 102:6: "I am like the pelican of the wilderness".

Pelican
Detail from the tabernacle in Church of Blondefontaine, Haute-Saône.

PEN *see* ALBERT THE GREAT (DOMINICAN), ANSELM, MARK (WITH LION).

PENTECOST

Greek: Pneumatos parousia, Pentekoste; Latin: Adventus Spiritus Sancti; Italian: Discesa dello Spirito Santo; Spanish: la Pentecoste; French: la Pentecôte; German: die Ausgiessung (Herabkunft) des Heiligen Geistes, Pfingsten.
Feast day 50th day after Easter.

TRADITION

The narrative concerning the descent of the Holy Spirit, celebrated at Pentecost, is contained in the Acts of the Apostles (2:1-13): "When the day of Pentecost was fully come, they were all with one accord in one place. And suddenly there came a sound from heaven as of a rushing mighty wind, and it filled the house where they were sitting. And there appeared unto them cloven tongues like as of fire and it sat upon each of them. And they were all filled with the Holy Ghost, and began to speak in other tongues, as the Spirit gave them utterance." This event is presented as the realization of a First Testament prophecy: "And it shall come to pass afterward, that I will pour out my spirit upon all flesh; and your sons and daughters shall prophesy" (Joel 2:28).

As early as the paleochristian period, the descent of the Holy Spirit (associated with the Ascension until the fourth century) was celebrated fifty days after Easter at Pentecost (from the Greek *pentekoste*, fiftieth). It at once marks the birth of the Church and the gift of the Holy Spirit to all peoples. This collective apostolic feast was celebrated with particular splendour at St Sernin in Toulouse where some relics of the *collegium* of the apostles were preserved.

Pentecost
El Greco, 1605-6. Prado, Madrid.

REPRESENTATION AND ICONOGRAPHY

The great majority of images depicting Pentecost illustrate the first three verses of the second chapter of the Acts of the Apostles. The apostles "all with one accord in one place" receive the Holy Spirit descending from heaven in "cloven tongues like as of fire" on their heads. Before the fifteenth century, artists avoided placing this scene in any definable place, but later an archi-

tectural frame appeared around the apostles.

The gift of the Spirit is generally represented by tongues of fire raining down from the beak of the dove of the Holy Spirit. When these tongues of fire number seven, they signify the seven gifts of the Spirit. Occasionally, the dove is replaced by the Hand of God from the outstretched fingers of which the Holy Spirit emanates. In the middle ages, the apostles are often arranged side by side, in single or double file. From the twelfth century, first Peter, then Mary, occupy a privileged position in the middle of the group.

Mary at the Centre of the Apostles

This type evolves from a passage in Acts (1:14) which states that the apostles were grouped together in the Upper Room in Jerusalem where, in the company of the Virgin, they were absorbed in prayer. Hence Mary, though she does not appear in the passage in Acts 2 covering Pentecost, can nonetheless be found in illustrations. The Virgin is enthroned in majesty and her honorific presence corresponds to the tradition which makes her the personification of the Church itself. Examples of this type, relatively common even in the sixth century, became increasingly frequent from the twelfth (relief, end eleventh century, cloister of San Domingo de Silos, Burgos, Spain; large stained-glass window, c.1300, Cologne Cathedral). The motif became widespread in painting in the fifteenth and sixteenth centuries, but rarer in the seventeenth (El Greco, 1605-10, Prado, Madrid).

Peter at the Centre of the Apostles

This type is common above all during the early middle ages. Here, too, it is the birth of the Church which is underlined, with the effusion of the Holy Spirit, and St Peter's prediction as recorded in Acts (2:14:36).

In other scenes, both Peter and Paul can be placed to the fore, or even Christ himself: in certain versions he is shown in heaven blessing the apostles, and sending down the rays of the Holy Spirit. From the fifteenth century, Pentecost is also linked to the Holy Trinity: God the Father and Christ appear in a brilliant cloud hovering above Mary and the apostles.

These arrangements were inspired by theological speculations stressing the foundation of the Church and the apostles' mission, or the identification of Mary with the Church (under the increasing influence of the Marian cult in the second half of the middle ages), or the descent of the Holy Spirit itself and preaching to all people. From the tenth century, Byzantine manuscripts represent this last aspect in the guise of the *Kosmos*, the World, symbolized by a group of figures under arms or by a crowned monarch. The king, standing before the door to the *cenaculum* (Upper Room), holds in his hands a veil on which lie twelve parchment scrolls corresponding to the twelve apostles and to their various missions.

Cross-references: Apostles, Hand of God, Holy Spirit, Mary, Peter, Trinity.
Bibliography: G. Schiller, *Ikonographie der christlichen Kunst*, 1976, vol. IV, 1. S. Seeliger, *Pfingsten*, Düsseldorf, 1958.

PERPETUA AND FELICITY

St Perpetua
Joseph Félon, nineteenth century. West front, St Perpétue, Nîmes.

Latin: Perpetua et Felicitas; Italian: Perpetua e Felicità; French: Perpétue et Félicité.
Martyrs. Died 203. Feast 7 March.

LIFE AND LEGEND

Perpetua was arrested with her six-month-old son during the persecutions of Septimius Severus in Carthage. Her father was a wealthy man, resolutely opposed to Christianity. Perpetua's companions were a pregnant slave-girl, Felicity, her husband, and two other catechumens. Perpetua's father visited her in the house where she was at first incarcerated, but his remonstrations were unheeded. The narrative concerning these saints is partly comprised of the martyrs' own words, written before their death and finished later anonymously. Perpetua was thrown to the beasts, tossed aloft by an enraged heifer but, in ecstasy, did not even realize what was happening. She even assisted the gladiator ordered to cut her throat. Perpetua is the patron saint of nursing mothers: condemned to death, she asked mercy of the judge, not for herself, but for her baby.

REPRESENTATION AND ICONOGRAPHY

Perpetua figures among the virgins on the mosaic at S. Apollinare Nuovo at Ravenna (sixth century). On a frontal (fourteenth-century altar, Cathedral Museum, Barcelona), seven scenes from Perpetua's life surround an image of the saint: her confession of faith; her arrest; the visit of her parents to the prison; the vision of a heavenly ladder; the interrogation; the tortures; the argument with her father; her martyrdom.

Attributes: Cow, heifer or bull. ,

PETER

Latin: Petrus; Italian: Pietro; Spanish: Pedro; French: Pierre; German: Petrus, Peter.

Apostle. First bishop of Rome. Died 64 or 67. Feast days 29 June (date of his crucifixion and the beheading of St Paul), 22 February (commemorating Peter's ecclesiastical primacy), 18 November.

TRADITION

In spite of his considerable importance for the foundation of the Church, St Peter's life, if compared for example with St Paul's, remains obscure and legend plays an important role. Fishermen on the Sea of Galilee, Peter and his brother Andrew were the first two disciples called by Jesus. Initially called Simon, he received from Jesus the name Peter (Aramaic *Cepha* or Latin *Petrus*, rock) as a sign of the founding role he was to play in the construction of the Church.

Until the Ascension, Peter's life was closely linked to that of Jesus. He was present at all the important events, notably at the Passion. After Pentecost, Peter's apostolate took him to Palestine and Asia Minor where he performed numerous miracles and obtained many conversions. As head of the earliest Christian community in Jerusalem, he was imprisoned by Herod, but set free by an angel. Traditionally in the year 44 (but it might have been earlier), Peter left for Rome, where he remained until his death, preaching, drawing together Christ's disciples and organizing the Church of Rome, of which he was the first bishop. His death is placed either in 64 or 67, on the same day as that of Paul, during one of Nero's great anti-Christian persecutions. Peter was crucified and apocryphal writings recount that, thinking himself unworthy to suffer the same fate as Jesus, he asked to be nailed to the cross upside down.

Archeological and historical criticism has repeatedly questioned the

St Peter
Stained glass, 1220-25.
Cathedral, Bourges.

length of Peter's stay in Rome and the form of his martyrdom. It is true that the Acts of the Apostles make no mention of either event, and much concerning that part of Peter's life is subject to caution. Nonetheless, from an early period, the legends were endorsed by both faith and tradition. At the time when Jesus started his public life, Simon Peter was already married and had left his birthplace at Bethsaida in Galilee to live in Capernaum. Jesus called Peter and his brother Andrew to follow him as they were about to cast their nets (Matt. 4: 19-20; Mark 1:16-18). With his brother and the two sons of Zebedee, James and John, Peter was one of the disciples closest to Christ. Within the group of twelve, he played a dominant role. His profession of faith: "And Simon Peter answered and said, Thou art the Christ, the Son of the living God" (Matt. 16:16) can be compared in importance to the new name Jesus gave him: "And I say also unto thee, Thou art Peter, and upon this rock I will build my church ... And I will give you the keys of the kingdom of heaven" (Matt. 16:18-19). From that crucial event, a key – or a bunch of keys – became St Peter's characteristic attribute.

His privileged position is illustrated by the unheard-of boldness with which he asked Jesus to empower him to walk across the waters. After the feeding of the five thousand, Jesus frightened the disciples by coming towards them walking on the surface of the lake. Peter requested Jesus to prove to them that he was indeed Christ and not a ghost: "Lord if it be thou, bid me come unto thee on the water [and Peter] walked on the water" (Matt. 14:28). This episode was taken up in the legends of a number of Breton saints who are also supposed to have walked on water.

Peter is the main character in a number of other Gospel stories. He was present when the daughter of Jairus was miraculously healed (Mark 5:37; Luke 8:51) and at the Transfiguration (Matt. 17:1-9; Mark 9:1-7; Luke 9:28-36). He was also in the Garden during Christ's Agony (Matt. 26:36-46; Mark 14:33) and at his arrest (Matt. 26:51-53).

The denial of Peter (Matt. 26:69-75; Luke 22:54-62) has been illustrated and commented on at length. Jesus' famous prediction:"That this night, before the cock crow, thou shalt deny me thrice" (Matt. 26:34; John 13:38) is the reason for a cockerel as one of St Peter's attributes. After the Resurrection, as Christ appeared to the disciples on the shores of the Sea of Galilee, it was to Peter that Jesus repeatedly put the question: "Simon, son of Jonas, lovest thou me?" (John 21:15-17).

The Acts of the Apostles recount a series of incidents from the life of St Peter: his discourse at Pentecost (2:14-37); the restoring of a man born lame at the gate of the Temple (3:1-8); his imprisonment in the company of John (4:3); the death of Ananias and Sapphira (5:1-10); his shadow curing the sick (5:14-16, 48); his liberation from Herod's prison at the hands of an "angel of the Lord" (5:18-19); the curing of Aeneas (9:33-34); the resurrection of Tabitha (9:36-41); the baptism of Cornelius (10: 1-48).

Peter's *Acts*, an apocryphal text of the third century, narrates the story of his sea voyage to Rome. Thrown in to the Mamertine prison, he converted the two gaolers, Processus and Martinian, and baptized them with a spring he conjured up from the walls of the prison, a miracle which became extremely popular. As he was trying to escape from Rome, Peter encountered Christ on the Appian Way. Peter asked, "*Quo vadis, Domine?* [Whither goest thou, Master?]" and Christ replied, "To Rome, to be crucified anew."

Peter is at once one of the most important and popular of the saints. He is the "prince of the apostles", the representative of Christ on earth and the

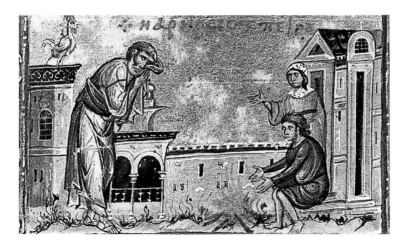

The Denial of St Peter
Codex, Biblioteca Palatina,
Parma.

guardian of heaven. From the earliest times, he has benefited from a universal and intense cult. His relics are to be met with all over Christendom, he is a very popular choice as patron, and the churches, particularly cathedrals, dedicated to him are innumerable.

REPRESENTATION AND ICONOGRAPHY

The earliest figurative representation of Peter is to be found on a fresco in the Chapel at Dura-Europos (c.245). From the fourth century, his appearance – elderly, but tall and well-built is remarkably constant. Unlike Paul, he has a short and bushy beard. Since the fifth century he has been shown tonsured (in remembrance of his status as the first priest), a detail deriving from apocryphal texts which state that he received tonsure while imprisoned in Rome. With his rather round head and his grey hair worn short and curly, Peter has all the ruggedness of a peasant. He can be depicted half- or full-length. By the thirteenth century, he is enthroned and dressed as a bishop or a pope.

At the end of the eleventh century he begins to appear in a series of double portraits with Paul (abbatial seals, statues, etc.), who can also be found in conjunction with other saints. In the fifth century, Peter and Paul had been shown flanking Christ as he hands the keys to the former. The theme continues throughout the middle ages in both the west and the east. In the Roman tradition, from the fifth to the thirteenth centuries, Peter stands to the left of Christ.

Among the scenes illustrating canonical texts, important ones are the vocation of the apostles, whom Jesus calls from the shores of the Sea of Galilee as they are casting their nets (mosaic in the Church of S. Apollinare Nuovo, sixth century) and the handing over of the keys of the kingdom of heaven. In the paleochristian period, Peter receives the keys with a veil lying over his hands. Traditionally, he has two keys, one for heaven, the other for the earth (Matt. 16:19). Other episodes often illustrated include the washing of the feet; his denial (Duccio, Maestà, 1308-11, Opera del Duomo, Siena; Jean Leclerc, 1620s, Galleria Corsini, Florence) and his repentance (El Greco, e.g. 1585-90, Bowes Museum, Bernard Castle, Durham, England; Georges de La Tour, 1645, Museum of Art, Cleveland, Ohio).

Peter is the embodiment of the New Law – the corollary of Moses, the incarnation of the Old. In his veiled hands, Peter, like a second Moses, receives from Christ the roll of parchment or the book of the New Testament, which does away with the Old. This theme had a long history and was often liked to the Transfiguration. Jesus stands on the mountain and presents Peter with the New Law, just as Moses received the Old on Mount Sinai. Paul raises his hands in acclamation.

The episodes which figure in the Acts of the Apostles – such as the baptism of Cornelius, the centurion (font, St Barthélemy, Liège, Belgium, twelfth century) – have been abundantly illustrated. Raphael dedicated a number of cartoons for tapestries for the Sistine Chapel to these scenes (*The Miraculous Draught of Fishes, The Handing of the Keys to St Peter, The Curing of the Lame Man, The Death of Ananias*, 1515, Victoria and Albert Museum, London).

From the period of his apostolate in the east, it is his Peter's miracles and his spells in prison which are most frequently depicted. The Roman episodes number the meeting with Paul; Peter's victory over the magician Simon, who tried to buy the secret of Peter's miracles (twelfth- and thirteenth-century Roman and Sicilian mosaics); Peter's period in the Mamertine prison and his conversion of the two gaolers; his miraculous escape from prison (Raphael, 1513-14, *Stanza d'Eliodoro*, Vatican; Hendryck van Steenwyck, 1621, Kunsthistorisches Museum, Vienna, where the prison is a kind of crypt; G.-B. Caracciolo, 1608-9, Church of the Monte della Misericordia, Naples); the meeting with Christ on the Appian Way as he tries to escape from Rome; and the crucifixion with his head facing downwards (Michelangelo, fresco, c.1540, Pauline Chapel, Vatican; Caravaggio, 1600-1, S. Maria del Popolo, Rome).

Attributes: Key(s). Cockerel. Inverted cross. Fishing boat. Net. Fish. Chains ("St Peter in Chains"). Papal tiara.

Cross-references: Andrew, Apostles, Appearances of the Risen Christ, Arrest of Christ, Mark, Multiplication of the Loaves and Fishes, Paul, Pentecost, Petronilla, Transfiguration.

Bibliography: H. Brinkmann, "Die Darstellung des Apostel Petrus", *Ikonographie-Studien zu der Graphik vom ausgehenden Mittelalter bis zur Renaissance*, Düsseldorf, 1936. E. Mâle, "Les apôtres Pierre et Paul", *Revue des Deux Mondes*, 1955; *Les Saints Compagnons du Christ*, Paris, 1958, pp. 87-123.

PETRONILLA

Latin: Petronilla, Petronella; French: Pétronille, Pernelle, Perette.
Martyr. First century. Feast day 31 May.

LIFE AND LEGEND

Sixth-century scholars elaborated a false etymology to transform an early Roman martyr, Petronilla, into the daughter of St Peter. According to various traditions, she was Peter's real, adopted or simply spiritual daughter. Like other Christian virgins, she caught the eye of a Roman leader, a certain Flaccus, who threatened to have her put to death if she resisted his advances. God then called her to his kingdom. For a long period, Petronilla was a patron saint of France, her relics having been placed in a chapel at St Peter's in Rome that had been vouchsafed to the kings of France since Carolingian times.

REPRESENTATION AND ICONOGRAPHY

Petronilla is represented as the companion of St Peter who is often shown

SS. Petronilla and Peter
Woodcut from James of
Voragine's *Golden Legend*,
1483 edition.

curing her of a fever, or as a Virgin of the Pietà (Michelangelo, 1499, St Peter's, Rome). Her burial is an occasional late theme (Guercino, 1622-3, Museo Capitolino, Rome).

Attribute: Keys (she is reputedly the daughter of St Peter).
Bibliography: E. Mâle, "Les chapelles de sainte Pétronille", *Rome et ses vieilles Eglises*, Paris, 1942.

PHIAL *see* JANUARIUS, REMIGIUS.

PHILIP

Greek: Philippos; Latin and German: Philippus; Italian: Filippo; Spanish: Felipe; French: Philippe.
Apostle and Martyr. First century. Feast day 3 May (since 1969; formerly 1 May).

TRADITION
Philip, from Bethsaida in Galilee, was one of the first disciples to follow Jesus. He probably started out as a devotee of St John the Baptist. It was at Philip's instigation that Nathanael (probably Bartholomew) joined the apostles. During the Multiplication of the Loaves and the Fishes, it was he that pointed out that no one could feed five thousand people with so little food. During Jesus' final speech, as reported by John, Philip asked to see God the Father himself but Jesus replied, "He that sees me, sees the Father" (John 14:11). At Pentecost, Philip was to be found with the other apostles (Acts 1:13).

St Philip
Woodcut from James of Voragine's *Golden Legend*, 1483 edition.

The remainder of his life is composed of various legends. Some pagans tried to force him to sacrifice to Mars, but a dragon emerged from beneath the statue's plinth and, with his poisonous breath, killed both the priest offering the sacrifice and two soldiers. Philip, filled with pity for these victims, exorcised the dragon (who disappeared) and raised the dead. The idol was smashed. Philip preached the Gospel in Phrygia and died at Hierapolis, first stoned, then crucified. He passed for being either the brother or the friend of Andrew; the two were the only apostles to have Greek names. Philip is the patron saint of hatters and pastry-cooks.

REPRESENTATION AND ICONOGRAPHY
In paleochristian and Byzantine art, Philip's appearance is no different from that of the other apostles. He is a young man, like St Thomas (mosaic medallion, S. Vitale, Ravenna, sixth century), but is often accompanied by the cross of his martyrdom. He occasionally carries loaves. From the medieval west through to the modern period, however, he is represented as a bearded apostle, often linked to St Andrew. Artists had a penchant for both the exorcism of the dragon and the crucifixion (Catalan retable with Philip and James the Less, fourteenth century, Museo de Arte de Catalunya, Barcelona). Often, when stress is laid upon his crucifixion, scenes from Philip's legend are confounded with that of St James the Less. Filippino Lippi dedicated a cycle to him (*Scenes from the lives of St Philip and St John the Evangelist*, 1503, Capella Strozzi, S. Maria Novella, Florence). He can be identified by his cross (El Greco, 1602-5, Toledo Cathedral).

Attributes: Cross or tree of the cross (since the thirteenth century). Loaves of bread. Dragon (or snake).

Cross-references: Andrew, Apostle, Multiplication of the Loaves and Fishes, Pentecost.
Bibliography: E. Mâle, *Les Saints Compagnons du Christ*, Paris, 1958.

PHILIP NERI

Latin: Philippus Nerius; Italian: Filippo Neri; Spanish: Felipe Neri; French: Philippe Neri; German: Philippus Neri.
Priest. Founder of the Congregation of the Oratory. 1515-95. Canonized 1622. Feast day 26 May.

LIFE AND LEGEND

Born in Florence in 1515, Philip Neri travelled to Rome in 1533. After following theological studies, he devoted himself to the care of pilgrims and of the sick. In 1548, he established the Confraternity of the Holy Trinity, which was designed to bring succour to pilgrims from foreign lands, before founding a pilgims' hospice. After entering into orders in 1551, Philip dedicated his life to the care and instruction of children, gathering round him several young priests who, because they stood on the squares in front of churches calling the faithful to prayer (Latin, *orare*), became known as the Oratorians. Philip Neri went on to form the Congregation of the Oratory whose statutes were approved by Pope Gregory XIII in 1575. The new society's guidelines might be compared to those of the Society of Jesus founded by Ignatius Loyola thirty years previously, but the Congregation's form was less rigid, being simply a grouping of churchmen linked by a common ideal of the priestly life – without particular vows and almost without community life – who strove simply to edify others by their piety and spread Christian culture.

Few legends surround his life, though he was renowned for his gaiety, perceptiveness and devotion, while his Confraternity is always associated with music (as in the term Oratorio). He was well-known for his ecstasies; once when he was sick the Virgin and Child appeared to him on a cloud.

REPRESENTATION AND ICONOGRAPHY

Philip Neri is always shown as an Oratorian, with black talar and biretta. He has a close-cropped beard and is occasionally shown holding a book inscribed with the passage from the Psalms beginning *Dilasti cor meum*. A portrait by F. Zuccaro (c.1593, Oratory, Bologna) is apparently a reasonable likeness. S. Maria in Vallicella, Rome, where he is buried, possesses a cycle of his life (Il Pomaranzio, before 1621) as well as one of the two ecstasies by Reni (early seventeenth century; the other is in the Chiesa Nuova).

Luca Giordano (1704, Hieronymite Church of S. Filippo Neri, Naples) composed an interesting work showing a meeting between Neri and Charles Borromeo with, in the foreground, angels together with workmen and masons symbolizing their work as founders.

Attributes: Biretta. Black talar.
Bibliography: G. Incisa della Rochetta, ed., "Contributo all'iconographia ..." in *Studi ... in onore di A. Petrucci*, 1969, Milan. E. Kirschbaum, *Lexikon der christlichen Ikonographie*, Freiburg im Breisgau, 1968-74, vol. VIII, cols. 207-8. L. Réau, op. cit., vol. III, iii, pp. 1027-73. M. Jouhandeau, *Life*, 1960.

PHILISTINES *see* DAVID, DELILAH, SAMSON.

PHOENIX

Latin: phoenix; Italian: fenice; Spanish: fénix; French: phénix; German: Phönix.

The phoenix is a mythical bird which dates from a very early period. Hesiod, the seventh-century BC Greek poet, compared the longevity of the phoenix (several thousand years) to the brevity of human life. Born in India, or Arabia, the phoenix is not unrelated to the sun as it was venerated in ancient Egypt, hence its bright plumage, which can be compared to that of the peacock. The tradition was further spread by Roman coinage, where the phoenix appeared to symbolize the Eternal Return. The interpretation offered by the Alexandrian *Physiologus* (second or third century AD) was adopted by medieval bestiaries and inspired countless artworks.

Every five hundred years, the phoenix set out from India towards the cedars of Lebanon. Once its feathers were impregnated with the scent of the trees, it flew to Egypt, and appeared to a priest of Heliopolis. There, in a place sacred to the sun god, it was immolated on an altar. The next day, a worm – or else a fledgling – emerged from the ashes of the offering. Three days later, the phoenix was reborn as an adult and returned to India. The *Physiologus* explained that the phoenix symbolized the death and Resurrection of Christ. It also incarnated the resurrection of the dead and eternal life in a fresco in the catacomb of Priscilla (third century, Rome).

PIETA *see* DEPOSITION.

PIG, PIGLET *see* ANTONY THE GREAT (HERMIT), BLAISE (BISHOP), PRODIGAL SON.

PILATE *see* ECCE HOMO, TRIAL OF JESUS.

PILGRIM

Italian: pellegrino, palmiero, romeo; Spanish: peregrino, romeo; French: pèlerin; German: Pilger, Wallfahrer.

The pilgrim wears a long surcoat with a hood ("pilgrim's hood"). From around the fourteenth century onwards, his headdress is a felt hat with a very broad rim. Various tokens signifying the ultimate destination of the pilgrimage are sewn on to this headwear: a scallop for those going to Santiago de Compostella, and overlapping crosses for those on their way to Rome. The flask – originally a gourd – is fastened to the pilgrim's belt and he carries a long staff or crook. He is also equipped with a scrip (bread bag) containing loaves and other provisions.
Type: James the Greater, Roch.

PILGRIMS OF EMMAUS

Italian: i Pelligrini di Emaus; Spanish: les Peregrinos de Emaus; French: les Pèlerins d'Emmaüs; German: Emmaüs Jünger.

TRADITION

The episode of the Pilgrims of Emmaus is cited in the Gospel according to St Luke (24:13-35). The "pilgrims" are two disciples, going "to a village called Emmaus". In the preceding verses, mention is made of the women discovering the empty sepulchre. On their way from Jerusalem to Emmaus, the two apostles discuss events. Christ Resurrected joins them on the road and asks to know the subject of their conversation. They talk of the death of "Jesus of Nazareth, which was a prophet mighty in deed", their immense sadness

The Pilgrims on the Road to Emmaus
Pieter Bruegel the Elder, after 1571. Bibliothèque Albert I, Brussels.

and their puzzlement at hearing of the empty tomb. Christ, having interpreted various passages of Scripture, accepts their offer of a meal. Then, "he took bread, and blessed it, and brake, and gave it to them [and] their eyes were opened and they knew him; and he vanished out of their sight" (24:30-31). The two apostles then return to Jerusalem to announce the Resurrection to the other disciples.

REPRESENTATION AND ICONOGRAPHY

The two episodes of the conversation and the meal are often treated as separate scenes.

The Way to Emmaus (Luke 24:13-28)

This episode appeared early in western art. The scene comprises three figures, Christ and the two disciples, often dressed as pilgrims (mosaics, S. Apollinare Nuovo, Ravenna, sixth century). This episode became less important in the middle ages (though it appears on the Royal Portal of Chartres Cathedral, thirteenth century). At the dawn of the Renaissance, the scene was presented in a landscape. Rembrandt restored the religiosity of the scene in a famous etching.

The Meal at Emmaus (Luke 24:29-31)

In the east, this meal evokes the Eucharist. In the medieval west, it was rarely depicted (stained glass, cathedral of Le Mans, thirteenth century). In the fifteenth and sixteenth centuries, however, the theme flourished, particularly in Spain and Flanders (Veronese, 1559-60, Louvre, Paris; Caravaggio, c.1600, National Gallery, London; Velasquez, 1620, Metropolitan Museum of Art, New York; Rubens, c.1630, Prado, Madrid). In the seventeenth century, the Flemish played with the constrast between the surrounding darkness and the startling brilliance of the candles. Rembrandt devoted more than one work to this theme (1628, Musée Jacquemart-André, Paris; 1648, Louvre, Paris).

Cross-references: Appearances of the Risen Christ, Noli me tangere.
Bibliography: L. Réau, op. cit., vol. II, 2, pp. 561-67. L. Rudrauf, *Le Repas d'Emmaüs*, Paris, 1955-6.

PINCERS *see* AGATHA (BREASTS), ELIGIUS (WITH DEMON).

St Antony visiting St Paul the Hermit in the Desert. Grünewald, Isenheim Altar, 1512-16. Musée d'Unterlinden, Colmar.

The Pilgrims of Emmaus. Rembrandt, 1648. Louvre, Paris.

PLAGUE *see* MOSES, PLAGUES OF EGYPT, ROCH, SEBASTIAN.

PLAGUES OF EGYPT

Italian: le dieci Piaghe d'Egitto; Spanish: las diez Palgas de Egipto; French: les dix Plaies d'Egypte; German: die zehn Aegyptischen Landesplagen.

TRADITION

The Ten Plagues of Egypt figure in Exodus, among the Lord's miracles designed to obtain the Pharoah's consent to allow the Hebrews to leave his kingdom (Ex. 7-11). They are the turning of the waters of the Nile to blood; the invasion of frogs in the apartments of the Pharaoh; Aaron turning "the dust of the earth" to "lice throughout all the land of Egypt"; "swarms of flies" covering the country; the death of Egypt's cattle; "handfuls of ashes of the furnace" being transformed by Moses into "boils" and "blains upon man and beast"; "very grievous" hail which destroys the crops; locusts that "cover the face of the earth, that one cannot be able to see the earth"; utter darkness; the death of all the firstborn in Egypt. At the final massacre, the Pharaoh resolves to let the Hebrews leave Egypt.

REPRESENTATION AND ICONOGRAPHY

It is unusual to find all ten plagues illustrated in a single image. In the more frequently depicted scenes, Moses raises his hand or his rod and a plague descends. In the seventh plague, he brandishes his rod and a huge quantity of enormous hailstones fall from the sky, devastating the earth, killing both man and beast. In the main, artists chose to represent the tenth plague, split into three separate episodes.

Passover (Ex. 12:8-11)
"And they shall eat the flesh in that night, roast with fire and unleavened

The Plagues of Egypt: the Passover
Dieric Bouts, *Last Supper* polyptych, 1468 (detail). St Pierre, Louvain, Belgium.

bread and with bitter herbs they shall eat ... And thus shall ye eat it; with your loins girded, your shoes on your feet, and your staff in your hand; and you shall eat it in haste: it is the Lord's passover". The Jewish Passover prefigures the Last Supper. Men and women hold the bones of the paschal lamb which they have gnawed clean but not broken, as prescribed by rite (Bernardino Luini, 1521-3, Brera, Milan).

The Blood of the Lamb Smeared on the Doors (Ex. 12:22-23)

"And ye shall take a bunch of hyssop, and dip it in the blood that is in the bason, and strike the lintel and the two side posts with the blood ... the Lord will pass over the door, and will not suffer the destroyer to come in unto your houses to smite you." Christian tradition sees in this T-shaped sign inscribed on the Hebrews' doors a prefiguration of the Cross. The theme was illustrated particularly by goldsmiths and enamel-workers from the Moselle region (Nicolas of Verdun, 1181, Klosterneuberg altarpiece, Klosterneuberg Stiftsmuseum, Austria).

The Extermination of the Firstborn in Egypt (Ex. 12:29)

"At midnight, the Lord smote all the firstborn in the land of Egypt, from the firstborn of Pharoah that sat on his throne unto the firstborn of the captive that was in the dungeon; and the firstborn of cattle". This massacre, a prefiguration of the Massacre of the Innocents, also announces the Descent of Christ into Limbo (or Hell), between the Crucifixion and the Resurrection. On a capital in the Basilica at Vézelay (twelfth century), the massacre is encapsulated by the death of the son of the Pharoah at the hands of the exterminating angel.

Cross-references: Aaron, Exodus, Massacre of the Innocents, Passover.

PLANTS

Plants occur frequently in artworks related to Biblical or hagiographical sources. They may give structure to the narrative space, differentiate the various stages of a single scene or serve to link a sequence of episodes. A symbolic dimension may supplement this syntactic function. In symbolism, plants appear as less tainted than animals, serving to give a more positive nuance to their surroundings. Moreover, every vegetable, tree, fruit or flower is possessed of a specific signification in Christian or Biblical symbolism. Nonetheless, it is often difficult actually to distinguish the plant concerned: branches, leaves, fruit and flowers are not always distinct and often the context alone allows identification. For example, nothing is shown that differentiates an apple from any other round fruit. If Eve is shown picking a fruit and offering it to Adam, or if Christ hands it to his mother, then the intended fruit clearly is an apple. In a similar way, very different flowers can in art be represented in identical fashion. The rose and the ox-eye daisy, the lily and any other long-stemmed bloom with three petals, can appear the same and the context alone clarifies the case. The problem of recognition is all the more irksome as many plants serve as personal attributes, where identifying the flower is tantamount to identifying the individual.

A further point to be stressed is that in older works (basically, until the middle of the fourteenth century, although the phenomenon persists in early woodcuts), it is by no means uncommon for the plant world to be ruled by a kind of metonymy: a single branch can stand for a shrub, a tree for a whole

forest and a flower for a garden. This economy (which also affects other elements) has to be grasped for the image to be read and interpreted.

Tree
The tree, more than any other member of the plant world, is used to organize the space of the image. It can create and give relative weight to zones, organize the image plane and show the major axes, and is a fundamental building block in both medieval and modern iconography. Among other things, a single tree can be employed, in one picture, to differentiate inside from outside, the religious from the secular, the present from the past or main protagonists from secondary characters. When a narrative is treated linearly, trees can serve to divide the various episodes.

As in the case of other plants, the particular value of any specific tree in an image is often hard to determine. Only a few frequently represented trees – such as the oak, pine or lime – can be readily identified by their characteristic leaves or fruits. On the other hand, one is often hard-pressed to say exactly which tree is shown: the beech and the birch, the elm and the chestnut, the apple and the hazel are indistinguishable. This too is regrettable as the name of the tree, together with its symbolism or mythology, might help to identify a specific personage, to understand a particular scene or to make the link between different images.

In general, trees are life symbols, linked to the cycle of the seasons and the tide of events. Trees blossom, bear fruit, lose their leaves, and die, only to burst forth once more and give more fruit. Sterile trees, such as the fig cursed by Christ in the Gospels, have a disturbing power. Like the dragon – but unlike other beings – the tree lives in all three of life's realms: its roots underground, its trunk on earth, while its branches and summit reach up to heaven (see Tree of Jesse).

Palm
The palm, as a bough or spray of leaves, is nearly always a symbol of victory, not only of a military nature but also of triumph over evil, the wicked and death. It is thus a symbol of resurrection and eternal life. The palm carried by Christ at his entry into Jerusalem on Palm Sunday prefigures his Resurrection, while the palm of martyrdom, used in iconography as early as the paleochristian period, signifies both the resurrection of the righteous and the immortality of the soul. The palm can take on very different forms in iconography, unlike anything to be seen in reality. The same can be said of the palm tree which is often impossible – in pictures of the Flight into Egypt, for example – to distinguish from other fruit trees.

Vine
Except when heavy with bunches of grapes, the vine, which figures on many artworks, is not easily differentiated from other, similar plants. Rather than a shrub or low-lying plant, the vine occasionally appears in the guise of a fully fledged tree, whose trunk and leaves are in every respect identical to those of any other fruit tree. Once again, it is the context which enables us to decide whether or not it is a vine. Often it is, for many peoples in the Bible – in particular the Hebrews – treated the vine as a sacred plant and offered up wine, symbol of both life and knowledge, to the Lord. Some traditions identify the vine with the Tree of Life itself. Others, however, following the letter of Genesis 10:20, in which Noah is credited with ushering in a new age by planting the very first vines, hold that it can therefore date only from after the Flood.

The vine is also a strongly Messianic symbol, and so the Chosen People are often presented as the Lord's vine, with God himself the vine-grower. Still more often, the Messiah is symbolized by a fruitful and redemptive vine. Here, the metaphoric connection between wine and blood finds its full force. The iconographic theme of the mystic wine-press first appears in the thirteenth century, which also saw much growth of the cult of the Holy Grail (*see* Crucifixion).

Lastly, the vine, in a Biblical context, may be a symbol of property and of an inheritance one strives to leave to one's descendants. A vine should be fruitful: an unproductive one is cursed and must be uprooted.

PLOUGHSHARE *see* CUNEGUND.

POLITICS (SAINTS IN THE SERVICE OF) *see* GENEVIEVE, JOAN OF ARC, MÉDARD, RADEGUND, REMIGIUS.

PONTIUS PILATE *see* ECCE HOMO, TRIAL OF CHRIST.

POPE

Latin, Italian and Spanish: Papa; French: Pape: German: Papst.

Unlike bishops, the Pope does not carry a crozier but a pastoral staff surmounted by a triple cross. Like archbishops, he wears the pallium, originally a long strip of white wool embroidered at both ends with a black cross. In the ninth or tenth century, this pallium comprised a circle of cloth from which hung two vertical bands. The vestments have remained white, which was the archetypal colour of all ecclesiastical garments. The Pope wears a conical tiara which was once encircled with a single crown at its base but which, since the fifteenth century, is set with a triple crown.
Type: Gregory the Great.

**The Papal Tiara
and Keys**
1619. Façade of the Palais
des Monnaies, Avignon.

POTHINUS *see* BLANDINA.

PRECURSOR *see* JOHN THE BAPTIST.

**Presentation of Mary at
the Temple**
Cima da Conegliano, early
sixteenth century. Staatliche
Kunstsammlungen, Dresden.

PRESENTATION OF MARY

Feast day 21 November

TRADITION

The apocryphal *Protevangellum* of James recounts the childhood of the Virgin:
at the age of three, Joachim and Anne took her to the Temple to consecrate
her to God, in the presence of the house of Israel. She was received and
blessed by the high priest Zacharias, and then lived for twelve years in the
Holy of Holies, with him as her tutor.

This account took as its model the vocation of Samuel (I Sam. 1:24), given
to God by his mother. James of Voragine's *Golden Legend* featured the story
heavily, enriching it with picturesque details – the temple had fifteen steps
leading up to the sacrificial altar: Mary, an infant of three, after being placed
on the first, managed to climb them unaided. Her parents then left her at
the Temple "with the other virgins".

REPRESENTATION AND ICONOGRAPHY

The iconography surrounding the Presentation of Mary is abundant. The
episode appears in an illustration in *Homelies du moine Jacques*, a Greek man-
uscript from the first half of the twelfth century (Bibliothèque Nationale,
Paris). A bronze portal relief at Pisa Cathedral (1180) shows Mary climbing
the steps, with the high priest Zacharias at the summit. A fresco by Giotto
(Scrovegni Chapel, Padua, fourteenth century) is dedicated to the theme,
which is also treated by Carpaccio (1504-8, Brera, Milan), Titian (1534-8,
Accademia, Venice), and Tintoretto (1556, Madonna del Orto, Venice).

Cross-references: Anne, Mary, Presentation of the Lord.

PRESENTATION OF THE LORD

Variant: Presentation of Christ in the Temple. Latin: Praesentatio Domini;

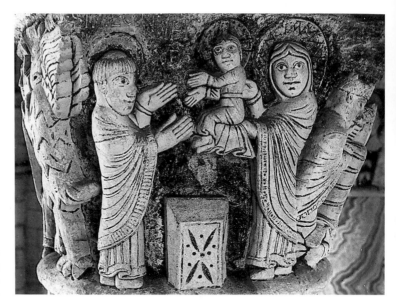

**Presentation of Christ in
the Temple**
Capital, twelfth century.
St Pierre, Chauvigny.

Italian: la presentazione di Gesù al Tempio; Spanish: la presentacion del Niño
en el Templo; French: la présentation de Jésus au Temple; German: die
Darbringung (Präsentation) Jesu im Tempel.
Feast day 2 February (Candlemas together with the Purification of the Virgin).

TRADITION

The Gospel of St Luke is the sole source for this episode of the life of Christ
(2:22-40). In accordance with Mosaic Law (Ex. 13:2), Jesus' parents made their
way to Jerusalem to present their newborn son to the Lord and offer up a pair
of turtledoves as a sacrifice. A just man, Simeon, encouraged by the Holy Spirit
to go to the Temple that day, took Jesus in his arms and cried out to God:
"Lord, now lettest thou thy servant depart in peace ... For mine eyes have
seen thy salvation ... A light to lighten the Gentiles" (2:29-32). Simeon pre-
dicted that "a sword shall pierce though" Mary's soul. This was the origin
for the theme of the Seven Sorrows of the Virgin. Anna, a prophetess, who
lived in the Temple, also began to talk of the Child "to all them that looked
for redemption in Jerusalem" (2:38).

The light heralded by Simeon is commemorated by the blessing of the
candles at the Feast of Candlemas (*Festum candelarum*). In the middle ages,
this feast was more often called the Purification of the Virgin Mary. The
Eastern Church emphasized the meeting between Simeon and Anna and
named the feast *hypapante* (*obviatio*, meeting). The feast of the Meeting
between Simeon and Anna was celebrated as early as the fourth century in
Jerusalem. Justinian I promoted it to a solemn feast day of the Byzantine
Church. 2 February also marks the celebration of the associated feast of the
Purification of the Blessed Virgin (Luke 2:22).

REPRESENTATION AND ICONOGRAPHY

The first extant treatment of this theme occurs on a mosaic on the triumphal
arch at S. Maria Maggiore at Rome (432-440). All four main protagonists are
shown: Mary, the Child, Simeon and Anna, while Joseph is also present. From

the Carolingian period, two types of representation exist side by side. Mary presents the Child to Simeon, wearing a tiara or mitre like a high priest, who holds him up and returns him to Mary. In the fourteenth century, the number of figures increased. Ambrogio Lorenzetti provided an example of the second type: in the foreground the meeting between Simeon and Anna and, in the background, the high priest sacrificing some doves or pigeons (1342, Uffizi, Florence). This type continued well into the fifteenth and sixteenth centuries in Italy.

The candlelit procession of Candlemas made its appearance in the twelfth century (stained glass, Chartres Cathedral): a cortège of women carrying lighted candles follows the Virgin. Lochner shows Simeon as high priest holding up the Child who stands on the Temple altar (1447, Hessische Landesmuseum, Darmstadt). The Virgin, kneeling, offers up doves; Joseph counts out the fee for the ceremony; on the left, Anna utters her prophecy. The composition is dominated by God the Father who blesses the scene below. A procession of choirboys carrying altar candles fans out over the ground strewn with holly leaves and berries.

The composition by Rubens (1611-14, Antwerp Cathedral) had a considerable influence in the seventeenth century. Rembrandt treated the motif a number of times (1631, Mauritshuis, The Hague; *Simeon in the Temple*, 1669, Nationalmuseum, Stockholm). Similar compositions to this last, with Simeon alone with the child, also occur (Petr Brandl, c.1731, Narodnl Galerie, Prague).

Cross-references: Anna (the Prophetess), Joseph of Nazareth, Mary.
Bibliography: D. C. Short, "The iconographical development of the Presentation in the Temple", *Art Bulletin*, 28, 1946, pp. 17-32.

PRODIGAL SON

Italian: il figlio prodigo; Spanish: el hijo prodigo; French: l'enfant prodigue; German: der verlorene Sohn.

TRADITION

The Gospel according to St Luke is the only one to contain this parable of Jesus. A rich man had two sons. The younger claimed his birthright and, with his father's agreement, the inheritance was split between the two brothers. The younger then left for a distant country and squandered all his wealth, falling into penury and ending up starving as a swineherd. In his mind's eye, he pictured his father's house where a table always stood ready laid even for the hired servants, and so he decided to return home. As soon as his father saw him, filled with compassion, he rushed out to meet him and embraced him. The son confessed to his father that he had "sinned against heaven and in thy sight". But his father gave him fine robes to wear and killed the fatted calf in celebration.

Meanwhile, the elder son returned from work in the fields and found everyone already at table. Enraged, he gave vent to his resentment, but the father replied : "Son, thou art ever with me ... It was meet that we should make merry and be glad: for this thy brother was dead, and is alive again; and was lost, and is found" (15: 31-32). Luke describes in detail the father embracing his lost son, the fine robes, and the ring he gives him. He also evokes the music the elder brother hears on his return from the fields while

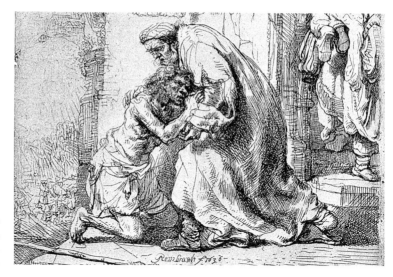

**The Return of the
Prodigal Son**
Rembrandt, 1636 (detail).
Rijksmuseum, Amsterdam.

the fatted calf is mentioned three times. Later commentators compared this parable to that of the lost sheep (Luke 15: 4-6) and of the repentant sinner (Luke 7: 37-50).

REPRESENTATION AND ICONOGRAPHY

The parable does not seem to have been illustrated before the twelfth century (capitals at St Nectaire, Puy-de-Dôme, France, with the Prodigal Son keeping pigs), and the theme remains rare until the sixteenth century. Illuminators and stained-glass painters concentrated mainly on the dissipated life of the younger son (stained-glass windows at Bourges Cathedral, seventeen scenes; Chartres, twenty-seven scenes). In the fifteenth century, Dürer showed the Prodigal Son among his swine and his repentance (engravings, c.1495-96). Flemish painters preferred the quainter side of the theme, showing the son's debauchery. Rembrandt devoted no fewer than seven drawings, a print and a painting to this theme (c.1668, Hermitage, St Petersburg). Jacques Callot (1635) dedicated a series of engravings to the story. A version by Murillo in the picturesque mode has a little dog recognizing the lost son (1667-70, National Gallery, Washington).

Cross-reference: Good Shepherd.
Bibliography: L. Réau, op. cit., vol. II, 2, pp. 233-38. E. Vatter, *Der Verlorene Sohn*, Düsseldorf, 1955.

PROPHET

Italian and Spanish: profeta; French: prophète; German: Prophet.

The Biblical Prophets are the spokesmen of the Lord, who calls them according to a mysterious process of election. All who speak in their own name are false prophets. Through their actions and words, the Prophets of Israel translate the will of God.

Cross-references: Anna (the prophetess), Elijah, Ezekiel, Isaiah, Jeremiah.

PROSTITUTE *see* **MARY OF EGYPT, MARY MAGDALENE, JERICHO, REVELATIONS.**

PSALMS *see* **DAVID.**

PURIFICATION OF THE BLESSED VIRGIN MARY *see* **PRESENTATION OF THE LORD.**

PURSE *see* **CUNEGUND (QUEEN), JUDAS ISCARIOT, LAURENCE (IN CHALICE), NICHOLAS (THREE).**

PUTIPHAR, PUTIPHAR'S WIFE *see* **JOSEPH.**

QUEEN OF SHEBA *see* SHEBA.

QUENTIN

The Martyrdom of St Quentin
Bibliothèque Nationale, Paris.

Variant: Quintin. Latin and German: Quintinus; Italian: Quintino; Spanish: Quintin; French: Quentin.
Martyr. Died in 303(?). Feast day 31 October.

LIFE AND LEGEND

The martyrdom of St Quentin – whose name is recorded in Bede's *Historia Ecclesiastica* (731) – took place at Veromanduorum, now called St Quentin, in the département of Aisne, France. This is the only recognized historical fact concerning a saint around whom rich and fantastic legends have sprung up. These affirm that he was a Roman citizen who, in the company of St Lucian of Beauvais, attempted to evangelize the Gauls. He was arrested at Amiens by Prefect Rictiovarus and suffered a series of excrutiating tortures: two skewers are forced through his shoulders down into his thighs, and nails are hammered in beneath his fingernails. He was finally beheaded and his body, weighed down by a millstone, was thrown in the River Somme. Fifty years later, a Roman matron, St Eusebia, miraculously discovered his corpse and had it buried on a hill where the town of St Quentin is now situated. The saint also performed posthumous miracles such as rescuing from the scaffold a man guilty of stealing a horse from a priest. St Quentin is the patron saint of tailors.

REPRESENTATION AND ICONOGRAPHY

The life and legend of St Quentin can be seen illustrated in a series of illuminations (twelfth century, Basilica at St Quentin). He is attached to a pillar or is tortured with nails (relief, south porch at the transept of Chartres Cathedral). He can also be figured seated, a nail through each shoulder and others under his fingernails (a polychrome statue from the studio of Amiens, sixteenth century, Musée Tavet-Delacour, Pontoise). The Church at Nucourt (Seine-et-Oise) contains an altarpiece devoted to his legend. The episode where he saves a horse-thief from hanging is figured on a tapestry (fifteenth century, Musée de Cluny, Paris).

Attributes: Nails (in head, shoulders and under fingernails).

QUILL *see* ALBERT THE GREAT (DOMINICAN), ANSELM (BENEDICTINE), MARK (WITH LION).

QUO VADIS *see* PETER.

RADEGUND

Italian: Radegonda; Spanish: Radegunda; French: Radegonde; German: Radegunde.
Queen and abbess. c.521-87. Feast day 13 August.

LIFE AND LEGEND

In 536, this princess from Thuringia was forced to marry Clotaire I (or Chlotar), King of Neustria. She founded a hospital in the Villa Athies donated by Clotaire. She later left her husband and petitioned Médard, Bishop of Noyon, to allow to take the veil. Once this was achieved, she retired to Poitiers, close to the tomb of St Hilary, to escape Clotaire as he sought to recover her. Clotaire, though bloodthirsty and profligate, clearly had some respect for Radegund (who had founded a hospice for lepers and paupers in Saix), and built the monastery of the Holy Cross at Poitiers for his estranged wife. In 569, Radegund placed in the abbey a fragment of the Holy Cross which she had received from the Byzantine emperor, Justinian II. A woman of great piety, Radegund died in 587.

In the fifteenth century, Charles VII promoted a solemn cult of Queen Radegund. As a symbol of the legitimacy of the Capetian royal family opposed to the claims of the victorious English, the king intended her to give authenticity to the line descending from Clovis and his baptism to the French kings of the fourteenth and fifteenth centuries. In 1517, Francis I authorized the publication of *L'histoire et chronicque de Clotaire I ... et sa très illustre espouse dame saincte Radegonde*

REPRESENTATION AND ICONOGRAPHY

Generally, Radegund is depicted as a nun. Sometimes a crown is laid next to her. In the sixteenth and seventeenth centuries, she appeared as a reigning queen, with crown and royal insignia (Jacques Callot, engraving, *Les Images de tous les saints...*, 1636). The sceptre can on occasion be replaced by an abbess's crozier. A manuscript (eleventh century, Library of Poitiers) illustrated the various episodes of her life. In the nineteenth century, Puvis de Chavannes painted *St Radegund listening to a reading by Fortunatus* (1874, Hôtel de Ville, Poitiers).

Attributes: Royal crown. Sceptre. Crozier.
Cross-reference: Médard.

St Radegund
Life of St Radegund, end of the eleventh century.
Bibliothèque, Poitiers.

RAISING OF LAZARUS *see* LAZARUS (RAISING OF).

RAM *see* DANIEL.

RAPHAEL

Italian: Rafaele, Raffaello; Spanish: Rafael; French: Raphaël; German: Rafaël.
Archangel. Feast day 29 September (with SS. Michael and Gabriel).

TRADITION

"I am Raphael, one of the seven holy angels, which ... go in and out before the glory of the Holy One" (Tobit 12:15, Apocrypha). With these words the

Raphael and Tobias
Francesco Botticini, second
half of the fifteenth century.
Galleria dell'Accademia,
Florence.

archangel Raphael revealed himself to Tobit and his son, Tobias. In the story of Tobit, the archangel took on a dual role. He both healed Tobit's eyes of a cataract (Tob. 11:7-14) and served as guide and protector to Tobias (Tob. 5). Devotion to Raphael was promoted by the institution of the cult of the guardian angel in 1526 by François d'Estaing, Bishop of Rodez. Patron saint of apothecaries and physicians, Raphael also watches over travellers.

REPRESENTATION AND ICONOGRAPHY

Raphael is a beardless youth, who is clothed in an identical manner to the other archangels. As a companion of Tobias, he wears a pilgrim's garb, with staff, gourd (or flask) and scrip. He naturally occurs in Tobit cycles (Pollaiuolo, second half of the fifteenth century, Galleria Sabauda, Turin). He also appears accompanied by Gabriel and Michael in depictions of the archangels.

Attributes: Staff, gourd and scrip (as a pilgrim). Fish (in reference to the capture of a miraculous fish by Tobias: Tob. 6). Vase or jar (containing the fish gall with which Raphael restores Tobit's sight).
Cross-references: Archangels, Gabriel, Michael, Tobit.

RAVEN

The raven is the first bird to be mentioned in the Bible. It is released from the Ark by Noah to see if the waters of the Flood have receded, but it flies off and feeds on carrion, never returning to the Ark (*see* Introduction). Christians see in this eminently black bird an image of the pagans who turn away from God, or else of earthly sinners who live in trespass. In hagiographical tradition, however, there also exists a good raven. This brings food to hermits in the desert, or else protects them from attack. It is a divine messenger and a faithful companion.

Cross-references: Antony (and with Paul), Benedict (flying off with bread), Elijah (in desert), Noah (and Ark), Paul the Hermit (and with Antony), Vincent of Saragossa (two on boat), Vitus (with cauldron or lions). *See also* Introduction.

REBECCA *see* ISAAC, JACOB.

RED SEA *see* EXODUS.

REMIGIUS

Variant: Remi. Latin and German: Remigius; Italian: Remigio; French: Remi. Archbishop of Reims. Fifth-sixth century. Feast day 1 October.

LIFE AND LEGEND

The life of St Remigius is known to us through a number of texts, one of which, *Vita Sancti Remigii*, was written by another Archbishop of Reims (845-82), Hincmar. Born c.436, Remigius (Rémi) became Archbishop when only 22, baptizing Clovis I around 496. Legend attributes various miracles to him. Manotanus, a blind hermit, predicted Remigius' birth in spite of the advanced

age of his mother, and added, "When you are nursing your infant, do not forget to moisten my eyes with a drop of your milk so I shall recover my sight." The prophecy was realized. Named as archbishop, Remigius, with a wave of his hand, put out a fire which threatened to engulf Reims. One day, visiting a relative called Celsa, he noticed that wine was running short: he approached and blessed the empty barrel, whereupon wine poured out of it, flooding the cellar.

The most famous event of legend, however, is the miracle of the Sainte Ampoule. This was described by Hincmar who was keen to give the ceremony the allure of the archetype of the consecration of the Carolingian kings. The dove of the Holy Spirit came down from heaven bringing Remigius a phial filled with chrism which was miraculously replenished. This was kept in Reims, at the abbey of St Rémi, until its destruction in the Revolution. His cult was closely linked to the Capetian monarchy, whose main sanctuaries were Reims Cathedral and the Basilica of St Denis, near Paris.

REPRESENTATION AND ICONOGRAPHY

Remigius is represented as an archbishop, with a book and the Sainte Ampoule. At Reims, he is associated with Callistus and Nicasius, who are particularly revered there. Iconographically, the legendary scenes borrow intensively from the life of Christ. The hermit whose sight is restored has an obvious parallel in Elisabeth's husband Zacharias, struck dumb for having doubted the Word of God and who recovers the power of speech at the birth of St John the Baptist. The dove at the baptism of Clovis evolves directly from that which appears at the Baptism of Jesus. The most ancient depiction of Remigius is on a carved ivory book-casing (tenth century, Musée de Picardie, Amiens). On the tympanum of the St Calixte portal at the Cathedral of Reims, scenes from Remigius' youth show him as a monk. Among scenes from his life, the baptism of Clovis is most often shown. The compositions strongly suggest the consecration of a king (for example on the south door at the transept of Chartres Cathedral). In the sixteenth century, the legend is shown in detail on ten wall-hangings given by Archbishop Robert de Lenoncourt to the Abbey of St Rémi at Reims.

Attributes: Chrism in phial. Dove. Bishop's crozier. Book.
Cross-references: Baptism of Christ, Holy Spirit, Zacharias.

St Remigius
La vie de saint Rémi, 1531 (detail). Musée des Beaux Arts, Reims.

REST ON THE FLIGHT INTO EGYPT *see* FLIGHT INTO EGYPT.

RESURRECTION

Latin: Resurrectio; Italian: Risorgimento; Spanish: Resurrección; French: Résurrection; German: Auferstehung.

TRADITION

The narrative of the Resurrection appears, with variants, in all four Gospels (Matt. 28:1-10; Mark 16:1-8; Luke 24:1-9; John 20:1-18). Three days after Christ's Passion, at the end of the Sabbath, the women made their way to the Holy Sepulchre with sweet spices to embalm his body, wondering how they would be able to roll away the heavy stone in front of the tomb. They

found the tomb already open and a youth dressed in white who told them, "Ye seek Jesus which was crucified. He is not here; for he is risen" (Matt. 28:5-6). Resurrected on the morning of the first day of the week, Jesus first appeared in person to Mary Magdalene, who initially took him for a gardener.

The feast of Easter celebrates the Resurrection and is the most important day in the Christian calender, around which the remainder of the liturgical year revolves. Tradition sees in Jonah's three days in the belly of the whale a prefiguration of Christ's Resurrection. A similar role is played by Samson carrying the "doors of the gate" of Gaza on to Mount Horeb and Daniel set free from the lions' den, although these symbols are less frequent.

The *Speculum Humanae Redemptionis* discerns the symbolic meaning of the Resurrection in certain animals as they appear in medieval bestiaries: in the lion, which after three days roars and resuscitates its young; in the phoenix, which comes back to life from its own ashes, and in the pelican, which restores its infants to life and nourishes them with blood from its own breast.

REPRESENTATION AND ICONOGRAPHY

In the paleochristian period, the Resurrection was not represented directly, but symbolically: in the fourth and fifth centuries, a Cross with the monogram of Christ symbolizes the Redeemer's victory over death. Even during the middle ages, this penchant for symbolism, an inherent part of Christian thought, never entirely disappeared. In the west, since the ninth century, the sun has symbolized the Resurrection (Utrecht Psalter, c.930). In the fourteenth century, the Risen Christ was depicted by a glowing apparition and, from the fifteenth, by a sunrise over a landscape (Altdorfer, 1518, Kunsthistorisches Museum, Vienna).

The Resurrection naturally possesses a very rich iconography which can be studied chronologically, following the episodes treated by artists, or else according to the kinds of artworks which sustain the iconology. A long tradition is provided by psalters and books of hours.

The Resurrection
Andrea da Firenze, 1365.
S. Maria Novella, Florence.

The individual stages of the event do not appear before the eleventh century. At that time, a front-facing Christ was shown emerging from his tomb, raising his right hand in blessing. From the early middle ages to the fifteenth century, this type continued to predominate in Germany (Master Francke, early fifteenth century, Kunsthalle, Hamburg). It gained Italy by the fourteenth century (Piero della Francesca, c.1454, Pinacoteca, Borgo San Sepolcro, with Christ victorious coming forth from the tomb). Here, Christ, with the end of his standard poised on the edge of the open grave, can clearly be seen against the background of a landscape situated somewhere on the border between Tuscany and Umbria. The tomb can also be associated with an altar, as in the Assumption of the Virgin, and was therefore shown on altars (Grünewald, detail from the Isenheim Altarpiece, c.1510-15, Colmar). On both left and right, angels equipped with altar candles swing censers over the scene, thereby making concrete the connection between iconography and the Paschal liturgy. The increasing tendency to realism during the fourteenth and fifteenth centuries coincided with the invention of perspective, yet was guided by a desire to preserve the transcendental mystery of the event.

The motif showing Christ hovering over the tomb appeared in fourteenth-century Italy and evolved during the Renaissance, continuing well into the seventeenth and eighteenth centuries. Some artists adopted a severe hieratic style, while others approached the subject more freely. The earliest Italian work of this kind is a fresco of Andrea da Firenze (1365, S. Maria Novella, Florence). Ghiberti (1424, Baptistry, Florence) and Tintoretto (1587, Scuola di San Rocco, Venice) also took up the theme.

One favourite Renaissance type presented Christ standing on top of the tomb, doubtless in an echo of the Easter practice in which a statue of Christ would be placed on the altar (Dürer, *Passion*, 1512). However, the tomb could also look something like a rocky cave. In the seventeenth and eighteenth centuries, this type was predominant and symbolized the elevation of Christ. At this date, too, he could be shown standing before the empty sepulchre.

The Guards at the Tomb (Matt. 28:4)

The guards at the tomb (whom Matthew is alone in mentioning) number only two or three, and appear, half asleep, in the early middle ages. From around the fourteenth century, they become more numerous and occupy more space. They are blinded by the light coming from the apparition, and appear terrified. From the fifteenth century onwards, the pathos of their poses and gestures is accentuated. They are dressed anachronistically, wearing the clothes and carrying the weapons of contemporary soldiers.

Cross-references: Daniel, Jonah, Lion, Mary Magdalene, Noli me Tangere, Samson, Holy Women at the Sepulchre.
Bibliography: W. Braunfels, *Die Auferstehung*, Düsseldorf, 1951.

RESURRECTION OF ALL FLESH, or OF THE DEAD
see LAST JUDGMENT.

RESURRECTION (OF LAZARUS) see LAZARUS (RAISING OF).

REVELATIONS

Also known as the Revelation of St John, the Book of the Apocalypse. Italian: Apocalisse; French: Apocalypse; Spanish: Apocalipsis; German: Apokalypsis, die Offenbarung Johannis.

TRADITION

Generally attributed to St John, Revelations was probably written at the end of the reign of Domitian (81-96); the name Apocalypse comes from the Greek *apocalupsis,* meaning revelation, particularly of a divine nature. In the Jewish world, apocalypses, divinely inspired or purportedly so, began to multiply from around the second century BC. They attempted to predict the date of the end of the world and the coming of a Messiah, describing, in esoteric language, the final cataclysm.

As a mystical text of specifically Christian inspiration, the Revelations of St John constituted a break with that tradition. Counted among the canonical books of the Bible, it is recognized by the Church as Holy Writ. In the Christian Gospel, it is placed at the end of the New Testament. St John was more concerned with the mystery of Christ's revelation, the *Parousia* (Second Coming) and the kingdom to come heralded by the Eucharist, than with the circumstances of the end of the world. His language when he describes higher realities or reveals hidden truths is, however, of a traditionally esoteric nature.

The Vision of St John (Rev. 1:9-20)

The author introduces himself as a certain John. He outlines how, while he was "in the Spirit" (1:10) on the island of Patmos, he heard a voice, like a trumpet, proclaiming: "What thou seest, write in a book" (1:11). John turns round and sees seven golden candlesticks and in the middle "one [person] like unto the Son of man". This mysterious personage – "his head and his hairs were white like wool, as white as snow" – holds in his right hand seven stars. He announces: "I am the first and the last: I am he that liveth and was

The Apocalypse of Angers
c.1360-80. Musée des Tapisseries, Angers.

dead". Then comes the text of the letters to the seven churches of Asia, to which the Book of Revelations is dedicated (1:2-3).

The Throne of God and the Four and Twenty Elders (Rev. 4:1-11)
After the Spirit had finished dictating the letter to the Laodiceans, John discovered a door opening into the sky. Through it, he could see a throne on which "he that sat was to look upon like a jasper and a sardine [sardonyx] stone" (4:3). "Four and twenty" elders, dressed in white, sit around this throne. In front of the throne stand seven lamps and issuing from it are "lightenings, thunderings and voices" (4:5). Four animals prefigure the symbols of the Evangelists. A litany of praise pours forth from all present – animals and elders alike – and goes up to the throne. John can see in the hand of him who sits enthroned "a book written within and on the backside, sealed with seven seals" (5:1). Only "the Lamb as it had been slain" (5:6) has the right to open these seven seals.

The Seven Seals (Rev. 6-7)
The opening of the seals is the signal for the judgment and the onset of the *Dies irae*, the "day of his wrath" (6:17), manifested by a series of earthly catastrophes. The opening of the first four seals heralds the arrival of the Four Horsemen of the Apocalypse (6:1-8). The fifth seal ushers in the martyrs who demand justice for spilt blood, while the opening of the sixth results in massive upheavals such as earthquakes and the blackening of the sun, while "the stars of heaven fell onto the earth." The day of wrath has come. Chapter 7 ends with a vision of an immense crowd dressed in white carrying palms and celebrating the liturgy before the throne of God.

The Seven Angels with Seven Trumpets (Rev. 8, 9, 10 and 11:15-19)
The Lamb opens the seventh and last seal: seven angels enter and are given seven trumpets. At each sounding, cataclysms occur (8, 9). The end of world approaches. Locusts the size of battle-horses burst upon the earth (9:7-11). A mighty angel descends "clothed in a cloud: and a rainbow was upon his head and his face was as it were the sun and his feet as pillars of fire" (10:1-3). He is the harbinger of another divine intervention: John is about to describe it when he is stopped by a voice amid the "seven thunders". The angel with "his right foot upon the sea and his left foot on the earth" tells him to take the book and eat it. In John's mouth, it was "as sweet as honey"(10:8-10).

The Woman and the Dragon (Rev. 12)
When the seventh angel has sounded his trumpet, the twenty-four elders fall upon their faces and adore God (11:15-19). A great wonder appears in heaven: "a woman clothed with the sun, and the moon under her feet and upon her head a crown of twelve stars". She is with child and is imperilled by a seven-headed red dragon, ready to devour her infant at birth. The child is brought up to God. St Michael and his angels fight against the dragon which is defeated and cast down to earth. He throws himself after the Woman who is given the two wings "of a great eagle" (12:14) and flies to safety into the wilderness. The dragon "cast out of his mouth water as a flood" after the Woman to drown her, but the earth opens up and swallows the river, and she is saved (12:15-16).

The Two Beasts (Rev. 13)
Furious at his failure, the dragon makes war against all those who "keep the

commandments of God" (12:17). He is then followed by two monsters. The first has seven heads like the dragon, while the second is so devised as to cause "the earth and them which dwell therein to worship the first beast" (13:12). All those who had previously been marked on their foreheads with the seal of the living God (7:3-8) are taken up to heaven where they sing "as it were a new song" (14:1-3) before the Lamb.

The Fall of Babylon (Rev. 17, 18)
Seven angels "pour out the vials of the wrath of God upon the earth" (16:1). One of them shows John the "judgment of the great whore that ... sits upon a scarlet coloured beast"— that is, "Babylon the Great" (17:1-5). The ruin of Babylon then follows and its "smoke rose for ever and ever" (19:3). The ultimate victory over the powers of evil is now proclaimed and the army of the "Faithful and True" one (19:11), who sits upon a white horse, throws the Beast and his prophet into an eternal "lake of fire burning with brimstone" (19:20). An angel chains up the dragon. After one thousand years (20:3, 7), Satan will come out of his prison "to deceive the nations ... to gather them together to battle" (20:8). Satan, too, is thrown into the lake of brimstone.

The New Jerusalem (Rev. 21)
The Last Judgment follows (20:11-15). In a further vision, John perceives a "new heaven and a new earth" (21:1) and "he that sat upon the throne said, It is done. I am Alpha and Omega, the beginning and the end" (21:6). Carried up "in the spirit to a great and high mountain", John sees the New Jerusalem "coming down from God out of heaven" (21:2), full of light and dedicated to the number twelve.

REPRESENTATION AND ICONOGRAPHY

Cycles
The few depictions of Revelations from the paleochristian period tend to avoid the scenes of catastrophe, concentrating instead on the different manifestations of the Lord. After the victory of Constantine over Maxentius in 312, such scenes become more frequent. An important series was developed in Spain during the tenth and eleventh centuries, in the various illuminated manuscripts of the *Commentary on the Apocalypse* by Beatus, abbot of Liebana. This trend is equally prevalent in south-west France (*Apocalypse de St Sever*, manuscript, ninth century, Bibliothèque Nationale, Paris). These illuminations were probably one of the main inspirations behind the bestiaries of the Romanesque cathedrals. The frescoes on the porch of the church at St Savin sur Gartempe (Vienne, twelfth century) are an important landmark in the development of the theme, as can be adduced from the *Apocalypse d'Angers* (c.1360-80, Musée des Tapisseries, Angers). There are also the frescoes by Cimabue in the Lower Church of Assisi (c.1270-80); the rose-window on the front of the Sainte Chapelle in Paris (early sixteenth century), and the *Apocalypse* cycle by Dürer (twelve engravings, 1498).

The Four and Twenty Elders (Rev. 4:4)
"And round about the throne were four and twenty seats: and upon the seats I saw four and twenty elders sitting, clothed in white raiment; and they had on their heads crowns of gold" (4:1). Each time the "Animals" honour him who sits on the throne, the elders throw themselves to the ground and worship him. At the church of St Pierre at Moissac (tympanum of the main door, twelfth century), the twenty-four elders occupy a privileged position.

The Four Horsemen (Rev. 6:1-8)

The Horsemen appear individually after the breaking of each of the first four seals. Medieval commentators viewed the first Horseman, on his white horse signifying the Church, as a symbol of Christ. The second signified war, the third famine and the fourth plague. In the manuscripts of Beatus' *Commentary*, the Horsemen are represented separately. They are only grouped together – in rank or file – from the fifteenth century onwards. El Greco illustrated the episode of the opening of the fifth seal (1608-14, Metropolitan Museum of Art, New York).

The Woman of Revelations (Rev. 12)

The Fathers saw in this figure a symbol of the Church itself. From the ninth century, another interpretation gained ground in the west: the Woman stands for a prefiguration of the Virgin Mary. The Victorious Virgin celebrated by artists since the sixteenth century can be associated with the triumph of the Woman of Revelations over the dragon. Since the seventeenth century, the Virgin is crowned with stars like the Woman and crushes underfoot the serpent, symbol of evil.

The Combat between St Michael and the Dragon (Rev. 12:7-12) *see* Michael.

The Great Whore (Rev. 17)

One of the seven angels shows John the "great whore that sitteth upon many waters ... And I saw", John continues, "a woman sit upon a scarlet coloured beast ... arrayed in purple and scarlet colour and decked with gold and precious stones and pearls." (17:3-4). Seated on the back of the Beast, the Whore combs her hair (*Apocalypse de St Sever*; on two hangings of the *Apocalypse d'Angers*, the Whore combs her hair seated on the waters and holds up the cup "full of abominations and filthiness"). In later art, it is an infrequent subject. It was a frequent Puritan epithet for the Roman Catholic Church, in allusion to the luxury and vice of Rome.

The Apocalypse of Angers
c.1360-80. Musée des Tapisseries, Angers.

The New Jerusalem (Rev. 21)

This is depicted on a sarcophagus of the fourth century (St Ambrose, Milan). In a mosaic (apse of St Pudenziana, Rome, early fifth century), the historic Jerusalem stands in for its celestial equivalent. In one of Dürer's engravings, the New Jerusalem appears as sixteenth-century Nuremberg.

Cross-references: Evangelists, Last Judgment, Mary, Michael.
Bibliography: F. Didot, *Les Apocalypses figurées, manuscrites et xylographiques*, Paris, 1870. L. Réau, op. cit., vol. III, pp. 663-726. *La Tenture de l'Apocalypse d'Angers, Cahiers de l'Inventaire, ministère de la Culture*, Paris, 1989. F. Van der Meer, *L'Apocalypse dans l'art*, Paris, 1978.

RIDDLE *see* BENEDICT.

RIVERS OF PARADISE *see* CREATION, EVANGELISTS, PARADISE.

ROCH

Latin: Rochus; Italian: Rocco; Spanish: Roque; French: Roch; German: Rochus, Rokh.
Hermit. c.1350-80. Feast day 16 August.

LIFE AND LEGEND

Roch was born in Montpellier, the son of a rich merchant. He became a hermit, and made numerous pilgrimages throughout his life. Returning from Rome, where he had stayed from 1368-71, he discovered he had the plague. To avoid spreading contagion, he hid deep in the woods and was fed by a dog who stole him a loaf of bread a day from his master's table. An angel cured him of his affliction and he returned to Montpellier, where no one recognized him and his own uncle even accused him of espionage. He was thrown into prison where he died, bathed in supernatural light. A different legend asserts that he was accused of spying and imprisoned at Angleria, in Lombardy, continuing to care for plague-sufferers until his death there. St Roch is the patron saint of the plague-stricken.

REPRESENTATION AND ICONOGRAPHY

Though there exists a fourteenth-century wooden statue of him (Musée de Peinture et de Sculpture, Grenoble), Roch's cult was not widespread until the fifteenth century. He is shown as a bearded pilgrim, complete with hat, cloak, staff, gourd and scrip. Either his hat or his cloak may be ornamented with a scallop shell. He is accompanied by a dog with a loaf of bread between its jaws. Often, the saint exposes a plague bubo on his thigh (Quentin Metsys, early sixteenth century, Alte Pinakothek, Munich). Tintoretto decorated the Venetian church dedicated to his name after the translation of his relics from

St Roch
End of the sixteenth century. Musée des Arts décoratifs, Saumur, Maine-et-Loire.

Montpellier (1567, S. Rocco). St Roch is often associated with St Sebastian, another saint who is invoked against the plague (fresco, 1520, Rymättyla, Finland). Rubens painted an altarpiece consecrated to St Roch (1623-26, St Martin, Aalst). As late as 1780, David painted an intercession of the saint (Musée des Beaux Arts, Marseille).

Attributes: Pilgrim's staff and scrip. Scallop shell. Plague bubo. Dog (from the sixteenth century).

ROD *see* AARON (BUDDING ROD), ANGEL, ANNUNCIATION, ARCHANGEL, ARK OF THE COVENANT (BUDDING ROD), BURNING BUSH (BUDDING ROD), CANA (CHRIST WITH STICK), COLUMBAN (MONK WITH STAFF), EXODUS (BUDDING ROD), GABRIEL (ARCHANGEL), JAMES THE LESS (FULLER'S CLUB), JOHN THE BAPTIST (ROD *or* CROOK), JOSEPH OF NAZARETH (BUDDING ROD AND SUITORS), LAZARUS (RAISING OF) (CHRIST WITH STICK), MARRIAGE OF THE VIRGIN MARY (JOSEPH AND BUDDING ROD), MULTIPLICATION OF THE LOAVES AND FISHES, PLAGUES OF EYGPT (AARON *or* MOSES), RAPHAEL (ARCHANGEL), SIBYLS.

ROSE

The rose, which in pagan mythology had been sacred to Venus, was dedicated by Christianity to the Virgin Mary, a rose without thorns – i.e. one born without the stain of sin. Nonetheless, this symbolism is relatively late. Until the thirteenth or fourteenth centuries, the lily, symbol of purity, was more important than the rose. The red rose can also be associated with blood spilt by or for Christ and linked to the notion of martyrdom, whereas the white rose is a symbol of purity. The golden rose which popes send to certain dignitaries is the emblem of their benediction. A universal attribute of love, the rose, in the guise of a rose bush, can also represent divine love.

Cross-references: Dorothy, Mary, Sibyls.

RUTH *see* BOAZ.

SABBATH *see* CREATION.

SACRIFICE *see* ABRAHAM, CAIN AND ABEL, CRUCIFIXION, GOLDEN CALF, ISAAC, MOSES.

SALOME

Italian and French: Salomé; German: Salome.
Jewish princess. Died c.72.

TRADITION

Daughter of Herodiade and of Herod Philip, Salome, through her father, was granddaughter of Herod the Great. At her mother's instigation, she danced for her uncle, Herod Antipas, and obtained as a reward the head of St John the Baptist (Matt. 14:3-11; Mark 6:17-28; Luke 3:19:20).

REPRESENTATION AND ICONOGRAPHY

The theme of the dance of Salome (south door of Auxerre Cathedral, twelfth century; stained glass at Rouen and Bourges) flourished at the end of the middle ages (Donatello, bronze relief, 9423-27, font, Baptistry, Siena) and in the sixteenth century (Luini, c.1520, Kunsthistorisches Museum, Vienna; Titian, 1560, Prado, Madrid). It has remained popular (Moreau, several versions, 1870s, Musée Gustave Moreau, Paris). The motif of Salome bringing in St John the Baptist's head on a platter was immensely successful (mosaic, c.1350, Baptistry, St Mark's, Venice; Caravaggio, 1606-7, National Gallery, London; G.-B. Caracciolo, early seventeenth century, Uffizi, Florence).

Cross-reference: John the Baptist.
Bibliography: B. Vitaletti, *Salome nella leggenda e nell'arte*, Rome, 1908.

SAMSON

Italian: Sansone; Spanish: Sanson; French and German: Samson.

TRADITION

A Biblical hero of colossal strength, Samson embodied the Israelites' struggle against the Philistines. His life and deeds were recounted in the Book of

Judges (13-16). His strength was illustrated in a number of episodes: he tore a lion in half with ease (14:6); he set his enemies' corn on fire by loosing three hundred foxes with firebrands on their tails into the fields (15:4-5); after freeing himself from his bonds, he slaughtered a thousand Philistines with the jawbone of an ass (15:14-16).

The most famous episode concerns Samson and Delilah (16:4-22). Discovering that Samson's strength lay in his long hair, she betrayed him to the Philistines who shaved off his "seven locks", blinded him (16:19) and amused themselves by setting him to turn a millstone. According to the Christian interpretation, Samson's misfortune prefigured the Mocking of Christ. Samson's hair having grown again, he tested his renewed strength by uprooting a tree. The Philistines took him to a temple dedicated to their god, Dagon, but Samson had his revenge by pulling down two columns with his bare hands, destroying the temple and killing both himself and all the Philistines (16:26-31). This narrative was interpreted symbolically by medieval commentators. Samson's fight with the lion heralded Christ's triumph over demonic powers and death; his victory over the Philistines announced the Resurrection, Christ emerging from his sepulchre and putting the forces of evil to flight. In the middle ages, Samson was often linked to Hercules.

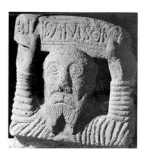

Samson
St Géraud, Aurillac, Cantal.

REPRESENTATION AND ICONOGRAPHY
Traditionally, Samson is shown as a long-haired man in the prime of life. He is normally bearded, but can also be beardless in cycles which stress his youth. From the fifteenth century onwards, he is often shown naked (Ghiberti, 1403-24, bronze doors, Baptistry, Florence). Dürer has him wearing a lionskin and clearly assimilates him to Hercules (engraving, c.1497). The figure of Samson is often employed to decorate pulpit supports.

The Combat between Samson and the Lion (14:6)
The hypothesis of any connection between Samson and the iconography of Mithra killing the bull has been definitively rejected. In the earliest depictions, Samson is shown standing in front of the lion and either suffocating it or cutting its throat (catacomb, Via Latina, Rome, fourth century). Occasionally he is shown, as the Bible implies, dislocating the animal's jawbone. In the middle ages, he "rents" the lion by kneeling on its back (stained glass, Sainte-Chapelle, thirteenth century, Musée de Cluny, Paris). Giovanni Pisano places this episode opposite Samson and Delilah (c.1278, Fontana Maggiore, Perugia).

Samson Slaying One Thousand Philistines (15:14-16)
The scene is sculpted on the north door of Chartres Cathedral (thirteenth century) and is a frequent subject (especially in sculpture: Giambologna, two-figure marble, 1565-7, Victoria and Albert Museum, London).

Samson and Delilah (16:4-22) *see* Delilah.

Samson Destroying the Temple (16:25-31)
This is a common subject in the Renaissance (Bartolommeo Bellano, relief, 1483-4, S. Antonio, Padua).

Cycles
These appear at an early date (catacomb, Via Latina, Rome, fourth century; pavement mosaics, S. Maria Maggiore, Rome, end fourth century) and remain

numerous in medieval French sculpture and in sixteenth-century Flemish painting.

Attributes: Jawbone of an ass. Club and lion's head (Renaissance). One or two columns.
Cross-reference: Delilah.
Bibliography: L. Réau, op. cit., vol. I, 1, pp. 236-48.

SAMUEL

The Prophet Samuel
Claude Vignon, seventeenth century (detail). Musée des Beaux Arts, Rouen.

Italian: Samuele: Spanish, French and German: Samuel.

TRADITION

The story of Samuel, the last of the Judges of Israel, is found in the First Book of Samuel. His mother Hannah was childless, but "the Lord remembered her" (1 Sam. 1:19-20) and she gave birth to a son, Samuel. He was taken while still a child to the temple at Shiloh and, called by God three times, was dedicated to the Lord by the priest, Eli. During a war which proved disastrous for the Hebrews, the Philistines captured the Ark of the Covenant, returning it seven months later (6:1). Samuel, as a man dedicated to God, was present at its recovery. The Philistines were finally defeated, leaving Samuel as Israel's spiritual and political head, to rule "Israel all the days of his life" (8:15). Under the inspiration of God, Samuel anointed Saul as the chief of the people of Israel: he took "a vial of oil and poured it upon his head and kissed him" (10:1). Israel later went astray, however, displeasing God who rejected Saul and ordered Samuel to fill his horn with oil and go instead to the house of Jesse, father of David (16:1). After Samuel's death, in an uncanny scene, his ghost was summoned up through a medium (the Witch of Endor) by Saul, who wanted his advice (28:7-25).

REPRESENTATION AND ICONOGRAPHY

The Consecration of Samuel in the Temple at Shiloh (1:24-28)
As a child, he is led before the priest Eli. God calls Samuel on three occasions (1:21-28). This episode occurs on a wall-hanging of the Life of the Virgin (sixteenth century, Reims Cathedral) and is interpreted as a prefiguration of the Presentation of Christ in the Temple.

The Capture and the Return of the Ark of the Covenant by the Philistines (5-6)
Artists concentrate on the events which persuaded the Philistines to dispose of the Ark. Their idol, Dagon, placed next to the "Ark of God", keels over and shatters. Poussin (*The Plague of Ashdod*, 1630-31, Louvre, Paris) shows the Hand of God bringing a plague upon the Philistines.

The Death of Agag (15:32-33)
During the war against the Amalekites, Samuel kills King Agag, whom Saul hopes to be able to spare. Agag begs for mercy but is hacked to pieces.

Saul and the Witch of Endor (28:3-25)
The witch evokes the spirit of Samuel which appears draped in a shroud before Saul (Salvator Rosa, 1668, Louvre, Paris).

Attributes: Lamb (offered as a sacrifice by Samuel). Horn (containing oil).
Cross-references: Ark of the Covenant, David.

The Resurrection. Hans Memling, triptych panel, second half of the fifteenth century. Louvre, Paris.

Jesus and the Woman of Samaria at the Well. Duccio, panel from the predella of the Maestà polyptych, 1308-11, Thyssen-Bornemisza Collection, Lugano.

Bibliography: L. Réau, op. cit., vol. II, 1, pp. 250-52.

SATAN *see* **DEVIL.**

SAUL (OLD TESTAMENT) *see* **DAVID, SAMUEL.**

SAW *see* **ISAIAH, SIMON (APOSTLE).**

SCALES *see* **LAST JUDGMENT, MICHAEL.**

SCALLOP *see* **JAMES THE GREAT (APOSTLE WITH STAFF), PILGRIM, ROCH (WITH DOG).**

SCEPTRE *see* **CUNEGUND (QUEEN WITH PLOUGHSHARE** *or* **MONEY-BAG), ECCE HOMO (REED SCEPTRE), EDWARD THE CONFESSOR (KING WITH RING), ELIZABETH OF HUNGARY (WITH LOAVES), GABRIEL (ARCHANGEL), LOUIS (KING WITH FLEUR-DE-LIS), RADEGUND (QUEEN WITH CROZIER), REVELATIONS, SOPHIA (WITH DAUGHTERS** *or* **THREE-TIERED CROWN).**

SCHOLASTICA *see* **BENEDICT.**

SCOURGE *see* **CATHERINE, FLAGELLATION, MOSES (PLAGUES), PLAGUES OF EGYPT.**

SCOURGING OF CHRIST *see* **FLAGELLATION.**

SEAL *see* **REVELATIONS.**

SEBASTIAN

Latin: Sebastianus; Italian: Sebastiano, Bastiano; Spanish: Sebàstian; French: Sebastien, Bastien; German: Sebastian.
Martyr. Died 288(?). Feast day 20 January (west), 8 December (east).

TRADITION
Sebastian, probably born in Milan, was martyred in Rome and buried in a

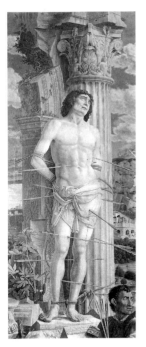

catacomb on the Appian Way, near the basilica which bears his name. The legend told in the fifth-century *Acts* embroiders upon these bald facts. Sebastian, it recounts, was an officer enlisted in Rome in 283. Diocletian named him Commander of the Praetorian Guard, unaware that he had become a Christian. Sebastian sustained the courage of the two imprisoned confessors, Mark and Marcellian, as well as that of other Christians persecuted for their faith. He did nothing to conceal his own evangelical work, and was arrested and sentenced to die by being shot with arrows by two soldiers. Irene, the widow of St Castulus the martyr, removed the still breathing saint to a safe place and treated his wounds. Once cured, Sebastian braved the Emperor once again; this time he was stoned and thrown into the biggest Roman drain, the *Cloaca Maxima*. He then appeared to a Christian woman in a dream and showed her where to find his corpse. She followed his instructions and buried Sebastian in the catacomb.

Sebastian, with SS. Martin and Maurice, is a soldier-saint and his cult was immensely successful in the middle ages. He was held to be able to prevent the plague, a characteristic which has been compared to an ancient belief that such epidemics resulted from arrows loosed by a divinity. In the *Iliad*, for example, Apollo was responsible for the scourge while, reading between the lines, the Bible had Jehovah bringing about the same events. However, Paul the Deacon attributed the end of the plague which laid Rome waste in 680 to the intercession of Sebastian; apparently, the saint had not been considered as a patron of the plague-stricken before this. After Peter and Paul, Sebastian is the third patron of Rome. He is also the patron saint of gunsmiths and is invoked not only against plague but also against epilepsy.

St Sebastian
Mantegna, 1480 (detail).
Louvre, Paris.

REPRESENTATION AND ICONOGRAPHY

Two types of depiction of St Sebastian exist. The earliest occurrence of the older type is a fifth-century fresco in the St Cecilia crypt in the catacomb of Callista, Rome. St Sebastian is shown among other figures dressed in togas. In the seventh century he wears golden armour over an embroidered tunic and carries a gem-studded crown (mosaic, S. Pietro in Vincoli, Rome, where he is elderly and bearded). He can wear Roman garb, or else be dressed as a knight or some other figure from medieval courtly literature (Benozzo Gozzoli, *Scenes from the Life of St Augustine*, 1465, S. Antonio, San Gimignano). In a composition which can be linked to the Virgin of All Mercy, Sebastian is shown sheltering the inhabitants of the city from the arrows of the plague which Jesus flings from heaven. He can also appear as a middle-aged Roman soldier with white hair and beard, wearing a breastplate and armed with a heavy javelin (*pilum*), short sword and shield (fresco, attributed to Pietro Cavallini, thirteenth century, apse of S. Giorgio in Velabre, Rome).

A second type appeared in the thirteenth century and became pervasive by the fifteenth (Jean Bourdichon, *Hours of Anne of Brittany*, 1508, Bibliothèque Nationale, Paris). In the west, artists competed in depicting him as a handsome and naked young man pierced with arrows. He can be shown attached to a column (Rogier van der Weyden, *Last Judgment Altarpiece*, 1445-50, Musée de l'Hôtel-Dieu, Beaune, France). In the Italian Renaissance, numerous artists treated the theme (Botticelli, c.1473, Berlin-Dahlem Staatliche Museen, Berlin; Polloaiuolo brothers, c.1475, National Gallery, London; Mantegna, 1481, Louvre, Paris). A variant is represented by Piero della Francesca. A naked St Sebastian, peppered with arrows, is not tied to a stake or to a tree, but simply stands with his hands bound behind his back

(*Madonna of Mercy Polyptych*, Pinacoteca Communale, San Sepolcro). Occasionally, Irene, in the guise of a Benedictine nun, is shown removing arrows from Sebastian's body (Georges de La Tour, 1649, Berlin-Dahlem Staatliche Museen, Berlin and Louvre, Paris; Nicolas Regnier, first half of the seventeenth century, Ferens Art Gallery, Hull, England; Paul Troger, mid-eighteenth century, Osterreiche Gallerie, Vienna).

The Spanish school shows a clothed Sebastian who is not a centurion, but a hunting squire, carrying bow and arrows (Francisco Pacheco, 1616, formerly Alcal de Guadaira, Spain).

Attributes: Arrows. Bow.
Bibliography: H. Delehaye, *Les légendes grecques des saints militaires*, Paris, 1909.

SECOND COMING *see* ASCENSION.

SIEVE *see* BENEDICT.

SEPULCHRE *see* ENTOMBMENT, HOLY WOMEN AT THE SEPULCHRE.

SERAPH *see* CHERUB AND SERAPH.

SERPENT

The snake or serpent is present throughout the Bible, symbolizing evil and Satan. Occasionally, as in Revelations, he is presented in the guise of a dragon, but the idea remains the same. When a figure is shown trampling on a serpent, it represents the triumph of sainthood over the demon. In this role, the serpent is the attribute of numerous saints. In secular iconography, the snake is sometimes allied to knowledge and prudence, a characteristic also present in Christian imagery, but to a lesser extent.

Cross-references: Adam and Eve, Benedict (Benedictine with snake in goblet), Christina of Bolsena (snakes and millstone), Devil, Dragon, John (emerging from goblet), Moses (brazen serpent), Patrick (chasing snakes with a stick), Paul (bitten by snake), Philip (with idol), Revelations.

SET-SQUARE *see* THOMAS.

SHEBA (QUEEN OF)

Italian: Regina di Saba; Spanish: Reina de Saba; French: reine de Saba; German: Königin von Saba.

TRADITION

The Queen of Sheba's visit to Solomon is recounted in the First Book of Kings (10:1-13) and in the Second Book of Chronicles (9:1-12). Jesus announces her coming at the Day of Judgment (Matt. 12:42; Luke 11:31): "the queen of the south shall rise up in the judgment with the men of this generation and condemn them; for she came from the utmost parts of the earth to hear Solomon". Biblical exegetes interpreted the Queen of Sheba as prefiguring the Church of the Gentiles (as against the Church of the Synagogue), the bride of Christ, that new Solomon "greater than Solomon". The homage paid Solomon by the queen is seen as heralding the Adoration of the Magi. One legend of the queen's journey describes how she crossed a lake on a plank made of wood from the Tree of Knowledge – wood which was later employed in making the Cross. This legend forms part of the elaborate cycle of the True Cross.

REPRESENTATION AND ICONOGRAPHY

Since the twelfth century, the Queen of Sheba is shown standing and wearing her crown. She holds a roll of papyrus or a vase, which stand for her gifts. She is often joined by King Solomon (Lorenzo Ghiberti, 1403-24, bronze doors, Baptistry, Florence). At the north door of Chartres Cathedral, she stands on a console in the shape of a black woman. At the west door at Amiens, she is linked with the Three Kings. From the twelfth century, her meeting with Solomon is illustrated frequently in Bibles. The king, who can be shown standing or kneeling, pays homage to the queen as she sits on a throne: this has been the favourite subject of artists from the sixteenth century.

The Queen of Sheba's journey is a rare subject before the end of the mid-

The Queen of Sheba Adoring the Cross
Piero della Francesca, 1460 (detail). S. Francesco, Arezzo.

dle ages. It can be combined with the legend of the True Cross (Piero della Francesca, 1460, S. Francesco, Arezzo; Claude Lorrain, 1648, National Gallery, London, in an elaborate seascape).

Cross-references: Magi, Solomon.

SHEEP *see* GOOD SHEPHERD.

SHELL *see* AUGUSTINE (WITH CHILD), JAMES THE GREAT (SCALLOP), MICHAEL (ANGEL), ROCH (WITH DOG *or* BUBO).

SHEPHERD *see* ANNUNCIATION TO THE SHEPHERDS, GOOD SHEPHERD, CAIN AND ABEL.

SHEPHERDESS *see* GENEVIEVE, JOAN OF ARC, PASTRIX BONA.

SHIELD *see* SEBASTIAN (WITH ARROWS IN BODY), THEODORE (ROMAN SOLDIER *or* KNIGHT), WENCESLAS (CROWNED KNIGHT).

SHOE *see* CRISPIN AND CRISPIAN.

SHROUD *see* HOLY WOMEN AT THE SEPULCHRE, LAZARUS (RAISING OF), VERONICA.

SIBYL

Italian: Sibila: French and German: Sibylle.

TRADITION

In the ancient world, the Sibyls were women with the gift of prophecy. Their myth arose first in Asia Minor before passing to Rome via Greece. In the west, Pythia, priestess of the Apollonian oracle at Delphi, was known to be proficient in predicting the future. Antiquity recognized ten Sibyls, which were later adopted by the Fathers of the Church who added two more and interpreted their prophecies as heralding the coming Christ.

For St Augustine, the Sibyls fulfilled for the pagan world the same oracular function as the Old Testament Prophets, whose utterances have also been deciphered as annunciations of the advent of Christ on Earth. Just as the

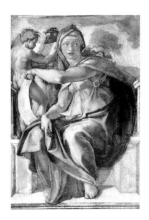

The Delphic Sibyl
Michelangelo, 1509 (detail).
Sistine Chapel, Vatican.

The Erythraean Sybil
Lucas van Leyden,
beginning of the sixteenth
century. Kunstsammlungen
der Veste, Coburg.

Jewish world contributed to Christian revelation, so the pagans – Gentiles admitted to the Church by St Paul – had been mysteriously foretold of the Messiah who would come. The Sibylline Oracles and other Sibylline collections began to appear from the second century AD and contributed much to Jewish and Christian thought alike. It was in this guise that the Sibyls held a major place in the western artistic imagination.

REPRESENTATION AND ICONOGRAPHY

Medieval depictions of the Sibyls are designed to prove the messianic nature of Jesus Christ and to show that the pagan world too furnished evidence of the Christian message.

The Sibyls in Isolation

Medieval art treated two Sibyls in particular: the Erythraean and the Tiburtine. The oldest, the Erythraean, is cited in the thirteenth-century *Dies Irae*: "*Teste David cum Sibylla*" – that is, like David, the Sibyl predicted the end of the world. If, in the thirteenth century, the Erythraean Sibyl was associated with the Last Judgment, in the fifteenth she was linked to the Annunciation. She can be identified by an inscription on a scroll (fresco in the Church of S. Angelo in Formis, near Capua). She is accompanied by Biblical kings and prophets, and carries a scroll bearing a quotation from St Augustine. Simply dressed, she places her foot on a celestial globe to show her scorn for pagan wisdom.

The day of the Nativity of Christ, Emperor Augustus, who had gone to ask the Tiburtine Sibyl whether he should accept deification, was graced with a vision of the Virgin and Child. This legend is closely linked to the founding of the Roman Church of Ara Coeli. The theme of the Sibyl and Emperor Augustus remained popular from the thirteenth to the sixteenth centuries. Rogier van der Weyden illustrated the appearance of the Virgin and Child to the Sibyl and Emperor (*Nativity Triptych*, 1450-60, Berlin-Dahlem Staatliche Museen, Berlin). The Virgin can be replaced by a cross surmounting the chrismon (Ghirlandaio, end of the fifteenth century, fresco, S. Trinità, Florence).

Very often, there is no inscription allowing a particular Sibyl to be identified (the Ingeburghe Psalter, 1210, Musée Condé, Chantilly, has a crowned Sibyl in the Tree of Jesse with the Old Testament Prophets; Nicolas Regnier, c.1650, Accademia, Venice, shows the Sibyl as a portrait of one of the artist's daughters).

Groups of Sibyls

Since the early medieval period, the Sibyls have always been associated with the Old Testament Prophets (Ambrosius Benson, The *Virgin with Prophets and Sibyls*, second quarter of the sixteenth century, Koninklijk Museum voor Schone Kunsten, Antwerp). As there were twelve Prophets, the number of Sibyls was often increased to that figure. They are occasionally shown grouped with a number of pagan philosophers (manuscript of Rabin Maur, eleventh century, Monastery of Monte Cassino: ten Sibyls and ten Philosophers). The mosaic pavement in Siena Cathedral (c.1370-80) is a famous Sibylline ensemble. Figures of the Sibyls became immensely successful in Italian Renaissance art where they were interpreted as the heralds of Christ (Raphael, 1514, S. Maria della Pace, Rome; Michelangelo, 1508-12, Sistine Chapel, Rome).

Attributes:

Erythraean Sibyl: Celestial globe. Sword (symbol of divine retribution). Lamb.

Rose (referring to the Annunciation).
Tiburtine Sibyl: Tiger skin or goatskin. Stick.
Cumaean Sibyl: Book (she was meant to have written a vanished collection of oracles, the *Sibylline Books*). Rich clothing.
European Sibyl: A young, richly dressed princess. Sword (referring to the Massacre of the Innocents).
Libyan Sibyl: Young, dressed in blue. Crown of roses or lighted altar candle (announcing Christ, the Light of the World). Laurels and broken chain (symbolizing the end of the Jewish Law).

Cross-references: Annunciation, Magi, Tree of Jesse.
Bibliography: E. Mâle, *L'Art religieux de la fin du Moyen Age en France*, Paris, 1949; *L'Art religieux du XIIIème siècle en France*, Paris, 1958.

SICKLE *see* ISIDORE.

SIMEON *see* PRESENTATION OF OUR LORD IN THE TEMPLE.

SIMON

Italian: Simone; Spanish, French and German: Simon.

Among the New Testament individuals called Simon (other than the Apostle) are the two figures in the Gospels who invited Jesus to share a meal. Simon the Pharisee received Jesus in his home. While they were at table, a sinner, occasionally taken wrongly to be Mary Magdalene, came and poured ointment over Jesus' feet (Luke 7:40-50). Simon the Leper, who should perhaps be identified with Simon the Pharisee, also invited Jesus to share a meal shortly before the Entry into Jerusalem (Matt. 26:6; Mark 14:3). During this meal, Mary of Bethany, sister of Lazarus, poured precious ointment over Jesus' head. A third Synoptic figure also bears this name: Simon of Cyrene, compelled to carry Christ's Cross on the way to Golgotha (Matt. 27:32; Mark 15:21; Luke 23:26).

SIMON (APOSTLE)

Italian: Simone Apostolo, lo Zelote; Spanish: Simon; French: Simon le Zélote; German: Simon Zelotes.
Apostle. First century. Feast day 28 October (west), 1 July (east).

TRADITION
Simon the Apostle is called the Zealot in both the Gospel according to St Luke (6:15) and in Acts (1:13). This name, transcribed from the Greek, is a translation of the Aramaic *gan'anai*, signifying the apostle's membership of an extremely orthodox Jewish sect. Because he came from Cana, he is also known as the Canaanite or Cananaean. Like the other apostles, after Pentecost Simon vanished from view. Most or less trustworthy legends place his missionary work in Egypt. According to a sixth-century apocryphal tradition, he preached the Gospel in Persia with Jude (Judas Thaddaeus), where they

St Simon
Dürer, 1523. Bibliothèque
Nationale, Paris.

311

were both martyred. Found guilty of overturning statues of the idols at the end of an argument with pagan priests and magicians, their throats were cut. According to another version, Simon was sawn in two, like the prophet Isaiah.

REPRESENTATION AND ICONOGRAPHY

A twelfth-century relief designates Simon by the inscription, *Cananaeus* (cloister at Moissac). In numerous depictions, Simon is linked with Jude (Luis Borrassa, *St Clare Altarpiece*, 1414, Museum, Vich, Spain). The most common scenes including both apostles are the toppling of the idols (from which, according to the *Golden Legend*, emerge two "naked and black" Ethiopians) and their martyrdom. Simon was tied to a wheel while two executioners cut through his chest with a bucksaw (capital, Collegiate Church at St Aubin, Guérande, twelfth century). In the sixteenth century, Dürer shows Simon carrying a saw (engraving, 1523, Bibliothèque Nationale, Paris).

Before the thirteenth century, the Apostle is shown holding a scroll or a book. The saw appears as a specific attribute only later, becoming predominant by the 1400s. In the seventeenth century, however, Simon the Zealot is occasionally shown leafing through a book.

Attributes: Book. Saw (since the fifteenth century). Sword or spear (of martyrdom, very rare).
Cross-reference: Apostles.
Bibliography: E. Mâle, *Les Saints Compagnons du Christ*, Paris, 1958.

SIMON OF CYRENE *see* CRUCIFIXION.

SIMON PETER *see* PETER.

SINAI *see* AARON, EXODUS, MOSES.

SKULL *see* BRUNO (WHITE HABIT), CATHERINE OF SIENA (DOMINICAN WITH LILY), CRUCIFIXION (AT BASE OF CROSS), DENIS (SLICE OF SKULL *or* HEAD), JEROME (WITH LION), MARY MAGDALENE (LONG-HAIRED, IN GROTTO), THOMAS BECKET (TOP OF SKULL WITH SWORD).

SLING *see* DAVID.

SNAKE *see* SERPENT.

SODOM AND GOMORRAH *see* ABRAHAM, LOT.

SOLOMON

Italian: Salomone; Spanish: Salomón; French: Salomon; German: Salomo.

TRADITION

Solomon, sixth son of King David, was the favourite of his mother Bathsheba, who had him blessed by David and chosen as successor to the throne. The prophet Nathan later anointed him king (1 Kings 1:32-40). His wisdom was renowned: "And Solomon's wisdom excelled the wisdom of all the children of the east country" (1 Kings 4:30). His power was measured by his numerous wives who led him into idolatry abominable in God's eyes. His might was also manifested by his building of the Temple in Jerusalem and the visit made to him by the Queen of Sheba. Solomon was the reputed author of the Book of Proverbs, Ecclesiastes and the Song of Solomon. His wisdom is illustrated by the famous Judgment of Solomon, concerning a conflict between two prostitutes about which of them was the mother of a disputed child (1 Kings 3:16-28).

In the east, Solomon was credited with magic powers. He vanquished certain demons thanks to Solomon's Seal, a six-pointed star. Christian exegesis saw in him a prefiguration of Christ: his arrival at Gihon to be anointed as king was an annunciation of Christ's Entry into Jerusalem, while his adjudication between the two women heralded the Last Judgment.

REPRESENTATION AND ICONOGRAPHY

In western art, Solomon often appears among the ancestors of Christ in the Tree of Jesse, accompanied by his father David. He is often linked to the Queen of Sheba and to Marian Iconography.

The Crowning of King Solomon (1 Kings 1:38-39)

Sitting astride King David's mule, Solomon makes his entrance into Gihon as Christ does later into Jerusalem (large rose window, façade of Reims Cathedral, thirteenth century). In a ceremony reminiscent of the coronation of the sixth- and seventh-century Merovingian kings, as he is crowned he is lifted high up on a shield.

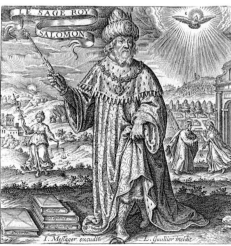

The Temple of Solomon
Bibliothèque Nationale, Paris.

King Solomon the Wise
I. Messager, seventeenth century. Bibliothèque Nationale, Paris.

The Judgment of Solomon (1 Kings 3:16-28)

Two prostitutes living in the same house both give birth to children. One accidentally suffocates her infant while he sleeps, then claims that the other woman's child is her own. The two mothers ask Solomon to decide to whom the surviving child really belongs. The king asks for a sword and announces that he will cut the child in two and "give half to the one and half to the other". One of the prostitutes cries out, "O my lord, give her the living child and in no wise slay it," and Solomon in his wisdom realizes that she is the real mother. Since the fourth century, this theme has been represented countless times (Bonifazio, 1533, Accademia, Venice). Poussin claimed that his best painting was a treatment of this subject (1649, Louvre, Paris).

The Building of the Temple (1 Kings 5:15-32)

This theme was illustrated in the fifteenth century by Jean Fouquet in an illumination, showing the Temple as a Gothic cathedral, topped by a kind of cupola (*Antiquités judaïques*, before 1475, Bibliothèque Nationale, Paris).

The Visit of the Queen of Sheba (1 Kings 10:1-13) *see* Sheba (Queen of).

Solomon's Idolatry (1 Kings 11:4-8)

In his old age, King Solomon, under the influence of his innumerable wives, turned away from the One True God and sacrficed to both Moloch and Astarte. He is shown kneeling in front of the idol, a woman at his side. The scene can be associated with the story of Samson and Delilah (embroidery, sixteenth century, Kunsthaus, Zürich).

Cross-references: David, Entry into Jerusalem, Last Judgment, Sheba (Queen of), Tree of Jesse.
Bibliography: L. Réau, op. cit., vol. II, 1, pp. 287-97.

SOPHIA

St Sophia and her Three Daughters
Slovak Master, *Partizanskka Altarpiece*, c.1430. Slovensk Narodni Galeria, Bratislava.

Greek: Hagia Sophia; Latin: Sapienza, Sofia; Spanish: Sofia; French: Sophie; German: Göttliche Weisheit.
Martyr. Feast day 30 September; her children, 1 August.

LIFE AND LEGEND

Sophia, the personification of divine – and, in particular, Christic – knowledge, was intensely revered in Byzantium and in Slav countries. Justinian dedicated to her name the most impressive church in Constantinople, the Hagia Sophia (seventh century). Sophia had three daughters: Faith, Hope and Charity. All four suffered martyrdom; Faith was placed on a gridiron and burnt with molten wax and boiling oil. Sophia encouraged her daughters throughout their passion before dying last. These events were supposed to have occurred at Rome under Emperor Hadrian. The cult of Sophia and her daughter, Faith, is particularly strong in Alsace. It was attested in Rome by the sixth century.

REPRESENTATION AND ICONOGRAPHY

In Byzantium, St Sophia resembles an angel. Wearing a bejewelled crown and carrying a sceptre, she sits on a throne. In the west, she is shown in the guise of an austere Roman matron wearing a three-tiered crown. She is enthroned between her three daughters (fresco in the grotto of the Saviour at

Vallerano, c. tenth century). Faith may be shown with her griddle, the attribute of St Faith of Agen.

The three daughters at Sophia's feet each carry the instrument of their martyrdom (triptych, c.1460, Muzeum Narodni, Warsaw). In the fifteenth century, Sophia, resembling the Virgin of All Mercy, shelters her daughters beneath the folds of her mantle (painted wood sculpture group, Church at Eichau, near Strasbourg).

Attributes: Crown (three-tiered or with gemstones). Sceptre. Three daughters.
Cross-reference: Faith.
Bibliography: G. de Tervarent, "Contribution à l'iconographie de sainte Sophie et de ses trois filles", *Analecta Bollandiana*, 68, 1950, pp. 419-23.

SPADE *see* FIACRE, NOLI ME TANGERE.

SPEAR *see* LANCE.

SPRINKLER *see* MARTHA.

STAG

From very early times, the stag was considered both as an image of Christ and as an attribute of the catechumen, ready to slake its thirst at the Lord's spring. As such, the stag occurs in many early Christian works of art. At a later date, it symbolizes both moral uprightness and longevity. The stag is also naturally the attribute of a number of huntsman saints.

Cross-references: Eustace (stag with cross, and Roman soldier), Hubert (stag with cross, and knight), Julian (without cross), Paradise.

STANISLAUS

Italian: Stanislao; Spanish: Estanislao; French: Stanislas; German: Stanislaus. Bishop and Martyr. c.1030-79. Canonized 1254. Feast day 11 April.

TRADITION

Stanislaus, consecrated Bishop of Cracow in 1072, soon quarrelled bitterly with the bloodthirsty and lascivious King Boleslaus II, whose excommunication had been demanded by the Polish noblemen. Boleslaus countered by accusing Stanislaus of extorting land from a certain Peter, who had died of chagrin as a result. Stanislaus raised Peter from the dead, thereby enabling him to witness to Stanislaus' honesty before a court, but the king himself killed the bishop who had so resolutely defended the rights of the Church. St Stanislaus' fate has often been compared to that of Thomas Becket. Stanislaus is one of the patron saints of Poland.

St Stanislaus
Studio of the Master of St John the Almsgiver, 1500 (detail). Wawel National Art Collection, Cracow.

REPRESENTATION AND ICONOGRAPHY

These are innumerable in Poland and in eastern Europe. Stanislaus is always depicted as a bishop. Often the dead man he resuscitated lies at his feet (altarpiece, sixteenth century, Fine Arts Museum, Wroclaw). He is often linked to other Polish patrons such as Sigismund, Casimir, Hyacinth (Iazech) or to Ignatius Loyola.

Cross-reference: Wenceslas.
Bibliography: M. Walicki, *La Peinture d'autels et de retables en Pologne*, Paris, 1937.

STAR

The star is one of the most ancient symbols of the divine. The Bible and the Christian faith both employ this symbol a great deal: the star which guides men through darkness is God's star, showing them the true path. The star may also mark a recent happening, or herald an event to come, and as such has a particular connection with the Messiah. The most famous is the star which leads the three Magi. It alludes to a prophecy in the Book of Numbers: "There shall come a star out of Jacob; and a Sceptre shall rise out of Israel" (24:17).

On the forehead of certain saints, or hovering above them, the star is a sign of their innocence. Twelve stars stand for the twelve tribes of Israel or else for the twelve apostles. All these stars are in general five-pointed. The star of David (the Magen David), which has become the symbol of Judaism, has six points.

Cross-references: Annunciation to the Shepherds, Apostles, Balaam (man on ass), Creation, Dominic (on forehead of child), Francis of Assisi (with stigmata), Hugh of Grenoble (seven stars), Magi, Mary.

STEPHEN

Latin: Stephanus; Italian: Stefano; Spanish: Esteban; French: Etienne; German: Stephan.
Protomartyr. First century. Feast day 26 December.

LIFE AND LEGEND

St Stephen's story is told in the Acts of the Apostles (6; 7:55-60). Stephen is selected as one of the "Seven men of honest report, full of the Holy Ghost and wisdom" (6:3) – the seven deacons, who are chosen to "serve tables" (i.e. distribute alms). Accused of speaking blasphemous words against the God of Moses, he was taken before the Sanhedrin. His accusers, incensed at hearing him assert that he saw "the heavens opened, and the Son of man standing on the right hand of God" (7:56), expel him from the town and stone him. The text makes clear that the witnesses to the charges had laid their clothes at the feet of a young man called Saul who "was consenting unto his death" (8:1). This Saul was of course St Paul before his conversion on the road to Damascus. *The Legend of St Stephen Protomartyr* (tenth century) tells how he was kidnapped at his birth by Satan and rescued by a bishop, Julian. The history of his relics and their translation is also rich in legend.

REPRESENTATION AND ICONOGRAPHY

Stephen is always depicted as a young man without a beard. He wears the deacon's dalmatic and stole and holds the Gospels in his hands (statue on the pier at the main door of St Etienne in Sens). Since the twelfth century, he also carries – in his hands, balanced on his head or placed on a book – one or more stones alluding to his death. He is often shown in the company of two other deacons, St Vincent and St Laurent.

The most frequent scene depicted shows the stoning. Three frescoes of the Carolingian period show his preaching, judgment and stoning (crypt at St Germain, Auxerre, c. tenth century). In front of a stylized town, two figures are shown brandishing a stone in Stephen's direction. The saint stands and turns towards a Hand of God emerging from the sky. Elsewhere, Stephen is represented kneeling, his eyes staring up into heaven, being beaten to death by men armed with rocks (Cortona, c.1660, Hermitage, St Petersburg). At Notre Dame, Paris, the south door tympanum (thirteenth century) treats all the episodes of St Stephen's life, including the reception of his soul into heaven by God. Fra Angelico (1445-55, Vatican, Rome) and Carpaccio (1511-20, Brera, Milan; Louvre, Paris; Staatsgalerie, Stuttgart; Staatliche Museen, Berlin-Dahlem) both dedicated series of paintings to him. Other cycles include legendary scenes and the history of the saint's relics (gothic wall-hangings, end fifteenth century, Musée de Cluny, Paris; Juan de Juanes, five extant paintings of the life, third quarter of the sixteenth century, Prado, Madrid, and J. van Scorel, 1540-41, Musée de la Chartreuse, Douai). Jean Fouquet's *Madonna and Child* (Melun Diptych), c.1450, Staatliche Museen, Berlin-Dahlem) shows Estienne Chevalier, the patron, and his saintly namesake. Annibale Carracci also composed a martyrdom (1604, Louvre, Paris).

Attributes: Stones. Dalmatic. Stole.
Cross references: Deacon, Laurence, Vincent of Saragossa.

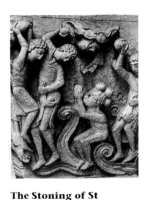

The Stoning of St Stephen
Capital, twelfth century,
St Lazare Cathedral, Autun.

STICK *see* CHRISTOPHER (STAFF AND INFANT JESUS), COLUMBAN (MONK WITH WALKING STICK), JOSEPH OF NAZARETH (STAFF), LAZARUS (RAISING OF) (CHRIST WITH STICK), MULTIPLICATION OF THE LOAVES AND FISHES, PATRICK (USED AGAINST SNAKES).

STIGMATA

A stigma is a trace left on the skin by a wound or by disease. In a devotional context, the plural *stigmata* designates marks similar to those of the five wounds of Christ Crucified. St Francis of Assisi was stigmatized on his hands, his feet and his right side on Mount La Verna in 1224.

Cross-references: Catherine of Alexandria, Francis of Assisi.

STONING *see* JEREMIAH, STEPHEN.

SUSANNA

Latin and German: Susanna; Italian: Suzanna; Spanish: Susana; French: Suzanne.

TRADITION

The story of Susanna and the Elders occupies Daniel 13 (Apocrypha). Two salacious "ancients of the people" (13:5), seeing Susanna – the wife of a wealthy man called Joachim – bathing in her garden, were "inflamed with lust toward her" (13:8). The elders demanded favours of her, but were rebuffed. This enraged the "powerful judges", and they accused her of a crime: they claimed to have surprised her in her garden lying in the arms of a young man beneath a tree. Daniel, charged with elucidating the affair, elicited contradictory evidence from the two elders, thus exonerating Susanna.

Numerous theological commentaries have been devoted to this narrative. Tertullian, Ambrose and Augustine all interpreted the story symbolically. As early as the paleochristian period, "chaste Susanna" was held to stand for a saved soul. Later, she symbolized the Church slandered by both Jew and pagan. Though the emphasis is normally placed more on the innocence of the accused than on the wisdom of the judge, comparison of Daniel's role with the Judgment of Solomon is occasionally made.

REPRESENTATION AND ICONOGRAPHY

The Susanna cycle developed fully from the the fourth century onwards (three scenes in the catacomb of Priscilla, Rome). It comprises the two elders plotting; their accusing of Susanna; the condemnation of the elders; the acquitted Susanna, with Daniel; an elder before his execution. The two central episodes are Susanna in the bath and the stoning of the elders.

Susanna in the Bath (Dan. 13:15-20)

The scene had a symbolic meaning in paleochristian and medieval art and was initially treated with delicacy and restraint. After the fifteenth century,

Susanna and the Elders
Tintoretto, 1557.
Kunsthistorisches Museum,
Vienna.

however, artists began expoliting the theme for its erotic potential (Veronese, second half of the sixteenth century, Louvre, Paris; Francesco Trevisani, 1709, Collection Weissenstein, Pommersfelden, Germany).

The Judging of Susanna and the Stoning of the Two Elders (13:50-62)
The youthful Daniel sits on a throne between Susanna and her accusers (stained glass, sixteenth century, Church at Brou, Ain). The two elders are tied back to back, and stoned (Altdorfer, 1526, Alte Pinakothek, Munich).

Cross-reference: Daniel.

SWAN *see* HUGH OF LINCOLN.

SWORD

The sword is not only the symbol of authority and justice which Christ carries at the Last Judgment, but also the attribute of the numerous saints who were martyred by its use (Agnes, James, Jude, Matthias, Martha and, above all, Paul). This weapon is also associated with law and might (the latter serving to enforce the former) and, for this reason, it is one of the attributes of God's representatives in the form of the sword of Jehovah or of Gabriel, head of the celestial host. Sometimes, God's word can be compared to a sword (Eph. 6:17 and Rev.1:16), and can therefore be depicted by it. Finally, when the sword transfixes the heart of certain figures – the Virgin Mary, for instance – it symbolizes extreme suffering or great emotion.

Cross-references: Agnes (long hair and lamb), Apostle, Catherine of Alexandria (wheel or crown), Elijah (flaming sword), George (horseman with dragon), James the Greater (with scallops), Joan of Arc (female warrior), Judith (with Holofernes' head or bag), Last Judgment (held by Christ), Lucy (with eyes on platter), Martin (cutting cloak), Matthew (with book or angel), Michael (archangel with demon), Paul (beheaded), Sibyls, Simon (apostle), Thomas Becket (in church), Vitus (with cauldron or globe).

SYNAGOGUE *see* CHURCH AND SYNAGOGUE.

TABLES OF THE LAW *see* GOLDEN CALF, MOSES.

TAU

The tau is the Greek letter τ. During the early persecutions, Christians adopted it as a symbol of the Cross. The tau is also the attribute of St Antony and St Francis. The T-shaped cross appears in the legend of a number of saints in the form of a kind of cane or a crutch.

Cross-references: Antony the Great (with pig, raven or hermit), Francis of Assisi (with stigmata), Plagues of Egypt (blood on doors at Passover).

TEMPTATIONS OF CHRIST

Italian: Tentazione di Cristo; Spanish: Tentaciónes de Cristo; French: Temptations du Christ; German: Versuchung Christi.

TRADITION

Christ was subjected to temptation on more than one occasion. In concluding the narrative of the Multiplication of the Loaves and the Fishes, Matthew recounts how the people recognized Christ as the Prophet, as the new king who would revive the power of Israel: "And when he had sent the multitudes away, he went up into a mountain apart to pray" (Matt. 14:23).

In the wilderness, to which Jesus retired after his baptism, he was tempted three times (Matt. 4:1-11). Christ was hungry after a forty-day fast; the tempter addressed him, saying, "If thou be the Son of God, command that these stones be made bread." But Jesus replies: "Man shall not live by bread alone, but by every word that proceedeth out of the mouth of God." Later, taken to the top of the Temple of Jerusalem, Christ was invited to jump off, Satan asserting that angels would protect him from harm. "It is written again," Jesus

Christ Tempted by the Devil
Miroir de l'humaine Salvation, fifteenth century. Musée Condé, Chantilly.

St Sebastian. Mantegna, 1480. Louvre, Paris.

The Healing of Tobit. Jan Metsys, middle of the sixteenth century. Musée de la Chartreuse, Douai.

retorted, "Thou shalt not tempt the Lord thy God." Finally, high up on the summit of a mountain, the Devil offered to give him the kingdom of the world, whereupon Jesus cried out, "Get thee hence, Satan." These temptations were reputedly prefigured in the trials and tribulations of Israel during the Exodus: the forty days in the desert equalling the first temptation; the crossing of the Red Sea, the Baptism of Christ; the mountain from which Moses saw the Promised Land, the mountain of the third and last temptation.

REPRESENTATION AND ICONOGRAPHY

No depiction of these episodes predates the Carolingian period (ninth to the tenth centuries). In the eleventh century, the two temptations were presented together (mosaic in the Basilica of St Mark's, Venice). The demon is a kind of black dwarf with wings. In the fourteenth century, Duccio takes up the theme (back of a panel from Siena Cathedral, Maestà, 1308-11, Frick Collection, New York). Christ, accompanied by two angels, rejects the tempter's offerings. Occasionally, the demon is of hideous appearance, with cloven feet and horns coming out of his forehead. By the end of the middle ages, however, he has managed to conceal himself beneath a monk's habit (Botticelli, fresco, 1481-82, Sistine Chapel, Rome, where the Devil is dressed as a Franciscan). In the sixteenth century, Lucas van Leyden (engraving, 1518) shows Satan, in a monkish frock with his cloven feet peeking out, wearing a kind of cap resembling that of a medieval fool. The demon offers a stone to Jesus, who pushes him away with his right hand. Christ is very nearly always shown standing, although there is an example of him sitting on a tree trunk framed by two demons (capital, Church at Plaimpied, Cher, thirteenth century).

Cross-references: Baptism of Christ, Devil, Exodus.
Bibliography: L. Réau, op. cit., vol. II, 2, pp. 304-10.

TEN PLAGUES OF EGYPT see PLAGUES OF EGYPT.

TERESA OF AVILA

Variant: Theresa. Italian: Teresa di Gesù; Spanish: Teresa de Jesùs, de Avila; French: Thérèse d'Avila; German: Teresa von Avila.
Mystic, Doctor of the Church. 1515-82. Canonized 1622. Feast day 15 October.

LIFE AND LEGEND

Born in Avila in 1515, Teresa of Jesus entered the Carmelite convent of the Incarnation in that town aged 18. Her *Life* tells of her visions and ecstasies. A great mystic, she was also notable for her elevated philosophy and her intensely active life. She managed to reform the Discalced Carmelite Order, founding the first reformed house, dedicated to St Joseph, in Avila in 1562. The many ecstasies and visions she described in her works include the Transverberation (or Transfixion) of her heart which took place in 1559. An angel of the Order of Cherubim appeared to her: "In his hands I saw a great golden spear, and at the iron tip there appeared to be a point of fire. This he plunged into my heart several times so it penetrated to my entrails ... and left me utterly consumed by the great love of God" (*Life*, chapter 29). Another

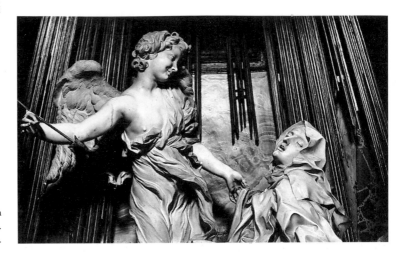

The Ecstasy of St Teresa
Bernini, 1645 (detail).
S. Maria Vittoria, Rome.

famous vision concerned a dove whose wings were dappled with mother-of-pearl and who hovered over her head at Pentecost (chapter 38). A vision of St Joseph and the Virgin offering Teresa a mantle also deserves mention: "I seemed myself clothed in a robe of great whiteness" (chapter 33). The Virgin was on the right, and Joseph, her "protector and father", on the left. The Virgin promised that her plan to found a reformed convent would come to fruition and she hung a necklace bearing a cross around Teresa's neck. Teresa was canonized in 1622 and declared a Doctor of the Church in 1970 by Pope Paul VI. She is co-patron of Spain with St James the Greater.

REPRESENTATION AND ICONOGRAPHY

A portrait of St Teresa of Avila exists, painted from life by Brother Juan de la Miseria (1576, Convent of the Discalced Carmelites, Valladolid). The most important depiction of the scene of the Transverberation is the marble group by Bernini (1645-52, Cornaro Chapel, S. Maria Vittoria, Rome). An angel, filled with compassion, directs an arrow towards Teresa's heart. Her vision of the mantle and the necklace was illustrated by Lanfranco (first half of the seventeenth century, S. Giuseppe, Rome). Rubens composed a St Teresa praying for the souls in Purgatory (1635, Koninklijk Museum voor Schone Kunsten, Antwerp).

Cross-references: Cherub and Seraph, Joseph of Nazareth.
Bibliography: H. Guerlin, *Sainte Thérèse*, Paris, n.d. *Sainte Thérèse d'Avila dans l'art*, Musée du Luxembourg, Paris, 1983. G and M. Duchet-Suchaux, *Les Ordres religieux*, Paris, 1993.

Tetramorph: Christ Encircled by the Symbols of the Four Evangelists
Majestas Domini, twelfth-thirteenth century. Museu de Arte Antica de Catalunya, Barcelona.

TETRAMORPH

This term designates the symbols of the four Evangelists as a group of animals. The symbols themselves derive for the most part from two sources: Revelations (4:6-8) and Ezekiel (1:5-12). "Round about the throne, were four beasts full of eyes before and behind. And the first beast was like a lion, and the second beast was like a calf, and the third beast had a face as a man, and the fourth beast was like a flying eagle" (Rev. 4:6-7). The Fathers of the Church read these symbols as applying to the four Evangelists: the lion for Mark, the

young bull for Luke, the man (or angel) for Matthew, and the eagle for John. These symbols can either accompany their Evangelist or emblematically replace him. The Tetramorph, in the guise of an imaginary four-footed animal, can serve as a throne to a young queen who personifies the Church. It has the body of a lion and four different heads and feet (sculpture group, south door, Worms Cathedral, fourteenth century).

Cross-references: Christ in Majesty, Evangelists, Ezekiel, Revelations.
Bibliography: "Tetramorph", in E. Kirschbaum, *Lexikon der christlichen Ikonographie*, vol. IV, Freiburg im Breisgau, 1968-74.

THADDAEUS *see* APOSTLES, SIMON.

THEODORE

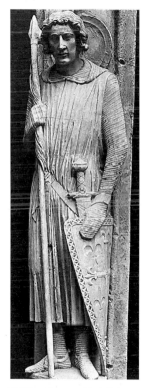

St Theodore as Knight
Thirteenth century.
Cathedral of Notre-Dame,
Chartres.

Greek: Theodoros; Italian and Spanish: Teodoro; French: Théodore; German: Theodor.
Martyr. Died c.306. Feast day 9 November.

LIFE AND LEGEND
Theodore came from Amasea (in the province of Pontus, Asia Minor) and was a *tiro*, a new recruit in the army of Emperor Maximianus. He was converted to Christianity and set fire to the Temple of Cybele in Amasea. Theodore the Recruit (or the Conscript) was viciously tortured and then burnt alive, his soul ascending into heaven.

In the ninth century, this legend was duplicated by the creation of a second Theodore, a general (*Stratelatus*). Like SS. George and Michael, Theodore the General slew a dragon. He was made to undergo all manner of tortures before being crucified like Christ himself. An angel descended in the night and detached him from the cross. He was finally beheaded.

Like SS. George and Demetrius, St Theodore is one of the military saints venerated since the early middle ages. He was the patron saint of the Byzantine armies and his cult was most widespread in the eastern empire. It was attested, however, in sixth-century Rome in the Basilica of SS. Cosmas and Damian.

REPRESENTATION AND ICONOGRAPHY
Both saints Theodore are first depicted as Roman legionaries before, in the middle ages, turning into knights. In the middle of the tenth century, the two saints begin to differ in their appearance. Theodore the General is shown older and sports a beard trimmed into two points. Theodore the Recruit is generally beardless. The victory over the dragon originally belonged to Theodore the General, but from the eleventh century the two saints are often amalgamated in the east where their iconography is very rich. In the west, both Theodores occur on mosaics in those regions of Italy where Byzantine influence remained strong (Cappella Palatina and La Martorana, Palermo, twelfth century, and the Basilica of St Mark's, Venice). The presence of a statue of St Theodore at the south door of the transept at Chartres is explained by the fact that the saint's head was taken to the cathedral in 1120.

Attributes: Uniform of a Roman legionary. Knight's shield or spear. Dragon.

Bibliography: H. Delehaye, *Les Légendes grecques des saints militaires*, Paris, 1909. L. Mavrodina, "St Theodore, Evolution et particularités de son type iconographique dans la peinture médiévale", *Bulletin de l'Institut des arts*, 1969, pp. 31-52.

THEOPHILUS (DEACON) *see* DEVIL, MIRACLES OF THE VIRGIN MARY.

THOMAS (APOSTLE)

Latin: Geminus; Italian: Tommaso, Maso, Masaccio; Spanish: Tomas, Tomé; French and German: Thomas.
Apostle. First century. Feast days 3 July, 21 December (west), 6 October (east).

TRADITION

All four Evangelists mention Thomas the Apostle (Matt. 10:3; Mark 3:18; Luke 6:15; John 11:16; 14:5; 20:24; 21:2; Acts 1:13). His soubriquet is Didymus (in Greek *Didymos*) from the Aramaic for twin, though whose twin he might have been is undecided; an apocryphal text, the *Acts of Thomas*, specified that he was the twin brother of Jesus himself. His better-known nickname is Doubting Thomas.

His incredulity showed itself on a number of occasions. First, Thomas refused to believe that Jesus was truly resurrected. Christ appeared and said, "Behold my hands; and reach hither thy hand, and thrust it into my side; and be not faithless, but believing" (John 20:27-28). This episode has been compared to Christ's forbidding Mary Magdalene to touch him with the words, "*Noli me tangere.*"

In the second, purely legendary episode, the apostle doubted the Assumption of the Virgin. He had her tomb opened and found it full of flowers. The Virgin, ascending into heaven, undid her belt (or girdle) and let it fall into Thomas' hands. The girdle plays the same role in this story as the Holy Shroud found by the Women at the Tomb. The legend and the associated cult of the Sacra Cintola have their roots in Tuscany. The relic itself, retrieved from the Holy Land in 1141, was housed in the Cathedral of Prato by 1365.

According to yet another legendary tradition, disseminated by both the *Acts of Thomas* and the later *Golden Legend*, the apostle was invited to India by an envoy from King Gondophorus to build a palace for his sovereign. Instead of the promised palace, Thomas declared that he would build a "heavenly palace", and distributed the money for the project to the poor. The king was at first outraged and had Thomas thrown into prison, but he later pardoned him. Following a tradition much in evidence among the Malabar Christian community, Thomas, having first evangelized the region, was martyred at Mylapore, near Madras. His remains were translated to Edessa in 394. Another version had his body remaining in India at a place now called San Tomé.

In Italy, St Thomas is the patron saint of the towns of Prato, Parma and Urbino. Due to his activities in India, he is also patron of both judges and architects.

The Incredulity of St Thomas
Duccio, Maestà polyptych, 1308-11 (detail). Museo dell'Opera del Duomo, Siena.

REPRESENTATION AND ICONOGRAPHY

St Thomas, in both paleochristian and Byzantine art, is a beardless young apostle, often linked to Jesus in deference to the tradition that called him Christ's twin brother. In the thirteenth century, Thomas acquired a beard and was occasionally associated with SS. Cosmas and Damian (fresco, fourteenth century, Turmkapelle, Michaelskirche, Vienna). His attribute is a T-square (thirteenth-century statue, east door of Bamberg Cathedral), referring to his legendary position as architect to the Indian king.

In the scene of Doubting Thomas, Christ, in the centre, flanked by John and Peter, guides the apostle's hand towards his wound (tympanum of St Thomas, Strasbourg, thirteenth century). He can also be shown with other saints (The Master of St Bartholomew, c.1490-1500, Wallraf-Richartz Museum, Cologne). In the seventeenth century, the scene was treated by Caravaggio (1601-2, Neue Residenz, Potsdam) and Rembrandt (1634, Pushkin Museum, Moscow). In the twentieth century, the subject has been treated by Emil Nolde (1912, Seebüll Foundation). The incredulity of Thomas with respect to the Assumption of the Virgin is the subject of a work by Agostino Gaddi (1394-5, *The Story of the Virgin and her Girdle*, Cappella della Sacra Cintola, Prato Cathedral).

Attributes: Belt or girdle of the Virgin Mary. T-square. Spear (of his martyrdom, from the seventeenth century).
Cross-references: Appearances of the Risen Christ, Apostles, Assumption, Noli me Tangere.
Bibliography: E. Mâle, *Les Saints Compagnons du Christ*, Paris, 1957.

THOMAS AQUINAS

Latin: Thomas Aquinas, Thomas de Aquino; Italian: Tommaso d'Aquino; Spanish: Tomas de Aquino; French: Thomas d'Aquin, German: Thomas von Aquino.
Theologian. 1225-74. Canonized 1323. Feast day 28 January (since 1969; formerly 7 March).

LIFE AND LEGEND

Thomas Aquinas was born in the castle of Rocca Serra into a family proud of its noble lineage. His father was the lord of Aquino who, foretelling great things for his son, whose lively intelligence was evident from the first, sent him to undertake his initial studies at the prestigious abbey of Monte Cassino. Thomas, however, left the environment of the Benedictine monastery to pursue courses at the newly established University of Naples, where he encountered Aristotelian philosophy. His father, indignant at his subsequent decision to enter the Friars Preachers, had Thomas apprehended on the road to Paris. After a year, Thomas' family gave in and allowed him to enter the Order's Neapolitan abbey.

In 1245, the Dominicans sent him to the abbey of St James in Paris. At the university, Thomas' master was Albert of Swabia, known as Albert the Great (Albertus Magnus), who, laying emphasis on the disciplines of Greek science, offered to expound Aristotle's teaching to Latin scholars. When Albert founded a theology faculty at Cologne, Aquinas joined him and studied both theology and philosophy. He was later ordained and, returning to Paris, from 1256 occupied one of the two professorial chairs reserved for Dominicans.

At this time, the university was split into opposing factions over Aristotle and Averroes, and the relationship between faith and reason. Thomas obtained a position as magister with Bonaventura on 15 August 1257. Two years later, he was recalled to Italy and, between 1265 and 1268, was Professor of Theology in Rome where he began to compose his *Summa Theologica*. After refusing the archbishopric of Naples, Thomas returned to Paris where he taught for a further four years.

Thomas Aquinas endeavoured to prevent the rift between profane and sacred wisdom by giving sufficient latitude to philosophy in the context of harmony between a dominant faith and a subordinate reason. This severe Dominican friar has not inspired a vast legendary literature, though his well-known revelation of 1272 inspired a considerable body of works of art. Apart from his love of wisdom, it is his chastity above all which is stressed in literature. One legend recounts how, in his youth, he scared off with a burning coal a lewd woman who had been sent to corrupt him.

Thomas ended his life in the Cistercian abbey of Fossa Nuova. Pope Urban V had his remains removed to Toulouse in 1369. He was canonized in 1323 and made Doctor of the Church in 1567.

REPRESENTATION AND ICONOGRAPHY

Thomas Aquinas was, by all reports, a tall and rather corpulent figure, but depictions tend to idealize him as an emaciated monk. He is always shown in Dominican habit, and is often accompanied by a star or a dove (representing the Holy Spirit under whose inspiration he dictated his doctrine). In isolated cases, he has wings or wears the cingulum castitatis, chastity belt, which may be shown being applied by angels.

Fra Angelico's famous *Coronation of the Virgin* (from the abbey at Fiesole, 1430-35, Louvre, Paris) has an early example of his likeness, and there is a very frank depiction by Fra Carnevale (fifteenth century, Poldi-Pezzoli, Milan). Like St Augustine, Aquinas is often shown trampling the unorthodox underfoot (F. Lippi, 1489-93, Cappella Caraffa, S. Maria sopra Minerva, Rome, where he is shown supreme above a defeated Averroes). Thomas is depicted as a theologian by Zurbarán (1631, Museo de Bellas Artes: he is positioned between the four Doctors of the western Church and the Holy Dove). As a philosopher, he is shown flanked by Aristotle and Plato as Averroes writhes at his feet in a work by Francesco Traini (c. 1345, S. Caterina, Pisa) and with his *Summa* in a fresco by Andrea da Firenze (1370, Cappella dei Spagnoli, S. Maria Novella, Rome). The saint's chastity is emphasized in a Temptation by Gaspard de Crayer (1644, St Sauveur, Bruges).

The most complete cycle of St Thomas Aquinas' life is an engraved series of nineteen scenes by Charles Boel of 1610.

Bibliography: P. A. Uccelli, *Del'iconographia di S. Tommaso d'Aquino*, Naples, 1867. G. K. Chesterton, *Thomas Aquinas*, London, 1947. L. Réau, op. cit., vol. III, i, pp. 1277-80. E. Kirschbaum, *Lexikon der christlichen Ikonographie*, Freiburg im Breisgau, 1968-74, VIII, cols. 476-85.

THOMAS BECKET OF CANTERBURY

Latin: Thomas Cantuarensis; Italian: Tomaso Beckett; Spanish: Tomas Cantuariense; French and German: Thomas Becket.
Archbishop and Martyr. 1118-70. Canonized 1173. Feast day 29 December.

LIFE AND LEGEND

Thomas Becket was named as Chancellor of England in 1155 by King Henry II before becoming Archbishop of Canterbury in 1162. He abandoned the position of Chancellor in order to follow a life of great austerity. He opposed Henry II in the Investiture Controversy and condemned his disorderly life. He was exiled, taking refuge in France, first in the Cistercian monastery at Pontigny and then, in 1166, at Sens.

Apparently reconciled with the king, the archbishop returned to England in 1170, but their quarrel flared up with renewed violence and finally he was assassinated in his own cathedral by four armed barons. His murder rocked Europe to its foundations and he was instantly acclaimed as a martyr who had died in defence of the freedom of the Church. The pilgrim route to Canterbury soon became one of the most frequented in Christendom.

Until the Reformation, the centre of Thomas of Canterbury's cult was England. King Henry VIII, however, emulated his royal predecessor's hostility and destroyed the reliquary containing the saint's body as well as the immense majority of images depicting St Thomas. The king even suppressed his name in liturgical texts. This second onslaught explains the relative scarcity of English representations of Thomas Becket.

REPRESENTATION AND ICONOGRAPHY

In the earliest extant representation of the saint (twelfth century, mosaic in Monreale Cathedral, Sicily), Thomas is shown wearing both chasuble and pallium. He is occasionally shown in connection with two other saints Thomas: the apostle and St Thomas Aquinas (altarpiece showing all three saints, fifteenth century, Sankt Jürgen, Weimar). Numerous ensembles are dedicated to cycles of his life (Michael Pacher, second half of the fifteenth century, Steiermärkisches Landesmuseum Joanneum, Graz). One picturesque episode deserves particular mention: as Thomas makes his escape from Canterbury, his horse's tail is cut off. This detail derives from another local legend: while the archbishop was fleeing from London during his quarrel with the king, the population of Rochester cornered him and, to show their lack of respect, cut off his horse's tail.

One author explains the importance of Thomas Becket's cult in medieval Europe by comparing the frequency of depictions of his murder in the cathedral to that of images of St Martin sharing his cloak with a beggar and St George's combat against the dragon. Just as SS. Martin and George

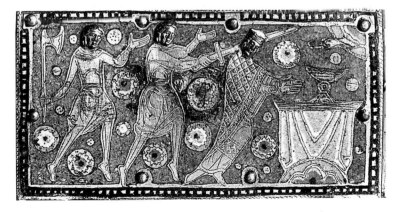

The Assassination of St Thomas Becket
St Thomas Becket reliquary, twelfth century (detail). Louvre, Paris.

327

embodied courtly and monarchical power, so the murder of Thomas Becket symbolized the freedom of the Church in the face of overweening politicians. A number of details enable this murder to be distinguished from that of analogous martyrs: one of the assassins carries an axe; the scene takes place before an altar set with a chalice; the Hand of God blesses the scene.

Attributes: Pallium, mitre and crozier of archbishop. Sword (in his skull). Part of the top of the skull (which he carries).

Bibliography: T. Borenius, *St Thomas Becket in Art*, London, 1932. R. Foreville, *Le Jubilé de saint Thomas Becket du XIIIème au XVème siècle, 1220-1470*, Paris, 1958.

THREE KINGS *or* THREE WISE MEN *see* MAGI.

THRONE *see* ELIJAH, REVELATIONS, TETRAMORPH, TRINITY.

THURIBLE *see* CENSER.

TIARA *see* GREGORY THE GREAT (WITH CROZIER), PETER (WITH KEYS), SOPHIA (THREE-TIERED CROWN).

TOBIAS *see* TOBIT.

TOBIT (AND TOBIAS)

Greek: Tobit; Latin: Tobias; Italian: Tobia, Tobiolo; Spanish: Tobias padre, Tobias menor; French: Tobie père, Tobie fils; German: Tobias Vater, Tobias Sohn.

TRADITION

The story of Tobit and his son, Tobias, is recounted in the Book of Tobit (Apocrypha). It is presented as a tale told by Tobit set in an ostensibly historical background. Deported to Nineveh, Tobit made his fortune. In defiance of royal edicts, he buried the bodies of certain Jews who had been put to death by the king's assassins, a misdemeanour for which all his property was confiscated. After burying one of these unknown corpses, he fell asleep beneath a wall. Some sparrow droppings fell into his eyes and blinded him (2:10).

The centre of interest then turns to the family of Raguel exiled to Ecbatane. Raguel's only daughter Sara was prey to a demon who had killed each of her seven husbands one by one. God listened to both Sara's and Tobit's prayers, sending the archangel Raphael to help them (3:17). Young Tobias was sent by his father to Media to recover a sum of money he had hidden there earlier (4:20-21). Raphael asked Tobit (who did not recognize the

angel) whether he might escort his son on his journey and, in company with Tobias' faithful hound, they departed together. They reached the Tigris, where Tobias was attacked by a gigantic fish. The archangel ordered him to capture it and had him remove and conserve its gall, heart and liver (6:1-5).

The two travellers arrived in Ecbatane where the archangel asked Tobias to take his cousin, Sara, for his wife. In the nuptial chamber Tobias grilled the fish liver, and the smell scared off the demon who had despatched Sara's first seven husbands. Raphael, Tobias and Sara returned to Nineveh where they were received with joy by Tobit. The archangel instructed Tobias to apply the fish gall to his father's eyes, thus restoring his sight (11:1-14). Raphael then revealed that he was "one of the seven holy angels, which present the prayers of the saints" (12:15). Like Job, to whom he is often compared, Tobit is a "man of sorrows", one of the "servants of the Lord" (Is. 53:3), who prefigure the Passion of Christ.

Blind Tobit
Rembrandt, 1651. Albertina, Vienna.

REPRESENTATION AND ICONOGRAPHY

Due to its Christological import, the paleochristian period concentrated on the story of the fish: the five initial letters of the three Greek names for Christ (*Iesus Christos Theou Yios Soster*, Jesus Christ, Son of God, Saviour) form the word for fish, *Ichtys*. The fish gall to which Tobit owes his regained sight was from an early date treated as an annunciation of Christ, the Light of the World (B. Strozzi, 1635, Hermitage, St Petersburg).

Tobias and Raphael (3:17 ff.)

The scene showing Tobias' departure appears in the twelfth century (capital in the Church at Besse-en-Chandesse, Puy-de-Dôme). In the fourteenth and fifteenth centuries, the theme was a frequent one in Italian art (Botticelli, 1500-5, Courtauld Institute Galleries, London). Botticini shows Raphael walking hand-in-hand with the young Tobias between the two other archangels, Gabriel and Michael (1470, Uffizi, Florence). Pollaiuolo's version even includes Tobias' dog (1464, Pinacoteca Reale, Turin). Later, the motif became less frequent (G.-A. Gandi, c.1749, Church of Angelo Raffaele, Rome).

Tobit Loses his Sight (2:10)

Rembrandt produced a drawing of this scene (Museum Boymans-van Beuningen, Rotterdam).

Tobias Catches the Monstrous Fish (6:1-5)

Savoldo (1520-30, Galleria Borghese, Rome) shows a frightened Tobias pulling the fish on to the bank as Raphael urges him on. Rembrandt treated the subject a number of times (Dresden Library).

The Wedding of Sara and Tobias (7:11; 8:1-15)

In the thirteenth century (the archivolt moulding at the north door to the transept, Chartres Cathedral), Tobias and Sara are shown at prayer in the bridal chamber, while Raphael prepares the heart and liver of the fish.

Cycles

One particular Bible (thirteenth century, Bibliothèque de l'Arsenal, Paris) presents a sequence of six scenes from the story of Tobit and Tobias. The archivolt in Chartres mentioned above (thirteenth century) includes twelve episodes. Pierre Parrocel painted fourteen scenes in the seventeenth century (Musée Borely, Marseille).

Cross-references: Archangels, Raphael.

Bibliography: E. Kirschbaum, *Lexikon der christlichen Ikonographie*, Freiburg im Breisgau, 1968-74, vol. III, p. 320. L. Réau, op. cit., vol. II, pp. 318-27. F. Zimmermann, *The Book of Tobit*, New York, 1958.

TOMB *see* APPEARANCES OF THE RISEN CHRIST, ASSUMPTION, ENTOMBMENT, HOLY WOMEN AT THE SEPULCHRE, LAST JUDGMENT, LAZARUS (RAISING OF), RESURRECTION.

TOWER *see* BABEL (TOWER OF), BARBARA (THREE WINDOWS), CHRISTINE (LOCKED IN TOWER).

The Transfiguration
Taddeo Gaddi, fourteenth century (detail). Galleria dell'Accademia, Florence.

TRANSFIGURATION

Italian: Trasfigurazione di Gesù; Spanish: Transfiguración del Señor; French: Transfiguration du Christ: German: Verklärung, Transfiguration.

TRADITION

The Transfiguration of Christ is mentioned both in the Synoptic Gospels (Matt. 17:1-13; Mark 9:2-13; Luke 9:28-36) and in Peter's Second Epistle (1:16-18). Luke describes the event in the following manner: "[Jesus] took Peter and John and James, and went up into the mountain to pray. And as he prayed, the fashion of his countenance was altered, and his raiment was white and glistering." Two men talked with him: Moses and Elias (Elijah). "Peter and they that were with him were heavy with sleep: and when they were awake, they saw his glory, and the two men that stood with him." Peter suggests they erect three tabernacles, "one for thee, and one for Moses, and one for Elias". Even as he spoke, a cloud overshadowed them and a voice said: "This is my beloved Son: hear him."

In the east, the Transfiguration was probably celebrated as early as the sixth century, though in the west it was 1457 before the Feast of the Transfiguration was instituted by Pope Callistus III. In the middle ages, the guild of dyers placed itself under the protection of Christ Transfigured.

REPRESENTATION AND ICONOGRAPHY

Areas under the influence of Byzantium, due to the early celebration there of the cult of the Transfiguration, are conspicuous by numerous representations of the event. The Transfiguration is evoked by the symbol of a blue circle studded with golden stars (mosaic, S. Apollinare in Classe, Ravenna, c.550). Elijah and Moses kneel on either side of the circle of light, while the three apostles appear in the guise of three white lambs. Above the scene the Hand of God can be seen.

By the end of the sixth century, the scene is represented by means other than symbolic. Seven rays of light issue from Christ (apse, Monastery of St Catherine in Sinai, c.565). Following the iconoclastic period of the eighth and ninth centuries, the scene often formed part of the wall decoration of Byzantine churches. Christ's face is encircled by a white or blue aureole. Most often, John and James have thrown themselves to the ground while Peter turns to look at Jesus. From the fourteenth century, there is an increasing

tendency to confuse the Transfiguration with the Ascension. Whenever western medieval artworks follow Byzantine or similar precepts, they too fall prey to this confusion. In the fourteenth century, Christ, with outstretched arms, hovers above Moses and Elijah who kneel in prayer. The apostles are totally overcome.

A hovering Christ continues as the dominant choice in iconography until the eighteenth century (Raphael, 1518-20, Pinacoteca Vaticana, Rome). The three tabernacles are then replaced by the cloud, which itself seems to herald the Ascension. The Carmelites, founded in 1451, promoted the theme since the traditional founder of their Order, Elijah, was present.

Cross-references: Apostles, Ascension, Elijah, John the Evangelist, James the Great, Hand of God, Mandorla, Moses, Peter.
Bibliography: E. Mâle, *L'Art religieux du XIIème en France*, Paris, 1922, pp. 93-6. A. de Waal, "Der Ikonographie der Transfiguration in der Aelteren Kunst", *Römische Quartalschrift für christliche Alterstumkunde*, 16, Freiburg im Breisgau, 1902, pp. 25-40.

TREE OF JESSE

Variants: Stem or Rod of Jesse, Jesse('s) Tree. Italian: Albero di Jesse; Spanish: Arbol de Jesé; French: Arbre de Jessé; German: Jessebaum.

TRADITION
This name traditionally designates Christ's genealogical descendence represented as a tree having its roots in Jesse, the father of King David. The name Jesse is the Hellenistic equivalent of Isaiah to be found in the Septuagint. In Revelations, Jesus announces himself with these words: "I am the root and the offspring of David" (22:16). The genealogies of Christ given by Matthew (1:1-17) and Luke (2:23-38) both end with Joseph, foster-father of Jesus, and not with Mary. Traditionally, however, the Fathers of the Church accept that it is Mary who descends from David.

Louis Réau attempted to explain this patristic interpretation by the version of the passage as it appears in the Vulgate. In the prophecy of Isaiah (11:1-3), "And there shall come forth a rod out of the stem of Jesse, and a Branch shall grow out of his roots," the Latin of St Jerome is as follows: "*et egredietur virga de radice Jesse, et flos de radice eius egredietur*," where *virga* means rod but also virgin. The Tree (or Stem) of Jesse has been represented in a number of symbolic ways and linked to the Tree of Life in Genesis as well as to the Tree of the Cross of Christ.

REPRESENTATION AND ICONOGRAPHY
The iconography of the Tree of Jesse is extremely plentiful. It first occurs in the ninth century in an illumination of the genealogy of Christ according to St Matthew (Lorbach, *Codex aureus*). The *Bible de St Bénigne de Dijon* (thirteenth century, Dijon Library) shows the original form of the stem, its seven branches issuing from Jesse, whose prone position is a reference to the sleep of Adam. It was Abbé Suger (c.1080-1151), however, who was responsible for the definitive form of the motif: the Tree emerges from Jesse, who can either stand or lie, while in the branches are visible the Prophets (Jesus' spiritual ancestors) and the Kings (his earthly ones).

The Tree of Jesse
Ingeburge Psalter, 1210.
Musée Condé, Chantilly

Jesse

He is generally shown as an old man with a long beard. He wears a pointed cap of the type traditionally associated with the Jews. The Tree emerges from his chest, from his entrails or, less often, from his mouth.

Composition of the Tree and its Branches

Most frequently, the Tree carries twelve ancestors – bodily (kings) and spiritual (prophets). King David carries his harp, Solomon wears a turban: they can both be identified in the Ingeburge Psalter (c.1200). In the miniature concerned, a dove hovers above the heads of each of the six Prophets standing to the left and right of the Tree. The Cumaean Sibyl (Virgil, *Eclogue* IV, 4-7) is used to complete the series of the Prophets. As for the large stained-glass window at St Denis produced under Suger's abbacy (c.1140-45), its *schema* was reproduced identically in Chartres Cathedral.

The topmost branches of the trunk itself are occupied by Christ enthroned in majesty. Examples include a ceiling mural in Hildesheim (St Michael's, late twelfth century), a painting by Jan Mostaert (early sixteenth century, Rijksmuseum, Amsterdam), and a polychrome, life-sized wood version in Portugal (1750, São Francisco, Oporto).

Christ at the summit can also be surrounded by the seven angels symbolizing the seven gifts of the Holy Spirit (Rhineland stained-glass windows show the Dove of the Holy Spirit descending towards him). Under the impetus of the Marian cult in the thirteenth century, the Virgin began replacing Christ at the top of the Tree. As the cult of the Immaculate Conception became prevalent, it is the Virgin's descendance which is traced back to King David in preference to Joseph's (tympanum of the main door of Rouen Cathedral, 1513; Church of SS. Gervais and Protais, Gisor, Eure, sixteenth century). The theme, associated by the end of the middle ages with the Immaculate Conception, was also exploited by the French monarchy and by various religious orders. The whole motif disappeared in the Renaissance.

Cross-references: Adam and Eve, Holy Spirit, Isaiah, Joseph of Nazareth, Mary, Prophets, Sibyls.

Bibliography: J. Corblet, "Etude iconographique sur l'arbre de Jessé", *Revue de l'Art chrétien*, 4, 1860, pp. 49-61, 113-125, 169-181. L. Réau, op. cit., vol. II, 2, pp. 129-40. M.-L. Thérel, "Comment la patrologie peut éclairer l'archéologie", *Cahiers de civilisation médiévale*, 6, 1963, pp. 145-58.

TREE OF KNOWLEDGE *or* OF LIFE *see* ADAM AND EVE, CREATION, PARADISE, TREE OF JESSE.

TRIAL OF JESUS

Variant: Judgment of Jesus. Italian: Interrogatorio di Gesù; Spanish: Interrogatorio de Jésus; French: Procès de Jésus; German: Verhör des Christus.

TRADITION

After his arrest, Christ is handed over to the jurisdiction of the high priest and then led before the procurator or governor of Judaea, Pontius Pilate (Matt. 27:11-26; Mark 15:1-15; Luke 23:1-25; John 18:28-40). After an interrogation, Pilate can "find no fault in this man" (Luke 23:4) and sends him, since he

The Trial of Jesus: Christ before Caiaphas
Lucas Cranach the Elder, *Die Passion*, woodcut, 1509. Bibliothèque Nationale, Paris.

is a Galilean, to Herod. This last "mocked him and arrayed him in a gorgeous robe" (Luke 23:11) and sent him back to Pilate who, in the presence of the "chief priests and the rulers and the people", proposes to release him. They all cry out that Christ should be crucified and Barabbas (a murderer) should be set free in his place. Pilate, to keep them quiet, "took water, and washed his hands ... saying, I am innocent of the blood of this just person" (Matt. 27:24); he then released Barabbas, had Jesus scourged, and handed him over for crucifixion.

REPRESENTATION AND ICONOGRAPHY

Jesus is taken by Pilate before Herod who returns him to the *praetorium* (common hall) where the procurator has his court. These two preliminary scenes are less frequently illustrated than the succeeding sequence when Christ appears before Pilate for the second time. Nonetheless, these were depicted as early as the fourth and fifth centuries. Other episodes, such as Pilate washing his hands, may appear in Passion cycles.

Pilate Washes his Hands (Matt. 27:24)

One of the wooden panels of the door of the Church of S. Sabina in Rome (c.430) combines Jesus' appearance before Pilate and the Carrying of the Cross. The sequence is split into two scenes: the appearance and questioning of Christ on one side and Pilate's final judgment and washing of his hands on the other. In the middle ages, this latter episode tended to predominate (bronze door of the Cathedral at Hildesheim, 1008-25; Schongauer, engraving, end fifteenth century). In the modern period (from the sixteenth century), depictions of the trial become rarer.

Cross-references: Arrest of Christ, Crowning with Thorns, Crucifixion, Ecce Homo, Flagellation.
Bibliography: L. Réau, op. cit., vol. II, 2, pp. 449-61.

TRIANGLE *see* GOD, TRINITY.

TRINITY

Italian: Santa Trinità; Spanish: Trinidad; French: sainte Trinité; German: Trinität, Heilige Dreifältigkeit.

TRADITION

The mystery of the Holy Trinity, of the Three-in-One, and the long theological development of its doctrine, derives from more than one New Testament text. The three Persons are evoked at the Baptism of Christ, as reported by all four Gospels: "And Jesus, when he was baptized, went up straightway out of the water: and, lo, the heavens were opened unto him [St John the Baptist] and he saw the Spirit of God descending like a dove, and lighting upon him: And lo a voice from heaven, saying, This is my beloved Son, in whom I am well pleased" (Matt. 3:16-17). The three Persons are present: Jesus the Son, God the Father, and the Holy Ghost in the guise of a dove. The basis for innumerable theological interpretations and elaborations is in the Gospel according to St Matthew: "Go ye therefore, and teach all nations, baptizing them in the name of the Father, and of the Son, and of the Holy Ghost" (28:19).

The Trinity: Triangle of Light
Abraham Bosse, seventeenth century. Bibliothèque Nationale, Paris.

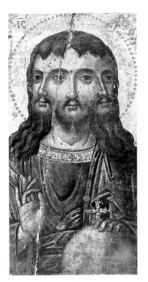

Three-headed Trinity
Museum, Athens.

Representation and Iconography

The depiction of the Trinity in its abstract and transcendental aspects is subject to a number of iconographical and theological difficulties. No imagery of the Trinity as such predates the early medieval period.

The Three Persons in Human Form

In the Byzantine church, this treatment of the theme derives from the appearance of the three visitors at Mamre: "And he [Abraham] lift up his eyes and looked, and, lo, three men stood by him" (Gen. 18:2), on which St Augustine comments: "And Abraham saw three persons, yet adored but one." The earliest representations occur in the fifth century (mosaic, S. Maria Maggiore, Rome). The three persons have similar faces. From the fourteenth century, their appearances begin to differ: the central figure, taller than the other two, is God the Father (Andrei Rublev, 1411, Tretiakov Gallery, Moscow).

In the west, the three Persons may be placed side by side or they may overlap. They are identical in every respect and each carries the same attributes: crown and sceptre and a globe surmounted by a Cross. God the Father can wear a papal tiara, the son is indicated by his wounds, whereas the Holy Spirit is winged. From the fifteenth century, the Father has a white beard, the Son is a young man, while the Holy Ghost is a youth or a dove.

The Three-headed Trinity

This *monstrum*, as St Robert Bellarmine (1542-1621) calls it, is either a three-headed being or else a head with three different faces. This fanciful form is not confined to Christianity (Louis Réau compared it to a number of tricephalus Celtic divinities widespread in ancient Gaul). The type is attested by the eleventh century, and quickly became sufficiently widespread to be condemned as heretical by Antony of Florence (1389-1459). Andrea del Sarto employed the motif as late as the sixteenth century (fresco, refectory, S. Salvi, Florence) and, in spite of a papal interdict in 1628 under Urban VIII, it survived until the nineteenth century.

The "Throne of Grace"

This unusual form, which probably arose in twelfth-century France, presents God the Father holding the Crucified Christ in front of him. The dove of the Holy Spirit hovers above the overlapping figures. From the thirteenth century, the Son's body lies in the Father's lap. This position, which derives from the Pietà, corresponds to the mystically oriented craving to emphasize the suffering felt by the Father (El Greco, 1577-9, Prado, Madrid).

God the Father can be represented by the Hand of God and the Son by the Lamb, in reference to the words of John the Baptist at seeing Christ: "Behold the Lamb of God, which taketh away the sin of the world" (John 1:29). The Holy Ghost is portrayed by a dove or book, symbol of the Spirit which inspires Scripture.

Symbolic Representations

The most ancient sign representing the Trinity is the equilateral triangle. In the fourth century, St Augustine gave voice to his distrust of this symbol, alleging that the triangular form of the Trinity was revered by the Manicheans. The triangle almost disappeared until the eleventh century and was never widespread before the fifteenth. Its heyday lay in the seventeenth and eighteenth centuries; it was much used by Goya, for example, in the fres-

coes for El Pilar, Saragossa (1772) and in his *Annunciation* (Sketch, 1785, Museum of Fine Arts, Boston).

From the sixteenth century, the triangle was no longer placed apex-down but on one side. The signification of the symbol was made plain by the appearance of the Hebrew name of Jehovah or of God's all-seeing eye in the centre of the shape. From about the fifteenth or sixteenth century, the triangle served as an aureole framing the head of God the Father. Circumscribed by a circle symbolizing perfection, it may also be held by God the Father. In the middle ages, the sign of the Trinity surfaced in the lives of the saints: St Barbara's three-windowed tower manifests her faith in the Three-in-One, while the three Churches of St Clare, the three girls preserved from prostitution when St Nicholas gives them dowries, and the three children Claude saves from drowning are all symbols of this form.

Cross-references: Abraham, Augustine, God, Hand of God, Holy Spirit, Numbers.
Bibliography: R. Bauerreiss, *Reallexikon zur deutschen Kunstgeschichte*, 1955. W. Braunfels, *Die Heilige Dreifaltigkeit*, Düsseldorf, 1954. V. Lasareff, "La Trinité d'André Roublev", *Gazette des Beaux-Arts*, vi, 1959, pp. 289-300.

TRUMPET *see* ANGEL, ARCHANGEL, JERICHO, LAST JUDGMENT, REVELATIONS.

UNCTION *see* DAVID, ELIJAH, JUDAS ISCARIOT, SOLOMON.

UNICORN

The unicorn is a purely imaginary animal, first mentioned in the fifth century BC by Ctesias, a Greek physician living at the Persian court. Later, Pliny the Elder described an elephant-footed *monoceros*. The unicorn appeared in medieval bestiaries compiled from ancient sources and from the Greek *Physiologus* (second or third century AD) and is characterized by a sharp horn projecting from the middle of its forehead, a horse-like body and elephantine hooves. When angered, it uses its horn to impale its attacker. A unicorn may only be captured by a virgin: as soon as the animal sees one, it approaches and leans its head on the maiden's breast, and it can then be caught by the huntsmen.

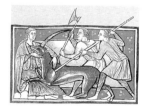

Unicorn
Twelfth-century bestiary,
Pierpoint Morgan Library,
New York.

The unicorn may symbolize Christ, born of the Virgin Mary, as in a mosaic in S. Giovanni at Ravenna (fifth century). In a frieze portraying animals in the Baptistry of Parma, the unicorn is linked to images of the Virgin, and this Marian symbolism becomes predominant from the fifteenth century. At the end of the middle ages, two series of tapestries gave the unicorn a secular role: the *Dame à la Licorne* (end fifteenth century, Musée de Cluny, Paris) and the *Chasse à la Licorne* (c.1500, Metropolitan Museum of Art, New York) are both rich in non-religous symbolism and allegory.

Cross-references: Annunciation, Gabriel.
Bibliography: "Einhorn", in E. Kirschbaum, *Lexikon der christlichen Ikonographie*, Freiburg im Breisgau, 1968-74, vol 1. A. Erlande-Brandenbourg, *La Dame à la Licorne*, Paris, 1989.

URIAH *see* DAVID.

URSULA (AND THE ELEVEN THOUSAND VIRGINS)

Latin, Spanish and German: Ursula; Italian: Orsola; French: Ursule.
Virgin and Martyr. Feast day 21 October, suppressed in 1969.

LIFE AND LEGEND

As in the case of the purely legendary saints, Ursula's story was extrapolated from early evidence concerning one or several martyrs and enriched by authors steeped in hagiographical literature. The basis of the narrative is an early fifth-century Latin inscription found carved in stone in the Church of St Ursula in Cologne. It states that Clematius had the ruined church restored in respect for a group of virgin martyrs. Honouring the names of unknown martyrs was traditionally proscribed, however, and the name of Ursula herself did not appear before the ninth century. By about a century later, the number of virgin martyrs had increased to eleven thousand, doubtless through mistaking the abbreviation XIMV (*undecim martyres virgines*, eleven virgin martyrs) for *undecim millia virgines*, eleven thousand virgins. This impressive number was later utilized in the saint's legend, which became fixed in the *Golden Legend* of James of Voragine.

Ursula was the daughter of a British Christian king betrothed to a pagan prince. As she wished to preserve her virginity, she asked her father if she could accept the marriage on condition that the prince's father gave her ten "most noble" virgins, each with a thousand virgins in her service; moreover, that she should be allowed three years to consider. Certain bishops, including the Bishop of Basel, offered their protection as the virgins embarked on a crusade-cum-cruise: after an eventful sea passage, they went up the Rhine as far as Cologne, later sailing on to Basel, and then, after a pilgrimage to Rome, they returned to Cologne where they were put to the sword by a king of the Huns.

In 1155, the discovery at Cologne of an extensive hoard of bones – immediately identified as those of Ursula and her companions – gave further credit to this story. In spite of its incoherence, the cult of Ursula and the Eleven Thousand Virgins was immensely popular in the middle ages, its main centres being the Rhineland, the Low Countries, northern France and Venice. Particularly venerated at Cologne, this virgin martyr is the patron saint of

St Ursula and the Eleven Thousand Virgins
Woodcut from James of Voragine's *Golden Legend*, 1483 edition.

young girls and drapers, as Ursula at one point was protected by a miraculous cloak.

REPRESENTATION AND ICONOGRAPHY

St Ursula's iconography developed at a relatively late date, starting in the fourteenth century. Between the fourteenth and sixteenth centuries, around twenty-five cycles of her legend were recorded, several being found in Cologne (e.g. Sankt Ursula, 1456). In Belgium, the most famous cycle is by Hans Memling (six panels of the *Reliquary of St Ursula*, 1489, Sint Jans Hospital, Bruges). The narrative begins with the disembarkations in Cologne, Basel and Rome and ends with the massacre of the virgins aboard their vessel, Ursula herself being peppered with arrows before the king of the Huns' tent. In Italy, Carpaccio dedicated a series of nine canvases to her legend (1490-98, Accademia, Venice). He introduced a number of new elements, derived from the visions of Elisabeth von Schönau, in the meeting in Rome between Ursula and Pope Cyriacus, and also added a bishop and a cardinal to the number of her martyred companions.

Attributes: Virgins. Arrows.
Bibliography: C. Kauffmann, *The Legend of St Ursula*, London, 1964. G. de Tervarent, *La Légende de sainte Ursule dans la littérature et dans l'art du Moyen Age*, Paris, 1930.

VALENTINE

Latin: Valentinus; Italian: Valentino; French: Valentine; German: Valentin. Bishop and Martyr. Died 273. Feast day 14 February.

LIFE AND LEGEND

Valentine, a Roman priest, was beheaded in 273 and buried somewhere on the Famininan Way. He has been confused and identifed with another Valentine, Bishop of Terni, whose feast is celebrated on the same day. Valentine is much revered in France, particularly in the diocese of Jumièges. He is the patron saint of lovers as his feast, it is said, falls on the day that birds start mating.

Finally, there is Bishop St Valentine of Rhaetia who lived in the fifth century. He is interred at Mais, near to Merano in the Italian Tyrol. In the eighth century, his body was translated to Passau in Bavaria, where he became one of the patrons of the diocese. This Rhaetian Valentine was invoked in Germany against epilepsy (Louis Réau accounted for this by a probable pun

St Valentine
Woodcut from James of Voragine's *Golden Legend*, 1483 edition.

on his name: it is linked to the verb *fallen*, the root of which is to be found in *Fallsucht* meaning epilepsy, the falling sickness).

REPRESENTATION AND ICONOGRAPHY

The earliest imagery probably pertains to the Roman Valentine as it is to be found in that city's churches. He has a book, while a scroll occasionally indicates his position as a priest (fresco, S. Maria Antica, Rome, eighth century).

In Germany, it is the Rhaetian Valentine who is always shown. Since the end of the fifteenth century, the bishop stands over an epileptic child lying at his feet (retable, end of the fifteenth century, Sankt Neithard Chapel, Ulm Cathedral; anonymous painting, c.1520, Germanisches Nationalmuseum, Nuremburg).

Attributes:
Roman Valentine: Priest's habit. Scroll. Book.
Valentine of Terni: Bishop's vestments.
Rhaetian Valentine: Bishop's vestments. Epileptic child at his feet.

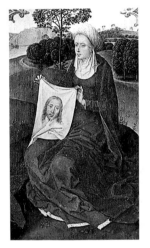

St Veronica
Hans Memling, panel from the *Adoration of the Magi* triptych, 1479 (detail). Sint Jans Hospital, Brussels.

VERONICA

Latin and Italian: Veronica; French, Véronique, Bérénice; German: Veronika. First century. Feast day 12 July.

LIFE AND LEGEND

The oldest version of Veronica's life is of the legendary type and appears in a Latin interpolation to an apocryphal text by Nicodemus dating from about the fifth century. Her story is closely linked to the road to Calvary. Christ's feet give way beneath the weight of the Cross. A woman approaches and wipes his face: the imprint of his face remains on the cloth. By the eighth century, this Veil of Veronica was conserved in St Peter's in Rome.

According to a rarer version, the whole episode took place during Jesus' public life, but the stronger tradition has the events taking place on the road to Calvary. Though Veronica does not figure in the Roman martyrology, during the late medieval period she was the subject of considerable popular veneration. Her cult was transmitted by the mystery plays and formed part of the growing tide of Franciscan devotion.

The name Veronica has itself been the subject of discussion. It most probably bears some relation to *vera icona*, a hybrid phrase – half-Latin, half-Greek – meaning true image. According to David Hugh Farmer, the story of Veronica is simply a legend, invented to explain the relic. The extraordinary success of the narrative in the middle ages derived from the increased interest in the(humanity of Christ and in the Passion's more physical aspects. Veronica has recently become the patron saint of photographers, in addition to her traditional role as patron of washerwomen and laundresses.

REPRESENTATION AND ICONOGRAPHY

Since the thirteenth and fourteenth centuries, Veronica's appearance in imagery has remained remarkably consistent. Dressed as a matron, with headscarf or coif, she holds out in front of her a fine cloth veil which carries the imprint of the face of Christ (statue, c.1310, Collegial Church, Ecouis, Eure; Francesco Mochi, sculpture, 1630s, St Peter's, Rome). The tradition which shows an idealized image of Christ derives from the first of the two legends, while the Christ wearing the Crown of Thorns derives from the Gospel of

Nicodemus, and is the commoner from the fourteenth century on. The motif seems to have been particularly popular in the Low Countries in the late middle ages (Robert Campin, c.1430, Städtelsches Kunstinstitut, Frankfurt).

Veronica also appears in various scenes in connection with the Road to Calvary (Schongauer, copper engraving, c.1479; Dürer, *Große Passion* and *Kleine Passion*, 1507-13). Veronica can also be shown in the process of wiping Christ's face (sculpture group, *Calvary*, Plougastel-Daoulas, Finistere, seventeenth century).

Attributes: Headscarf, coif or other headdress. Veil with the effigy of Christ.
Cross-references: Crucifixion, Holy Face.
Bibliography: D. H. Farmer, *Oxford Dictionary of Saints*, Oxford, 1979. E. Mâle, *L'Art religieux à la fin du Moyen Age en France*, Paris, 1949. P. Perdrizet, *De la Véronique et de sainte Véronique*, Prague, 1943, pp. 1-15.

VINCENT OF SARAGOSSA

Latin: Vincentius; Italian: Vincenzo; Spanish: Vicente; French: Vincent; German: Vinzenz.
Deacon and Martyr. Died 304 (traditional date). Feast day 22 January.

LIFE AND LEGEND

Vincent was deacon to Valerius, Bishop of Saragossa, one of the members of the Council of Elvira (c.306). His legend was first detailed by the poet Prudentius (348-c.410/15) in his *Peristephanon*, or Crown of Martyrs (*see* Introduction). By the time of St Augustine (354-430), Vincent's cult had spread all over the Roman Empire.

Thrown into prison by the governor Dacien, he was racked and slashed with iron hooks, roasted upon a gridiron and finally thrown into a prison

St Vincent of Saragossa
Master of Estimariu, fourteenth century. Museu de Arte Antica de Catalunya, Barcelona

strewn with glass (or earthenware) shards. After his death, his remains were laid in a wasteland and defended by a raven from a huge wolf. Dacien then had Vincent's corpse thrown into the sea with a millstone round his neck. Miraculously, the body floats to the shore. One of St Vincent's translations has him taken from Cape St Vincent (in the south of Portugal) to Lisbon, in a boat escorted by two further ravens.

REPRESENTATION AND ICONOGRAPHY

The first depiction of Vincent dates from the eighth century (fresco in the Portian cemetery, Rome). A young man, wearing the deacon's dalmatic, he is shown at prayer. In various episodes of his martyrdom, Vincent is shown tied to the rack (or cross saltire), which is one of his attributes (anonymous retable, fourteenth century, and Jaime Huguet the Elder, altarpiece from Sazria Chapel, mid-fifteenth century, both in the Museu de Arte Antica de Catalunya, Barcelona). The saint's body is protected by a raven against a great wolf (anonymous, fifteenth century, Prado, Madrid); seamen are shown throwing him into the sea with a millstone tied round his neck.

In France, the legend of St Vincent is illustrated on stained glass in the cathedrals of Angers, Bourges and Chartres. The most important episode is Vincent on his gridiron (south door at Chartres). This griddle, which appeared first in Vincent's legend, is then appropriated to the life of St Laurence. From the sixteenth century, the new motif of St Vincent the vine-grower surfaces (painted statue, seventeenth century, Church at Massy-sur-Seine, Aube), and countless brotherhoods commissioned depictions of their patron saint (engraving published in 1697 by La Confrérie St Vincent et St Geneviève, Paris).

Attributes: Dalmatic. Rack or cross saltire. Millstone. Gridiron. Raven. Vine-grower's pruning-knife. Bunch of grapes.
Cross-references: Laurence, Miraculous Sea Voyage.
Bibliography: G. Duchet-Suchaux, *Vincent, un prénom à découvrir*, Paris, 1983.

VINE *see* NOAH, PLANT, VINCENT OF SARAGOSSA.

VIRGIN *see* ANNUNCIATION, ASSUMPTION, CRUCIFIXION, DEPOSITION, ENTOMBMENT, MARRIAGE OF THE VIRGIN, MARY, REVELATIONS, VISITATION.

VIRTUES AND VICES

Italian: le Virtù e i Vizi; French: les Vertus et les Vices; die Tugenden und die Laster.

TRADITION

The theme of the battle between the Virtues and the Vices has as its source a passage in the Epistle to the Ephesians (6:10-20). St Paul advised that the believer "put on the whole armour of God", with the breastplate of righteousness, the helmet of salvation and the sword of the Spirit. In the second century, such metaphors were repeated and embroidered by Tertullian, in *De Spectaculis*, xxix. The poet Prudentius in his *Psychomachia* (fourth century)

divided his description of the Virtues' military campaign against the Vices into seven bellicose episodes. The battle ends with their victory and their entry into the Temple of Wisdom. The manuscript illustrations of this seminal Latin text served as a springboard for a vast iconography, beginning probably as early as the fifth century and continuing throughout the middle ages. Prudentius opposed a series of antagonistic couples: *Fides* (faith) against *Cultura deorum* (the worship of pagan gods); *Pudicita* (modesty) against *Libido* (lust), *Patientia* (patience) against *Ira* (anger), *Humilitas* (humility) against *Superbia* (pride), etc.

REPRESENTATION AND ICONOGRAPHY

From the ninth century on, illuminated manuscripts of Prudentius provide a sequence of definable iconological types. The most frequent scenes show the protagonists confronting one another in single combat. For instance, *Libido* sets about *Pudicita*, who disarms and stabs her. *Superbia* attacks both *Humilitas* and *Spes* (hope), trampling them beneath her horse's hooves, only to fall in a trap set by her colleague *Fraus* (guile).

At first, the Virtues, wearing veils, are dressed in long robes. The appearance of the Vices springs from the sculpted decoration found on Roman monuments, such as Trajan's Column. A capital in the Church of Notre-Dame-du-Port at Clermont-Ferrand (twelfth century), for instance, adopts the archetype provided by manuscripts of the *Psychomachia*. Manuscript influence is also shown by Herrad von Landsberg's drawings on the theme for the *Hortus Deliciarum* (second half of the twelfth century). The twenty combatants – dressed as warrior knights – are shown in twos, with the duel opposing *Humilitas* and *Superbia* opening the battle. The theme still occurs in art as late as the sixteenth century.

The outcome of the battle results in a different series of illustrations. In oriental fashion, the Virtues are shown trampling on their vanquished enemies who lie prone on the ground. The motif occurs in wallpainting in Saint-Gilles and in Montoire. On portal archivolts in St Pierre at Aulnay (c.1130), the Virtues are portrayed fully armed. More or less concealed behind their shields, they appear to be stamping on demonic dragons corresponding to the Vices.

The compositons become more varied in the Gothic period. On the west front of Laon Cathedral (c.1200), eight Virtues stand over the defeated Vices, no longer in the guise of demons but tiny human figures. Each figure is accompanied by an inscription and some of the Virtues possess specific attributes. The theme is repeated at the east door of the north transept in Chartres Cathedral (c.1220). There, practically all the figures have a specific attribute: Prudence has a book, Justice (or Righteousness) a pair of scales. The motif which shows the all-conquering Virtues trampling the Vices underfoot continues throughout the middle ages, though the Virtues can now be found treading on villains from history: *Fides* triumphs over Arius, *Spes* over Judas and *Justicia* over Nero. These allegorical figures may be represented in many different ways and the complex iconology that results remains a question for further research.

Cross-reference: Wise and Foolish Virgins.
Bibliography: M. Evans, "Tugenden" and "Tugenden und Laster", in E. Kirschbaum, *Lexikon der christlichen Ikonographie*, Freiburg im Breisgau, 1968-74, *Allgemeine Ikonographie*, vol. IV, cols. 364-90.

The Visitation
School of Ferdinando
Castiglia, eighteenth century
(detail). Prado, Madrid.

VISITATION

Latin: Visitatio Beatae Mariae Virginis; Italian: Visitazione, Incontro di Maria Virgine con Sant'Elisabetta; Spanish: Visitación de la Virgen; French: Visitation; German: Heimsuchung.
Feast day 31 May (since 1969; formerly 2 July).

TRADITION

In his Gospel, Luke recounts (1:39-56) how a pregnant Mary visited her cousin Elisabeth who was carrying St John the Baptist. "And Mary arose in those days, and went into the hill country with haste, into a city of Juda; And entered into the house of Zacharias, and saluted Elisabeth. And it came to pass that, when Elisabeth heard the salutation of Mary, the babe leapt in her womb" (1:39-41). "Filled with the Holy Ghost", Elisabeth links with Mary's greeting the first sign her baby makes of his presence. There follows Mary's *Magnificat* (1:46-56). "And Mary abode with her about three months, and returned to her own house."

REPRESENTATION AND ICONOGRAPHY

The Visitation of Our Lady is generally addressed in cycles of the Virgin, but can also appear in the Life of Christ and, more rarely, in cycles of St John the Baptist. The earliest surviving examples (fifth century), however, are paired with the Annunciation, an episode which has in common with the Visitation the presence of two figures. The Visitation is centred on the meeting of the two women, while the Annunciation features the archangel. The Visitation takes place in the open air, Mary standing just in front of Elisabeth's house, whereas the Annunciation always occurs indoors. The two women greet each other from a distance and bow (porch of Moissac Church and portal at Reims Cathedral, thirteenth century). The expansion of the cult of Mary and of Franciscan-inspired literature from around the thirteenth century encouraged artists to depict Elisabeth kneeling before the Virgin, thus emphasizing her pre-eminence; in fact, Elisabeth is kneeling before the unborn Christ. This motif became predominant in the Renaissance (Ghirlandaio, 1486-90, fresco, S. Maria Novella, Rome and 1491, Louvre, Paris).

In Germanic countries, the Visitation was on occasion treated realistically (Master Bertram, second quarter of the fourteenth century, Musée des Arts Décoratifs, Paris, shows Mary heavily pregnant). The background too can vary: Master E.S. (1506, Szepmuveszeti Museum, Budapest) and Marx Reichlich (c.1500, Osterreiche Gallerie, Vienna) both show the episode taking place far from the house, in the countryside or street. From the end of the middle ages, the two women are shown kissing. Commentators compare the scene to the meeting of Joachim and Anne at the Golden Gate of Jerusalem. The salutary kiss itself derives from the Roman rite of the kiss of peace.

The cycle of the Visitation includes the following five episodes: Mary's journey, sometimes accompanied by either a maidservant or Joseph; the meeting between the two women; the singing of the Magnificat; the birth of St John the Baptist; Mary's homecoming.

Cross-references: Anne, Annunciation, Elisabeth, John the Baptist, Jesus, Mary, Zacharias.

VITUS

Variant: Guy. Latin: Vitus; Italian: Guido, Vito; French: Guy, Gui; German: Veit.
Martyr. Died c.300. Feast day 15 June.

LIFE AND LEGEND

Of Lucanian roots, St Vitus was, according to legend, born in Sicily. At seven, persecuted for his faith by his father, he fled the parental home in the company of his tutor Modestus and his nurse Crescentia. The three fugitives reached Italy on a boat guided by an angel. In Rome, denounced as a Christian to Diocletian, Vitus was tortured in spite of having exorcised the Emperor's son. Like John the Evangelist, he was flung into a cauldron of burning oil and, like the prophet Daniel, thrown into the lions' den. He was finally hanged with his two companions.

Vitus is popular in Germany and also in Bohemia, where he was the patron of the Imperial family. He is also the patron saint of boilermakers and their related corporations and of dancers. The last is due to the nickname "St Vitus' dance" given to chorea, a disease of the central nervous system that results in uncontrollable movement; the possession of Diocletian's son is commonly held to have been epilepsy.

REPRESENTATION AND ICONOGRAPHY

Until the beginning of the fifteenth century, he is presented carrying a sword and the palm of martyrdom. He is a young boy, wearing the clothes of a nobleman. Sometimes, in his capacity as patron of the Bohemian emperors, he is shown with an ermine wrap, and Imperial crown and orb. He can be shown naked in a cauldron which stands over hot coals. The retable of the Church of the Hermits of St Augustine (fifteenth century, Germanisches Nationalmuseum, Nuremberg) depicts the principal episodes of his legend.

Attributes: Cauldron. Sword. Imperial orb. Crow or raven. Lions.

St Vitus in the Lions' Den
Altarpiece of the Hermits of
St Augustine, fifteenth
century (detail).
Germanisches National-
museum, Nuremberg.

VLADIMIR

Russian: Vladimir Sviatoi, Volodia; Italian: Vladimiro (il Grande); French:
Vladimir de Kiev; German: Wladimir der Heilige.
Russian prince. c.955-1015. Feast day 15 July.

LIFE AND LEGEND

Vladimir, son of a Russian-Norman prince called Sniatoslav and a concubine belonging to his wife's entourage, was brought up as a pagan. At his father's death in a battle against the Bulgarians, Vladimir was forced to flee to Scandinavia. Returning later to Russia, he subdued his brother Jaropolk and took Kiev. He assisted the Byzantine emperors, the brothers Basil II and Constantine VIII, to put down an army rebellion. Fresh from this success, he asked for the hand of their sister, Ann, a request which was granted with the proviso that he first become a Christian. He converted and the wedding took place, Vladimir being christened in the baptistry of Cherson (Herson) in the Crimea.

Once back in Kiev, Vladimir had the entire population baptized. The city managed to elude the increasing political influence of Otto I, Vladimir pursuing his diplomatic ties with the Holy See. He had a new church built in Kiev dedicated to the Virgin Mary. His merit as a saint rests on his promotion – in agreement with Rome – of the Christian religion in lands peopled

by eastern Slavs. Vladimir was also a founding father of the history of what was to become the Ukraine. The Greek Church honours him with the expression *isapostolos*, "equal of the Apostles". His cult is also recognized by the Roman Church and his sons, Boris and Gleb, number among the national saints of Russia.

REPRESENTATION AND ICONOGRAPHY

Vladimir is depicted as a bearded saint, wearing a crown. In one hand, he carries a cross, and in the other, a sword. He is most often shown in the company of his two sons SS. Boris and Gleb, as in a late-fifteenth-century Novgorod icon (Korin Collection, Moscow). He also appears in cycles of the lives of Boris and Gleb (Moscow icon, early sixteenth century, Tretiakov Gallery, Moscow).

Cross-reference: Boris and Gleb.

WELL *see* ISAAC, JACOB, WOMAN OF SAMARIA.

WENCESLAS

Varient: Wenzel; Polish: Waclaw; Czech: Vaclav; Italian: Venceslao; French: Wenceslas; German: Wenzeslaus, Wenzel.
Martyr. Died 1038. Feast day 28 September.

LIFE AND LEGEND

Brought up by his grandmother, Ludmilla, Wenceslas was instrumental in both the promulgation of Christianity and the spread of Germanic influence in his duchy of Bohemia. His brother Boleslaus I assassinated him during a half-pagan, half-nationalist uprising. He is buried in St Vitus Cathedral, Prague. He is venerated as the patron saint of Bohemia and as a Czech national hero.

REPRESENTATION AND ICONOGRAPHY

Wenceslas, wearing either a ducal cap or royal crown, is shown in the armour of a knight, complete with lance and a golden shield decorated with the Imperial eagle (reredos, Wenceslas altar, end of the fourteenth century, Aachen Cathedral). His martyrdom is a frequent subject (School of Cranach, 1543, Wenceslas Chapel, St Vitus Cathedral, Prague). The saint often carries a bunch of grapes and a wine-press (choirstalls, Church at Bardowieck, Czech Republic).

Attributes: Ducal cap or royal crown. Knight's armour, with lance and shield. Dagger. Bunch of grapes and wine-press (rarely).
Cross-reference: Stanislas.
Bibliography: O. Kletz, "Der heilige Wenzeslaus im Spiegel der Kunst", *Die christliche Kunst*, 28, 1931-32, pp. 289-300.

WHALE *see* **BRENDAN (PREACHING), JONAS (THROWN TO, SWALLOWED** *or* **REGURGITATED), MALO (ABBOT TAKING MASS).**

WHEEL *see* **CATHERINE OF ALEXANDRIA (BROKEN, WITH SWORD), CHRISTINA (NEAR LAKE, WITH MILLSTONE), ELIJAH (CHARIOT OF FIRE), EZEKIEL (TETRAMORPH).**

WHIP *see* **AMBROSE (THREE-CORD WHIP), COLUMBAN (ABBOT), FLAGELLATION OF CHRIST.**

WHORE (OF BABYLON) *see* **REVELATIONS.**

WILDERNESS *see* **EXODUS, MOSES, TEMPTATIONS OF CHRIST.**

St Wenceslas
Sixteenth century. St Wenceslas Chapel, St Vitus Cathedral, Prague.

WILLIAM OF GELLON

Latin: Guilielmus; Italian: Guglicmo; Spanish: Guillermo; French: Guillaume de Gellone; German: Wilhem.
Hermit. Died 812. Canonized1066. Feast day 28 May.

LIFE AND LEGEND
William (in Provençal, Guilhem or Guillem) was, through his mother Aude, the grandson of Charles Martel. He was commanded by Charlemagne to defend the Marca in Spain. The Battle of Orbien against the Saracens, at Villedaigne, Aude, was indecisive. In 801, William helped in the taking of Barcelona. He was a friend of Benedict of Aniane and founded the monastery of Gellone, where he took orders on 28 May 812. He was the hero of a celebrated cycle of *chansons de geste*.

REPRESENTATION AND ICONOGRAPHY
William is shown as a beardless young man in armour, carrying a sword or a lance with a standard. He can wear a helmet or else hold one in his fist. A miniature (*The Hours of the Maréchal de Boucicaut*, c.1410, Musée Jacquemart-André, Paris) shows him in the robes of a Benedictine, carrying his helmet. A scene in which Benedict gives William his habit has also been treated (painted panel, St Guillaume, Strasbourg, sixteenth century): the saint

St William of Gellon
Boucicaut Hours, fifteenth
century. Musée Jacquemart-
André, Paris.

has a coat of mail bolted to his skin by two blacksmiths. From the seventeenth century on, he is constantly confused with the founder of the Gulielmites, William of Malavalla (twelfth century), a bearded figure, often depicted as a hermit, with a coat of mail beneath a black cloak.

Attributes: Helmet. Ducal crown. Armour. Sword. Lance with standard.
Bibliography: B. Perdrizet, "Saint Guillaume", *Archives alsaciennes d'histoire de l'art*, 1932.

WINE PRESS *see* CRUCIFIXION, WENCESLAS.

WISE AND FOOLISH VIRGINS

Latin: Prudentes et fatuae virgines; Italian: Virgini savie e fatue; Spanish: Virgines prudentes y fatuas; French: Vierges sages et vierges folles; German: klugen und törrichten Jungfrauen.

TRADITION

Matthew is the only Evangelical source for this parable (25:1-13). Ten maidens await the arrival of the bridegroom. When he finally arrives, the lamps of the five who brought oil with them are still lit, whereas the lamps of those who forgot their supplies have gone out: these virgins are the *virgines fatuae*, the Foolish Virgins. The narrative ends with an urgent plea: "Watch therefore, for ye know neither the day nor the hour wherein the Son of man cometh" (25:13). The Evangelist stresses the close links between this parable and the Last Judgment. The Fathers of the Church furnished abundant commentary on this theme and on its symbolic relationship to the Judgment. The young girls whose lamps remain lit stand for the elect; the others, taken unprepared by the bridegroom's arrival, are the damned. The parable can also be compared to the theme of the Vices and the Virtues and to the Virgin Mary, who receives the blessed into heaven. The spread of the theme was encouraged by mystery plays.

The Wise and Foolish Virgins
Martin de Vos, sixteenth
century. Musée Jeanne
d'Aboville, La Fère.

Representation and Iconography

The theme of the Wise and Foolish Virgins appears in the fourth century (fresco, catacomb of S. Cyriaca, Via Tiburtina, Rome). In the sixth century, the whole parable is illustrated in a manuscript of Byzantine origin (*Codex Rossanesis*). The Wise Virgins, wearing veils and flowing white robes, carry flaming torches. The Foolish Virgins, whom Jesus forbids to enter Paradise, sport striped clothes. The theme became frequent in the middle ages and, linked to the Last Judgment, features as a complementary element on reveals, door casings, lintels and archivolt mouldings (door trim, centre portal, west front, Basilica of St Denis, near Paris, c.1140). The Virgins are also associated with the Coronation of Mary or with the Church and Synagogue.

Only in thirteenth-century Germany does the theme appear in life-size monumental sculpture, most often at the Portal of the Virgin (*Brautpforte*, Magdeburg Cathedral). In France, such large-scale monumental treatment in high relief is reserved for seminal themes (Annunciation, Visitation, Last Judgment). Unlike the alternative preferred by French sculptors of the Gothic period, the Wise Virgins walk towards Christ as bridegroom, and the Foolish ones towards Satan, a garishly dressed seducer. A dose of realism characterizes those sculpture groups based on the Magdeburg prototype. In the seventeenth century, Abraham Bosse transformed the theme into a genre scene, with Louis XIII costumes and decor (seven etchings). In the nineteenth century, Blake (watercolour, c.1822, Fitzwilliam Museum, Cambridge) and Peter von Cornelius (c.1815, Kunstmuseum, Düsseldorf) also treated the subject.

Attributes: Torches (early middle ages). Lamps (upright for the Wise Virgins, upside down for the Foolish Virgins).
Cross references: Church and Synagogue, Coronation of the Virgin, Last Judgment, Virtues and Vices.

Wise Men *see* Magi.

Woman of Samaria

Italian and Spanish: la Samaritana; French: la Samaritaine; German: die Samariterin.

Tradition

St John's Gospel is the only one to report this parable (4:1-38). Jesus, crossing Samaria on his way to Galilee, found himself near the city of Sychar at Jacob's well, on land given by Jacob to his son, Joseph. Christ rested near the well, while the disciples went off to get supplies from the town. A woman from Samaria came up to the well to draw water. Jesus asked her, "Give me to drink." The woman, astonished that a Jew should address a Samaritan, answered, "How is it that thou, being a Jew, askest drink of me, which am a woman of Samaria?" (4:9). Jesus replied that if she knew who he was and if she had asked him for drink, he would have given her "living water". The woman observed that Jesus carried nothing to draw water with: "From whence then hast thou that living water?" Jesus asserted, however, that "whosoever drinketh of the water that I shall give him shall never thirst" (4:14). She believed and added, "I know that Messias cometh, which is called Christ" (4:25). And Jesus declared: "I that speak unto you am he."

The disciples' arrival made the woman run off, dropping her waterpot.

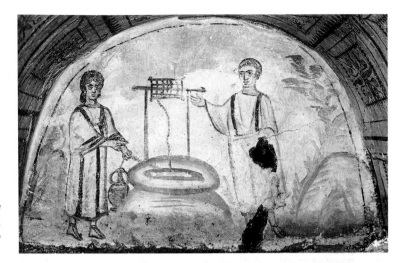

**Jesus and the Woman of
Samaria at the Well**
Fourth century. Catacomb
in the Via Latina, Rome.

In the town, she told everyone, "Come, see a man, which told me all things that ever I did: is not this the Christ?" The people gathered at the well. The disciples begged Jesus to eat the food they had brought, but he replied: "My meat is to do the will of him that sent me, and to finish his work" (4:34), and then went on to tell them the parable of the sowers and the reapers.

Exegesis has treated Jacob and Rachel at the well (Gen. 29:10-14) as a prefiguration of the woman of Samaria at Jacob's well. By the same token, water – the source of life described by Christ – has been seen as a parallel to the water of baptism, and the food brought by the disciples to the Eucharist and to submission to divine will.

REPRESENTATION AND ICONOGRAPHY
The theme in its basic form as found in catacomb art presents Jesus, the woman and sometimes one or two apostles coming back from the town of Sychar. Occasionally, Jesus holds the shaft of his Cross, so underlining the deeper message of the parable. By the ninth century, the scene occurs in Carolingian manuscripts. It is rarer in medieval monumental sculpture (back of the west front of Reims Cathedral, thirteenth century). Through the influence of liturgy, the woman of Samaria is sometimes linked to the woman taken in adultery – the Friday following the Third Sunday after Lent, the reading is taken from John 4:5-42; the next day, the parable of the adulteress is read (John 8:11). From the sixteenth century, the theme became universal and more frequent (Veronese, 1580, Kunsthistorische Museum, Vienna; in *pietre dure*, G.A. Caroni et al, c.1600, Kunsthistorisches Museum, Vienna; Rembrandt, 1655, Berlin-Dahlem Staatliche Museen, Berlin, and Metropolitan Museum of Art, New York; 1659, Hermitage, St Petersburg.)

Cross-references: Jacob, Woman taken in Adultery.
Bibliography: L. Réau, op. cit., vol. II, 2, pp. 322-4.

WOMAN TAKEN IN ADULTERY

Italian: Adultera davanti a Cristo; Perdón de la adultera; French: Femme adultère; German: Ehebrecherin vor Christus.

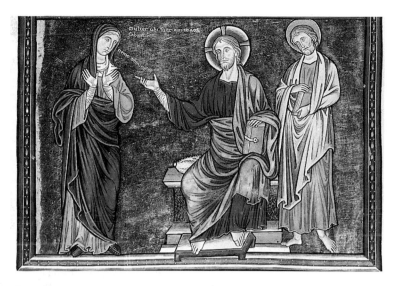

**Christ and the Woman
taken in Adultery**
Ingeburge Psalter, 1210.
Musée Condé, Chantilly.

TRADITION

This episode figures solely in St John's Gospel (8:1-11). While Jesus was teaching in the Temple, the Scribes and Pharisees brought him a woman taken "in the very act" of adultery. In such a case, the law prescribed stoning (Deut. 22:22-23). "But what sayest thou?" they asked. Jesus did not reply but bent down and wrote on the ground. As they pressed further, he replied: "He that is without sin among you, let him first cast a stone at her" (John 8:8). One by one they left, until Christ was alone with the woman: "Hath no man condemned thee? ... Neither do I condemn thee: go, and sin no more" (8:10-11).

REPRESENTATION AND ICONOGRAPHY

From earliest times, this text has been considered as the distillation of the Christian spirit of forgiveness freely given. The scene is linked to that of the woman of Samaria at the fountain (mosaic, S. Apollinare Nuovo, Ravenna, sixth century). The weeping woman kneels beseechingly before Christ (enamelled earthenware dish, attributed to the School of Bernard Palissy, c.1580, British Museum, London). A series of manuscript miniatures (tenth and eleventh centuries) incorporates the various episodes: Christ is shown teaching; the woman is presented to him; Christ addresses her. One tradition (mosaics at Monreale, Sicily, twelfth century) centres on showing Christ either writing on or pointing to the ground. This sequence is the most widespread from the end of the middle ages to the nineteenth century (Poussin, 1653, Louvre, Paris; Blake, watercolour, 1810, Fine Arts Museum, Boston).

Cross-reference: Woman of Samaria.
Bibliography: L. Réau, op. cit., vol. II, 2, p. 324. E. Schedelmayer, *Die Ehebrecherin vor Christus*, Paris, 1912.

WOMEN AT THE HOLY SEPULCHRE *or* AT THE TOMB *see* HOLY WOMEN AT THE SEPULCHRE.

YAHWEH *see* JEHOVAH.

ZACCHAEUS *see* CHRIST'S ENTRY INTO JERUSALEM.

ZACHARIAS

Variant: Zachary. Italian: Zaccaria; Spanish and German: Zacharias; French: Zacharie.

TRADITION

The Gospel according to St Luke tells of a "certain priest named Zacharias, of the course of Abia" (Luke 1:5), who is alerted by an angel that his wife, Elisabeth, will give birth to a boy called John. Zacharias treats this prophecy with scepticism: "I am an old man, and my wife well stricken in years" (1:18). The messenger, the archangel Gabriel, pronounces that he will remain blinded until the day the prediction is realized. The future St John the Baptist is born and so puts an end to his mother's "reproach among men" for her sterility.

REPRESENTATION AND ICONOGRAPHY

Zacharias is shown in isolation from the beginning of the middle ages. He appears as a high priest, with pectoral and mitre. He is often found with Elisabeth and John the Baptist. His iconography is, however, not a vast one

The Visions of Zacharias
Herrad von Landsberg,
Hortus Deliciarum, c.1180.

(A. Vittoria, sculptures on the tympanum and the stoup in S. Zaccaria, Venice, sixteenth century). Most of the time, Zacharias appears in cycles of the life of St John the Baptist, during the flight into the wilderness of St Elisabeth with her child.

Attributes: Pectoral. Mitre.
Cross-references: Anne, Elisabeth, Gabriel, St John the Baptist, Visitation.

ZECHARIAH

Italian: Zeccaria; Spanish and German: Zacharias; French: Zacharie.
Prophet.

TRADITION
The Book of Zechariah, one of the "minor prophets" who lived in the sixth century BC, recounts, as well as his eight visions, certain discourses and a number of prophecies announcing a Messiah who is "lowly, and riding upon an ass" (Zec. 9:9). Christ refers to this passage during his Entry into Jerusalem. He sends two of his disciples to fetch "an ass tied, and a colt with her: loose them, and bring them unto me ... All this was done, that it might be fulfilled which was spoken by the prophet" (Matt. 21:2-5).

REPRESENTATION AND ICONOGRAPHY
The heralding of a Messiah sitting on an ass is often depicted (archivolt moulding, St Honoré Portal, Amiens Cathedral, thirteenth century). In the fifth of Zechariah's visions (4:2), he discovers a seven-branched candlestick. The angel asks him, "What seest thou?" and the prophet replies, "I have looked, and behold a candlestick all of gold [and] seven lamps thereon, and seven pipes to the seven lamps". The woman of the seventh vision is enclosed in a bath ("ephah", 5:8) and carried up to heaven by two angels. She symbolizes the evil and wickedness expelled forever from the Holy Land and sent to rule over their own kingdom on the other side of the world (quatrefoil medallion, façade of Amiens Cathedral, thirteenth century).

There are rare later portrayals of Zechariah having his visions (Michel Crozet, late eighteenth century, Musée des Augustins, Toulouse, with the prophet pronouncing above eight eyes ensconced in a rock).

Attribute: Seven-branched candlestick.

The Prophet Zechariah
Claus Sluter, *Well of Moses*, 1395-1405. Chartreuse de Champmol, Dijon.

ZODIAC

TRADITION
It was observed in antiquity that the known planets never strayed in their apparent movement from the annual path followed by the sun. The zone in which the planets seem to orbit extends around seven degrees on either side of this path, called the ecliptic. The zone itself was termed the zodiac (from the Greek *zodiakos kuklos*, animal circle). This oblique strip, inclined to the equator, was divided into twelve equal areas, each corresponding approximately to a constellation, with the sun being supposed to cross one of them every month; the areas themselves were named with "signs" at an early date, in Sumer and Babylon. The system thus contrived by Babylonian astronomers/astrologers is closely linked to the earthly calendar which derives from it, but also has connections with magic and religion.

Zodiac
From an undated
manuscript. Bibliothèque
Municipale, Boulogne
sur Mer.

The Egyptians, who adopted the zodiac at a relatively late date (around
the sixth century BC), introduced a system of "decans" in which the twelve
signs are divided up into three equal parts each of ten degrees. The thirty-
six bands so constructed correspond to the thirty-six astral gods. The signs
of the zodiac were employed by various different religions at the end of the
ancient period – from Zoroastrianism to the cult of Mithra – in building up
their theologies. They were still of considerable importance in medieval spec-
ulative philosophy and iconography, in spite of being subjected to attack from
the Fathers of the Church.

REPRESENTATION AND ICONOGRAPHY

The signs of the zodiac are in general accompanied by depictions of the
labours of the months (sculpted column at Souvigny, Indre et Loire; piers
in Ripoll, Catalonia). The combination can also be found on Romanesque
tympana at Aulnay de Saintonge and at Vézelay, for example, where the
zodiac gives a cosmic dimension to the iconographical scheme. An astro-
logical theme originating in antiquity and continuing throughout the mid-
dle ages links parts of the human body with specific signs: this so-called
melothesia is still to be found in the fifteenth century, in the *Très Riches Heures
du Duc de Berry* (Limburg brothers, from 1413, Musée Condé, Chantilly), and
in the sixteenth with the *Grant Calendrier et Compost des Bergers* by Nicolas
Le Rouge.

The zodiac is used throughout the baroque period in painting to sym-
bolize the universe and, by extension, the omnipotence of God, and is espe-
cially frequent in large-scale frescoes on domes and cupolas. Combined with
the labours of the months or with the seasons, it is also a frequent subject
in sixteenth-century tapestries.

The signs of the zodiac
SPRING
Aries, the Ram: generally treated as the first, since the beginning of the year was held to be the spring equinox
Taurus, the Bull
Gemini, the Twins, occasionally shown as Castor and Pollux
SUMMER
Cancer, the Crab
Leo, the Lion
Virgo, the Virgin
AUTUMN
Libra, the Scales
Scorpio, the Scorpion
Sagittarius, the Archer, sometimes a centaur with a bow
WINTER
Capricorn, the Goat, often with a twisted tail as hindquarters
Aquarius, the Water-carrier
Pisces, the Fish, generally two

Bibliography: "Zodiaca", *Enciclopedia Cattolica*. F. Caumont, "Zodiacus", in Daremberg et al., *Dictionnaire des Antiquités grecques et romaines*, Paris, 1919. F. Kirschbaum, *Lexikon der christlichen Ikonographie*, Freiburg im Breisgau, 1968-74, "Zodiacus", *Allgemeine Ikonographie*, vol. II.

Attributes and their associated figures

Altar candle(s)
 Blaise, Brendan, Bridget of Sweden,
 Libyan Sibyl, Lucy
Angel (dictating)
 Matthew
Antlers (with crucifix)
 Eustace
Anvil
 Eligius
Archbishop's robes
 Charles Borromeo
Ark
 Noah
Armour
 William
Arrows
 Christina of Bolsena, Edmund,
 Sebastian, Ursula
Ass
 Martin
Ass's jawbone
 Samson
Aspergillum
 Martha
Axe
 John the Baptist
Banner
 Joan of Arc
Banner with cross
 the Church, George, Maurice
Battleaxe
 Olaf
Bats' wings
 Devil
Bear
 Columban, Gall, Martin
Beard
 Noah
Beehive
 Ambrose, Bernard
Bees
 Bernard
Bell
 Antony of Egypt
Bellows
 Gudule
Bible
 Jerome
Biretta
 Francis Xavier, Ignatius of Loyola,
 Ivo, Philip Neri
Bishop's vestments
 James the Less, Valentine
Blindfold
 the Synagogue
Blue clothes
 Libyan Sibyl
Boar
 Cyricus

Boat
 Julian
Boiling oil
 John
Book
 Albert the Great, Ambrose, Anna,
 Anne, Bernard, Bridget of Sweden,
 Catherine of Siena, Columban,
 Cumaean Sibyl, Dominic, Elizabeth
 of Hungary, Fiacre, Genevieve,
 Januarius, Jeremiah, Mark, Matthew,
 Paul, Remigius, Simon the Zealot,
 Valentine
Book (closed)
 the Synagogue
Book (open)
 the Church
Book of *Constitutions*
 Ignatius of Loyola
Book of Revelations
 John
Bow
 Sebastian
Branch (leafy)
 Isaiah
Breastplate
 Olaf
Breasts (severed)
 Agatha, Anastasia
Bull
 Blandina, Luke, Perpetua
Bull (brazen)
 Eustace
Camelskin tunic
 John the Baptist
Candle
 Genevieve
Candlestick with
 seven branches, Zechariah
Cardinal's hat
 Charles Borromeo, Jerome
Carding-comb
 Blaise
Carpenter's tools
 Joseph of Nazareth
Carthusian habit
 Bruno
Cauldron
 Maccabees
Censer
 Aaron
Chain (broken)
 Libyan Sibyl
Chains
 Denis, Peter
Chalice
 the Church, Eligius, Laurence
Chalice (with emerging
 Christ Child), Hugh of Lincoln

Chalice (with emerging snake)
 John
Chariot (heavenly)
 Ezekiel
Chariot of fire
 Elijah
Child (dictating)
 Matthew
Chrism (in phial)
 Remigius
Christ Child
 Antony of Padua, Christopher
Ciborium
 Barbara
Cistercian habit
 Bernard
Cloak
 Martin
Cloven feet
 Devil
Club
 Samson
Coal
 Isaiah
Cockerel
 Odilia, Peter
Columns
 Samson
Cord (round neck)
 Charles Borromeo
Cow
 Perpetua
Crab
 Francis Xavier
Crook
 Genevieve
Cross
 Helen, Margaret, Philip
Cross (inverted)
 Peter
Cross (with olive branch)
 Clare
Cross (processional)
 Laurence
Cross saltire
 Andrew, Vincent
Crow
 Vitus
Crown
 Bridget of Sweden, Christina of
 Bolsena, the Church, Cunegund,
 David, Edmund, Edward the
 Confessor, Elizabeth of Hungary,
 Eulalia, Helen, Louis, Olaf,
 Radegund, Sophia, Wenceslas,
 William
Crown (on ground)
 the Synagogue

BIBLIOGRAPHY

ART AND ICONOGRAPHY

Anderson, M. D. *History and Imagery in British Churches*, London, 1971.

Aurenhammer, H. *Lexikon der christlichen Ikonographie*, Vienna, 1959.

Barbier de Montaux, X. *Traité d'iconographie chrétienne*, 2 vols., Paris, 1890.

Baümer, R. and L. Scheffczyck *Marianlexicon ...*, 4 vols., St Ottilien, Belgium, 1988-92.

Behling, I. *Die Pflanze in der mittelalterlichen Taffelmalerei*, Weimar, 1957.

Bible in Art, The, Phaidon, London, 1956.

Boespflug, F.-D. and N. Lossky *Nicée II (787-1987): douze siècles d'images religieuses*, Paris, 1987.

Braun, J. *Tracht und Attribute der Heiligen in der deutschen Kunst*, Stuttgart, 1964.

Cahier, C. *Caractéristiques des saincts dans l'art populaire*, 2 vols., Paris, 1867.

Callot, Jacques *Les Images de tous les saints et saintes de l'année*, Paris, 1636.

Childe, Heather and Dorothy Colles, *Christian Symbols: Ancient and Modern*, London, 1971.

Corblet, C. *Vocabulaires des symboles et des attributs employés dans l'iconographie chrétienne*, Paris, 1877.

Daniélou, Jean *Les Symboles chrétiens primitifs*, Paris, 1961; trans. Donald Attwater, *Primitive Christian Symbols*, London, 1964.

Delehaye, Hippolyte *Les Légendes hagiographiques*, 3rd edn., Brussels, 1927.

Didron, Adolphe Napoléon *Iconographie chrétienne*, Paris, 1843; trans. E. J. Millington, *Christian Iconography*, 2 vols., London, 1851.

Didron, Adolphe Napoléon *L'Evangile. Etudes iconographiques at archéologiques*, 2 vols., Tours, 1874.

Drake, Maurice and Wilfred *Saints and their Emblems*, London, 1916.

Dubois, J. and J. L. Lemaître, *Sources et méthodes de l'hagiographie médiévale*, Paris, 1993.

Duchet-Suchaux, G. and M. *Les Ordres religieux*, Paris, 1993.

Every, George *Christian Mythology*, London, 1970.

Ferguson, George *Signs and Symbols in Christian Art*, London, 1954; 2nd edn., New York, 1961.

Garnier, F. *Le Langage de l'image au Moyen Age*, 2 vols., Paris, 1982-89.

Geldart, Ernest *A Manual of Church Decoration and Symbolism*, Oxford and London, 1899.

Grabar, André *Les Voies de la création en iconographie chrétienne*, Paris, 1979; trans. Terry Grabar, *Christian Iconography, a Study of its Origins*, Princeton, N.J., 1968.

Greene, E. A. *Saints and their Symbols*, London, 1913.

Guénébault, L.-J. *Dictionnaire iconographique des légendes, figures et actes des saints*, Paris, 1850.

Hall, James *Dictionary of Subjects and Symbols in Art*, rev. edn., London, 1984.

Heath, Sidney *The Romance of Symbolism*, London, 1909.

Hughes, Robert *Heaven and Hell in Western Art*, London, 1968.

Hulme, Edward *Symbolism in Christian Art*, London, 1891; rev. edn., Dorset, 1976.

Husenbeth, F. C. *Emblems of Saints*, London, 1850.

James M. R. *The Apocalypse in Art*, London, 1931.

Jameson, Mrs Anna Brownell *Sacred and Legendary Art*, 2 vols., London, 1848.

Jameson, Mrs Anna Brownell *Legends of the Monastic Orders*, London, 1850.

Jameson, Mrs Anna Brownell *Legends of the Madonna, as represented in the Fine Arts*, London, 1890.

Kaftal, G. *Saints in Italian Art*, 4 vols., Florence, 1978-86.

Katzenellenbogen, A. *Allegories of the Virtues and Vices in Medieval Art*, 2nd edn., London, 1989.

Kirschbaum, Engelbert, ed. *Lexikon der christlichen Ikonographie*, 8 vols., Freiburg im Breisgau, 1968-1976.

Kuenstle, K. *Ikonographie der christlichen Kunst*, 2 vols., Freiburg im Breisgau, 1926-1928.

Mâle, Emile *L'Art religieux du XIIème siècle en France*, 7th edn., Paris, 1966; trans. Marthiel Mathews, *Religious Art in France, the Twelfth Century*, Princeton, N.J., 1978.

Mâle, Emile *L'Art religieux du XIIIème siècle en France*, 9th edn., Paris, 1958; trans. (1) Dora Nussey, *The Gothic Image: Religious Art in France of the Thirteenth Century*, London and Glasgow, 1961; trans. (2) *Religious Art in France, the Thirteenth Century*, Princeton, N.J., 1984.

Mâle, Emile *L'Art religieux de la fin du Moyen Age en France*, 5th edn., Paris, 1949; trans. *Religious Art in France, the late Middle Ages*, Princeton, N.J., 1986.

Mâle, Emile *L'Art religieux du XIIème au XVIIIème siècle*; trans. *Religious Art, from the Twelfth to the Eighteenth Century* (selections), London, 1949.

Mâle, Emile *L'Art religieux après le concile de Trent*, Paris, 1932.

Milburn, Robert *Saints and their Emblems in English Churches*, Oxford, 1949; rev. edn., Malvern, 1991.

Molsdorf, W. *Christliche Symbolik in der mittelalterlichen Kunst*, 2nd edn., Leipzig, 1926.

Nieuwbarn, M. C. *Church Symbolism*, London, 1910.

Pastoureau, M. *Figures et couleurs: Etudes sur la symbolique et la sensibilité médiévales*, Paris, 1986.

Pitt-Rivers, George *The Riddle of the "Labarum" and the Origin of Christian Symbols*, London, 1966.

Post, W. Ellwood *Saints, Signs and Symbols*, London, 1964.

Réau, Louis *Iconographie de l'art chrétien*, 6 vols., Paris, 1955-59.

Reed, Olwen *An Illustrated History of Saints and Symbols*, Bourne End, 1978.

Sachs, A., et al. *Christliche Ikonographie in Stichworten*, Munich, 1975.

Schiller, Gertrud *Ikonographie der christlichen Kunst*, 5 vols., Gütersloh, 1971-80; trans. Janet Seligman, *Iconography of Christian Art*, London, 1971- .

Seznec, J. *La Survivance des dieux antiques*, Paris, 1980.

Taylor, Gladys, *Saints and their Flowers*, London, 1956.

Tervarent, G. de *Attributs et symboles dans l'art profane, 1450-1600*, 2 vols., Geneva, 1958-9.

Urech, E. *Dictionnaire des symboles chrétiens*, Neuchâtel, 1972.

Whittick, Arnold *Symbols, Signs and their Meanings*, London, 1960.

Wimmer, O. *Kennzeichen und Attribute der Heiligen*, Innsbruck, 1987.

LIVES OF SAINTS

Attwater, Donald *A Dictionary of Saints*, Harmondsworth, 1965.

Baudot, J. *Dictionnaire d'hagiographie*, Paris, 1925.

Benedictines of Paris, *Vie des saints et des bienheureux*, 13 vols., Paris, 1935-59.

Benedictine monks of St Augustine's Abbey, Ramsgate *The Book of Saints: a Dictionary of Servants of God canonized by the Catholic Church*, 6th edn., London, 1994.

Bibliotheca sanctorum, 14 vols., Rome, 1961-86.

Butler, Alban *Lives of the Saints*, 4 vols., rev. edn., London, 1954.

Butler's Lives of the Saints, ed. Michael Walsh, new concise edn., Tunbridge Wells, 1991.

Coulson, J. *Dictionnaire des saints*, Paris, 1924.

Farmer, David Hugh *The Oxford Dictionary of Saints*, 3rd edn., Oxford, 1992.

Histoire des saints et de la sainteté chrétienne, 11 vols., Paris, 1986-90.

Holweck, F. G. *A Biographical Dictionary of the Saints*, London, 1924.

Reclams Lexikon der heiligen und der biblischen Gestalten, Munich, 1968.

Voragine, James [Jacobus de] *Legenda aurea* [Golden Legend], c.1270, trans. into French by Jean de Vignay before 1340; into English, published by William Caxton, 1483; *The Golden Legend of master William Caxton done anew*, ed. F. S. Ellis, printed by William Morris at the Kelmscott Press, London, 1892; David A. Mycoff, *Legenda aurea: a critical edition of the legend of Mary Magdalena from Caxton's "Golden Legend" of 1483*, Salzburg, 1985.

Picture Credits

Page references are to illustrations in black-and-white, roman plate numbers to illustrations in colour.

Alinari-Giraudon 26 (bottom), 33, 43, 60, 64, 230, 237, 292, 308, 330
Anderson-Giraudon 9, 38, 55, 86, 94, 101, 114, 165, 189, 203, 215, 233, **256,**
 267, 294, 310, 322 (top), 324, 342
Artephot/Colotheque: cover/jacket
Bayerische Staatsbibliothek, Munich 209
Bernard Biraben 303
Bibliothèque Nationale, Paris 21 (both), 24 (top), 25, 27, 32 (bottom), **50, 56,**
 57, 58, 65, 70, 73, 78, 88, 89, 95, 104, 117, 128, 142, 156, 172, 177 (both),
 182, 186, 193, 220, 236, 242, 243 (bottom), 246, 270, 290, 311, 313, **332,**
 333
Bodleian Library, Oxford 102 (top)
British Library, London 55, 167
Brogi-Giraudon 207
Bulloz 66, 69, 139, 262, 346 (top)
CFL-Giraudon XIX
CNMHS—Lonchampt-Delehaye/© 1990 Spadem 272
Direction générale du tourisme, Paris 287
Flammarion 26, 34, 36 (both), 47 (top), 76, 100, 106, 120, 125, 136, **140, 160,**
 173, 187, 198, 213, 225, 228, 229, 231 (bottom), 269, 277 (both), **336, 337,**
 350, 351
Garancher-Lauros-Giraudon
Germanisches Nationalmuseum, Nuremberg 343
Giraudon 14, 29, 37, 38, 42, 47 (bottom), 49, 62 (top), 74, 75, 77, 115, **118,**
 123, 126, 130, 131, 133, 138, 144, 155, 162, 166, 169, 175 (both), **176, 180,**
 184, 185, 192, 195, 197, 199, 200, 202, 204, 214, 218, 221, 222, 223, **231**
 (top), 245, 250, 254, 258, 263, 265, 271, 282, 285, 291, 293, 296, **297, 300,**
 302, 306, 314, 318, 322 (bottom), 323, 327, 331, 334, 338, 349, IX, **XI, XIII,**
 XIV, XV, XXI, XXIX, XXXII
Hanfstaengl-Giraudon 135, 228
Hurault 150, 317
Marie-Odile Jaquet 181
Hubert Josse VII, XVIII, XXIV, XXV, XXXI
Kunsthistorisches Museum, Vienna 19
Lauros-Giraudon 23, 46, 54, 63, 67, 80, 84, 102 (bottom), 108, 109, 11**2, 146,**
 152, 159, 164, 170, 235, 239, 243, 253, 304, 315, 320, 345, 346 (bottom), II
Jean Lechartier 147 (top), 219
Erich Lessing/Magnum 157, III, VI, VIII, X, XII, XVI, XVII, XIV, XXVI, **XXVII,**
 XXVIII, XXX
Pont. comm. di Arch. sacra 15, 40, 348
Réunion des musées nationaux, France V, XX
Scala 205, I, IV, XXII, XXIII
Skira 45, 87
Tosi 275
Leonard Von Matt, Switzerland 122, 248
Walters Art Gallery, Baltimore 141 (all)